THE BACKYARD ASTRONOMER'S GUIDE

FIREFLY BOOKS

THE BACKYARD ASTRONOMER'S GUIDE

THIRD EDITION REVISED AND EXPANDED

TERENCE DICKINSON & ALAN DYER

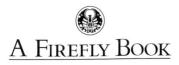

Published by Firefly Books Ltd. 2008

Copyright © 2008 Terence Dickinson and Alan Dyer

All rights reserved. No part of this publication may be reproduced, stored in a retrieval system or transmitted in any form or by any means, electronic, mechanical, photocopying, recording or otherwise, without the prior written permission of the Publisher.

First Printing

Publisher Cataloging-in-Publication Data (U.S.) Dickinson, Terence.

The backyard astronomer's guide / Terence Dickinson ; and Alan Dyer. 3rd ed.

[368] p. : photos. (some col.) ; cm. Includes bibliographical references and index. Summary: An illustrated guide to equipment and techniques for amateur astronomers. Includes full-color atlas of the Milky Way, how to use a telescope, observation tips, how to use a digital camera to shoot the night sky and updated information on astronomy software and computerized equipment.

ISBN-13: 978-1-55407-344-3 ISBN-10: 1-55407-344-8 1. Astronomy – Amateurs' manuals. 2. Astronomy – Observers' manuals. I. Dyer, Alan. II. Title. 520 dc22 QB64.D535 2008

Published in the United States by Firefly Books (U.S.) Inc. P.O. Box 1338, Ellicott Station Buffalo, New York 14205

Produced by Bookmakers Press Inc. 12 Pine Street Kingston, Ontario K7K 1W1 (613) 549-4347 tcread@sympatico.ca

To Susan, who inspires me always.

—T.D.

For all the friends I've met under the stars. —A.D.

Printed in China

Robbie Cooke

Original design by

Library and Archives Canada Cataloguing in Publication

Dickinson, Terence

The backyard astronomer's guide / Terence Dickinson and Alan Dyer. – 3rd ed. Includes bibliographical references and index. ISBN-13: 978-1-55407-344-3 ISBN-10: 1-55407-344-8

1. Astronomy – Amateurs' manuals. I. Dyer, Alan, 1953 - II. Title. QB64.D513 2008 522 C2008-900204-0

Published in Canada by Firefly Books Ltd. 66 Leek Crescent Richmond Hill, Ontario L4B 1H1

Front Cover: CCD image of Horsehead Nebula in Orion by R. Jay GaBany

Other books by Terence Dickinson: NightWatch The Universe and Beyond Exploring the Night Sky Exploring the Sky by Day From the Big Bang to Planet X Other Worlds Summer Stargazing Splendors of the Universe (with Jack Newton)

The Publisher gratefully acknowledges the financial support for our publishing program by the Government of Canada through the Book Publishing Industry Development Program.

Foreword

Astronomy: Getting Started Right

Do you suppose there's an "astronomy gene" coded into human nature?

I don't know whether such a thing exists —probably doesn't—but you do have to wonder. Everybody feels a tug from the stars under the right circumstances. Even the most committed urban dwellers, totally at home in the world of concrete, are stunned when they confront an inky-black sky strewn with stars. There's something in that sight to make any person grow very quiet.

The everyday world we live in is a much noisier place, audibly, visually and informationally. Too many of us live our entire lives in that world without getting more than brief glimpses of what lies on the other side of sunset. The grand spectacle of night parallels our human world, dwarfing it, in fact. But for many people, the only personal experience they have of astronomy is what they see on vacation far from civilization the north woods, perhaps, or the desert or far out at sea.

This unfamiliarity with the sky sometimes has a funny side. Tales are told of people who see the Milky Way clearly for the first time and worriedly demand to know what's happened—there's all that smoke in the sky! (Confession time: Even experienced skygazers can fall for this. While observing on a dark, moonless night, I once mistook the rising Milky Way for oncoming clouds and prepared to pack up the telescope.) Others are astonished to learn that you can see the Moon almost every day of the month and that stars can be found in the daytime.

The night sky's remoteness from human affairs creates almost a cultural barrier for anyone caught by an interest in astronomy. Not surprisingly, the science of astronomy —astrophysics, really—is forbiddingly complex and requires years of professional training. But even astronomy as practiced by amateur astronomers lies very far from most people's everyday knowledge. For them, even finding Square One, let alone moving off it, is a big challenge.

Planetariums and science museums offer informative, even thrilling programs. But the shows and displays are always mediated by professionals, and the voyage away from Earth is scripted tightly. Even the best of them is no substitute for exploring the heavens on your own.

This is by far the best book I know of for helping anyone become a knowledgeable skygazer. Terry and Alan have spent most of their lives as backyard astronomers. And their jobs regularly bring them into contact with beginners who stand in astronomy's doorway, wondering how to come in. The guidebook they have written has such newcomers firmly in mind, and if you, too, feel the tug of the stars, there's no better place to begin than here.

> — Robert Burnham former Editor-in-Chief, Astronomy magazine

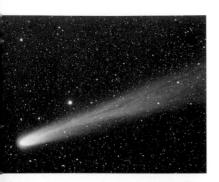

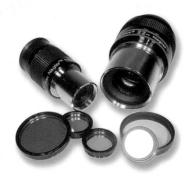

CONTENTS

.....

Introduction	9
Chapter One: Amateur Astronomy Comes of AgeNaturalists of the Night • Amateur Astronomy Today • Are You Ready?	10
PART 1: Choosing Equipment for Backyard Astronomy	
 Chapter Two: Binoculars for the Beginner and the Serious Observer Selecting Binoculars • Exit Pupil • Field of View • Eyeglasses and Binoculars Binocular Tests • Recommendations • Giant Binoculars 	18
 Chapter Three: Telescopes for Recreational Astronomy A Brief History of Telescopes • Choosing a Telescope • The Magnification Scam Photographic Fever • Types of Optics • Decoding Telescope Specs • Surveying the Telescope Market • Signs of a Good Starter Scope • The Mounting Menagerie Pros and Cons of Telescope Types • Do You Need a GoTo Telescope? • The 8-inch Schmidt-Cassegrain • Recommended Telescopes • The Used-Scope Lot 	28
 Chapter Four: Essential Accessories: Eyepieces and Filters Focal Length • Field of View • Calculating Power • Eye Relief • Coatings • Wide-Field Eyepieces • Long-Eye-Relief Eyepieces • Nagler-Class Eyepieces • Barlow Lenses Eyepiece and Barlow Performance • Recommended Eyepieces • Coma Correctors Planetary Filters • Lunar Filters • Deep-Sky or Nebula Filters 	64
 Chapter Five: The Backyard Guide 'Accessory Catalog' Upgraded Finderscope • Reflex Sighting Devices • Red Flashlight • Dew-Remover Coils Polar-Alignment Scopes • Heavy-Duty Tripods and Wedges • Wheeley Bars and Scope Covers • Collimation Tools • Digital Setting Circles • Binocular Viewers • Domes and Shelters • Focus Motors • Astro-Travel and Touring 	
 Chapter Six: Using Your New Telescope Decoding Directions • The Mount • The Optical Tube • The Tripod • How a Telescope Moves • Telescope Assembly, a 10-Step Program • Daytime Adjustments • Getting Lined Up • Sharpening the Finder • Nighttime Use • Doing the Equatorial Tango 	.00

PART 2: Observing the Celestial Panorama 41

Chapter Seven: The Naked-Eye Sky

• Phenomena of the Day Sky • Halos and Sundogs • Phenomena of the Sunset Sky

• A Change of Latitude • First-Light Do's and Don'ts • Top 10 Newbie Questions

• Earth's Shadow • Phenomena of the Darkening Sky • Earthshine • The Best Planetary Conjunctions 2008-2020 • Phenomena of the Dark Sky • Meteors • Fireballs and Meteorites • Auroras • Our Home in the Galaxy • Recording Your Observations

Chapter Eight: Observing Conditions: Your Site and Light Pollution

• The Eroding Sky • Dark-Sky Preserves • Observing From the City • Evaluating the Observing Site • Rating Your Observing Site • Remote Observing Site • Conventions at Dark-Sky Sites • Limiting-Magnitude Factors • Averted Vision

156

126

Chapter Nine: Observing the Moon, Sun and Comets

• Lunar Observing • Is There Anything Left to Discover? • Equipment for Lunar Observing • Solar Observing • Solar Viewing by Projection • Solar Filters for Telescopes • Comets • Bright Comets: 1957 to 2007 • Discovering a Comet

Chapter Ten: Observing the Planets

- The Lure of Other Worlds Observing Mercury by Day Venus Telescopic Appearance Observing Mars Mars Oppositions Planetary Filters Jupiter
- Jupiter's Four Major Satellites Saturn Saturn's Satellite Family Uranus Neptune

Chapter Eleven: Finding Your Way Around the Sky

- How the Sky Works As the World Turns Under the Celestial Sphere The View From Space March of the Constellations Path of the Planets Wobbling Earth
- Ecliptic Highs and Lows Learning to Star-Hop Fifth-Magnitude Star Atlases
- Sixth-Magnitude Star Atlases Seventh-Magnitude Star Atlas Eighth-Magnitude Star Atlas Ninth-Magnitude Star Atlas Eleventh-Magnitude Star Atlas

Chapter Twelve: Exploring the Deep Sky

- The Deep-Sky Zoo Distribution of Deep-Sky Objects Low-Power Limit
- Messier's Catalog The NGC and IC Herschel's Catalog Beyond the NGC
- Deep-Sky Tour One: The Stars It's All Greek to Me Deep-Sky Tour Two: Star Clusters • Deep-Sky Tour Three: Where Stars Are Born • Asterisms, the Un-Clusters
- Glowing Gas Clouds Dark Nebulas: Silhouettes on the Sky Deep-Sky Tour Four: Where Stars Die • Deep-Sky Tour Five: Beyond the Milky Way • The Local Group
- Galaxy Groups Sketching at the Eyepiece The Great Southern Sky

PART 3: Advanced Tips and Techniques

Chapter Thirteen: Digital Astrophotography

- The DSLR Revolution Point and Shoot vs. DSLR Lenses and Accessories
- Tripod Subjects Star Trails Time-Lapse Shooting Working With Webcams
- Selecting a Telescope and Mount for Astrophotography Piggyback Shooting
- Prime-Focus Deep Sky Guiding Tips and Techniques Dark Frames Image Processing and Enhancement

Chapter Fourteen: High-Tech Astronomy

• SkyScout and MySky • GoTo Tips and Techniques for Any Telescope • Guide to Software • Planetarium Programs • Star-Charting Programs • Connecting Telescope and Computer

Chapter Fifteen: Polar Alignment, Collimation and Cleaning

• Polar-Aligning Fork-Mounted Telescopes • Polar-Aligning German Equatorial Mounts • Polar Sighting Scopes • Cleaning Telescope Optics • Collimating Telescope Optics • Star-Testing Optics • Atlas of Aberrations

The Milky Way Atlas by Glenn LeDrew

Epilogue Further Reading Index The Authors 172

186

206

232

272

306

316

338

360

362

365

368

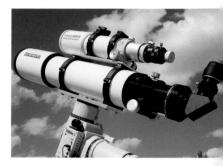

Facing page, top to bottom:
Terence Dickinson, Mike
Wirths, Terence Dickinson,
Alan Dyer (both). This page,
top to bottom: Terence
Dickinson, Alan Dyer (both)

INTRODUCTION

Since the publication of the first edition of *The Backyard Astronomer's Guide* in 1991, amateur astronomy has evolved in several important areas. This prompted a major rewrite and redesign for the Second Edition in 2002. Even more rapid developments since then bring us to this Third Edition and another major overhaul, which now expands the book substantially beyond its original 295 pages.

As always, new developments in equipment are behind most of the revisions, led by affordable computerized telescopes and the entry of China as a major player in telescope manufacture. More unexpected was the speed of the digital-camera revolution, which opened a new wonderland of astrophotographic opportunities undreamed of in the days of film. That, combined with a wider array of telescopes and accessories at better prices than ever before, meant that every chapter required revisions, ranging up to a complete rewrite of the astrophotography section, Chapter 13.

In response to readers' requests for howto reference guides to fundamental telescope setup, use and maintenance procedures, we've added two new chapters (14 and 15). More than 200 new photos and illustrations accompany these changes, both major and minor, in every chapter. (Prices given are average U.S. dollar dealer prices.) To keep the text uncluttered and readable, we have avoided embedding a lot of website addresses throughout. To locate the websites for companies and products described, simply Google the names. Finally, at the back of the book, we've added a beautiful and practical Milky Way atlas, created by Glenn LeDrew.

In almost all cases, we have used photographs of equipment that were taken in the field and in our own studios rather than relying on stock shots from manufacturers. (We've really used this equipment!)

In many respects, this book is a sequel to coauthor Dickinson's *NightWatch: A Guide to Viewing the Universe*, which emphasizes reference material for the absolute beginner. In *The Backyard Astronomer's Guide*, we provide more in-depth commentary, guidance and resources for the enthusiast.

We invite readers to visit the book's website (see below), where updates and links to other informative sites can be found.

> Terence Dickinson NightWatch Observatory

Alan Dyer Telus World of Science-Calgary

website: www.backyardastronomy.com Big Dipper over Canadian
 Rockies by Alan Dyer.

C H A P T E R O N E

Amateur Astronomy Comes of Age

There is something deeply compelling about the starry night sky. Those fragile flickering points of light in the blackness beckon to the inquisitive mind. So it was in antiquity, and so it remains today.

Only in the past two decades or so, however, have large numbers of people chosen to delve into stargazing—recreational astronomy—as a leisure activity. Today, more than half a million people in North America call themselves amateur astronomers.

The magic moment when you know you're hooked usually comes with your eye at a telescope eyepiece. It often takes just one exposure to Saturn's stunningly alien, yet serenely beautiful ring system or a steady view of an ancient lunar crater frozen in time on the edge of a rumpled, airless plain.

The stars wheeling overhead at night beckon backyard astronomers outside fur a personal exploration of the cosmos, whether from an urban home or a rural retreat away from city lights. Time-exposure photo by Alan Dyer.

Naturalists of the Night

American 19th-century poet and essayist Ralph Waldo Emerson once wrote:"The man on the street does not know a star in the sky." Of course, he was right then and now. Well, almost. In recent years, a growing number of people want to become acquainted with the stars. Sales of astronomy books, telescopes and astronomy software have reached alltime highs. More people than ever before are enrolling in the astronomy courses offered by colleges, universities and planetariums. Summer weekend gatherings of astronomy enthusiasts for telescope viewing and informative talks (known among the participants as "star parties") now attract thousands of fans. There is no mistaking the signals: Astronomy has come of age as a mainstream interest and recreational activity.

Not coincidentally, the growth of interest in astronomy has paralleled the rise in our awareness of the environment. The realization that we live on a planet with finite resources and dwindling access to wilderness areas has generated a sharp increase in activities which involve observing and appreciating nature: birding, nature walks, hiking, scenic drives, camping and nature photography. Recreational astronomy is in this category

Wait Until Dark 🕨 The twilight colors are fading, the sky is growing darker, and the telescope is beginning its task of revealing celestial wonders at a woodland campsite. Just when most people are retreating inside, recreational astronomers are gearing up for hours of exploration under the stars. Once the pursuit of an eccentric few, astronomy is now the pastime of people of all ages. Photo by Alan Dyer.

too. Amateur astronomers are naturalists of the night, captivated by the mystique of the vast universe that is accessible only under a dark sky.

In recent decades, the darkness that astronomy enthusiasts seek has been beaten back by the ever-growing domes of artificial light over cities and towns and by the increased use of security lighting everywhere. In many places, the luster of the Milky Way arching across a star-studded sky has been obliterated forever. Yet amateur astronomy flourishes as never before. Why? Perhaps it is an example of that well-known human tendency to ignore the historic or acclaimed tourist sights in one's own neighborhood while attempting to see everything when traveling to distant lands. Most people now perceive a starry sky as foreign and enchanting rather than something that can be seen from any sidewalk, as it was when our grandparents were young.

That is certainly part of the answer, but consider how amateur astronomy has changed in two generations. The typical 1960s amateur astronomer was usually male and a loner, with a strong interest in physics, mathematics and optics. In high school, he spent his weekends grinding a 6-inch f/8 Newtonian telescope mirror from a kit sold by Edmund Scientific, in accordance with the instructions in Scientific American telescope-making books. The fourfoot-long telescope was mounted on what was affectionately called a plumber's nightmare—an equatorial mount made of pipe fittings. In some cases, it was necessary to keep the telescope out of sight to be brought out only under cover of darkness to avoid derisive commentary from the neighbors.

Practical reference material was almost nonexistent in the 1960s. Most of what there was came from England, and virtually all of it was written by one man, Patrick Moore. Amateur astronomy was like a secret religion—so secret, it was almost unknown.

Thankfully, that is all history. Current astronomy hobbyists represent a complete cross section of society, encompassing men and women of all ages, occupations and levels of education. Amateur astronomy has finally come into its own as a legitimate recreational activity, not the pastime of perceived lab-coated rocket scientists and oddballs. Indeed, it has emerged as a leisure

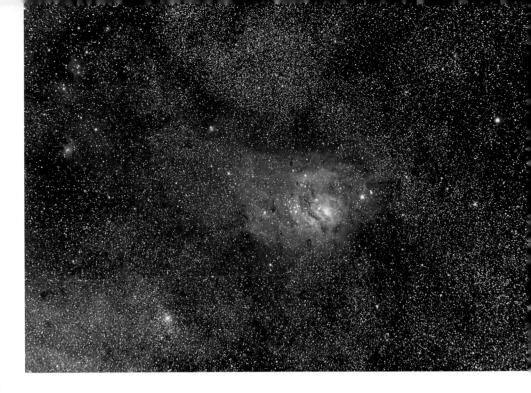

activity with a certain prestige. Unlike some hobbies, it is not possible to buy your way into astronomy. Astronomical knowledge and experience take time to accumulate. But be forewarned: Once you gain that knowledge and experience, astronomy can be addictive.

AMATEUR ASTRONOMY TODAY

Amateur astronomy has become incredibly diversified. No individual can master the field entirely. It is simply too large; it has too many activities and choices. In general, though, amateur astronomers divide fairly easily into three groups: the observers, the techno-enthusiasts and the armchair astronomers. The last category refers to people who pursue the hobby mainly vicariously —through books, magazines, lectures, discussion groups or conversations with other aficionados. Armchair astronomers are often self-taught experts on nonobservational aspects of the subject, such as cosmology or astronomical history.

The techno-enthusiast category includes telescope makers and those fascinated by the technical side of the hobby, especially the application of computers to astronomical imaging and telescope use and the application of technological innovations related to amateur-astronomy equipment. It can also involve crafting optics, though this type of telescope making is less prevalent than ▲ Star-Formation Nebula At a distance of 5,000 lightyears, the Lagoon Nebula is faintly visible to the naked eye and easy in binoculars. Photo by Alan Dyer.

▼ Sharing the Sky Although traditionally a lone pursuit, amateur astronomy is now more often enjoyed together by families and friends.

Red-Light District

Amateur astronomy has few regulations and little formality, but show up at a star party like this with white lights blaring, and you'll be in for a rude greeting. To preserve night vision, red lights are the rule. The Texas Star Party near Fort Davis (right) is one of the meccas of amateur astronomy. Photo by Alan Dyer.

Looking Up 🔻

While a special event such as a comet can awaken a latent interest, the sky presents us with something new and wonderful to see every night.

it was a few decades ago. With the vast array of commercial equipment available today, "rolling your own" is not the common activity it once was.

This book is written primarily for the third kind of amateur astronomer, the observer, one whose dominant interest in astronomy is to explore the visible universe with eye and telescope. Observing, we believe, is what it is all about. The exhilaration of exploring the sky, of seeing for yourself the remote planets, galaxies, clusters and nebulas—real objects of enormous dimensions at immense distances—is the essence of backyard astronomy.

GETTING IN DEEPER

Amateur astronomy can range from an occasional pleasant diversion to a fulltime obsession. Some amateur astronomers spend more time and energy on the hobby than do all but the most dedicated research astronomers at mountaintop observatories. Such "professional amateurs" are the exception, but they are, indeed, the true amateur astronomers—that is, they have selected an area which professional astronomers, either by choice or through lack of human resources, have neglected. They are, in the purest sense, amateurs: unpaid researchers.

In the past, such impassioned individuals were often independently wealthy and able to devote much time and effort to a singleminded pursuit. This is seldom the case anymore. For instance, Australian Robert Evans is a pastor of three churches, has a family with four daughters and is by no means a man of wealth or leisure. Yet he has spent almost every clear night since 1980 searching for supernovas in galaxies up to 100 million light-years away. He discovered 18 within a decade—more than were found during the same period by a team of university researchers using equipment designed exclusively for that purpose.

Similarly, most bright comets in recent years have been found by committed amateur astronomers. However, the persistent supernova or comet hunter represents just a tiny fraction of those who call themselves amateur astronomers. The vast majority —at least 99 percent—are more accurately described as recreational backyard astronomers. Although this term has not gained wide usage, it more precisely describes what most amateur astronomers do. They are out enjoying themselves under the stars, engaging in a personal exploration of the universe that has no scientific purpose beyond selfedification. It's challenging and fun.

Backyard astronomy was neatly summed up a few years ago in *Astro Notes*, the newsletter of the Ottawa Centre of The Royal Astronomical Society of Canada: "The objective is to explore strange new phenomena, to seek out new celestial objects and new nebulosities, to boldly look where no human has looked before...and mainly to have fun."

Tom Williams, a chemist by profession and an astronomy hobbyist from Houston, Texas, has taken an interest in the distinction between the vast majority of casual stargazers and the handful of scientific amateurs. Williams points out some parallels with ornithology: "There are 15 million bird watchers in North America, but they call themselves birders, not amateur ornithologists. The real amateur ornithologists are the few thousand people involved in migration analyses, and so on." Similarly, he notes, "Of the 500,000 astronomy hobbyists, the same small percentage are scientific

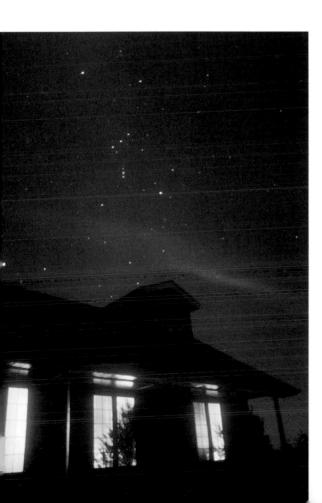

amateur astronomers who contribute in some way to research. The rest are recreational astronomers. The majority are in these activities for pure enjoyment, nothing more." The somewhat confusing aspect is that both groups—the scientific amateurs and the recreational amateurs—call themselves the same thing: amateur astronomers.

That is not to say there is no place for systematic and potentially scientifically valuable observing. Quite the contrary. But it is not every backyard astronomer's duty. Some choose to take a more rigorous approach to the hobby; most do not. Our book is dedicated to the latter group.

REACHING FOR THE STARS

Some of the activities of astronomy buffs totally baffle those not afflicted with the bug. Take the arrival of Comet West, for instance, one of the brightest comets visible from midnorthern latitudes in the past century. Comet West was at its best in early March 1976, but the weather over much of North America was terrible. Astronomy addicts were having severe withdrawal symptoms as they stared at the clouds each night, knowing that the comet was out there, just beyond reach. In Vancouver, several young enthusiasts decided that they had had enough."The comet was peaking in brightness. We had to do something," recalls Ken Hewitt-White, then a producer at Vancouver's MacMillan Planetarium and

▲ Shock Wave of Star-Stuff Backyard telescopes can show us objects such as the Veil Nebula, blown into space by a supernova explosion. While a long-exposure photo reveals stunning colors, most such objects are subtle ghostly glows to the eye. The real thrill comes in knowing the true nature of celestial targets you can find and view for yourself. Photo and eyepiece simulation (inset) by Alan Dyer.

▲ Awarc of the Night You know you are an amateur astronomer when, upon stepping outcide at night, you automatically look up just to see what the sky contains. In this case, the distinctive constellation Orion greets the observer in a moonlit evening sky. Photo by Terence Dickinson.

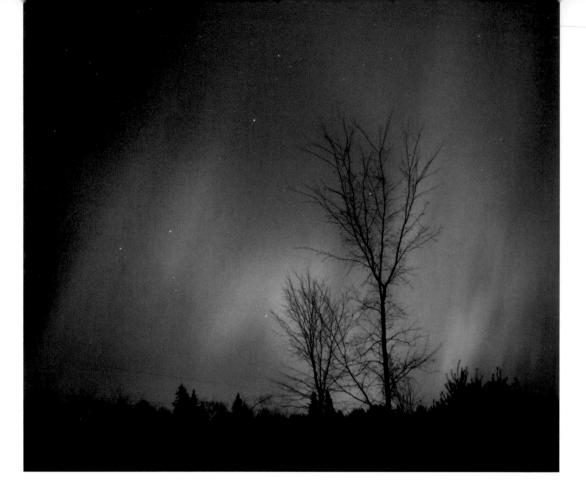

Sky Fire 🕨

A bright, rippling aurora, pulsing in shades of green and red, is one of the sky's most memorable shows. It ranks an 8 on our 1-to-10 scale of sky sights. Photo by Terence Dickinson.

Just Passing Through ▼ When something rare appears overhead, like a bright comet, public interest soars, and even hardened amateur astronomers have been known to go a little crazy, especially if clouds threaten to rob them of the opportunity for a once-in-a-lifetime view. Photo of Comet Hale-Bopp by Ken Hewitt-White.

the mastermind of the Great Comet Chase.

They rented a van and began driving inland over the mountains, which the forecast predicted would be clear of cloud cover by 4:30 a.m., the time when the comet was to be in view. The outlook for Vancouver was continued rain. "There were five of us with our telescopes, cameras and binoculars all packed in the van," says Hewitt-White." A sixth member of our group had to get up early for work and reluctantly stayed behind.

"It was a nightmare from the start—a blinding snowstorm. 'It's got to clear up,'we told each other. We drove 200 miles, and it was still snowing. After a few close calls on the treacherous mountain road, we finally turned back. Then, as we crossed the high point in the Coast Mountains, the sky miraculously began to clear. It was exactly 4:30. We pulled over and immediately got stuck. But we had not gone far enough—a mountain peak blocked the view.

"Five comet-crazed guys in running shoes started scrambling up the snowdrifts on the nearest cliff to gain altitude. By the time we reached a point where the comet should have been in view, twilight was too bright for us to see it. Half-frozen and dripping wet with snow, we pushed the van out and headed back to Vancouver. Within minutes, we drove out of the storm area and saw cloudless blue sky over the city. When we got home, we heard the worst: The guy who stayed behind had seen the comet from a park bench one block from his home."

The eclipse chasers, another subgroup of recreational astronomers, spend countless evenings planning every detail of an eclipse expedition—a trip, sometimes to remote regions of the globe, for the express purpose of standing in the Moon's shadow to watch a total eclipse of the Sun. Given the vagaries of the weather and the inevitable glitches in foreign countries, probably half of these pilgrimages are partial or complete failures. Ventures have been foiled by dust storms blowing away tents, lost luggage, broken-down rental cars and balky camera equipment.

Regardless of the outcome, though, as soon as they get home, the eclipse stalkers whip out maps and start planning the next year's expedition. For anyone who has not seen a total solar eclipse, the behavior may seem odd. But for veteran eclipse chaser Robert May of Scarborough, Ontario, it is "the greatest of all natural spectacles, a truly awesome phenomenon. I want to see every one I can while I am still physically able to do so."May says that for him, eclipse chasing has added a new dimension and a real purpose to foreign travel.

ARE YOU READY?

As we said previously, astronomy is not an instant-gratification hobby. It takes time and effort to appreciate what you are looking at and to coax the best performance out of your telescope or binoculars. Moreover, backyard astronomers come to know how enjoyable it is to hear the "oohs" and "aahs" from people who are looking through a telescope for the first time. The ultimate thrill, though, is to be uttering the oohs and aahs yourself. With this in mind, we offer the backyard astronomer's Aah Factor, a 1-to-10 scale of celestial exclamation.

Factor 1 on the scale is a detectable smile, a mild ripple of satisfaction or contentment. Factor 10 is speechless rapture, an overwhelming rush of awe and astonishment. Here are a few examples to aid in developing your own Aah Factor list.

One: Any routine celestial view through binoculars or a telescope; a faint meteor; a well-turned phrase in a good astronomy book.
Two: Finding the planet Mercury; sunspots; the Moon's surface through a telescope; discovering how clear things look through binoculars mounted on a tripod; cloud belts on Jupiter.

• Three: Saturn or the Orion Nebula through a telescope, even if you have seen them umpteen times before; the starry dome on a clear, dark night in the country; Jupiter's Red Spot; a colored double star.

• Four: A beautiful sunset or sunrise; seeing a bright Earth satellite for the first time; a partial eclipse of the Moon; a close conjunction of two planets or of the Moon and Venus; Earthshine in binoculars; finding the Andromeda Galaxy for the first time.

• Five: Identifying Jupiter's moons through binoculars for the first time; a moderately bright comet in binoculars; telescopic detail on Mars; a meteor shower.

• Six: Recognizing your first constellation; a bright meteor; a good telescopic view of a galaxy or a globular cluster; the shadow of one of Jupiter's moons slowly crawling

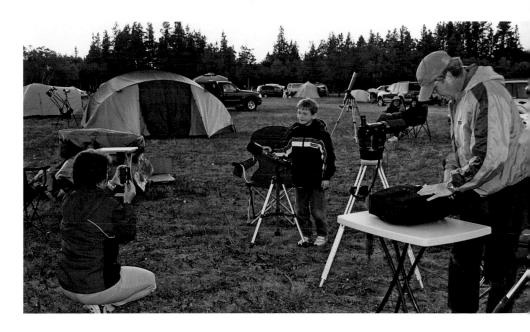

across the planet's face; your initial look at your first successful astrophoto.

• Seven: A first view of the Moon through a telescope; a first view of the Milky Way with binoculars; a total eclipse of the Moon; a bolide or a fireball meteor.

• Eight: A rare all-sky multicolored auroral display; the moment you begin to realize how immense the universe is.

• Nine: A bright comet with a naked-eye tail; your *first* view of Saturn's rings through a telescope; a meteor storm.

• Ten: A perfect view of a total eclipse of the Sun; discovering a comet or a nova.

It is nice to log a two or a three on the scale cach night. Soon, you will be climbing the scale of celestial aahs. It is captivating and addictive. It can even get out of hand. For instance, one rabid enthusiast we know became physically ill while attending a concert with his wife and friends because he had noticed a spectacular aurora brewing when they were parking the car. He felt tortured by not seeing it but did not want to spoil the evening for the others. Such is the power of the night sky. How far you are taken by its spell depends on you.

Of course, there is always the frustration of being clouded out after preparing for an eclipse or other major celestial event for weeks—or even years. This is an activity with frustration minefields along with the rapture. It's not for everybody. But with the help of this book, you will soon know whether it's for you. ▲ Camp Under the Stars No matter where you live, there's a star party near you, where families gather to enjoy the sky.

📥 Star Tours

A feature of many star parties now is a laserguided beginners' tour of constellations and binocular targets, an ideal way to start your lifelong love of the night sky.

Part 1: Choosing Equipment for Backyard Astronomy

C H A P T E R T W O

Binoculars for the Beginner and the Serious Observer

Veteran backyard astronomers always have binoculars within easy reach. Why? Binoculars are midway between unaided eyes and telescopes in power, field of view and convenience. Of all the equipment an amateur astronomer uses, binoculars are the most versatile and the most essential. Yet the capabilities of good binoculars are often underrated by backyard astronomers, especially beginners. This is a pity, because binoculars are so much easier to use than a small telescope.

Admittedly, binoculars are not nearly as exotic as a telescope, yet they can be found in almost any home. Even so, many people ignore them when they think of celestial observing. They purchase a telescope without ever turning their binoculars to the night sky, thinking that only a telescope can truly reveal the universe.

Binoculars are ideal for scanning the Milky Way to reveal star clusters and nebulas or, as here in Australia, for checking out the Magellanic Clouds. Photo by Alan Dyer.

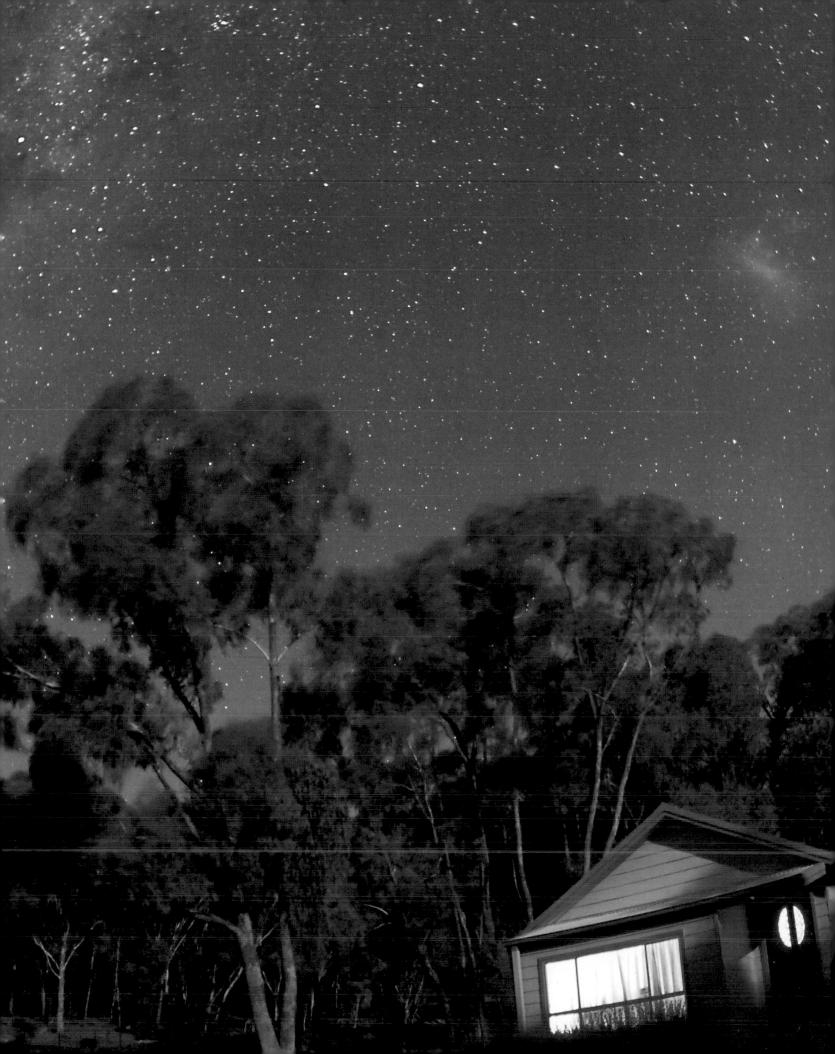

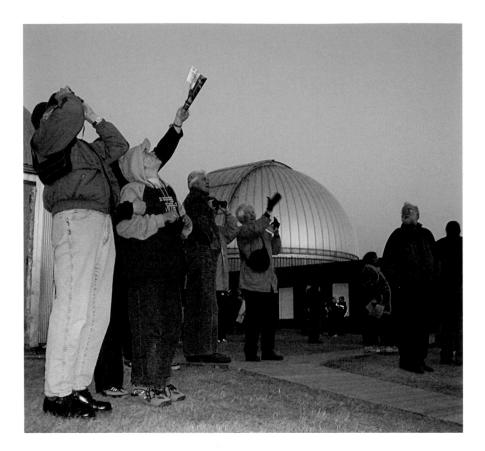

Planet Watch 🔺

During a visit to the local university observatory on a fine spring evening, astronomy enthusiasts raise their binoculars to identify the planets as they become visible in the darkening sky.

Consider the Humble Binocular

Here are some of the celestial objects binoculars will reveal:

• In a dark, moonless sky, ordinary birdwatcher binoculars can pick up more than 100,000 stars, compared with the 4,000 or so visible to the unaided eye. The hazy band of the Milky Way breaks up into countless thousands of stars—one of the great treats in amateur astronomy.

• Star colors, ranging from blue to yellow to rusty orange, are more evident with binoculars than without.

• Any night that Jupiter is visible, two to four of its large moons can be seen close beside the brilliant planet.

• The planets Uranus and Neptune are easy targets with binoculars when you know where to look.

• The Andromeda Galaxy, a huge city

of stars larger than our entire Milky Way Galaxy, is plainly visible as an oval smudge near overhead in autumn and early winter for northern-hemisphere observers.

• Star clusters of exquisite beauty, such as the Pleiades and Hyades, are seen in their entirety in binoculars, whereas most telescopes (because of their smaller fields of view) can show only portions of them.

• On the Moon, at least 100 craters and mountain ranges are visible, as well as subtle shadings on the flat plains that 17th-century astronomers thought were seas.

The utility of binoculars goes far beyond this list. Planets hidden in twilight glow are most often first detected by sweeping with binoculars. Earthshine on the Moon (the faint illumination of the Moon's nightside) is greatly enhanced by binoculars. There is no better instrument for watching a lunar eclipse, for monitoring a planet's motion through a constellation over weeks or months or for observing a bright comet. Nearly every celestial object visible to the eyes alone will be improved by binoculars.

Moreover, binoculars can reveal a multitude of objects completely invisible to the naked eye: nebulas (star-forming regions); wispy remnants of ancient supernovas; and star clusters ranging from bright stellar splashes to dim patches of starlight. Most challenging are the galaxies, great islands of stars like our Milky Way Galaxy that dot the void of deep space. With practice, you can detect several dozen galaxies up to 30 million light-years from Earth. They are not easy to find, but just seeing them with binoculars is astonishing. For 30 million years, the galaxy's light has been on its way to Earth, ending its journey by entering the eyes of a curious observer. Not bad for binoculars.

Easier quarry for beginners are star clusters in the Milky Way. These range from naked-eye collections of stars like the Pleiades to such glittering jewels as the Double Cluster in Perseus or M7 in Scorpius. Hundreds of celestial sights await observers with binoculars, enough to keep a backyard astronomer busy for years. Far from being a substitute for a small telescope, binoculars are indispensable partners in the exploration of the universe.

One further advantage: Using two eyes for celestial viewing allows you to see more. Your body is more comfortable, and the A telescope is not necessary for examining many celestial objects, and sometimes binoculars or even the unaided eyes can provide a better view. This inventory shows the versatility of humble equipment—or no equipment at all.

Naked Eye	Binoculars
constellations*	star clouds o
meteors*	Earthshine of
auroras*	planetary m
Earth satellites*	bright come
solar and lunar halos*	lunar eclipse
a few double stars	details of co
five planets	moons of Ju
planetary motion	dozens of lu
bright comets	dozens of va
a few star clusters	dozens of do
three galaxies	dozens of st
a few nebulas	several gala
a few variable stars	several nebu
solar eclipses	seven plane
lunar eclipses	solar eclipse
largest sunspots	sunspots
Milky Way	bright aster

of Milky Way* on the Moon* notion* ets* es* onstellations* ipiter unar craters ariable stars ouble stars tar clusters axies ulas ets es oids

Telescope

hundreds of double and multiple stars* hundreds of variable stars* hundreds of galaxies* hundreds of star clusters* dozens of nebulas* planetary detail* planetary satellites* planetary phases* thousands of lunar features* sunspots and solar detail* solar eclipses comets lunar eclipses planetary motion lunar occultations asteroids

*Asterisked items in each column indicate the viewing targets most easily seen.

brain is at ease receiving messages from both eyes. When observed with two eyes, objects at the threshold of vision register as real, whereas one-eyed detection produces fleeting and uncertain cerebral messages. How much more can be seen? Experts estimate 40 percent above single-eye viewing.

SELECTING BINOCULARS

Binoculars are, in essence, miniature telescopes—a pair of prismatic spotting scopes reduced in size and linked together in parallel for vicwing with two eyes. The prism system has a threefold purpose: reducing the length of the optical system by folding the light path; reducing the overall weight; and finally, producing a right-side-up image for convenient terrestrial viewing. Binoculars come in a bewildering array of sizes, magnifications, models and prices.Virtually useless toy binoculars with plastic lenses can be had for a few dollars; at the other end of the scale, the colossal Fujinon 6-inch refractor binoculars (25x150) cost as much as a new car. In between, there is something for everybody.

There are two basic types of prism binoculars: porro prism and roof prism. Roof prism binoculars have straight tubes and are generally smaller and more expensive than porro prism models of otherwise equivalent optical size (two 8x40s, for instance). Although roof prism binoculars are available with main lenses up to 63mm in diameter, the primary advantage of the design—compactness—is defeated in sizes over 50mm. Porro prism binoculars, with the familiar humped, Nshaped light-path design, are available in all sizes. For astronomy, we've found good optical performance in roof prism binoculars only in the premium models with features such as phase-corrected coatings. Porro prism models that provide top-notch images are much less costly.

Binoculars have two numbers engraved on the body, such as 7x50, usually near the eyepiece end. The first number is the

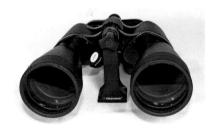

Tripod Adapter

Sky observers consider the inexpensive L-shaped binocular tripod adapter as an essential accessory. A threaded hole at the foot of the L accepts the tripod head screw. The steadied view afforded by the tripod significantly increases the detail visible. When purchasing a new binocular, be sure it has a threaded hole to accept the adapter.

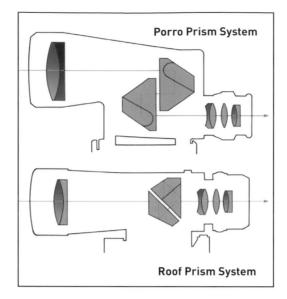

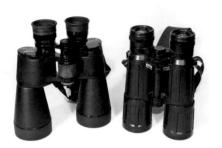

Two Types of Binoculars Roof prism binoculars (on the right) are more compact than porro prism binos in sizes under 42mm. They are generally more costly too. On the other hand, top-of-the-line roof prism glasses are superb in every way. For general astronomy binoculars at a reasonable price, the authors recommend porro prism models in the 7x50 and 10x50 sizes. magnification (the "x" means magnification, or power); the second number is the diameter of the front lenses in millimeters. Thus 7x50 means 7 magnification and 50mm-diameter objectives (main lenses). There are dozens of combinations, from tiny 6x16 binoculars to 25x150 monsters. There are, predictably, advocates of every combination of size and magnification for different purposes. The optimum magnification for astronomical binoculars is a subject of ongoing debate. We'll try to guide you through it.

Acceptable-quality binoculars can be purchased for about \$100. First-class glasses are in the \$200-to-\$500 range. For connoisseurs of fine optics, the sky's the limit. Price is a major guide in this competitive market. There is usually a good reason why one binocular is three times the price of another, even though they may look the same on the outside. We have tested superb binoculars with famous labels, but we've also discovered equally good glasses marketed with labels we'd never heard of before. One thing we didn't find were any zoom binoculars that met our standards of acceptable optical quality for astronomy.

Weight is also an important consideration. Binoculars in the popular 7x50 and 10x50 sizes can range from 26 to 50 ounces. Every ounce counts in astronomy, because binoculars are held tilted above horizontal, a more tiring position than horizontal or lower, as in most terrestrial viewing. We recommend forgoing ruggedness for light weight. Astronomers tend to use their equipment in low-impact environments, so"armor" cladding or "military specs" only add extra baggage. A good binocular weight is 22 to 32 ounces. Most people can hold this weight long enough for a satisfying observation before returning to an arms-down position. In this weight category are the 8x40, 7x42 and 8x42 glasses traditionally used by birders. We regard these sizes as the minimum for astronomy, so if you already own a pair, they could serve perfect double duty.

EXIT PUPIL

In many observing references, you will read that for maximum efficiency under typical low-light astronomical conditions, the light cone exiting the binocular (or telescope) eyepiece—called the exit pupil—should be the same size as that of the dilated pupil of the eye. The theory is that all the light from the instrument should enter the pupil rather than some light falling uselessly on the surrounding iris (the colored part of the eve). Most people under the age of 30 have pupil diameters of seven to eight millimeters in dark conditions. After 30, everyone generally loses one millimeter every 20 years or so throughout life, as the eye muscles become less flexible. So applying the 7mm rule to all observers ignores age variations. Furthermore, the outer edges of the lens of everybody's eyes have some inherent optical aberrations.

For these reasons and as a result of tests we have done on binocular performance using our own eyes with many different binoculars, our conclusion is that the glasses which actually reveal the most detail on all kinds of celestial objects have exit pupils in the 2.5mm-to-4mm range. A binocular's exit pupil need not be measured directly; it can be quickly calculated by dividing the aperture in millimeters by the magnification. For example, 7x50 glasses have 7.1mm (50 \div 7) exit pupils.

An important caveat must be added here: The tests mentioned in the paragraph above were done with the binoculars tripodmounted, to make sure it was an "apples and apples" comparison. But what about the 7mm conventional wisdom? For full details, we refer you to an important article on binoculars in astronomy that is reprinted each year in the annual *Observer's Handbook* of The Royal Astronomical Society of Canada. Written by retired physics professor Roy Bishop, who has had a longstanding interest in this question, the article argues for a new way of evaluating binocular performance.

The principal factors influencing what can be seen in the sky at night with binoculars are the amount of light entering the instrument and the amount it is magnified. No surprise there. But what is surprising is that the most meaningful way of gauging binocular performance on both stars and extended objects like the Moon and nebulas, says Dr. Bishop, is to multiply the aperture in millimeters by the magnification. He calls this the Visibility Factor (VF).

Thus the VF for 7x50s is 350 and for 10x50s is 500. For 11x80s, a common size of giant binocular, the VF is 880. And the VF for the new-generation 18x50 Canon image-stabilized binocular (see page 24) is 900! This is definitely unconventional wisdom. But is it true? Side-by-side tests (by TD) suggest it is. The 18x50s showed the same 10th-magnitude galaxies (NGC3077 and NGC2978) as the 11x80s, both handheld and tripod-mounted. On some celestial objects, 11x80s had the edge; but on others,

the 18x50s revealed more. Overall, it was a draw.

Another point raised by comparisons like this is emphasized by the huge difference in VF between 7x50s and 18x50s, both of which have the same aperture but a large difference in performance. So why not 50x50s? As Dr. Bishop explains, the VF applies to binoculars with exit pupils from 3mm to 7mm.

Now before anyone rushes out to purchase large and/or high-powered binoculars with aVF close to 1,000, a big however has to go in here: To retain the fundamental convenience of binoculars, they should be used handheld and carried on a strap around your neck.

Most people find that 10x is the limit for comfortably holding binoculars, because every quiver of the arms is also magnified by 10x. A steadier view can be had with 7x or 8x glasses. It is here that the 7mm exit pupils of 7x50s have their secret advantage. It's not so much the long-touted matching of the 7mm exit pupil to the eye, but the big exit beams from the 7x50s' eyepieces make it easier for the average observer to get fully illuminated exit pupils positioned where they need to be on the eyes. Even more

🔺 Exit Pupil

The famous 7mm exit pupil is displayed on these 7x50 glasses for all to see. Although many astronomy guidebooks have stated otherwise for decades, the 7mm exit pupil is not necessarily ideal for astronomical binoculars.

Focusing Tip

Most binoculars are brought to focus by turning a knurled knob on the central bar of the instrument. This focuses both eyepieces by the same amount. However, the precise focal point can be slightly different for each eye. To accommodate this, the right binocular eyepiece usually has a separate focusing capability with a scale and a zero point. To set this diopter adjustment, as it is called, focus with the left eye only (right eye closed), using the center focus wheel. Then focus with the right eye only (left eye closed) using *only* the right eyepiece. When the right eye is in sharp focus, note where the right-eyepiece scale is set. Try to remember this setting. Whenever someone else uses your binoculars, you will probably have to reset the scale. Once your diopter is set, just use the center focus wheel to focus for both eyes simultaneously. So-called permafocus binoculars are just a gimmick and are especially unsuited to astronomy. We also avoid "quick-focus" rocker-focus models, which may be fine for other applications but are too coarse for astronomy.

The diopter scale on the right eyepiece is of crucial importance for taking full advantage of your binoculars' optical capabilities. Carefully follow the focusing sequence described above to achieve quick, sure focus.

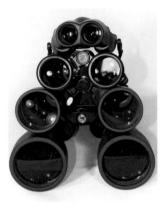

▲ Aperture Compared A misconception is that wider aperture = wider field of view. Not so. More aperture = brighter images; field of view is determined only by the eyepiece design.

important, though, 7x50s have, by their nature, wide fields of view, typically seven degrees. This is the reason we also recommend this size (or the slightly larger 8x56s): They are easy to look through and easy to aim, especially for beginners or in groupobserving situations.

To summarize: Ideally, the objective (front) lenses of astronomy binoculars should be as large as possible for producing the brightest possible image. But hand-holding intervenes, limiting the weight that can be hoisted to the eyes. Fifty-six-millimeter binoculars tend to be the largest size that is convenient to hold for any length of time.

FIELD OF VIEW

The diameter of the circle that can be seen through binoculars is called the field of view.

This is often expressed as the number of feet that span the field when viewed from a distance of 1,000 yards (or meters at 1,000 meters). Thankfully, this awkward nomenclature seems to be fading in favor of the more convenient angular diameter in degrees. For conversion purposes, one degree is equivalent to 52.5 feet at 1,000 yards, or 17 meters at 1,000 meters. Most 7x50 binoculars have seven-degree fields; 10x50s typically have six-degree fields. While some models offer a wider field of view, it often comes at the expense of optical quality.

Binoculars designated as wide-angle or ultra-wide-angle can have 8-to-12-degree fields of view. Invariably, though, these models have severe optical distortions around the edge of the field. This is usually not objectionable in everyday terrestrial use, but in astronomy, when all the stars in

Canon Image-Stabilized Binoculars

Introduced in 1996, these techno-breakthrough binoculars stand apart—way apart from all other binoculars we have ever used. With our first look through these glasses, we immediately lost our socks in the distant trees somewhere, so explosively were they blown off by the views. Ever since, these glasses have been our personal workhorse astronomy binoculars. Because of their unique capabilities, we have singled them out for special treatment here.

Pressing a button atop the binoculars engages motion sensors coupled to tiny microprocessors that control the shape of accordionlike prisms in the light path. The prisms contain a high-refractive-index liquid that bends the light path to compensate for the quivers imparted by the user's arms. We'll dispense with further details. The fact is, the quivering and dancing images so familiar in handheld binoc-

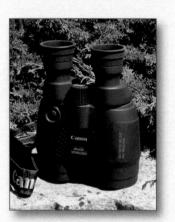

ular views are compensated for instant by instant. The corrections smooth out the jerkiness in a unique, fluidlike manner that most observers find magical. The huge advantage resulting from the stabilization is that magnifications of up to 18x are possible with less image quivering than with standard, unstabilized 7x glasses.

Although Canon produces 10x30, 12x36 and 10x42 image-stabilized models, astronomy buffs gravitate to the 15x50 and 18x50 models. All are roof prism designs with superb optics and wide-angle eyepieces that are among the best we've seen in any binocular at any price. The 15x50 models have a 4.5-degree field; the 18x50 has a 3.7-degree field. Many astronomy users prefer the 15x glasses because they are easier to aim into a starry sky than are the narrower 18x ones. However, the higher power does reveal more detail. Both 50mm glasses have standard threaded holes for tripod mounting. A marginal disadvantage with the 50mm image-stabilized Canons (besides price: about \$1,100) is weight. At 42 ounces, some find them tiring to hold. The excellent 12x36s, though smaller in aperture, are 18 ounces lighter and about half the price.

The 15x50 and 18x50 image-stabilized models are identical in appearance. Depressing the button on top locks in the stabilizer. A second button push (or a five-minute default timer) disengages it. Two AA batteries power the stabilization feature.

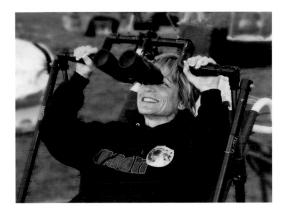

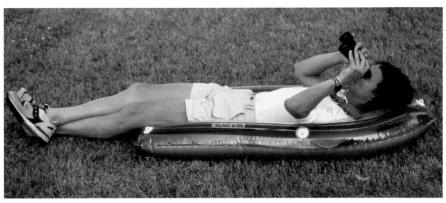

the outer field resemble comets or seagulls, there is no advantage. Frankly, we think the effect spoils the aesthetics of the view. When stars are sharp across the field, it's like looking through a porthole into the universe; but when stars turn into blobs at the edge of the field, it's like looking at the heavens through a glass ashtray. We'll sacrifice the wider field for a sharp one.

EYEGLASSES AND BINOCULARS

Binocular users who must wear eyeglasses for correction of astigmatism or who prefer to keep their glasses on while observing will benefit from so-called high-eyepoint binoculars, designed to push the exit pupil 18mm to 26mm from the surface of the eyepiece lens, compared with 10mm to 15mm for normal binoculars. This allows room for the lens of the glasses to fit between the exitpupil point and the eyepiece.

High-eyepoint binoculars come with oversized rubber eyecups that, when folded down, provide the extra distance for eyeglass users. When up, they act as a guide for positioning the eyes when the user is not wearing glasses. Achieving the high eyepoint requires larger and, consequently, more costly eyepieces. But as the population ages, accommodation for eyeglasses in binoculars has become more common.

BINOCULAR TESTS

As a quick check for viewing comfort and optical quality, follow points one through six outlined here when shopping for binoculars. Point seven is a more rigorous test.

1. Weight. How heavy are the binoculars?

Eliminate all glasses built to withstand jungle warfare. You shouldn't need Arnold Schwarzenegger arms and shoulders to hold them up for a reasonable length of time.

2. Prisms. Hold the binoculars a few inches in front of your eyes, and look in the eyepieces. Aim the glasses at the sky or a window. The illuminated optical path should be completely round and evenly illuminated. Discard those glasses with a squarish rather than a circular appearance to the illuminated field.

3. Craftsmanship. Check all the moving parts. Moderate but even pressure should be required to adjust focus and interpupillary distance. Hold the binoculars with the eyepieces pointing up. With the index finger of each hand, push down on the eyepiece housings, alternating between left and right. Be careful not to touch the actual eye lenses. Look for excessive rocking of the two eyepieces and the bridge that connects them. If they are too sloppy, it will be hard to maintain focus on both sides simultaneously, especially when making contact with your eyebrows.

4. Optics Check. The central area of the field of view should be pin-sharp, with no evidence of fuzziness, false color or double imaging. Many glasses with perfectly acceptable image sharpness in the central region of the field quickly lose their definition toward the edge. We generally rate binoculars unacceptable if the image grows fuzzy less than 50 percent of the way from the center to the edge. This capability can be tested during the daytime by looking at sharp detail, such as the branches of a distant tree or the top of a building against the bright sky. Such testing will also reveal other potential problems. In high-contrast situations, a blue

Observing Comforts Sailing the celestial seas is best done in a boaton land. Try using a small inflatable child's boat (about \$25) to scan the night sky in complete comfort. Head, legs and shoulders are supported more effectively than in a lawn chair. The head can be raised or lowered by varying the leg pressure. Above left: Observer using a swiveling binocular chair made by Astrogizmos.com (\$335).

▲ Eyeglass Mode Many binoculars have fold-down eyecups to accommodate people who wear their glasses while observing. Before buying, be sure to check that the eyecups provide full field-of-view access with eyeglasses on as well as comfortable eye position with eyeglasses off.

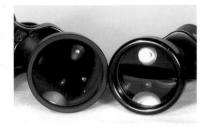

Antireflection Coatings Shining a bright light into the front of your binoculars provides a quick check of coating quality. The multicoated optics on the left exhibit subdued greenish reflections from glass that seems to disappear. On the right are cheap binos with minimal single-layer coatings, whose lenses light up with bright white reflections, making it hard to see into the interior of the binoculars. or green color fringe, called a chromatic aberration, may be obvious around the edge of objects, which is a sign of lower-quality optics.

5. Coatings Check. Light transmission is increased and flare and ghosting from internal reflections are reduced by coatings on the lenses. The best binoculars are multicoated on all optical surfaces, including the prisms. It may be printed on the binoculars themselves or in the literature provided with them that the glasses are coated or multicoated. When held under bright light, coated lenses (meaning single-layer coatings) are generally pale blue, while multicoated lenses usually give off a deep green or purple sheen.

Coating increases light transmission at each optical surface to about 97 percent, compared with 93 percent for no coating. Multicoating lets about 99 percent of the light through at each glass-to-air surface. The problem is determining whether all the optical surfaces are coated—often, they are not. To find out, shine a bright light into the binoculars from the objective (large lens) end. Looking down into the glasses, tilt them slowly back and forth and watch for the multiple reflections from the coated-lens surfaces. All should be roughly equally subdued blue, green or purple, depending on the coatings used. Noticeably brighter white reflections are a sign of uncoated elements.

6. Collimation. If, after using the binoculars for a few minutes, you feel eyestrain and for some reason have to force the images to merge, the binoculars are probably out of collimation, which means that the two optical systems are not precisely parallel. This is the main thing to watch for when purchasing used binoculars. All it takes is accidentally dropping the binoculars from about eye height to the ground for the collimation to be knocked out. It then requires professional attention to repair.

7. Astronomical Testing. Optical perfection is a never-ending quest among amateur astronomers, and all but the very finest binoculars usually yield evidence of some optical imperfections when used to observe the stars. Viewing brilliant point sources on a black background is the most rigorous test of optics. In the center of the field, a bright star should show near-pointlike imagery, with small, irregular spikes emerging from the bright central point. The fewer spikes seen, the better; but the important thing is that they must be symmetrically arrayed around the point, with no obvious flaring in any direction. If you find there is flaring and you normally wear glasses, put them on and

Key Factors to Consider When Selecting Binoculars

• Larger main lenses mean brighter images, but for most people, binoculars with 50mm (or 56mm) main lenses are the practical weight limit for handheld use.

• Binoculars with 7mm exit pupils are easier to bring to correct position in front of the eye, an advantage for young people and beginners of any age.

• Higher magnification means better resolution of detail, but it also means more stringent optical-quality standards to produce sharp images.

• Higher magnification results in amplified jiggling during handheld operation. This factor alone limits binocular magnification for handheld astronomical viewing to 10x (except with image-stabilized binoculars).

• When we put all of this together, the most popular sizes are 7x50 and 10x50, with the 8x56 size also a consideration. For those who prefer smaller and lighter glasses, we recommend the 7x42 and 8x42 sizes.

• All other things being equal, aren't the 10x50s the obvious choice over the 7x50s? But all other things are never equal. Aiming and observing through binoculars at night is much easier for some people than for others. In our experience, 7x50s are easier to use. On the other hand, 10x50 glasses will yield fainter stars and more detail on the Moon and many other celestial objects than will 7x50s. More detail makes sense because of the higher power, but why are dimmer stars apparent if the aperture is the same 50mm? Part of the reason is that the smaller exit pupil helps avoid the edge-of-eye aberrations (producing sharper stars), but mainly, it is that the higher magnification in effect spreads out the sky background, darkening it in the process.

see whether the asymmetry disappears. If it is still there, the binoculars are likely at fault and should be rejected. Now move the bright star toward the edge of the field. It will begin to grow wings, usually parallel to the edge of the field. This indicates astigmatism in the eyepieces, which is nearly always present to some degree because it is a very difficult defect to eliminate in short-focal-length systems such as those of binoculars. Compare carefully, because there are great differences among binoculars in the amount of astigmatism present.

RECOMMENDATIONS

Early in the 21st century, the ground shifted in the low- to mid-priced binocular market as manufacturing adjusted to the entry of an 800-pound gorilla into the marketplace: China. Today, China is the major force in the manufacture of binoculars in the under-\$300 segment. If you have purchased binoculars in that price bracket in the past few years, they were probably made in China. From a value standpoint, this is, on balance, a positive development. We have found that the relative quality and the dollar-for-dollar value of these binoculars are excellent.

For example, for his adult evening astronomy classes, author Dickinson selected the made-in-China Celestron Ultima DX 8x56 binoculars. Considering their price (in the \$200 range), these glasses have excellent optics. After the use of many dozens of pairs, they have proven themselves as both popular and durable and are a good choice for backyard astronomers.

This is not, however, an across-the-board endorsement for Chinese-made binoculars. Yes, most of them are perfectly satisfactory, but some are less satisfactory than others. Take the Celestron Ultima DX 9x63 binoculars, for example, which we have found have notably inferior optics to the Celestron Ultima DX 8x56 binos.

Interestingly, we have discovered that many models of the best-known brand names are no more or less impressive than similarly priced models by relatively unknown manufacturers. For this reason, we urge anyone in the market for new binoculars to compare as many brands and models as possible. The limiting factor is usually finding a well-stocked dealer.

Here are some specific recommendations, starting with the compact Celestron Outland 8x42 roof prism binoculars (about \$100), for the beginner or enthusiast who prefers a smaller binocular than the ones mentioned so far. Moving up to the \$200-to-\$400 class, we like the relative light weight, good eve relief and excellent optics of the Orion Vista 7x50 and 10x50 and the Adlerblick 7x50 and 10x50 by Carton Optics of Japan. Favorites in the high-end class (\$500 and up—sometimes way up) are the 15x50 and 18x50 Canon image-stabilized glasses, already praised earlier. Conventional but superbly crafted glasses in this price category (where brand names definitely do mean something) are the top models of the 7x42 or 8x42 roof prism binoculars from Leica, Zeiss, Nikon and Swarovski-all premium dual-purpose birding/astronomy glasses.

GIANT BINOCULARS

Sizes of giant binoculars used in backyard astronomy are 9x63, 10x70, 15x70, 11x80, 15x80, 20x80, 14x100 and 25x100, and they range from \$100 to several thousand dollars. But once into the over-60mm category, a tripod and binocular-tripod adapter are essential. The steady views through big binoculars are wonderful, but the handheld convenience of standard binoculars is lost.

With the introduction, in the 1990s and early in this century, of a wider selection of short-focal-length 70mm-to-100mmaperture apochromatic refractor telescopes, along with modern eyepieces that can match or approach the low powers and wide fields of giant binoculars, we are less enthusiastic about these big glasses than we were in earlier editions of this book. One of the continuing problems is overhead viewing, even in models with 45-degree eyepicce diagonals, although a few of the more costly giant binoculars have right-angled eyepiece housings that make viewing near the zenith easier on the neck.

Also available, usually from small cottageindustry suppliers, are counterweighted parallelogram holders for cantilevering the binoculars away from the tripod head so that the observer can get underneath them. Even so, you are forced to crane your neck way back to look up; neither of us has ever become a frequent user of these binocular stands.

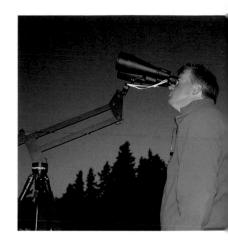

▲ Binoculars Take a Stand A cantilevered binocular stand for big binos can be bulky and costly. It is an effort to set up and is a strain when looking straight up at the zenith.

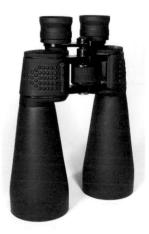

Excellent Big Bino Big binoculars we can highly recommend are the Celestron Skymaster 15x70s. Light in weight and with excellent optics and eye relief, they are a joy to use tripod-mounted or even occasionally handheld for quick scans around the sky. Made in China, the same binoculars are available under various brand names. The Celestron unit sells for \$100-at that price, you can't go wrong!

C H A P T E R T H R E E

Telescopes for Recreational A

With the increasing popularity of recreational astronomy, telescope companies have evolved from basement operations to publicly traded companies. Competition is intense, with manufacturers conducting lavish advertising campaigns.

All too often, such advertisements are the only sources of information many buyers use to make a decision. To widen the information base, we decided to include not only general information on telescope designs but also our opinions about many of the models on the market, recommendations gleaned from our use and testing of dozens of telescopes. We have not relied upon opinion surveys, Internet "wisdom" or secondhand accounts from reviewers we don't know. We report on what we know from firsthand experience, to assist you in choosing a telescope in what has become a complex market.

Astronomy

bewildering array of telescopes from which to choose. One compilation lists more than 1,000 models. From left to right are representative samples: a small refractor (the type that uses a lens to gather light) on a sturdy altazimuth mount, a larger refractor on a German-style equatorial mount, a compact mirror-lens Schmidt-Cassegrain and a Newtonian reflector (one that uses a mirror) on a simple but effective wood Dobsonian mount.

......

Today's buyer has a

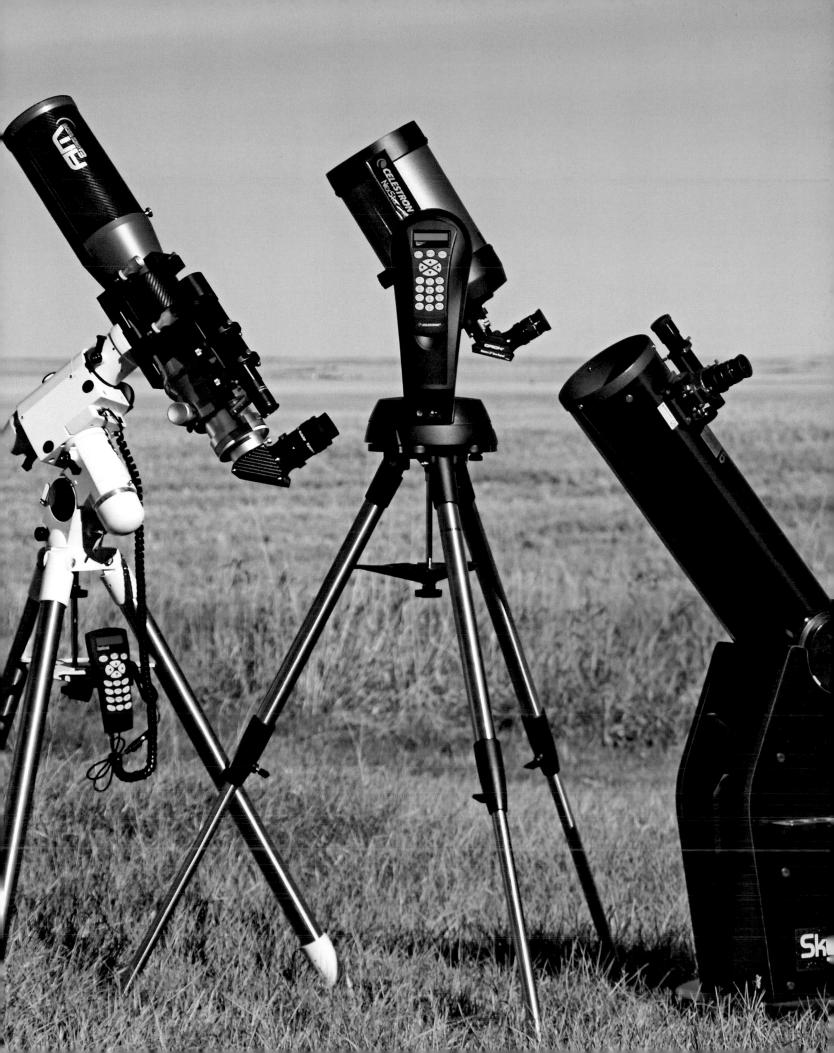

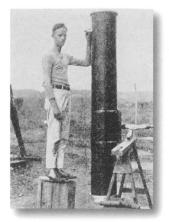

Ancient Astronomy 🔺 How would you like to look through this telescope? The optics were probably fine, but the mount and operating convenience leave something to be desired! Before the era of commercial telescopes, homemade longfocus Newtonian reflectors were standard issue for backyard astronomers. One of the most successful of a new line of commercial telescopes in the 1960s and early 1970s (facing page) was the classic Criterion RV-6 Dynascope. It offered great 6-inch f/8 optics on a sturdy mount for \$195.

Refractors 🕨

Long focal length was the rule in refractors as well, leading to huge telescopes even in the 4- and 6-inch models depicted in this Unitron ad from the 1960s. They were as portable as the pillars of Stonehenge. Yet using classic long-focus telescopes, amateurs helped map the Moon and planets. Facing page: Saturn by Charles Giffen, using a 15.5-inch refractor; drawings of Jupiter and the lunar surface by Alika Herring, using a 12.5-inch Newtonian.

A Brief History of Telescopes

Life used to be simple. In the past, one type of telescope predominated, making the choice of which instrument to buy downright easy: You bought what everyone else was buying. Indeed, you had few other choices. Observing tastes also followed in lockstep fashion. Whatever type of observing the telescope in vogue excelled at was what most people concentrated on. It has long been our opinion that the history of amateur astronomy can be largely divided into periods during which a single type of telescope—and observing—defined the backyard astronomer's universe.

BEFORE 1950: SMALL-REFRACTOR ERA

If you wanted a telescope before 1950, chances are, you made your own. If you could afford to buy a telescope, it was likely a 2-to-3-inch brass-fitted refractor that looked good in a study beside an oak bookcase. Larger telescopes were available, but at a very high price. Commercial telescopes were expensive relative to the wages of the working person. They were made for the genteel astronomers of wealth and leisure. The chief observing activities of such amateurs were viewing the Moon and planets, logging descriptions of the colors of double stars and scanning a handful of clusters and nebulas. A few advanced observers engaged in the more technical activity of measuring the positions of double stars and the brightnesses of variable stars—tasks well suited to a small refractor.

1950 to 1970: NEWTONIAN ERA

After World War II, small telescope companies, such as Cave Optical, Criterion, Optical Craftsman and Starliner, began to offer high-quality Newtonian reflectors at a more reasonable price. With relatively large apertures of 6 to 12 inches and costs well below that of sizable refractors, the Newtonian quickly became the most popular instrument of the day.

The Newtonians of the 1950s and 1960s were medium- or long-focal-length telescopes (f/7 to f/10). With the required equatorial mounts, they were big and awkward.

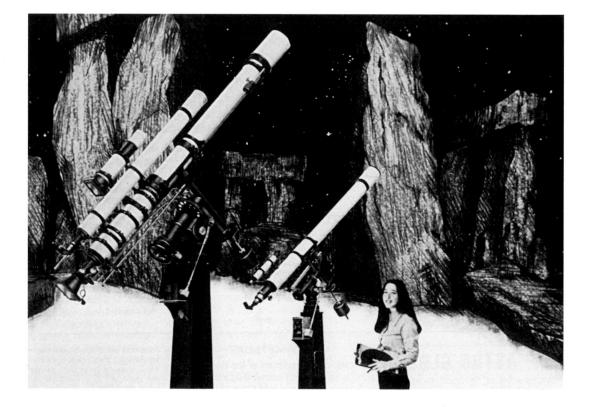

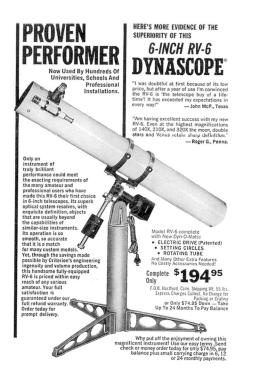

However, long-focus Newtonians were, and remain today, excellent for high-resolution planetary observing. As a result, we entered the golden era of planetary study by backyard astronomers. It was a time when the journal of the Association of Lunar and Planetary Observers was filled with wonderful drawings of the Moon, Venus, Mars, Jupiter and Saturn.

Deep-sky objects such as nebulas and galaxies remained a minor sideline. The books of the day bear this out. Norton's Star Atlas, the observer's bible of the 1950s and 1960s, lists only 75 deep-sky objects in the descriptive tables of the 1959 edition, yet thousands of deep-sky objects are within reach of a good 6-inch telescope. J.B. Sidgwick's classic Observational Astronomy for Amateurs, first published in 1957, devoted 270 of its 310 pages to solar system objects; the deep-sky realm of nebulas and galaxies was all but ignored, even though from the modestly light-polluted backyards of the time, telescopes could have revealed hundredo of them with no difficulty.

Then, in 1965, Mariner 4 became the first interplanetary probe to return close-up images of Mars, revealing a cratered surface unlike anything telescopic observers had imagined. The pictures from Mariner 4 and a string of follow-up Mars probes into the 1970s removed much of the romance of the

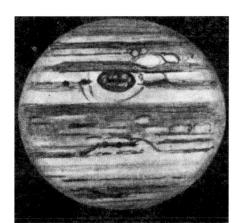

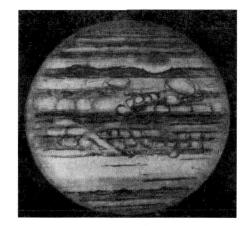

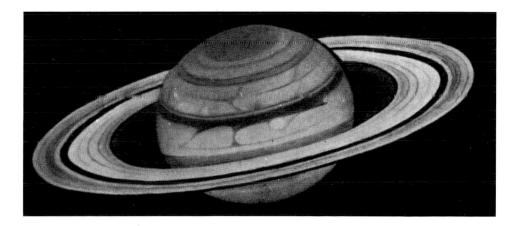

Trendsetters 🔺

Celestron's early Schmidt-Cassegrains of the 1970s and Coulter Optical's first Dobsonian, seen below at its debut in 1980, changed the hobby forever. enigmatic red planet. Meanwhile, robotic voyages to other planets and the Apollo Moon landings effectively removed the Moon and the planets as rich targets of opportunity for amateur astronomers, and consequently, planetary observing as a primary activity plummeted.

But, at the same time, the space program of the 1960s heightened public interest in astronomy and space. The hobby turned from a fringe pursuit into a mainstream pastime, setting the stage for the next era.

1970 to 1980: SCHMIDT-CASSEGRAIN BREAKTHROUGH

The many converts to astronomy during the Apollo era increased telescope sales to the extent that companies could introduce mass-production techniques for serious amateur telescopes. At that time, Californian Tom Johnson was a pioneering telescope maker. Lured by the theoretically near-perfect star images that a Schmidt-Cassegrain could

produce, Johnson built a 19-inch unit for himself. This prototype was the forerunner of all Celestrons. In 1964, Johnson renamed his electronics company Celestron Pacific and began making telescopes.

In 1970, Celestron introduced a compact 8-inch f/10 Schmidt-Cassegrain, the original orange-tube C8 (even the color was novel). The retail price for the basic telescope, without tripod, was \$795. Considering that topgrade 8-inch Newtonians cost \$600 at the time, the C8 was expensive. But because of its compact size and ease of use, many amateurs flocked to the new instrument, dubbed a catadioptric, or "cat."

The new mirror-lens telescope, along with its turnkey array of photo accessories, another innovation, was marketed by the first modern advertising in the field. In many ways, the hobby as we know it today began with this telescope.

Schmidt-Cassegrains are at their best when used for deep-sky observing and astrophotography. Their portability enabled amateur astronomers to transport telescopes of significant aperture to dark-sky sites, an uncommon practice prior to the rampant spread of light pollution in the 1970s. Despite the growth in light pollution, observing and photographing deep-sky objects began to soar in popularity. Refractors and cumbersome reflectors on heavy equatorial mounts were threatened with telescope extinction.

1980 to late 1980s: NEWTONIAN REBORN

The new interest in deep-sky observing propelled by the orange 8-inch Schmidt-Cassegrain created a hunger for even more aperture. As compact as the design is, a Schmidt-Cassegrain larger than 8 inches in aperture is still a hefty instrument. How could enthusiasts move to yet bigger telescopes and retain the portability so essential for observing at remote sites?

The solution: Return to the Newtonian, but sacrifice the automatic tracking of equatorial mounts by using simple, squat altazimuth mounts. Popularized by California amateur astronomer John Dobson, these telescopes are now universally called Dobsonians. Beginning in 1980, companies such as Coulter Optical offered lighter, thin-mirror Dobsonians for as little as \$500 for a 13inch model. Aperture fever swept the land.

Once again, the instrumentation led observers into new territory. The big light buckets, as large Newtonians are irreverently called, were unsurpassed at revealing faint deep-sky targets. Objects that were barely perceptible smudges in an 8-inch Schmidt-Cassegrain became impressive spectacles in the 17-inch Dobsonian typical of the early 1980s. Armed with giant Dobsonians, observers pursued deep-sky targets previously thought inaccessible.

Late 1980s to mid-1990s: REFRACTOR REBORN

Despite their reputation for sharp, contrasty optics, refractors as serious backyard-astronomy equipment were all but gone by the 1980s. Their inherent chromatic aberration (false color) plus high cost had removed them from contention. However, the Schmidt-Cassegrains and Dobsonianmounted Newtonians that were dominating the market did not win over everyone. A substantial number of observers complained of the fuzzy views offered by the large but low-cost light buckets typical of the 1980s. Others were disappointed by a spate of poorly made Schmidt-Cassegrains that reached the market during the "Halley boom" in the mid-1980s. It was this situation, plus interesting new developments in glass technology, that led two telescope designers, working independently in the mid- to late 1980s, to revolutionize the refractor for recreational astronomy.

Al Nagler, a military optics expert and amateur astronomer, began developing ways to reduce the focal ratio without increasing chromatic aberration, the traditional flaw of refractors. His Tele Vue Renaissance and Genesis 4-inch models were instrumental in reestablishing the refractor as a serious tool for backyard astronomy.

Aerospace engineer and amateur astronomer Roland Christen also attacked chromatic aberration. In the mid-1980s. Christen's firm, Astro-Physics, marketed the first tripletlens refractors priced for amateur astronomers. Christen's telescopes have a threeelement objective lens. Each element is made from a different type of glass, and together, they produce virtually false-color-free, or apochromatic, images. His design breakthrough allowed reasonably priced 4-, 5-, 6and even 7-inch apo refractors.

The race for bigger telescopes that had driven amateur astronomy since the 1950s gave way to the desire for better telescopes. Planetary observing, which requires firstclass optics, saw a resurgence with the return of the refractor.

The 1990s: QUALITY AND CHOICE

In the 1990s, the doors swung wide open to every type of observing interest and choice of equipment. The only common factor demanded by backyard observers was quality.

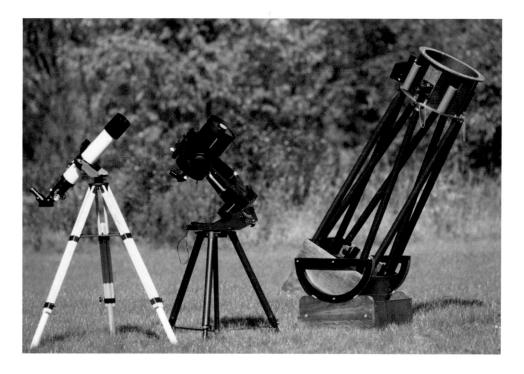

Regardless of the size and design of the instrument, telescope users looked for top-grade optics on solid mounts, and manufacturers were forced to deliver.

By the close of the 20th century, for the first time in the history of the hobby, the three main classes of telescope optics refractor, reflector and catadioptric (the Schmidt-Cassegrain)—shared equal billing in popularity. No one telescope dominated. Similarly, for the first time, amateur astronomers pursued their eclectic observing interests, enjoying a wide range of celestial targets, from the nearby Moon to distant clusters of galaxies. ▲ Telescopes of the 1990s Three classes of telescopes were equally popular by the 1990s, each with its own merits: the new high-quality refractor, left, the compact Schmidt-Cassegrain, center, and the targe-aperture Newtonian, right, now configured on a new generation of solid but portable Dobsonian mounts. From left to right: Tele Vue Genesis, Celestron Ultima 8 and Starsplitter 14.

Telescope Democracy Attend a star party today, and you'll see every type of telescope equally represented. Owners are happy to show off their homemade scopes, such as Jack Milliken's elegant trusstube Dob (top left) and Kathryn Peterson's classic solid-tube Dob (top right). Few people make their own mirrors these days, but crafting a wooden Dobsonian is still popular, not to save money but to have a scope you can truly call your own. In commercial scopes, fast apo refractors on basic altazimuth mounts, like Bill Pellerin's Tele Vue NP101 (bottom left), take equal pride of place beside sophisticated GoTo Schmidt-Cassegrains, such as the Meade LX200 (bottom right). Any of these telescopes, and many more, can provide a lifetime of viewing enjoyment. Today, no one telescope can make a claim to be "the best" on the market.

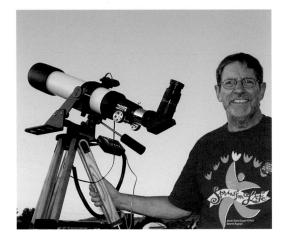

The 2000s: COMPUTERS TAKE CONTROL

With optics perfected to such a high art and available in such a diverse array of telescope designs, what was next? Like most consumer products in the 1990s, telescopes were revolutionized by computers, a change that swept into the mass market of affordable telescopes as the 21st century opened.

While Celestron had introduced a computerized telescope as far back as 1987, with its CompuStar, the first high-tech scopes to make an impact were Meade Instruments' LX200 models, introduced in 1992 (LX stood for long exposure). However, computerized scopes remained high-end models throughout the 1990s, aimed at enthusiasts willing to spend thousands of dollars.

In 1999, Meade broke the price barrier for computerized telescopes with the introduction of the ETX-90EC and its welldesigned Autostar computer. For \$750, one could now own a telescope that aimed itself, solving the problem that discourages so many beginners: how to find celestial objects. In 2000, Meade shattered the price barrier again by offering what has since become known as GoTo technology for as little as \$300. Promoted by widespread advertising and mass-marketed through chain-store outlets, the little ETX-60 and ETX-70 refractors and competitive scopes from Celestron began to supplant the usual "Christmas trash telescope" as the entry-level instrument of choice, even for the most novice stargazers.

The appeal of computerized GoTo has put a lot more telescopes into the hands of people who might never have purchased a telescope or taken up the hobby. So, in that sense, these scopes are also expanding the hobby in new directions. It's an exciting time to be an amateur astronomer.

Choosing a Telescope

Because no single telescope dominates the market anymore, the choices facing the prospective buyer can be daunting. Time and again, we are asked, What is the best telescope? or Which telescope would you buy?

While we do provide recommendations (see page 52), the truth is, there is no single best telescope, just as there is no single best car, camera or computer. Furthermore, a telescope we would choose may not be the one best suited to your needs. Each telescope has its good and bad points, which we will outline. Many veterans who recognize the strengths of each type of telescope own more than one. That's the real answer to finding the perfect telescope.

Still, faced with the task of picking one "best" telescope from a field of hundreds, buyers often fret with endless deliberation. Don't be afflicted with" paralysis by analysis." Pick one of our recommended telescopes in the price range that suits you, and buy it. You'll have fun with it, see a lot and discover where you might like to go next: perhaps a bigger scope for deep-sky exploring, a supersharp scope for planetary views or a scope designed for astrophotography—the avenues are many.

Our advice is to make your decision not on "refractor versus reflector" or "altazimuth versus equatorial" but on other factors far more important for ensuring enjoyable nights under the stars. We will outline these, then dive into our survey of models.

THE MAGNIFICATION SCAM

First, we must point out the one telescope trait you can ignore: how much the telescope magnifies. Magnification is a meaningless specification. With the correct eyepiece, any telescope can magnify hundreds of times. The question is, How does the image look at, say, 450x? Probably faint and blurry. Why? There are two reasons:

Not Enough Light

The telescope simply is not collecting enough light to allow the image to be magnified to that extent. When an image is enlarged, it is spread out over a greater area and becomes too faint to be useful. In other words, the telescope has been pushed beyond its limits.

How much can a telescope magnify? The general magnification limit is 50 times the aperture in inches, or 2 times the aperture in millimeters. For example, the maximum usable power for a 60mm telescope is only 120x. Claims that such a telescope can magnify 400x are misleading, intended solely to lure the unsuspecting buyer.

Blurry Atmosphere The Earth's atmosphere is always in motion, distorting the view through a telescope. Some nights are worse than others. At low power, the effect may not be noticeable, but at high power, atmospheric turbulence (poor seeing) can blur the image badly.

Most amateur astronomers find that a magnification of about 300x is the practical upper limit, even for a large-aperture telescope. People do not build or buy giant instruments to obtain highly magnified images but, rather, to get brighter, sharper images and to see fainter objects.

So **Rule #1** when buying a telescope: Avoid any telescope sold on the basis of its magnification ("Powerful 475x Model") or any beginner telescope that promises powers over 300x. We've seen models advertised as providing 675x! All are sure signs that the telescope is just a junky toy in disguise.

BEWARE OF APERTURE FEVER

The most important specification of a telescope is its aperture. When amateurs speak of a 90mm or an 8-inch telescope (both metric and imperial units are used), they are referring to the diameter of the main lens or mirror. The larger the aperture, the brighter and sharper the image appears.

With the magnification myth dispelled, you might think you need as much aperture as you can afford. Right? If you are not careful, you might catch aperture fever. The first symptoms are longer and longer perusals of the ads in astronomy magazines, accompanied by imagining the views to be had with the "Colossal SuperScope."

However, be warned. Big telescopes do not always foster contentment among astronomers, for several reasons.

Simpler Times Sporting the requisite Perry Como sweater, a 1950s teenager demonstrates a 60mm refractor, a classic junk telescope similar to those still sold today under the banner "250x Professional Model." Unfortunately, such misleading claims sell telescopes, usually to novices and well-intentioned parents and spouses. Aren't these instruments better than nothing? We think the money would be more wisely spent on good-quality 7x50 or 10x50 binoculars and star charts, complemented with time spent learning the sky.

▼ Mirrors and Lenses All telescopes can be divided into two main classes: those which use mirrors to collect light (reflectors, as at left) and those which use lenses (refractors, as at right).

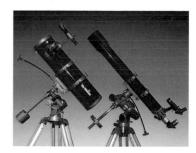

Spot the Errors! ▲
 In this 1991 departmentstore ad, a classic 4.5-inch Newtonian telescope has been caught in an embarrassing position (or two!):
 The light-gathering end of the tube is aimed at the ground, not the sky.
 The finderscope is mounted backwards.
 The mount is polaraligned for the equator.
 And beware the ad that claims 450 power!

Minimum Aperture
A 70mm-aperture telescope is the smallest telescope that aspiring astronomers should consider.

Portability

One often-overlooked fact is that large telescopes do not fit into small cars. It is surprising how many amateur astronomers buy or make a huge instrument without considering how to transport it—or carry it. For a first telescope, in particular, any instrument you cannot easily carry out to the backyard in one or, at most, two pieces is unlikely to be used after the novelty wears off.

The Shakes

Another problem with big telescopes is the shakes. A lightly mounted large-aperture telescope might be portable, but the images will dance about with every puff of wind and every touch of a hand. Such an instrument is simply not fun to use. Yet a mount sturdy enough to steady the telescope might also be too heavy and cumbersome. By having a smaller aperture, you can get a solid telescope that retains portability. **Rule #2:** A good mount is just as important as good optics.

* Price

Big telescopes can be expensive. If you lose interest in the hobby, you will have a sizable investment tied up in a telescope that may be tough to sell. Lose interest? Never, you say. Yet lots of people do. The reasons can often be traced right back to big telescopes that are awkward to set up. We have seen just as many people drop out of the hobby because they bought too much telescope as we have people who became disenchanted because they bought too small a telescope.

Our advice? The beginner should resist any temptation to buy a first telescope larger than 8 inches in aperture. Think twice about that 10-inch Schmidt-Cassegrain or Newtonian. **Rule #3** for telescope buying: The best telescope for you is the telescope you will use most often. A small well-made instrument that is convenient to use will provide a lifetime of enjoyment.

MATCHING SCOPE TO SITE

An important consideration when picking the best telescope for you is your observing site. Can you observe from your home? If so, are the skies dark, or are they heavily lightpolluted? Are views restricted by trees, houses or streetlights? How far will the telescope have to be carried? And will you have to move the scope around the yard to sight different areas of the sky?

If you are plagued with light-polluted skies at home, f/6 to f/15 telescopes are preferred. As a general rule, they have better optical quality than most ultrafast f/4 to f/5 telescopes, while yielding higher powers with a given set of eyepieces. Both characteristics will provide more pleasing images of the Moon and the planets, the best targets in light-polluted skies.

If there is little possibility your telescope will be used at home, then base your decision on portability and ease of transportation. A 4-to-5-inch Maksutov-Cassegrain, a 5-to-8-inch Schmidt-Cassegrain, a 6-inch Newtonian or a 3-to-4-inch refractor on an equatorial mount will probably be used far more than will a bulkier instrument.

From firsthand experience, we suggest **Rule #4:** Telescopes that require more than 5 to 10 minutes to load into a vehicle or to set up suffer a steady decline in use after the first year of ownership. Instead of enjoying your telescope, you feel guilty for not using it. And a year or two later, you will probably sell it.

If, on the other hand, you are fortunate enough to live under dark rural skies and can conveniently store a large telescope for quick setup, then by all means consider a largeraperture reflector, perhaps a 10-to-15-inch Dobsonian or a 10-to-12-inch Schmidt-Cassegrain. Even short-focus apo refractors, used primarily in urban settings for lunar and planetary views, perform well under dark skies, excelling at wide-angle views of deep-sky star fields.

PHOTOGRAPHIC FEVER

A common demand of the first-time telescope buyer is, "I want to be able to take pictures through my new telescope." Usually, the prospective buyer means images of colorful nebulas and galaxies. However, this type of photography requires a minimum of \$3,000 in telescope gear alone, and the best scope for imaging is not always the first choice for visual use.

Some types of astrophotos can be taken easily and cheaply, but close-up shots of nebulas and galaxies aren't among them. As enticing as the photographs look in books, we propose our **Rule #5:** A beginner should initially ignore astrophotography and instead buy the sharpest, sturdiest affordable telescope for the pleasure of observing by eye.

Can You Lift It, and Will It Fit?

Consider the reality of transporting a big telescope to dark-sky sites. Can you lift it onto and off the mount or tripod? Will the packed lelescope and all Its bits fit into the family vehicle? This Meade 10-inch Schmidt-Cassegrain just makes it —as long as you leave the family behind!

Types of Optics

Achromatic Refractor

The classic refractor uses a doublet lens with elements made of crown and flint glass. In f/10 to f/15 focal ratios, chromatic aberration is negligible.

Apochromatic Refractor

To eliminate false color, some apos use doublet or triplet lenses with one element made of ED glass. Others use small corrector lenses near the focuser.

Newtonian Reflector

Invented by Isaac Newton in 1668, this classic design uses a concave primary mirror (preferably with a parabolic curve) with a flat secondary mirror.

Schmidt-Cassegrain (SCT)

An aspherical corrector plate compensates for aberrations in the f/2 spherical mirror. A convex secondary folds the light path down the stubby tube.

Maksutov-Cassegrain

This uses a steeply curved corrector. The secondary is often a reflective spot on the inside of the corrector. Like all Cassegrains, light exits out a hole in the primary mirror.

Schmidt-Newtonian

This hybrid design, usually f/4 or f/5, combines a Schmidt corrector with Newtonian optics to reduce the off-axis coma inherent in fast Newtonians.

Maksutov-Newtonian

Usually made in f/6 focal lengths, this design boasts a view free of aberrations across a wide field at low power and refractorlike images at high power.

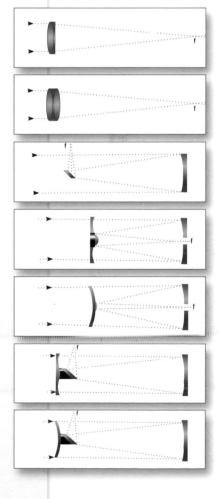

Decoding Telescope Specs

The following terms, and not magnification, represent the most important optical specifications of any telescope.

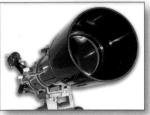

Aperture and Light-Gathering Power

Telescopes are rated by their aperture. A 4-inch instrument has a main lens or mirror four inches in diameter. The larger the lens or mirror, the more light it collects, providing brighter and sharper images. An 8-inch telescope has four times the surface area, and therefore light-gathering power, of a 4-inch, making its images four times brighter.

Resolution

In theory, an 8-inch telescope can resolve twice as much detail as can a 4-inch instrument. The resolving power of a telescope can be estimated with a simple formula: Resolving power (in arc seconds) = 4.56 ÷ aperture of telescope (inches); or 116 ÷ aperture of telescope (mm). This is the empirical rule devised by William Dawes in the 19th century. When manufacturers list a resolving power, they are merely stating the Dawes limit for that aperture of telescope, not a measured performance value for that specific model.

Focal Length

The length of the light path from the main mirror or lens to the focal point (the location of the eyepiece) is the focal length. With Maksutov- and Schmidt-Cassegrains, the optical path is folded back on itself, making the tube shorter than the focal length.

Focal Ratio

The focal ratio is the focal length divided by the aperture. For example, a 100mm telescope with a focal length of 800mm has a focal ratio of f/8. For photography, faster f/4 to f/6 systems yield shorter exposure times (therefore, these are known as fast focal ratios). But when used visually, image brightness depends solely upon the aperture. Focal ratio has nothing to do with it.

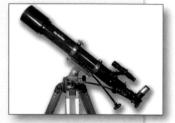

Diffraction-Limited

A promise of "diffraction-limited optics" means aberrations in the optics are small enough that image quality is affected primarily by the wave nature of light and not by errors in the optics. This is equivalent to stating that the optics provide a final error at the eyepiece of only one-quarter of a wavelength of light (the wavefront error), meeting the so-called Rayleigh criterion, a minimum standard for amateur telescopes. Anything worse, and planets will look soft, if not blurry. Contrary to some ad claims, diffraction-limited does not mean the optics cannot be improved upon. Premium telescopes can do better, with wavefront errors of 1/6 to 1/8 wave. Under good conditions, tests have proved that the difference is noticeable, but the performance edge over 1/4-wave optics comes at a high cost.

Central Obstruction

While the secondary mirror in a reflector blocks some light, the loss is not significant. The noticeable effect is the smearing of image contrast caused by the added diffraction of light from the obstruction. This effect is proportional to the diameter of the secondary mirror. As such, central obstruction should be stated as a percentage of the diameter of the aperture. An 8-inch scope with a 2.75-inch-diameter secondary mirror has a central obstruction of 34 percent. To make the numbers seem smaller, some companies state obstruction as a percentage of area (12 percent in this example). In general, a central obstruction of 20 percent or lower *by diameter* produces a negligible effect.

The refractor telescope at top has an aperture of 70mm. Its focal length is 700mm, close to its actual tube length, as shown at center. This makes the entry-level scope an f/10 instrument, a focal ratio good for ensuring sharp views of the planets. Most reflector telescopes, such as the Schmidt-Cassegrain above, have a secondary mirror that obstructs the main aperture.

Surveying the Telescope Market

No telescope design guarantees superb images. Only quality of craftsmanship can guarantee quality of images. A well-made Newtonian will outperform a poorly made refractor, and vice versa. Ignore Internet discussion-group gurus and ardent club members who tout one particular telescope design as "the best." Sooner or later, every telescope brand and type will be named, only adding to the confusion. Instead, seek out quality coupled with portability and convenience. Combine those traits, and you will have a great telescope no matter what its optical design.

That said, here is a rundown of what the current market has to offer in quality telescopes, sorted by optical design. We follow that with our recommendations, broken down by price category.

ACHROMATIC REFRACTORS (70mm to 6-inch)

A 60mm refractor (\$100 to \$200) has long been a popular beginner's telescope. This instrument is in every big-box chain and camera store at Christmastime and is hawked on home-shopping channels. While there have been some excellent 60mm refractors in the past, such as legendary instruments from Unitron, we have seen few 60mm refractors in recent years that we could recommend.

The flaw of most 60mm refractors is not so much the main lens but everything else —poor eyepieces, a dim finderscope, lack of slow-motion controls, a flimsy mount and a shaky tripod. Our advice to people who inquire about buying a low-cost 60mm telescope is to spend more to acquire an 80mmto-90mm refractor or a 4-to-6-inch reflector, or save money by purchasing binoculars.

With the jump to an 80mm or a 90mm refractor, the quality of the telescope improves greatly. Most f/10 to f/11 refractors in this aperture class are worthy beginners' telescopes. In our opinion, they represent

the minimum for a serious buyer. Color correction of the crown/flint doublet lens is excellent, and the telescope is portable, durable and virtually maintenance-free for decades. Many companies and dealers offer a telescope in this category. Most are identical units made in China and branded by the local distributor. We've found their quality excellent for the low price of \$300 for altazimuth-mounted versions. Look for units with slow-motion controls and one or two high-grade Kellner or Plössl eyepieces providing no more than 100x to 150x, rather than several eyepieces of dubious quality providing excessive magnification.

A just acceptable notch down in quality is a smaller 70mm refractor (\$150 to \$200), but only if it is fitted to a sturdy mount, preferably an altazimuth mount with slow-motion controls. (Most equatorial mounts supplied with telescopes of this size are too flimsy.) Even so, a few 70mm refractors are still hampered by poor eyepieces (those marked H, HM or SR in the 0.965-inch barrel size, rather than the industry standard 1.25-inch size) and tiny 5x24 finderscopes with poor optics. Avoid those units.

A step up in aperture to a 4-inch f/8 to f/10 refractor is a fine choice for about \$450. However, for this size telescope, an altazimuth mount doesn't work as well. The telescope hits the mount when aimed high, and the constant adjustments required to keep objects centered at higher powers

▲ Short-Tube Achromat Despite its simple achromatic doublet lens, the Stellarvue 80mm f/6 Nighthawk (seen here in an earlier incarnation) provides very good color correction for a fast achromat and works well at high power and for low-power wide-field sweeping, the primary use for "shorttube" achromats. The Nighthawk is the best of this breed of telescope.

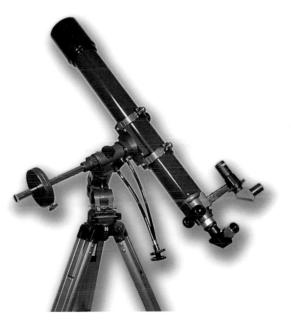

Classic 90mm Refractor Achromatic refractors in the 80mm-to-90mm size and with f/10 to f/11 focal ratios have long been popular as entry-level telescopes, and rightly so. Made in China, this \$400 Sky-Watcher 90 on a sluidy EQ-3 mount provides sharp and contrasty planetary details. Unlike simpler altazimuth mounts, this German equatorial mount (so called because it was designed in Germany in the 19th century) allows convenient tracking of celestial objects, either by hand or with an optional motor.

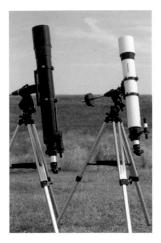

Large Achromats ▲ The line of Synta-brand telescopes includes 4.7- and 6-inch refractors at previously unheard of prices. The 4.7-inch (on the right) is a fine choice, but the heavy 6-inch demands a better mount than the standard issue. Loyal fans rebuild the EQ-4 mount and replace its light aluminum legs with sturdy wooden ones.

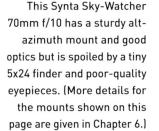

Starter Refractor 🔻

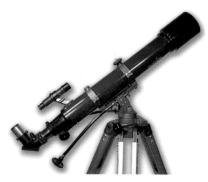

become annoying. An equatorial mount solves these problems and is essential for this size scope.

Achromatic refractors larger than a 4-inch aperture used to be rare and expensive, but the line of achromats made in China by Synta Technology Corp. and carried by dealers under brand names like Sky-Watcher now includes 4.7- and 6-inch refractors. For the breakthrough price of \$500 for the 4.7-inch and \$900 for the 6-inch, you get a refractor in a size that once cost thousands. To compete with Synta, Meade offers 5- and 6-inch achromats on its LXD75 German equatorial GoTo mount.

There are trade-offs, of course. To keep the tube length manageable, the focal ratios have been reduced to f/8 or f/9. In an achromat, this inevitably introduces aggressive false color around bright stars and planets. (The faster the focal ratio of the refractor, the worse the false color becomes.) Jupiter appears yellow-green surrounded by a violet haze. Image sharpness of these large achromats varies, but views through units we've used have proved perfectly acceptable for such a low-price refractor, despite the false color. Some observers prefer to employ a minusviolet filter, which eliminates some of the false color but adds a pale green tint.

We particularly like the Synta 120mm (4.7-inch) f/8.3 refractor sold under a variety of brand names around the world. (Note: Synta owns Celestron, and the two partner with Orion, so you'll see similar models under all three brands.) However, Synta's 6-inch f/8 achromat is a big instrument on a shaky mount, with an eyepiece that ends up too close to the ground to be comfortable to look through. It fails to meet our criteria for a friendly telescope. Although these low-cost big refractors attracted a loyal following when they first appeared, 6-inch achromats have since fallen out of favor.

Many dealers stock so-called Short-Tube refractors, f/5 achromats with apertures ranging from 80mm to 120mm. These are fine instruments for low-power sweeps of the Milky Way under dark skies but are often not good enough for high-power use.

Signs of a Good Starter Scope

Look for these features in entry-level telescopes. The smaller and less capable EQ-2 mount is usually supplied with this 90mm refractor.

6x30 finderscope (not a 5x24 or simple red-dot device for a non-GoTo telescope)

1.25-inch focuser (not a 0.965-inch)

Smooth, wobble-free focuser (geared rack-and-pinion or Crayford roller-style)

25mm and 10mm Plössl eyepieces (or similar) with 1.25-inch-diameter barrels (a 4mm eyepiece is a sign of poor-quality accessories) Sturdy mount with slow-motion controls (on either equatorial or altazimuth type)

APOCHROMATIC REFRACTORS (66mm to 7-inch)

Technically, the term "apochromatic" means the telescope brings three colors to the same focus, rather than just two, as in a standard achromat. In practice, however, a good apo will reduce false color below the eye's threshold of detection. This is the level of performance achieved by two-, three- and four-element apos using fluorite or extralow-dispersion (ED) glass in one element of the main lens. A 4-inch f/8 ED refractor less than three feet long can outperform a fivefoot-long 4-inch f/15 achromat, long considered the minimum focal ratio for colorfree performance from such a scope.

As a rule, apo refractors with triplet lenses provide color correction a notch better than do doublet apos, though often at a considerably higher cost. Apos employing the lowest-dispersion Ohara FPL-53 ED glass, either in a doublet or triplet design, also usually provide better color correction than models with FPL-51 ED glass.

The past few years have seen a profusion of apos on the market, most with optics made in China or Taiwan. As often as not, similar models are sold in domestic markets under a variety of brand names. Nevertheless, the quality remains high while prices have tumbled. Paying \$1,000 to \$1,500 per inch of aperture used to be the norm for apos, but Chinese imports have dropped that to as low as \$250 to \$500 per inch.

However, let's start at the top end: Some of the finest apo refractors and mounts sold today come from Astro-Physics. All its American-made apos employ a threeelement objective with the finest grade of ED glass forming the middle element. Images are completely color-free and textbookperfect, even under extreme temperature conditions. Models are offered in 130mm, 140mm and 160mm apertures (\$5,500 to \$9,000). Over the years, Astro-Physics has produced larger and smaller refractors (its 90mm and 105mm models are prized), as well as slower f/8 and f/12 versions. A used Astro-Physics refractor is a valuable commodity, often fetching higher-than-new prices. Snapping up a used model may be the only way to get an Astro-Physics apo, as wait times now extend to years. Order one now, and your children may enjoy it when they grow up!

A pioneer and still a leading name in premium apo refractors is the Japanese firm Takahashi. In all sizes, from the diminutive 60mm to the giant 150mm, Takahashi refractors provide outstanding images, but at a premium price. A popular model, the TSA-102S, a 4-inch f/8 triplet with Takahashi's excellent EM-11 equatorial mount, for example, is about \$7,000. However, a Takahashi refractor has a big advantage: Most models are available from stock.

Also from Japan but much more affordable are the Vixen apo refractors. Construction quality doesn't match a"Tak" but is still very good. Models are offered from 80mm to 115mm apertures, most with doublet ED lenses providing very good color correction.

Since the 1980s, Tele Vue Optics has offered consistently excellent apo refractors with color correction that has improved with every new model. Ultraportable 60mm, 76mm and 85mm models (\$800 to \$2,200) use doublet lenses for very good color correction

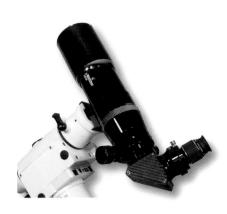

▲ Sky-Watcher Equinox The 80mm and the larger 100mm and 120mm Sky-Watcher Equinox apos represent excellent values. All use ED doublet lenses and are made in China or Taiwan. Similar models are sold around the world under different brand names, such as Celestron's Onyx 80ED.

◀ Meet Stellarvue Many fine brands of telescopes come from small companies run by families, such as Vic and Jen Maris, the couple behind the Stellarvue line of refractors and mounts. Offshore optics are assembled into U.S.-built cells, tubes and focusers, then tested by Vic.

◀ William Optics 90mm Another leading name in apos, Taiwan-based William Optics, owned by brothers William and David Yang, offers apos from 66mm to 130mm. Its optical and mechanical quality consistently rates very high, but with low prices. At left is the superb 90mm f/7 Megrez (\$1,300), an ED doublet with excellent color correction and compact portability.

Glorious Glass 🔺

The best-quality apos, like this Russian-made TMB triplet, use lens elements made of fluorite or extralow-dispersion (ED or Super ED) glass for low color.

Dream Apo 🕨

Nobody does it better than Tele Vue. The 5-inch NP127is is Tele Vue's top-end apo refractor. Its four-element f/5.4 Petzval design produces a wide, flat field for big-chip imaging and no false color. The altazimuth Gibraltar mount shown here is just for visual use. Tele Vue prestige comes at a price: This tube assembly alone sells for close to \$7,000.

Trendsetter Apo 🔻

Here's the apo that started the current boom: the \$550 f/7.5 Synta/Orion 80ED.

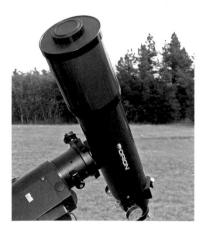

—only a tad below that of the best apos on the market. The top-of-the-line NP101, a 4-inch f/5.4 instrument (\$3,700), uses a four-element design for total elimination of false color and any other image-smearing aberrations. Its Petzval design uses a front doublet coupled to a rear sub-diameter doublet to flatten the field and reduce the effective focal ratio. (For \$300 more, a photo version, the NP101is, has added features for astrophotography.) The doublet Tele Vue 102 (\$2,200) offers color correction nearly as good, but with a

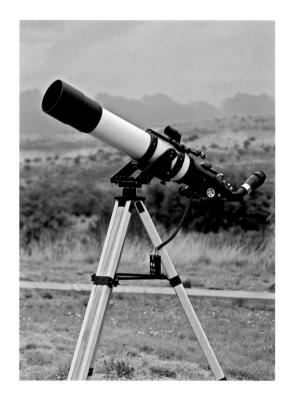

longer tube and an f/8.6 focal ratio. For a primarily visual telescope, it is a great choice.

To meet the demand for premium instruments, other manufacturers have introduced competitive telescopes that are often more affordable and in stock. The U.S. company TMB Optical offers triplet apos the equal of Astro-Physics' optics. Lenses were designed by the late Thomas M. Back, with most manufactured in Russia. The quality is exquisite. Models range from the jewel-like Signature Series 80mm triplet ED (\$1,000) to huge 8-inch refractors (\$Call!). (Most prices we're quoting for apos are for the optical tube assembly only, without the mount.)

TMB-designed lenses can be found in other brands of telescopes. For example, A&M Astrotech Engineering of Italy offers apos, some with TMB lenses, from 80mm to 180mm apertures, all in lustrous carbonfiber tubes with Italian-designer style. These are the Lamborghinis of apos!

In a similar league are the highly regarded triplets (140mm to 200mm) from the Telescope Engineering Company of Colorado. At the other end of the size scale are the Japanese Borg ED refractors (50mm to 125mm). All employ a modular construction for compactness and portability. Color correction is a notch below the best, but Borgs offer wide, flat fields ideal for astrophotography at focal ratios as fast as f/4.

The price-breakthrough telescope that started the apo explosion is the Chinese Synta 80ED, an f/7.5 doublet with excellent color correction for \$600. This model is sold worldwide under the Sky-Watcher brand name and in the United States by Orion. Offering a finer grade of finish and better focusers is the Sky-Watcher Equinox line of apos (66mm to 120mm). Optical quality is superb and the value outstanding.

Much of the explosion in affordable apos has come from companies such as William Optics, Stellarvue and Astro-Tech. Their offerings are numerous and fast-changing. Models range from 66mm jewels to 150mm dream apos. Most feature optics sourced from Russia, China or Taiwan. The offshore suppliers often sell the same optics to competitive companies. No one can test all that these companies offer, but models we have used have proved excellent.

DOBSONIAN REFLECTORS (4.5-inch to 30-inch)

For our money, this class of telescope offers the most outstanding value in a beginner's scope, providing generous aperture, good optical quality, excellent fittings and solid mounts for not a lot of money. What more could anyone want?

Unfortunately, we have heard stories of youngsters bursting into tears after receiving a Dob as a Christmas gift. "That's not a telescope!" they blubber. It seems a long, white tube sitting high atop a jiggly tripod is the only "real" telescope for them.

Although most knowledgeable amateur astronomers (including us) continue to praise these bargain telescopes, many buyers bypass them for high-tech computerized scopes or reflectors on undersized equatorial mounts.

Assembling a Dob

Most entry-level Dobsonians in the 6-to-12-inch sizes have solid tubes, but for telescopes over 10 inches in aperture, a breakdown truss-tube Dob is much easier to transport. Here, a Meade Lightbridge Dob is being assembled in the field. The truss poles are inserted into the mirror tub (far left), then the upper tube assembly is placed onto the poles. The final result is solid yet very portable for the aperture.

We will continue to fight the tide and recommend a 6-inch or 8-inch Dobsonian reflector as the best scope for a beginner.

Our favorites continue to be the metaltubed models made in China by Synta, sold under the Sky-Watcher brand, and Orion's SkyQuest Dobs (and others made by Guan Sheng Optical in Taiwan). Similar units are sold under many brand names around the world. The mirrors are well made and mounted, and the focusers and finderscopes are excellent. The altitude tension control and Teflon bearings provide essential smooth motions. The 6-inch is a great starter scope capable of showing far more than any 70mm or 80mm refractor or 4.5-inch equatorial or GoTo reflector of comparable price.

At \$400, the 8-inch is perhaps the best telescope deal in the history of the hobby. We set up one (a Synta) right out of the box that was in perfect collimation after traveling all the way from China. In optical tests, it performed as well as telescopes costing six times as much.

The 10-inch models (\$550) are also an incredible bargain, providing even more aperture for hunting deep-sky denizens. All three sizes of introductory Dobs have steel tubes and melamine-covered wood mounts that make them rugged performers.

Other popular models are the series of American-made Dobs from Discovery Telescopes. Its 10-inch solid-tube PDHQ offers fine craftsmanship and optical quality, though at a premium price of \$1,300.

Moving into 12-inch sizes and up, we

have always recommended a truss-tube model, one with a two-part tube held together with truss poles. Such models were once available only in premium brands. But Meade's Lightbridge Dobs (8-, 10-, 12.5and 16-inch sizes) represent price-breakthrough models offering very good quality

◀ Down Under Dob For observers in Australia and New Zealand, Peter Read's company, SDM Telescopes, makes fabulous first-class Dobs in the classic style of the U.S.-made Obsession brand. One of us enjoyed an evening exploring the southern skies with this 20-inch f/5 SDM at the

◀ Roll 'Em Up

South Pacific Star Party.

Most large truss-tube Dobs collapse into a tidy yet hefty box. But by attaching the wheelbarrowlike handles and tires that come with these scopes, you can roll them up into a van or truck without having to lift any heavy components—a very clever and convenient way to move big apertures to dark-sky sites.

Land of the Giants A giant Dob can be broken down, but not the ladder. To avoid this nuisance, consider a Dob no larger than 15 to 18 inches in aperture.

2007 Dobsonian Debut ▲ Dave Kriege, mastermind of Obsession Telescopes, unveils his new 18-inch f/4.2 Ultra Compact.

Classic Small Newtonian ► One of the most popular beginners' telescopes, the 4.5-inch Newtonian is being supplanted by the 5.1-inch Newtonian from Synta, such as this f/5 model on a German equatorial mount. Featuring parabolic, not spherical, mirrors, units like this one provide the sharpest images. for a good price (for example, \$1,000 for our favorite model, the 12.5-inch).

Beyond the Lightbridges, we enter the realm of the high-end Dob with handcrafted optics. All feature truss-tube designs and furniture-grade finishes. In this league of telescope, prices vary but typically range from about \$3,000 for a 12-inch to \$6,000 for an 18-inch model. It is even possible to buy a giant 25- or 30-inch Dob!

Manufacturers of premium Dobs are small home-based operations run by dedicated amateur astronomers who exercise an uncommon commitment to quality. Companies include Discovery Telescopes (12.5to-24-inch), Obsession (12.5-to-30-inch), Starmaster (11-to-28-inch) and Starsplitter (8-to-30-inch). We've used or owned telescopes from these brands and love them for their craftsmanship, smooth movement and superb mirrors from top names like Galaxy, Nova, OMI, Pegasus, Swayze, Torus and Zambuto. Some even have computerized drives that GoTo, then track. Other brands include Anttlers Optics, Night Sky Telescopes, MC Telescopes, Starstructure, Tele-Kits, TScopes and Webster Telescopes.

EQUATORIAL NEWTONIANS (4.5-inch to 18-inch)

The standard instruments of the 1960s —6-inch f/8 or 8-inch f/7 Newtonians on German equatorial mounts—have attempted comebacks now and then but have never caught on. Dobsonian-mounted versions remain the more popular choice.

However, smaller equatorial Newtonians continue to populate the entry-level market. Tens of thousands of amateur astronomers started their astronomical lives with a Tasco 4.5-inch Newtonian, the 11TR, marketed for decades. It had several deficiencies: a small 5x24 finderscope, poor 0.965-inch eyepieces, a spherical rather than parabolic mirror and a shaky mount. Models similar to the old 11TR are available from Bushnell and as house-brand items from telescope and camera stores. We suggest bypassing these instruments altogether, no matter whose name is on them. (Tasco itself is now defunct.)

Largely replacing the Tasco-style 4.5-inch is another ubiquitous telescope, the Synta 5.1-inch reflector offered in either f/7 or stubbier f/5 versions (\$250 to \$300). Sold under various brand names, this telescope's mount is the EQ-2 style that has been on the market for at least 40 years. The mount is just adequate, but the fittings and accessories of these 5-inch reflectors are fine, indeed. We recommend the shorter and sturdier f/5 instrument. The optical quality of its parabolic mirror is very good.

Larger 6-to-10-inch Newtonians on Taiwanese-made mounts, such as the Orion AstroView and SkyView models (\$400 to \$1,100), also provide good-quality choices, though we avoid Newtonians larger than 6 inches on most equatorial mounts, as the big tubes tend to be shaky and the scopes are heavy and complex to set up.

At the top end of the price spectrum, the finest big-aperture Newtonians on equatorial mounts are the NGTs (Next Generation Telescopes) sold by Jim's Mobile, Inc. (JMI). Both the 12.5-inch (\$5,000) and 18-inch (\$15,000) are carried on a well-engineered, split-ring mount that is surprisingly compact considering the size of the telescope. However, a Dobsonian on an equatorial platform (see Chapter 5) is a more popular solution to aperture with tracking.

MAKSUTOV-CASSEGRAINS (3.5-inch to 7-inch)

Among the most popular of the "hybrids," these telescopes combine a mirror with a form of lens that serves to eliminate optical aberrations. The designs are usually named after their inventor.

The Maksutov-Cassegrain was invented in the 1940s by Dmitri Maksutov. Most "Maks" are f/12 to f/14 Cassegrain systems, in which the light is directed out the back of the telescope through a hole in the primary.

The legendary Maksutov of this style is the 3.5-inch f/14 Questar, introduced in 1954 as a top-of-the-line compact telescope. More than fifty years later, it still is. Everything viewed through a Questar is wonderfully crisp and totally free of any aberrations, though contrary to mythology, a Questar cannot outperform larger instruments of good quality.

Nonetheless, the American-made Questar is a superb 3.5-inch instrument. Complete with mount, drive, leather case and tabletop tripod (but no GoTo), it costs more than \$4,500. Is it worth it? Judging by its halfcentury on the market, it is the right"prestige" telescope for many people.

Larger Maksutov-Cassegrains are available as tube assemblies or fully mounted telescopes. Compared with the Questar, prices are attractive: \$300 for a 100mm tube assembly, \$400 for a 127mm, \$600 for a 150mm and \$1,200 for a 180mm. All are f/12 or f/15 instruments. While many excellent Maks have come from Russia, the Chinesemade models tend to dominate most domestic markets these days. Models include the Orion StarMax units and the Synta Sky-Watcher Series. All are good general-purpose instruments that provide the portability we suggest is so important.

The one proviso we would note is that large Maks (150mm and up) take a long time to cool down. They can provide superb planetary images but only if left to cool for an hour or more to eliminate thermal currents inside the closed tube, often emanating from the thick corrector lens.

The Trendsetting ETX

In 1996, Meade introduced a low-cost clone of the little Questar, the ETX-90, short for Everyone's Telescope. The concept was to pack maximum performance into a small package for the lowest price possible. The introduction was an immediate success. And rightly so. The ETX-90s and the larger versions that followed consistently offered optics which matched the Questar for a fraction of the price. (The ETX-90PE now sells for \$700.) The ETX lacks the machining precision of the Questar—the fork mount and rear cell are ABS plastic. But the brushed-aluminum tube is alluring, and the optics are tack-sharp. We've used several ETXs of various sizes, and all have had fine optics.

A larger ETX-125 model followed (about \$1,000), as did a compact ETX-105, though that fine scope has since been discontinued. A smaller 80mm ETX model (\$300) is not a Maksutov but a short-focus achromatic refractor that lacks the high-power sharpness of its larger Mak cousins.

With their GoTo Autostar computers, it is fair to say that the ETXs became the bestselling quality telescopes in the world. The latest versions, the Premiere Edition PE models, offer a system that finds north and levels the scope for you, simplifying the initial alignment of the excellent GoTo system. The primary drawback to the Maksutov ETXs is the narrow field provided by the f/14 or f/15 optics. These scopes are best suited to lunar and planetary viewing, not low-power deep-sky views. The little focus knob is also hard to reach when the telescope is aimed up high. The Autostar system can be troublesome if not set up right (see Chapter 14),

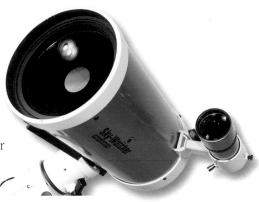

🔺 Mak Glass

In a Cassegrain reflector (named for its 17th-century inventor Guillaume Cassegrain), the secondary mirror bounces light down the tube to exit out the back of the telescope. Maksutov-Cassegrains also incorporate a steeply curved meniscus lens as a front corrector element. The superb Sky-Watcher Pro 150mm Mak (above) is similar to the Orion SkyView Pro.

• Orion Mak

Orion Telescopes is the main U.S. dealer for Chinesemade Maks. This is Orion's excellent 127mm StarMax, another sharp Mak that is well suited for a small portable mount.

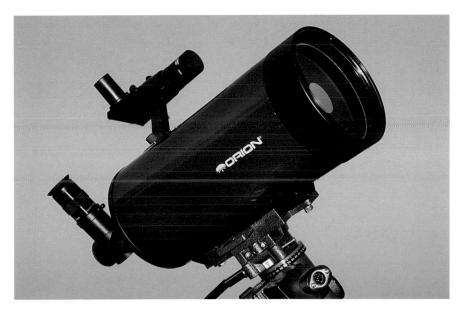

Pros and Cons of Telescope Types

.....

Туре	Advantages		ing Price h Mount
Achromatic refractor	Low cost; sharp, contrasty images; rugged and durable design	Chromatic aberration, especially in fast f/5 to f/8 designs	\$200
Apochromatic refractor	Freedom from most aberrations; excellent for deep-sky imaging	Highest cost per inch of aperture; limited aperture	\$800
Newtonian reflector	Lowest cost per inch of aperture; adaptable to Dobsonian mount	Coma at field edge; requires occasional collimation	\$300
Schmidt-Newtonian	Wide field of view; reduced coma	Large secondary obstruction	\$600
Schmidt-Cassegrain	Compact; good for some imaging	Large secondary obstruction	\$800
Maksutov-Cassegrain	Compact; sharp optics; long focal length good for planetary viewing	Slow focal ratios and narrow field; long cooldown in large apertures	\$400
Maksutov-Newtonian	Wide, flat field; sharp, contrasty optics; small secondary obstruction	Long cooldown time; heavy; limited availability and high cost	\$1,100

Meade ETX Maks 🔻

The 125mm (left) and 90mm (right) ETX models offer sharp optics in a portable package and now feature the fine Autostar GoTo system (it was an option on earlier ETX models). causing the telescope to bang against its hard stops as it tries to slew to a target. As with any GoTo scope, you are dependent on battery power, which can drain to nothing in cold weather or with prolonged highspeed slewing. Early models had flimsy tripods, but sturdy deluxe tripods are now standard. The plastic gears are noisy—the scopes sound as if something is not working right. But they do indeed slew to and track objects very well.

OTHER OPTICAL DESIGNS

Over the years, Meade has offered Schmidt-Newtonians, an f/4 design that employs a Schmidt corrector plate to reduce some of the aberrations inherent in a fast Newtonian, notably off-axis coma. We find that with its large secondary-mirror obstruction and fast focal ratio, the Schmidt-Newtonian is best for wide-field views under dark skies, rather than high-power planetary views.

Another variation is the Maksutov-Newtonian. Its small secondary mirror yields planetary views that match the sharpness and contrast of a similarly sized apo refractor at a fraction of the price. However, the design never really caught on and is now mostly offered in select models specialized for imaging, from companies such as Hutech, ITE Telescopes and Orion.

Takahashi manufactures f/12 Mewlon Dall-Kirkham Cassegrains, which users have praised as superb planetary telescopes.Vixen offers Cassegrains with sub-diameter corrector lenses in the light path. Popular with astrophotographers is Vixen's 8-inch f/9 VC200L (\$1,800). In Britain, designer Peter Wise and Cape Instruments provide unique coma-free Newise Newtonians with integrated corrector lenses near the focus.

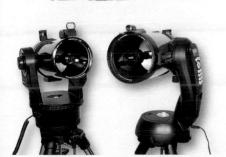

The Mounting Menagerie

Just as there are many types of optics, there are many types of mounts, creating endless mix-and-match possibilities. While mounts have varying capabilities for tracking and finding targets, the most important trait is that the telescope be held steady yet be easy to move.

Altazimuth

The typical beginner's scope comes with a simple but often crude altazimuth (alt-az) mount. However, with the introduction of smooth yet solid alt-az mounts from the likes of Astro-Tech, DiscMounts, Helix, Orion, Stellarvue (its M1 is shown at left), Universal Astronomics and William Optics, many amateurs are turning again to this class of mount. It provides grab-and-go, no-fuss setup and is perfect for the new small apos.

Dobsonian

Like any alt-az mount, the Dobsonian mount moves side to side and up and down, but it cannot track the stars, at least not without the aid of an expensive tracking platform or computerized motor system. However, some Dobs, like Orion's Intelliscope (left), offer computerized finding—you push the scope around the sky until the display indicates you are on target. These scopes help you find objects but cannot track them.

German Equatorial

To track objects and keep them centered in the eyepiece, all you need is an equatorial mount with one axis polar-aligned (a straightforward process described in Chapters 6 and 15) and driven at the sidereal rate by a simple motor. Computers and fancy programming aren't required. However, many German equatorial mounts are now equipped with computerized motors that can slew to and find objects and track them once on target. For these functions to work, the mount must be polar-aligned (the polar axis aimed to the celestial pole) and synced to two or three stars to calibrate the computer GoTo system.

Auto-Tracking

This new class of computerized mount can track the sky but not find things. It is not a GoTo system. You must find objects on your own by electrically slewing the telescope—you cannot grab and push the scope around the sky. That tends to be awkward. This alt-az mount does not require polar alignment, just a simple initial aiming toward north, then adjusting the angle of the tube to match your local latitude. That information is all the mount needs to track objects well enough for casual visual use. For not much more money, you can get a full GoTo system on a nearly identical mount.

Full GoTo Mount

This type of scope can find and track objects. The fork-mounted models can be set up in altazimuth mode not requiring polar alignment. Each night, the scope must be aimed at and synced to two or three stars to calibrate the GoTo system. After that, the telescope can be instructed to slew to any of thousands of objects. Once on target, the computers then pulse the two motors (one on each axis) to keep the object centered. When buying a computerized mount, be sure you know just what its capabilities are. Can it find? Can it track? Can it find and track?

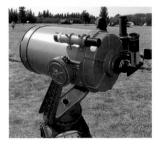

Starting the Revolution The modern hobby of backyard astronomy largely began when Celestron started mass-producing telescopes (top) in quantities unheard of before the 1970s. Early telescopes were orange-tube 8-inch SCTs with none of today's fancy features that, given inflation, sold for far more than current new models.

Midrange SCTs

Models and features change, but as of 2008, Celestron's midrange NexStar SE (Special Edition) Schmidt-Cassegrains come on a sturdy single-arm fork mount. The NexStar 8SE (left) has an orange tube in honor of the original C8. The Meade LX90 uses a twin fork mount and now comes with GPS as standard. (The nearly identical older non-GPS LX90 is shown at right.) Both have adjustable-height aluminum tripods.

THE REMARKABLE 8-INCH SCHMIDT-CASSEGRAIN

The telescope that for 40 years has been, and continues to be, at the technological forefront of amateur astronomy is the Schmidt-Cassegrain telescope, or SCT, a variation of a design invented by Bernhard Schmidt in the 1930s. Since 1970, the 8-inch model has been the top-selling serious recreational telescope. Its combination of aperture, portability and all-round good performance has made the Schmidt-Cass the telescope of choice for many buyers.

In the 1970s, Celestron had the field to itself. Its first serious competition came in 1980, when Meade Instruments brought out its Model 2040 4-inch and Model 2080 8-inch Schmidt-Cassegrains. Meade had started out in the early 1970s selling telescope accessories and good-quality Newtonians, but it soon realized that the future belonged to the SCT. Throughout the 1980s and 1990s, Meade and Celestron battled with advertising wars, price-cutting and feature wars. Whatever one company did, the other soon copied or bettered.

The fierce competition continues to this day. Optics have been made in the United States but may soon be manufactured in China. While larger and smaller models are offered, the 8-inch SCT remains the core product, and Meade and Celestron have settled on three lines.

German Equatorial Models (\$1,500 to \$1,800)

Both companies, as well as Orion, offer 8inch Schmidt-Cassegrains on lightweight German equatorial mounts. Celestron has its C8S-GT Advanced Series, Meade its LXD-75 and Orion its SkyView Pro, all with GoTo systems for \$1,500 to \$1,800.

The mounts are fine and the optics identical to what's in the higher-priced units. For most people, however, German equatorial mounts are more fuss to set up than necessary, requiring fairly accurate polar alignment as well as a two- or three-star alignment for the GoTo system.

Unless you intend to use the mount as a platform for other tube assemblies (the tube can come off these mounts), we suggest bypassing the German equatorial models —the next level up is simpler to use and sturdier yet costs about the same.

Midpriced Fork Models (\$1,400 to \$2,000)

This category introduces the classic fork mounts that work so well on stubby-tubed telescopes like SCTs. These GoTo instruments operate in altazimuth mode, making them easier to set up than the German equatorial models (no polar alignment). As of 2008, Celestron has the NexStar 8SE (\$1,400), while Meade offers the LX90-ACF (\$2,000). Both feature solid mounts and tripods that keep vibration to a minimum, especially in alt-az mode. This arrangement is much more

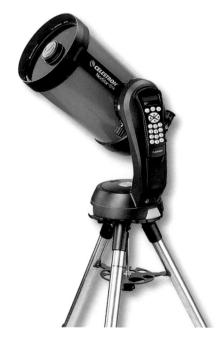

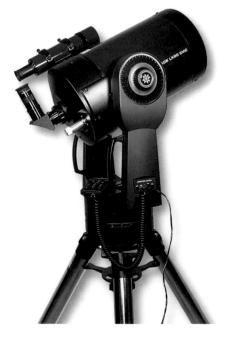

stable and vibration-free than being tilted over on a wedge for traditional polar alignment. The optional equatorial wedge is necessary only for long-exposure imaging.

The NexStar 8SE's single-arm fork is not the flimsy structure it appears to be. It is hefty metal and holds even the 8-inch tube quite solidly. Yet, at 33 pounds, the NexStar 8SE is fully 19 pounds lighter than the competing LX90, making the Celestron model easier to cart around the backyard.

The NexStar has a simple red-dot sighting device as a finder (good only for aligning on stars), while the LX90 has a red-dot finder and an 8x50 finderscope. Celestron employs its SkyAlign system, which requires that you level the tripod, then slew the scope to any three bright objects in the sky. It works very well, allowing you to align a GoTo scope even if you can't identify any bright star. (Chapter 14 has more details.)

Meade has its AutoAlign Level North Technology (LNT) system, which includes an electronic compass and level sensor that automatically judges when the tube is level and aims it due north for the initial GoTo alignment starting point. The scope then slews to two alignment stars it selects. (Both scopes allow you to select the alignment stars yourself, if you prefer.)

Should batteries fail, the LX90 can be moved manually; the NexStar can only slew electrically. The NexStar 8SE can accept an auto-guider for deep-sky imaging; using an auto-guider on the LX90 GPS requires an optional Accessory Port Module. Even so, the NexStar is designed more for uncomplicated visual observing. While both are battery-operated, they really need separate outboard power supplies. Neither has any hard stops to complicate initial setup.

As of early 2008, one difference in the midrange models is that Meade includes an integrated GPS (Global Positioning System) receiver in the LX90 (it is an optional module on the Celestron NexStar SE). The receiver picks up signals from orbiting satellites that tell the scope where it is on Earth and the precise time, so you don't have to enter that information manually.

The other big difference between the two competing brands is that Meade has moved away from Schmidt-Cassegrain optics. For its mid- and high-end models, Meade employs what it calls Advanced Coma Free (ACF) optics. The f/10 system uses mirrors and a corrector plate with slightly different optical curves than the classic Schmidt-Cassegrain. The result is lower aberrations across the field of view of large-chip imaging cameras, for sharper star images at the frame corners.

This new optical system, first introduced by Meade in its premium LX400 line of 10to-20-inch telescopes with advanced features for astrophotography (then labeled "RCX"), created quite a stir when it debuted in 2005, but by late 2007, Meade halted pro-

▲ LX200 Features

Meade's top-end LX200 Series adds the improved Autostar II (more objects and one-button direct access to databases) as well as an outboard motorized Crayford-style focuser, mirror lock-down and more control ports.

As of 2008, Celestron's high-end telescope is the CPC model (left), featuring a solid, quiet mount and GoTo system with GPS. Meade's top-end instrument, the LX200-ACF (right), uses a new optical design similar to an SCT but with a flatter field for imaging. The four telescopes shown on these two pages are set up in altazimuth; optional equatorial wedges are needed only for long-exposure astrophotography. Celestron photos courtesy Celestron.

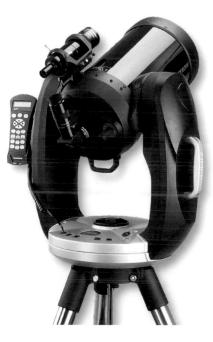

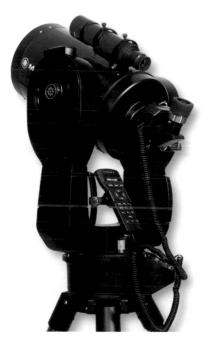

Premium Celestron A popular SCT is Celestron's 9.25-inch model, available in fork-mounted versions but shown here on the Sky-Watcher EQ-6 German equatorial mount. The 9.25inch has long had a reputation for fine optics, for both visual and photographic use, though it pushes the limits of convenient portability.

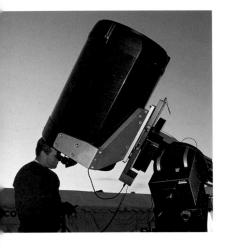

Monster Meade 🔺

A popular centerpiece at star parties and telescope shows, the huge \$50,000 20-inch LX400 and Max Mount was Meade's flagship product until it was dropped from production in 2007.

Meade 10-inch LX200 🔻

For any SCT bigger than 8 inches, carefully consider its weight and sheer bulk.

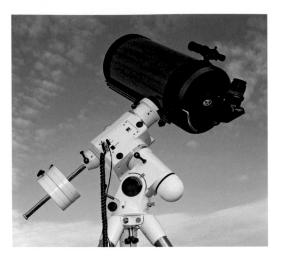

duction of the LX400s as part of cost-cutting measures.

However, the new "advanced" optical system migrated into the popular LX90 and LX200 Series. Meade originally named the new system Advanced Ritchey-Chrétien. Debate and lawsuits ensued about whether the design could be called a Ritchey-Chrétien, a two-mirror system invented by George Ritchey and Henri Chrétien in the 1920s and employed by many large research scopes, including the Hubble Space Telescope. Specialty companies, such as Optical Guidance

Systems and RC Optical Systems, manufacture true Ritchey-Chrétiens that are prized by advanced astrophotographers but carry a high price tag (\$10,000 and up). Optical experts argued that Meade's new system was more like a modified Schmidt-Cassegrain than a true Ritchey-Chrétien. Meade complied and renamed the models ACF, for their lack of off-axis coma, an advantage noticeable only when imaging.

Top-End Models (\$2,000 to \$2,700)

At the top end as of 2008, Celestron has the CPC Series (\$2,000 for the 8-inch) and Meade the LX200-ACF (\$2,700). Both models include GPS receivers, electronic compasses and level sensors to simplify GoTo alignment. These features used to be found only in the high-end models but are migrating down to the midrange scopes.

Instead, what now sets the top-end SCTs apart is, for the Celestron, even more solid twin fork arms, a heavier tripod and periodic error correction. Meade's LX200-ACF adds the more advanced Autostar II computer, as well as a sturdier mount, an auto-guider input, mirror lock-down and an external motorized focuser-excellent features for longexposure astrophotography. If deep-sky im-

Schmidt-Cassegrain Optics

Much has been written about the inherent quality of Schmidt-Cassegrain, or SCT, optics. Detractors maintain that the 35 to 38 percent obstruction of the secondary mirror degrades images unacceptably. In our experience, an SCT with wellmade optics (as they have been for several years) provides images sharp enough to please the vast majority of users. We've seen stunning views of planets through SCTs (with its central obstruction, an 8-inch SCT can deliver contrast and

sharpness that equal those of a 5-inch refractor). We're convinced the reason many SCTs don't perform well is that their optics are not collimated. With these telescopes, the slightest miscollimation of the critical secondary mirror softens planetary detail and degrades contrast. High-transmission coatings-"UHTC" on Meades, "Starbright XLT" on Celestrons-once an option, are now standard on most models and increase image brightness by 10 to 20 percent.

Meade now offers Advanced Coma Free (ACF) optics in its LX90 and LX200 Series, which primarily benefit astrophotographers. Visual observers are unlikely to see much difference between the ACF and conventional f/10 Schmidt-Cassegrain optics.

aging is your intention, the top-end units are worth considering for these features alone. But both 8-inchers are hefty units: the Celestron CPC with tripod weighs 61 pounds, while the Meade LX200-ACF is 73 pounds. They are solid!

Larger and Smaller SCTs While the 8-inch models are the most popular, both Meade and Celestron manufacture other sizes of SCTs. Celestron has its NexStar 5SE (\$800) and 6SE (\$1,000), wonderfully portable instruments with great optics and rock-solid mounts and tripods.

At the other end of the scale, Celestron has the CPC925 (9.25-inch, \$2,500) and CPC1100 (11-inch, \$2,800), two big-aperture telescopes that are as close to dream scopes as most people will want.

Celestron also offers the bigger SCT tube assemblies on its high-end CGE mount for astrophotographers. It is a solid mount but is hampered by its inability to cross the meridian, limiting exposure times.

Meade offers 10-inch (\$2,700) and 12-inch (\$3,300) scopes in its midrange LX90-ACF Series. However, the tall, light fork mounts are not a good match for the larger tubes. We advise against them.

Meade's LX200-ACF Series is a far better choice for the aperture-hungry buyer. The 10-inch (\$3,700) is just portable, but the 12-, 14- and 16-inch models (from \$4,700 to \$12,000) rank as observatory instruments. Unless you can leave the scope assembled and wheel it out to the driveway or patio on a dolly, our advice (true for either brand) is to stay with the 8-inch. Trust us! Bigger scopes simply will not get used.

* Celestron vs. Meade

A constant question in the minds of buyers is whether Meade or Celestron is better. We have examined images in dozens of Meades and Celestrons, in current versions and in telescopes that date back to their first years of production, and have seen good and bad instruments from both companies. In the mid- to late-1980s, in particular, the marketplace was flooded with hundreds of telescopes that were unable to form clean star images. The reputation of the Schmidt-Cassegrain took a beating. Both companies instituted sweeping quality-control measures, and the units we have tested and owned in recent years have all contained excellent optics with no consistent difference in optical quality between Meade and Celestron. It's a toss-up.

In hardware design, Celestron models tend toward elegant simplicity and ease of use by including just those features that most users will actually need. Meade telescopes tend to impress buyers with a long list of features. Some are useful, others are not; but some buyers like to have them all "just in case." The focusing mechanisms in Celestrons we've used tend to be more precise; in some Meades, focus has had a greasy feel, making it hard to nail the focus. Meades also tend to be noisier when slewing than Celestrons but are very accurate.

> Meade Autostar vs. Celestron NexStar

The Meade Autostar software generally features a larger database of useful objects, with various catalogs of deep-sky targets nicely cross-referenced (for instance, you learn that Caldwell 1 is also NGC188). Meade also provides more scrolling information about

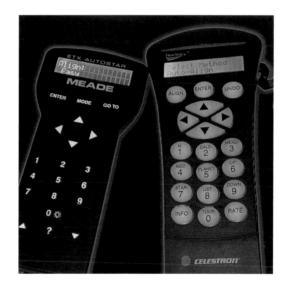

more targets and handy utilities like Sun and Moon rise/set times. Meade's programmed "Tours" are also more extensive and creative than Celestron's

However, the Celestron software offers all the databases most users would want, quickly accessible through single keypad buttons rather than a hierarchy of menus, as in the original Autostar software. The single Tour contains a good selection of showpiece targets. All this makes the NexStar software simpler to learn, with little fussing over motor training and calibration, as is required with the Meade Autostar scopes.

▲ Top-End Celestron Celestron's 11-inch SCT on a CGE German equatorial mount is a suitable observatory combo.

◀ Push-Button Astronomy Celestron's NexStar (the controller on the right) is easy to use and has all the features most observers would want. Meade's Autostar has more object information and extra features that can prove useful or perhaps just confusing. Both brands of GoTo computers can guide users through a lifetime of sky exploration.

Recommended Telescopes

Our list of favorite telescopes is biased toward models with several key characteristics: sharp optics, a steady, jitter-free mount, convenient portability and no-fuss ease of use, all at a price that is the best value in its class. Everyone nods in agreement that

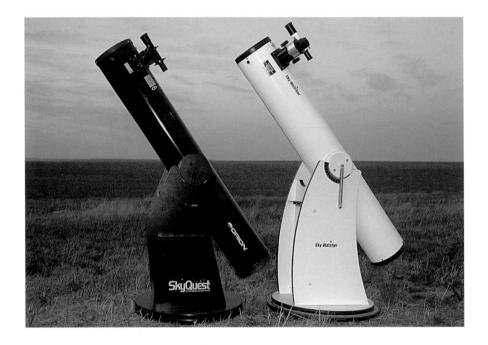

Great Starter Scopes 🔺

Almost identical in design, the Orion SkyQuest, at left, and the Synta Sky-Watcher, both sold worldwide under various brand names, offer sharp 6-inch f/8 optics on a sturdy mount for an affordable price. Larger 8-inch models are better for deepsky targets but are not as light or as portable. Note: In scopes under \$1,000, the same Chinese or Taiwanese unit is often sold under varying brand names, perhaps with differences only in finish or supplied accessories. these are the important traits of a good telescope. Yet, all too often, prospective buyers we talk to elect to ignore our advice, making their purchase based on other reasons: what was on sale at the local "Super-Mart;" which had the most convincing magazine ad; which has the biggest database in its handheld computer; or what might impress their friends and family the most.

Our aim is to outfit you with a telescope that will be easy to use and will show you the most for the money. The more you think "Wow!" when you look through the eyepiece, the more you'll want to continue to explore the night sky. Unlike telescope companies and stores, we aren't trying to sell you anything except the wonder and enjoyment the hobby can provide. No one can be expert in the 1,000 models now on the market. But of the telescopes we've used of late, the following are our favorites.

GETTING STARTED (\$150 to \$450)

These models represent our first choices for your first telescope. None require a major outlay, and all will retain good resale value. At this or any price point, the choice is often between a small computerized GoTo scope and a non-GoTo model with larger aperture for the same money. Go for the aperture. Low-cost GoTo scopes can be problematic, inaccurate and confusing to set up. Instead, opt for simplicity, a solid mount and image quality. Thus, topping our list...

> 6-inch f/8 Dobsonian (Orion SkyQuest or Synta Sky-Watcher)

These well-made \$300 scopes provide great optics on a stable mount and represent our first choice for the best value in a starter scope. In side-by-side tests with off-theshelf, shaky and cumbersome 6-inch achromatic refractors, an elegantly simple 6-inch Orion SkyQuest won hands down for revealing crisp planetary detail.

* Orion SkyQuest XT4.5 Dob Physically too short to be used by grownups, this little \$240 Dobsonian is perfectly kid-sized. With its no-fuss setup, ease of use, erect-image finder, quality eyepieces and solid metal and wood construction, we can think of no better telescope to encourage the interest of a young astronomer.

> 70mm f/10 Refractor on Alt-Az Mount (Celestron AstroMaster, Orion, Synta Sky-Watcher)

On an alt-az mount with slow-motion controls, the 70mm f/10 refractor (see photo on page 40) provides good optics and ease of use. It is the lowest-priced telescope of quality on the market. No other scope under \$200 is worth considering.

> 90mm f/10 Refractor (Celestron AstroMaster, Orion, Synta Sky-Watcher)

The Chinese-made 90mm long-focus refractors we've used (see photo on page 39) have amazed us with the sharpness of their optics at any price, let alone the \$300 these models cost. An altazimuth version is a fine starter telescope—most dealers carry a model under some brand name. For an equatorially mounted model, we prefer units on the larger EQ-3 mount. The added stability is worth the extra cost.

130mm f/5 Parabolic Reflector (Celestron AstroMaster, Orion, Synta Sky-Watcher)

The optics and fittings on these Chinese Newtonians (see photo on page 44) are very good, but the EQ-2 mount is just marginal. As with the 90mm refractor, a better though seldom-sold configuration is this tube assembly on the larger EQ-3 mount. The EQ-3 is used on Celestron's 6-inch f/5 Newtonian (the Omni 150) and on Orion's similar Astro-View 6, both excellent and recommended steps up in aperture for \$450. The Vixen R130sf is an f/5 130mm Newtonian with quality that's a cut above most imports.

* Celestron NexStar 130SLT With optics identical to the Synta 130mm f/5, this \$450 scope has a solid mount and good GoTo system. We suggest it as the minimum for an all-purpose GoTo. Celestron's 114mm SLT and Meade's similar DS-2114 (both 4.5inch GoTos) are Barlowed Newtonians we advise against (see page 63). The Celestron 102mm SLT and Meade's little ETX-80 are fast achromatic refractors that are great for lowpower deep-sky, but not planetary views images are soft with noticeable false color.

GETTING SERIOUS (\$500 to \$1,200)

If you're willing to invest more in a first telescope, these models provide either better optical quality or more features. Again, the choice might be between aperture and GoTo (i.e., between a large manual Dob and a small GoTo Mak or SCT). The GoTo technology at this price point is generally more accurate and reliable, but some may still prefer the sheer aperture and simplicity of a Dob.

Sky-Watcher Equinox 80ED Sold as a tube assembly only, this little f/6 doublet apo (see page 41) provides the best color correction we've seen for the price. It is more compact and has better fittings than the original lower-cost f/7.5 80ED model. It needs to be mated to a suitable mount.

✤ Meade ETX-90PE

Of the popular Meade ETX line, the nowdiscontinued ETX-105 stood out as our favorite. But for portability and sharp optics, the little \$700 ETX-90 can't be beat. The sturdy Deluxe Field tripod is now standard. And the GoTo works well. It will nicely complement a larger scope purchased later.

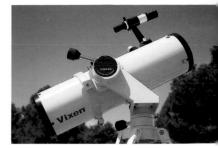

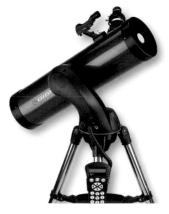

▲ Two 130mm Reflectors Vixen's R130sf on the solid altazimuth Porta Mount (top) is a high-quality choice for \$500. Celestron's NexStar 130SLT (above) offers GoTo for about \$450.

Four Entry-Level Mounts

EQ-1 This mount is too small and flimsy for most scopes it is asked to carry. An exception is Short-Tube 80mm refractors, but those wide-field telescopes are better placed on altazimuth mounts to make low-power scanning easier.

EQ-3 (aka SkyScan) We prefer this mount for 90mm refractors and 5-inch reflectors. It is too light for the 4.7-inch refractors often mated to it, taking seven to eight seconds to dampen vibrations.

EQ-2 This is a good mount for 60mm and 70mm refractors and Short-Tube 80mm and 90mm scopes but is strained by anything larger, such as the 4- and 5-inch reflectors with which it is commonly supplied.

EQ-4 (aka Celestron CG-5) This clone of the Vixen Super Polaris mount is not as solid as the original but is suitable for casual visual use with 4-to-5-inch lightweight refractors and 6-inch Newtonians.

These are the Chinese-made mounts you see most often on beginners' lelescopes. The mounts aren't bad in themselves, but in most cases, the telescope is supplied on a mount that is one size too small for the weight and size of the scope. If you have the option to outfit the telescope with the next larger-sized mount, we highly recommend doing so. The EQ-3 and EQ-4 are now offered with GoTo.

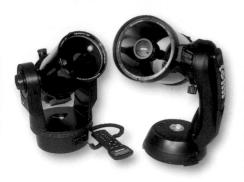

Competing "Cats" While both the Meade ETX-125PE (left) and the Celestron NexStar 6SE (right) are excellent performers, the NexStar offers more aperture for the money, faster f/10 optics (better for deep-sky) and a detachable tube assembly.

High-Tech Dob 🕨

The Orion Intelliscope comes with a Computerized Object-Locating System. While it does not have GoTo or tracking, it does point the way to thousands of deep-sky targets, providing high-tech aiming without sacrificing aperture, simplicity or reliability (the scope still works even if the computer fails or the batteries die).

Admittedly, this Synta Sky-Watcher 8-inch Dobsonian lacks the computers and other gadgets of widely promoted telescopes, but as a low-cost entry into serious viewing, it is unequaled. For a beginner's telescope, this could be the best buy on the market. Similar models made by Guan Sheng Optical are sold under many brand names around the world.

Best-Buy Telescope?

* Celestron NexStar 5SE & 6SE For the next step up in aperture in a GoTo scope, we have been impressed with the fork-mounted NexStar 5 and 6 SCTs. Their solidness, crisp optics, smooth, accessible focuser and reliable software make them a pleasure to use and give them an edge over the competitive Meade ETX-125PE.

* 127mm & 150mm Maksutovs

(Orion StarMax, Sky-Watcher) Differing only in cosmetic finish, the optics of these f/12 Chinese Maks are excellent, and the short tubes lend themselves to mating to any number of lightweight mounts, like the Orion SkyView or large Synta models.

> 120mm (4.7-inch) f/8 Achromat Refractor (Celestron Omni, Orion SkyView Pro or Synta Sky-Watcher)

If a refractor appeals to you, this is a terrific buy at \$650. The classic f/8.3 achromatic optics are fine and the fittings excellent for such an affordable scope. On the light Synta EQ-3 or Celestron Omni mount, images bounce for several seconds after touching the focuser; a far more solid mount is the EQ-4 or Orion SkyView.

William Optics 90mm & 110mm Megrez Doublets & 110mm FLT Triplet Apo Refractors

We've tested all these units, and they represent excellent values. Both the f/7 FLT triplet (\$2,800) and the 90mm Megrez (\$1,200) have better color correction than the 110mm f/6 Megrez doublet (\$1,400). But the latter is a good photo instrument. As an alternative, several dealers (Astro-Tech, Orion, Stellarvue) sell a 102mm f/7 ED doublet with similar specs but different fittings for about

\$1,100. We like the Stellarvue SV102 with the Feathertouch focuser option.

 & - & 10-inch Dobsonians (Orion SkyQuest, Synta Sky-Watcher and many others)

These telescopes give you serious aperture for deep-sky viewing without costing a bundle. They are well made, with excellent optical quality for the price (\$400 and \$550). The 8-inch is light enough to be handled without difficulty by most teens and adults.

* 8- & 10-inch Orion

Intelliscopes

We like these scopes! The nifty Dobs have fine fittings, solid tubes and the added hightech feature of computerized "push-to" encoders and a handheld computer help point the way to sky targets. The system is simple to align and use and provides com-

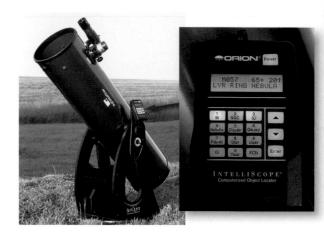

puterized finding without the expense and battery drain of motors. They are an ideal melding of simplicity and aperture with high tech. Highly recommended, especially in the 8- and 10-inch sizes (\$650 and \$800).

8-, 10- & 12.5-inch Meade Lightbridges

These terrific Dobs (see photo on page 43) provide aperture without taking up a ton of room in your car. The tubes break down into manageable components. The price is higher than solid-tube Dobs (\$600, \$800, \$1,000) and the setup time longer, but for apertures over 10 inches, a truss tube is a must. As of this writing, Meade did not offer computerized digital setting circles equivalent to the Intelliscope device, but third-party suppliers like JMI offer add-on encoder and computer kits if you want computerized finding. The 12.5-inch is a best buy in this aperture; the big 16-inch (\$2,000) is for the deep-sky fanatic.

Telescope Performance Limits

.....

Aperture (inches)	Aperture (mm; approx.)	Faintest Stellar Magnitude Visible	Theoretical Resolution (arc seconds)	Highest Usable Power
2	60	11.6	2.00	120x
3.1	80	12.2	1.50	160x
4	100	12.7	1.20	200x
5	125	13.2	0.95	250x
6	150	13.6	0.80	300x
8	200	14.2	0.65	400x
10	250	14.7	0.50	500x
12.5	320	15.2	0.40	600x
14	355	15.4	0.34	600x
16	400	15.7	0.30	600x
17.5	445	15.9	0.27	600x
20	500	16.2	0.24	600x

Even large scopes can rarely use magnifications over 600x or resolve better than 0.4 to 0.5 arc second.

GETTING MORE SERIOUS (\$1,300 to \$2,900)

This price range represents the top dollar that most buyers likely want to spend, though there is a soaring stratosphere of instruments above this.

Sky-Watcher Equinox 120ED This is an impressive apo. With nearly 5 inches of aperture, the doublet FPL-53 lens can reveal serious planetary detail. In our tests, images were tack-sharp and color correction was as good as if not better than any other apo in this price/aperture class.

Celestron NexStar 8SE

or Meade 8-inch LX90-ACF Unless you are a refractor or Dob diehard, the first choice in this price range has to be an 8-inch Schmidt-Cassegrain. All models feature the same optics regardless of price, and the GoTo systems are excellent, so why not have that convenience? These instruments are highly recommended for both serious beginners and intermediate astronomers who want an all-purpose scope.

Celestron CPC800 or

Meade 8-inch LX200-ACF

These models offer such premiums as improved mounts and tube assemblies and

advanced astrophotography features: better drive gears, periodic error correction, autoguider readiness and Meade's mirror lockdown and outboard focuser. The solid construction of these scopes will be appreciated even by nonastrophotographers.

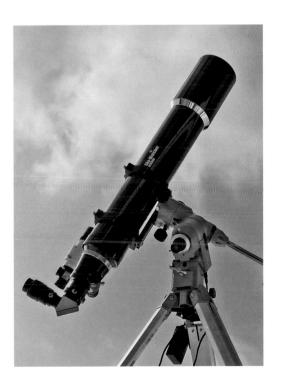

▲ The Limits of Power Even an 8-inch telescope like this Celestron CPC is usable at its highest practical power (400x) only on the few rare nights with the steadiest seeing conditions. Typically, most observing is done at far lower powers.

High-Value Apo

The optical quality and color correction offered by the 4.7-inch f/7.5 Sky-Watcher Equinox 120ED is bettered only by much more costly 5-inch triplets from the likes of Astro-Physics and TMB Optical. Fit and finish are excellent. At \$2,400 for the tube assembly, it's a bargain for an apo of this size, but be sure to budget for a good German equatorial mount, like the Sky-Watcher HEQ5/ Orion Sirius. Telescopes, Italian-Style ▼ Looking for a telescope that will catch admiring glances at star parties? Check out the designer apos from A&M in Italy (105mm and 80mm models shown). All feature carbon-fiber tubes and first-class fittings.

NOTHING BUT THE BEST (\$2,500 to \$10,000)

Here, we emphasize telescopes we either own or have used extensively and can therefore recommend from firsthand experience. Certainly, other top-class brands exist and have well-deserved reputations for quality. We simply haven't used them—yet. We'd be happy to receive samples for testing!

A&M Triplet Refractors

These classy apos feature triplet and quadlens designs for top-grade color correction. You can select from a choice of focusers and even pick the designer color for the accent rings around the slick carbon-fiber tubes. Coauthor Dyer uses the TMB-designed 80mm f/6 and 105mm f/6.2 and recommends them highly. Alternatives are any apo by Takahashi, such as the triplet TSA-102S, and Stellarvue's triplets, like the SV4.

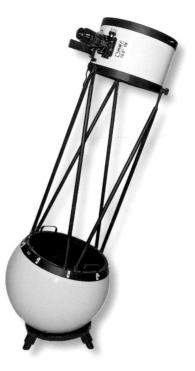

 MAG1 PortaBall 12 Reflector What a neat telescope! What fun to waltz around the sky using Carl Zambuto's superb optics, which provide good deep-sky views as well as terrific planetary views (the central obstruction is only 20 percent). The 12-inch f/5 provides the necessary aperture for serious deep-sky viewing while maintaining the superportability of the design. When broken down, it sits on a car seat. When set up, it swings around the sky with no awkwardness at the zenith, where traditional Dobs have a hard time aiming. The eyepiece rotates, so it's always at a convenient angle. The drawbacks: Heavy eyepieces may cause the scope to sink, and digital setting circles cannot be added. Original MAG1 owner Peter Smitka designed one of the world's great scopes. Now under the ownership of Dave Juckem, MAG1 Instruments promises to continue the tradition of innovative excellence.

Dancing with the Stars ► The MAG1 PortaBall trusstube reflector uses a large fiberglass ball that rests on three Teflon pads. The scope is easy to swing around the sky and rotate to place the eyepiece at the right height and angle for ergonomic comfort. You just about dance with this scope.

Cure for Aperture Fever ► You want aperture without compromising quality of optics? This 30-inch Starmaster Newtonian is perhaps the finest big telescope money can buy. The views of deep-sky objects and planets through any Starmaster are consistently breathtaking.

Tele Vue NP Refractors

Optics don't get any better. From wide-field panoramas to high-power planetary views, the four-element Nagler-Petzval NP101 and NP127 (see photo on page 42) do it all. Couple them to Tele Vue's Gibraltar altazimuth mount and Star Tour digital setting circles for computerized finding. For imaging, step up to the "is" versions, which have better focusers and larger rear elements.

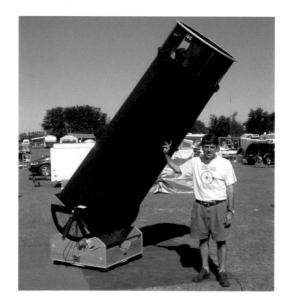

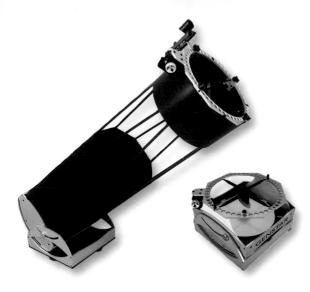

Starmaster Dobsonian Reflectors

This ultimate premium Dobsonian has it all. Company owner Rick Singmaster spent more than a decade perfecting the design of big but highly portable Dobsonians with mounts motorized for Go To and tracking. Imagine an 18-inch Dob, only slightly taller than an adult of average height, that swings on command to any deep-sky object, then tracks like an equatorial mount. Now add unsurpassed Zambuto optics, and wow! They are available with GoTo in sizes from 14.5- to 30-inch. Although the bigger units strain the definition of portable, the 14.5-to-18-inch models are wonderfully transportable.

 Genstar 10-inch Dobsonian Reflector

We'll admit to our local Canadian bias here, but Edmonton craftsman and telescope maker Dwight Hansen has created an elegant and beautifully machined low-profile 10-inch Dob, marketed as the Genstar by his company Hansen Optical. The size and weight are as low as we've seen for a 10-inch.

ASTRO-IMAGING SPECIALIST (\$3,000 minimum)

The following instruments are designed first and foremost for deep-sky imaging, with DSLRs and CCD cameras.

Borg 77, 101 & 125 Models Borg refractors can be mated with focal reducers optimized for photography. They project flat fields onto formats as large as a fullframe 35mm chip yet are extremely light and break down into small components for airline travel. The 77mm f/4 is a favorite scope of ours for wide-field imaging.

Ultralight Dob

The Canadian-made Genstar 10 can collapse into a package small enough to be airline-portable (also shown). Coauthor Dyer keeps a prototype Genstar in Australia. Photo courtesy Hansen Optical.

▼ Borgs Ready to Fly

The little Borgs split apart for easy packing. The 77mm and 101mm objectives (both are shown here) can share the same tube and rear reducer assembly.

Buying for a Child or the Family

The number-one telescope question we (and every amateur astronomer) are asked is, "What's the best telescope for my child, who is really interested in the stars and planets?" Our first reply is one the curious parent doesn't want to hear: Don't buy a telescope at all. Most kids (and beginning adults) are simply not ready for a telescope. They must first learn to pick out the bright stars and planets. If they can't point to Saturn, how will they aim a telescope at it? Yes, some GoTo scopes promise to circumvent the need to learn anything about the sky, but we find that being able to identify bright objects and constellation patterns is an essential first step, one gained by simply getting outside with a child, star map in hand, to explore what's up there. When a child—and parent—is ready to graduate to a scope, we

suggest a simple Dobsonian, like the Orion StarBlast or SkyQuest 4.5 or any 6-inch. These are great values but may not be available in local stores, and on-line ordering may be necessary. A well-fitted 70mm refractor (or any scope described under the "Getting Started" category on page 52) will serve a young astronomer well. Despite the temptation, avoid the power-mad trash scopes sold at big-box superstores (most of these telescopes end up collecting dust in closets and basements).

Everyone starts out with a simple scope. Look for models with sturdy full-height tripods, slow-motion controls on the axes (for altazimuth mounts), a good finderscope (a red-dot unit on this model is better than many cheap optical finders) and decent eyepieces that don't provide excessive magnification. See page 40 for more tips on what to look for in a starter scope for any age.

Astrographic Apos ► Known for pinpoint stars across the biggest digital chips, the Takahashi FSQ106ED (near right) is more compact than the original FSQ. (Photo courtesy Jay Ouellet.) Competing are apos from Pentax, seen on display (far right) at the RTMC Astronomy Expo in Big Bear, Calif.

No-Frills Mounts 🖤

While astrophotography requires elaborate mounts and tracking systems, visual observers often opt for one of the new generation of high-quality alt-az mounts, such as this one from DiscMounts (top), handcrafted by Tom Peters, or the William Optics Eazy-Touch, shown at bottom handling a pair of apos.

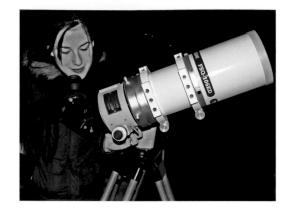

Takahashi FSQ106ED

First introduced in 1998, this telescope quickly gained a well-deserved reputation as one of the finest photo-visual scopes ever manufactured. The latest version employs a doublet front objective and a doublet rear field flattener (each with an ED element) in a classic Petzval design. The result is a superb yet compact f/5 refractor for the aficionado. The cost is \$4,000, but budget another \$1,000 for all the photo accessories.

Pentax Refractors

We'll admit to not having used these new models, but since they come from Pentax, we can be assured of top-quality performance. Designed with imaging in mind, they are available in 75mm to 125mm apertures. Particularly attractive is the 100 SDUF, a 3.9-inch f/4 astrographic apo for \$3,000.

Ritchey-Chrétiens & CDKs Every telescope type takes its turn as the favorite among astrophotographers. Today, those seeking the finest optics for advanced CCD imaging and research opt for Ritchey-Chrétien Cassegrains from RC Optical Systems or Optical Guidance Systems or a "CDK"Corrected Dall-Kirkham from Plane-Wave Instruments or Ceravolo Optical Systems. At \$25,000 to \$60,000 with a suitable mount, these are dream "retirement" systems requiring an equally dream observatory, preferably at a retirement astronomy village in Arizona!

Premium Mounts

Astrophoto systems are often mix-andmatch affairs, with a tube assembly from one manufacturer mated to a mount from another. Astrophotography demands the best no-compromise mount. Two of the most popular models for small 3-to-6-inch scopes include the GM-8 and G-11 models made

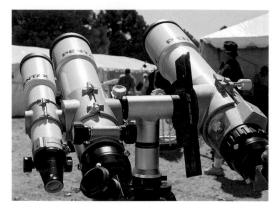

by Scott Losmandy's company, Hollywood General Machining. These solid mounts provide accurate tracking and precisionmachined components, all for a reasonable price of \$2,500 for the GM-8 and \$3,200 for the larger G-11, with the excellent but complex Gemini GoTo system. For the best values in top-class mounts available from stock, Losmandy is a fine choice.

For a small scope mount, we've been impressed with Vixen's Sphinx SXD (\$2,700). However, the best value in a small astrophoto mount is Sky-Watcher's HEQ5 Pro (\$1,200), sold by Orion as the Sirius EQ-G.

The mounts of choice among many astrophotographers, including us, are Astro-Physics' premium mounts: the portable Mach1 and the 900, 1200 and monster 3600. They are beautifully made, with one of the best GoTo systems we've used. The Mach1 (\$6,000) easily carries a 5-inch apo refractor, while the 900 is a solid mount for a 6-inch apo. The 1200 mount carries just about any scope under 14 inches that an astrophotographer would want to attach to it. Unfortunately, these mounts require long waits.

Although we've not used them, other big premium mounts are offered by 10Micron, Mountain Instruments, Parallax Instruments, Software Bisque and Takahashi.

DEEP-SKY EXPLORERS (\$3,000 and up...way up!)

If aperture fever has you in its grip, the only antidote is a big Dobsonian. Besides Starmaster, the following are among the best.

Obsession Dobs

These telescopes have long ruled the bigaperture universe. Designed by Dobsonian guru Dave Kriege, Obsession Dobs feature

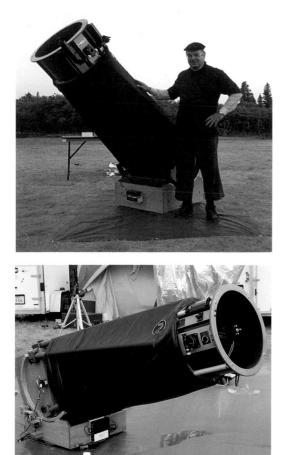

woodworking and finish of fine-gradefurniture quality. Though large, they break down into components that can readily be carried or wheeled by one person. However, setup and takedown of the largest instruments are usually best handled by two people. We particularly like the 15- and 18inch models as manageable and satisfying one-person telescopes that don't require a large ladder.

Kriege's new Ultra Compact 18 (\$6,600), shown on page 44 being unveiled at the 2007 Texas Star Party, is particularly attractive, as it collapses into a package that can fit into any vehicle. It's another clever design from the fellow who changed the face of the Dob and made big-aperture scopes feasible.

Starsplitter Dubs

Just a notch down in the grade of woodworking from Obsessions, Jim Brunkella's line of high-quality Starsplitters has expanded over the years to include lightweight designs and compact dual-truss models. As with other Dobs, we suggest a model in the 14-to-18inch range for maximum convenience of eyepiece height.

PLANETARY PERFORMERS (\$5,000 and up and up...)

Any telescope whose optics are good enough to reveal the finest planetary detail will work well on all types of viewing. But the following instruments are good choices if the planets and first-class optics are your first line of interest.

Astro-Physics Apo Refractors As with the apos below, we list these premium refractors under the planetary category, but they could also be considered as among the finest astrophoto instruments on the market or simply as telescopes coveted by anyone looking for "nothing but the best." We love these scopes. Optics don't get any better—which is why these refractors are in such demand but low supply.

> TMB & A&M 130mm and Larger Apos

Anyone looking for first-class performance and construction has lots to choose from in the lines of triplet refractors offered by TMB and A&M. These large apos demand a sizable mount, but there's no better choice for the well-heeled planetary enthusiast and apo refractor aficionado.

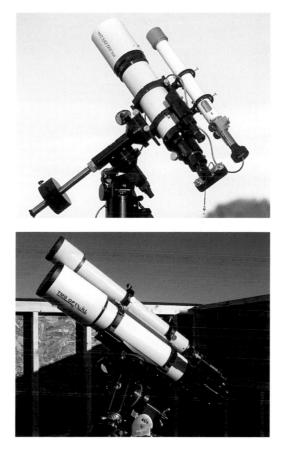

Dobs on Parade

Happiness is a big scope under dark skies. The Starsplitter line includes a variety of truss-tube designs like this one (top). The classic Obsession 18 (bottom) is the aperture we consider to be the largest user-friendly size for a big Dob. (Oh, we're happy to look through bigger scopes -we just don't want to set them up and navigate them and their huge ladders around the sky!) As with most truss-tube scopes, a black nylon shroud covers the otherwise open tube to prevent stray light from reaching the optics.

▲ Astro-Physics Apo The authors have owned Astro-Physics refractors in every size ever made, from 90mm to 178mm. This is the original 130mm f/6 EDT, now replaced by a similar model with a tube that breaks apart for transport.

ТМВ Аро

In 2007, TMB Optical introduced a 130mm t/7 Signature Series apo that, at \$4,000, represented a price breakthrough for this size of triplet apo. We cannot speak from firsthand experience, but observers we trust report excellent performance. Both 130mm scopes are shown on Losmandy G-11 mounts.

Portable Takahashi A The Sky90 has fine 90mm f/5.6 optics and fittings typical of all Japanesemade Takahashis.

PORTABILITY PLUS (\$300 and up)

Any small apo scope is durable and airlineportable, but these units are particularly compact and high in quality.

William Optics 66mm Apo Little 66mm apos now abound from several suppliers. We own and have tested units from William Optics and love these gems.

 Takahashi Sky90 Fluorite Apo About the same weight as the Tele Vue 85mm but the length of many 80mm apos, this doublet fluorite has dead-sharp optics with just a trace of false color. The optional Extender-Q reduces color at high power, while the optional reducer/field flattener is essential for deep-sky imaging. Fully outfitted (\$2,500), it is unmatched for portability.

The Used-Scope Lot

If well cared for, a telescope can last a lifetime and can work as well now as it did years ago. A used telescope can be an excellent buy. Check the classifieds on websites such as www.astromart.com, www.astrobuysell.com or, in Australia, www.iceinspace.com.au. A caution on using eBay: Most scopes sold on eBay are the trash scopes that remain junk at any price. With that, here are some of our favorite, and not so favorite, telescopes of years past.

GREAT TELESCOPES OF THE PAST

Celestron GPS Models

Celestron's Schmidt-Cassegrains just prior to the current CPC models (as of 2008) were the GPS models with carbon-fiber tubes (shown above right and described at bottom of facing page). They are terrific scopes.

Celestron Ultima 2000

This battery-operated GoTo scope featured light weight, quiet motors and great portability. A unique feature that is lacking in any telescope today was its ability to be moved by hand and still keep track of where it was pointed.

Celestron C5 (almost any vintage)

The C5 has gone through many face-lifts through the years but has always featured excellent optics.

Celestron/Vixen Fluorite Apo Refractors

In the early 1990s, Celestron offered a series of supersharp Vixen 70mm, 80mm, 90mm and 100mm fluorite apo refractors, often on the superb Vixen Super Polaris mount. They were labeled SP-70F, SP-80F, and so on, and are among the finest small-aperture refractors ever made. Fluorite models that were sold for a time under the Orion name are equally good.

Meade LX90 and LX200 Schmidt-Cassegrains

Earlier Schmidt-Cassegrains from Meade may lack some of the features of the current models (i.e., Coma Free optics, GPS, Level North sensors), but with excellent optics and an Autostar computer, which can be updated to the latest version of firmware, they will still work very well. Expect to pay 60 to 75 percent of new for an earlier-generation high-tech scope.

Meade ETX-90

The original late-1990s ETX-90 was a plain non-GoTo scope (offered for a time as the "RA" model). For a handy no-frills second scope with fine optics, a "classic" ETX-90 is a great choice.

Quantum 4

This limited-production Maksutov-Cassegrain (a 6-inch was also offered) was produced in the early 1980s to compete with the Questar. Quantums are rare and are still prized for their fine optics.

Any Early-Model Questar 3.5

The quality of the Questar 3.5 has been consistent over the decades, with the only significant change being the option of a more convenient DC-powered drive (PowerGuide) in models made after the 1990s. Because their design has changed so little over the years, Questars retain their value, unlike the obsolescence of high-tech scopes.

* iOptron GoTo Mount

This neat little mount offers GoTo and tracking in a compact, affordable package (about \$250; \$360 with GPS and deluxe hand controller). A standard Vixen-style dovetail plate accepts many tube assemblies, making this a terrific mount to match with a small apo or Maksutov-Cassegrain for a portable package. Pointing accuracy is good enough for use with wide-field refractors, and the display presents four lines of information. The mount weighs 8.2 pounds.

Portable GoTo

In our tests, the iOptron "Cube" mount proved to be a good performer. The standard controller has a 5,000-object database (though most are stars referenced only by obscure code numbers) and can handle tubes up to about seven pounds. It comes with an aluminum tripod.

Any Early-Model Takahashi Refractor

This is another brand name you can trust for fine optics, no matter the era. A small Tak makes a great second scope. **Any Early-Model Tele Vue Refractor**

The 4-inch models, in particular, were not as well color-corrected as the most recent models (the older the model, the worse the color), but Tele Vue optics have been consistently sharp and well made.

Any Early-Model Astro-Physics Refractor

Used Astro-Physics refractors are in such demand, they get snapped up by word of mouth and command as-new, if not higher-than-new, prices. These scopes actually increase in value. The legendary 105mm Traveler is shown below.

USED TELESCOPES TO AVOID

Any Early-Model Criterion or Bausch & Lomb Schmidt-Cassegrain

The optical and mechanical quality of these 4-, 6- and 8-inch SCTs from the 1970s and 1980s left much to be desired.

Almost Any German Equatorially Mounted Schmidt-Cassegrain

With rare exceptions, these models by Celestron and Meade were consistently undermounted.

Almost Any Schmidt-Cassegrain Produced in the Mid- to Late 1980s

During the Comet Halley era, optical quality slipped terribly, giving SCTs a bad reputation that persisted for years. **Any Celestron C90**

Its fuzzy optics and crude rotating-tube focusing are reasons to avoid the incarnations of this 90mm Maksutov.

Any Coulter Blue- and Red-Tube Dob

They started the Dobsonian revolution, but today's entry-level Dobs are far better in all respects.

Any of Meade's MTS Series Fork-Mount or LXD-55 German Equatorial Scopes

The older MTS fork mounts were shaky, while the original LXD-55 GoTo mount suffered from numerous problems. **Any of the Early-Model Meade DS Series of Beginner GoTo Scopes**

These small refractors and reflectors with add-on motors had several problems with balky drive mechanisms. **Meade 16-inch Starfinder Equatorial**

Bought by the aperture-fever-afflicted, this scope is way too big and shaky to be usable. Buy a Lightbridge. **Meade Non-GoTo 10-inch Schmidt-Cassegrains**

Ten inch models from the 1980s, like the LX3, LX5 and LX6 units, have fork mounts and wedges that are too light and bouncy for the heavy tube assembly. Avoid the temptation of large aperture for low cost. Classic 8-Incli Meades (and Celestrons) from the pre-GoTo days can be fine and should be bargain-priced, but check the optics first.

The Celestron GPS8 (facing page, right) is a fine GoTo telescope from the early 2000s. It and the larger GPS11 featured an attractive carbon-fiber tube and a power connection point that did not rotate, preventing cables from wrapping and tangling.

Making the Purchase

Now, the final hurdle. After making your selection, or at least narrowing down the choices, the question is, Where do you buy the telescope?

WHERE TO LEARN MORE (Clubs, Internet, Reviews)

First, you may want additional real-world information. Observing nights and star parties hosted by local astronomy clubs are great places to see telescopes in action—especially scopes you may be considering purchasing. Seeing and handling a telescope provides a valuable reality check of your expectations of ease of use and of what a telescope can actually show you.

Magazine reviews (we regularly write them ourselves) also provide valuable details on how a telescope performs. Magazine websites usually have reviews archived for download, though perhaps for a fee.

The Internet is a source of still more opinions—lots more. But we caution you: Many of these opinions are highly biased, if not inflammatory, for and against specific brands or types of telescopes. Biased opinions that would never make it past the eyes of an astronomy-magazine editor go through no such filter when posted on a private web page or forum. They are not objective reports, though this may not be at all obvious to the novice looking for guidance. Unqualified statements such as "This is the best telescope I've ever used" beg the question, How many has the reviewer actually used?

A simple rule applies here: No matter how bad the telescope, someone will defend it as the best value on the planet! Yet amid the web dross are thorough reviews written by observers who know telescopes and whose expert opinions can be trusted. Tom Trusock's reviews on cloudynights.com and Ed Ting's on scopereviews.com stand out as among the best.

DIRECT PURCHASE FROM THE MANUFACTURER

So where to buy? Many companies sell solely through dealer networks. Some small manufacturers have select dealers and also sell via mail or web-based orders. Others sell only direct from the factory.

In some cases, smaller-volume producers construct the telescope only after the order is received. Demand is often so great, they can never produce enough units to maintain a stock anyway. Such operations usually require a payment of one-third to one-half of the total cost of the instrument when the order is placed. The balance is due when the equipment is ready to be shipped.

Ninety-nine percent of the time, there is no risk in this procedure. But, as in any field of manufacturing, companies can go out of business. If this happens while a company has your money, you may be out of luck. To guard against such a problem, seek recommendations about companies from knowledgeable amateur astronomers. If there are waiting lists for a company's products, ask whether the company has shipped one of its products recently. If someone you know has been waiting well past the stated delivery date,

Tons o' Scopes ► Today, you can choose to buy from a major manufacturer that makes and stocks scopes by the thousands, as here, or from a "boutique" supplier that builds telescopes to order. The choice of models is now wider than ever.

Web Wisdom 🕨

A good site to check for peer reviews of scopes and other astro-gear is www.cloudynights.com. Other sites include: • www.scopetest.com • www.scopereviews.com • www.iceinspace.com.au The telescope user groups on Yahoo (it seems there is one for every brand and model) can provide a feel for how people are liking their telescopes.

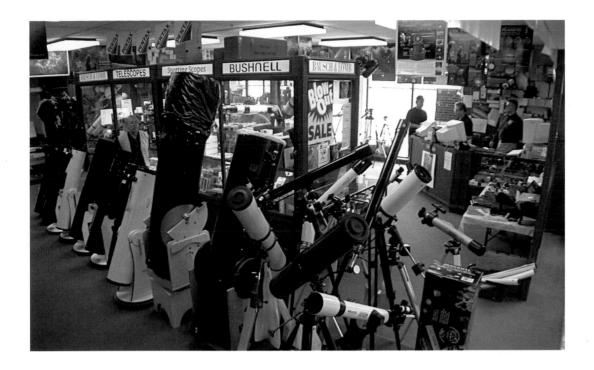

Scopes 'R' Us

Primed with the information in this chapter, you should now be ready to walk into a telescope store like this wellstocked showroom, ask the right questions and make an informed purchase of a telescope that's right for you.

then exercise caution. However, if the reports reveal that delivery dates have been adhered to, it is probably safe to proceed. Although one of us waited 20 months for a telescope, it arrived only a few weeks past the originally stated deadline. Long waits are not in themselves cause for alarm.

ORDERING BY PHONE OR VIA THE INTERNET

The major astronomy magazines have dozens of advertisements from dealers selling nationally by mail, phone and the Internet. Some, such as Astronomics and Orion Telescopes and Binoculars, market only telescopes, binoculars and accessories. Other outlets, such as Adorama and Focus Camera, are discount warehouses that retail mostly cameras, electronics and other consumer goods but also sell telescopes, often at appealing prices. The savings offered by out-of-town dealers may be attractive, but read the fine print about shipping costs, so-called crating charges and restocking charges if something is returned. Also consider the differences in personal service between local and mail-order dealers.

If the price differential or a lack of local outlets makes a mail-order dealer your choice, try to find someone who has dealt with that company. Discussion groups such as sci.astro.amateur on the web are filled with comments about users' dealer experiences. Ordering via the web is a well-established and reliable procedure. But if you are unsure about a company, call and talk to a real person. Telephone etiquette is an important tip-off. Any sign of impatience or lack of product knowledge by the salesperson at the other end of the line should be your signal to try elsewhere.

PURCHASE FROM A LOCAL DEALER

The safest and usually the most convenient method of buying a telescope is from a dealer within driving distance of your home. You can get expert advice, see what you are getting before you pay and load the goods into your car and drive away.

If a local dealer does not stock the item you want, chances are, it can be ordered for you. We generally recommend this option over ordering it yourself direct from the man ufacturer, even if it costs a few dollars more. Why? Consider this: If the telescope subsequently does not perform as advertised, it can be returned to the store where it was purchased. That's a tremendous convenience compared with packing up a telescope for reshipment back to the manufacturer, often at your own expense, then trying to deal with the manufacturer's customer-service personnel by phone.

Scopes to Avoid

.....

4.5-inch (114mm) Short-Tube f/9 Newtonians

These scopes have a 2x Barlow lens in the focuser to double the focal length. The optics are fuzzy.

3-inch Newtonians

Small aperture and flimsy mounts make these poor choices compared with a 4.5-inch Dob.

Undermounted Models

In a series of scopes offered on the same equatorial mount, the small scope will be solid, the biggest scope will be too shaky and the middle scope will be just acceptable.

C H A P T E R F O U R

Eyepieces and filters

have improved mark-

edly since the 1980s.

backyard astronomer with a bewildering

but wonderful array

of accessories that, if

well chosen, can en-

hance the performance

of any telescope,

large or small.

providing today's

Essential Accessories: Eyepieces and Filters

Since the 1970s, both of us have taught introductory courses for recreational astronomers. During each course, one or two class members come forward to ask why they are having trouble using their telescopes. Invariably, the instruments are the standard "450-power" beginner's model the same type we unwittingly purchased as our own first telescopes.

Apart from the rickety mounts and vague instruction manuals, these telescopes (usually 60mm refractors) are notorious for their poor-quality eyepieces, filters and Barlow lenses. Typically, only one evepiece of the two or three included is usable-the one offering the lowest magnification. Our suggestion to the disappointed owner is to toss the other eyepieces in the trash, use the lowpower eyepiece and forget the filters and Barlow lens. Those items are added simply to give the appearance of fancy accessories. Upgrading to a better class

of eyepieces is the best improvement a new owner can make to a starter scope.

Even owners of more expensive telescopes need to buy eyepieces, as upscale telescopes rarely come with more than one eyepiece. Just as photographers add wide-angle and telephoto lenses to their camera bags, astronomers add eyepieces to enable their telescopes to show more. A well-chosen set of filters can also enhance the view through any telescope.

Together, eyepieces and filters represent the first and foremost accessories every telescope owner needs to consider. In addition, top-quality eyepieces tend to hold at least two-thirds of their value when sold as used equipment. This chapter is a guide to these essential accessories. We either own or have used virtually everything mentioned on the following pages.

No.58

No. 38/

Eyepieces

High-quality evepieces, sometimes known as oculars, are as essential to sharp views as is a good primary mirror or objective lens. The telescope's main mirror or lens gathers the light and forms the image. The eyepiece

Eyepiece Quality 🔺

Many manufacturers now supply at least one decentquality eyepiece with their beginner telescopes. The units above are good examples. However, some telescopes still come with the same poor eyepieces that have plagued beginner scopes for decades.

A Full Set 🔺

Eyepieces come in a wide range of focal lengths, as seen with these superb Meade Series 5000 Plössls. The shorter the focal length, the higher the power. magnifies that image. Poor optics at either end of the telescope result in less-thanoptimum performance.

On all astronomical telescopes, the eyepieces are interchangeable. Switching them is how you change magnifications. Selecting a set of evepieces best for your telescope and budget requires understanding the merits of various eyepiece designs. However, the most important specification of any eyepiece is simply its focal length.

FOCAL LENGTH

Like any lens or mirror, an eyepiece has a focal length, indicated in millimeters and marked on the top or side of the unit. A long focal length (55mm to 27mm) provides low power and shows a large region of sky. A medium focal length (26mm to 13mm) offers med-

ium power and takes in a smaller area (typically less than one Moon diameter). A short focal length (12mm to 3mm) produces high power and shows only a tiny region of sky.

As tempting as it might be, it is not necessary to collect an entire series of eyepieces, from the shortest to the longest

focal lengths. A starter set of three (one from each eyepiece group) will provide a range of magnifications sufficient to handle most astronomical targets, from large, faint nebulas to small, bright planets.

FIELD OF VIEW

How much sky is seen through the eyepiece depends on the magnification it provides and on its apparent field of view. The apparent field of view depends on the optical design of the eyepiece. If you hold an eyepiece up to the light and look through it, you will see a circle of light. The apparent diameter of that circle (measured in degrees) is the eyepiece's apparent field of view, a figure usually given in the manufacturer's specifications.

Standard eyepieces, such as Orthoscopics and Plössls, have apparent fields of view of 45 to 55 degrees. Wide-angle eyepieces have 60-to-70-degree fields. Extreme wide-angle

Calculating Power

To determine the magnification of a given eyepiece, divide the telescope's focal length in millimeters by the eyepiece's focal length. For an 8-inch Schmidt-Cassegrain telescope, for instance, with a 2,000mm focal length:

- a 40mm eyepiece yields $2000 \div 40 = 50x$ (low power)
- a 20mm eyepiece yields $2,000 \div 20 = 100x$ (medium) power)
- a 10mm eyepiece yields

 $2,000 \div 10 = 200x$ (high power) Those same three eyepieces on a telescope with a 1,000mm focal length would yield only 25x, 50x and 100x, respectively. As you can see, the power an eyepiece provides depends not only on its own focal length but also on the focal length of the scope with which it is used. That's why no astronomical eyepiece is marked with a magnification.

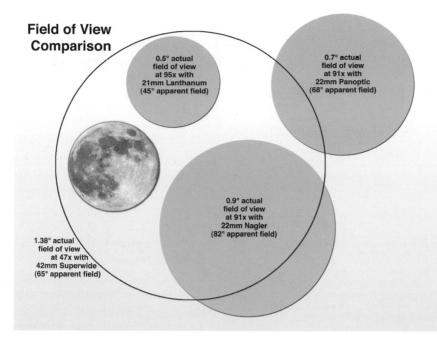

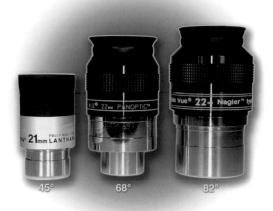

eyepieces, such as Tele Vue Naglers, Meade Ultra Wides and William Optics UWANs, have 82-to-84-degree fields.

To find the actual or true field of view (in degrees) that an eyepiece gives on your telescope, divide the eyepiece's apparent field by the magnification it provides. For example, take a 20mm Plössl eyepiece with a 50-degree apparent field. On an 8-inch f/10 Schmidt-Cassegrain telescope, it yields 100x. At that power, its actual field is about half a degree (50 degrees \div 100 = 0.5 degree), just wide enough to show the entire disk of the Moon. A typical 20mm wide-angle eyepiece (with a 65-degree apparent field) provides the same power but shows more sky, about 0.65 degree, enough to reveal black sky around the Moon.

For purists, another formula provides a more precise measure of actual field of view for wide-field eyepieces: (eyepiece field-stop diameter ÷ telescope focal length) x 57.3 degrees. The problem with using this formula is that almost no manufacturers, other than Tele Vue, supply field-stop-diameter specs for their eyepieces. Another method to determine actual field of view is to measure the time it takes for a star to drift across the eyepiece field. A star at the celestial equator takes four minutes to travel one degree.

Since they show a larger area of sky, eyepieces with wide fields are generally preferred for deep-sky observing. However, because of an aberration in the eyepiece optics called astigmatism, stars toward the edge of wide-angle fields can be distorted into lines orV-shaped blobs. Lateral color further spreads stars into little yellow-blue rainbows. The best wide-angle eyepieces (usually the most costly) reduce these aberrations to a minimum, but none can eliminate them entirely.

Although wide fields can provide exciting panoramic views of the Moon, they are not needed for planetary observing. Good views of the planets require high contrast and freedom from ghost images, characteristics compromised in some multielement, wideangle eyepieces.

BARREL DIAMETER

The lenses which constitute an eyepiece are mounted in a barrel that slips into the focuser or into the star diagonal of the telescope. Over the past century, cycpieces have evolved into three standard barrel diameters: 0.965-inch, 1.25-inch and 2-inch. The 1.25-inch size is by far the most common. Only the lowest-cost import telescopes still use the 0.965-inch standard. The selection and quality of eyepieces in this smaller barrel diameter are very poor. Indeed, the inclusion of eyepieces of this diameter as standard equipment with a telescope is a sure sign of an inferior-quality instrument.

Normal, Wide and Wider How much sky an eyepiece shows depends on its apparent field of view and its magnification with a particular telescope. In this illustration, several eyepiece fields are compared with the Moon's diameter as seen through a telescope of 2,000mm focal length. The three eyepieces -a 21mm Lanthanum, a 22mm Panoptic and a 22mm Nagler-have nearly the same focal length and yield almost identical magnifications (91x to 95x on this scope). Yet these three eyepieces show different amounts of sky. The standard-field (45-degree) eyepiece just takes in the whole Moon; the Panoptic (68 degrees) shows the whole Moon plus surrounding sky; and the Nagler (82 degrees) reveals an even wider field. The difference is in the eyepiece design: Wide-angle eyepieces show more sky at a given power. Finally, the largest circle displays the maximum field possible on this telescope using a 2-inch-barrel eyepiece (a 42mm wide-angle model).

Three Barrel Diameters Evepieces come in three barrel sizes: 2-inch, 1.25-inch and 0.965-inch. Today, all serious telescopes have standard 1.25-inch focusers and evepieces. The smaller 0.965-inch barrel is now found only on the lowestcost telescopes and should be avoided. The 2-inch size requires a telescope equipped with a 2-inch focuser and is generally reserved for low-power 22mm-to-55mm eyepieces.

Dual-Barrel Convenience 🕨

Some premium eyepieces, like the trio at far right, are really 1.25-inch units whose barrels are equipped with outer sleeves that allow them to slip into 2-inch focusers, a convenient feature to minimize fumbling with adapter rings.

Colorful Coatings ► Fully multicoated lenses, critical in eyepieces with five or more elements, appear greenish, although some have a purple hue.

Long Eye Relief 🕨

Eyepieces with long eye relief, such as these older Vixen Lanthanums or the Pentax XW, Tele Vue Radian and Orion Stratus models, have adjustable eyecups or extensions for comfortable viewing with or without eyeglasses.

Achieving both long focal length and wide field in an eyepiece requires expanding the barrel diameter, hence the 2-inch eyepiece. On an 8-inch Schmidt-Cassegrain, for example, a 55mm Plössl or 41mm Panoptic (both with 2-inch barrels) yields

an actual field of view of about 1.3 degrees. But with 1.25-inch eyepieces, the widest field possible is about 0.8 degree. Many top-of-the-line telescopes are routinely equipped with focusers for 2-inch eyepieces. A step-down ring allows 1.25-inch eyepieces to be used also.

EYE RELIEF

The distance the eye must be from the eyepiece in order to view the whole field is called the eyepiece's eye relief, an amount that depends on the eyepiece design. With most eyepieces, the higher the power, the shorter (and therefore less comfortable) the

eye relief. Most Plössl eyepieces, for example, have eye-relief values of about 70 percent of their focal lengths. A typical 17mm Plössl has an eye relief of roughly 13mm, a comfortable

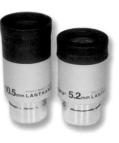

value. However, 4mm-to-6mm eyepieces have eye reliefs of only a few millimeters, almost forcing you to touch your eye to the eyepiece to peer through it.

While a longer eye relief is usually desirable, some 30mm-to-55mm eyepieces have eye reliefs so high (more than 20mm) that it is difficult to position your eye for a proper view. But eye relief is measured from the eyepiece's lens surface and can be reduced by extending the eyepiece housing or adding a rubber eyecup.

While long eye relief allows the observer to wear glasses when viewing, only people with significant astigmatism need to keep their glasses on while observing. A quick refocus of the telescope corrects for normal near- or farsightedness. Observers who need their glasses, or prefer to keep them on, should select eyepieces with at least 15mm of eye relief. Anything less, and you won't see the full eyepiece field.

COATINGS

Like camera lenses, all modern eyepiece lenses are coated to improve light transmission and to reduce flare and ghost images. The minimum coating is a single layer of magnesium fluoride applied to the eyepiece's two exterior lens surfaces, giving them a bluish tint. Better yet are single-layer coatings on all surfaces, dubbed "fully coated." A step up are eyepieces that have several layers of coating material ap-

plied to some of the lens surfaces to boost light transmission. In premium eyepieces, all lens surfaces are multicoated; they are called "fully multicoated."

MECHANICAL FEATURES

Some eyepiece brands are parfocal, which means that every eyepiece in the series focuses at the same point. Provided you stay within that manufacturer's series, switching eyepieces does not require significant refocusing, a convenient feature.

Ideally, the inside fittings should be blackened as a precaution against lens flares from bright objects outside the field. Better eyepieces also have a cleanly machined field-stop ring inside the barrel for defining the edge of the field. Low-cost eyepieces lack such a ring (yielding an ill-defined field edge) or have field stops with rough edges marred by metal burrs. On Orthoscopics and Plössls, the field stop is the metal ring just inside the bottom of the eyepiece in front of the first lens. On Naglers and many wide-field eyepieces, the field stop is inside the first lens near the bottom.

Many eyepicces are now supplied with rubber eyecups, which are good for blocking stray light and for keeping the eye properly centered. In the best eyepieces, the eyecups are adjustable and integrated into the design, rather than being loose-fitting addons that can fall off and get lost.

Upgrading to Larger Eyepieces

Upgrading a telescope to accept larger-diameter eyepieces can be as simple as adding the right accessory.

Switching from 0.965-inch to 1.25-inch

Anyone with a telescope employing 0.965-inch eyepieces might consider switching to the larger 1.25-inch standard. For a refractor, this can be done in two ways. A step-up adapter tube that accepts 1.25-inch eyepieces can be inserted into the eyepiece holder. Alternatively, a hybrid star-diagonal prism that fits a 0.965-inch eyepiece holder at one

end and accepts a 1.25-inch eyepiece at the other can be attached. Neither a hybrid star diagonal nor an adapter tube works for a Newtonian telescope with a 0.965-inch focuser, since both place the eyepiece too far from the tube to focus. Instead, the entire focuser on the side of the tube must be replaced with one that accepts 1.25-inch eyepieces. Check with local telescope dealers for the appropriate adapters and advice, or preferably, avoid buying an instrument with a 0.965-inch focuser in the first place, since it is definitely a liability.

But consider this: In many cases, an upgrade to 1.25-inch eyepieces costs as much as or more than the original purchase price of the telescope itself. Maybe selling the scope and starting over with a better, properly furnished instrument might be the best plan.

Switching from 1.25-inch to 2-inch

To move up to the 2-inch world on a Schmidt-Cassegrain requires only an upgrade to a 2-inch star diagonal or visual back equipped with a lock ring that screws onto the back of the instrument in place of the standard 1.25-inch visual back.

Upgrading a refractor to accept 2-inch eyepieces may be impossible, while upgrading a Newtonian requires swapping the focuser for a 2-inch model. New focusers can be purchased from JMI, Meade, Orion, Starlight Instruments and other specialty suppliers of Newtonian telescope parts. The best focusers for an upgrade are the low-profile type, which place the eyepieces close to the focal point of the telescope—a tall 2-inch focuser may place some eyepieces too far above the tube to reach focus.

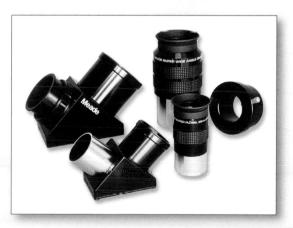

A "hybrid star diagonal" allows 1.25-inch eyepieces to work on small refractors that accept only 0.965-inch accessories. Adapters and diagonals to accept 2-inch accessories and eyepieces on Schmidt-Cassegrains are manufactured by Astro-Tech, Celestron, Meade, Tele Vue, Orion and William Optics. A 1.25-inch adapter ring allows additional use of smaller eyepieces.

Barrel Threads 🕨

Eyepiece barrels should be internally threaded for filters. Most 1.25- and 2-inch eyepieces have a standard thread that allows many kinds of filters to be screwed into the barrel. A few older eyepiece brands available secondhand have no threads.

Classic Orthoscopics The original legendary Zeiss Abbé Orthoscopics (shown here) had 0.965-inch barrels. Orthoscopics in 1.25-inch barrels are available from Baader, Pentax and University Optics.

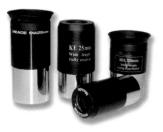

Entry-Level Eyepieces These entry-level Kellner-class eyepieces are good performers and are economical.

Modern Plössl Roots 🕨

The legendary French-made Clavé Plössls and Tele Vue's original Plössls (two at far right) started the trend to this design and still rate among the best. Plössls are the most popular eyepieces today and are available in a range of prices starting at \$40. These eyepieces work best in focal lengths of between 32mm and 15mm, where eye relief is good and aberrations are low.

STANDARD-FIELD EYEPIECES (\$30 and up)

An eyepiece design utilizes a particular combination of lenses (called elements) of a specific shape. The design determines the field of view and eye relief. With a few exceptions, manufacturers do not have exclusive license to a design. Plössl eyepieces, for example, are sold by nearly every telescope manufacturer. Many eyepiece designs are named for the pioneering telescope designers who invented them.

> Kellner and Modified Achromat (\$30 to \$50)

Since its invention by Carl Kellner in 1849, this was the standard workhorse eyepiece design until the 1980s. An economical threeelement type, the Kellner produces average images in a fairly narrow field of view by today's standards-typically, 40 degrees. It works best on long-focal-ratio telescopes (f/10 or longer) and suffers from some chromatic aberration. Several manufacturers sell a variation called the Modified Achromat (MA), often included with entry-level telescopes. Now discontinued, Edmund Scientific's RKE design (for David Rank modified Kellner for Edmund) reversed the lens elements from the standard arrangement, giving it a wider field (45 degrees). Although not a true Kellner, the RKE eyepiece was an improvement on the old design.

Orthoscopic and Monos (\$50 to \$280)

In 1880, Zeiss optical designer Ernst Abbé invented a four-element eyepiece with a 45degree apparent field and less chromatic aberration and ghost imaging than a Kellner. Many amateur astronomers still consider the Abbé Orthoscopic to be the best eyepiece for planetary observing.

Once the prime choice in premium eye-

pieces, Orthoscopics have been largely supplanted by Plössls and are now hard to find. Pentax still has its \$280 XO Orthos. Purists rank the now discontinued Zeiss Orthos as the ultimate in high-contrast planetary eyepieces. The Baader Planetarium of Germany has picked up the cause and offers a series of four-element "Genuine Orthos" for \$100 each. The classic Abbé Orthos from University Optics are also highly regarded and, at \$50 to \$80 each, reasonably priced. They are good when combined with a Barlow.

In the same league as Orthos are the Super Monocentric eyepieces offered by TMB Optical. The Super Monos use three cemented elements yielding just two air-to-glass surfaces for minimal light scatter. Planetary observers praise TMB Monos,

but only a planetary fanatic could love an eyepiece with a narrow 30-degree field and a \$200 price tag.

Plössls and Variations
 (\$50 to \$240)

This design, devised in 1860 by G.S. Plössl, enjoyed a resurgence in the 1980s as the result of intensive marketing by telescope companies stressing the advantages of the Plössl—not the least of which is that it is easier to manufacture than an Orthoscopic.

A true Plössl is a four-element design consisting of two nearly identical pairs of lenses. Compared with Orthoscopics, the Plössl has a slightly wider field (about 50 degrees), works better on f/6 or faster telescopes but has a shorter eye relief. The best Plössls are excellent for all observing tasks,

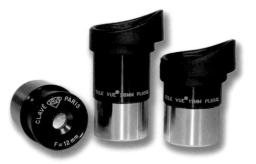

particularly planetary viewing, although eye relief is poor in 13mm and shorter versions. Tele Vue offers standard Plössls (\$80 to \$100). The Vernonscope Brandon (\$240), originally designed by Chester Brandon in the 1940s, is another classic in this category.

Many manufacturers now market fiveto-seven-element Plössl variations carrying various trade names. In some cases, the design is more akin to a five-element Erfle wide-angle eyepiece. Examples include the Meade Series 5000 Plössls (\$100) and Orion Ultrascopics (\$100), both excellent series. Another design comes with a built-in Barlow lens (see page 76) that increases power while retaining excellent eye relief. Examples include the Orion Epic ED (\$55) and Celestron XCel ED (\$70) Series, the Burgess/ TMB Planetary Series, Vixen Lanthanum NLVs and William Optics SPLs.

All these series have a standard 45-to-55-degree field of view and a design optimized to provide the contrast and sharpness desired by planetary observers.

Zoom Eyepieces (\$150 to \$400)

Why buy three or four eyepieces if one will do it all? That is the promise of zoom eyepieces, which use a sliding Barlow lens to vary their effective focal length. With improved glass types and coatings, today's best zooms offer superior performance to the cheap units of yesteryear, haunted as they were with ghost images. Most units offer a focal-length range of 8mm to 24mm. But their apparent field of view is restricted, narrowing to a tunnel-vision view of only 40 degrees at the lowest power, just where you want wide field. Inconveniently, most zooms require refocusing as you change powers.

Great for public viewing sessions, zooms have failed to win us over for serious observing—we prefer the higher quality of separate fixed-focal-length eyepieces.

Tele Vue's \$380 Nagler Zoom eyepieces are the exception. These specialized eyepieces are for high-power planetary observing with fast apo refractors. Image quality is superb, and the apparent field and focus stay constant throughout the zoom. Click stops define focal-length positions at 1mm increments. However, their short 10mm eye relief is a bit cramped.

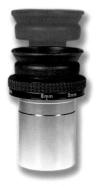

▲ Premium Zoom The Nagler Zoom is available in 3mm-6mm and 2mm-4mm models. Both are for dialing in the optimum power for planetary viewing with short-focallength telescopes. Despite its Nagler designation, the apparent field is a normal Plössl-like 50 degrees.

Designs to Avoid

Older amateur-astronomy handbooks (particularly those written by British authors) regale the reader with references to exotic eyepiece variations. Some, such as the Hastings, Steinheil and Tolles, are praised by planetary observers but are so rare that few amateurs will ever encounter them. Others, like the Huygenian and Ramsden, are so poor, they deserve mention so that they can be avoided.

This ancient two-element design from the 17th century is commonly supplied with poor-quality telescopes. These eyepieces are marked with an H, AH (for Achromatic Huygenian) or HM (for Huygens Mittenzwey).

Ramsden

This primitive two-element design is of little value. Variations add more lens elements to produce an Achromatic Ramsden (AR) or a Symmetrical Ramsden (SR). All are junk, with fuzzy tunnel-vision views and little eye relief. **War-Surplus Erfles**

Invented during World War II, the Erflc is a five-element, wide-angle design with a 60-degree apparent field. Ghost images from internal reflections make most models unsuitable for planetary observing, while astigmatism greatly distorts stars at the edge of the field. In longer focal lengths, however, Erfles can be decent, low-power, deep-sky eyepieces. Nevertheless, older war-surplus models (often filling swap tables at star parties) and new low-cost Erfles have been surpassed in all respects by modern wide-field designs.

'nÅ

These eyepieces give low-cost telescopes a bad name. They suffer from image-blurring aberrations, tunnel-like fields of view and lack of eye relief. Use the Huygenians and Ramsdens for dustcaps or solar projection.

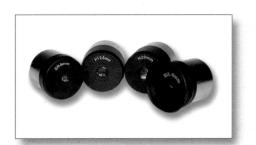

Super Wide Angle Set ▼ Open this jewel box of beauties at a star party, and you are sure to draw envious glances. This is the complete set of Meade Series 5000 Super Wide Angles, worth about \$1,600.

In the 1980s, TeleVue introduced its"Wide-Field" brand of eyepieces, with apparent fields of 65 degrees. The six-element design bore a family resemblance to the classic Erfle that had long been the mainstay for

> anyone wanting a wideangle eyepiece. But the new wide-fields offered less ghosting and better imagery across the entire field, especially with fast focal-ratio telescopes. Long discontinued in favor of even finer designs, the wide-fields set the stage for a plethora of new wideangle eyepieces, all offering

apparent fields of view of 65 to 75 degrees.

In 1991, for example, TeleVue introduced its Panoptic Series (the name derives from "panorama optic"), now with 19mm, 22mm, 24mm, 27mm, 35mm and 41mm models (\$250 to \$500). What distinguishes the sixelement Panoptics is their superior correction of aberrations over the entire 68-degree field. Even on fast focal-ratio telescopes (the toughest test), stars are pinpoints almost to the edge, making Panoptics the standard of comparison for wide-field eyepieces. No one has yet beaten "Pans" for image quality across a 60-to-70-degree field.

Other manufacturers followed suit with their own designs, often carrying proprietary brand names. For example, Meade offers its Super Wide Angles (with 68-degree apparent fields) in focal lengths from 16mm to a jumbo 40mm for \$180 to \$400. Celes-

Our Favorite Eyepieces I: Standard-Field Models

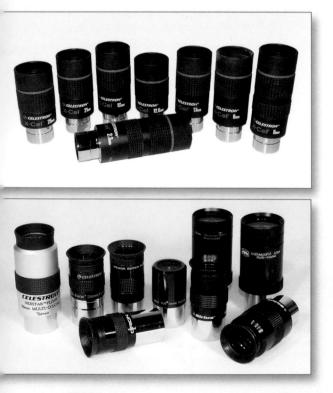

For a fine set of all-purpose Plössls, we use and can recommend models from either Tele Vue or the Meade Series 5000 line. Both are top-class Plössls or Plössl variations suitable for all types of viewing. At \$80 to \$100 each, however, a set of three or four such eyepieces can cost as much as many beginner scopes.

Brandon eyepieces are fine performers—we've both owned sets of them—and were once in the same price league (\$80 each). But at their current \$240 price point, we find it hard to justify their purchase over other top-end Plössls. Nor have we felt a compelling need to spend \$200 or more for specialized narrow-field planetary eyepieces like the TMB Super Monocentrics or premium Orthos.

For general-purpose viewing, the Celestron XCel and similar Orion Epic ED Series work well, providing a comfortable 20mm of eye relief. Also in the league of 20mm eye relief and standard 45degree field are the Vixen Lanthanum LV and newer NLVs (\$120).

For owners on a budget, we long suggested Edmund Scientific's now defunct RKE line for its quality and low price (\$40 each). However, Celestron's Omni Plössls, the Orion Sirius and Highlight lines of Plössls, Meade's Series 4000 budget Plössls and Vixen NPLs all provide excellent value at \$40 to \$50 per eyepiece. At that price, there's little reason to settle for anything less.

.....

Celestron's XCel line (top) provides long eye relief and good image quality. More conventional Plössls (bottom), such as those included with many Chinese-made import scopes or budget lines from Celestron, Meade and Orion, also provide good performance at an affordable price. We recommend any of these over Kellners and Modified Achromats because of their wider fields.

tron has its Ultima LX Series (5mm to 32mm for \$150 to \$200), and Vixen has its excellent Lanthanum LVWs (3.5mm to 42mm for \$200 to \$260). All rank just below Panoptics in optical quality. Lesser-grade clones of the Vixen LVWs are Baader's Hyperions and Orion's nearly identical Stratus (3.5mm to 24mm for \$120 each); both are good sets for anyone who wants affordable wide-fields. Also in the economy class is the William Optics SWAN line (9mm to 40mm for \$80 to \$120), though we've never been impressed with their performance, even for the price. At the top end are Pentax XWs (3.5mm to 40mm for \$350 to \$550). All but the Meades and SWANS fall into the category of long-eye-relief eyepieces.

LONG-EYE-RELIEF EYEPIECES (\$120 to \$550)

An aging population of amateur astronomers has created a demand for eyepieces that are easy to look through, which translates into long eye relief and large eye lenses that don't require squinting to see the whole field. Most eyepieces of all types in the 35mm-to-19mm focal-length range have excellent eye relief in any case. But finding comfortable viewing in shorter-focal-length eyepieces requires purchasing premium models designed specifically to provide long

eye relief. Most achieve their short focal lengths and long eye relief by means of integrated Barlow lenses.

In the category of Plössl-class eyepieces are the aforementioned Celestron XCel ED and Orion Epic ED Series, all clones of the original Vixen Lanthanum LVs. They offer a consistent 20mm of eye relief with standard

fields of view of 45 to 50 degrees and no ghost images. On-axis images in the shortest-focal-length models of these series tend to be a little softer than with conventional Plössls or Orthoscopics, but these are comfortable eyepieces to look through, even when wearing eyeglasses.

A big jump up in price and performance is Tele Vue's Radian Series, offered in focal lengths from 3mm to 18mm (\$250 each). These six-element eyepieces have a uniform 20mm of eye relief with tack-sharp, high-contrast images across a 60-degree apparent field. Although this puts them just into the wide-angle class, the forte of Radians is high-power planetary viewing. They can compete against the best Orthos and Plössls. Focal lengths longer than 18mm (best for deep-sky viewing) are not possible with the existing Radian design.

Among the best values in wide-angle eyepieces with long eye relief are the Orion Stratus Series already mentioned. Edge performance is good, with images blurring in the outer 50 percent of the 68-degree field. If these eyepieces are used on slower f/8 to f/10 telescopes, however, edge sharpness improves, as it does for all wide-angle eyepieces. A notch up is Celestron's fine Ultima LX Series, offering 70 degree fields and consistent 16mm eve relief.

Although much more costly, the Pentax XW eyepleces are hard to beat. Edge performance approaches Panoptic perfection across most of their 70-degree field. Contrast is high, and the eyecup design and long 20mm eye relief make these eyepieces a real pleasure to look through. With the exception of the big 30mm and 40mm models, all are 1.25-inch eyepieces, despite the appearance of having 2-inch barrels.

Ultra Wide Angles

Competing in the class of Ultra Wides with Nagler and Meade are William Optics UWANs, worthy competitors in the premium league and far superior performers to William Optics lower-priced SWANs.

▲ Separated at Birth Many eyepiece models are similar, as domestic suppliers secure deals with the same Chinese factories for their own house brands. Here, we see the family resemblance between the Baader Hyperion (left) and Orion Stratus eyepieces.

Ahh...Eye Relief

Pentax eyepieces (left pair) feature an adjustable eyecup that screws up and down to place the eye at the right distance for optimum viewing. Tele Vue's sliding Instadjust eyecup, found on its Radians (right pair) and some Naglers, performs a similar function. The Pentax design feels more comfurtable on the eye socket and doesn't keep slipping out of position like the Tele Vue system.

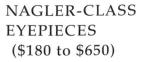

Talk eyepieces with any seasoned amateur astronomer for more than a few minutes, and the name Al Nagler will inevitably come up in the conversation. Through his Tele Vue products, Nagler has revolutionized eyepiece design and raised the bar on eyepiece performance.

The flagship of the Tele Vue line is the series of eyepieces that bears Nagler's name. The original 13mm Nagler eyepiece caused a sensation when it was introduced in 1982. Other focal lengths soon followed, all with seven steeply curved lens elements providing a whopping 82-degree apparent field that was unheard of at the time.

To create his revolutionary eyepiece, Al Nagler took an exotic, extremely wide-angle eyepiece design and placed a Barlow lens in front of it. The eyepiece and Barlow operate as a single unit—the aberrations of one cancel out the aberrations of the other producing exquisitely sharp images edge to edge, despite the extreme field of view. Naglers were an instant hit, even though they cost two to four times more than the best eyepieces of the day.

Other manufacturers soon took notice. By 1985, Meade had introduced its competitive line, the eight-element Ultra Wide Angle (UWA) Series. The original Series 4000 has since been replaced by the revamped Series 5000 line (\$200 to \$450), but in our testing, none of the new units quite match Naglers—or even the original 14mm and 8.8mm Series 4000 UWAs, which remain worthy Nagler competitors.

Falling far short of the mark is the Antares Speers-Waler SWA II Series of 82degree-field eyepieces (about \$200). They are less costly than Naglers, but their images are noticeably distorted in the outer half of the field. Their tall profile and odd focal point, which demands a lot of racking in to reach focus, make them awkward, if not impractical, to use on some telescopes.

Celestron has its 82-degree Axiom LX Series (\$180 to \$400), but these were still in the offing as we were assembling this edition. So far, the eyepieces that have come closest to matching the Naglers in our tests are the William Optics UWAN Series (4mm to 28mm for \$200 to \$400). Performance is commensurate with price: almost as good as Naglers for a lower price.

The original Type 1 Naglers were supplemented in 1987 by a series of eight-element

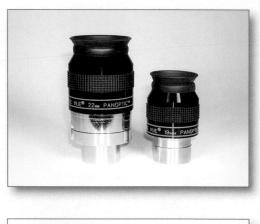

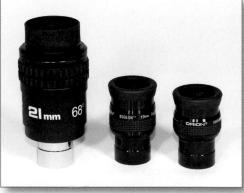

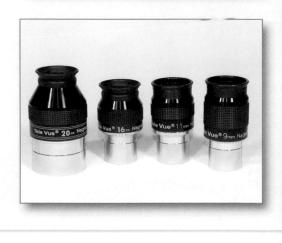

Biggest Eyepiece 🔺

Tele Vue[®] 31mm Nagler[™] i

The ultimate low-power eyepiece is the six-element 31mm Nagler Type 5. Its long focal length coupled with a wide 82-degree apparent field produce a panoramic view that is unmatched in edge-to-edge sharpness. The giant eyepiece (shown at 80% actual size) does have its drawbacks: It is one of the heavlest eyepieces (2.2 pounds) and, at \$650, one of the most expensive. And it requires about 16mm of inward focus travel compared with most other eyepieces, so it might not focus on some Newtonian reflectors.

Type 2 Naglers that have also since been discontinued but remain in demand on the used-equipment market.

In the late 1990s, Al Nagler began revamping his eyepiece lineup with new Nagler designs labeled Type 4, 5 and 6. (What the unseen Type 3 Nagler design was, let alone what lenses the Type 4 to 6 designs consist of, remains a corporate secret that in Al's words, "I could tell you all about as the cement hardens around your feet.")

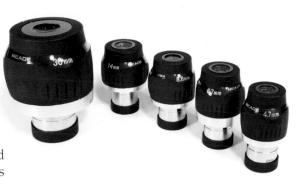

▲ Meade Ultra Wides It wasn't long before other Nagler-class eyepieces appeared. Among the latest are the Series 5000 Ultra Wide Angle eyepieces from Meade. All offer a similar 82-degree field of view. The cost is lower, but edge performance, as with other Nagler competitors, isn't quite up to Nagler standards.

Our Favorite Eyepieces II: Wide-Field Deep-Sky

One of the most-used eyepieces in both our collections is Tele Vue's 24mm Panoptic. It provides the widest field possible in a 1.25-inch eyepiece and is much sharper across the field than any competitor. If there is one premium eyepiece to buy for any telescope, this is the one. The dual-barrel 22mm Panoptic is another longtime favorite.

In the midpower range, two of our top choices are the compact Tele Vue 19mm Panoptic and the 16mm Nagler Type 5, with nearly identical actual fields of view. We can also praise the Vixen Lanthanum LVW Series, which provides near-Panoptic performance at a reasonable price for a premium eyepiece with long eye relief. A best buy for economy wide-fields are the Orion Stratus 68-degree eyepieces. More compact (and suitable for bino viewers) are Orion's Edge-On Flat Fields (\$100). While their field isn't nearly as flat as the ads suggest, both they and the Stratus are sharper to the edge than many "house brand" bargain wide-fields, which are often pretty bad at any price.

At the high end, we love the Pentax XW Series, especially the higher-power models from 14mm to 3.5mm. They provide razor-sharp, high-contrast views of both deep-sky objects and planets. "For sheer comfort of use, if I were restricted to owning one line of eyepieces," says author Dyer, "it would be the Pentax XWs—though I'd still beg for Panoptics in the longer focal lengths!"

Author Dickinson says the Tele Vue 27mm Panoptic is among his standout eyepieces: "I notice this eyepiece is often overlooked by observers in favor of the 35mm Panoptic, but many of my most awesome deep-sky views have been with the 27mm Panoptic. It's an ideal combination of power, wide field and great optics." In the Meade Series 5000, we find that the 28mm, 24mm and 20mm Super Wides and the 6.7mm and 4.7mm Ultra Wides stand out as the best of the series. The wide, flat tops of the largest eyepieces in this series make them uncomfortable to look through, as they press against your face and hit your nose! For first-class performance, the Nagler eyepieces are hard to resist. In a 2-inch

barrel, the 20mm Type 5 yields the same actual field as the 24mm Panoptic, but with higher power. We prefer it over the 22mm Type 4 Nagler. For higher power still, the 13mm through 7mm Type 6 Naglers quickly became favorites for views of galaxy fields and globular clusters. Being compact, they also work great in bino viewers, as does the 16mm Type 5 Nagler and the 24mm and 19mm Panoptics. But when the Ethos 13mm came out, we had to reset our standards. For most of our telescopes, it provides an amazing combination of power for resolving detail without sacrificing spectacular field of view. It and the 27mm or 24mm Panoptic or the 20mm Nagler Type 5 would be our top choices in premium eyepieces for the most-used magnifications.

Some outstanding wide-field eyepieces: the Tele Vue 22mm and 19mm Panoptics (facing page, top), the economy Orion 21mm Stratus and 19mm and 16mm Flat Fields (facing page, center), a set of late-model Naglers (facing page, bottom), including the 20mm and 16mm Type 5 and the 11mm and 9mm Type 6, and the Pentax 14mm and 7mm XW eyepieces (above).

Guru at Work 🔺

Al Nagler peers through his latest creation, the 100-degree-field 13mm Ethos eyepiece, which can be used in both 2- and 1.25-inch focusers.

Barlows: Power Boost 🕨

Barlows come in a wide price range. The most inexpensive (the long, thin tubes shown top right) make better doorstops than they do lenses. The Barlows included with the lowest-cost import telescopes fall into this category. We recommend the top-end 1.25-inch Barlows offered by Celestron, Meade and Tele Vue (bottom), selling for \$75 to \$200 each.

The current Type 4, 5 and 6 Naglers provide increased eye relief and contrast and, in some models, a more compact, lighter design. They succeed in this. The Type 4 models, in particular, offer far greater eye relief than earlier Naglers of the same focal length, but we've found the edge-of-field performance of the Type 4s falls short of the pinpoint-edge sharpness of the old Type 1 and 2 models and the current Type 5s and 6s. For example, the jumbo 31mm Type 5 Nagler provides some of the most outstanding panoramic views we've ever seen, while the wonderfully compact 20mm Type 5 (a well-used evepiece in our collections), 16mm Type 5 and all Type 6s (13mm to 2.5mm) offer higher power with good eye relief. Why combine a short focal length with an ultrawide field? Such an eyepiece is useful for scopes that lack tracking, like Dobsonians. The object stays in the field longer for high-power inspection.

Twenty-five years after introducing his namesake 13mm eyepiece, Al Nagler raised

the bar once again and created a buzz with his Ethos eyepiece, also introduced in a single 13mm focal length. The Ethos provides an amazing 100-degree field that has to be seen to be believed. The eyepiece truly gets out of the way for the ultimate spacewalk experience. And yet, despite the enormous field and complex glass, star images are pinpoint right to the edge and contrast is superb. The Ethos features a dual 2-inch/1.25inch barrel and weighs 20 ounces. At \$620, the 13mm Ethos is a serious investment, but if you want the best, this is it.

BARLOW LENSES (\$80 to \$250)

Barlows are negative lenses that increase the effective focal length of a telescope and multiply the power of any eyepiece. The name stems from Peter Barlow and George Dollond's 1834 scientific paper that first described this style of lens. Barlows are available in magnifications from 1.8x to 5x. With a 2x Barlow, the most common, a 20mm eyepiece effectively becomes a 10mm one. Barlows can double your eyepiece set if you plan carefully to avoid any unnecessary duplication of powers.

The advantage of Barlows is, they produce high power with longer-focal-length eyepieces that are easier to look through because of their better eye relief, compared with standard close-in viewing with 8mm-

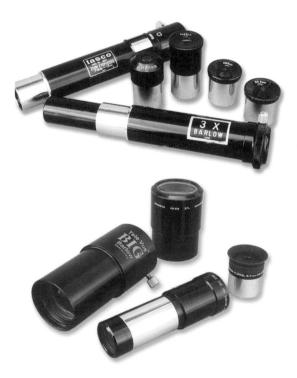

to-4mm eyepieces. For owners of fast telescopes, particularly f/4 and f/5 reflectors, Barlows are a recommended method of achieving high power. Their disadvantage is that they put more optics into the light path and potentially more aberrations and ghost images. Some people swear by them, others swear *at* them. But our tests show that the best multicoated Barlows introduce no detectable aberrations or light loss. Avoid Barlows with variable magnification, accomplished by a lens that slides up and down the barrel; Barlow lenses are designed to work best at one specific amplification.

Barlows come in various tube lengths, ranging from less than three inches to nearly six. Generally, the higher-amplification units are longer, but not always. It depends on the specific lens design. Some manufacturers offer "shorty" Barlows, usually in 2x amplification, that are useful on refractors because the Barlow can be placed between the eyepiece and the diagonal to yield the nor-

mal 2x and can also be placed between the diagonal and the focuser, where 3x (approximately) is achieved—effectively two Barlows for the price of one. The Celestron Ultima and the Orion Shorty-Plus (both 2x units for \$80) are first-rate Barlows in this shorty class. In our tests, they rated optically identical to the best "long" 2x Barlows, leading us to wonder why anybody makes a long 2x version. On the other hand, a couple of 3x shorty versions we tested did not compare favorably with the performance of the top longer-style 3x units.

Adding Magnification Placing a Barlow lens in front of a star diagonal (rather than inserting it into the star diagonal) adds approximately 50 percent to the magnification factor with a refractor. For example, a 1.8x Barlow becomes a 2.7x, a 3x becomes a 4.5x, and so on—an ideal arrangement for refractors in the 500mm- to-1,200mm focal-length range. Therefore, with one 25mm eyepiece and a 2.5x and 3x Barlow, a 1,000mm-focallength refractor can be used at five magnifications: 40x, 100x, 120x, 150x and 180x.

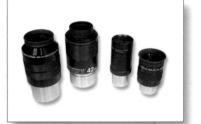

How Low Can You Go?

A 40mm wide-field eyepiece (such as the Meade Super Wide, Tele Vue 41mm Panoptic, Pentax XW, University Optics MK-70 König and Burgess/TMB Paragon) offers the maximum possible field of view for the 2-inch format. (Close runners-up are Tele Vue's 31mm Nagler Type 5 and 35mm Panoptic.) Advertising claims to the contrary, eyepieces with greater focal lengths do not

provide wider fields of view than these 40mm designs. An eyepiece's field of view is limited by the entrance aperture that receives the telescope light cone, not by the focal length. If the unobstructed diameter of the field lens is as wide as the inside of the 2-inch barrel, as it is with these 40mm-class eyepieces, the apparent field will be maximum as well.

On an 8-inch f/10 Schmidt-Cassegrain, for example, a 40mm Meade Super Wide Angle produces 50x and an actual field of 1.3 degrees. On the same scope, a Tele Vue 55mm or Meade 56mm Plössl eyepiece, which each have a narrower apparent field of view, produces a lower 36x but the same 1.3-degree actual field.

Seekers of the widest, lowest-power field possible must also be aware of another limit to how low you can go. If an eyepiece yields more than a 7mm exit pupil in obstructed telescopes, such as reflectors and catadioptrics, and the sky background is bright, you might see a field with a dark hole in the center. Exceed the low-power limit with a refractor, however, and the only ill effect is that not all the light collected by the telescope enters your eye. Your eye "stops down" the telescope's aperture. Either way, there are disadvantages to going lower than a 7mm exit pupil, and that's assuming your pupils can open as wide as 7mm. For people over age 50, that's rarely the case.

To determine the low-power limit of any telescope, multiply the telescope's focal ratio by 7mm (the diameter of a fully dark-adapted youtliful eye). For an f/4.5 reflector, for example, the longest eyepiece recommended is 31.5mm (4.5 x 7). A 40mm wide-field eyepiece is not recommended.

Above, the Meade 56mm Plössl (left) and the 42mm Vixen Lanthanum LVW (second from left) take in the maximum area of sky possible in a 2-inch-barrel eyepiece. For the maximum field in a 1.25-inch-barrel eyepiece, a 35mm Plössl, like the Orion Ultrascopic (second from right) and the Meade 24.5mm Super Wide Angle (right), provides nearly identical true fields of view.

Eyepieces: A Summary Comparison

Туре	Apparent Field	Advantages	Disadvantages	Price
Kellner	35° to 45°	Low cost. Good for long-focal-length scopes.	Narrow field. Chromatic aberration.	\$30 to \$50
Orthoscopic	45°	Good eye relief. Freedom from ghost images and most aberrations.	Narrow field for deep-sky viewing.	\$50 to \$250
Plössl ¹	50°	Excellent contrast and sharpness. Wider field than most Orthos.	Less eye relief than Orthos. Slight astigma- tism at edge of field.	\$40 to \$200
König & Erfle	60° to 70°	Wide field of view. Low cost for wide-field.	Astigmatism at edge of field.	\$80 to \$200
Modern Wide-Field ²	65° to 70°	Wide field of view. Minimal edge aberrations.	Moderate to high cost.	\$80 to \$400
Tele Vue Ask Radian	60°	Long eye relief with wide field and high contrast.	High cost.	\$250
Nagler ³ & Ethos	82° to 84° (Ethos = 100°)	Extreme field of view with few edge aberrations.	Expensive. Low-power models are heavy and large.	\$180 to \$650

1. Also Meade Super Plössl, Orion Ultrascopic (some Plössl-like units include a fifth lens element, like an Erfle or a built-in Barlow)

2. Includes Tele Vue Panoptic, Meade Super Wide Angle, Vixen LVW, Orion Stratus, Baader Hyperion, Pentax XW, William Optics SWAN

3. Also Meade Ultra Wide Angle, William Optics UWAN

Combined with the longer-focal-length Plössl eyepieces, a good Barlow (or two) provides a complete range of magnifications and high-quality images at a modest cost. One veteran observer we know, who must use glasses at the eyepiece, employs 26mm and 20mm Plössls and one of three Barlows (1.8x, 2.5x and 3x) with an 8-inch Schmidt-Cassegrain to achieve 77x, 100x, 138x, 180x, 200x, 230x and 300x, all with good eye relief.

Some manufacturers have introduced 2-inch Barlows that double the power of giant eyepieces, such as a 40mm wideangle or a 55mm Plössl. However, since 2-inch eyepieces are designed to yield low power, they are the ones you are least likely to want to amplify. Giant Barlows are of limited visual use, although they are excellent photographic accessories.

Tele Vue offers a series of advanced fourelement"Powermates" in 2x to 5x strengths (\$200 to \$300). Differing in optical design from the classic negative-lens Barlow, the Powermates have the advantage of being parfocal with the eyepiece used on its own —you don't have to alter the focus when you insert the Powermate, unlike when you insert a Barlow. The Powermates are superb optically and are a great accessory for webcam imaging.

EYEPIECE AND BARLOW PERFORMANCE

The purpose of a telescope is to collect light from a celestial object and bring it into focus at the eyepiece or camera lens. In effect, the parallel rays from the celestial source are forced into a converging cone by the main lens or mirror of the telescope. The higher the focal ratio, the longer and skinnier the cone. An f/15 system has a long, narrow cone; the rays at the edge are angled two degrees from those at the center. In an f/10 system, the edge rays are angled three degrees from the central rays, and in an f/5 system, they are angled six degrees. It is easier for an eyepiece to accommodate rays at a two- or three-degree angle from the central axis than at a six-degree angle.

Try a typical eyepiece—a 25mm Plössl, for example—on an f/15 refractor. The star field is perfectly sharp from edge to edge. Now use the same eyepiece on an f/5 telescope (regardless of the type); the stars toward the edge of the field are no longer perfect pinpoints but resemble seagulls or arcs, depending on the inherent aberrations of the telescope and eyepiece.

The steeper the light cone, the more difficult it is to design an eyepiece to suppress aberrations. At f/4, it is impossible. Even at f/5, all but the best eyepieces display astigmatism in the field's periphery. It is here that a good Barlow can improve eyepiece performance. The negative lens increases the effective focal ratio by reducing the steepness of the light conc entering the eyepiece. A 2x Barlow reduces the cone's angle by half, so an f/5 telescope becomes, in effect, an f/10—a situation in which any eyepiece will show improved performance.

RECOMMENDED EYEPIECE SETS

Eyepieces are easy to collect. Buy one of a series, and you may long to own the whole set. In truth, five, six or seven eyepieces are not needed. A set of four will do well, as will just two or three to start. Here are a few recommendations.

Budget Set

Many entry-level telescopes are supplied with 25mm and 9mm Modified Achromat or economy Plössl eyepieces. This is an acceptable starter set of two eyepieces for most small telescopes. For a set of three, 25mm, 12mm and 7mm Plössls provide low, medium and high powers. Or, better yet, consider 25mm and 17mm Plössls with a 2x Barlow for a complementary range of four powers. Observers on a tight budget could select secondhand Edmund RKEs, Plössls from Meade's Series 4000 or Orion's Sirius or Highlight lines (nearly identical Plössls are sold by other dealers).

Expanded Budget Set For telescopes that accept only 1.25-inch eyepieces and already come with both a 25mm and a 10mm eyepiece, a top priority should be an ultra-low-power eyepiece.

▲ A Big Eye Jumbo eyepieces can weigh up to two pounds, causing balance problems on some telescopes.

Our Favorite Eyepieces III: Lowest-Power Panoramic

The 41mm Panoptic (\$500) provides the widest possible field in a 2-inch eyepiece, yielding an amazing 4.6degree actual field on the sky with a typical 4-inch f/6 refractor. Stars are sharp edge to edge. We've had spectacular views with it. Offering an actual field just slightly smaller but with more magnification is the 31mm Nagler (\$650). The two are arguably the best panoramic eyepieces on the market. At a lower cost, the 35mm Panoptic (\$380) provides an apparent field only slightly smaller than the 31mm, yielding a 4-degree field with a 4-inch f/6 refractor.

35mm Panoptic, they are bargains.

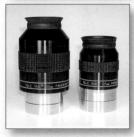

As already mentioned, the 27mm Panoptic is another of our favorites. Its lighter weight is preferable for telescopes where balance is critical. The 27mm is also the choice for f/4 to f/4.5 scopes, where eyepieces more than 30mm are not recommended. Close in performance to the above are the University Optics 40mm MK-70 König and the Burgess/TMB 40mm Paragon. At just over half the price of a

Tele Vue's giant 41mm Panoptic and 31mm Nagler eyepieces (top) and 35mm and 27mm Panoptics (bottom) count among our favorites for "big gulp" views of nebulas, galaxy clusters and Milky Way fields. Premium Priorities While we both have cases of eyepieces at home, we have to keep our gear compact and light when we travel. At those times, the 24mm Panoptic, 9mm Nagler Type 6 and a good 2x Barlow are our prime choices. For priorities in premium eyepieces, you can't go wrong with these. We recommend a 32mm-to-35mm Plössl. Regardless of brand, it is likely to have the maximum possible field of view (for a 1.25inch system) combined with excellent performance. (Plössls with a 1.25-inch barrel and 40mm focal length do not offer a wider field than the 32mm-to-35mm models.) For adding magnifications at the high-power end, we suggest another Barlow, perhaps a 2.5x or 3x model, rather than adding 8mm or shorter Plössls, with their attendant poor eye relief and tiny lenses.

Adding a Premium Eyepiece In our experience, the eyepiece you'll use the most for all types of viewing falls in

Our Favorite Eyepieces IV: High-Power Planetary

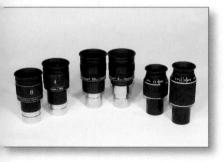

For achieving high power and contrasty planet images, we often use eyepieces in the 26mm-to-15mm range with a 2x-to-5x Barlow. Particular favorites of ours are Tele Vue's Powermate "image amplifiers," available in 2.5x and 5x models for 1.25-inch eyepieces. On our short-focal-length apo refractors, the 5x Powermate makes a great planet-viewing combination when coupled with a

26mm-to-20mm Plössl eyepiece (the Tele Vue and Meade Series 5000 Plössls are among the best).

Our other favorite high-power eyepieces include the Tele Vue Radians, which are, in effect, low-power eyepieces mated with a built-in Barlow. Other than cost, their main drawback is some field blackout if the eye isn't at just the right distance. With a wider field than the Radians, the high-power Pentax XWs and older XLs also get a lot of use on our fast focal-ratio scopes.

Competing very favorably with the Radians in all areas of performance but at half the cost (\$100 to \$130) are the William Optics SPL and similar Orion Edge-On Planetary long-eye-relief eyepieces. Images are crisp and color-free. Almost as good are the Burgess/TMB Planetary Series. Eye relief is long and image quality good, marred only by some residual color. But at \$60 to \$90, their price/performance value is excellent.

Planetary eyepieces on parade (from left to right): a pair of Burgess/TMB Planetaries, a pair of Tele Vue Radians and a pair of William Optics SPLs, all fine long-eye-relief models that incorporate integrated Barlow lenses.

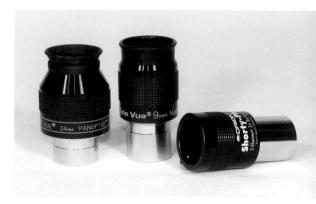

the medium-power range. A rule of thumb says that the eyepiece which best matches the eye's ability to resolve detail is the one that yields a 2mm exit pupil. To determine the focal length of this "optimum" eyepiece, simply multiply your telescope's focal ratio by 2. For example, the "best" eyepiece for an 8-inch f/10 Schmidt-Cassegrain would be a 20mm (10 x 2) eyepiece. It would provide 100x. Indeed, we did find that a 20mm eyepiece was the one we used most with the vintage C8 scopes we each owned for nearly a decade in the 1970s.

While this isn't a hard-and-fast rule, it serves to point out which eyepiece you should invest in most heavily. If you can afford just one top-end eyepiece, make it the one with a focal length about twice your scope's focal ratio. A Celestron Axiom LX, Meade Ultra Wide, Pentax XW, William Optics UWAN or Tele Vue Panoptic or Nagler all are fine choices for that first premium eyepiece. For the typical large f/5 Dobsonian, a 13mm Ethos eyepiece falls into this slot—costly, yes, but it will be used a lot!

Adding Deep-Sky Eyepieces Another prime slot for a premium wideangle eyepiece is in the low-power range for general-purpose deep-sky views. We can recommend nothing better than a Tele Vue 24mm Panoptic (for a 1.25-inch focuser) or, for a 2-inch focuser, a 27mm Panoptic or 20mm Nagler Type 5.

In the medium to medium-high range (120x to 200x), a Meade 6.7mm Ultra Wide, William Optics 7mm UWAN or Tele Vue 9mm or 7mm Nagler can provide enough power to resolve star clusters and reveal faint galaxies in a darkened sky without sacrificing field of view. These are perfect eyepieces for large Dobsonians, where the wide field helps keep objects in view.

Adding a Low-Power "Panorama" Eyepiece

For the widest field on a 2-inch system, the Tele Vue 41mm Panoptic or 31mm Nagler can't be beat. For less money and slower optical systems, the Meade 30mm Ultra Wide, William Optics 28mm UWAN or University Optics 40mm MK-70 König are good choices. If a 40mm eyepiece yields more than a 7mm exit pupil on your scope, opt for a Tele Vue 35mm Panoptic or the lower-cost Celestron 32mm Ultima LX.

Frankly, you can spend a lot on such an eyepiece and not use it that often. Don't forget to factor in the 2-inch nebula filter you'll also want. A pricey addition, but the views of big deep-sky objects, such as the North America Nebula or the Veil Nebula complex—possible only with such an eyepieceand-filter combination—are unforgettable.

* Adding a Planetary Eyepiece As mentioned, we often use a good Barlow rather than a standard 4mm-to-8mm eyepiece. Eye relief is much better, and performance is not compromised. Three thoughtfully selected eyepieces and a Barlow make a versatile collection that will offer a magnification for every observing situation, including ultra-high-power views of planets and double stars when the seeing permits. A more costly high-power alternative is one or two Tele Vue Radians or William Optics SPL eyepieces.

✤ A Reminder:

Know Your Limits

When selecting eyepieces, remember the low- and high-power limits. Avoid eyepieces that yield a power less than four times the telescope's aperture in inches (to keep the exit pupil below 7mm) and more than 50 to 60 times the aperture (the maximum useful power). In practice, your most-used eyepieces will be in the magnification range of 7 to 25 times the aperture in inches.

COMA CORRECTORS

While aberrations can be reduced to near zero in modern eyepieces, they are still present in the main optics. A premium eyepiece on a fast f/4.5 Newtonian telescope still shows some edge-of-field aberrations that make stars resemble tiny comets, the result of coma inherent in the parabolic primary mirror itself. Therefore, the next

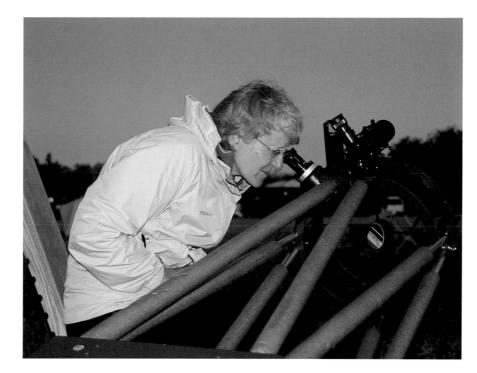

logical step is to optimize the eyepiece design to cancel out the flaws of the main optics, producing an entire telescope system that is aberration-free. The solution is a coma-corrector lens inserted into the optical path of a Newtonian, usually in the manner of a 2-inch-barrel Barlow that then accepts any eyepiece.

These accessories (\$200 for the Baader Multi-Purpose Coma Corrector with visual ring set; \$300 for the Tele Vue Paracorr) are highly recommended for f/4 to f/5 Newtonians to suppress off-axis aberrations. Anyone who spends serious money for a large Dobsonian will want to have one. Coma correctors work best at low power for panoramic viewing. The unit can be left installed for all but the most critical highpower planetary observing.

▲ Happiness Is

... a new eyepiece. Here, an observer with a wellequipped Dobsonian tries out a new high-power eyepiece on Jupiter in the early-evening sky.

Eradicating Coma Coma correctors are offered by Baader and Tele Vue. Baader's Multi-Purpose Coma Corrector (not shown) uses a complex series of adapter rings to mate directly to the eyepiece. Tele Vue's Paracorr is simpler to use but provides 15 percent magnification. It is available in both visual (shown here) and photographic versions and with an adjustable top to fine-tune the correction to the eyepiece used.

Filters

The best accessory for a telescope is a set of first-class eyepieces. The best accessory for the eyepieces is a set of good filters. The difference a filter makes is sometimes dramatic but more often subtle, requiring a trained eye to appreciate.

There are three types of filters for ama-

teur astronomy: solar; lunar and planetary; and deepsky. Although very different in construction, these filters have the same purpose: to reduce the amount of light that reaches the eye. Since the goal of telescope owners seems to be to increase lightgathering power, this

may sound strange.

It is easy to understand why a filter is required for observing the Sun, and because solar filters are integral to that task, they are dealt with separately in Chapter 9. But the planets? In a large telescope, planets such as Venus, Jupiter and Mars can sometimes be too bright; a filter cuts down glare without decreasing resolution. However, the main purpose of the filter is to enhance planetary markings by improving contrast between regions of different colors.

On the other hand, the motto for deepsky observing is "Let there be light!" So how does a filter help? Light from deep-sky objects is usually accompanied by ambient light from sky glow and light pollution. Nebula filters block the unwanted wavelengths and admit those from deep-sky objects, improving the contrast between the signal (the target object) and the noise (the sky background).

FILTER FEATURES

Most filters are mounted in cells that screw into the base of eyepiece barrels and are available for 0.965-, 1.25- and 2-inch eyepieces. All name-brand filters consist of optical glass with plane-parallel surfaces. Unlike for photographic applications, there are no gelatin filters for astronomy. Many current types of filter have the same antireflection coatings applied to lenses. With the exception of the Vernonscope Brandon models, all eyepieces made since at least the 1980s use a standard filter thread, so any brand of filter can be used on any eyepiece. The Brandon eyepieces, however, require either Vernonscope or Questar filters. Some filters have threads on both sides, which allow them to be stacked, although combining two filters usually does not produce a more beneficial color than that achieved with a single filter.

PLANETARY FILTERS

Beginners are attracted to planetary filters because they are inexpensive (\$15 to \$20 each) and come in every color of the rainbow. (Planetary filters are labeled with the same Kodak Wratten numbers used in photography. A No. 80A blue filter for planetary observing is the same color as the photographer's No. 80A.) As with eyepieces, the temptation is to collect the whole set, but you do not need them all.

Of all the shades available, the most useful are No. 12 yellow, No. 23A light red (to increase the contrast between dark and light areas on Mars), No. 56 light green (to enhance features such as the Great Red Spot and the dark cloud bands on Jupiter) and No. 80A blue (for occasional glimpses of subtle features in Venus's clouds). These constitute a basic set for planetary viewing. A No. 8 light yellow can be substituted for the No. 12, and a No. 21 orange or No. 25 deep red for the No. 23A light red.

In all cases, the improvements offered by planetary filters are subtle—often too subtle for a beginner to notice. Knowing what to look for is the key. A general planetary filter designed to reduce the chromatic aberration inherent in achromatic refractors is described in Chapter 10.

LUNAR FILTERS

The Moon can sometimes be too bright as well, especially in large telescopes. A yellow or neutral-density filter (\$15) can cut glare and ease eyestrain. For refractors, a No. 8 light yellow or No. 11 yellow-green filter is also helpful in canceling the chromatic aberration—a bluish fringe most noticeable

Rainbow of Filters

Colorful filters that screw into eyepiece barrels enhance planetary details, but the improvement is subtle. First, you must ignore the overall tint the filter imparts and concentrate on the planetary shadings. If Jupiter's Great Red Spot is not visible without a filter, it will not snap into prominence when a filter is added.

Planetary Filters: A Summary Comparison

Wratten #	Color	Object	Comments
1A	skylight		Haze penetration; mostly for photography
8	light yellow	Moon	Cancels blue chromatic aberration from refractors; reduces glare
11	yellow-green	Moon	Same as No. 8 but deeper color
12 or 15	deep yellow	Moon	Increases contrast; reduces glare
21	orange	Mars	Lightens reddish areas and accentuates dark surface markings; penetrates atmosphere
		Saturn	May be helpful for revealing cloud bands
		Sun	Cancels blue color of Mylar solar filters
23A	light red	Venus	Darkens blue-sky background in daytime observations (for Mercury too)
		Mars	Same as No. 21 but deeper in color
25	deep red	Mars	For surface details with large-aperture scopes
1		Venus	Reduces glare; may reveal cloud markings
30	magenta	Mars	Blocks green; transmits red and blue
38A	blue-green	Mars	Reveals clouds and haze layers
47	deep violet	Venus	Reduces glare; may help reveal cloud marking a very dark filter
56	light green	Jupiter	Accentuates reddish bands and Great Red Spo
		Saturn	Accentuates cloud belts
58	green	Mars	Accentuates details around polar caps
		Jupiter	Same as No. 56 but deeper color
80A	light blue	Mars	Accentuates high clouds, particularly near lim
		Jupiter	Accentuates details in belts and white ovals
82A	very light blue	Mars	For Martian clouds and hazes
		Jupiter	Similar to No. 80A but very light tint
85	salmon	Mars	Similar to No. 21; for surface details
96	neutral density	Moon & Venus	Reduces glare without adding color tint
- El la grada	polarizer	Moon	Darkens sky background during daytime for observations of quarter Moon
	1		observations of quarter Moon

See Chapter 10 for more about planetary filters.

on the Moon, Jupiter and Venus—present in all but the finest models.

Polarizing filters are useful as simple neutral-density filters for viewing the Moon. Their ability to block light waves that vibrate in a particular direction makes them good for sunglasses but has a limited benefit in astronomy. Their main application is for observing the first- or last-quarter Moon in daylight or twilight. Light is most polarized in the region of the sky 90 degrees from the Sun, where the quarter Moon is found. With

a polarizing filter (make sure it is rotated for the best effect), the sky background darkens, increasing contrast for daytime views of the Moon.

I Dim the View

Some manufacturers offer double polarizers containing two filters that rotate apparately to create a variable neutral-density filter. Crossed at right angles, the filters admit only 5 percent of the light, so the Moon can be dimmed to a pleasing level no matter what its phase.

DEEP-SKY OR NEBULA FILTERS

Nebula, or light-pollution-reduction (LPR), filters are rightly considered a significant advance in amateur-astronomy equipment. Much more than pieces of colored glass, nebula filters are, consequently, more expensive than lunar and planetary filters. Prices start at around \$60 and run as high as \$200 for a filter to fit eyepieces with 2-inch barrels.

These high-tech filters capitalize on the fact that nebulas emit light only at specific wavelengths, unlike stars, which emit across a broad spectrum of colors. Nebular light results mostly from hydrogen and oxygen atoms. Single gases have very well-defined emission lines, as do the gases contained in streetlights.

Mercury-vapor and sodium lights, which contribute heavily to the light pollution above and around cities, emit only in the yellow and blue ends of the spectrum. Since nebulas emit mostly in the red and green parts of the spectrum, one type of light can be blocked without interrupting the other. That's what nebula filters do.

Three kinds of deep-sky objects benefit from the use of a nebula filter: diffuse emission nebulas, planetary nebulas and supernova remnants. All emit their own type of light. Some nebulas (those seen as blue in long-exposure photos) shine only by reflected starlight and therefore do not benefit from nebula filters. Nor do nebula filters help when viewing galaxies or star clusters. Filters will just make these objects and the sky look dimmer.

Nebula filters can transform a poor, light-polluted sky into a moderately good location (at least for observing nebulas) and

Nebula Emission Lines

Nebulas are bright in these wavelengths.

Line	Color	Wavelength
Nitrogen-II	red	658nm
Hydrogen- alpha	red	656nm
Oxygen-III	green	501nm & 496nm
Hydrogen- beta	blue- green	486nm

a good observing location into a great one. Contrary to popular belief, nebula filters are not just for city dwellers. This is a persistent urban myth that discourages some telescope owners from laying out the money to buy one. Our advice: Don't delay! Get one. Their effect is even more dramatic under dark skies, where there is always some sky glow caused by weak auroral and airglow activity that the filter can reduce.

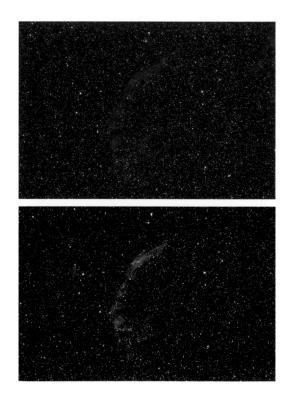

Nebula-Filter Revolution Introduced to backyard astronomy in the mid-1970s, silvery nebula filters were viewed by some as gimmicks. They are now considered essential accessories for the avid deep-sky observer. Lumicon has long made the most extensive line of nebula filters for eyepieces and cameras. Its products have become a standard by which others are measured. Competitive filters are offered by Celestron, Meade, Orion, Sirius Optics, Tele Vue and Thousand Oaks Optical.

Before and After a Filter 🕨

In this simulated view of a section of the Veil Nebula (top) as seen through a typical 5-to-6-inch telescope in a dark sky, the nebula is just visible as a faint arc. A simulated view of the same object through the same telescope but with an 0-III filter in place (bottom) reveals much more detail with increased contrast, even in a dark sky—in fact, especially in a dark sky.

TYPES OF NEBULA FILTERS

With nebula filters, the critical specification is the bandpass. All transmit a blue-green region of the spectrum, in addition to red wavelengths. However, some types let a broad swath of light through in the allimportant green band. (The human eye is most sensitive to green, and the majority of nebulas have strong green emission lines.) These broadband types are intended for mild light-pollution reduction (LPR) when viewing all types of deep-sky objects. Examples are the Lumicon Deep-Sky filter, Orion SkyGlow and Thousand Oaks LP-1.

Another variety has a much narrower bandpass that blocks unwanted light more effectively, improving contrast still further, but only for emission nebulas. Other deepsky objects just go dark. The Lumicon Ultra-High Contrast (UHC) filter, the original in this class, is still the standard. Others now include the Celestron UHC, Meade 908N, Orion UltraBlock, Tele Vue NebuStar and Thousand Oaks LP-2.

There are also "line" filters (the Oxygen-III and Hydrogen-beta filters) that use ultranarrow bandpasses which are adjusted specifically for wavelengths emitted by certain objects. O-III filters are excellent choices, but H-beta filters enhance so few objects (mostly the Horsehead Nebula), you may rarely use one. Celestron, Meade, Lumicon and Orion all offer these line filters; others are the Tele Vue Bandmate O-III and Thousand Oaks LP-3 and LP-4 filters.

We use UHC narrowband and O-III filters regularly but have found little use for the subtle improvement of broadband filters. If you are going to choose one filter, a UHC-class narrowband filter is the most useful for all telescopes. In our tests, even an 80 num f/12 refractor revealed the Orion, Veil and North America Nebulas more distinctly with this filter. If you get hooked on nebulao, add an Ω -III filter later, though on slow f/10 to f/15 telescopes, these filters darken the sky so much that users can have difficulty seeing the field of view.

While spending as much as \$200 on a nebula filter may seem excessive, the improvement to certain deep-sky views is like doubling the aperture of your scope. One view of the Veil Nebula with and without a filter will convince you of a filter's value.

Nebula Filters: A Summary Comparison

Nebula filters have become essential equipment for backyard astronomy because they improve the view of some of the best deep-sky objects regardless of light-pollution conditions. All these filters have a major transmission in the red portion of the spectrum (around the H-alpha emission line at 656nm). Their main difference is the transmission of wavelengths in the green band (around 500nm).

.....

Туре	Bandpass*	Comments
Broadband	90nm: 442nm–532nm	Widest bandwidth and brightest image but least amount of block- ing of light pollution. Good for photography. Can be used to some degree on non-nebula deep-sky objects. Examples: Lumicon Deep-Sky, Orion Sky- Glow, Thousand Oaks LP-1. Good for slow focal-ratio scopes.
Narrowband	24nm: 482nm–506nm	Narrow bandpass in green visual spectrum. Darkens sky further, with more dramatic contrast between sky and nebula. A good general-purpose filter for emission nebulas. Suitable for urban loca- tions. Examples: Lumicon UHC, Orion UltraBlock, Thousand Oaks LP-2; filters sold by other manufacturers are similar in transmission characteristics.
Oxygen-III	11nm, including 496nm & 501nm	A line filter—very narrow band- pass centered on green doubly ionized oxygen emission lines. Highest contrast and maximum blocking of light pollution. Good for planetary nebulas and supernova remnants. Best on fast focal-ratio telescopes.
I beta 9nm centered on 486nm		A line filter—very narrow bandpass centered on blue green H-beta emission line. Useful for Horsehead and California Nebulas but little else.

• Measured in nanometers. 1 nanometer = 10 angstroms = 1 millionth of a millimeter.

C H A P T E R F I V E

The Backyard Guide 'Accessory Catalog'

In the late 1950s, when the first Sputniks were flying and interest in space was keen, a toy manufacturer introduced a Luminous Star Locater. The product was a series of clear plastic disks with constellation figures etched in them. Each disk could be placed in an illuminated holder shaped like a small tennis racket that the observer would hold up to the sky and try to identify the real stars. It was a useless gadget.

Fast forward 50 years to devices that use GPS satellites and inertial sensors to allow you to aim at any star, and a voice or screen readout tells you all about it. The technology is magic. The Celestron SkyScout and Meade MySky offer it for \$400.

As enticing as such devices are, do you need them? While some products add enjoyment to a session under the stars, others are not so essential. Here's a catalog of common accessories, from the useful to the useless.

It isn't long before a new telescope owner starts to accessorize with new eyepieces, finderscopes, digital readouts and a host of other add-ons. Some are useful; others are

just gadgets.

Classic Finderscope A Adjusting the setscrews on the finder's bracket tweaks the finder so that it aims at exactly the same place in the sky as the main instrument. The best brackets employ two sets of adjustment screws, front and back, and like this 6x30 finder on an Orion XT6, they should have locknuts to hold the alignment in place.

New-Style Finder 🕨

A good alternative that is commonly found on Chinese import scopes uses two screws plus a springloaded bolt, as on this 6x30 finder. It is easy to adjust yet remains in alignment.

Quick-Release Finder A handy feature is a dovetail bracket to hold the finder on the telescope. This allows for quick removal of the finder for transport yet maintains alignment when the finder is reinstalled. The long stalk of this bracket makes it easier to get your head behind the finder to sight through it.

Highly Recommended

Eyepieces and star charts top the list of must-have accessories, so much so that we cover these items in their own chapters. Accessories for photography are specialized products also discussed in a later chapter. For the majority of observers, photographers or not, the following additional items deserve a place in website shopping baskets and on Christmas wish lists.

UPGRADED FINDERSCOPE

One of the challenges (or frustrations) of observing, for both novices and veterans, is finding celestial objects. The better the instrument's finderscope, the easier this will be.

With finders, better usually means bigger.

Many manufacturers of entry-level telescopes continue to supply inadequate finderscopes with their instruments, because most first-time buyers do not realize how important that accessory is until they actually use the telescope at night.

Even more expensive telescopes (smaller reflectors and basic Schmidt-Cassegrains) often have only 6x30 finderscopes, meaning 6 power with a 30mm-aperture lens. These are just adequate. They are sufficient for locating bright targets but are limited when you are searching for deep-sky objects. For 8-inch and larger telescopes, a finderscope with a true 50mm aperture and 7x to 9x is a far better choice, able to show ninth-magnitude stars while maintaining a wide six-degree field.

All finderscopes come with eyepieces that have crosshairs. A few have a special reticle that indicates where the true north celestial pole is in relation to Polaris. While a polar-alignment reticle does not hurt, precise polar alignment is not essential unless you are doing astrophotography.

Some finderscopes have illuminated reticles, using a battery-operated light on the side of the eyepiece. However, the tiny camera batteries required are expensive, and we have found that it's easy to forget to turn off the light at the end of an observing session. As a result, the illuminator is dead most of the time.

A 50mm finderscope costs anywhere from \$60 to \$100, depending on extras such as right-angle prisms, illuminated reticles and dovetail brackets.

REFLEX OR RED-DOT FINDERS

This may seem like a frivolous accessory, but most observers who use one soon can't do without it. Look through the window of a reflex, or unit-power, finder, and you'll see a red dot or bull's-eye target projected onto the naked-eye night sky. Popular models are the original Telrad designed by Steve Kufeld and the Rigel Systems QuikFinder. Both attach easily to most telescopes using a plastic base that fastens with double-sided tape or screws. Both are light enough to pose few balance problems, and their LED lamps draw so little power that the batteries last for ages. Either model is the best \$50 you can spend on improving your telescope.

An alternative is one of the gun-sightstyle red-dot finders, often dubbed RDFs. These devices present a small window through which you see a red dot projected onto the sky. Examples are the Orion EZ Finder, Burgess MRF, Astro-Tech ATF and Celestron's Star Pointer, all \$30 to \$60.

Some models have a small window that is sometimes dimmed with a coating, which makes it hard to see enough of the sky for star-hopping to faint targets. The multireticle finders sold by various suppliers work best. But for aiming at bright objects and simply aligning GoTo telescopes, any red-dot finder works just fine. When buying one, make sure you get it with the base that will fit on your scope. Some slide into the dovetail channel occupied by your existing finder. Others require bolting a new dovetail base to existing holes in your telescope tube. For scopes lacking such holes, the alternative is a base that attaches with double-sided tape. If you've ever groveled in the dirt to sight along the telescope tube only to discover that you were still way off target, a reflex or red-dot finder is the answer. We use them on many scopes.

RED FLASHLIGHT

You don't realize how essential this accessory is until you forget it one night. How do you read star charts? Equipped with thousands of dollars' worth of gear, you are lost in the stars for want of a \$15 flashlight.

Any pocket flashlight will do. Paint the bulb using red nail polish, or cover the faceplate with red cellophane or red paper. The red illumination preserves night vision. Buy a flashlight small enough to hold in your mouth so that both hands are free. The flashlight should be made of plastic; metal flashlights can become too cold to touch in winter. Flashlights with dual red and white LEDs are handy; a bright white light is good for assembling and dismantling

Novel Finders

For locating objects, a nonmagnifying finder may be all you need. At left is a suite of good units (from left to right): the Telrad, Rigel Quikfinder, Astro-Tech multi-reticle finder and Celestron Star Pointer. Above, a laser pointer attached to a telescope is a great finder aid.

Really Bad Finderscopes

Low-cost Christmas trash telescopes often have atrocious finderscopes. Sometimes, they are no more than hollow tubes with crosshairs. A few beginners' telescopes employ a flip-up mirror system that uses the main lens or mirror as a finderscope. It sounds good in theory, but in practice, the design fails miserably. The views are dim, and their orientation is confusing.

Inexpensive telescopes often come with a 5x24 finderscope. Most are junk. Many have aperture stops inside the tube, cutting

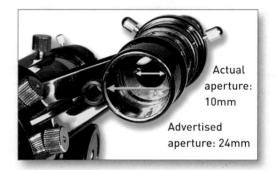

the advertised 24mm aperture down to an actual working diameter of 10mm to 15mm. Such a small aperture makes it difficult to sight anything dimmer than the Moon. Upgrading such a junk finder to a good-quality 6x30 makes a vast improvement.

Another feature offered with some finderscopes, even larger ones, is a right-angle prism. While it is easier to look through a right-angle finderscope when viewing high in the sky, the views are mirror images. They do not match the real sky or printed star charts—all the constellation patterns appear flipped left to right. To match a star chart, the chart must be turned over and viewed from the back by shining a flashlight through the paper, awkward at best.

To make things worse, the observer does not look in the same direction as the telescope when using a rightangle finderscope. With a straight-through finderscope, the real sky can be observed with one eye while the other takes in the finderscope view. Even though a straight-through finderscope can be a literal pain in the neck near the zenith, we recommend you stay with the design when upgrading.

Small 5x24 finders are often stopped down to 10mm or 15mm aperture by a stop just inside the main lens, because the finderscope lens is so bad that it cannot be operated at its full aperture of 24mm. If it were, its images would be completely fuzzy. The three-screw bracket of this economy model also makes it hard to align the finderscope precisely.

Astronomers' Flashlights 🔺

The best astronomy flashlights use dimmable red LEDs, which draw less power and are more reliable than lightbulbs. Flashlights with high-intensity white LEDs or krypton lamps are helpful for setup and takedown, when dark adaptation is not important.

Making a Good Case 🔻

A hard-shell case, like the JMI case for the Celestron 6-inch SCT (below), is essential for road trips. Smaller telescopes, like the 90mm short-tube refractor, can travel in a soft padded carrier, such as the Orion case (bottom left). Eyepieces and filters need their own case, like the Pelican camera case (bottom right).

equipment. Lights on flexible stalks are also useful for illuminating charts, accessory boxes and tabletops.

CLEANING AND TOOL KIT

A kit containing all the screwdrivers and wrenches your telescope may require can be an essential item. After a jostling road trip, parts come loose, optics need collimating and bolts require tightening. "No Tool" kits for some telescopes (such as from Bobs Knobs) can replace screws and bolts with large knobs that are easy to adjust by hand.

A packet of lens-cleaning tissue, cotton swabs and lens-cleaning fluid should also be in every telescope-accessory case. Throw in some electrical tape as well—it is amazing what a roll of tape can fix.

Don't forget the insect repellent in your field kit. Mosquitoes love astronomers. But that insect repellent can be a nuisance, too, when it greases up the telescope's knobs and buttons. Worse, repellents with high DEET content can eat into optical coatings and the vinyl on binocular bodies and cases.

CARRYING CASES

Eyepieces, filters and accessories require a proper case to carry them all. Camera stores and electronic shops offer all kinds of cases. Avoid those with several layers of compartments. The briefcase style is the best. Some have compartments with movable dividers. Others have foam that can be cut out as needed. Many have foam with "pick-andpluck" squares that can be removed—these inserts tend to fall apart but can be replaced. Then there's the telescope itself. Most

telescopes don't come with their own case. Many telescope dealers sell padded or softsided bags for carrying almost every kind of small telescope. Some bags can even accommodate tripods and mounts. Hard-shell cases, often a manufacturer option, are better choices for larger scopes such as Ritcheyand Schmidt-Cassegrains. JMI and Scope-Guard offer a wide range of cases.

DEWCAPS

The first line of defense against dew or frost is a dewcap, a tube that extends beyond the front lens or corrector plate. Many refractors have a built-in dewcap. Yet the telescopes that most need dewcaps—Schmidt-Cassegrains and Maksutovs—rarely come with one. Exposed to the sky, the corrector lenses of these telescopes readily attract dew. Dewcaps can be purchased separately from many companies and dealers. Or a simple homemade device can be made out of cardboard, foam or plastic. Commercial or homemade, a dewcap that slides or folds back down the telescope tube for compact storage is the best.

A dewcap usually keeps moisture off the lens for about an hour longer than would be the case without the cap. But if dew is forming elsewhere, it will sooner or later cover all exposed optical surfaces. Then what?

DEW GUNS

The first attack of dew can be repelled with a handheld hair dryer, blowing warm air (not hot) onto the affected lens. At home, a low-wattage AC hair dryer has saved us on many a night. If you are running on 12 volts DC, use a heater gun sold in automotive stores for melting frost off windshields. It plugs into the socket of an automobile cigarette lighter.

As convenient as it is, a handheld hair dryer is only a stopgap measure. On humid nights, the optics always fog up again. Once the telescope has donated all its heat to the air and the air temperature stabilizes, dew keeps re-forming and hair dryers cease to be effective. Furthermore, after many dew attacks, a lens surface can accumulate a sticky, hard-to-remove residue from heatdried dust and moisture. The secret is to keep the dew from forming at all.

Not Essential, but Nice to Have...

After the necessities of astronomical life have been met comes a list of items that aren't essential but can add enjoyment to any session under the stars.

DEW-REMOVER COILS

As we said, the best way to eradicate dew and frost is to prevent them from forming in the first place. The trick: a low-voltage heater coil. We recommend the Kendrick Dew Remover System, with heater coils and pads for all sizes of telescopes, finderscopes, Telrads, eyepieces, even laptop computers. The system uses a 12-volt, variable-intensity controller that can accommodate up to four low-voltage heaters designed to wrap around the outside tube wall near the objective or corrector lens, the finderscope lens and eyepiece and the main eyepiece any optical surface. The heaters can provide just enough warmth to ward off the formation of dew. An eyepiece heater is not necessary if you make your own heated eyepiece-accessory box, be-

cause an eyepiece that dews over can be exchanged for a warm one.

Do heaters affect the telescopic image? The critical element is the objective- or corrector-lens heater. If there is too much heat, seeing is degraded; too little, and dew encroaches. When set to a happy medium, heater coils produce no ill effects.

MOTOR DRIVES

Most first-time telescope buyers who purchase equatorial mounts do so because of the mount's ability to track the stars. Yet many never bother adding the optional

Dewcaps

A dewcap for a Meade ETX (left) or a larger Schmidt-Cassegrain telescope (below) may be the single most useful accessory a user can buy for this or any dewprone telescope, especially in humid locations in eastern North America.

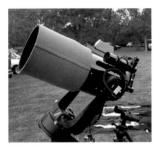

Dew: The Vampire of Astronomy

Countless observing sessions are cut short by dew. Like a vampire, it silently sucks the life out of a telescope late at night. As the temperature falls during the evening, moisture condenses out of the air onto the optics, forming

droplets of dew or, in cold weather, frost. Every backyard astronomer has cursed the plague of glazed optics that terminated a planet watch during an evening of excellent seeing or fogged an astrophoto midway through a 1-hour exposure.

Dew can be more than merely a nuisance—it can damage the coatings on mirrors and lenses. Our industrial civilization has, in many parts of the world, changed delicate dewdrops into acid dew, a cousin to acid rain. This stuff attacks coatings on lenses and mirrors and is especially brutal to enhanced silvered mirrors on reflectors. (The more common enhanced aluminum coatings are less susceptible.) In northeastern North America, where acid rain and acid dew are common, enhanced silver coatings are not recommended for Newtonians, whose optics are exposed to the air. (Such coatings are rarely offered today.) Owners of older Schmidt-Cassegrains or

Maksutovs with enhanced silver coatings should ensure that the tube is always closed to outside air, with either an eyepiece or a plug in place.

Owners of standard Newtonian telescopes usually don't have to worry about dew, since the optics are at the bottom of a long tube that keeps dew off the main mirror. But for Schmidt-Cassegrains, Maksutovs and refractors (like this fogged-up Meade ETX70-AT), dew can be a drawback the salesperson neglected to mention.

Polar Scopes

To aid polar alignment, all polar finderscopes, above and right, are equipped with a reticle (sometimes illuminated) that shows the position of the true pole in relation to Polaris (some also have reticles with patterns for southernhemisphere use).

Decked Out for Dew 🕨

A \$3,000 telescope can be heater-equipped front to back, including eyepiece, finderscope and/or Telrad, for about \$250. In the field, such a system does require a hefty source of 12-volt power, supplied by a car battery or a heavy-duty power pack. Or the heater controller can operate from AC power via a 12-volt power supply capable of putting out 3 amps or more.

Basic Tracking Motor Expect to pay anywhere from \$60 for a simple single-axis drive (seen here) to between \$150 and \$400 for a dual-axis drive system for the better small-telescope mounts.

motor drive needed to supply the very tracking the mount is capable of providing. Almost all import telescopes have optional battery-operated drives (110-volt AC motors have all but disappeared from the market). The lowest-cost models offer tracking in right ascension at a fixed speed. Better models have override buttons for an instant 8x, 16x or 32x speed change. This is useful for panning around the Moon and centering objects. Speed controls are worth having, because adding many of the optional drives to Chinese-import telescopes requires giving up the manual slow-motion control-there is no clutch assembly to allow both the motor and the slow-motion cable to turn the telescope, an inconvenience for centering targets. Deluxe models of drives come with two

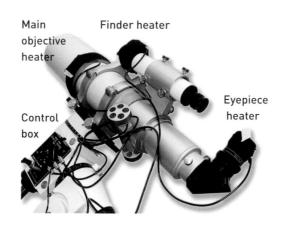

motors, one for tracking in right ascension (east-west) and the other for centering objects in declination (north-south). If the mount has a good manual slow-motion control in declination (most models do), then a dual-axis drive isn't essential for casual viewing, but the push-button convenience is handy. However, a dual-axis drive is recommended if you wish to pursue guided deep-sky photography.

POLAR-ALIGNMENT SCOPES

Equatorial mounts must be polar-aligned precisely for photography but only roughly for casual viewing. No matter the technique and degree of precision, polar alignment requires some way of aiming the mount's polar axis at the pole. Almost all German equatorial mounts sold today come with suitable controls for making fine adjustments to the azimuth and altitude angle of the polar axis.

What may be optional is a small polaralignment finderscope, located right in the mount, aimed up the polar axis. Looking through the polar finderscope makes it easy to sight Polaris (for northern-hemisphere observers) and to fine-tune the aim of the mount's polar axis. (See Chapter 15 for detailed instructions on methods for precise polar alignment.) But for visual observing, simply getting Polaris close to the center of the polar finderscope's field of view within one degree of true celestial north —is good enough.

POWER PACKS AND CAR CORDS

If the mount is driven by DC motors, it probably came with a battery pack that uses several penlight batteries or a single 9-volt transistor battery. These are not long-lived. D-cell batteries are really the practical minimum for drives. They hold up better in the cold through several long observing sessions. Another plan is to get the appropriate cable to plug the drive into the car battery. Or purchase a larger-capacity rechargeable pack that will be good for several nights' use before it needs to be recharged. A separate power pack allows the telescope to be set up anywhere and not be tied to the car.

For powering just a telescope's dual-axis drive, a power pack with a 7-ampere-hour capacity is more than adequate for many nights' use. But the high-speed motors of some high-torque GoTo telescopes can draw as much as 3 amps at 12 volts, quickly draining a small power pack before the night is over. Add antidew heater coils and CCD cameras, and the modern observer quickly encounters a mini energy crisis in the field. If everything has been hooked up to your

car battery, you may not be able to start your car in the morning. Separate power packs with 15-to-30-ampere-hour capacities are a minimum for the high-tech observer. Rechargers that work off solar panels are a great idea for long stays at remote sites.

UPGRADED FOCUSERS

A number of suppliers offer aftermarket upgrades to focusers. Some consist of addon gears that provide dual-speed focusing with a 10:1 gear reduction for fine focusing. Other units completely replace the existing focuser but have dual-speed coarse and fine focusing. Once you use these, you'll never go back, but they are certainly in the "just nice to have" league.

OBSERVING CHAIRS

Treat yourself to a place to sit while observing. If possible, lower the telescope so that the eyepiece is at eye height when you are seated. The increase in comfort is sheer luxury. A good observing chair is a stool whose height is adjustable. It should also fold up for easy storage. The stools sold in music stores for drummers are very comfortable, although not tall enough for some telescopes. Instruments bigger than 15-inch Dobsonians require an observing ladder. A small kitchen stepladder may be just the thing for reaching the eyepiece of these big telescopes when aiming at the zenith.

OBSERVING TABLES AND ACCESSORY TRAYS

Many observers have found it convenient to take a folding camp table to the observing site to hold star charts, books and other stargazing paraphernalia. Without one, observers are forced to work off tailgates or out of car trunks.

Some small suppliers make tripodmounted trays for common telescopes, such as Schmidt-Cassegrains, that lack a place to put anything. These accessory trays are great for holding eyepieces, auto-guiders and computer hand controllers that would otherwise dangle with no place to clip. Certainly, any aid that reduces fumbling around in the dark is a welcome convenience, as long as it does not require an inordinate effort to set up in the first place.

WHEELEY BARS AND SCOPE COVERS

Borrowing an idea from large TV studio and movie-camera dollies, Jim's Mobile, Inc. (JMI) designed Wheeley Bars, a set of rolling casters that fit under the tripod legs of large scopes, such as 10-to-12-inch Schmidt-Cassegrains. Other companies, such as Scope-Buggy, followed suit. If you can store such a telescope in a garage and if there's a clear access from there to your backyard viewing site, a telescope dolly is a great solution for a no-fuss setup. It can make an otherwise unwieldy large-aperture telescope a practical choice for casual stargazing. Just wheel the scope outside as a single unit.

For garage storage or for star parties and backyards where you can leave your telescope set up for a few nights, simply protect the telescope with a weatherproof cover. Dealers such as AstroSystems, Tele-Gizmos and Orion offer excellent sets of waterproof covers to fit many sizes and styles of telescopes. We use telescope covers ◀ Supplying 12-Volt Power In the field, the "jump-start" batteries sold at automotive stores (far left) are ideal. Conversely, users at home face the problem of powering 12-volt devices from AC. For some power-hungry GoTo scopes, a supply capable of outputting at least 3 amps, like the heavy-duty unit at near left, is essential.

▲ Deluxe Focuser Replacement focusers from MoonLite Telescope Accessories (shown here), JMI and Starlight Instruments offer fine focusing and solid wobble-free connections, ideal for astrophotography.

▲ A Place for Everything This durable camp table, sold by Orion, folds up into the tight roll seen propped up at left, making it easy to stuff into a car for field trips to dark-sky sites.

A Place to Sit ▲ This clever observing chair can be adjusted over a wide range of positions to suit different eyepiece heights.

Shelter From the Storm ► At star parties during the day, many telescopes are cocooned under waterproof nylon or silvery Mylar "Desert Storm" covers; the reflective blankets help keep the scopes cool. When leaving a scope set up over several nights at home or in the field, a protective cover is essential. The covers are available in sizes to fit all telescopes.

Aids for Alignment

A collimation tool, like a sighting eyepiece (left) or a laser collimator (right), is a useful accessory for owners of f/6 to f/8 Newtonian telescopes and is an essential tool for Newtonians with optics faster than f/6, which need tighter collimation. The slightest miscollimation in faster Newtonian systems can degrade image sharpness and contrast, blurring planetary and double-star views in particular. in all weather conditions and can recommend them. They are far more durable than garbage bags!

COLLIMATION TOOLS

Every owner of a Newtonian telescope should have a collimating eyepiece, a simple tube with crosshairs and a diagonal surface to reflect light down into the telescope tube. Sighting through such an eye-

piece (one type is called a Cheshire eyepiece) makes it much easier to center all the optical elements, especially if both the secondary and the primary mirrors are marked with a dot or ring at their centers (see Chapter 15 for collimation procedures). A collimating eyepiece costs no more than \$45. Put one on your stocking-stuffer Christmas

wish list.

A highertech solution is a laser collimator. These units range in price from \$70 to \$200. Howie Glatter offers a wide selection

(www.collimator.com). When placed in the focuser, a laser collimator projects a beam of laser light down the Newtonian tube. You then adjust the tilt of the telescope's mirrors until the beam returns exactly onto itself. It does work well, but a lower-tech collimation sighting eyepiece and a final tweak using a star test, which is often essential anyway, work just as accurately as the hightech laser devices.

If You Can Afford Them...

For the observer who has collected all the required toys, there is another realm of wonderful accessories, but some of them come with hefty price tags.

DIGITAL SETTING CIRCLES

Much of the computer-finding functionality of GoTo telescopes can be added to any telescope. JMI, Lumicon, Sky Commander, Tele Vue and Wildcard Innovations offer add-on boxes and axis-encoder kits for a variety of telescopes that provide digital readouts of the telescope's position. Databases of objects (the more costly the model, the larger the database) allow you to find targets simply by punching in the object's catalog number. You then watch the display as you manually swing the scope. When the display's coordinates read 00 00, you are on target.

With the required optical encoders that must be installed on each scope axis, expect to pay \$350 to \$800 to equip a telescope with one of these high-tech finders.

With GoTo telescopes now so affordable and prevalent, add-on digital setting circles are becoming less popular, but they are still excellent choices for adding computerized finding to Dobsonian reflectors.

DOB PLATFORMS AND DRIVES

The major limitation of Dobsonian telescopes—no tracking—can be overcome with an ingenious device: the equatorial platform. The telescope rests on a small, ankle-high table that can swivel around one axis, driven by a motor. Platforms, also known as Poncet mounts, typically provide about an hour of tracking until the threaded drive rod needs to be reset back to the beginning of its travel.

The alternative is adding computerdriven motors to premium Dobs. The Servo-CAT kits from StellarCAT are popular solutions. Either way, having an object stay put in the high-power eyepiece of a massive 20inch or larger telescope is a sight to behold.

Tracking systems can transform big Dobs with premium optics into the finest planetary telescopes available. Faint galaxies and nebulas that normally fly across the field of view in an undriven scope suddenly stand still for detailed inspection.

Expect to spend \$750 to \$2,500 for a commercially built equatorial platform or add-on tracking system. The latter is often packaged with digital setting circles.

SUPERBRIGHT DIAGONALS

If the focuser can accommodate it, a 2-inch star diagonal is a great addition to a refractor or a Cassegrain-style telescope. The best use full-thickness mirrors that incorporate multilayer dielectric coatings that reflect 99 percent of the incident light, a sizable notch up from the 89 percent reflectivity of standard overcoated aluminum. Modern ◀ Dobsonian Accessories This Australian-made SDM-brand Dob (far left) is well equipped with Argo Navis digital setting circles and antidew heaters. A typical homemade Poncet tracking platform Is shown at near left. Well-crafted commercial platforms are available from small companies such as Equatorial Platforms and Roundtable Platforms.

Where to Keep Your Telescope

Telescopes are pretty rugged instruments that, if handled and stored properly, can last a lifetime. There are three basic storage situations for telescopes used at home: a portable telescope kept in the house; a portable but bulky instrument stored in a garage; and permanently mounted equipment in an unheated observatory.

The advantage with unheated garage or observatory storage is that the telescope remains close to outside temperature, reducing the wait for the optics to reach the temperature stability required for optimum performance. The disadvantage, especially in a small observatory, is moisture, which, over time, can attack the surfaces of mirrors in Newtonian telescopes. The repeated coating and evaporation of dew on exposed lenses in refractors and eyepieces and on the metal parts and fittings of telescope mounts can be reduced with dewprevention heaters, which are often just as useful on a telescope in an observatory as one in the field. In a dry climate, windblown dust and grit can be an

annoyance. Prefabricated observatories, such as those shown here, often have a poured-concrete floor. Concrete is cold to stand on in an observatory environment. We recommend covering the floor with indoor-outdoor carpet *and* undercarpet. Not only is this comfortable to stand on, but when you drop that \$300 eyepiece, it will bounce rather than break.

Backyard-astronomy observatories used to be do-it-yourself projects, but today, a growing number of companies—most of them small specialty enterprises—offer both domed and roll-off-roof types installed at your designated location, often ready for your telescope in one day. Top: the SkyShed Pod. Above: two views of a Backyard Observatories installation.

Premium Diagonals ► An enhanced diagonal with dielectric coatings offers as high as 99 percent reflectivity, ensuring maximum image brightness. It is also mechanically much more rugged than most prism diagonals offered as standard equipment. Models are available from many suppliers in both 1.25- and 2-inch sizes.

Entry-Level Bino Viewer 🕨

Like all bino viewers, this William Optics unit accepts only 1.25-inch eyepieces, which include most Plössls and some wide-angle eyepieces, such as Orion Edge-Ons, William Optics SWANs and shorter-focal-length Naglers. The 24mm and 19mm Panoptics are superb bino eyepieces.

Portable Observatory 🕨

Sold by Kendrick Astro Instruments, this unique tent provides a sheltered home for telescopes on the road. It features a zip-off roof and a roofed sleeping area and workroom. It is ideal for extended stays at dark-sky sites, and owners rave about its comfort and convenience.

enhanced coatings are ultrasmooth and pose no durability or tarnishing problems. Now available for \$80 to \$200, such a superdiagonal extracts the ultimate performance from a high-end telescope.

BINOCULAR VIEWERS

At one time, we would have been talking big bucks here. Indeed, the best binocular viewers from Baader and Tele Vue go for upwards of \$1,000. But today, low-cost bino viewers made in China are sold by a number of dealers for just \$200. We were suspicious at first, expecting to see aberrations and miscollimation so severe that you'd get

headaches looking through one. Not so. They work amazingly well. We use a \$200 William Optics viewer and love it—the cost even included two decent 20mm eyepieces! Although it does not have quite the quality of prisms as the top-end models, it certainly provides sharp images with no added color or blurring of detail due to aberrations. At that price, why not have one? While you do have to factor in the cost of dual sets of eyepieces and filters, the price tag for twoeyed viewing is much less than it was a few years ago. Even so, is it worth it?

Once you are satisfied that you have a good telescope and good eyepieces, there may be no other accessory you can add that will provide as significant an improvement to the view. Even nonastronomy friends and relatives will be wowed.

Binocular viewers utilize a series of prisms to split the single beam from a telescope into twin collimated beams, one for each eye. The main caveat is that the added length of the light path through a binocular viewer typically requires four inches of extra in-focus travel of the focuser. Some premium apo refractors can accommodate this, as do most Schmidt-Cassegrains. But Newtonian reflectors certainly cannot, unless the telescope tube or strut length is cut down specifically for binocular use.

To get around this, binocular viewers are usually supplied with a Barlow lens (often a 1.5x-to-2x model), which extends the focal point out far enough that the eyepieces, now perched on top of the binocular viewer, will reach focus. But the extra power of the Barlow and the restriction to 1.25-inch eyepieces conspire to make it impossible to achieve very low power and wide fields with binocular viewers. Don't expect three-degree-wide views of the North America Nebula in two-eyed splendor. However, deep-sky objects at moderate power and planets at high power become all new experiences when viewed with eyes wide open-both of them!

DOMES AND SHELTERS

The ultimate accessory for any telescope is a house to put it in. Observatories can be rotating domes or shelters with roofs that roll off, flip off or fold down. Most backyard astronomers build their own structures, though commercial companies offer prefabricated domes for existing structures or complete observatories from the ground up.

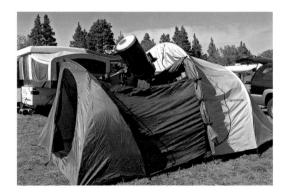

Even if you live under less-than-ideal sky conditions, having your scope permanently set up and ready to go may be the most convenient arrangement for you.

For a less permanent facility, companies such as AstroGizmos offer nylon domes wrapped around a skeleton of strong plastic tent poles. Staked down, these domes can withstand high winds, allowing them to remain in a backyard as a temporary structure. (Visit www.backyardastronomy.com for links to manufacturers, or look in a current issue of *Sky & Telescope* for ads of the latest products from dome and shelter suppliers. There are lots to choose from.)

Not Essential...

Some items are tempting, but in an effort to "simplify, simplify," these are gadgets you can happily live without. The more gadgets you have, the more time it takes to set up and the more that can go wrong.

GREEN LASER POINTERS

A bright green laser pointer is superb when conducting public observing sessions. How did we ever point out stars and constellations without one? With difficulty! But for individual amateurs, this is not essential, though it can be fitted to a scope and used as a finder. Just be careful where and when you aim it, as the light can interfere with imaging. Some star parties ban its use.

FOCUS MOTORS

Celestron, Meade and third-party suppliers, such as JMI, make battery-operated motors for virtually every focuser and telescope on the market. Hands-off focusing reduces vibrations and image shake, but many focus motors suffer from hesitation, backlash and run-on, making it hard to home in on precise focus. In fairness, some of the problems may reside in the focuser itself, not the motor. In frustration, we often want to grab the focus knobs and turn them by hand, but manual control is often not possible. We find the extra batteries and cables a nuisance. Some people love focus motors; we have managed to survive without them.

VIBRATION DAMPENERS

These small pads are placed under the legs of a telescope tripod. A ring of rubber set into high-density metal absorbs vibrations and prevents their being transmitted up the tripod leg. These \$60 pads work, cutting the time it takes vibration to dampen by a factor of two or more, but few observers use them. People prefer their telescopes to be firmly set into solid ground. This is especially true of telescopes that need precise alignment, such as GoTo scopes and those intended for photography.

LAPTOP/PALMTOP COMPUTER

GoTo telescopes can be controlled by an external computer running astronomy software. Chapter 14 contains all the details on how to make the connection. The advantage over using the telescope's own hand controller is that the computer (perhaps a laptop, PDA or smartphone) can display a star map showing where your telescope is pointed and the location of other nearby targets, which makes it easy to explore a region of the sky thoroughly, instead of randomly bouncing around the sky following the hand controller's lists of numbered targets. The disadvantage is the extra gear that needs to be set up, the tangle of connecting cables and adapter plugs required and the fuss about charged batteries to run it all. Computers make sense in a permanent observatory, but for mobile observers, they represent just that much more paraphernalia to set up.

▲ Footpads for Scopes A partial solution to shaky mounts are these vibrationsuppression pads.

▲ Motorized Focusing Focus motors, like this unit from JMI, reduce vibration introduced by touching the focuser. Of course, the ideal solution is a more rigid mount. Another application of motorized focusing is extremely precise focusing, which is often required in astro-imaging.

◀ Computer-Aided Viewing GoTo telescopes, such as this Celestron SCT, can be connected to a computer to run under its control. Click on an object on the computer's display and whir—the telescope slews to find that target. Very neat, but not essential.

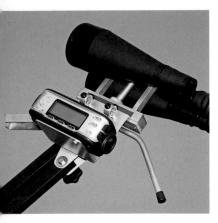

SkyScout in Use Here's one clever way to put a SkyScout to work—as a finder aid for big binos.

ELECTRONIC STAR POINTERS

Here, we return to the devices we mentioned at the beginning of the chapter: the high-tech star pointers, such as the Celestron SkyScout and Meade's MySky. These units work amazingly well and evoke a cry of delight from anyone who first uses one, veteran or beginner. The wonder is, How does it work? Once you accept the magical technology, you quickly put it to use.

While a star pointer can certainly introduce rank beginners to the sky, we wonder whether the \$400 might not be better spent on simpler, lower-tech star charts and binoculars that would then actually show something. More advanced amateurs likely won't need such a device other than as a fun toy

to play with or to spark the interest of the public at star parties. Fun, yes...essential, no.

ERECT-IMAGE FINDERS

No section of the previous edition of our book received more feedback than did our proscription against erect-image finders. Fans of these devices wrote in to champion their fave finder! We'll admit that an erectimage finder can be very useful because its view matches the naked-eye sky, but the advantage is apparent only if the finder is a straight-through model-a rarity. Most are right-angle models, which makes them convenient to look through when aimed high in the sky but still prone to the problem inherent in all right-angle finders: They force you to look 90 degrees away from the direction the telescope is aimed, making it hard to relate the finder view to where the scope is pointed, despite the right-side-up orientation of the field. So our advice remains: To those new to the sky, an erect-image

The Two-Eyed Advantage

Looking through a telescope equipped with a binocular viewer is an impressive sight. Objects appear to float in three-dimensional space. Planets seem to take on extra detail. The Moon looks like a real landscape just outside your spaceship window. And the comfort and ease of viewing are far greater than with one-eyed observing.

The obvious question with binocular viewers is the loss of light. Each eye can receive, at best, only 50 percent of the light that a conventional single eyepiece would provide. However, when the brain merges the two dimmed images back together, the result is a view that is nearly as bright as the same view would be with a single eyepiece. Even so, all the extra optical elements do introduce some light loss. Users report about a 0.5-magnitude drop in light-gathering power compared with a single-eyepiece view. For smaller scopes, that's roughly the equivalent of dropping down one imperial-unit notch in aperture: An 8-inch scope performs like a 6-inch for image brightness, a 10-inch like an 8-inch, a 12.5-inch like a 10-inch, and so on.

Binocular-viewer aficionados maintain that these drawbacks are offset by the additional detail which all objects seem to present. Our experience tends to confirm this conclusion. Images from both eyes present the brain with a view that has a greater signal-to-noise ratio. Views seem less grainy. Those dark and nasty eye floaters (dead blood cells in the eye) that drop in front of planets at high power are now largely suppressed, allowing continuous and unimpeded views of the planets.

Depending on the telescope and what you're looking at, the binocular-viewer experience can be unforgettable. Tele Vue and Baader make the best bino viewers, but high-quality viewers are available from Denkmeier at half the cost of the top-end units, while low-cost viewers from China are sold under a variety of brand names, such as Burgess, Lumicon, Orion and William Optics, and are surprisingly good considering their modest \$200 price tag.

нА

Tele Vue and Baader started the interest in binocular viewers with models that sell for \$1,000 or more. Denkmeier opened up the market with lower-cost but high-quality bino viewers (shown here), and China soon followed with even lower-cost units.

finder may seem essential, but most observers learn to live without one. A good substitute is a red-dot or reflex finder coupled with an optical finder.

BLINKING TRIPOD-LEG LIGHTS

Just like aircraft warning lights on the top of antennas, these little LEDs attached to tripod legs tell unsuspecting visitors: Don't trip here! They are strictly for the gadget lover, although we'll grant them one legitimate use: to mark the location of a camera atop a tripod placed off in the distance for an unattended long-exposure photo.

EYE PATCHES AND GOGGLES

In theory, an eye patch makes it easier to view through your telescope with your uncovered eye.

Perhaps, but no one wants to look like a geeky landlocked pirate, even in the dark.

Another goofy accessory, red-filtered goggles, helps you retain your dark adaptation if you go inside a brightly lit building. Double ditto on the geek factor. Astro-Goggles

Yes, they work, preserving night vision under bright lights, but do you want to be seen wearing them?

Astro-Travel and Touring

The best accessory for your telescope is a dark sky. But why not have a dark sky that comes already equipped with great equipment and comfortable accommodation? That's the attraction of a growing number of astro-resorts. Destinations such as New Mexico's StarHill Inn and New Mexico Skies offer an impressive array of telescopes and cameras that can be rented on a nightly basis, or you can set up your own gear next to your private cabin under pristine desert skies. At Jack and Alice Newton's Observatory B&B (bottom right), visitors are offered sky tours and optional CCD-imaging tutorials as well as firstclass bed-and-breakfast accommodation. Even Kitt Peak Observatory near Tucson is in the business of astro-tourism: Visitors can book guided sessions or reserve a 20-inch RC Optical Systems telescope for a night of personal viewing and imaging.

In the 1980s and 1990s, eclipse chasing grew from the pursuit of a dedicated few to a sizable segment of the ecotourism market. For each total eclipse of the Sun, dozens of tour companies offer to take you into the path of the Moon's shadow. Eclipses are a great way to combine the trip of a lifetime to an exotic locale with the experience of a lifetime: the sight of the Sun

being suddenly extinguished from the daytime sky. In the next few years, eclipse travelers will explore China (2008 and 2009), Easter Island (2010) and the South Pacific (2012, also the year for the transit of Venus in the South Pacific). For the addicted, maps of future eclipse paths serve as lifetime vacation planners.

mA.

Jack and Alice Newton offer luxury accommodation (above) at their Osoyoos, B.C., bed and breakfast, with telescopic tours in the dome as a unique bonus. Eclipse chasers (top) set up on the volcanic landscape of the Chilean altiplano in November 1994.

CHAPTER SIX

Using Your New Telescope

Whether you are unpacking your first purchase or the latest addition to a growing collection, setting up a new telescope is always a thrill. If you have never set up a telescope before, the anticipation of seeing your first celestial object through the sparkling new optics may make you toss the instruction manual aside.

Even if you are patient enough to read manuals, you may find the instructions for your foreign-made telescope more than a little baffling. We've seen many imported telescopes packed with misleading manuals or, worse, no manuals.

First light through a new telescope is an experience charged with anticipation, whether the telescope is a high-end model, as here at a dark-sky

To aid first-time telescope owners, we've assembled this chapter as our own "guide to using your new telescope," with tips drawn from our own experiences and from the many questions we've handled over the years from puzzled owners.

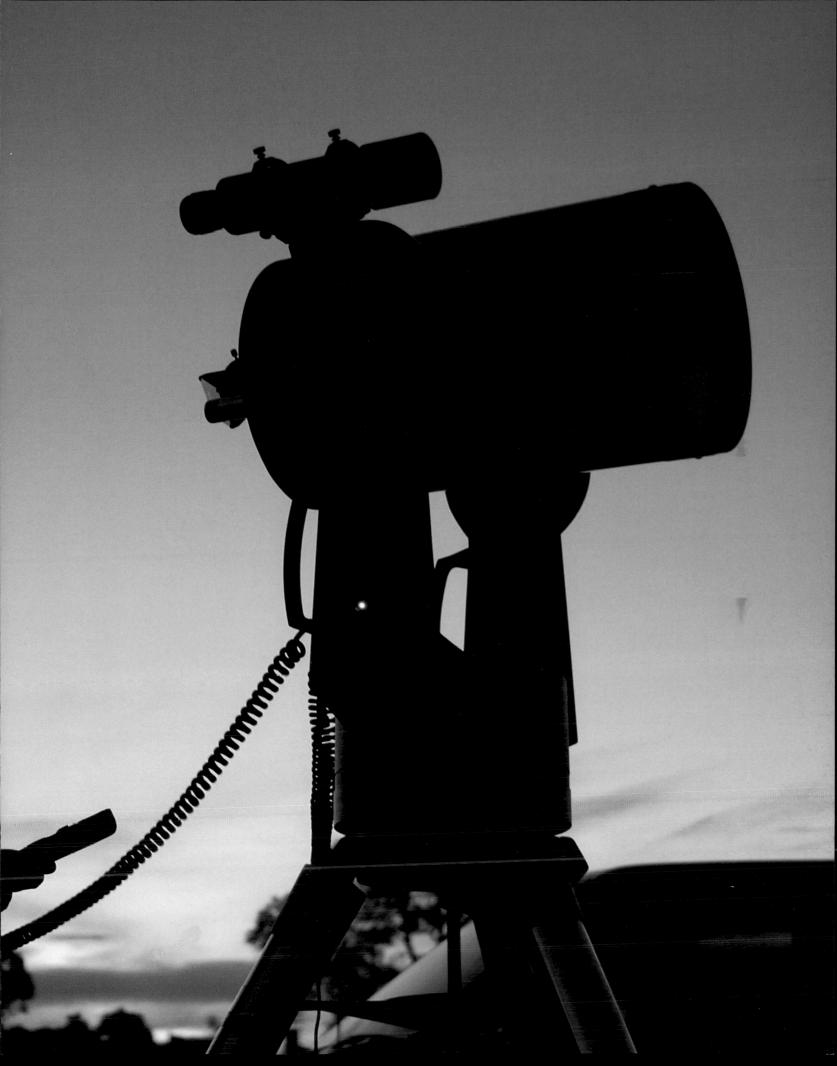

Introducing the Beginner's Telescope

This chapter is a guide to setting up and using your first telescope. As examples of beginners' scopes, we have selected two Chinese-made import telescopes, since these represent the most common entry-level telescopes you are likely to encounter. Telescopes virtually identical to

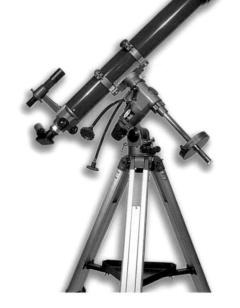

What Is Best to Start? Though a Dobsonianmounted telescope (in use below) remains our first recommendation for a beginner's telescope, models with German equatorial mounts (right) remain popular as starter scopes. This chapter addresses the common questions owners have about setting up and using these models.

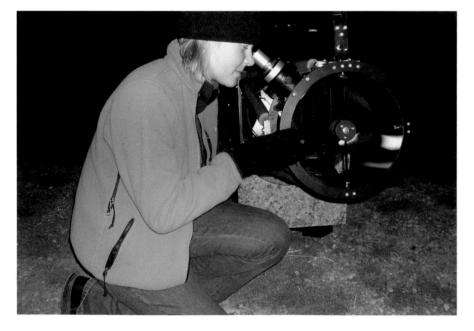

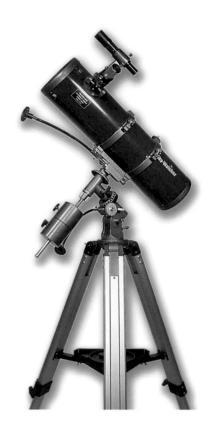

the two shown throughout this chapter are sold worldwide by a variety of dealers under many national and house-brand names.

We're not saying that these specific telescopes are necessarily the ideal beginners' scopes; but the fact is, they are very successful products, and huge numbers of them are in the hands of novice astronomy buffs.

From our experience, these telescopes, although excellent buys, also elicit the most cries for help from new owners. The equatorial mounts and scientific appearance of the models, which tend to attract the novice in the first place, are also at the root of the "What's this for?" questions that these instruments always generate.

Consider this chapter a tutorial for the assembly and use of any beginner's telescope, because many of our tips about finderscopes, eyepieces and successful firstlight views apply to any instrument. (For advice on using today's generation of computerized GoTo telescopes, see our array of tips in Chapter 14 for accurate pointing with these electronic marvels.) Many beginners, though, go with a noncomputerized scope for starters, which is why we concentrate on that type here.

A TOUR OF YOUR TELESCOPE

While some telescopes, such as Meade's ETX or Celestron's NexStar Series, come out of the box as one-piece items, most require some assembly. Tripods must be bolted together, mount heads need adjusting and tightening, and fittings have to be attached to the main optical tube.

Before diving into the assembly tutorial, we will tour our typical telescopes to learn what all the parts are and what they do. We will even point out parts that have no purpose other than to confuse new owners! Although specific models are shown in our illustrations, keep in mind that these same components can be found on any equatorial mount and on most reflector and refractor telescopes.

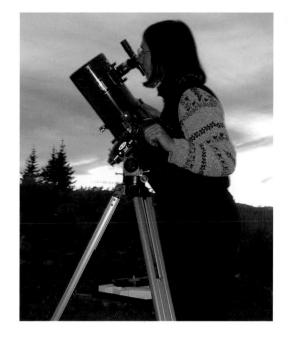

Getting Started

A young astronomer has assembled and aligned her new telescope and is ready to explore the darkening sky at a mountaintop site. Puzzled by how telescopes work, many new owners encounter difficulty getting to this stage.

Decoding Directions

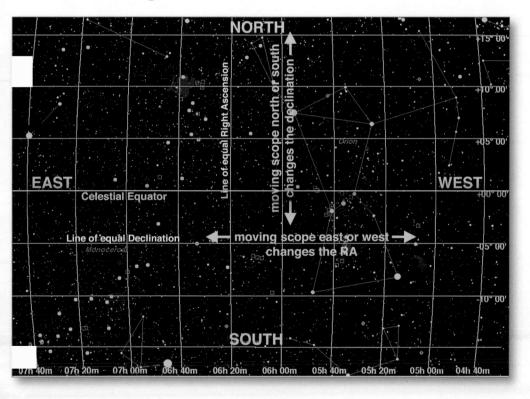

We cover celestial coordinates more thoroughly in Chapter 11, but assembling any equatorial mount introduces the owner to the concepts of right ascension (R.A.) and declination (Dec.). An equatorial mount moves through these two directions.

Declination is like latitude on Earth: Changing the declination moves the telescope north or south in the sky along a line of R.A. Right ascension is like longitude: Changing the right ascension moves the telescope east or west along a line of declination. All equatorial mounts have two axes set at right angles —one for right ascension (eastwest) motion and one for declination (north-south) motion.

The sky is gridded into lines of declination and right ascension. While using celestial coordinates to locate objects is not the method we recommend for finding your way around the sky (see Chapter 11), learning which direction is which helps you understand how your equatorially mounted telescope moves on its two axes. (Map courtesy TheSkyTM/Software Bisque)

THE MOUNT

The standard beginner's telescope is often supplied with a German-style equatorial mount like this, commonly called the EQ-2 model. It's not as complicated as it appears, and there are some knobs and dials you will probably never use. But first, you need to know what the parts are called and what each does.

Setting Circles and Index Pointers

Graduated scales for dialing in the coordinates of celestial targets. You'll rarely use these. The right ascension (R.A.) setting circle (at bottom, marked 0 to 23 hours) can be turned independently of the mount; the declination (Dec.) setting circle (at top, marked 0 to 90 degrees) should be fixed.

Declination Axis Lock

R.A. Setting Circle Lock Screw Tightening this little screw allows the R.A. setting circle to turn with the telescope when the R.A. lock is loose. This is unnecessary—leave this little screw loose.

Motor-Attachment Bolt

(under R.A. setting circle) This is where an optional fixed-speed R.A. motor drive attaches (the lowestcost motor option).

Slow-Motion Control

Latitude Bolt and Scale This is where the angle of tilt of the mount is adjusted for your latitude, a onetime adjustment. Turn this bolt with caution, as the entire mount will flop down once it is loose.

Fine Latitude Adjustment

(partially hidden at back) Turning this moves the mount up and down slowly for fine-tuning the tilt of the mount. This is for ease of polar alignment.

Azimuth Lock

Loosening this allows the entire mount head to swing in azimuth (i.e., parallel to the horizon). This lock and motion are for polar alignment only, not for turning the telescope to find targets.

Equatorial Head

Comes as a single unit out of the box, but its angle of tilt needs to be set to your latitude, a onetime adjustment. Here, the mount is set for 45 degrees latitude.

Slow-Motion Controls (two of them) Once the locks are tightened, the slow-motion controls engage and can be used to fine-tune the pointing and to follow objects.

Right Ascension Axis Lock

Loosen the R.A. and Dec. locks to allow the scope to turn freely to swing to a new target. Tighten them once you are close to a target.

Mystery Wheel and Lever

This is a gear-and-clutch mechanism for older-style AC motors and one type of variable-speed DC motor.

Mystery Screw

Does little. This is removed to attach the variable-speed motor. Can serve as a spare for the little setscrews on some focusers.

Counterweights

The number and size vary with the telescope. These slide up and down the screw-in counterweight shaft to balance the telescope around the R.A. axis.

THE MOUNT

This EQ-3 model is a somewhat beefier German equatorial mount commonly supplied with an 80mm-to-100mm refractor telescope. The advantage with this stronger mount is increased stability, an important factor because refractors require taller tripods. The illustration highlights parts unique to this larger mount.

Motor-Attachment Plate

In optional dual-axis drives, this is where the declination motor (not shown) attaches.

Locks (two of them) Lever-type knobs lock the scope in position in right ascension and declination. On this mount, these can be awkward to find in the dark. The R.A. lock must be engaged for the motor to drive the mount.

This is where the optional variable-speed R.A. motor drive attaches.

Motor-Attachment Bolt

R.A. Setting Circle Lock Screw Leave this loose for the R.A. setting circle to work properly.

Bubble Level (partly hidden on base) To aid in leveling the tripod. You'll likely never use it.

Polar Scope Fitting

This mount's polar axis is hollow and can accept an optional borescope for sighting Polaris for polar alignment. Fine Azimuth Adjustment Two more bolts push the scope from side to side for precise polar alignment. Very nice feature.

Fine Latitude Adjustment Two screws, in a push/pull arrangement, allow for fine aiming of the telescope's polar axis toward the celestial pole.

THE OPTICAL TUBE

Finderscope

Dustcap

Remove the whole cap to use the scope. So what's the off-axis hole for? For viewing the Sun through a smaller aperture, with unsafe and now largely unavailable eyepiece solar filters. This hole has little purpose today.

Finder Adjustment Screws Two bolts at right angles move the finder so that it points at the same place as the main telescope. The third knob contains a springloaded bolt that holds the finder tube in place.

Piggyback Bolt

This 1/4-20 stud bolt and threaded ring allow you to attach a camera (or ball-andsocket tripod head) for piggyback photography. Very handy.

Spider Bolts These three bolts hold the struts (called the spider), which in turn hold the secondary mirror in place. Don't loosen these.

Focuser

whose tension can be adjusted by the two or four screws between the focus knobs. The black screw-on ring at the top is essential (it's the adapter for 1.25-inch eyepieces). If it is missing, eyepieces have no place to sit. This ring is threaded for optional camera adapters.

A rack-and-pinion type

Eyepiece Setscrew One or two screws that hold the eyepiece in place. Don't lose them!

Tube Rings

The Newtonian optical tube is the business section of the beginner's telescope. The finderscope and focuser are the

most frequently adjusted parts of your telescope.

A low-power (usually 6x) scope for sighting and

centering targets. Many now attach to the main

quick removal for packing and transport.

tube with a dovetail bracket (shown here), aiding

Loosen the clamps to slide the tube up and down the rings for balancing in declination. In Newtonians, these also allow you to rotate the tube to place the eyepiece at a convenient angle and height.

THE OPTICAL TUBE

The optical tube of a refractor is basically a simple spyglass with the main lens at the top and an eyepiece at the bottom for magnifying the object being viewed.

Dustcap

Yes, there's that smallaperture hole again (for solar viewing with dangerous filters and for stopped-down dim viewing of night-sky objects). Of little value. Tape the small filler cap in place so that it won't get lost.

Dewcap

A plastic extension tube helps prevent dew from forming on the main lens.

Tightening this prevents the focuser from moving; useful for stopping a heavy camera from sliding out of focus.

Focuser Lock

Setscrews Little screws hold the diagonal and eyepiece in place. These "mission critical" components are easy to lose and almost impossible to replace.

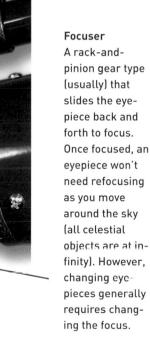

Star Diagonal

A 90-degree prism for preventing neck and back strain. With it, you can comfortably look down into the telescope instead of having to stoop and crane to look straight up through the telescope. Essential for some refractors to reach focus. Adapts from focuser drawtube's diameter to 1.25-inch eyepieces. Removed for some camera adapters. Don't lose this.

Adapter Tube

THE TRIPOD

Many beginners' telescopes are supplied with lightweight but sturdy aluminum tripods. The legs and fittings are usually packed as separate components that must be bolted together.

Accessory Tray

Bolts to the spreader bar and steadies the tripod. When the tray is in place, the legs cannot be folded up, so the tray must be removed for transport to the field (don't lose the bolts!).

Spreader Bar

Comes as a unit but must be bolted to each tripod leg. This important component prevents the legs from flailing out but allows them to collapse inward for transport.

Leg-Height Clamps

Allow the inner leg tubes to slide down to extend the tripod's height. These should be tight to prevent a leg from collapsing.

Foot Bolt

Legs

Each leg must be firmly

the telescope.

bolted to the equatorial head.

head. Loose clamping bolts

cause major wobbles in

Some tripods come with a short extension knob that screws onto this bolt. Even without it, though, this vestigial bolt can be used for its intended purpose, as a point to place your foot to press the tripod leg firmly into the ground.

EYEPIECES

10mm eyepiece

At least one eyepiece, if not two or three, is supplied with most telescopes. You change power by changing eyepieces. The lowest-power eyepiece is the one marked with the largest number (often 25mm).

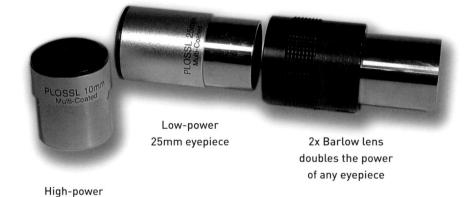

Barlow Lens

Inserted between the eyepiece and the telescope, a Barlow lens doubles or triples the power of any eyepiece. The premiumgrade Celestron Ultima Barlow is one of our favorites. The lowcost Barlows included with many beginners' telescopes are often of just acceptable if not downright poor quality.

HOW A TELESCOPE MOVES

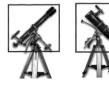

swings around two axes. One of these, the polar axis, must be set to aim toward the sky's celestial pole (near the North Star for observers north of the equator).

To move across the sky, an equatorial mount

Declination Axis The telescope moves north-south around the axis shown. You move the scope around this axis to find a new object in the sky.

Right Ascension, or Polar, Axis 🕨

The telescope moves east-west around the axis shown. To follow an object across the sky as Earth spins, the scope turns around this axis. Because the axis must be aimed toward the celestial pole to polaralign the mount, it is commonly called the polar axis.

How NOT to Set Up a Telescope

What's wrong with this picture? Lots! Yet this is how reflector telescopes are often depicted in discount-store catalog ads (we have the ads on file to prove it!) and set up in chain stores by staff who know little about telescopes.

1. The eyepiece is at the bottom of the telescope, where all eyepieces should be, right? Not on a Newtonian reflector. This scope has its tube pointed at the ground.

2. The finderscope is mounted backwards, here pointed at the sky, to be sure, but 180 degrees away from where the main optics are aimed, rendering it useless as a finder. Worse, we've seen the Barlow lens installed here as if it were the finder.

3. The equatorial mount is polar-aligned for a location near the North or South Pole, near 90 degrees latitude, an unlikely home for most buyers. It will be impossible to find and track objects.

4. The counterweight shaft and its weights are missing, making for an unbalanced and unstable telescope.

5. The 2x Barlow and 4mm eyepiece are in place, in the misguided belief that more power is better.

Some Assembly Required

The majority of entry-level telescopes require a similar assembly procedure for turning the box of assorted parts into a working telescope. Be sure to do this first-time assembly indoors, in the light, warmth and comfort of your home.

TELESCOPE ASSEMBLY, A 10-STEP PROGRAM

Here's the basic procedure for putting together the typical import reflector or refractor on an equatorial mount. The steps apply to most small telescopes and involve attaching the legs to the equatorial mount first, then assembling the rest of the tripod. Only after you have a secure and solid tripod (Steps 1 through 3) should you attach components such as the counterweights and tube to the mount. Fail to follow that order, and your telescope could collapse.

STEP 1

Bolt Legs to Mount Head

Notice there's a hinge halfway down each leg. The hinge goes on the inside and is for holding the spreader bar.

Variation: On some mounts, the legs attach to a separate top plate. The main mount head then attaches to this plate with one large bolt. This arrangement makes the scope easier to disassemble for transport.

STEP 3

Attach Accessory Tray Use the small wing-nut bolts to attach the tray to the spreader bar. This helps stabilize the scope.

STEP 2

Attach Spreader Bar

Stand the tripod and mount on a nonslip floor, and attach each arm of the spreader bar to a tripod leg by pressing the bolt through the leg's hinge and the spreader bar's arm. A Phillips head screwdriver (likely not supplied) is required for the final tightening. On some scopes, the legs come with the spreader bar already attached.

STEP 4

Attach the Counterweight Shaft

This screws into the head (leave the weight off for now). The shaft acts as a good handle for the next step, which is likely necessary, since most mounts come packed in the wrong orientation.

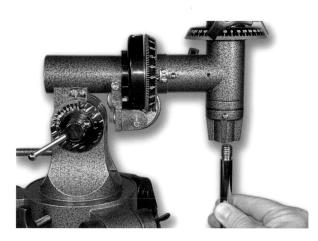

mount. This will help hold it in place.

STEP 5

Adjust Mount Angle

Set pointer to your latitude

> Loosen latitude bolt carefully

Latitude fine-adjust screw

STEP 6

Attach Slow-Motion Cables Use a small flat-bladed screwdriver (or the little tool supplied) to attach each cable to its shaft on the mount. The setscrew in each cable's sleeve mates with the flat side of the D-shaped shaft. The long cable goes on the declination axis.

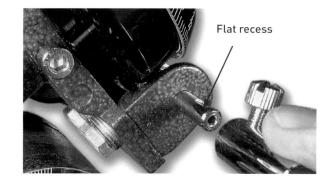

Loosen the large latitude bolt (carefully!) while holding the mount head. Tilt the mount to your latitude (use the scale on the side of the mount as a guide). Just get it close at this point. Then lock that large bolt down good and tight. You won't need to adjust it again. Turn the latitude fine-adjust screw in until it pushes against the

Refractor

For a refractor, turn the head so that the declination slowmotion control extends to the bottom, to place it near the eyepiece.

Reflector

For a reflector, turn the head so that the declination slow-motion cable is at the top—closest to the eyepiece.

111

STEP 7

Bolt Tube Rings to the Head

Use the supplied bolts and lock washers to fasten each ring to the head. The ring with the piggyback camera bolt can go at the top of the mount. Do this without the telescope tube—just fasten the rings on first.

STEP 8

Slide on the Counterweight

Undo the screw at the bottom of the shaft so that the counterweight can slide onto the shaft. Put the weight about halfway up the shaft for now. Be sure to replace the screw at the bottom of the shaft—it prevents the weight from accidentally sliding off the shaft and onto your foot!

Install this

STEP 9

Place the Tube in the Cradle Remember, if it's a reflector, the eyepiece goes at the top!

STEP 10

Install the Finderscope

First, insert the finderscope into the bracket. Many finders come with a small rubber O-ring (you may find it strung around the bracket). The O-ring goes into the recessed notch on the finder tube and acts as a spacer to hold it steady. To insert the finder, you may have to pull back the spring-loaded silver bolt (if your finder has that style of bracket). The bracket then clamps into the dovetail channel on the telescope tube.

Pull back spring-loaded bolt

Variation: Some brackets must be bolted directly to the tube.

MOTOR-DRIVEN

The most common option for this EQ-2 mount is the single-speed DC motor for the right ascension axis. It attaches to a bolt hole on the side of the polar axis and slides onto the shaft normally occupied by the R.A. slow-motion control. Attaching the motor forfeits the east-west slow-motion control and any ability to fine-tune the position of the scope manually in the east-west, or R.A., direction. But once on a target, the scope continues to track it automatically, a great convenience.

Direction Switch Flicking the N-S switch to S makes the motor turn the opposite way for use in the southern hemisphere. If you live north of the equator, set it to N. If objects drift out of the field even faster with the motor turned on, chances are that it's on S.

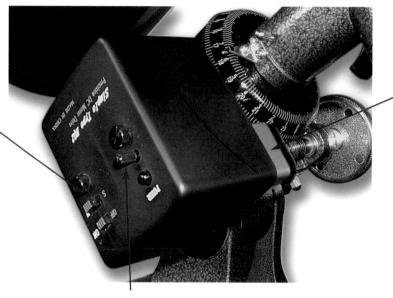

Battery

All drives today operate with batteries rather than AC power. This one uses a 9-volt transistor-radio battery that lasts, at best, for only a few nights of use. A rechargeable battery is a good choice here.

MD-5

Speed Controls

Turning this knob speeds up or slows down the motor. Getting it to turn at the right speed to track stars is trial and error on this model. Turn it to the highest setting as a start.

Another Option

A better, though more expensive, choice for the EQ-2-class mount—and the only choice for better-grade mounts, like this EQ-3 model is a variable-speed motor drive. This unit has push-button controls for 2x and 8x speeds for fine centering of objects and for guiding longexposure astrophotos taken with a camera piggybacked onto the telescope tube. Variable-speed motors also run off separate battery packs with multiple C or D cells for much longer battery life. Better dual-axis units can also control motors on both axes.

Daytime Adjustments

Setting up at night is *not* the next step to using your new telescope. Take your scope out first during the day for some simple but crucial adjustments. This daytime checkout is a highly recommended procedure that many owners of new telescopes bypass, anxious to experience the thrill of first light with their telescope under a starry sky. However, essential adjustments, such as lining up the finderscope and getting the telescope focused for the first time, are much easier to do during the day than at night. You can find suitable targets more easily, and you'll know what they are supposed to look like once you get them in view.

Attempting to make these initial adjustments at night "cold turkey," on targets you can't find (because the finder isn't lined up yet) or can't focus on (because the focuser is way off position), is inviting frustration and disappointment.

UP TIGHT

First, ensure that all the tripod bolts are firmly cinched down. A loose tripod makes for a wobbly telescope and a jittery image. Then play with moving the telescope around. Learn where the locks are. Unlock the axes to swing the telescope close to a target. Once there, lock the axes and use the slow-motion controls to center a target. As you do, you'll notice a couple of things:

The telescope tube will collide with the slow-motion cables or with the tripod itself when aimed in certain directions (mostly straight up). There is a trick to avoid this to some extent. Read on!

BALANCING ACT

Unlock the telescope, move it to point at a new area of the sky, then let it go. If the scope swings away on its own, it is out of balance. An unbalanced telescope tends to point wherever it wants to and makes it hard to find the targets you'd like to observe. Motor drives might not work well either, as they labor to turn the telescope. To fix this:

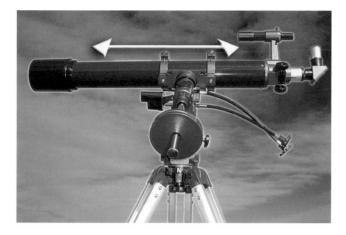

Adjust Balance in Declination

With the declination lock loose and the tube horizontal, loosen the cradle rings and slide the tube along the cradle until it is balanced in the north-south, or declination, direction. In most cases, the telescope balances with the cradle in the middle of the tube. Large refractors are top-heavy, however, and balance with the main lens nearer the cradle.

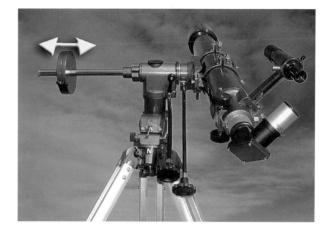

Adjust Balance in Right Ascension

With the R.A. lock loose and the counterweight shaft horizontal, slide the counterweight(s) along the shaft. The scope is balanced when, with the lock loose, it stays put when you let it go, no matter where it is pointed in the sky. When balancing any scope, be sure the finderscope and the eyepiece are in place and the lens cap is not.

BECOME FOCUSED

It is much easier to focus a new telescope first during the day on a familiar landscape object, rather than at night on an unfamiliar stellar target. To do this:

1. Insert the low-power eyepiece. With most entry-level telescopes, that's the one marked 25mm or 20mm, not the ones marked 12mm, 9mm or 6mm. If you have a refractor, insert the star diagonal first, then slide the eyepiece into it. Don't use any Barlow lens that might have been supplied.

- 2. Swing the telescope to a distant target on the horizon (sight along the tube to get it close). It should be several hundred meters away, not just across the street.
- 3. Rack the focuser back and forth until the image sharpens to a crisp focus. With a daytime object, it should be obvious when you are getting closer to focus.

4. Leave the focuser as is. You are now close to being perfectly focused for night-time objects in the sky.

GETTING LINED UP

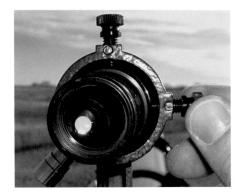

Use the adjustment bolts (often just two on many models now, but three or six on some finderscopes) to tilt the finder's tube until your target object is centered at the intersection of the finder's crosshairs.

Once the low-power finder is collimated in this fashion, any object placed on the crosshairs is automatically centered in the main high-power telescope. You may need to recollimate the finder from time to time. The little low-power finderscope on the side of the tube is an essential aid to trouble-free telescope enjoyment. To be of value, the finderscope must be lined up so that it points to the same place as the main telescope. This is easiest to do during the day on a distant landscape target. To do this:

With the low-power eyepiece in place in the main telescope, find a recognizable object on the horizon (a power pole or an antenna, perhaps).

Now look through the small finderscope, and locate the same object; it will likely be off-center.

View through the finderscope

View through the telescope

SHARPENING THE FINDER

If the view through the finderscope is fuzzy, you'll need to focus the optics of the finder. Most units allow this, though it is not always obvious how. Some finder eyepieces turn. As they twist, they slide in and out to focus. For other less obvious units:

1. The finder view is focused by moving the main lens, not the eyepiece, up and down the finderscope's tube. This lens (usually a 25mm- or 30mm-diameter objective) is contained in a metal or plastic cell screwed onto the tube. It is not glued and is designed to turn. To adjust the focus, first grip this black lens cell.

2. Turn the lens cell counterclockwise to unscrew it. A short retaining ring behind the lens cell will also loosen at this point. You may need to turn this ring to back it away from the main cell. This will expose enough of the threads to give you room to move the main lens. The threads are fine, because adjusting for most users' eyesight requires only a minor focus change.

3. Turning the lens cell moves the main lens up and down the tube, changing the focus. Don't worry if it comes off the tube; the optics shouldn't fall out

4. When images of distant objects look sharp, turn the retaining ring so that it locks back up against the lens cell. The finder is now focused for your eyes and shouldn't need to be adjusted again. Choose whether you want the finder to be focused for viewing with your glasses on or off—either way is fine.

Nighttime Use

Many entry-level telescopes are compact and light enough that they can be left assembled and carried outside as a unit for impromptu viewing sessions. That is the best arrangement. But usually, removing the tube from the mount is required each night.

When reassembling your telescope, you

may need to balance it for proper operation of the mount.

Once outside, all equatorial mounts must be aligned to the celestial pole, a procedure with an undeserved reputation for being complex and intimidating. Yet it can be accomplished in seconds.

Even when the mount is aligned, aiming at some areas of the sky may be awkward. This is one quirk of a German equatorial mount that is easy to work around.

TELESCOPE BREAKDOWN

If you do need to break down your scope after each night's use, keep the procedure as simple as possible.

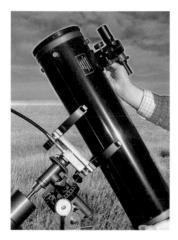

1. Remove the tube. Unless your telescope tube and rings attach to the mount via a quick-release dovetail mechanism, the easiest "no-tool" method of removing the tube is to open the cradle rings and simply lift out the tube. When replacing it, be sure the tube is balanced in declination and not sitting too far up or down the cradle rings.

2. Remove the counterweights from the shaft. This makes the mount lighter and less cumbersome.

3. If you need to break the scope down further, remove the tripod's accessory tray so that the tripod legs will fold in. Remove the tripod legs themselves only If you need to pack the scope into a small space for transport

4. If you are packing the telescope in a car, remove the finderscope, slow-motion controls and eyepiece. Protruding as they are, they can get damaged or lost. Keep the counterweight well packed 50 that it can't bang against the tube.

ON THE LEVEL

Precise leveling of any telescope mount simply isn't necessary. However, if you have the angle of the equatorial head set for your latitude, then leveling the scope ensures that the polar axis of the mount is, indeed, pointed close to the celestial pole.

1. Use the height adjustment on the tripod legs to level the mount. Eyeballing it should be sufficient.

2. If the scope is out of level, just turn the fine latitude adjustment screws to shift the mount's angle up or down to aim at the celestial pole.

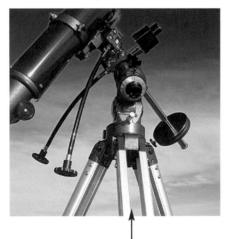

Adjust south leg

3. As an alternative to adjusting the head, simply raise or lower a north- or south-facing tripod leg (loosen the wing nut as shown to adjust the leg) to accomplish the same thing, effectively leveling the scope and aiming the polar axis at the celestial pole.

TIME TO ALIGN

To track objects properly (or at all!), any equatorial mount must be aligned so that its polar axis points at the celestial pole. The sky rotates around this point, and the mount must too. If you ignore polar alignment, you may as well have bought a cheaper altazimuth mount! For users in the northern hemisphere, the task requires but a few simple steps.

Latitude scale

Bubble level

1. Adjust the polar axis so that its angle of tilt equals your latitude. You can look that number up in most atlases and do this during the day.

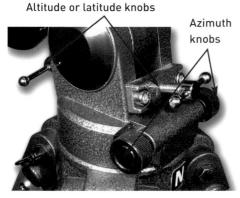

2. Place the telescope outside at night so that the polar axis aims due north toward Polaris (that's true north, not magnetic north). Some mounts indicate which side should face north with a large N on the base. Knowing which way is north at your site and how to locate Polaris are essential to finding anything in the sky. See Chapter 11 for tips.

3. Use the fine azimuth or altitude adjustments to tweak the aim of the mount, if needed (this is easier than trying to shift the whole tripod to aim the mount due north).

Variation:

Sighting Polaris through an optional polar scope inserted into the polar axis allows for more precise alignment. But for casual observing, roughly aiming the polar axis due north will suffice; objects will stay in the eyepiece for several minutes at a time.

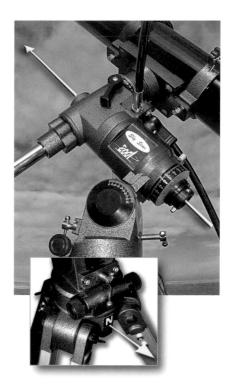

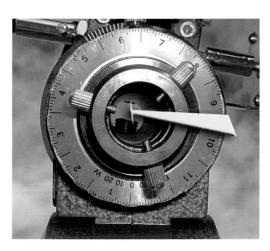

4. If your mount has a hollow polar axis (the EQ-3, Celestron CG-5 and Orion AstroView types, for example), you can sight Polaris through the axis to achieve a more precise centering.

On subsequent nights, all you'll likely need to do is simply place the scope at your favorite backyard spot so that the polar axis aims due north. For more advanced alignment methods for astrophotography and settingcircle use, see Chapter 15.

AIMING FOR THE SKY

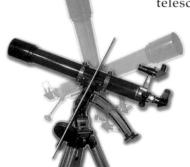

4. If you have a motor on the R.A. axis, you may find the slow-motion control in that axis no longer works (many entrylevel scopes have no clutch mechanism to allow the axis to be turned by hand when a motor is attached). If that's the case, leave the R.A. axis just barely unlocked, with a slight tension on it, and nudge the scope by hand until the object is centered. Then lock up the axis, and the motor should engage and start driving.

Now you are ready to move the telescope around the sky in search of celestial targets. Once you are lined up on the celestial pole, you do not use the azimuth or altitude adjustments again—they are not for finding objects. Instead, move the telescope around the right ascension and declination axes. Here's the process:

1. To swing the tube around to where you want to look in the sky, first loosen the R.A. and Dec. locks. Once near a target (as sighted through the finderscope), lock the axes, then use the slow-motion controls to zero in on the spot.

2. Move the telescope around the Dec. axis as shown at left to move it north or south in the sky. Move the telescope in this direction only when you want to change targets.

3. Move the telescope around the R.A. axis as shown at right to move it east or west in the sky. The telescope moves from east to west to follow objects across the sky during the night. A motor can attach to this axis for automatic tracking.

5. As a final step, if the motor has 8x speed controls, you can fine-tune an object's position by speeding up, stopping or reversing the motor, which makes a variable-speed drive a good choice.

YOU CAN'T GET THERE FROM HERE

Swinging a German equatorial mount around the sky is where most people get tangled up. There are some places in the sky where such a mount simply won't point easily. For example:

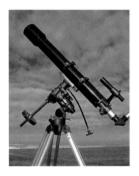

 Here's a German equatorial mount aimed due north at Polaris. No problem.

2. Here's the same mount with the scope aimed high in the southeast, where you'll usually be looking (at the Moon and planets, for example). Also fine.

3. But here's the mount with the scope aimed high overhead. Oops! The tube hits the tripod. This is inevitable with most telescopes on this type of mount and tripod.

4. This EQ-2 mount has an even worse problem. The motor drive is badly positioned, making it impossible to aim the telescope high into the west or northwestern sky (the tube collides with the motor casing). With the better EQ-3 mount, the drive moves with the mount and does not get in the way, no matter where the scope is aimed.

DOING THE EQUATORIAL TANGO

All German equatorial mounts, even the best, share a limitation: They cannot track an object all the way across the sky in one uninterrupted arc. Here's the situation:

1. The telescope is aimed east and is following an object as it rises into the sky to a position due south. No problem. 2. If the telescope stays with the object as it moves into the west, the tube or slow-motion cables will eventually collide with the mount or tripod. What to do?

3. The solution is to "flip" the tube to the other side of the mount, a little pas de deux all owners of German equatorial mounts must learn to perform.

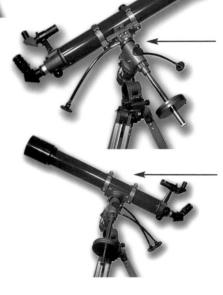

4. Now the scope is aimed at the same area of the sky, but the tube is on the other side of the mount and can follow the object into the west. In general, when looking west, the eyepiece should be on the east side of the mount.

5. Conversely, when looking at the eastern sky, the eyepiece should be on the west side of the mount. Learning how and when to tango with your telescope will give you unimpeded observing of most of the sky.

A CHANGE OF LATITUDE

The only time you will need to alter the mount's home position for the polar-axis angle is when you travel far north or south in latitude.

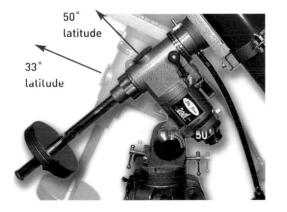

Traveling east or west but staying at the same latitude makes no difference to how you set up your telescope.

In Vancouver, British Columbia, you would set the mount's latitude angle to +50 degrees, but travel south to Phoenix, Arizona, and the angle would have to be adjusted to +33 degrees.

Travel to Sydney, Australia, and the angle (+34 degrees) would be nearly the same as at Phoenix, but the telescope would have to be placed so that its polar axis points due south, at the south celestial pole. The motor drive would need to be switched to the S position so that the scope turns around the polar axis in the other direction.

First Light

Even after assembling their telescopes and checking them out during the day, new scope owners often have disappointing first-light experiences at night. By heeding a few do's and don'ts, you should enjoy wonderful views your first night out.

DON'TS

DON'T look over a heat source A cooled-down scope will be handicapped if it must peer through warm air rising from a nearby chimney, a heat vent or even a warm car hood. Black asphalt that was searingly hot during the day will also release its warmth at night.

DON'T insert the Barlow lens

The 2x and 3x Barlow lenses often supplied as standard equipment can be just as debilitating to telescopic views. Good-quality Barlows can be a useful accessory; poor-grade Barlows become doorstops.

DON'T use your highest-power eyepiece Higher power isn't better. The 4mm and 6mm eyepieces supplied with many entry-level telescopes yield blurry views, not to mention fields of view so narrow that even finding the Moon becomes a challenge.

DON'T look through a window

Window glass distorts views through telescopes, usually by producing double images. Opening the window doesn't help, because the warm air rushing out of the window blurs the image even more. Telescopes must be placed outside. If the night is particularly cold (freezing or below), allow 15 to 45 minutes for the telescope to cool down, as warm air inside the tube can also blur images.

DON'T take apart lenses

If you disassemble your eyepieces or main refractor lens, chances are that you'll never get the optics back together properly.

DO'S

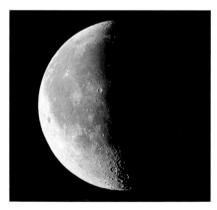

D0 make the Moon your first target The Moon presents such a wealth of detail in any telescope, it's hard not to be impressed.

D0 use your lowest-power eyepiece The 25mm or 20mm eyepiece will produce the brightest, sharpest image for your first views.

DO use the star diagonal on refractors Many refractors will not focus without the star diagonal in place.

Star diagonal

Why Is the View Upside Down?

Astronomical telescopes, and even their small finderscopes, almost never present right-side-up views. The extra optics needed to flip the image the right way around would just add to the cost and detract from the image by dimming the light and distorting high-power views.

The upside-down views may seem confusing at first, but the only celestial object where the image is obviously flipped compared with the naked-eye view is the Moon. With the stars and planets, an erect image in the telescope has little value, since these objects look like points to the naked eye anyway. Far better to have the sharpest, brightest image at the eyepiece. You'll soon learn to maneuver your telescope so that the image moves the way you want it to without having to give a second thought to which way is up.

Where the inverted image can be confusing at first is in the finderscope. Straight-through finders are easiest to orient; simply turn a star chart upside down to match the view. However, finders with right-angle eyepieces present mirror-image views of the sky. Matching these to a chart requires flipping the chart over and shining a flashlight through the paper or viewing the chart in a mirror. One solution is to print out custom finder charts using computer programs that can flip the sky horizontally. Avoid this nuisance by purchasing a new finderscope with an erecting prism, preferably a straight-through variety for ease of aiming.

Erect-Image View as in...

- Binoculars
- Terrestrial spotting scopes
- Finderscopes with an Amici or erecting prism

Inverted View as in...

Newtonian reflectors

(or any telescope with an even number of reflections (i.e., two mirrors)

• Straight-through finderscopes with no erecting lens

Mirror-Image View as in...

- Refractors and catadioptric telescopes with a star diagonal
- (or any telescope with an odd number of reflections)
- Finderscopes with a 90-degree right-angle star diagonal

To orient yourself at the eyepiece, remember:

1. With no motor tracking, objects drift across the field from east to west. An object "preceding" another lies to the west and enters or leaves the eyepiece first. An object "following" another lies to the east and follows its companion across the field.

2. Bump the scope toward Polaris, and new sky will appear at the north edge of the field of view.

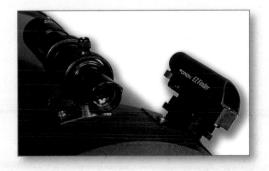

To find objects, we prefer to use a straight-through finder, as shown above right, augmented with a window-style finder that projects a red dot or bull's-eye onto a naked-eye view of the sky. The red-dot finder helps you to aim the telescope to the right area of the sky, while a good 6x30 or 7x50 finder allows you to see many targets.

Top 10 Newbie Questions

Many of the usual questions that first-time telescope owners ask (How much does it magnify? Can I see the rings of Saturn? and others) are covered throughout this book. But here are some quick answers to a few common questions from those new to the hobby of backyard astronomy.

1. How far can I see?

Even with the unaided eye, you can see the Andromeda Galaxy, some 2.5 million light-years away. A telescope can reveal fainter galaxies hundreds of millions of light-years away, so distant, in fact, that their light has been traveling to us since long before the Age of Dinosaurs.

2. Can I see the flags left on the Moon?

So near and yet so far. Flags, footprints and landing craft on the Moon are simply too small to resolve in any earthbound telescope.

3. Is something wrong? Stars look just like points...

When a telescope is in focus, all the stars should look like points. Beyond the Sun, no star is close enough to show itself as a disk. If stars look like large shimmering disks or donuts (as at right), the telescope is out of focus.

4. ... and planets look like tiny dots.

Don't expect the planets to look like the poster-class pictures taken by space probes. Even at 200x, planet disks remain small, but the detail is there. The trick is learning to see that detail, a skill that takes time to acquire but comes with practice.

5. In a reflector, doesn't the secondary mirror block some of the light?

Yes, but not enough to dim the image noticeably (the area of the secondary mirror is often no more than 10 percent of the area of the primary). When the image is in focus, the secondary mirror's presence is invisible. Only when you throw a star out of focus do you see the secondary mirror's silhouette as a hole in the center of the donutlike image.

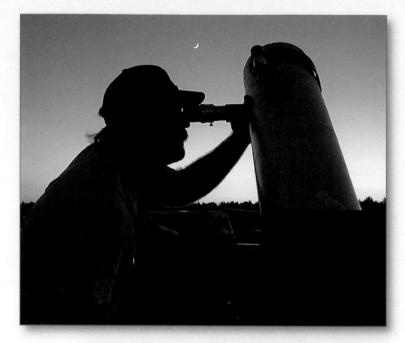

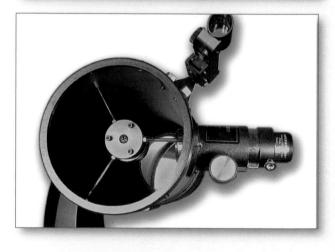

Almost all reflector telescopes employ a secondary mirror to deflect the light to the side or down to the bottom of the tube. The secondary mirror's presence becomes obvious as a shadow only when the image is thrown far out of focus, as shown in center image above in a series of images of a defocused star distorted by rippling waves of atmospheric turbulence.

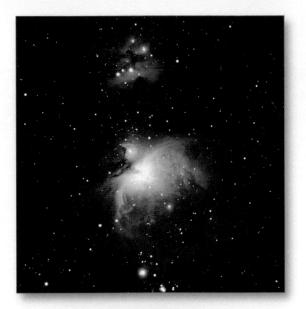

6. How do I find objects?

For owners of noncomputerized telescopes, the best method is to star-hop. Using a star map or a guidebook to point the way, first locate a bright naked-eye star near your target, then hop through recognizable star patterns. Place the spot where your target lies at the crosshairs of your finderscope. The object should now be in the field of your low-power eyepiece. See Chapter 11 for more details and recommendations for charts and star-hopping guidebooks.

7. Why do objects move so fast across the eyepiece?

This always surprises first-time telescope owners. Telescopes magnify not only the size of an object but also the effect of the sky's east-to-west motion. At low power, objects drift from the center to the edge of the field in two to three minutes. At high power, objects must be recentered every 20 to 30 seconds. That's why slow-motion controls, smooth Dobsonian mounts or motor-driven mounts are so important to the enjoyment of using a telescope.

8. Why can't I see colors in nebulas?

Although we cover this elsewhere, the point bears repeating here: Even through large telescopes, nebulas and galaxies are too faint to excite the color receptors in the eye. They appear as monochrome patches of light, as in Adolf Schaller's drawing of the Orion Nebula at left. Only long-exposure photographs can pick up the colors emitted by glowing nebulas.

9. Is the view better outside the city?

For faint objects such as nebulas and galaxies, yes. The darker the sky, the better. But the Moon and planets, being bright, can look just as sharp and clear in a light-polluted city sky as they do from the country. The main tip is to avoid looking over heat sources that can produce image-blurring turbulence. See Chapter 8 for advice on picking a site.

10. Where can I learn more?

Your local astronomy club, science center or planetarium likely conducts regular stargazing sessions at an observatory, a park or a nature area. These are good opportunities to look through a variety of telescopes and learn what you should see at the eyepiece. At large regional star parties, a smorgasbord of equipment (as at left) provides even experienced amateur astronomers the opportunity to compare various models of telescopes.

To make the most of your telescope when viewing deep-sky objects, like the Orion Nebula (top), travel far from city lights, perhaps to view with a group at a star party (above). While the vivid colors may not be visible, bright deep-sky objects can still reveal a breathtaking amount of detail in dark skies. Nothing beats the live view through a telescope (center).

PART 2: OBSERVING THE CELESTIAL PANORAMA

C H A P T E R S E V E N

The Naked-Eye Sky

The most lasting benefit of recreational astronomy is not the lessons in astrophysics you learn, as valuable as they may be, but the lifelong awareness you gain of the sky's wonders. Whenever you step outside, you automatically look up. Backyard astronomers soon learn to look for, and see, amazing sights that almost everyone else misses.

The play of light and shadow in the day sky along with nighttime glows, both subtle and dramatic, provide a never-ending sky show unfolding overhead. Enjoying the show doesn't require elaborate telescopes or superdark skies. Remarkably, many of the sky's finest offerings can be seen from the city with no more than unaided eyes—guided by the knowledge of what to look for under just the right atmospheric conditions.

There is no more spectacular sight in nature than a total eclipse of the Sun. It can be enjoyed with a telescope, binoculars or, as some aboard the MS *Paul Gauguin* did in 2005 at this eclipse in the South Pacific, just with unaided eyes. Photo by Alan Dyer.

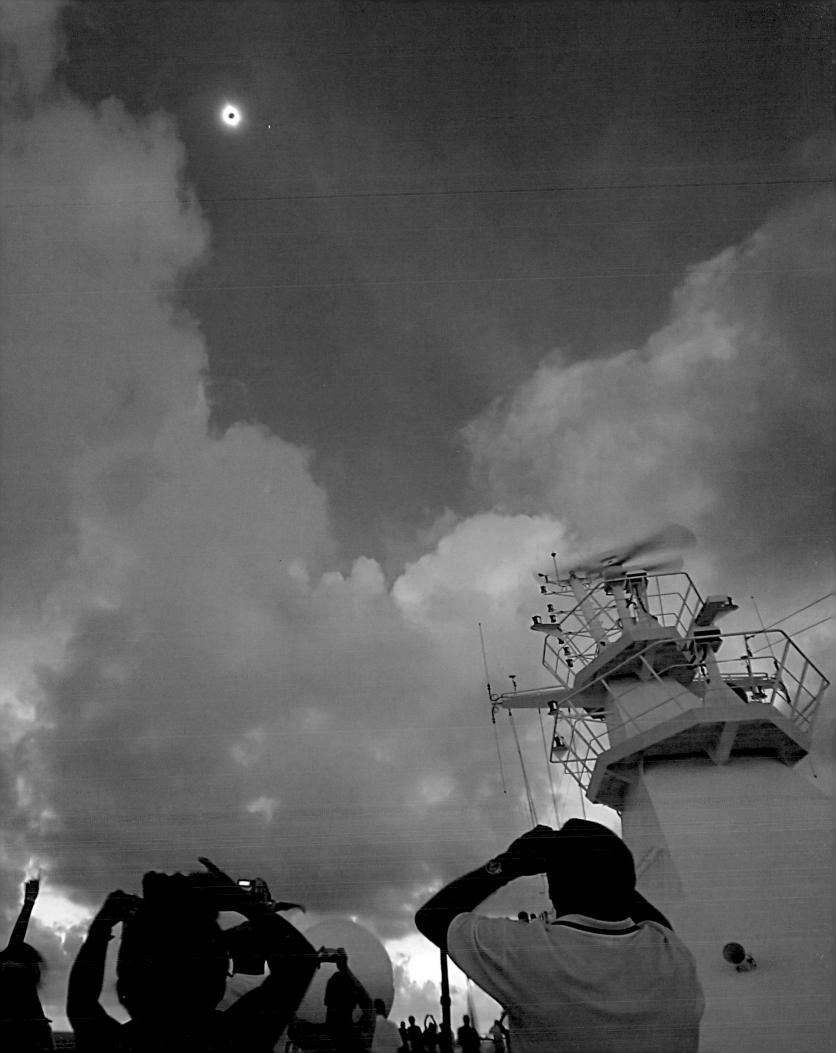

Phenomena of the Day Sky

We typically think of astronomy as a nocturnal pursuit. But a roster of unusual effects of light and shadow plays across the daytime sky. Almost all are strictly naked-eye phenomena. The most familiar is the one we take for granted: the color of the daytime sky.

THE BLUE SKY

The sky is blue—not green, yellow or pink —because blue and purple light have the shortest wavelengths of all the colors of the visible spectrum. Short-wavelength light is most easily scattered by the air molecules of our atmosphere. Think of a crowd of bantamweight wrestlers trying to force their way through a line of heavyweight sumo champions. The hapless bantamweights get scattered at random in a wild melee. So it is with blue light waves, in a process called Rayleigh scattering.

How blue the sky appears depends on how clean and dry the air is and on how much air lies above you. Water vapor whitens a sky by scattering all wavelengths equally. Dust and pollution also turn a day sky pale blue, if not brown or gray. Lower-altitude sites are

Reaching for the Sky 🕨 The Earth's atmosphere is an ocean of life-sustaining air that cloaks our planet. As serene as the atmosphere appears on a clear day, astronomers know that the more air they look through, the more layers of natural turbulence they encounter. That means researchers favor high-altitude sites, such as this 14,000-foot summit in Hawaii. Recreational astronomers need not go to such extremes.

likely to have more contaminants in the air than will mountaintop sites, especially if those summits are in dry desert locations.

On a cloudless early morning or late afternoon, look around the canopy of blue. Where is the sky bluest? You might think it would be the point overhead, where light passes through the least amount of water vapor and contaminants. But look carefully, and you'll see that the bluest sky lies along a band 90 degrees away from the Sun. Scattered light from the sky is naturally polarized (the light waves all vibrate in the same direction), and the degree of polarization is greatest at right angles to the Sun. Even without the aid of a polarizing filter on your camera, this natural polarization darkens the sky, creating a band of deeper blue arcing across a clear day sky.

While it may not be obvious, the sky is also blue on moonlit nights. Moonlight is just reflected sunlight with the same range of colors, simply much fainter and below the eye's threshold of color sensitivity. Take a long exposure, and you'll record a sky painted with scattered blue sunlight that has reflected off the Moon first.

RAINBOWS

If a rainstorm has just passed by and sunlight is breaking through, look around for a rainbow. A sunbeam shining through a raindrop will, after one reflection within the drop, head back in roughly the same direction as it entered. In the process, the beam of light is split into its component colors by the prismlike qualities of the raindrop. Multiply this effect by millions of raindrops, and the result is a curving swath of color arching around the point in the sky directly opposite the Sun. To be precise, rainbows always lie at a radius of 42 degrees from the antisolar point. To find the antisolar point, stand with your back to the Sun and imagine a line extended from the Sun through your head toward the ground in front of you.

From ground level, the antisolar point always lies below the horizon. So we never see a rainbow as a complete circle. Instead, we see the top arc of the full circle. The closer the Sun is to the horizon, the more of the rainbow we see. However, from an aircraft or a mountain peak, it is possible to see a rainbow as a full circle. On the other hand, if the Sun is high overhead, you can never see a rainbow. For a rainbow to be visible against the sky, the Sun cannot be more than 42 degrees above the horizon. For that reason, rainbows are a late-afternoon or an early-morning phenomenon.

Double rainbows occur when the sunlight is particularly strong and the sky saturated with raindrops. A second rainbow appears as a result of light bouncing through two reflections inside the raindrops. The fainter second bow shows up outside the primary bow at a radius of 51 degrees from the antisolar point, with its colors in reverse order—red on the inside of the arc rather than the outside, where it appears in the main rainbow.

Other rainbow-related effects to watch for are the brightening of the sky inside the main bow and the darkening of the sky between the primary and secondary rainbows, an effect called Alexander's dark band, named for the Greek scientist who first described it in 200 A.D. Also watch for the appearance of supernumerary arcs—purple and green bands on the inside edge of the main bow. Created by interference effects among the various beams of light exiting

the raindrops at slightly different angles, supernumerary arcs appear only when the main rainbow is especially intense.

A rare type of rainbow can be created by the full Moon at night. Moonbows are faint and colorless to the naked eye. A longexposure photograph, however, reveals all the colors of a moonbow as if it were a daytime rainbow.

Another unusual but more obvious form of rainbow is the fogbow. When the air is filled with fine droplets of mist or fog, look for a white bow smaller than a conventional rainbow opposite a brilliant light source, perhaps the Sun breaking through the mist or, at night, a bright artificial light. After the Storm

Sunlight breaks through as a storm recedes, producing the ideal conditions for a classic double rainbow. Note how the sky within the bow appears brighter. Photos by Alan Dyer.

Moonbow

An aurora, lightning and a moonbow (at lower right), created by light from the full Moon, present a naked-eye feast.

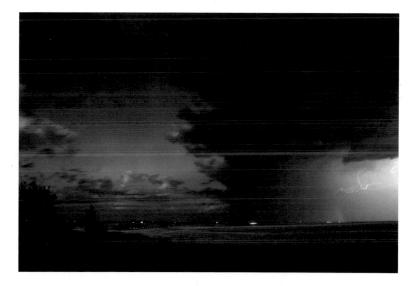

Circles in the Sky Compare the similar appearance of solar halos (two photos directly below) with a lunar halo (right). The refraction of ice crystals in cirrus clouds causes both. Photos by Alan Dyer.

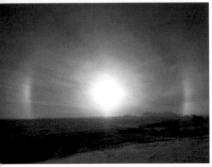

Pillar of Light 🕨

Ice crystals floating in still air can reflect light from sources on the ground or near the horizon. The result is pillars of light above streetlights or, in this case, above the setting Sun, called a solar pillar. Photo by Terence Dickinson.

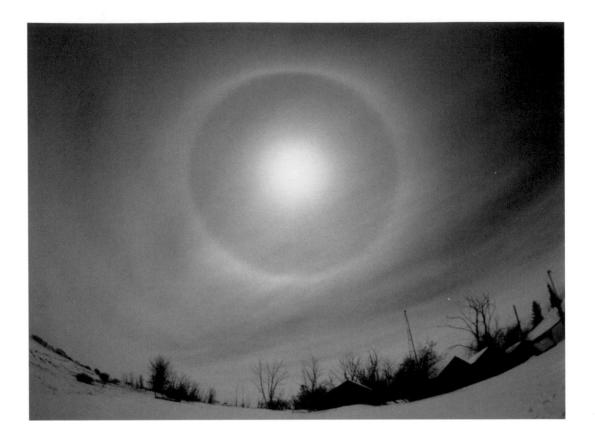

HALOS AND SUNDOGS

Planetariums and observatories often receive calls from people reporting unusual rings of light around the Sun or the Moon. Solar and lunar halos are more common than rainbows but are not nearly as well known. They are caused by light refracting through hexagonal ice crystals. Unlike rainbows, most halo phenomena are centered around, not opposite, the Sun or Moon. Halos are usually a cold-weather phenomenon but can occur anytime the sky is covered with high-altitude cirrus clouds or icy haze.

The most common halo is a ring of light 22 degrees from the Sun or Moon. A much larger and fainter circle can sometimes be seen 46 degrees from the Sun.

Sundogs (officially called parhelia) appear as bright spots, sometimes colored, on either side of the Sun. (At night, look for rare moondogs.) When the Sun is low, as it is in winter, sundogs lie 22 degrees from the Sun and show up as intense areas on the inner halo. When the Sun is higher in the sky, sundogs appear just outside the inner halo.

The next most common halo phenomenon is the circumzenithal arc, a rainbowlike arc high in the sky curving away from the Sun. It is part of a circle centered on the zenith. It often appears tangent to the large 46-degree halo.

When the Sun is high in the sky, a horizontal arc can sometimes be seen passing through the Sun, running parallel to the horizon around the sky. Bright spots can appear on this horizontal arc at 90 degrees or 120 degrees to the Sun or even directly opposite the Sun. Other arcs can sometimes be seen tangent to the sides, bottoms or tops of the inner or outer halos.

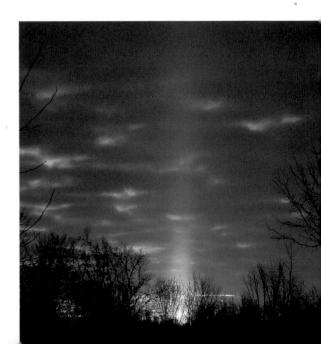

It all depends on the way the light refracts through the combinations of facets on the six-sided ice crystals. If you see any sort of halo, be sure to scan the sky—there may be other rare and subtle effects of refraction shimmering nearby.

Light can also reflect off flat ice crystals, creating a pillar of light that rises up from the low Sun. On cold, calm nights, light pillars can form above bright streetlights, producing the effect of a sky filled with searchlights.

GLORIES AND CORONAS

Glories and coronas are colored rings that form when light is diffracted by water droplets, ice crystals or even pollen grains in the air.

The corona is a small, circular glow surrounding the Sun or Moon, usually with a diameter of no more than 10 degrees. It is often plain white but, at times, can appear as a series of colored rings—diffraction rings—much like those found around star images in a telescope. In order for a corona to form, the Sun or Moon must be embedded in a light haze. When distinct clouds are nearby, they may be fringed with iridescent colors (these are part of the corona). Dark sunglasses are essential for picking out coronas and iridescent clouds in the bright sky around the glaring Sun.

A similar effect, the glory, occurs around the point opposite the Sun. Your best chance of seeing a glory is from an aircraft. Sit on the side of the plane away from the Sun. As you break through the nearby clouds, look for the plane's shadow on the clouds below. The shadow may be surrounded by colored rings. A form of glory known by its German name *heiligenschein* can sometimes be seen as a soft glow of light around the shadow of your own head when it is projected onto a dewy lawn or low lying fog in the morning.

DAYTIME SIGHTINGS

A popular misconception is that the Moon "only comes out at night." But on a late afternoon around first-quarter phase, look 90 degrees away from the Sun to the east, and there you'll see the rising Moon, plain as day in the blue sky. At last-quarter Moon in the early morning, look 90 degrees from the Sun to the west for the setting Moon. Both quarter moons make fine daytime telescope targets. Use a red filter or, better yet, a polarizing filter to darken the sky and increase contrast.

When Venus is near one of its greatest clongations, roughly 45 degrees east or west of the Sun, the brilliant planet becomes another daytime target. The challenge is finding it. Two high-tech methods involve the use of either a computerized telescope to point the way or a conventional telescope's setting circles to offset from the Sun by the correct number of degrees (a planetarium computer program can provide that angle).

A low-tech method is to wait for a day when the crescent Moon is nearby. Find the Moon first, and let it lead you to Venus. Binoculars may be necessary to glimpse Venus initially, but once you have located it, look with your unaided eyes. The trick is getting your eyes to focus on the pointlike Venus surrounded by nothing but blank blue sky. Once your eyes"auto-focus" to infinity, Venus suddenly becomes obvious.

Far more challenging is Jupiter. When it is near the point in the sky 90 degrees away from the Sun (at quadrature), the giant planet lies in the sky's natural polarization band, where the daytime sky is darkest. The air must be clean and clear, but it is possible to sight Jupiter under these conditions with binoculars and, with perseverance, no more than your unaided eyes.

If you have a computerized telescope that can be left outside aligned from the previous night, try waking it in the daytime

▼ Surprise Moon

The Moon can be seen in the daytime sky 10 or more days a month, yet many urban residents who tune out their natural surroundings have never seen a daytime Moon and are amazed that such a sighting is possible. Photo by Alan Dyer

This pale, circular rainbow, known as the glory, is caused by the diffraction and reflection of sunlight by water droplets in the clouds. The geometry of

this phenomenon ravors sightings from airplanes.

Photo by Alan Dyer.

View From a Height

Ó

Green Flash 🕨

The rarely seen lunar red flash (above) has origins similar to the more famous solar green flash (right) rimming the top limb of the Sun's disk when it is on the horizon. Photos by Leo Henzl.

Squashed Sun 🔻

Atmospheric refraction can generate a layer-cake effect when the Sun is within a degree of the horizon. Photo by Alan Dyer. Phenomena of the Sunset Sky

stars of the Summer Triangle.

You have driven to a hilltop site, anxious for a night under the stars. The Sun is going down, and you are busy setting up your telescope gear. But wait. Take a moment to watch the sunset. Close inspection will reveal some beautiful effects beyond the familiar red undersides of clouds that everyone notices.

and slewing to some bright stars. Focus the

telescope first on something far away on

land. Then, if it's late summer, punch in

Sirius. Zip! There it is in your eyepiece, a sparkling gem set in the blue sky of day. The

stars you see in the daytime in summer are the same stars you see at night in winter.

Similarly, in January, your computerized

scope can direct you to daytime views of the

GREEN FLASH

As the Sun sets, its disk can dim and redden enough that it can be observed safely with binoculars or a telescope—usually. Exercise extreme caution. If you must squint when looking at the Sun, then it is too bright.

On most occasions as the Sun sinks below the horizon, its disk becomes red and flattened, often with a boiling upper edge.

Watch this edge—you will likely see it rimmed with blue or green. In the last moments before the Sun disappears, a vivid green blob of light sometimes appears at the top of the disk and breaks off. It lasts only a second or two. This is the green flash.

The flash is caused by a prismlike dispersion of colors created by our atmosphere. The bottom of the setting Sun's disk becomes red, while the top becomes blue. Well, not quite. The short-wavelength blue light that would normally rim the top of the Sun becomes so scattered, it disappears, leaving the top edge of the Sun rimmed with green. If the atmosphere is layered into regions of varying temperatures, as in a mirage, the normally thin green rim can stretch and detach into a short-lived green blob at the top of the Sun's disk. Under such conditions, a separate patch of red light can appear at

the bottom of the Sun, creating an extremely rare red flash. The same effects can be seen at sunrise but are easy to miss, as the rapidly rising Sun takes observers by surprise.

To see the green flash, you need a clear view of the true flat horizon, over either land or water. Lucky observers have even witnessed rare green and red flashes on the rising and setting Moon and on Venus.

CREPUSCULAR RAYS

When the Sun shines from behind clouds or distant hills, another effect can appear: crepuscular rays. The rays are usually seen as shafts of sunlight beaming down through holes in a cloud deck. Crepuscular rays are especially evident with the setting or rising Sun. The rays then appear as shafts of sunlight and shadow spreading out from the sunset or sunrise point and arcing across the sky. They sometimes converge opposite the Sun, where they are called anticrepuscular rays. The diverging and converging effect is due to perspective, as the rays and shadows are actually parallel beams.

TWILIGHT AND THE EARTH'S SHADOW

Once the Sun has set, watch the changing colors of the sky. If the atmosphere is clean and clear, you will see the western sky painted the entire spectrum, from reds and yellows near the horizon through green-blues a few degrees up to deep blue-purples at 20 degrees altitude or more. Under crystal-clear

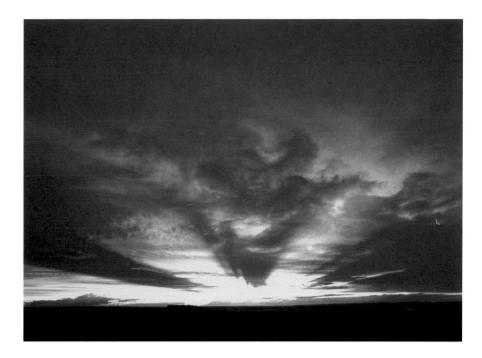

skies, this twilight purple can linger for 30 minutes or more in the west. If the atmosphere is filled with high-altitude smoke from forest fires or aerosols from distant volcanic eruptions, the postsunset sky will look redder than usual.Volcanic sunsets can appear around the world for months following a major eruption.

Now turn and face east. Look for a dark blue arc rising along the horizon. This is the Earth's shadow cast onto our atmosphere and into space, the same shadow that intersects the Moon's orbit and creates a lunar eclipse. In a clear sky, look for the so-called belt of Venus, a pinkish glow rimming that shadow, caused by the last red rays of the Sun lighting up the high atmosphere to the east. As the Sun sets farther below the horizon, the Earth's shadow climbs higher in the east. It is easiest to see when the Sun is about five degrees below the horizon. As the sky darkens, the boundary of the Earth's shadow becomes invisible, but it is still there, evidenced by its effect on orbiting satellites, which will be discussed later.

HARVEST MOON

On full-Moon nights, you'll see the Moon rising embedded in the blue shadow of Earth. Because it lies opposite the Sun, the full Moon comes up as the Sun goes down, rising at a point on the horizon directly opposite the Sun. Like the low Sun, the ▲ Shafts of Sunlight Crepuscular rays are often created by cloud and mountain shadows.

Earth's Shadow

At twilight time, look opposite the sunset or sunrise point for a dark blue band along the horizon. That's the shadow of the Earth projected onto the upper atmosphere. The pink region above it, called the "belt of Venus," is where sunlight is still illuminating the upper atmosphere. Here, a full Moon setting in penumbral eclipse adds to the scene of our planet's shadow on our atmosphere and on the Moon. Both photos by Alan Dyer.

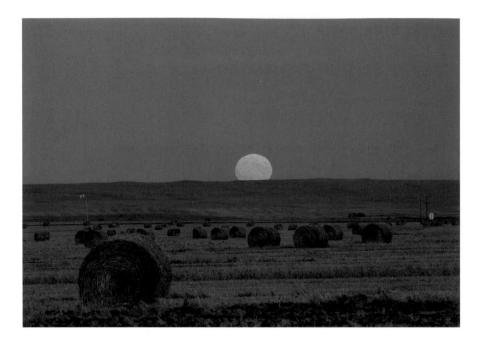

Shine On 🔺

The Harvest Moon lingers in the east for several consecutive evenings in September. Photos by Alan Dyer. rising Moon looks flattened by atmospheric refraction and reddened by atmospheric absorption of the shorter blue wavelengths. The orange tint of the Moon contrasts with the deep blue shadow and the pastel pink belt of Venus above to create one of the sky's most colorful scenes.

The best time to see this panorama is at Harvest Moon—the full Moon closest to the autumnal equinox. In autumn, the Moon rises only 20 minutes or so later each night (compared with as much as an hour later at other times of the year). For two or three nights in a row, we see a golden Moon rising nearly due east in the early evening, a combination of factors that makes the Harvest Moon an obvious sight to even the most casual skywatcher. Smoke or dust in the atmosphere at harvesttime also contributes to the Moon's golden hue and dramatic appearance.

Adding to the scene is the Moon's apparently large size when it is near the horizon. And the Moon isn't the only object to provide this illusion. A constellation rising in the east also looks much larger than it does several hours later, when at its highest altitude. It's as if we perceive the sky above us not as a semicircular dome but as a flattened arc—close to us overhead but far away at the horizon.

Why Does the Moon Look So Big?

One of the greatest puzzles of astronomy isn't the origin and fate of the universe or the existence of alien life—it's "Why does the Moon look so big on the horizon?" It is an optical illusion, something you can prove by taking photos of the Moon when it is both low and high in the sky. The Moon's disk is the same size (about 0.5 degree) no matter where it is in the sky. Yet most people will report that a rising full Moon looks about 1.5 to 2 times larger than a normal high Moon.

The Moon is no closer to us when it is rising or setting than when it is high up. So what causes the effect?

Every few years, a new theory is offered, each claiming to be the final word. While no one theory has ever been fully accepted, one explanation suggests that it is a form of the Ponzo Illusion (Google that!), where objects thought to be farther away are perceived to be larger. For example, in the drawing, the pillar to the right looks larger because the perspective lines make it seem more distant. Yet all the pillars are the same size. Clouds near the horizon really are farther away than when they are overhead, so perhaps that is why we tend to think of the Moon on the horizon as being farther away and therefore larger. Horizon objects add other distance cues.

The illusion can be made to go away by crossing your eyes or by looking at the Moon with your head upside down. Stand with your back to the rising Moon, then bend down and put your head between your legs. Silly, but it works!

The Moon's extraordinary size when seen near the horizon is one of the most powerful visual effects in nature. Yet it is pure illusion. Hold an aspirin tablet at arm's length when the full Moon is near the horizon and again when it is well up. When you compare sizes, you'll see that there is no size difference at all between a low Moon and a high Moon.

134

Phenomena of the Darkening Sky

Cinematographers refer to the brief time of twilight as the magic hour. So it is for astronomers. While you are waiting for dark to settle, look for unique phenomena that appear only in the deepening blue of a twilight sky.

EARTHSHINE AND THIN MOONS

You have seen the effect many times but may not know what it is. A crescent Moon hangs in the west. Only a thin sliver of the disk is illuminated by the Sun, yet you can see the entire disk of the Moon. The "dark side" of the Moon appears faintly visible, an effect colloquially known as the old Moon in the new Moon's arms.

The dark portion of the lunar disk is experiencing nighttime on the Moon. But in the lunar night sky hangs a large and brilliant Earth displaying a nearly full phase. Sunlight reflecting off the oceans, clouds and polar icecaps of Earth lights up the nightside of the Moon with a blue-white light. Some of this Earthshine is reflected back to Earth, enabling us to see the dark side of the Moon.

Don't confuse the "dark side" of the Moon with the far side of the Moon—there is a side of the Moon we never see from Earth, but the lunar far side experiences the same cycle of day and night as does the side that perpetually faces Earth. The only places on the Moon "where the Sun never shines" are a few deep craters at the lunar north and south poles.

Spring is the best season for seeing Earthshine. In springtime, the waxing crescent Moon stands at its highest above the horizon, putting it into clearer air and allowing it to hang in the sky well after the sky is fully dark.

Spring is also the best season for seeing the youngest Moon possible. A young Moon appears low in the sky as an ultrathin crescent embedded in the bright twilight, making it a challenge to see. According to the U.S. Naval Observatory, the record for a nakedeye sighting is of a Moon only 15.5 hours old (after the official moment of new Moon). For a telescopic sighting, the record is a 12.1-hour-old Moon. Most of us would consider any sighting of a Moon less than 24 hours old an accomplishment to add to our "life list" of astronomical phenomena. Use binoculars to find the Moon, then try it with your unaided eyes.

SIGHTING MERCURY

Another twilight challenge is locating the innermost planet, Mercury. It has the reputation of being difficult to sight, but once you see Mercury under good conditions, you'll be amazed how easy it is. The key factor is "good conditions."

Mercury never appears more than 28 degrees from the Sun, and then only for a little more than a week at a time. It darts back and forth from the evening to the morning sky, putting in six or seven appearances at dusk and dawn each year. Some apparitions of Mercury are better than others. It appears highest in the evening sky in spring and highest in the morning sky in autumn. Even at such favorable apparitions, however, Mercury shines just 10 to 15 degrees above the horizon, making cloudless skies a must.

Binoculars are also essential, allowing the planet to be spotted in a darkening sky not long after sunset and a good 15 to 20 minutes before it becomes visible to the unaided eye.

▲ Dark Side of the Moon? The subtle illumination of the nightside of the Moon is impressive and often puzzling when observed for the first time. Known as Earthshine, the ghostly light is sunlight reflected off Earth and toward the Moon. Binoculars show it well. Photo by Alan Dyer.

Sighting Mercury

Mercury is always a challenge to find, but when it is near the Moon or Venus, becomes easier to spot. Here, Mercury shines below Venus in the evening twilight. Although fainter than Venus, Mercury is surprisingly bright. Photo by Alan Dyer.

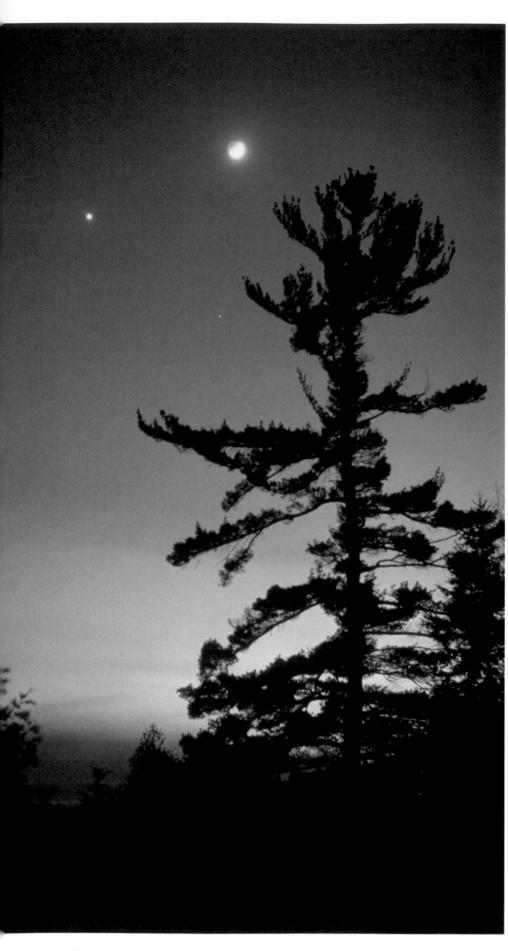

There is usually little confusion—Mercury outshines all but the brightest stars found near the ecliptic, such as Aldebaran, Betelgeuse, Procyon, Regulus, Spica and Antares, and can be a full magnitude brighter. Once you see Mercury, you'll wonder how you missed it before.

MOON-PLANET CONJUNCTIONS

As the planets wander among the stars in our night sky, they occasionally appear to meet up with one another, at least from our point of view as observers standing on

	(
	1		
DA	TE		

DATE	
December 1	2008
December 31	2008
February 27	2009
October 13	2009
April 15	2010
August 5	2010
March 15	2011
May 11	2011
March 13	2012
July 15	2012
November 27	2012
May 26	2013
August 18	2014
February 22	2015
June 30	2015
October 25	2015
December 7	2015
January 29	2016
August 27	2016
October 28	2016
October 5	2017
Јапиату б	2018
July 15	2018
November 24	2019
March 18	2020
December 21	2020

another planet, the Earth. These close approaches are called conjunctions. In common usage, as in the table below, the term conjunction refers to any close gathering of planets or of planets and the Moon. (Technically, two planets are not in conjunction unless they share the same right ascension.)

The naked-eye outer planets—Mars, Jupiter and Saturn—can meet in conjunction high in a dark sky. Meetings between slow-moving Jupiter and Saturn are very rare, occurring only once every 20 years. The next one is not until 2020. Although Mars can pair up with Jupiter or Saturn in a dark sky, the best Mars-Jupiter and MarsSaturn conjunctions between now and 2020 are morning or evening twilight events.

So it is with any conjunction involving Venus or Mercury. They can join any of the three naked-eye outer planets, but twilight conjunctions of Venus and Jupiter, the two brightest planets, are the most spectacular. Tightly spaced three-planet gatherings are noteworthy enough to make the nightly news reports. Just as popular are events when four or even all five of the naked-eye planets are clustered in the same region of the morning or evening sky.

Although not a conjunction, the planets under these circumstances create a line of

Interview One-Night Stand

This distinctive triangle of the Moon, Venus and Saturn (faintest) lasted only one evening, because the Moon moves about 12 degrees eastward every 24 hours. Photo by Terence Dickinson.

The Best Planetary Conjunctions 2008 – 2020

A selected list of the most noteworthy planetary and lunar conjunctions of the early 21st century

PLANETS INVOLVED

Crescent Moon, Venus and Jupiter form 3°-wide triangle in evening sky Mercury and Jupiter 1.2° apart low in evening sky, with Venus and Moon pairing above Crescent Moon and Venus 2° apart in evening sky Venus and Saturn 0.5° apart in dawn sky with Mercury just below Crescent Moon 1° from Mercury, with Venus 6° above pair in evening sky Venus, Mars and Saturn form 5°-wide triangle low in evening sky Mercury and Jupiter 2° apart in evening sky Mercury, Venus and Jupiter form a 2°-long vertical line low in dawn sky with Mars nearby Venus and Jupiter 3° apart in evening sky (Moon joins them on March 25) Crescent Moon between Venus and Jupiter in dawn sky Venus and Saturn less than 1° apart in dawn sky Venus and Jupiter 1° apart in evening sky with Mercury nearby Venus and Jupiter a mere 0.25° apart and 1° from Beehive star cluster low in dawn sky Venus and Mars 0.5° apart in evening sky (Moon near the pair on February 20) Venus and Jupiter 0.5° apart in evening sky Venus and Jupiter 1° apart in dawn sky; they form a triangle with Mars on October 28 Crescent Moon and Venus 2° apart in dawn sky Venus and Saturn 0.5° apart in dawn sky Venus and Jupiter just 0.2° apart low in evening sky, with Mercury 5° below Crescent Moon and Jupiter 1° apart in dawn sky Venus and Mars just 0.2° apart in dawn sky (Moon joins them on October 17) Mars and Jupiter just 0.3° apart in dawn sky Crescent Moon and Venus 1° apart in evening sky Venus and Jupiter 1.5° apart in evening sky Clustering of Mars, Jupiter, Saturn and waning crescent Moon within 8° field Jupiter and Saturn an amazing 6 arc minutes apart in evening sky

нÅ

Readily visible conjunctions of the night sky's two brightest objects, the Moon and Venus, can be real head turners if they are less than two degrees apart. They occur infrequently enough to prompt an extra effort to see. Photos by Terence Dickinson.

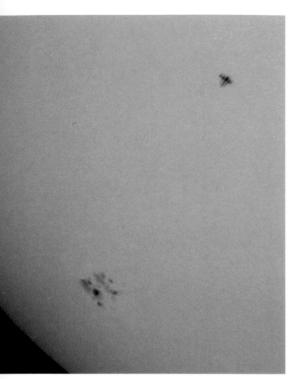

The ISS in Transit 🔺

Shane Finnegan captured this remarkable image of the ISS and shuttle (upper right) flying in front of the Sun near a large sunspot.

Celestial Streaker

Above right: The ISS with shuttle mission STS118 docked to it cruises over the Saskatchewan Summer Star Party in 2007. Photo by Alan Dyer.

Shuttle Reentry 🔻

On September 26, 1996, the space shuttle STS79 reenters the atmosphere over southern Alberta. Photo by Alan Dyer.

worlds strung along the ecliptic in the twilight. Add the Moon to the lineup, and you have a memorable night, indeed.

A close conjunction of Venus and the crescent Moon, with both set in the deep blue of twilight, is another top-ranked event in the list of naked-eye spectacles. During each nine-month-long morning or evening apparition of Venus, the Moon passes it once a month. One or two of these conjunctions will be a close and special event worth seeing and photographing.

SATELLITES AND SPACE STATIONS

In the 50 years following the launch of Sputnik 1 in 1957, humans have sent about 5,000 payloads into space, with a launch rate that puts 100 more objects into orbit each year. That translates into an orbiting population of not just thousands of satellites but also spent boosters and other space debris. By the turn of the 21st century, the number of orbiting objects larger than the size of a grapefruit was 8,700, though only a few hundred were working satellites. Spend any time looking through a telescope, and you will see some of these objects zipping across the field of view.

Satellites look like stars, even when mag-

nified through a telescope. The exception is the football-field-sized International Space Station (ISS). It exhibits a definite size and shape in a telescope. It moves so fast, it can be tough to follow but is worth the attempt.

But you don't need a telescope to see satellites. The brightest are easily visible to the naked eye. However, you won't see satellites at any time of the night. They are best observed during the 90 minutes after sunset or before sunrise. The Sun is then below the horizon for earthbound observers but is still shining at the satellite's altitude. That's how, and only how, we see satellites—they reflect sunlight.

Satellites in low Earth orbit (160 to 1,600 kilometers up) can appear as bright as firstor second-magnitude stars. The space shuttle can become as bright as magnitude –1 or 2. The brightest object in Earth orbit is the ISS, which, in the later stages of its construction, is peaking at a magnitude of –3 to –4, between Jupiter and Venus in brilliance but with a yellow tint from its huge goldcolored solar panels. With an orbital inclination of 51.6 degrees and an altitude of 400 kilometers, the ISS can be seen from anywhere on Earth between 60 degrees north and 60 degrees south latitude.

How quickly a satellite crosses the sky depends on its altitude: The higher the

altitude, the slower it moves. Satellites in low Earth orbit take 90 to 200 minutes to complete one orbit around the planet. Such a satellite can take two to five minutes to traverse your local sky. Most objects travel from west to east (never east to west), but polarorbiting objects, such as Earth-observing and spy satellites, glide across the heavens from north to south or south to north.

Satellites provide some unusual visual phenomena. In the evening sky, objects brighten as they head east and become more fully illuminated, just like a full Moon opposite the Sun. Sometimes, they flash briefly as sunlight flares off a reflective surface. Tumbling objects often pulse in brightness. Now and then, two or more objects can be seen traveling together-the shuttle arriving at or departing from the ISS provides the best opportunity to sight double satellites. If you see a triangle of satellites flying in formation, don't panic. It isn't an alien invasion. You're witnessing a pass of one of the U.S. Navy's Naval Ocean Surveillance System (NOSS) triplets. Orbiting 1,000 kilometers above Earth, the NOSS satellites travel in threes to triangulate the positions of ships at sea.

In the evening, a satellite might fade out halfway down the eastern sky. This occurs as the object enters the Earth's shadow. It has orbited into our planet's nightside and has just experienced a sunset. As the night goes on, our shadow rises higher to engulf the entire sky, so no satellite can be in sunlight. Only people who live at northern latitudes (above 45°N) can see satellites crisscrossing the sky all night long, and then just in summer, when the Sun can light high-altitude objects even at local midnight.

NOCTILUCENT CLOUDS

As the name suggests, noctilucent clouds are seen at night. They look like silvery blue cirrus clouds across the northern horizon, glowing with an opalescent quality unlike any other clouds. Though they have been seen from as far south as Colorado, sightings of noctilucent clouds are usually confined to latitudes between 45 and 60 degrees north. The strange apparitions appear only around

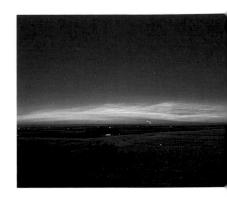

▲ Clouds of Summer Noctilucent clouds shimmer on the northern horizon at summer solstice in Alberta, one of the best places in the world to see this high-latitude phenomenon. Photos by Alan Dyer.

Iridium Flares

The most famous flashers in the night are the Iridium satellites. A fleet of more than 60 of these communications satellites was launched in the late 1990s to provide global satellite cellphone service. The costly service never caught on, and the private Iridium consortium went bankrupt. The satellites were to have been de-orbited and intentionally burned up in the atmosphere but were saved at the eleventh hour by the U.S. Department of Defense.

Orbiting 780 kilometers up, the Iridium satellites have highly reflective antennas, each the size of a door. The antennas act as flat mirrors, creating brief but intense flashes of sunlight. In a few seconds, an Iridium can rise from its normal magnitude of +6 (barely visible to the naked eye) to as high as magnitude –8, which is 25 times brighter than Venus. A brilliant "star" literally appears out of nowhere, then, after a few seconds of prominence, quickly disappears. Iridium flares are visible almost every night but are highly localized. A friend in the next county won't see the same flare you see. For predictions, see www.heavens-above.com.

rsth.

A time exposure records the brief reflective flare-up and fading of an Iridium satellite as a streak in the sky. At least one Iridium flare of modest brilliance is likely visible every night; really bright ones occur only every few days or weeks.

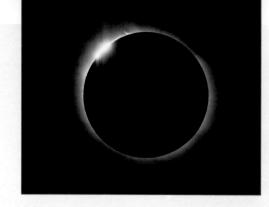

Eclipses and Transits

When worlds align, we are treated to rare and spectacular sights. The Moon passing through the Earth's shadow produces a lunar eclipse. The Moon passing in front of the Sun creates a solar eclipse. Mercury and Venus can also cross the face of the Sun in rare transits. The next transit of Venus is June 6, 2012, the last until 2117. The next transit of Mercury is May 9, 2016.

TOTAL SOLAR ECLIPSES 2008-2020

2009 July 22 China, South Pacific	
2009 July 22 China, South Fachic	
2010 July 11 South Pacific, including Easter Island	
2012 November 13 Australia, South Pacific	
2015 March 20 Arctic Ocean north of Scandinavia	
2016 March 9 Indonesia, North Pacific	
2017 August 21 North America (another occurs in 2024)	
2019 July 2 South Pacific	
2020 December 14 South Pacific, South America, South Atlant	C

TOTAL LUNAR ECLIPSES 2008-2020

2010	December 21	North America
2011	June 15	Africa, Asia
2011	December 10	western North America, Australia, Asia
2014	April 15	North and South America
2014	October 8	western North America, Pacific Rim
2015	April 4	western North America, Pacific Rim
2015	September 27	Africa, Europe, North and South America
2018	January 31	Australia, Asia
2018	July 27	Africa, Asia
2019	January 21	North and South America

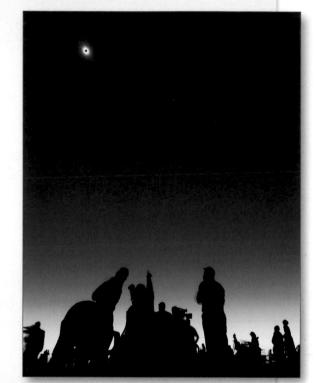

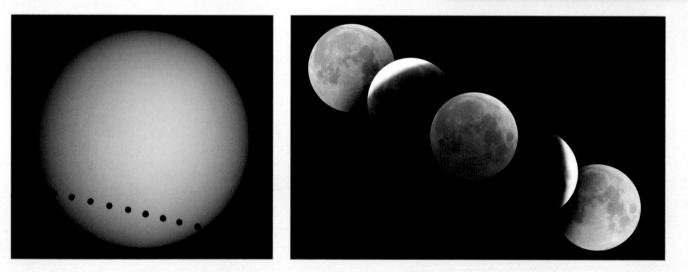

Coauthor Dyer captured close-up (top left) and wide-angle (top right) views of the March 29, 2006, total solar eclipse from the deserts of Libya. He traveled to Luxor, Egypt, to witness the rare transit of Venus on June 8, 2004 (captured in a composite time exposure at above left). But for the October 27, 2004, total lunar eclipse (above right), he stayed in his backyard.

summer solstice, when from northern latitudes, the Sun is just 6 to 16 degrees below the horizon, even at midnight.

Noctilucent clouds occur at an altitude of 80 kilometers, five times higher than 99 percent of our planet's weather systems. This amazing height puts them well above the stratosphere, at the very fringes of the Earth's atmosphere, where the clouds remain sunlit all through a summer night.

These are not normal clouds. They may be made of ice crystals precipitated around dust from incoming meteors or man-made pollutants wafted into the mesosphere and trapped in cold polar regions. If you are at a high northern latitude near the end of June or early July, be sure to look north between midnight and 3 a.m. for the eerie forms of noctilucent clouds.

Although these clouds appear in the middle of the night, we still think of them as a twilight phenomenon, because in early summer at high latitudes, twilight never ends. A glow can be seen along the northern horizon all night long. And it is within this perpetual twilight of a short summer night that noctilucent clouds are seen.

Phenomena of the Dark Sky

Once the sky is completely dark, a new set of glows and lights in the heavens is on display for the watchful observer.

METEORS

About 1,000 tons of dust and rock enter the Earth's atmosphere every day. A particle the size of a sand grain produces a typical meteor (called a falling, or shooting, star by nonastronomers) as it penetrates the atmosphere and incinerates. A brilliant, shadowcasting meteor slashing across the starry dome might be created by an object the size of a basketball. Even these are so rare and short-lived, you will be lucky to be outside looking in the right direction to see one more than once or twice in a lifetime.

During a prolonged watch on any given

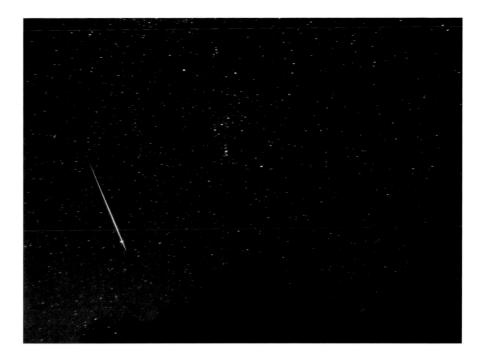

night, you will inevitably see a handful of meteors appear randomly across the sky. Astronomers call these sporadics. The typical meteor, at magnitude 1 to 4, produces a strcak of light lasting only a second or two, the classic "falling star." A bright meteor, at about magnitude –1, might travel more slowly over a longer path and be visible for two to three seconds. Such a meteor often leaves an ionized trail that glows long after the meteor itself has burned up and faded.

Most meteoric material comes from old comets spreading a trail of dusty debris throughout the solar system. When a comet approaches the Sun to within the orbit of ▲ Flash in the Night Meteors appear as shortlived streaks of light in the sky. Although they often look as if they hit Earth, most meteors burn up completely at an altitude of dozens of kilometers. Here, a December Geminid meteor seems to slice through the star Sirius.

◀ Falling Stars of Summer A brilliant Perseid meteor streaks down the summer Milky Way. The most popular of the year's eight or so major meteor showers, the Perseids are seen on warm summer nights each August 11 or 12. Photos this page by Alan Dyer.

Main Meteor Showers

Quadrantids	Jan. 3
Lyrids	Apr. 21
Eta Aquarids	May 4
S. Delta Aquarid	ls July 29
Perseids	Aug. 11-12
Orionids	Oct. 20
Leonids	Nov. 17
Geminids	Dec. 13-14
	Section Section

Mars, its icy surface begins to vaporize from solar radiation. Dust and debris encased in the ice since the solar system formed 4.6 billion years ago are released to drift into space, and some of those particles plunge into the Earth's atmosphere as meteors. A few large meteors originate in the asteroid belt between Mars and Jupiter. These are literally chips off the large rocky objects that orbit in this zone by the thousands.

METEOR SHOWERS

Next to eclipses and bright comets, the celestial events that receive the most publicity are meteor showers. These are predictable annual events during which, for one or two nights, the normal sparse count of meteors jumps to around 20 to 80 meteors per hour. About eight major meteor showers can be seen in the northern hemisphere each year.

During a meteor shower, Earth crosses the orbit of a comet, passing through the dust left in the wake of the comet's previous trips around the Sun. The Perseids are thought to be the flotsam left behind by Comet Swift-Tuttle, last seen in 1992. The Geminids are debris from the asteroid Phaethon, which is more likely a tailless, fizzled-out comet.

Meteor Radiant 🔺

Meteor showers take their name from the constellation from which the member meteors appear to radiate. Here, superimposed exposures capture the Leonids radiating from the head of Leo the lion. Meteor showers tend to be a disappointment for many first-time viewers, especially if the news media publicize one that occurs when the Moon is visible. Even the best showers, the Perseids (August 11-12) and the Geminids (December 13-14), produce only one meteor per minute on average. Of course, meteors never appear on a precise one-per-minute schedule. At the peak of a shower, several minutes may go by without any meteor; then there will be a flurry of six or seven within a minute or two and nothing again for 5 to 10 minutes. Some showers can try an observer's patience. In the late 1980s and early 1990s, the Perseids put on wonderful shows, but their intensity has declined after the parent comet, Swift-Tuttle, headed back to the outer reaches of the solar system. The Geminids currently provide the best annual show; the Perseids are a close second.

For any shower to be seen at its best, the site must be dark, with no Moon in the sky. The observing equipment is simple: a lawn chair, blanket or sleeping bag, a hot beverage and some favorite music. Just sit back and watch the skies. If you are with longtime amateurs, you will hear "Time!" yelled out with every meteor spotted. It becomes an automatic reaction, a useful habit for sessions when someone is recording the time of each meteor seen by a team of observers.

One of the first things you will notice about shower meteors is that their trails point back to the same spot in the sky. For the Perseids, this radiant point is in the constellation Perseus, hence the name. For the Geminids, it is in Gemini. The Quadrantids of early January are named for the obsolete constellation Quadrans the mural, a pattern once charted in the Draco-Boötes area.

The apparent convergence of meteor trails is due to perspective. Earth actually passes through a parallel stream of meteors. But because a meteor's path in the sky can be more than 160 kilometers long and its end point is closer to the Earth's surface and you—than is its beginning point, meteor paths undergo the same perspective effect as do railroad tracks or any parallel lines stretching off into the distance.

Shower meteors can appear anywhere in the sky. Meteors seen near the radiant are short and slow; meteors far away from the radiant are faster and leave lengthier trails A meteor entering head-on at the radiant appears as a brief starlike flash.

A common practice of veteran meteor watchers is to wait until after midnight (or 1 a.m. when daylight time is in effect). More meteors, both shower and sporadic, grace the skies of the postmidnight hours. At that time, the side of Earth we are on is turned in the direction of our planet's orbital motion around the Sun. Therefore, we face "into the wind." Any meteoric debris we run into hits the atmosphere with greater speed and produces a brighter, hotter trail.

FIREBALLS AND METEORITES

A night spent watching a meteor shower inevitably prompts the question, Do shower meteors ever hit Earth? The answer is a qualified no. No meteor-shower debris has ever been known to strike the Earth's surface. Since shower meteors are made of fine, crumbly comet dust, they all burn up at altitudes of 60 to 120 kilometers. Of course, everyone has heard of meteorites, the correct name for objects that do hit Earth. These rocky chunks have a different origin than do most meteors: They are fragments of asteroids that have collided somewhere between the orbits of Mars and Jupiter.

Any meteor brighter than –4, the brightness of Venus, is called a fireball. Few produce meteorites. A meteor that appears to explode in a fireworkslike display is called a bolide. If a bolide produces several glowing pieces that carry on past the main explosion, it's possible that some small fragments will survive to the surface. A very slow but

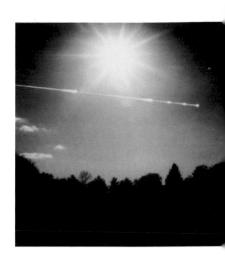

▲ Daylight Meteor While driving along a freeway near Niagara Falls, amateur astronomer John Nemy saw a brilliant fireball meteor streak across the daytime sky. He quickly pulled over and photographed the scene, then used drawing software to sketch in the fireball exactly where he had seen it.

Meteor Storms and Outbursts

One annual shower, the Leonids, enjoyed a rise in activity, and publicity, in the late 1990s. This shower typically produces no more than 30 to 40 meteors per hour. However, every 33 years, the Leonids' parent comet, Tempel-Tuttle, returns to the vicinity of Earth. In 1833, 1866 and 1966, the Leonids produced oncein-a-lifetime meteor storms of tens of thousands of

meteors per hour. Observers reported an effect that must have resembled a science fiction starship warping into hyperspace.

In 1998, the Leonids produced a fireball shower, a display of unusually bright meteors, though their numbers

were far below storm proportions. In 1999, the predicted storm year, observers in the Middle East and Europe saw a brief burst of up to 3,000 meteors per hour. Remarkably, astronomers had predicted this peak with unprecedented accuracy. For 2001, the same models predicted a good show for North America—another successful forecast. Observers throughout the United States and Canada reported up to 20 meteors per minute, by far the best display seen in decades by backyard astronomers on this continent.

Using the meteor stream modeling techniques learned from the Leonids, astronomers were able to predict a brief outburst of the normally quiet Aurigid meteors on September 1, 2007. An intense

outburst of the Draconids might come in October 2011. We may see a new shower in 2022 created by the recent breakup Comet Schwassmann-Wachmann 3.

This 4-hour exposure on November 17, 1998 (above right; courtesy of Slovak Academy of Sciences), shows the streaks of dozens of brilliant meteors emerging from the constellation Leo. The Leonid showers of 1998 to 2001 were the closest we have come in recent times to duplicating the colossal meteor storms of 1966, 1833 and 1799 (woodcut above left).

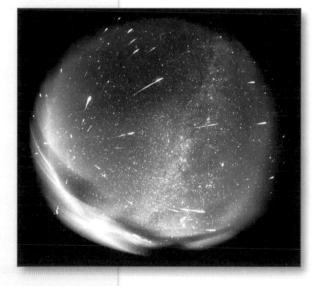

brilliant (magnitude –10 or brighter) fireball with little sign of a final burst is also a candidate for a meteorite fall. Report such a sighting to your local planetarium, observatory or college astronomy department. Note the meteor's direction of travel, its height above the horizon in degrees (or in hand widths at arm's length) and cardinal directions of the start and end points. Record the time and your location (many sightings are made from moving cars). Make note of any unusual sounds, such as rumbling, hissing, whistling or short sonic booms, and any time delay between sight and sound.

Keep in mind that while the bolide may appear to have fallen just a few hundred meters away, bolides explode at altitudes of 12 to 25 kilometers, far into the stratosphere and well above the cruising altitude of commercial jets. What looks as if it were just over the next hill could be in the next state.

How do you distinguish a natural bolide from a reentering artificial satellite? Experienced observers have found that satellites burn up more slowly, last longer (at least 30 seconds) and traverse a greater angle (100 degrees or more) than do natural bolides. Even very bright bolides exhibit a quick terminal burst and burnout.

ZODIACAL LIGHT AND GEGENSCHEIN

A far more subtle effect of interplanetary dust can be seen in the evening skies of spring and the morning skies of fall (true for both northern and southern hemispheres). On a moonless night in spring, for example, wait until the bright glow of twilight has left the western sky. If your site is dark, with little horizon glow from distant cities, look for a faint pyramid-shaped glow stretching 20 to 30 degrees above the horizon. It is fainter than the brightest parts of the Milky Way and is often taken for the last vestiges of atmospheric twilight. The glow is actually sunlight reflecting off comet-strewn dust in orbit around the Sun in the inner solar system. It is known as the zodiacal light, because it appears along the ecliptic, the region of the zodiac. The closer you live to the equator, the better your chance of seeing these light pyramids, both morning and evening. On clear moonless nights, however, attentive observers as far north as 60 degrees latitude can pick them out.

Much tougher to see are the other zodiacal light effects: the gegenschein and the zodiacal band. The gegenschein appears as a large (about 10 degrees wide), very subtle brightening of the sky at the point directly opposite the Sun (gegenschein is German for counterglow). It is produced by sunlight scattering off meteoric dust beyond the Earth's orbit. Late March to early April and early October are the best times for detecting the gegenschein, since it is then projected onto star-poor regions. Seeing this elusive glow is a naked-eye observing challenge. Even more difficult to observe is the zodiacal band, a stream of light connecting the eastern and western zodiacal pyramids to the gegenschein.

AURORAS

High-latitude observers are often treated to (some say plagued by) displays of northern or southern lights—aurora borealis or aurora australis. Auroras can be the most entertaining of all the naked-eye phenomena, providing light shows that ripple like waving curtains or plumes of colored smoke.

An aurora is a phenomenon of the upper atmosphere. Auroral curtains extend from

False Twilight 🕨

On a February evening in the Arizona desert, the zodiacal light is visible after dusk as a narrow pyramid of light emerging from near the sunset point. The zodiacal light appears to trace the ecliptic, the pathway of the planets. It is rarely as bright as seen here. Photo by Terence Dickinson.

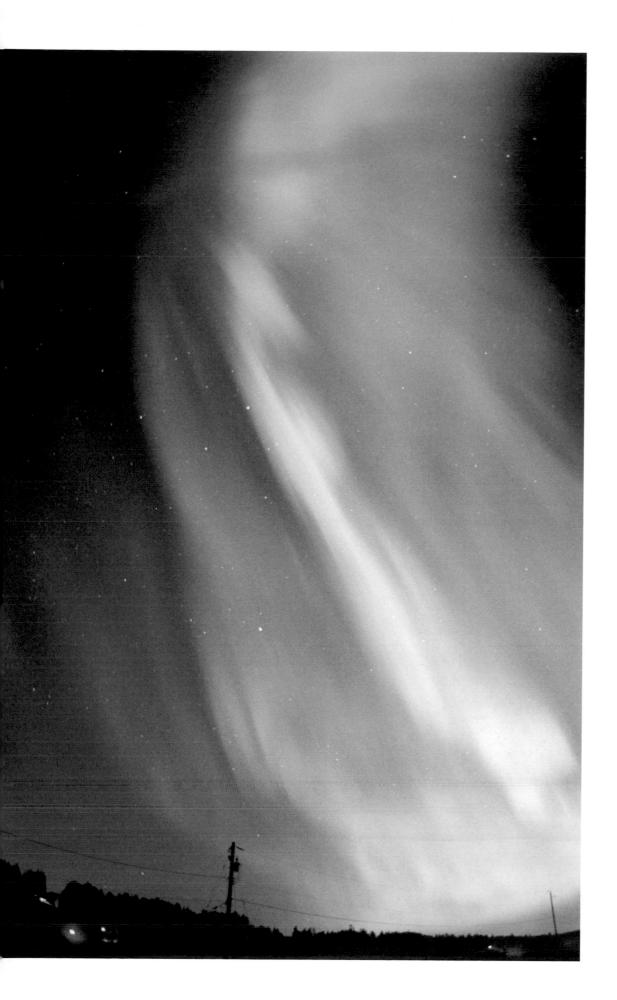

Among the most awesome of celestial displays, auroras can fill the sky with waving curtains of light. Green from glowing oxygen molecules predominates, but pinks, reds and blues can appear during intense displays. Film photo by David Lee, taken from near Victoria, British Columbia, August 12, 2000.

500 kilometers (higher than the space station) down to no lower than about 80 kilometers. In the case of the more commonly seen northern lights, an aurora usually appears first as a greenish band of light low along the northern horizon. But during a full-blown display, luminous shafts climb high into the sky, eventually filling the heavens with curtains and streamers. An aurora can reach up

Capturing the Show

A massive all-sky aurora in 2001 (above) was captured on film (Ektachrome 200, in this case). The other shots on these two pages were obtained with stock DSLRs, which offer superior results for auroras.

to the zenith, forming a coronal burst that looks like the tunnel effect in the movie 2001: A Space Odyssey. After an outburst, called a substorm, a typical display often turns into patches of light pulsing on and off all over the sky.

The predominant green color, at a wavelength of 557.7 nanometers, is from glowing oxygen atoms. Energetic displays exhibit blood-red tints from a much fainter emission line of atomic oxygen, at 630.0 nanometers. A combination of blue-green and red light from ionized nitrogen can add a pink fringe to the bottom of an auroral curtain.

Displays of aurora borealis are a common sight in Alaska, in Canada's northern territories and Prairie Provinces and in northern Ontario and Quebec, where up to Nights of the Aurora Brilliant auroras can be continental phenomena, visible in the skies over millions of square kilomctors. The display on the night of November 7, 2004 (above), was seen from all of Canada and as far south as northern California and Oklahuma. The photos above and at near left were taken from eastern Ontario by Terence Dickinson. Facing page: The bottom photo was taken from central Ontario by Todd Carlson; the film photo, top, was taken from southern Alberta by Alan Dyer.

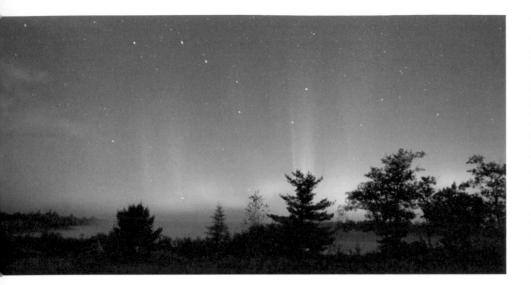

200 displays a year are visible. In Europe, extreme northern Norway and Sweden record similar numbers. In the northern United States and southern Canada, the skies shimmer with auroras a few dozen times a year. The east and west coasts of North America and the southern United States have auroras 5 to 10 times a year. Rare superauroras can extend as far south as Mexico and the Caribbean, but such displays occur only once a decade on average.

Despite the relatively high geographic latitude of the populated parts of Europe, auroras are rarely seen there, compared with the equivalent latitudes in North America. Canada and the northern United States are

Painting the Sky With Light Although there are obvious similarities, no two auroras are identical. Indeed, the beauty of the phenomenon is in the subtle variations from one display to another, as demonstrated by the photos on these pages, taken from southern Ontario (above) by Terence Dickinson, southern Alberta (right) by Alan Dyer and eastern Maryland (far right) by Paul Gray. much closer to the magnetic north pole, located in the Canadian high-Arctic islands. Auroras form in an oval-shaped zone with a radius of roughly 2,400 kilometers centered on the magnetic north pole. Oddly enough, the Earth's true geographic North Pole gets no more auroras than are seen from the northern Prairie Provinces.

The same situation exists in the southern hemisphere, with the aurora australis forming around the south magnetic pole, in Antarctica. Because there are few populated landmasses underneath the southern auroral zone, most displays of southern lights are seen only by penguins.

A common misconception about auroras

is that they occur most often in winter. In fact, March, April, September and October usually host the best auroral displays. Brilliant auroras can also appear in summer. Their cause is unrelated to the weather on Earth. The trigger is a bombardment of the upper reaches of our atmosphere by electrons and protons that originate at the Sun. Occasionally, the outer atmosphere of the Sun, its corona, lets loose with a coronal mass ejection, and part of the Sun's atmo sphere is literally blown into space, perhaps set off by a powerful explosion on the surface. Some mass ejections shoot streams of charged particles toward Earth, where they saturate the radiation belts surrounding our planet. The exact process is only now becoming understood, but it seems that the radiation belts act as particle accelerators, beaming intense currents of energy onto the Earth's rarefied upper atmosphere. Like a planet-sized television screen, our atmosphere glows when hit by the electron beams.

A typical aurora requires an energy input of about 1,000 billion watts, hundreds of times greater than the output of the largest

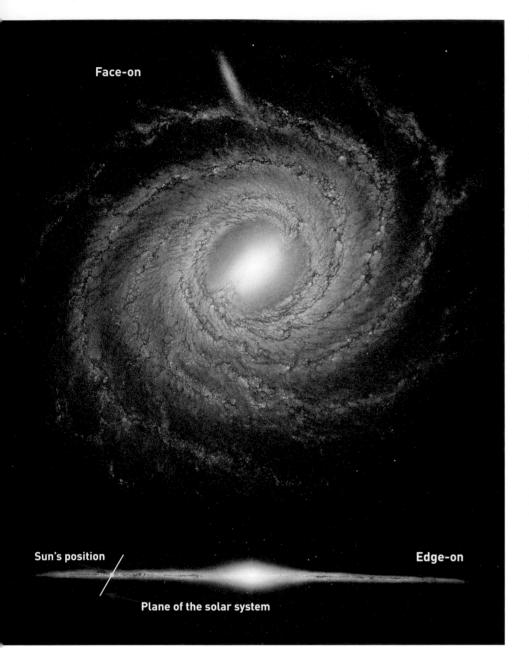

Our Galactic Home A The Earth's orbit around the Sun is tilted at nearly right angles to the galactic equator and the disk of the Milky Way. For this reason, each season presents a unique view of the Milky Way: toward the galactic downtown core in northern summer; toward the galactic city limits in northern winter; out the top and bottom of the Milky Way's flattened disk in spring and fall. Art by Adolf Schaller. hydroelectric power plants. During an intense display, up to one million amperes of current flow along an aurora, enough to create fluctuating magnetic fields on Earth. This, in turn, produces damaging currents that flow along extended electrical conductors, such as Arctic pipelines and powergrid networks. Auroral storms have been known to short-circuit satellites in orbit.

Auroras follow the rise and fall of solar activity, peaking every 11 years. The solar maximum of 1989 produced auroras that were so energetic, one shut down the Quebec power grid, plunging the entire Eastern Seaboard into darkness. The maximum of 2000/2001 was less intense but was the first to be observed by a flotilla of dedicated satellites. The Solar and Heliospheric Observatory (SOHO), the Advanced Composition Explorer (ACE), NASA'S THEMIS probes, Europe's CLUSTER probes and Japan's Hinode and twin STEREO satellites watch the Sun, the solar weather and the Earth's magnetic domain minute by minute. They provide alerts of impending solar storms and geomagnetic upsets. If you'd like to find out about possible displays, the website http://spaceweather.com is a good place to start or check out NOAA's Space Weather Prediction Center (www.swpc.noaa.gov).

The Best Dark-Sky Sight: The Milky Way

Only one other sky-spanning phenomenon can rate with an aurora for spectacle. Unlike displays of northern lights, this wonderful sight appears almost every night of the year yet, sadly, goes unnoticed from urban backyards. But from a site away from light pollution, little can surpass the naked-eye view of the Milky Way.

OUR HOME IN THE GALAXY

The Milky Way appears as a delicate, misty band of light punctuated with bright glowing clouds of stars and split by obscuring lanes of dark interstellar dust. Aim any optical aid at the Milky Way, as Galileo discovered in 1609, and it resolves into thousands of stars too faint and far away to be seen as individual stars with unaided eyes.

When you look at the Milky Way, you are seeing a giant galaxy—ours—edge-on. All the stars you see at night with the unaided eye belong to the Milky Way Galaxy and lie relatively close to us, within a few thousand light-years of the Sun. But our entire spiral-shaped galaxy stretches 100,000 light-years from side to side. It is the light of the more distant stars lining our galaxy's spiral arms that blends together to form the band we call the Milky Way.

Our solar system lies about 25,000 light-

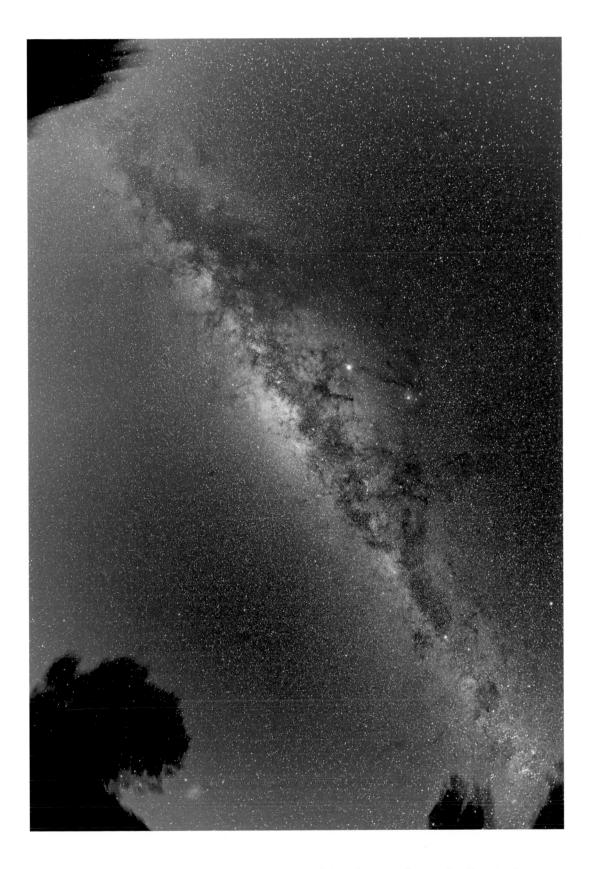

Emu in the Stars From a latitude of 30 degrees south, the center of our galaxy passes overhead, producing a remarkable and symmetric view of the Milky Way. Our place far from the bright core of the galaxy becomes obvious. In Australia, where this image was taken, many aboriginal cultures see an emu in the dark clouds of the Milky Way. The head is the Coal Sack at lower right; the neck is the dark lane running up to and over the center of the galaxy; the body is formed by the glowing galactic core; and the tail and feet are In the dark lanes at top left, in Scutum and Aquila. Photo by Alan Dyer.

years from the center of the Milky Way Galaxy, about halfway from the galaxy's hub to the visible edge. When you picture our solar system in the galaxy, the image that likely comes to mind is of Earth and the rest of the planets orbiting the Sun in the same plane as the pinwheel disk of the galaxy. It's a neat picture, but there is no cosmic requirement which dictates that the planes of the solar system and galaxy line up. In

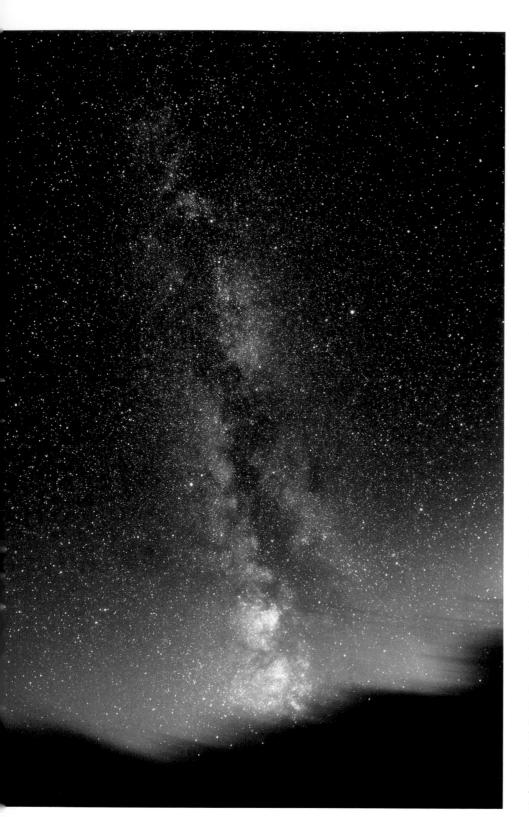

Summer Milky Way In July, from midnorthern latitudes, the Milky Way runs from north to south, with the galaxy's core above the southern horizon. fact, the solar system is tilted almost at right angles to the disk of the galaxy, which is why the ecliptic (the line that defines the plane of the solar system) crosses the sky from west to east, while on northern midsummer and winter evenings, the Milky Way band (marking the disk of the galaxy) bisects the sky from north to south, at right angles to the ecliptic.

WHEN TO SEE THE MILKY WAY

As if gazing out from a spinning carousel, we look in different directions into the Milky Way's spiral arms as the Earth's revolution carries us around the Sun. From June to August, the Earth's nighttime hemisphere is turned toward the galactic center. We see the glowing core of the galaxy in Sagittarius, due south in the middle of the night. Because we are then looking toward its densest collection of stars, the Milky Way appears at its brightest. Many of the star clusters and nebulas we see at this time of year belong to the Sagittarius Arm, the next spiral arm inward from our galactic home in the Orion Arm.

Six months later, from December to February, the nightside of Earth faces the opposite direction, toward the outer edge of the galaxy and the constellations Orion and Gemini. Because we live in an outer spiral arm, there isn't as much galaxy between us and the dark depths of intergalactic space in this direction. The Milky Way in this region of the sky appears fainter, populated with fewer distant stars. The impressive bright stars we see surrounding Orion all lie close to us, within 1,500 light-years or so, the product of active regions of star formation in our local Orion Arm. Many of the nebulas and star clusters we see, from Monoceros to Perseus, belong to the outer Perseus Arm just beyond our own.

Between these two seasons, in spring and autumn, Earth is oriented to look at right angles to the Milky Way, out the top of the galaxy from March to May and the bottom of the galaxy from September to November. In autumn, though, we never lose sight of the Milky Way completely: As the sky turns, the summer Milky Way twists to become a band oriented east-west across the sky. By dawn, the Milky Way has rotated still farther to become oriented north-south again, forming the familiar winter Milky Way. For sessions of nonstop exploring along the spiral arms of our galaxy, autumn nights are best, in either hemisphere (from September to November in the north, March to May in the south).

In springtime from either hemisphere, however, we do lose sight of the Milky Way. On spring nights, it lies along the horizon, wrapping around us in a 360-degree panorama. We look straight up toward a galactic pole: the north galactic pole in northern spring and the south galactic pole in southern spring. It is around these galactic poles, far from the Milky Way's obscuring dust clouds, that we can peer farthest into space. Here, we find the richest collection of galaxies beyond ours. For telescope owners, spring is galaxy-hunting season, whether you live in Sydney, Nova Scotia, or Sydney, Australia.

WHERE TO SEE THE MILKY WAY

To see the Milky Way at its best, head as far from city lights as you can. Under the darkest August skies, for example, our galaxy's subtle glow can be seen extending far from the main star clouds into constellations such as Delphinus and Lyra. The Great Rift of dark interstellar dust that splits the Milky Way through Cygnus and southward becomes obvious. Diagonal dark lanes in southern Ophiuchus and Sagittarius form what looks like a prancing horse. Under superb conditions, the dark lane that delin-

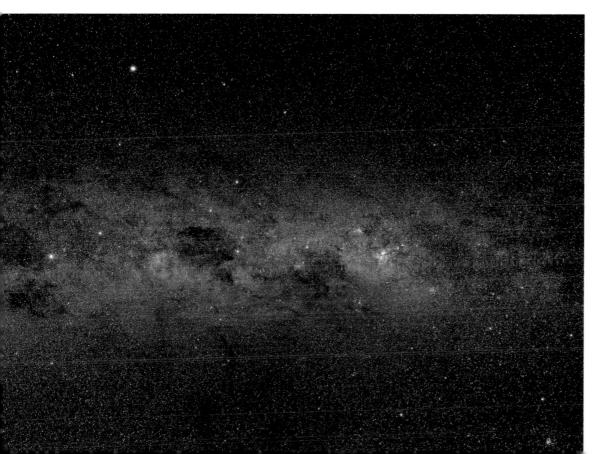

▲ Winter Milky Way In January, from those same midnorthern latitudes (Canada, the United States and Europe), a fainter Milky Way, created by the outer spiral arm of our galaxy, spans the sky.

Southern Milky Way

Autumn is the best season for seeing the Milky Way, no matter what hemisphere you live in. This is the most southerly portion of the Milky Way as it passes through Carina, Crux and Centaurus, a segment that is best seen in April and May—autumn Down Under. Photos by Alan Dyer. eates the horse's front legs can be traced as far as Antares, in Scorpius.

The Milky Way is most spectacular through Sagittarius and Scorpius, home of the center of the galaxy. From Canadian and northern European latitudes, these constellations crawl along the southern horizon, denying northerners decent views of the best part of our galaxy. To see this area of the sky well, go south. From the southern United States or Caribbean latitudes, the glowing star clouds of Sagittarius climb high enough that they shine as the dominant naked-eye feature of a dark summer sky. Even a trip to the Caribbean, however, gets you less than halfway to a full view of the southern sky. The magic latitude is 30 degrees south: central Chile, Australia and southern Africa. From there, under dry desert skies, the center of the galaxy passes overhead on winter evenings (June to August), glowing so brightly, it can cast a shadow. Lie back, gaze up at the galactic core and enjoy a threedimensional experience unlike any other in astronomy. Our location on the outskirts of a spiral galaxy suddenly becomes obvious. You sense your place in the universe. This is naked-eye astronomy at its finest.

Recording Your Observations

By Russell Sampson

One June day as I was walking in a park near my home, I happened to glance skyward and saw an elaborate and peculiar solar halo. The sky was full of colorful circles and arcs. I made a quick sketch in a small notebook I carry and later produced a finished drawing. One of the arcs was an extremely rare and mysterious eight-degree-radius halo I had never seen before. Trying to describe this event accurately from memory would have been difficult at best.

Amateur astronomers record sky phenomena for many reasons, but the main one is simply as a personal reminder of what was seen and when. Drawings, data tabulations and written notes have the added benefit of sharpening an observer's skills. Whether I am sketching the planet Jupiter or jotting down a series of variable-star estimates, I keep my records in a small coil-bound artist's sketchpad. The thick paper withstands the effects of dewing better than ordinary notepaper. A small paper clip prevents the pages from flapping in the wind. On cold winter nights, a pencil inserted through a piece of one-inch wooden doweling provides a better grip with gloves on.

Preparation before going outside may be necessary. If you plan to observe a planet, draw its outline. For deepsky observing, draw a circle to mark your eyepiece's field of view. Dividing this circle or planetary outline into

quadrants helps when positioning objects or features. Once outside, record the date, the time, the observing conditions and the instrument used. Write things down as you see them; try not to rely too much on your memory. Instead of finishing your sketch on the spot, draw outlines of features and use a numerical scale for brightness. For planetary detail, try a scale of one to five, where five is the darkest. The same method can be used for deepsky drawings.

When drawing large-sky phenomena, such as a solar halo or an aurora, use an extended fist to estimate angular size or separation. A bare fist, viewed at arm's length, is between 8 and 11 degrees from little finger to thumb. For some obscrvers, these quick field notes are enough. I recopy and finish my draw-

ings onto the pages of a bound artist's sketchbook as soon after the observation as possible. For finished planetary sketches, I use a soft pencil, a white drafting eraser (the pencil-shaped erasers are the best) and a blending stump. As its name suggests, a blending stump is used to smear or blend graphite onto paper. It costs less than a dollar and is sold in art-supply stores.

One of the most challenging aspects of planetary sketching is making a realistic outline of the planet. Saturn's complex system of rings, Jupiter's equatorial bulge and the phases of the inner planets are difficult to render in a

The Milky Way Galaxy's wheel-shaped structure is so obvious when you see the core overhead, it doesn't take much of a leap to imagine that the Greek philosophers would have been able to figure it out more than 2,000 years ago had they simply been positioned at the appropriate latitude. As it happened, though, it was not until early in the 20th century that astronomers were able to settle the question of the Milky Way's shape, burdened as they were with their northern-hemisphere viewpoints.

After a few minutes under the southern Milky Way, the first order of business for the

northern astronomer is coping with the disorientation in the sky caused by viewing our galaxy from the opposite end of the planet. What is upright in our sky is upside down in theirs. Thus Orion, Canis Major and Leo—to mention only a few—are seen turned on their heads.

Overshadowing the novelty of the flipped constellations is a huge sector of new sky: dozens of unfamiliar constellations and a great swath of Milky Way littered with the sky's best star clusters, globular clusters, nebulas and galaxies. (For more on this, see Chapter 12.)

lifelike manner. A technique used by modern graphic designers can be adapted to make a planet outline. First, find an image of the planet in its proper phase or orientation, such as the line drawings of planet disks that appear in every issue of Guy Ottewell's annual *Astronomical Calendar*. Then photocopy selected images, and cover the back side of the photocopy with a thick layer of pencil graphite. Carefully tape the photocopy onto your sketchbook, and trace

over the image with a pen or pencil. The graphite is transferred onto the page in the form of an outline. The photocopies can be used over and over again.

Dark planetary or lunar features are added with the pencil and blending stump. Black areas, such as the background sky or shadows on the Moon, can be applied using an opaque watercolor called gouache. You will need a very fine brush to outline the planet and a wider brush to fill in the background.

Color drawings can be done with pencil crayons; they are inexpensive and easy to use. The best and most widely available are Prismacolor Crayons by Berol. The choice of paper is important. Smooth papers, like loose-leaf, are not abrasive enough to take the pigment off the crayon.

The shape of the crayon tip is also critical to keep the colors diffuse and uniform. With a sharp knife, sculpt the tip of the crayon into a broad, slightly rounded stump. For large color fields, like the background sky, keep the broad face of the

crayon flat on the paper and use a gentle circular motion. If you apply only light pressure, the crayon will produce a soft airbrushlike quality. To color small markings or features with sharp edges, angle the crayon tip off its broad face to its edge. For deep-sky objects, try a white pencil crayon on black construction paper.

Keep your ambitions and plans in perspective. Attempting to draw the entire face of the Moon as seen through a telescope is unrealistic. Try sketching one interesting lunar feature at a time. The satisfaction of having a "hard copy" of your observation is a reward in itself.

Russ Sampson is an astronomy educator and longtime amateur astronomer originally from Edmonton, Alberta, and now teaching astronomy at a university in Connecticut.

CHAPTER EIGHT

Observing Conditions: Your Site and Light Pollution

When our grandparents were children, the splendor of a dark night sky thronged with stars and wrapped in the silky ribbon of the Milky Way was as close as the back door.

Not anymore. Giant domes of yellow light cover every city in North America at night. Major metropolises are visible 100 miles away as glows on the horizon. From 40 miles, they wreck most of the sky.

We are not suggesting that night lighting isn't needed in modern society. The problem is waste lighting. It's everywhere: Empty parking lots are floodlit all night; security lights pour into neighbors' windows rather than being confined to the target area; and inefficient streetlights spill as much as 30 percent of their output horizontally, reaching only the eyes of distant drivers and the air above our heads.

At the request of astronomers

wastage as well as the loss of nature's night sky, some local, county and state governments have introduced sensible lighting legislation in Arizona, New Mexico, California, New Jersey and New York State. Other regions are considering the idea. Coauthor Dyer's home city of Calgary is currently refitting all streetlights with full-cutoff fixtures, not for the sake of astronomers but to save energy and cut greenhouse gases.

The longest-standing lighting ordinance, dating from the 1970s, is in Tucson, Arizona, where all light fixtures are designed to aim down to bathe the street, sidewalk, parking stalls or other targets and not the sky or neighboring property. Highway signs and billboards are illuminated from the top down, rather than the reverse. Drivers see the road instead of glare from lighting, as is the case in most major cities

The ideal dark-sky site reveals the Milky Way down to the horizon, as in this image taken at the 100,000acre Cypress Hills Interprovincial Park in Saskatchewan, Canada. Photo by

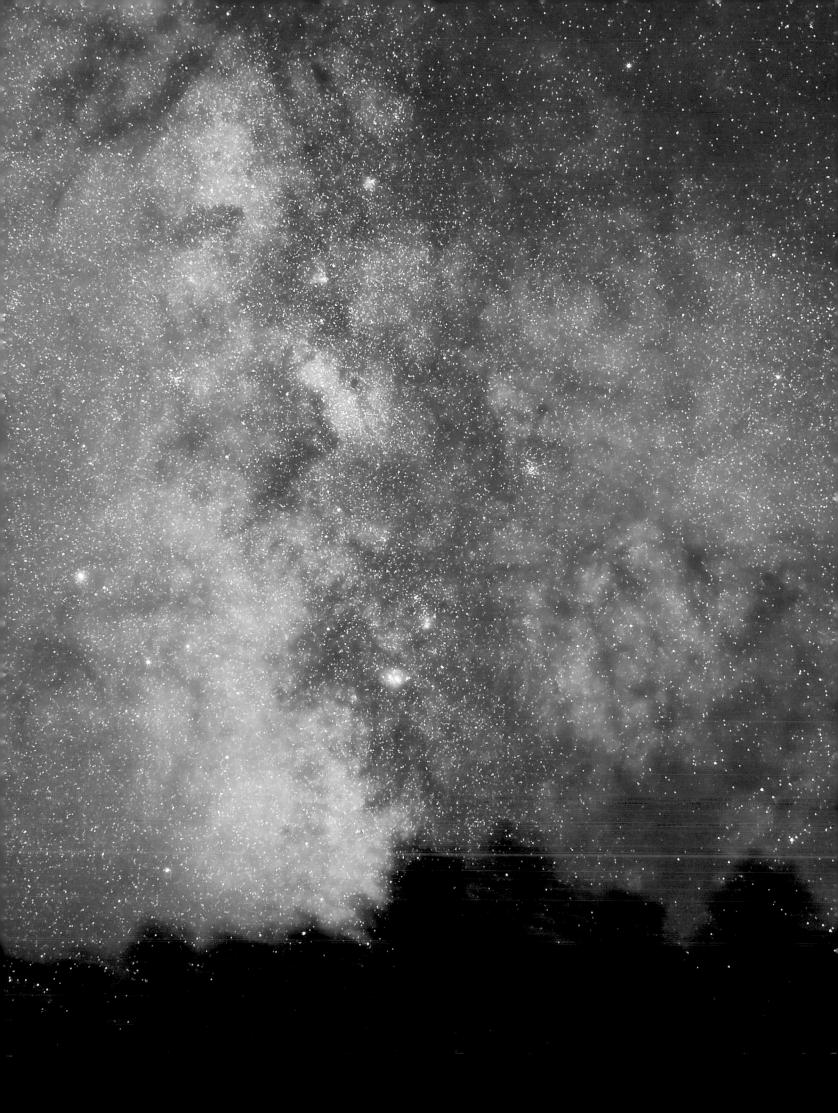

The Eroding Sky

If stargazing were the exclusive casualty of the growth in inefficient night lighting, a call for action might be considered trivial. But astronomy is just part of it. In the United States, poorly designed or badly installed outdoor lighting wastes more than \$1 billion worth of electricity annually by producing light that streams into the sky, illuminating nothing but airborne dust and water vapor.

Like most bureaucrats, municipal authorities tend to resist change. Unshielded streetlamps are mass-produced and inexpensive, and they do the job. Why replace them? People are accustomed to glaring streetlights because that is all they have ever seen. "Nobody's complaining to me about too much light," one township engineer told us."People want more light, not less." This

attitude will change only when people are presented with alternatives and a reason for change. Shielded lights are simply more efficient: By eliminating the waste component, each fixture can have lower-wattage lamps, yet the target area still receives the same amount of light. Shielded lights are the environmentally friendly alternative.

"Yes, all that may be true," said the township engineer, "but they cost more, and they look dimmer. People don't like it." However, the reality is that the residents of Calgary and Tucson readily accepted the new lights once they understood the reasons for the change, thanks to education campaigns by both the city and environmental groups.

Big, Bad and Ugly ► On a hazy night, examples of waste lighting like this abound. The pole-mounted parking-lot fixture is aimed such that its illumination shoots almost horizontally. About 40 percent of the light emitted never touches the ground but floods uselessly into the sky. A shield shaped like the bill of a baseball cap atop this fix-

ture would eliminate most of the waste. Regrettably, these shields are rarely installed unless legislated by local or state law.

Tucson's Tale 🔻

Taken from the summit of Kitt Peak, in Arizona, these photos reveal the growth in night lighting in Tucson from 1959 to 2003. Spurred to action by such pictures, Tucson has passed some of the toughest anti-lightpollution laws anywhere. Courtesy NOAO.

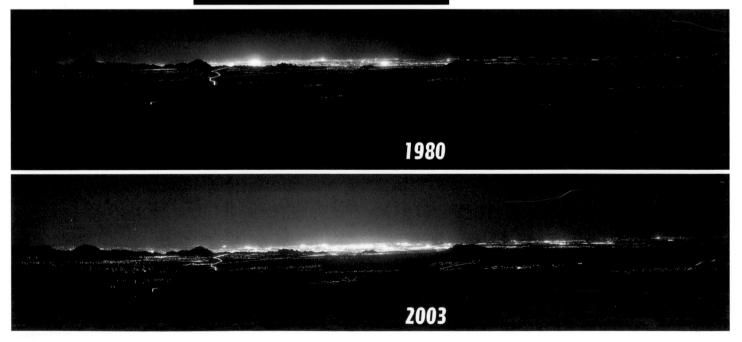

Fortunately, there are signs of a slow but definite shift in attitudes toward lighting. Sales of full-cutoff fixtures that direct their beams downward to road level are growing every month. While researching this chapter, we spoke with several major outdoor-lighting suppliers. In many cases, the price difference between fully shielded lights and the former standard cobra-head fixtures is now close to zero. Most manufacturers and civic lighting engineers are convinced that shielded equipment will eventually take precedence in roadway lighting and assured us that there is a slowly growing commitment to eliminating the glare produced by the old fixtures.

Professional astronomers urge municipalities near their observatories to use lowpressure sodium lamps, because the narrow spectrum of the illuminated sodium vapor can be filtered out at the telescope more easily than other light sources. For what backyard astronomers enjoy doing, however, these filters are of limited advantage. Containing the overall brightness of the sky and eliminating the direct interference from specific lights are the main issues. In that regard, shielding is much more important than the type of light source.

The inspiration of a dazzling starry night is unknown to most children today and is a

dim memory to seniors who saw the spectacle from the front porch in their youth. We cannot go back to the good old days, but as with any other aspect of our planet's natural heritage, we should preserve at least some of the night sky for future generations.

There is no way to reveal again stars over the city as our grandparents once saw them. But now the situation is deteriorating in the country too. A single dusk-to-dawn polemounted mercury-vapor lamp dims the starscape for hundreds of yards in every direction. One of these lamps several miles away appears brighter than the star Sirius.

DARK-SKY PRESERVES

Inefficient and wasteful outdoor lighting light pollution—is an environmental issue whose time has come. Something must be done soon, primarily for energy efficiency and cutting greenhouse-gas emissions but also to restrict light trespass and preserve what little dark sky remains in areas within a reasonable driving distance of cities.

One of the most interesting approaches we have seen is the establishment of Dark-Sky Preserves that encompass an alreadyexisting state, provincial or national park. Preserving the natural night sky meshes well with the overall goals of the park.

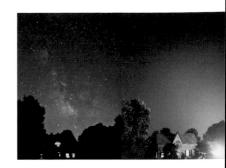

▲ Blackout Skies On August 14, 2003, Todd Carlson took advantage of a power blackout across eastern North America to photograph the Milky Way from suburban Toronto (left). Then the lights came back on (right).

▼ Let There Be Dark

In 2004, park officials and astronomy club members worked together to have Cypress Hills Interprovincial Park on the Saskatchewan-Alberta border declared a dark-sky preserve. Photo by Alan Dyer.

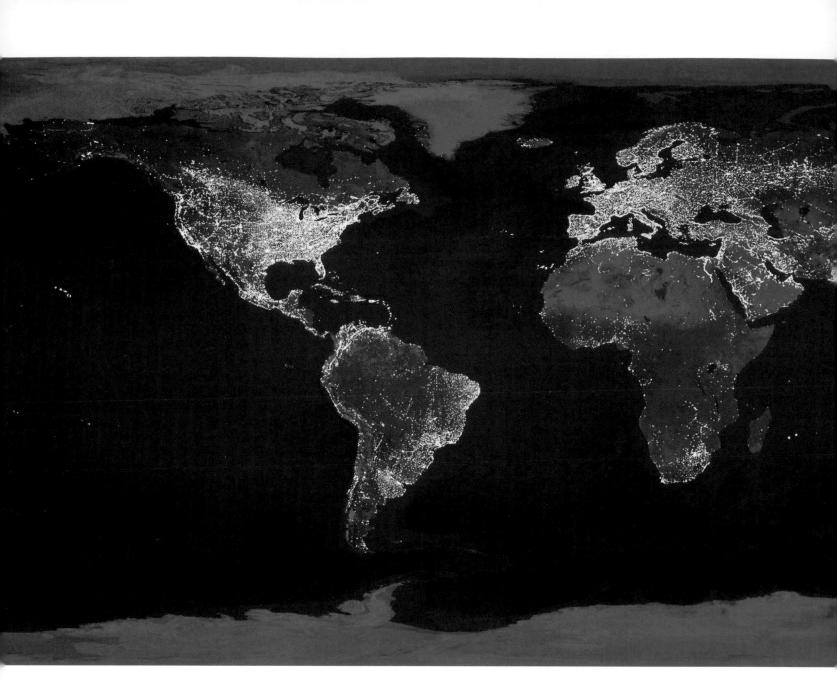

Global Night Lighting 🔺

Satellite imagery of our planet shows that night lighting closely matches regions of dense population or industrialization—usually both. Courtesy NOAA. Often, the park is already dark, and all that needs to be done is to shield a few existing lights and have the Dark-Sky Preserve added to the park's mandate by legislation. This requires time and legwork to arrange because of the necessary government wheels that have to turn, but it can be a worthwhile project for an astronomy club or a less formal group.

What can an individual do? Take a good look at the outdoor lighting at your home or business. If it involves dusk-to-dawn security lights, calculate their yearly operating cost. Electricity is not inexpensive any more. Can the job be done with fewer lights? Are the fixtures shielded? For security,

consider floodlights with an infrared motiondetector switch. Infrared systems use negligible electricity and, compared with all-night lighting, pay for themselves in a year or two. If the lighting is primarily decorative rather than functional, smaller-wattage lamps will usually do the job. Does your outdoor light spill into your neighbors' yards or windows? They may not appreciate it. Does a streetlight or other powerful light reduce your quality of life or prevent you from sleeping? Politely but firmly complain to the municipality or to the light's owner. All bad lights can be shielded. Unwanted light is in the same nuisance category as a blaring stereo in the neighborhood. In some cases, when

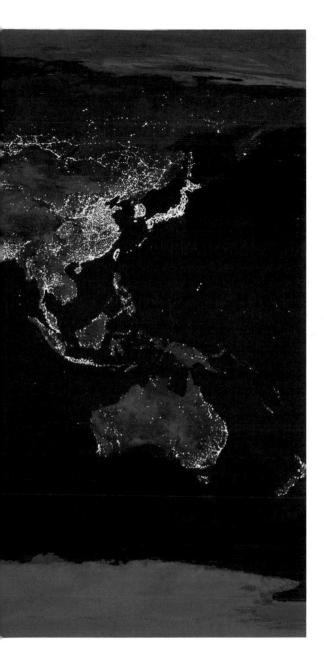

such approaches have failed, several annoyed citizens have taken the dispute to small-claims court and won. But this type of extreme action remains very rare.

Sharing your telescope and the wonders of the universe with your neighbors can yield hidden benefits in this regard. In an outdoor situation at night, gently point out the reality of light pollution. Nearly everyone is open to learning more about environmental issues. Do not preach; simply inform. Most people are receptive. They may even turn off their lights for you.

For more information on light pollution, contact the International Dark Sky Association, a nonprofit organization established to advance awarcness of the problem (visit www.darksky.org). In 2001, The George Wright Society devoted a full issue of its journal, *The George Wright Forum*, to light pollution, particularly in relation to national parks and other dark sites throughout the United States. This entire issue (Vol. 18, Issue #4) is available at the following website: www.georgewright.org/pubslist.html

YOUR OBSERVING SITE

Astronomy can be conducted from just about anywhere. A view of the sky, however restricted or veiled by lights and haze, still shows something. Occasionally, astonishing results emerge under even the most adverse conditions. English comet and nova hunter George Alcock proved this in 1983 when he took a break during an outdoor observing session to have a cup of tea in his kitchen. Sitting at the table, he picked up his binoculars and began scanning, through a closed window, a familiar field of stars in the constellation Draco. Resting his elbows on the back of a chair to steady his 15x80 binoculars, he spied a fuzzy patch he knew did not belong. It was a comet, his fifth discovery.

Alcock's comet-hunting prowess suggests that ideal weather is not a prerequisite either. The British Isles are notorious for cloudy conditions. Perseverance lies behind Alcock's success.

Ideally, of course, all backyard astronomers would like to live on a mountain where the sky is clear more than 200 nights a year. Realistically, however, even if the sky were perfectly clear that often, few of us would be able to make full use of it. The frustration arises when nature's schedule and the observer's do not harmonize. Take a cue from Alcock: Accept the local weather, and make the best of it. Think of how the protessional research astronomer must feel when, after booking time a year in advance on one of the world's largest telescopes and traveling thousands of miles to use it, the site is clouded out. It happens to everybody.

In any case, the chief drawback is usually not the number of clear nights but the local observing conditions. Most of us live in or near urban areas where light intensity grows worse every year. In the center of a

Street Smart

The standard cobra-head streetlamp (top), affixed to millions of poles throughout North America, hasn't changed much since the basic design was developed four decades ago. Then, as now, illumination from the fixture's central lamp not only lights up the street below but also shines horizontally out the sides of the hemispheric lens. This side glare shooting off into the distance is a complete waste of illumination. A more efficient design (above) is the full-cutoff streetlamp, which has a flat lens that eliminates light escaping horizontally. This design directs the light more effi ciently where it is needed and reduces glare in the eyes of approaching drivers and nearby pedestrians. Next time you are in an aircraft at night, notice how the illumination from the streetlamps below is shining directly into your eyes.

Not in My Backyard! ▼ A close encounter of the unwanted kind—in the form of a giant multiscreen theater—landed not far from where some backyard astronomers live in suburban Vancouver. With some lobbying, they were able to secure a reduction in the hours the searchlights were used. Photo by Ken Hewitt-White.

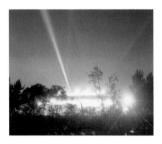

large city, the light pollution can be so intense that only the Moon, Venus, Jupiter and a few first-magnitude stars poke through. Yet even heavy light interference can be circumvented to a degree.

OBSERVING FROM THE CITY

Amateur astronomer Ted Molczan lives in a 33-story high-rise apartment a few blocks from the heart of Toronto. From the roof of the building, with the city lights blazing below, Molczan has seen, with the naked eye, fifth-magnitude stars in the overhead region and even a vague hint of the Milky Way in Cygnus at the zenith. Using 11x80 binoculars, he has no trouble seeing ninthmagnitude stars. Most people in a similar situation would have given up without even trying. By making the best of what is at hand, Molczan has conducted a program of artificial-satellite observations that has led to the recovery of several lost satellites and to the refinement of the orbits of others.

Some apartment and condominium dwellers may even be limited to observing through a window. While this is better than nothing, the window glass always introduces some distortion and/or multiple imaging to binocular and telescopic viewing.

Observers in suburban situations can position their telescopes in a part of their yard that is shielded by fences or bushes from surrounding porch and street illumination. After a few minutes, when the observer's eyes have adapted to the semidarkness, there is lots to see. Typically, fourth-magnitude stars are visible from the suburbs of a large city, and fifth-magnitude stars can be seen from the outer reaches of a smaller metropolis. Of course, it depends on local conditions, but once a spot is found that is protected from direct glare (or action is taken to block such light by erecting a fence or planting a row of dense evergreen trees), the result can be surprising.

Suppose, for example, that the local observing site shows 4.5-magnitude stars at the zenith, third magnitude at 40 degrees altitude and nothing much below 25 degrees. What does this offer? Plenty. The Moon, Venus, Mars, Jupiter and Saturn are bright and largely unaffected by light pollution. An atmospheric inversion layer induced by big-city heat and pollution sometimes steadies the air so that seeing is occasionally better than in the country. Metropolitan telescopic views of Jupiter or Mars often show as much detail as those at a dark location and make wonderful showpiece objects for visitors to your telescope.

Other kinds of observing, such as looking at lunar occultations and bright variable stars, examining the brightest star clusters and tracking the paths of asteroids, are affected by urban conditions to some extent but are generally possible from moderately light-polluted environments. The toll exacted by urban glow is a brightening of the sky background; the telescope's resolution is not affected. An 8-inch telescope under suburban fourth-magnitude skies, for example, will be limited to roughly the same deep-sky targets as a 3-inch telescope under black sixth-magnitude skies. But the resolution of the 8-inch instrument is unchanged, so what is seen can be studied in greater detail. However, such comparisons should not be carried too far. Much depends on the specific object being observed. The use of light-pollution filters changes the equation too, but only by a limited amount. Light-pollution filters make nebulas easier to see but cannot transform urban skies into rural dark-site skies.

EVALUATING THE OBSERVING SITE

When you are considering a telescope purchase, it's a good idea to have a specific observing site in mind. Unless there is absolutely no alternative, do not rely exclusively on a remote, albeit ideal, site. Carefully evaluate the types of observing you can do from a site near home as well as the convenience of the site. Consider the following:

• Is the local site limited to binoculars, or is there room for a telescope to be used in reasonable privacy? (If you will be easily visible to neighbors or passersby "doing something" with a telescope, don't assume that the first thing people will think of will be astronomy!)

• If a telescope is useful at the local site, how far will it have to be carried?

• How many pieces must the instrument be broken into for setup at the local observing site versus the remote site?

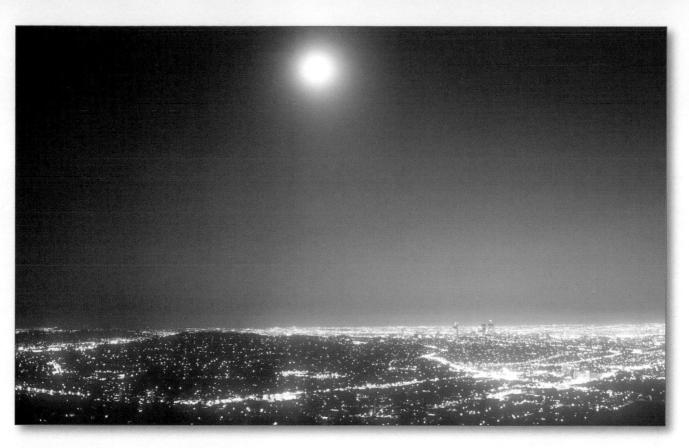

Rating Your Observing Site

How can you evaluate an observing site? Experience is the best guide, but here is a checklist that will help you rate your site. If you use more than one site, each should be assessed separately.

• Convenience: If you can observe in comfort from your own yard, take 5 points; 3 points for a short walk; 2 for a short drive; 0 for an hour or longer drive.

• Ground Level: If your site is outside a ground-level entrance where your equipment is stored, take 5 points. Take 3 points if car loading is required, but score 0 if any full flights of stairs are involved.

• Privacy: No possibility of surprise interruptions by people, animals or unwanted car lights is worth another 5 points. Score 0 if you sometimes feel nervous at the site.

• General Light Pollution: Score 10 if, on a good night, you can see magnitude 6.5 overhead, the Milky Way is obvious and the dome of light from the nearest city bulges less than 10 degrees above the horizon. Score 0 if you cannot see the Milky Way at all or any star fainter than magnitude 5.0. Estimate values for intermediate conditions.

• Local Light Pollution: A crucial factor. Zero points if you cannot avoid a local light as bright as the Moon. Score 4 points for a site that requires moving around to remain protected from light while observing. For a full 10 points, the brightest unobscured light should be fainter than Venus.

• Horizon: A clear, flat horizon to the south earns 5 points. South obstructions higher than 30 degrees rate just 2 points. Similar obstructions in all directions score 0.

• Insects: Mosquitoes are the enemy. Subtract up to 5 points if they are predictably annoying for more than one month each year.

• Snow: Snow cover has no redeeming value in astronomy. Apart from the cold weather that accompanies it, snow reflects light and increases overall light pollution. Subtract 1 point for each month of likely snow cover at the site.

Maximum possible score (for a site next to your home, at a perfectly dark location, with little chance of mosquitoes or snow) is 40 points. Any score over 20 should be considered perfectly acceptable for regular use.

The full Moon looks down on the myriad lights of the Los Angeles basin. Photo by Leo Henzl.

Where Are Dark Skies? The answer depends on where you live and what you mean by "dark." While true dark skies could be many hours away, a moderately dark environment might be relatively nearby. Experienced observers regard a limiting naked-eye magnitude of seven overhead as superbly dark. Those skies are visible from the black areas on this map. The gray regions are also excellent, with stars of magnitude 6.5 regularly visible to the naked eye. The mauve sections yield at least sixth magnitude-very good by today's standards of rampant light pollution. The green areas are afflicted with noticeable light pollution on the horizon, but overhead is still good, with close to sixth magnitude at the zenith. Yellow indicates that even overhead, the sky has deteriorated so that stars of magnitude 5.5 are usually the faintest visible. Orange is distant suburbs, where the worst source of light pollution wipes out the sky in the direction of the largest city and the limit overhead is fifth magnitude. Red is near-suburban environment that seldom allows fourth-magnitude stars to shine through. White is severe urban light pollution -typically, the faintest stars visible are magnitude 2.5. (The above are averages only, and intrinsic visualmagnitude limits vary from person to person.) Courtesy P. Cinzano et al, copyright Royal Astronomical Society.

• How many trips will have to be made back and forth to the car or house during a typical telescope setup?

• Can the equipment safely be left unattended while the telescope is being assembled and disassembled? If not, can everything be carried at once?

• Is power available for the motor drive (if applicable)?

Considering the above, the key question becomes: Is one telescope suited to both the local and the remote site? A telescope that can be carried outside without being disassembled, even into just a few pieces, will be used more frequently than one requiring a several-step assembly and disassembly. At first, this might seem like a minor point, but the process of setting up and breaking down the instrument looms as a much bigger factor once the initial euphoria of the new telescope has worn off. The "paraphernalia effect" makes the pieces seem to grow larger and more awkward each time the telescope is transported to the observing site -local or remote. Frequently, the solution is two telescopes: one suited for the lessthan-ideal local site and another for use at a remote dark site.

REMOTE OBSERVING SITE

Few people live where sixth-magnitude stars are visible from their backyards. Most amateur astronomers must hunt for such a site, and reaching it can be an expedition if you live in or near a city of more than a million people. A 90-minute drive simply to get a reasonable view of the Milky Way is, unfortunately, a commonplace experience.

Well outside the city, there are still obstacles. More and more homeowners have installed dusk-to-dawn security lights that pump light horizontally into the corner of a sky observer's eye perhaps two miles away. But beyond the aggravation of rural farm and home lighting is the question of where to observe from once you are in the country.

Stopping on an infrequently traveled country road is fine for binocular gazing, but it's less than ideal for setting up equipment that cannot be retrieved and put in the car in a matter of seconds. There is the slight but very real possibility of being mistaken for a trespasser or some other form of law-

breaker. Amateur astronomers tell horror stories about being routed by suspicious landowners (who can blame them?) or, worse, by a carload of troublemakers.

Heading out on your own and driving country roads in search of a good dark site from which to observe an aurora, a meteor

shower or a bright comet is always a gamble. But sometimes, it is the only way —especially in the case of a comet that is situated near the horizon or some other specialized celestial quarry that needs specific viewing geometry. In general, though, a predetermined safe and dark site, free of

intruders, should be a long-term goal. Begin with inquiries at the local astronomy club, or if there is no club, ask other amateur astronomers in the area. Find out where they go for dark skies. They may have a private observatory at an ideal location, or perhaps they have found a state park or a campPlanets From the City ▼ On May 3, 2002, Dan Falk recorded all five naked-eye planets over Toronto. From bottom right to upper left: Mercury, Venus, Mars above Saturn, then Jupiter. site that has an area perfect for stargazing.

What constitutes an ideal observing site? The Milky Way should be distinctly visible. Under the very best conditions, the Milky Way has a textured appearance to the naked eye, with many levels of intensity and obvious rifts from dark nebulas. Third-magnitude

stars should be visible less than five degrees from the horizon, and binoculars should reveal stars right down to the true horizon. It is almost impossible not to have at least one dome of light somewhere on the horizon from a nearby town or a more distant city, but if the largest such dome is toward the celestial pole (north, in the northern hemisphere), it will be least annoying. Objects in that direction are visible near overhead two seasons later.

The specific terrain of the observing site can influence sky conditions as well. Snow cover is the worst situation, not just because it is cold but because it reflects light. Even if there is little light pollution, the starry sky itself illuminates the ground. When that light is reflected back toward its source, it illuminates the dust and moisture particles in the atmosphere from below. Observing sites under a blanket of snow rate at least half a magnitude worse because of this reflectedskylight effect. Cold, crisp nights may look good on first inspection, but the overall brilliance of northern winter nights is partly an illusion caused by the brightness of Orion and its star-rich neighbor constellations.

The ideal dark site is an isolated, slightly elevated clearing in an area with fairly heavy vegetation: dense grass, scrub shrubbery or trees or a combination of these. Coniferous vegetation is preferable to leafy trees because the former releases less moisture (i.e., dew) into the atmosphere. A further advantage is the skylight-absorbing qualities of dark vegetation. A thick ground cover also acts as an insulating blanket, slowly releasing the ground's heat at night and protecting it during the day from soaking up as much heat as would bare ground.

Deserts may seem to be an ideal place from which to observe, and in one important respect, they are: lots of dry, dew-free, clear nights. But pale desert soil has undesirable skylight-reflecting qualitics, and the large day-to-night temperature fluctuations in arid areas can work against a stable atmosphere. The sky may be clear, but layers of convection turbulence can affect the stability of high-resolution planetary images. Also, a wind-prone desert site and its associated dust can put an end to an otherwise clear observing session. All that being said, we have had many outstanding observing experiences in Arizona, California, Utah and

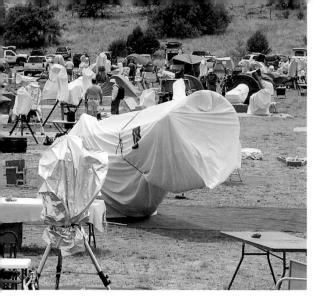

New Mexico. The chief attraction is the percentage of clear nights, which is easily double what we enjoy at home.

CONVENTIONS AT DARK-SKY SITES

One significant sign that recreational astronomy has come of age is the explosive growth in observing conventions at good dark-sky sites. The agenda is to have fun observing and interacting with fellow amateur astronomers. Until the 1970s, there was only one main convention, Stellafane, in southern Vermont. But in North America today, there are at least a dozen major conventions and another three dozen that each attract 100 enthusiasts or more. One of them should be within driving distance.

Stellafane was the first and is still the best-known meeting of amateur astronomers in North America. Each summer, several thousand people gather for a weekend atop a granite knoll named Stellafane, shrine to the stars. The convention has grown from a tiny gathering of 20 enthusiasts at its first meeting in 1926 to crowds of up to 3,000 who swarm over the rocks, bulge out of the lecture tent and devour thousands of hamburgers and hot dogs while examining the display telescopes with gem inspectors' eyes and, undoubtedly, a certain amount of envy. During the convention, which runs from Friday evening until early Sunday morning, telescopes are set up to be judged for optical and mechanical performance. Other telescopes are assembled for viewing purposes alone. At one time, Stellafane was a magnificent dark site, but as is happening almost everywhere, encroaching urbanization is beginning to take its toll on the once pristine skies. However, the skies still rate a "B."

Unlike Stellafane, most amateur-astronomy conventions at favorable observing sites are of recent vintage. Some trace their roots to the tireless efforts of a single enthusiastic individual, such as the late Cliff Holmes, the driving force behind the Riverside convention held each May near Big Bear Lake, northeast of Los Angeles. Called the RTMC Astronomy Expo (formerly the Riverside Telescope Makers Conference), it now centers around commercial vendors, with telescope making a side attraction. Prominent amateur astronomers give talks on observing techniques, astrophotography and the use of equipment. The big drawing card, however, is the vendor area in which all major telescope manufacturers are represented, many with discount offerings. (Commercial exhibits are still prohibited at Stellafane.) The night skies are hindered by the glow from the L.A. basin, but the altitude makes up for part of it, providing "B+" conditions overall. (The convention is always held on the Memorial Day weekend, so the Moon interferes some years.)

Another big annual astronomy meeting is the Texas Star Party, held since the late 1970s in May at the Prude Ranch in southwest Texas, near Fort Davis. It lasts for one week and is a 2½-hour drive from Midland or El Paso, the nearest good air services, but it is the meeting with the greatest potential rewards for dark-sky-hungry backyard astronomers. The southern latitude (31 degrees north) and the site's extreme isolation from major urban areas provide some of the best skies in North America. It merits a dark-sky rating of "A+."

Telescope City

By day, telescopes at star parties look like fields of ghosts, as the instruments remain shrouded, protected from the Sun, dust and rain. Only at nightfall are they unveiled to explore the sky. Here, we see the main telescope field at the Texas Star Party, held each year at the Prude Ranch in west Texas.

▼ Equipment New and Used Although Stellafane has never permitted commercial exhibits, all other amateur astronomers' conventions feature them prominently. Both used and new equipment are offered for sale, sometimes at bargain prices. The images below were taken at the 2007 RTMC Astronomy Expo.

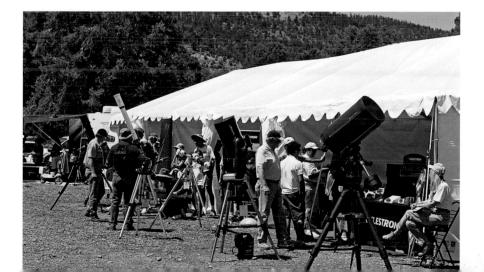

Astrofest and the Prairie Skies Star Party, both held in September in central Illinois, are major conventions at campsites with good observing conditions (skies"B"). These

Stairway to Heaven ▲ Star parties offer memorable views through telescopes far larger than most of us are willing to transport. Here, Australian observer John Bambury gets his first ever look at the Whirlpool Galaxy through Larry Mitchell's 36-inch Dobsonian at the Texas Star Party. Photo by Alan Dyer. weekend meetings have become the largest amateur-astronomy conventions in the Midwest, with an excellent range of astronomical equipment displayed by both amateurs and commercial exhibitors.

Other meetings at fine dark sites that draw large crowds are the Winter Star Party in the Florida Keys in February (skies "B," with excellent seeing); the Black Forest Star Party in north-central Pennsylvania (skies "A"); Starfest, near Mount Forest, Ontario, in August (skies"A-"); and the Saskatchewan Summer Star Party in southwestern Saskatchewan in August (skies "A"). Information on these and other meetings can be found on the websites of the major astronomy magazines, or just Google the star-party name for the party's own website.

LIMITING-MAGNITUDE FACTORS

How faint are the dimmest stars visible through a telescope? It depends on much more than just the instrument's aperture. Factors include seeing, the transparency of the atmosphere at the observing site, the quality of the telescope's optics, their cleanliness, the type of telescope, its magnification, the observer's experience and use of averted vision and the type of celestial object being viewed.

Many amateur-astronomy guidebooks deal with limiting magnitude in one or two short paragraphs and a table. The table lists a telescope aperture and a corresponding limiting magnitude, not taking into account many of the factors mentioned above or clarifying which factors are considered. In our table of Telescope Performance Limits on page 55, the magnitudes listed are based on good-quality optics, transparent dark skies and a reasonably experienced observer looking at a stellar object at high magnification, 20x to 30x per inch of aperture. If any of the conditions are not met, expect to see less for the reasons mentioned below.

An experienced observer can generally see a magnitude fainter than can a novice. Hundreds of hours of observing through a telescope train the eye to detect threshold detail, whether it is definition of features on a planet or the subtle wisps of a nebula. Of all factors, experience is the most important. Visual acuity varies from person to person, but the difference seldom amounts to more than half a magnitude.

Young people's eyes generally have slightly more sensitivity to objects at the threshold of vision, but veteran observers who are in their fifties or older can usually come within two-tenths of a magnitude of eyes 30 years younger. The ability of a youthful observer's eyes to dilate to 7mm or 8mm, compared with 6mm or less for more senior eyes, has no bearing on the equation—higher magnification, which reveals fainter objects by darkening the sky background, is achieved by smaller exit pupils.

One of the many long-standing assumptions of backyard astronomers is that faint deep-sky objects are best seen at low magnification operating at maximum exit pupil. While this does apply to some large, diffuse nebulous objects, it is completely untrue when viewing faint stars.

Even on the darkest nights, the sky background is not black but gray. At low power, more sky is included in the view, so the overall brightness of the background sky actually increases as magnification decreases. Conversely, the sky background can be darkened by increased magnification —up to a point, of course. Magnification beyond 50x per inch of aperture seldom produces any further advantage.

Simply stated, the advantage of high magnification is that the sky background is darkened while the apparent size of the star image stays the same or is only marginally increased. A point source on a blacker background is easier to detect. Visual acuity is enhanced at higher magnification as well. Above 25x per inch of aperture, the exit pupil is down to 1mm or less, so the light cone, if centered on the eye's pupil, is passing through the most optically perfect part of the human vision system.

Everyone who has looked through a telescope is familiar with the effects of poor seeing, manifested as ripples on the Moon or undulations distorting the face of a planet. Stars and deep-sky objects are affected by seeing as well. Tiny stellar point sources are fuzzy and distorted at high power, and their light is spread out rather than concentrated into as small a point as possible, as it is with good seeing. Faint stars at the threshold of vision are significantly easier to detect in perfectly steady air than under turbulent, poor-seeing conditions. Bad seeing can remove a full magnitude from the penetration limit of a steady-air night.

Do different types of telescopes have different magnitude-penetration limits? Yes, but there is not much variation. It depends more on quality of optics than on the type of telescope. High-quality optics yield pinpoint star images instead of the tiny puffballs that never quite come into focus in mediocre telescopes. The more a star's light is concentrated into a point, the easier the point is to see; the star's per-unit surfacearea brightness is higher than when its light is spread out by poor-quality optical systems or improperly collimated optics.

Finally, what about the unaided eye? The standard naked-eye limit for most people is sixth magnitude. In rare instances, under superb skies, people with abnormally good vision can see to 7.0 and even 7.4. Typically, the limit is 6.5, but it depends on the specific sky conditions. Binoculars are more limited ▼ Visual-Magnitude Limits Ursa Minor, the Little Dipper, is an ideal eye chart for determining your naked-eye magnitude limit. Use the clearest, darkest night at your favorite site to establish your limit. Star magnitudes are shown with the decimal point omitted to avoid confusion with star images. Inset chart can be used for binoculars.

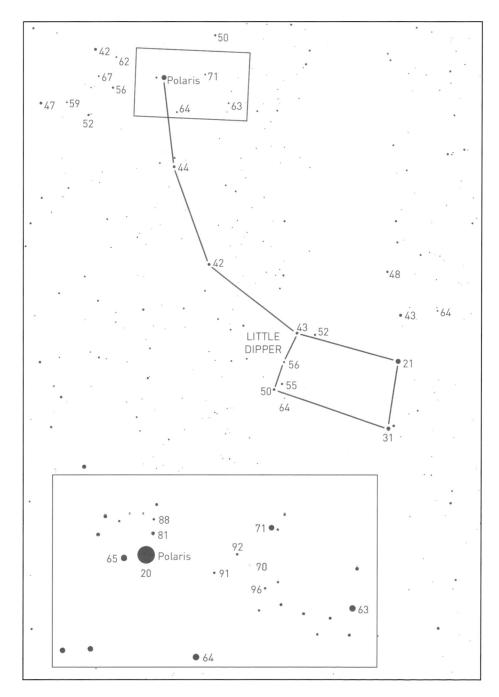

169

Telescope Limit ▲ On a clear moonless night, use this chart of the star cluster M67 to determine the limiting magnitude of your telescope. Magnitudes are given in tenths, with the decimal points omitted. For orientation, north (toward Polaris) is at top. Base photo by Martin Germano.

Calgary Clear Sky Clock working the second second

> Clear Sky Clock ▲ An essential tool for North American observers is Attilla Danko's website, www.cleardarksky.com, and its Clear Sky Clock. Here, you'll find predictions for cloud cover, transparency, seeing and humidity for thousands of sites.

than telescopes of the same aperture because of their fixed low power. It is an achievement to reach magnitude 9.8 with standard 50mm binoculars and 10.8 with 80mm glasses.

THE DARKEST SITES IN THE WORLD

By this, of course, we mean the darkest *accessible* sites in the world. If you can't get there with your telescope and other observing equipment, the main point is lost.

We also impose one other restriction: altitude. For most people, higher altitude causes some dizziness and breathing difficulty. Just as important, though, reduced oxygen above 9,000 feet begins to have a negative impact on dark adaptation—you slowly lose the ability to detect faint objects at night. For instance, on the 14,000-foot summit of Hawaii's Mauna Kea, which is dotted with giant observatories, the sky to the naked eye looks less starry than at the 9,000-foot level.

Thus our definition of a truly great darksky site is one that is located at an altitude of between 3,000 and 9,000 feet, with an arid low-humidity climate, well away from sources of light pollution and accessible by paved road. (Lengthy treks on dirt roads raise intolerable amounts of dust that inevitably coat your optics and work into your mount and drives.) Well-known sites that

Averted Vision

Averted vision allows the observer to pick up fainter objects than can be seen by looking directly at them. The technique is simple. Look slightly away from the object under study while continuing to concentrate on it. Averted vision is most effective if the observer looks at a point halfway from the center to the edge of the field of view (the object in question is presumably at the center). The technique works especially well for diffuse objects such as comets, nebulas and galaxies, but it helps reveal fainter stars too.

It is a good practice to use the averted-vision technique from a variety of angles, because the highly effective dim-light sensors in the peripheral areas of the eye have different sensitivities. The overall gain achieved with averted vision can amount to more than half a magnitude. However, most backyard astronomers do not consider a sighting to be definite unless it is seen with direct vision. A notebook may read: "Glimpsed with averted vision but uncertain with direct vision." Such an observation is usually regarded as "probable." Definite sightings of faint objects need to be at least "apparent with averted vision and glimpsed directly."

The chief advantage of averted vision is gaining initial awareness of the existence of a threshold object. Then, once the target is detected, vision can be concentrated on it to attempt a direct confirmation.

fit this description are sectors of Australia, Chile, the American West and Southwest, parts of Hawaii, British Columbia and Alberta. These locations are home to some of the largest research observatories on the planet. We have observed from all of them.

However, even the most well-heeled enthusiast can't go flying off to a world-class site for every observing session. A good site close to home is the first priority. To place comparisons of observing sites in perspective, we first need to examine the factors affecting all sites.

• Natural sky glow. No matter where you are on Earth, the night sky has a natural brightness, a gray luminance that becomes obvious to fully dark-adapted eyes. Three sources cause natural sky glow: (a) zodiacal light (sunlight reflected off dust particles that orbit the Sun in the plane of the solar system); (b) the atmosphere's permanent low-level auroral glow, which varies with solar activity; and (c) illumination of the Earth's atmosphere by starlight. Natural sky glow is a given; it's always there.

• Atmospheric extinction. Small particles in the air scatter and absorb light coming to our eyes from celestial objects. Chief among these are dust and water vapor (humidity). The illumination of these particles by sources of light pollution accounts for most of the sky glow seen from the average observing site. Even assuming no light-pollution interference, the absorption factor amounts to at least 0.3 magnitude at a site near sea level and 0.15 magnitude at an altitude of 7,000 feet. This assumes an arid site. A typical site in eastern North America loses another 0.2 magnitude to atmospheric extinction from higher average humidity (added water vapor in the air compared with arid sites).

At superb sites, such as the Atacama Desert in Chile and the best locations in the American Southwest, all these factors add up to a loss of one-third to one-half magnitude compared with observing from, say, the space shuttle. This has been confirmed by astronomer-astronauts who have made careful visual comparisons between views from the space shuttle and those from the finest Earth-based sites.

There are many locations across North America, however, where experienced observers, whose feet remain firmly on the

The Magnitude Scale

The brightness of a star—its magnitude—is rated on a scale that runs backward to what might be expected. The brighter the star, the lower its magnitude number. A difference of five magnitudes in brightness is equal to a brightness difference of 100 times.

Magnitude	Celestial Object
-27	Sun
-13	Moon
-4.2	Venus at its brightest
-2.9	Jupiter at its brightest
-1.4	Sirius (brightest star)
0 to +1	The 15 brightest stars
+1 to +6	The 8,500 naked-eye stars
+6 to +8	Deep-sky objects for binoculars
+6 to +11	Bright deep-sky objects for amateur telescopes
+12 to +14	Faint deep-sky objects for amateur telescopes
+15 to +17	Objects visible in large amateur telescopes
+18 to +22	Objects visible in large professional telescopes
+24 to +26	Faintest objects imaged by largest ground-
	based telescopes

ground, have confirmed that the legendary sites don't have a monopoly on the best skies on this planet. For example, observers and astrophotographers in the American Southwest don't all swarm around Palomar Mountain in California or Kitt Peak in Arizona on clear nights. They know there are many accessible places in these states that compare favorably to Palomar and Kitt Peak. Some are even better. The key is light pollution—or, more precisely, avoiding it.

On the North America light-pollution map on pages 164-165, all the black and dark gray regions are excellent hunting grounds for skies of pristine quality. Admittedly, there are no black or dark gray zones within an easy drive of the lightsaturated Boston-Washington megalopolis or within well-populated states in the Midwest, such as Illinois, Indiana and Ohio. Conversely, note that parts of Arizona, Texas and New Mexico are darker than Kitt Peak Observatory. By using this map, you can be prepared when you travel to areas of lower population density. C H A P T E R N I N E

Observing the Moon, Sun and Comets

The Moon and the Sun were probably the first celestial objects Galileo looked at with his telescope four centuries ago. The excitement that he must have felt as he gazed at the Moon's rumpled face for the first time is part of the legacy of the telescope as an instrument of exploration. Even in the crude 32x instrument, crippled by nearly every aberration known to optics, Galileo still saw features never before observed or imagined: craters on the Moon and spots on the Sun.

So it is today. Sunspots or lunar craters are usually the first details brought to the focus of a new telescope. Many newcomers to recreational astronomy are surprised to learn that all the lunar details visible in the image at right can be seen in the eyepiece of a modern entrylevel telescope.

Using a digital camera, Gordon Bulger took five images of sections of the last-quarter Moon, then "stitched" them together into this seamless single highresolution image.

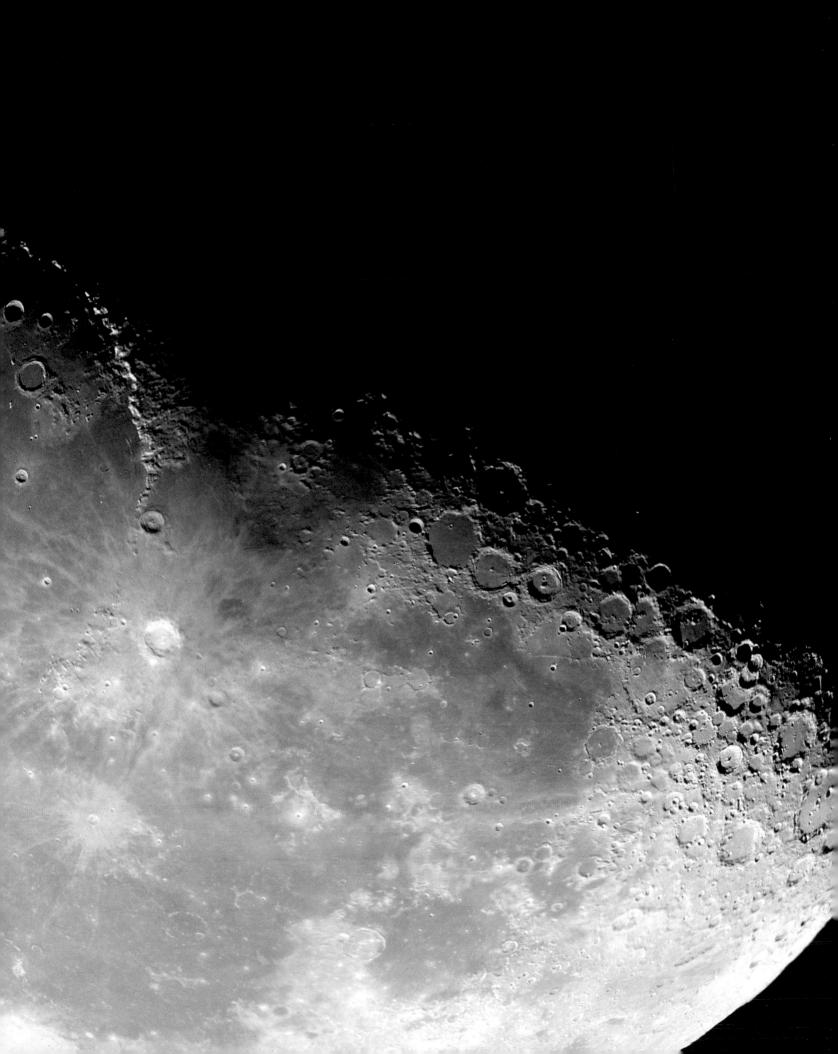

Lunar Observing

Everybody's first look at the Moon through even the simplest of optical instruments is instantly rewarded by a wonderfully detailed image of our nearest cosmic neighbor. The eye and the mind are overwhelmed by detail—wrinkled plains, rugged fields of craters jumbled together, mountain ranges, valleys—all in stark relief, undistorted by even a wisp of haze or fog or mist (on the Moon, that is). The Moon is so close, its features are so easily visible and the detail is so abundant that even with poor seeing, there is always something of interest to examine.

Today, telescopic observation of the Moon is limited almost exclusively to introductory observing and to showing off the wonders of the universe to people who rarely have an opportunity to look through a telescope. Along with Saturn, the Moon is the number-one showpiece object—near, yet clearly alien. Without an atmosphere to protect it, the surface of the Moon has been bombarded for billions of years by meteorites, comets and asteroids—debris left over from the formation of the solar system. Its cratered face is testament to this. On a smaller scale, the powdery material kicked up by the Apollo astronauts is the result of micrometeorites that grind down the surface into fragments as fine as dust.

As recently as the early 1960s, the lunar surface still had many secrets to divulge to backyard astronomers. By the late 1930s, much of the Earth-facing side of the Moon had been photographed to a resolution of two kilometers, and a few exceptional pictures showed features near the shadow line, or terminator, to a resolution of a few hundred meters. But unlike time exposures of deep-sky objects, which reveal far more detail than the eye can see through the same telescope, Earth-based lunar photographs always showed less. Exposures of 1 to 2 seconds, typical of high-resolution lunar photography, are somewhat degraded by the Earth's atmospheric turbulence. (By high resolution, we mean close-up images of small areas of the Moon, rather than fulldisk images.)

Even today, lunar photography has a tough time equaling what the eye can see through the same telescope. It takes good

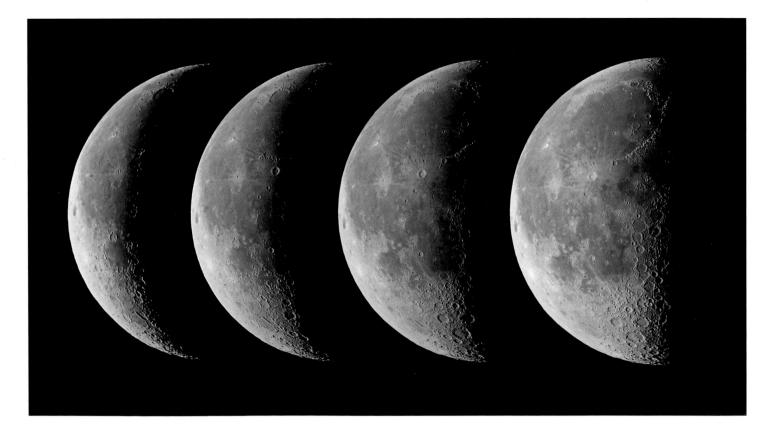

Moving Terminator ▼ The dividing line between the sunlit side and the nightside of the Moon moves across the lunar face from night to night, placing new features along the terminator region, where long shadows reveal the most detail. This series of images was taken on four successive nights as the Moon waned from last quarter to crescent. Photos by Alan Dyer. seeing and stacking techniques with a webcam or a CCD camera to match what the eye can discern. The experienced observer can watch for the momentary flashes of perfect seeing that occur during typical observing situations. At such times, resolution of better than two kilometers is commonplace in a 6-inch scope, and occasionally, amazing amounts of fine detail almost magically emerge. But you have to wait for it.

IS THERE ANYTHING LEFT TO DISCOVER?

Today, the vast majority of backyard astronomers regard the Moon as little more than a source of natural light pollution—a celestial nuisance whose light spoils views of dimmer objects. Other than as a showpiece for relatives and neighbors, the Moon is seldom deemed a worthy telescopic subject. The reality is, too many amateur astronomers have been duped by the notion that if there is nothing new to discover, there is no point looking. The Moon is a wonderland of alien landscapes; to see them, the observer needs to know *how* to look more than what to look for.

A high-resolution photograph of the Moon gives only an inkling of the truly impressive views that are possible with even moderate-aperture telescopes. Indeed, lunar observing is probably the one case in which aperture works almost in reverse-less is sometimes better than more. The Moon's image is so bright that even small apertures used at very high powers provide enough light to show the displayed features clearly; when using apertures greater than 6 inches, what can be seen is limited not by the telescope but by the steadiness of the atmosphere. Of course, at exorbitantly high powers—more than 60x per inch of aperture the image often becomes fuzzy because of the limits of resolution of the optical system. As a general rule, however, the Moon can be viewed with higher magnifications than any other celestial object.

For instance, we have used a 5-inch apochromatic refractor up to 450x for lunar observation. However, the most common lunar-observation magnification used with that telescope is 220x, and the images are sharp and detailed—the equivalent of looking out the porthole of a spacecraft orbiting the Moon at an altitude of 1,600 kilometers. With such a telescope on a solid, smoothly driven equatorial mount, our satellite becomes a fascinating world to explore. The crawling terminator alters the appearance of the features in deep shadow within minutes, and in fine seeing, it is possible to distinguish every feature shown in the best lunar atlases.

What will keep drawing you back to the Moon, though, is the exquisite beauty and the barren alien nature of the lunar surface, which constantly changes with the continuous sweep of the terminator.

EQUIPMENT FOR LUNAR OBSERVING

At first glance, the telescopic image of the Moon is often overwhelmingly bright. But the glare is easy to control with a lunar neutral-density filter (about \$15), which screws into the base of a 1.25-inch eyepiece in the same way that deep-sky and color filters do. The neutral-density filter blocks 90 percent of the light passing through it yet affects the image in no other way. This low-tech accessory reduces lunar glare to a comfortable level on most scopes.

Another way to reduce brightness is to use a twin polarized filter (about \$40), sold as two separate 1.25-inch filters or, better, as two filters in a housing that fits on top of the eyepiece. An adjusting lever varies the amount of polarization between the dual filters, regulating the quantity of light entering the eyepiece from 50 percent to less than 1 percent. It works well for casual scanning, but the critical observer will notice a slight loss in resolution that does not occur with a single neutral-density filter. However, for casual lunar observing, the variable polarizer is an easy way-sometimes the only way besides extreme magnificationto reduce the Moon's brilliance in a large telescope to a satisfactory level.

A more serious glare-reduction device, advantageous with 10-inch and larger Newtonians and Schmidt-Cassegrains, is an offaxis diaphragm. Placed over the front of the instrument, it's a simple cardboard or metal mask that has a one-third-aperture hole —precisely circular and smooth-edged located toward the edge, where it will not be obstructed by the secondary mirror or its support vanes.

▲ Sketching the Moon A rendering from the 1970s of the region around the 40-kilometer-wide lunar crater Aristarchus captures abundant subtle detail on the Moon's sunrise terminator. Amateur astronomer Matthew Sinacola used 175x on his 6-inch Criterion Newtonian reflector.

🔺 Plato's Craterlets

A traditional test of good optics and steady seeing is to examine the floor of the crater Plato for craterlets (the largest is about three kilometers wide) when the Moon is one or two days past first quarter. Webcam image stack by Mike Wirths.

Colossal Clavius 🔺

A favorite target for lunar observers using any size telescope is the giant crater Clavius, at 225 kilometers across. The smallest features visible in this webcam image stack taken through an 18-inch Newtonian are about one kilometer wide, generally considered the limit for visual observers and Earth-based imaging. The largest crater within Clavius is 50-kilometer-wide Rutherford; the large crater at lower left is Blancanus (105 kilometers across). Photo by Mike Wirths.

Off-axis diaphragms reduce the amount of light entering through a telescope to about 13 percent of the full-aperture value, similar to the reduction obtained when using a standard neutral-density filter. Because the aperture is now unobstructed like that of a refractor, contrast is enhanced, a definite bonus for lunar viewing.

Some lunar observers who use achromatic refractors prefer color filters. The favorites are green, deep yellow and orange. These inexpensive color filters have the advantage of dimming the Moon while greatly reducing chromatic aberration and thereby sharpening the view. The overall color cast is soon easy to ignore. Color filters have no advantage over a neutral-density filter in other types of telescopes.

PROBING LUNAR VISTAS

Anyone who has offered views of the Moon to the general public at stargazing events or to friends has heard the question, Can we see where the astronauts landed? The answer is, yes and no. The location can be pinned down by using a lunar map, but what the person really wants to know is whether it's possible to see the footprints, lunar lander and other paraphernalia left on the surface. A good way to answer is to point out that the smallest crater visible under ideal conditions in a large telescope is several times larger than the biggest sports stadiums in the world, whereas the largest piece of hardware left by the Apollo astronauts is smaller than a two-car garage.

The likelihood of seeing any changes on the Moon—a meteorite hitting the surface, for instance, or possible volcanic activityis infinitesimally small. A meteorite large enough to produce a cloud of ejecta visible from Earth would strike the Moon no more than once or twice a century-at least on the daytime areas. The lunar nightside is another matter. During the heavy Leonid meteor showers in 1999 and 2001, low-light video cameras viewing through moderateaperture telescopes recorded impact flashes on the lunar nightside. These were caused by meteors perhaps the size of tennis balls. It would take a much larger object to create a visible flash on the lunar dayside. In any case, none have been recorded.

A few decades ago, a small band of enthusiasts maintained that searches for socalled transient lunar phenomena (clouds of dust that could arise with the release of gases from the Moon's interior) were viable observing programs for backyard astronomers. However, there's no unequivocal proof that this type of activity has ever been observed.

Solar Observing

Examining the intensely brilliant surface of the Sun is possible only with proper filtration. Never look at the Sun through any optical device unless you are sure that it is safely filtered and you know what a safe filter is. A very dense filter is necessary. It must not only reduce all visible wavelengths to a safe level but also block infrared and ultraviolet light. This is serious stuff. These invisible wavelengths can damage the retina of the eye and, in extreme cases, cause partial or complete blindness. *Do not take chances*. Astronomy is a benign hobby with few opportunities for personal injury. But this is one of them. Read the following carefully. Over the years, especially around solareclipse events, many materials have been recommended as solar filters. Most are unsafe. Do *not* use smoked glass, sunglasses, layers of color or black-and-white film (no matter how dense), photographic neutral-density filters or polarizing filters. People have even been known to look through the bottoms of beer bottles. This seems laughable, yet many novice amateur astronomers use a type of solar filter that is far more dangerous than anything listed above.

The filter in question, which comes with many small department-store telescopes—

especially older models picked up at garage sales—is a piece of dark green glass that screws into the bottom of an eyepiece. Such "sun filters" are unsafe because they sit at the focus of the telescope, where all the light and heat are concentrated. When the instrument is aimed at the Sun, the temperature near the filter can reach hundreds of degrees, cracking it and letting in a blinding wash of sunlight. Eyepiece solar filters are rarer than they once were but are still included as an accessory with some small telescopes given to children for Christmas

The simplest, safest and most readily available filters for gazing at the Sun with unaided eyes are No. 14 welders' filters. They are sold in two-by-four-inch rectangles for a few dollars at well-stocked weldingsupply outlets. Because the filters are made to exact specifications for the welding trade, they are reliable and have the right density to be completely safe. Only the No. 14 grade is appropriate; the more common No. 12 welders' filter is too light.

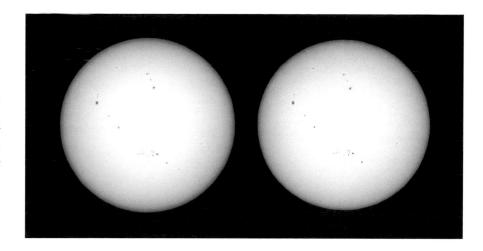

To observe the Sun with a No. 14 welders' filter, place the filter in front of your eyes before you gaze up at the Sun. Individuals with 20/20 vision or better will see sunspots that are Earth-sized or larger. People with exceptional vision, 20/12 or better, can see spots almost daily with no optical aid other than the welders' filter.

A pair of seldom-used binoculars can become a permanent sunspot device if two welders' filters are securely taped over the front of the main lenses. Spots the size of Asia can be seen. However, for detail on the spots, a telescope is needed. A 60mm-to-80mm refractor is ideal and, if properly filtered or used for projection, reveals a wealth of fine structures in and around sunspots. Sunspot Observations

For full-disk solar viewing -either projection or filtered—a small, inexpensive refractor will do the job. To prove it, Bob Botts took these identical photos (above) with two 70mm refractors, one worth \$150, the other 10 times as much. The image of a sunspot at left was taken with a 70mm apo refractor. The superb close-up (below), taken with front-line research equipment, shows impressive detail. Courtesy SSVT.

Solar Filter 🔻

The only safe solar filters for telescopes are the ones that fit over the front of the instrument. They can be made of metal-coated glass or, as here, Mylar.

Solar Projection ▼ Done with care, an unfiltered telescope can be used to project the Sun's image onto a white card. This is best done with low-cost eyepieces, as the heat can damage eyepiece coatings.

SOLAR VIEWING BY PROJECTION

Solar projection is the filterless way of observing the Sun. Aim the telescope at the Sun by watching the instrument's shadow, not by gazing up the tube at the Sun and especially not by peeking into the finderscope. (Always cover the front of the finderscope during any solar observing.) When the telescope's shadow becomes circular, the telescope is aimed approximately sunward. Now hold a white card a foot behind the eyepiece to catch the Sun's image. Using an eyepiece yielding about 30x, focus the projected image. This method is ideal for group observing and is particularly effective if the white card is mounted on an easel or a tripod and shaded from direct sunlight to increase contrast. However, the detail visible in direct filtered viewing cannot be equaled.

Even so, projection is preferred for making full-disk drawings of sunspot positions and their relative sizes. For orientation consistency, determine the celestial east-west axis for each drawing by watching the solar disk drift into or out of the undriven field of view. The centerline of the drift motion is celestial east-west. A few months' worth of drawings reveal fluctuations in the numbers of spots. Small spots may last several days or grow into large spot groups and stay on the solar face for weeks. Because of the 3½-week solar-rotation period, the scene changes a little every day and a great deal in a week.

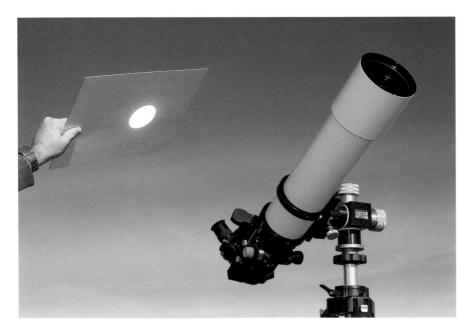

For projection, the telescope's aperture should be limited to 80mm or less to avoid damage to the eyepiece. Small refractors are ideal; larger telescopes must be covered with a diaphragm. A hole in a piece of cardboard covering the aperture works fine for refractors or Newtonians, but never practice solar projection with a catadioptric telescope (Schmidt-Cassegrain or Maksutov-Cassegrain). Heat quickly builds up inside these instruments before you are aware of a problem, causing unwanted seeing effects or even damaging the telescope.

Sunspots wax and wane in an 11-year cycle. The last maximum was in 2001. Solar activity continues throughout the cycle, and there are usually a few spots no matter when you look. A surprising amount of detail is visible around a large sunspot and is best seen by direct viewing with the appropriate filter.

SOLAR FILTERS FOR TELESCOPES

A proper solar filter, known as a full-aperture filter, or prefilter, is made to fit snugly over the front of your telescope, where it safely reduces the intensity of sunlight before it enters the tube. The most durable are made with optical plane-parallel glass coated with a nickel-chromium alloy. Thousand Oaks Optical is one of the major suppliers of these filters for any size telescope. Prices range from \$50 for a 60mm refractor to \$150 for a 12-inch Schmidt-Cassegrain.

Metal-coated thin Mylar film, a sturdy plastic material that is about the thickness of shrink-wrap, is an alternative to the glass filter. The Mylar must be in a cell that is press-fit over the front of the telescope. Several telescope manufacturers make these filters, or you can make your own from a piece of the filter material, available as a stock item from large telescope dealers. We have found that the Mylar filters equal or exceed the optical quality of glass filters. This is especially true for the Baader solar-filter material, which revealed the sharpest sunspot detail in our tests with 4-inch apo refractors. As you would expect, you pay a premium for a filter made from the Baader material.

Some Mylar filters impart an unnatural blue cast. This characteristic is correctable with a No. 23A eyepiece filter, commonly used for Mars observations, which absorbs

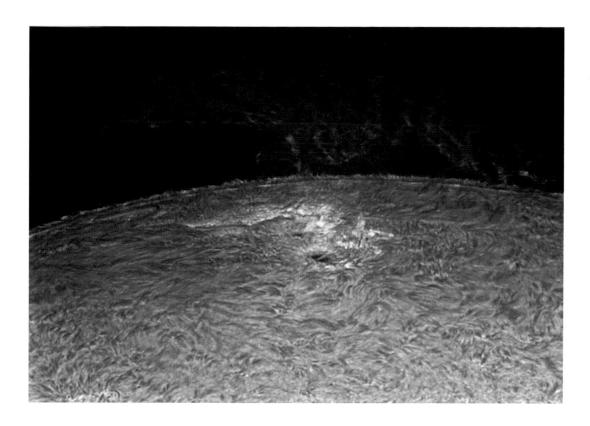

the blue and gives the solar disk a yellow cast. Most metal-on-glass types also present a more natural-looking yellow Sun.

Another word of caution: Not just any Mylar will do. Do not run out to your local hardware or automotive-supply store to buy sheets of Mylar for homemade filters. Most metallized Mylar sold for use on van and camper windows and incorporated into materials like "space blankets" is unsafe for solar viewing. It is not dense enough and does not necessarily block harmful infrared and ultraviolet light. Use only filters sold specifically for astronomical applications by telescope manufacturers. With them, you and your friends and family can watch sunspots for hours in complete safety.

All the solar filters discussed so far show the Sun in white light; that is, they reduce the amount of light across the entire spectrum. A very specialized type of solar filter eliminates all light from the Sun except the single wavelength emitted by hydrogen atoms—656 nanometers. When the Sun is viewed in the light of hydrogen atoms, previously invisible features appear, such as solar prominences, filaments and flares. Prominences are normally seen only during a total solar eclipse. With a Hydrogen-alpha filter, they are visible on any cloudless day.

H-alpha filters add a new dimension to the hobby of astronomy, but they are expensive. They run between \$700 and \$10,000, depending on the aperture and bandwidth. The most common sizes have apertures of 40mm to 90mm and work best on refractors in the same range. Coronado and Daystar are the principal manufacturers. Because seeing in the daytime is poorer than seeing at night—owing to solar heating of both the air and the ground, a double whammyfilter apertures over 90mm have a diminishing advantage. Also, H-alpha filters are more fragile than typical astronomy accessories. Always transport them with care and lots of foam protection.

▲ Jack Newton at Work Using a Coronado 90mm Hydrogen-alpha filter attached to a 5-inch refractor, Jack Newton captures amazing solar portraits with a Meade Pictor CCD camera. He takes two pictures—a short exposure of the surface and a longer exposure of the fainter prominences—then digitally stitches them together for the final image (left).

Coronado PST

The Coronado Personal Solar Telescope (PST) is a dedicated but affordable H-alpha solar scope. It can be tripod mounted for quick looks. Despite its 40mm aperture it provides excellent views of prominences.

Alan Rides a Comet ▲ Satisfied that he has conquered the final frontier, author Dyer stands atop a cometlike "dirty snowball" —the melting remnants of a winter's worth of parkinglot snow piled at the edge of one of North America's largest shopping malls.

The Great Hale-Bopp 🔻

Members of a 1997 college astronomy class watch with binoculars as the most readily visible comet since Halley's in 1910 graces the northeastern skies. Photo by Terence Dickinson.

Comets

Comets are agglomerations of ice impregnated with dust. Not glacier-type ice—more like a pile of dirty snow about the size of a small city. Comets orbit the Sun as the planets do, but in more exaggerated, elongated paths. When a comet ventures closer to the Sun, within the orbit of Mars, it becomes the quarry of the backyard astronomer. At this distance, sunlight heats the comet's icy surface, releasing gas and dust that are swept into a tail by the solar wind and the pressure of sunlight in the vacuum of space.

Apart from a few historical exceptions, comets are named for their discoverers. Comet Hale-Bopp, for example, was spotted on the same night in July 1995 by New Mexico comet hunter Alan Hale and amateur astronomer Tom Bopp of Arizona.

Comets that boast tails easily visible to the unaided eye are relatively rare, averaging two per decade. Of course, that is just an average. Two such comets were seen six months apart in 1957 and two others just 12 months apart in 1996 and 1997.

Halley's Comet, by far the most famous comet of all time, made its most memorable appearance in April 1910, when it reached first magnitude, sported a 30-degree tail

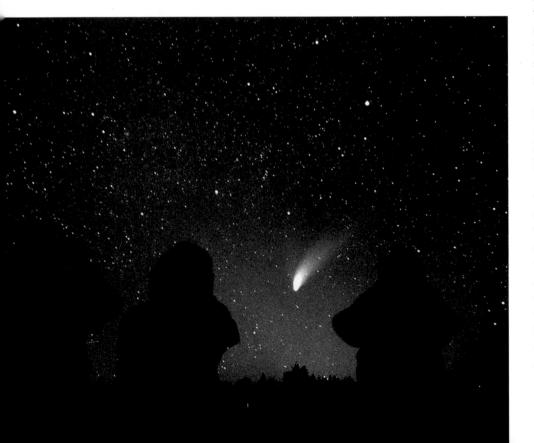

and was watched by millions. The comet's fame stems from its 76-year orbit, which closely matches the average human life span, making the feathery cosmic visitor a true once-in-a-lifetime event. Although astronomers correctly predicted its feeble return in 1986 (magnitude 3.5 at best in the northern hemisphere), huge crowds turned out whenever a science center or an astronomy club announced a public telescope viewing. The throngs came because of the name, and many went away disappointed with the reality. Even though correct brightness predictions were widely disseminated through the news media, we live in a celebrity culture, and Mr. Halley's comet is as big a celebrity as astronomy has.

BRIGHT COMETS: 1957 to 2007

Despite Halley's lackluster performance in 1986, the last 50 years have seen some remarkable comets. Two bright, naked-eye comets made nearly back-to-back appearances in 1957. The first, Comet Arend-Roland, became a brilliant first-magnitude object with a 15-degree tail during the last week of April. It was notable for its luminous antitail, a dust tail that, because of our perspective from Earth, appeared to extend from the comet's nucleus toward the Sun.

The second comet that year was Comet Mrkos, a first-magnitude object discovered with the unaided eye in twilight by a pilot on July 29. During the initial week of August, the comet was well placed in the evening sky and had an overall magnitude near 1 and a five-degree tail.

A respectable entry in 1962 was Comet Seki-Lines, which briefly reached third magnitude in the April evening sky and had a tail that was more than 10 degrees long when viewed through binoculars.

The brightest comet of the 20th century was Comet Ikeya-Seki of 1965, a member of a rare class of sungrazers that swoop to within one or two solar diameters of our star's surface. The explosive vaporization of the comet's ices during its rapid hairpin turn around the Sun generated a dense coma and a huge tail that made Ikeya-Seki visible to the unaided eye in broad daylight if the Sun was blocked from view. When only two degrees from the Sun, the comet was an astounding magnitude –10 and had a twodegree tail. As it swung into the morning sky during the last few days of October, an amazing 45-degree tail extended from a small but brilliant nucleus. Although Ikeya-Seki was stupendous in the southern hemisphere, it was poorly seen north of 40 degrees north latitude, because the tail was angled low toward the horizon.

Comet Bennett, discovered in December 1969 by John C. Bennett of South Africa during a deliberate comet search, was a conspicuous object in the evening sky in the northern hemisphere in April 1970. Shining at second magnitude overall and sporting a 20-degree-long tail, it was one of the first comets to be photographed extensively in color by backyard astronomers.

Three years later, the infamous Comet Kohoutek arrived. On March 18, 1973, Lubos Kohoutek of Germany's Hamburg Observatory discovered a tiny 16th-magnitude smudge—a comet—on a photograph he had taken two weeks earlier. Orbit calculations showed that the comet was still five times the Earth's distance from the Sun, heading toward its closest point to the Sun on December 28. In early January 1974, Comet Kohoutek would emerge into the evening sky near Venus and Jupiter.

How bright would it be? In September 1973, NASA published a guide to Comet Kohoutek that predicted the comet would reach magnitude –4, equal toVenus, making it the brightest dark-sky comet in four centuries. Astronomy enthusiasts were bursting with anticipation.

By December, it was clear that something was wrong. The so-called Comet of the Century was falling far below predictions. Even at its best, Kohoutek was no brighter than fourth magnitude, barely visible to the naked eye. The public, primed for a "blazing spectacle," saw nothing.

Comet Kohoutek taught astronomers a very sorry lesson: The brightness of comets can be unpredictable. In Kohoutek's case, it was a comet on its initial visit to the inner solar system from the Oort cloud, the comet reservoir beyond Neptune. As the comet warmed in its first exposure to solar heating, readily vaporized materials formed a cloud around the frozen comet nucleus at a huge distance from the Sun, giving the false impression that the activity would continue unabated closer to our star. Once

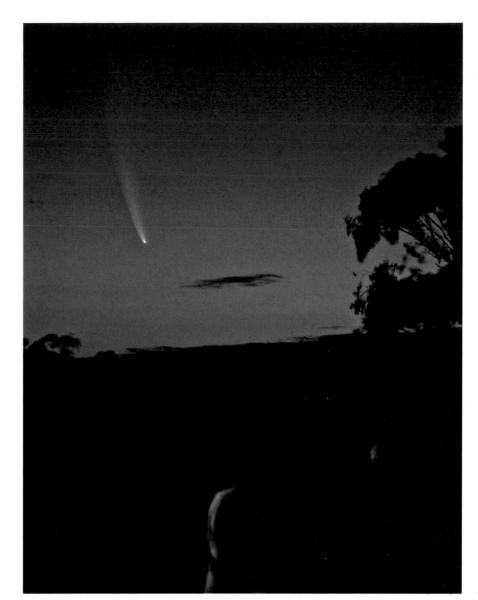

these materials had dissipated, however, the rate of brightening declined sharply.

Comet Kohoutek will always be remembered as the comet that fizzled. After Kohoutek, astronomers learned to be much more guarded about making brightness Taking the prize for the most outstanding tail seen in recent history is Cornet McNaught, in January 2007. Captured by Rick Twardy in Australia (above) and Andrew Drawneek in New Zealand (left), McNaught exhibited an astonishing banded tail that stretched like a windblown water fountain across more than 40 degrees of the evening sky. Celestial geometry gave southern-hemisphere observers the best show.

Tail of the Century

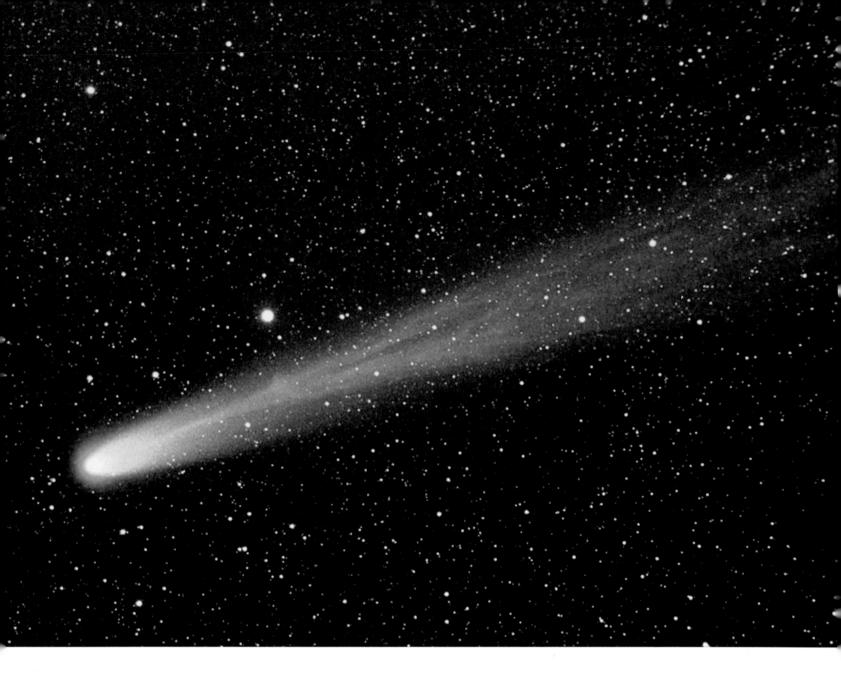

Comet Hyakutake 🔺 After a comet "drought" lasting a generation, Comet Hyakutake made a dramatic appearance in northern-hemisphere skies in the spring of 1996. Sporting a slender 55degree-long tail, it reached first magnitude in late March and was visible all night when it was nearest Earth. This 5-minute photo of the comet was taken through a 180mm f2.5 telephoto lens on Fuji 400 print film by Terence Dickinson. predictions. They were determined not to make the same predictive goof again.

Then along came Comet West, which was discovered in November 1975 at the European Southern Observatory in Chile. As it approached the Sun, it was much dimmer than Kohoutek at similar distances, so it attracted little attention. But as fate would have it, West did the opposite of Kohoutek and brightened much faster than predicted.

In early March 1976, the cosmic visitor moved out from behind the Sun and into the morning sky, where it appeared at magnitude –1. On March 7, a beautiful comet sporting a dust tail 30 degrees long adorned the predawn sky for northern-hemisphere observers.

By March 13, the show was over, unob-

served by the general population. With the Kohoutek fiasco still fresh in their minds, news editors had ignored Comet West, so few people beyond the amateur-astronomy community even knew about it. Others (including the authors) missed Comet West because of bad weather.

For the comet to become 50 times brighter than initial predictions, something unusual must have occurred. Around the time of perihelion, three huge chunks broke away from Comet West's nucleus, releasing far greater amounts of gas and dust than would be expected of an intact comet.

The key is the dust. Particles of dust are wonderful reflectors of light. Lots of dust, pushed into the sweeping tail by the pressure of sunlight, results in a bright tail.

RECENT COMETS

By 1995, there was talk of a comet drought, as no bright, long-tailed comets had been seen since Comet West, a generation earlier. In early 1996, the drought ended. Using a pair of giant 25x150 comet-hunting binoculars, comet hunter Yuji Hyakutake of Japan picked up a comparatively small comet, later determined to have a two-kilometer-diameter nucleus, compared with Halley's 11kilometer-wide icy core. But Comet Hyakutake came within 14 times the distance to the Moon. On a cosmic scale, that's close. Even a small comet looks big at that distance. (For comparison, Comet Halley remained more than 400 times farther away than the Moon during its 1986 visit.)

In late March and early April, Comet Hyakutake put on a great show, growing a 60-degree tail—more than twice the length of the Big Dipper—and reaching first magnitude as it moved quickly across the sky. Some observers still consider Hyakutake the most beautiful comet they have seen.

Then came the undisputed king of the comets: Hale-Bopp. Almost everyone reading these pages will remember this magnificent object, which reached first magnitude and remained visible for weeks during March and April 1997. Although exact comparisons are difficult, Comet Hale-Bopp is probably the most impressive comet seen in the northern hemisphere since the 1880s, edging out even the great Halley in 1910. Far from hosting a comet drought, the 1990s laid claim to two of the outstanding comets of all time.

In the spring of 2002, five years after Comet Hale-Bopp, northern-hemisphere observers were treated to another fine comet with stamina. Comet Ikeya-Zhang remained at magnitude 3.5 as it approached Earth and receded from the Sun in late March and early April. In dark rural skies, it was a wonderful binocular sight, with a classic 5-to-10-degree tail. Even though it equaled or exceeded Halley in every respect, Ikeya-Zhang drew little popular interest, proving once again that name recognition is an all-powerful cultural phenomenon.

During the first week of 2007, a comet surpassed predictions as it emerged from twilight into the northern-hemisphere evening sky to become a first-magnitude celestial exclamation mark. Unfortunately for northern-hemisphere skywatchers, Comet McNaught remained in twilight glow as it sank toward perihelion on January 12. But when it was just five degrees from the Sun, McNaught reached magnitude -5.5 and became visible to the unaided eyes in full daylight (if the observer positioned the Sun behind a roof or other obstruction). That made it the brightest comet since Ikeya-Seki in 1965. And, like Ikeya-Seki nearly half a century earlier, it moved into southern-hemisphere skies over the following two weeks,

▼ 21st-Century Comet Third magnitude at its brightest, Comet Ikeya-Zhang was visible in spring 2002. It was a beautiful binocular comet, with a bright seven-degree tail. Photo by Alan Dyer using a Nikon 180mm f2.8 lens.

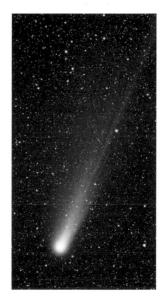

◀ The Great Hale-Bopp Displaying the classic two tails typical of a great comet-a straight blue gas tail and a curving white dust tail—Comet Hale-Bopp was at its best in spring 1997. The gas tail glows with its own light, while the dust tail shines only by reflected sunlight. Reaching near zero magnitude, the comet was visible to the unaided eye from city streets. This 10-minute exposure on 400-speed film was taken by Terence Dickinson using a 7.5-inch f/2.3 Maksutov-Newtonian.

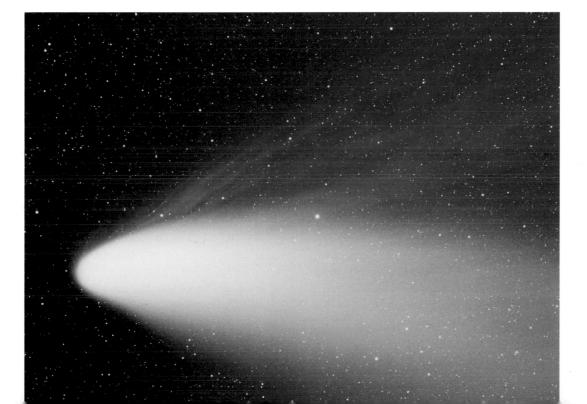

A Comet Tale 🕨

The evening of April 3, 2002, was cloudy at author Dickinson's observatory, preventing a view of Comet Ikeya-Zhang beside the Andromeda Galaxy. But a quick inspection of weathersatellite images on the web revealed a clear area about 75 miles north. With camera gear loaded in the car. the race was on. More than an hour later, the comet was visible from the car window, peeking out from under a cloud bank. Dickinson quickly pulled off the highway, skidding to a stop on the gravel shoulder. He set up and aligned a small equatorial mount with just seconds to spare. There was time for just one shot: this 90-second exposure on 400-speed slide film using a 135mm f2.8 lens. (Of course, author Dyer's backyard was perfectly clear!)

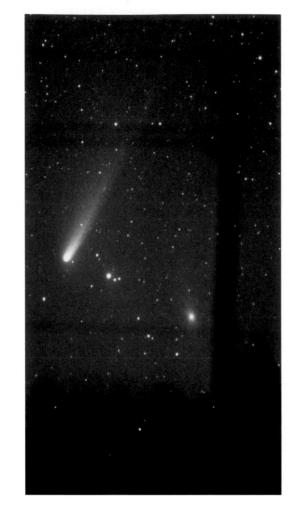

becoming a stupendous sight and ranking among the greatest comets of all time.

Unlike Comets Hale-Bopp and Hyakutake, whose celestial orientation favored observers in midnorthern latitudes, Comet McNaught flaunted for southern-hemisphere observers a huge fountainlike tail rich in dust and feathery striations—a genuine once-in-a-lifetime spectacle that far surpassed predictions.

In compiling this dossier of recent comets, we can't forget the comet that was torn apart by Jupiter's immense gravity: Comet Shoemaker-Levy 9. The pieces plunged into the giant planet in July 1994, leaving black bruises on Jupiter's cloudy face. Visible in a 60mm refractor, the impact scars on Jupiter were the most prominent features ever seen on a planet. Placing the event in perspective, codiscoverer and comet expert Gene Shoemaker estimated that a comet of this size (the original nucleus was perhaps two kilometers wide) collides with Jupiter on average about once every 1,000 years.

DISCOVERING A COMET

A generation ago, most comets were discovered by backyard astronomers scanning the night skies with modest-sized scopes. Some of the hobbyists turned the activity into a part-time career, gaining worldwide renown and literally notching their telescopes with each new find.

Those days are over. Apart from everincreasing competition from their peers, the main change for comet hunters occurred in 1998. That's when the U.S. Air Force, at the request of NASA and other scientific agencies, began using a one-meter robotically controlled telescope to search for asteroids that might smash into Earth at some time in the future. The telescope turned out to be a superb comet finder as well. Known by the acronym LINEAR (LIncoln, Near Earth Asteroid Research), the New Mexico-based instrument has found more than three-quarters of all comets visible from the northern hemisphere since it became operational.

The LINEAR telescope's success, and similar results from other robotic scopes that followed, has virtually put amateur comet hunters out of business. The pre-LINEAR rate of discovery by amateurs was four to eight comets a year. Now it is only one or two per year. Even rarer is the accidental visual find —someone chancing upon a previously unobserved comet.

But that's exactly what happened at the 2001 Saskatchewan Summer Star Party, an annual gathering of about 200 astronomy enthusiasts at a dark provincial park in the southwest corner of the province. As amateur astronomerVance Petriew was enjoying the views through his new 20-inch reflector telescope around 3:30 a.m. on August 18, he took a wrong turn on the way to aiming his telescope at the famous Crab Nebula in Taurus. Although that mistake meant he didn't find the Crab Nebula, Petriew did stumble upon a faint, fuzzy object that later proved to be a rare accidental visual comet discovery.

Comet Petriew was a 10th-magnitude comet, which means it would have taken at least an 8-inch telescope to detect. The comet never got much brighter, but the idea that an accidental comet discovery is still possible caused quite a stir in stargazing circles around the world.

Weird and Wonderful Comets of the 21st Century

The first few years of the new century have seen some astonishing comets—some spectacular even to the most casual skygazer, some fascinating only to amateur and professional astronomers and some just plain odd.

▼ Comet Schwassmann-Wachmann 3 (73P)

In April 2006, this odd comet returned in several pieces, forming a chain of comets across the sky.

▲ Comet McNaught (C/2006 P1)

In January 2007, this comet reached naked-eye visibility in northern skies and was a spectacle from Down Under.

▲ Comet Holmes (17P)

In October 2007, this normally faint comet exploded in brilliance by a factor of a million, becoming visible to the unaided eye even from city limits as a fuzzy star in Perseus.

Comet Machholz (C/2004 Q2)

VIsible In January 2005, this classic binocular comet sported a thin gas tail and a stubby dust tail at right angles as it passed near the Pleiades.

To keep up on comet news, check the websites of magazines such as Astronomy, Sky & Telescope and SkyNews. Or check spaceweather.com, a good website for breaking news of transient sky events.

Observing the Planets

Tens of thousands of years ago, prehistory's first Galileo would have noticed a few bright stars moving against the stellar background. This early planetary astronomer was probably also the first astrologer, because the natural question arises, Why do a small, select group of bright stars move, while the others remain fixed?

Astrological ruminations aside, planet watching remains a major element of today's recreational astronomy. On most nights of the year, at least one of the five naked-eye planets is visible. Often, it is the brightest object in the sky. When two or more planets cluster together, the sight can be so striking, it will turn the heads of people who normally do not look skyward. And if the crescent Moon joins the scene, it becomes one of nature's most alluring spectacles. Telescopically, the planets offer endlessly fascinating views of alien vet relatively nearby worlds.

he stunningly beautiful planet Saturn is seen in its full glory in this Hubble Space

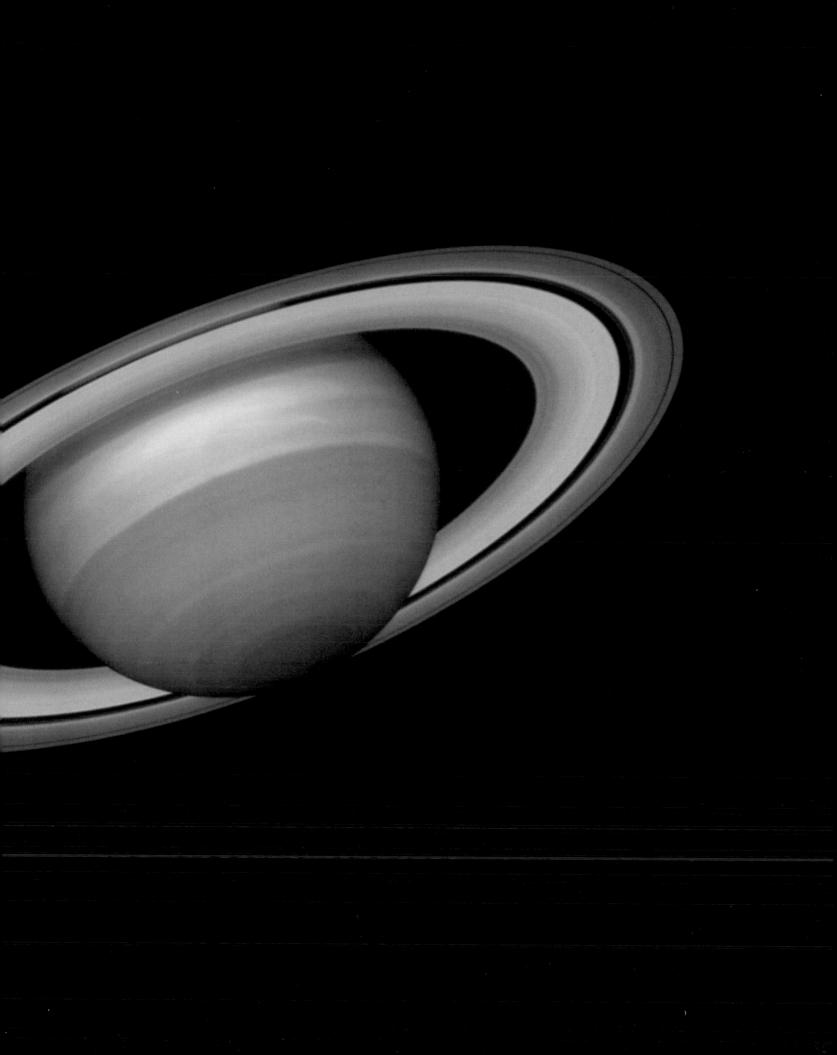

The Lure of Other Worlds

Ever since Galileo first gazed at Venus, Jupiter and Saturn with his new telescope in 1610 and saw objects with distinct shapes and, in the case of Jupiter, orbiting moons, humans have realized that other worlds exist beyond our own. In the four centuries since Galileo's historic observations, telescopic views of the planets have tantalized generation after generation of astronomers. Today, they remain as favorite targets of wonder and scrutiny.

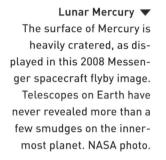

Although all seven of the classical planets (pictured at top of facing page) have been imaged close-up during the space age, the fact that three of them—Mars, Jupiter and Saturn—reveal visible changing surface features and detail in backyard astronomers' telescopes means that they are perched near the top of the pyramid of celestial targets of fascination.

Mercury

In many ways, Mercury is similar to our next-door world, the Moon. At only 1.4 times the Moon's diameter, it is a small, airless globe plastered with craters. But, at best, Mercury is more than 300 times farther away than the Moon. For a telescope user on Earth, the small world is typically six or seven arc seconds in diameter, only slightly larger than the apparent size of Uranus.

Mercury's surface material has approximately the same reflectivity and color as does the Moon's, and future explorers will undoubtedly find the landscapes of both worlds to be similar. In 1974, the Mariner 10 spacecraft made the first flyby observation of Mercury's cratered surface. The next spacecraft exploration of Mercury was not until one-third of a century later, when the Messenger robotic vehicle made a flyby in 2008 in preparation for long-term orbital study of the innermost planet.

Before the space age, the first telescopic Mercury observations of note were made by Eugène Antoniadi, a Greek-born French astronomer who became one of the greatest visual planetary observers of all time. Antoniadi did his best work during the 1920s with refractors ranging from 12 to 33 inches in aperture. He studied Mercury almost exclusively during the day and bright twilight, noting dusky patches and light regions on the planet's pale, creamy gray surface. Eventually, he was able to produce a map showing a rotation period of 88 days, the same time it takes Mercury to orbit the Sun. Antoniadi concluded that one hemisphere must constantly face the Sun.

Antoniadi was partly right. Through a quirk of celestial mechanics, Mercury's rotation is locked to its parent star, but not in the way he had thought. The planet actually

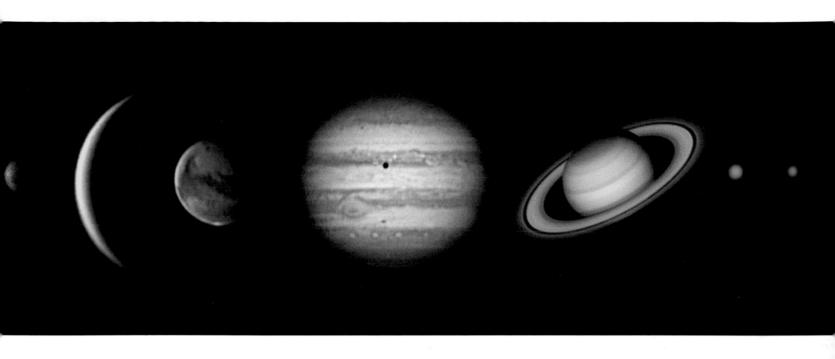

makes half a rotation during one orbit around the Sun, so the same face returns to a sunward position after two orbits. It is a complex bit of celestial clockwork that is largely irrelevant to backyard astronomers, because seeing anything at all on Mercury is one of the toughest assignments in amateur astronomy. But the problem illustrates how difficult telescopic observation of Mercury is, regardless of the equipment used.

Simply from a standpoint of convenience, planet observers typically observe Mercury in the evening sky. This is fine for naked-eye or binocular observing, but telescopically, conditions could hardly be worse. Once Mercury is located, it is generally less than 15 degrees from the horizon and is swimming in hopelessly bad seeing. Moreover, false color is usually apparent, especially blue, green or red fringes-an effect caused by dispersion associated with atmospheric refraction, which causes celestial objects to appear to be displaced to higher altitudes. The effect is wavelength-dependent (being less for longer wavelengths), so for planets at low altitudes, this creates a red tringe on the lower side of the planet and a green (or blue) fringe on the upper. The effect also produces chromatic smearing to the whole image.

One thing that will be visible in any decent telescope is Mercury's phase, which, during a typical three-week evening observing window, changes from nearly full to a delicate, slender crescent that is similar to a three-day-old Moon.

OBSERVING MERCURY BY DAY

For a good telescopic view of Mercury, you must do what Antoniadi did: observe during the day. The same applies to Venus, which can also be observed using the following technique. The challenge is to find the planet in a bright blue sky. Here is the simplest way to do it.

Start by selecting a date when Mercury is a morning "star," and locate it in morning twilight with the unaided eye or binoculars. In the northern hemisphere, late August, September, October and November are the best months because of the higher angle of the ecliptic relative to the horizon, which brings Mercury to its highest altitude. The actual observing window is just two to three weeks once or twice during the fourmonth span.

Using a telescope with a polar-aligned, motor-driven equatorial mount, begin observing the planet, ensuring that the telescope is tracking properly as Morcury climbs from the twilight sky into full daylight. Ninety minutes after sunrise, Mercury is about 30 degrees above the eastern horizon, high enough to allow a sharp view if the seeing is good. Daytime seeing is usually best around sunrise, before the Sun has warmed the air and the ground and pro-

It took him years to do it, but planetary imager Darryl Archer successfully collected webcam shots of all the planets. From left: Mercury, Venus, Mars, Jupiter, Saturn, Uranus and Neptune-all to the same scale, which means that this gallery shows exactly how the planets compare with one another in apparent size as seen in a telescope. As a baseline, Jupiter's apparent diameter is about 45 arc seconds. Mercury and Venus show phases because their orbits around the Sun are inside that of Earth, as explained in the illustration on page 192.

▲ Family Portrait

Shadings on Venus 🔺

The visible surface of Venus is a blanket of haze at the top of a dense, cloudy atmosphere. Amorphous features such as those seen here can be detected by ultraviolet photography, as in this Don Parker photo, but are generally invisible by eye at the telescope eyepiece, regardless of filters used.

Crescent Venus 🕨

Daytime or twilight observing offers views of Venus's phases set against a deep blue backdrop. The thin crescent phase is particularly impressive. Alan Dyer used a 4-inch apo refractor for this digital image. duced the convection currents that have long plagued solar astronomers. Because the Sun heats the telescope as well, convection currents build up both outside and inside the instrument, and seeing inevitably deteriorates toward noon.

One important accessory for daytime planetary observing is an extended dewcap made of black construction paper or something similar. The paper is wrapped around the telescope tube and taped in position so that it extends in front of the tube at least a foot beyond the length of the dewcap. This prevents direct sunlight from falling onto a refractor's lens, a Schmidt-Cassegrain's corrector plate or a Newtonian's secondary mirror. Some observers erect a patio umbrella or a makeshift shade for the entire scope once they have locked onto Mercury.

Under the best conditions of daytime or early-twilight viewing, Mercury is a sharply defined disk with hints of dark and light splotches just at the threshold of vision. During conditions of perfect seeing, however, the planet takes on a unique guise. Paler than Venus, its creamy surface has an appearance of being vaguely textured, like fine sandpaper. It is questionable whether observers are actually seeing evidence of craters on Mercury, but the planet is certainly different from Venus.

Venus

As the brightest luminary in the night sky after the Moon, Venus holds a preeminent position among celestial objects. It is so dominant when it is in the sky that there is no mistaking it. Nothing approaching it in brightness is seen in the west at dusk or in the east just before dawn.

The planet's brightness can be attributed to two factors: Venus comes closer to Earth than does any other planet and is often the nearest celestial object in the sky beyond the Moon; and the haze at the highest levels in Venus's atmosphere—the "surface" we see from Earth—is extremely reflective. Sixty-five percent of the sunlight that falls on Venus is reflected back into space, the highest percentage of any planet in the solar system. And because Venus is closer to the Sun than any planet except Mercury, it receives a high dose of sunlight per unit surface area, presenting the observer with a dazzling disk.

Although unrivaled in splendor when viewed with the unaided eye, Venus is generally a disappointment when seen through a telescope—it is as featureless as a cue ball. But it passes through phases, as does Mercury, and for the same reason. Its orbit is interior to the Earth's, but Venus is twice Mercury's distance from the Sun. Consequently, it takes longer to orbit the Sun and appears, at best, twice as far away from the Sun in our sky. The results are longer viewing cycles and more favorable sky positions than Mercury ever attains.

The thick layer of cloud and haze blanketingVenus is extremely uniform. Yet occasionally when the planet is viewed through a telescope, there are dusky patches and lighter poles at the limit of visibility. Cloud features and circulation motion do exist but become obvious only in ultraviolet wavelengths that are invisible to the human eye. Nonetheless, for more than a century, visual observers have reported these features, and their drawings have sometimes coincided with markings in ultraviolet photographs taken with Earth-based telescopes. The dark patches, although elusive, were drawn long before they were photographed.

When Venus is examined telescopically against the blackness of deep twilight, the contrast between the planet and the sky is so enormous that what little detail might be seen is lost. As well, a number of telescope aberrations that are commonly suppressed

below detectable levels loom into view. The slightest amount of chromatic aberration in a refractor can produce a blue or purple halo around Venus. The secondary-mirror supports in a Newtonian generate spikes extending from the image. Both of these effects impair resolution of detail and detract from the aesthetic appearance of the planet's pure white hue and symmetric phase. The worst aberration does not occur in the telescope but, rather, in the Earth's atmosphere. It is dispersion associated with atmospheric refraction, as explained in the previous section on Mercury.

The combination of ultrahigh contrast, annoying optical effects and atmospheric dispersion means that the least desirable condition for observing Venus is a dark sky at low altitudes. As with Mercury, daytime viewing is the preferred mode. And, like Mercury, conditions are optimum during an autumn-morning appearance, shortly before or after sunrise. However, because Venus is much brighter and roams farther from the Sun than its smaller neighbor, conditions for seeing it reasonably well are less restrictive.

At its brightest, Venus can be located with the unaided eye in a clear, deep blue sky any time after 3 p.m. (near eastern elongation) or before 10 a.m. (near western elongation). Even at hours when the planet cannot be found in full daylight with the unaided eye, binoculars will readily reveal it.

TELESCOPIC APPEARANCE

When observed by telescope in a rich blue daytime sky, Venus is a beautiful suspended pearl, its phase instantly evident and its sunward edge dazzling and distinct. Gone are the overwhelming contrast and the optical effects that come into play when it is low in the sky against a dark background.

The lower-contrast daytime observation of Venus reveals the surface's gradation in brightness—the difference between the sunward edge (the limb) and the day/night line (the terminator). Because the terminator receives only grazing sunlight compared with the direct rays that fall on the areas of the planet turned toward the Sun, it is more subdued than the brilliant limb.

The visible terminator is actually inside the geometric, or true, terminator, which is

90 degrees from the point on Venus's disk that lies directly beneath the Sun. Thus when the planet is half illuminated (a phase called dichotomy), it usually appears less than half illuminated in a telescope.

Because Venus passes from full phase toward crescent phase during its sevenmonth cycle through the evening sky, visual dichotomy occurs a few days prior to geometric dichotomy. The reverse happens when Venus is in the morning sky, passing from crescent to full phase. For decades, backyard observers have recorded these variances. Curiously, the morning-apparition figures do not match the evening ones. The difference between visual and geometrie dichotomy is 4 to 6 days in the evening sky and 8 to 12 days in the morning sky. No reasonable explanation has ever been proposed, yet the discrepancy seems to be real. In view of these differences, begin watching for dichotomy far enough ahead of the predicted dates (given in The Royal Astronomical Society of Canada's Observer's Handbook; listed as "Venus at greatest elongation east" for evening sky or "Venus at greatest elongation west" for morning sky).

▲ Mercury and Venus Although considerably fainter than Venus, Mercury is still bright and easy to see, as this morning-sky portrait attests. Photo by Alan Dyer.

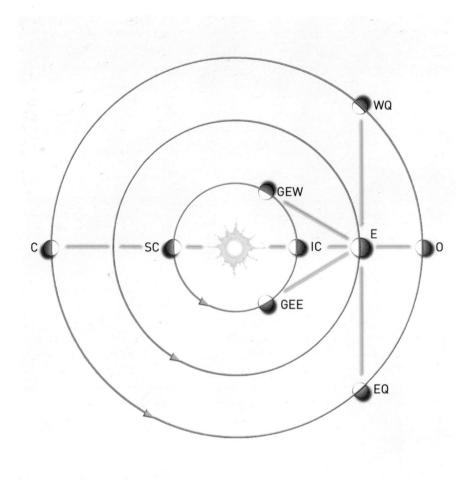

Phase Relationships 🔺 When describing certain relationships and positions of the planets as they orbit the Sun, astronomical jargon can be fairly dense. This diagram, based on an illustration in the Observer's Handbook, should simplify it. The Earth's orbit is the middle one of the three shown. Planets that orbit the Sun inside the Earth's orbit have four special configurations: inferior conjunction (IC); greatest elongation west (GEW); superior conjunction (SC); greatest elongation east (GEE). Planets outside the Earth's orbit have different special configurations: opposition (0); western quadrature (WQ); conjunction (C); eastern quadrature (EQ).

INFERIOR CONJUNCTION

The celestial clockwork brings Venus to inferior conjunction every 19¹/₂ months. The most interesting time to observe Venus is the two months either side of inferior conjunction, when it is nearest Earth and less than 40 percent illuminated. When Venus is within days of inferior conjunction, its slender crescent can expand to 60 arc seconds across as the planet glides a few degrees above or below the Sun in our sky.

The days leading up to and following inferior conjunction are prime observing periods. No other celestial object except the Moon is seen at such thin phase angles. When viewing the slender crescent of Venus, the chief objective is a sighting of an extension of the cusps (the crescent's points) into the planet's night hemisphere. This is not an illusion but sunlight illuminating Venus's upper atmosphere. Occasionally, the extension is seen as a complete ring, the extremely thin crescent and a very tenuous, ghostlike extension of the cusps making a full sphere. Conditions must be exceptional for such an observation, but it is far from impossible and does not require a large telescope.

Mars

Apart from the Moon, Mars is the only object in the universe whose solid surface is seen in reasonable detail through Earthbased telescopes. Yet it is just far enough away from Earth that its features are difficult to observe with clarity. Mars tantalizes.

Once Mars has been viewed through a telescope with fine optics when the planet is fairly close to Earth, it is impossible not to be impressed by the feeling that it is a real world, a globe with obvious similarities to our own: polar caps, dark continents in the global salmon-hued deserts, dust storms and the occasional clouds-all have their terrestrial counterparts. What is missing on Mars, of course, are the oceans of water that characterize most of the surface of our planet. Nevertheless, nowhere else can so many comparable features be seen, including a 24.6-hour rotation period and an axis tilt only two degrees different from the Earth's. All of these together make Mars the most Earth-like planet in the solar system. When the seeing is good and the telescope's optics are equal to the task, it is easy to understand why some late-19th-century observers were convinced that they were gazing at a habitable world.

The pale, pinkish orange desert world suspended in the black void of space is an enchanting and unforgettable sight, but memorable views of Mars are not common. For only two to four months every two years, when the planet is within 0.8 AU (1 AU, or astronomical unit, is the Earth-Sun distance), is the disk large enough to reveal rich detail. Even then, Mars is a supreme challenge for both eye and telescope.

Large telescopes are limited by turbulence in the atmosphere of our own planet, which only rarely permits detection of features below 0.3 arc second (sometimes stated as 0.3 second of arc, or 0.3"). This is a tiny angle, equal to 80-kilometer resolution on Mars when the planet is at its closest. However, it can be reached by comparatively small telescopes. The normal goodseeing limit is 0.5 arc second, while 1.0 arc second is typical of many nights of the year at most sites. One arc second is the resolution of a 4-inch telescope; half an arc second is the theoretical capability of an 8-inch telescope; and 0.3 arc second is a 15-incher.

Rarely does the Earth's atmospheric turbulence settle enough for a 15-inch-class telescope to show full resolution. But when near-perfect conditions do occur, the overwhelming detail visible on Mars in a highquality, large-aperture scope is astonishing. What large optics will do anytime, though, is make the planet appear brighter and enhance the color differences over the disk.

OBSERVING MARS

Any good-quality telescope with more than 70mm aperture should reveal surface features on Mars during the weeks around the biennial closest approaches, including changes in the outlines of Martian dark zones from one opposition to the next. Once thought to be evidence of tracts of vegetation changing with the seasons, the alterations are caused by winds of up to 400 kilometers per hour transporting vast

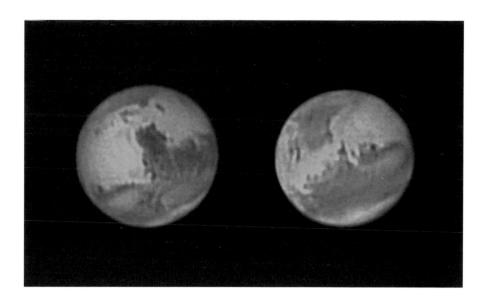

quantities of dark and light dust across the desert planet. Mapping the changes is therefore a study in Martian meteorology and geography. It is a challenging but rewarding area of planetary observation.

The clarity of Mars' surface features white polar caps and dark, irregular patches on a largely peach-colored sphere—depends to a great extent on the transparency of the Martian atmosphere. Dust storms can lower the contrast across large sectors of the disk ▲ Two Sides of Mars These fine 2001 Mars portraits by expert CCD planetary imager Ed Grafton were taken with a 14-inch Schmidt-Cassegrain.

Life on Mars and Percival Lowell (1855-1916)

In 1894, Percival Lowell, a wealthy American diplomat turned astronomer, built an observatory in Flagstaff, Arizona, to study thin linear features ("canals") reported on Mars by Italian astronomer Giovanni Schiaparelli a generation earlier. Schiaparelli had used an 8.5-inch refractor, but Lowell's new instrument was a 24-inch refractor.

Examining Mars with the new telescope, Lowell soon became convinced that the canals he observed were constructed by a Martian civilization to preserve a dwindling water supply on a desert planet. With the publication of a book about his theories and observations in 1895, Lowell quickly became the most famous astronomer of his day.

For the next two decades, Lowell continued his studies of Mars, making regular announcements about what he and his staff observed. The newspapers loved it. So did science fiction writer H.G. Wells, who, soon after reading about Lowell's theories, penned *The War of the Worlds*, about Martians invading Earth.

The canals ultimately proved to be the product of the brain's tendency to connect fine detail at the threshold of vision into linear features. There really are no straight lines on Mars. But the seeds had been planted, and Martians have been part of our collective psyche ever since.

An imposing figure, Percival Lowell sits in a reinforced wooden kitchen chair at the eyepiece of the 24-inch refractor at Lowell Observatory in Flagstaff, Arizona. Today, the telescope still looks much as it did then. Photo courtesy Lowell Observatory.

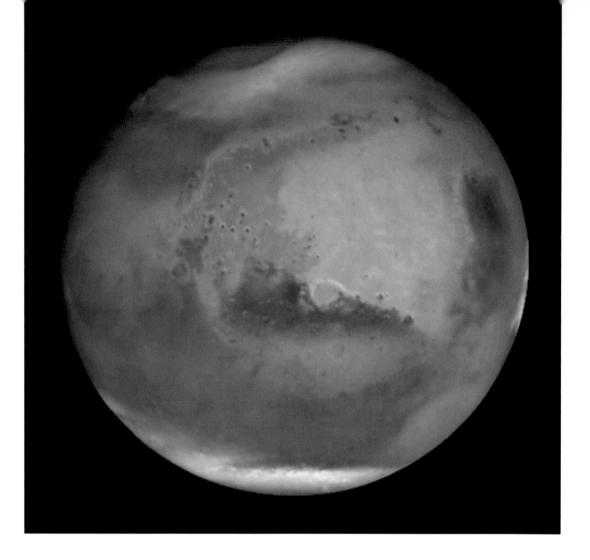

Hubble Portrait of Mars Taken June 26, 2001, this exquisite image of Mars was obtained (fortuitously, as it turned out) the day before a global dust storm began raging. In less than two weeks, the storm had enveloped the entire planet. Although atmospheric researchers were delighted to study it, the storm ultimately lasted for five months, ruining the view during that period for backyard telescope observers on Earth. North is at top. Meridiani Sinus is the dark feature at center. Syrtis Major is near the right edge.

Backyard Mars

On November 11, 2007, in nearly perfect seeing, Rolf Meier used a Lumenera webcam-type camera coupled to a 14-inch Schmidt-Cassegrain telescope to capture almost the identical sector of Mars as seen in the Hubble image above. At the time, Mars was only 13 arc seconds in apparent diameter.

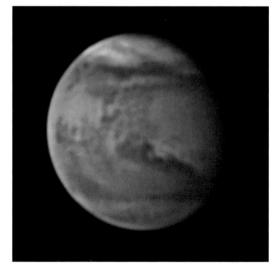

within days of a storm's onset. The planet may remain partly or completely shrouded for many weeks thereafter (as happened in late June 2001, spoiling Mars viewing for the following five months). Experienced observers can detect emerging storms on Mars when familiar desert areas of the red planet brighten and encroach on nearby dark features. Global dust storms are both rare and unpredictable. Only a few are well documented: 1956, 1971, 1973, 1977, the 2001 storm just mentioned and one in 2007.

The Martian south pole is tipped Earthward at oppositions favorable for northernhemisphere observers. The brilliant white polar cap shrinks during the prime observing window (90 days centered on opposition), sometimes revealing notches in the main polar cap or detached patches. Summer is then beginning in the Martian southern hemisphere. When the southern polar cap is reduced to a tiny white button, part of the larger northern polar cap may be visible. The North Polar Hood, a bluish white atmospheric haze, often masks the northern cap itself (see photo above). Both polar caps have a residual water-ice core that never disappears. Beyond the caps, more extensive regions of frozen atmospheric carbon dioxide rapidly expand or contract with the seasons. In winter, the polar regions are a brutal minus 140 degrees Celsius.

The best magnification for Mars is about

35x per inch of aperture up to 7 inches and 25x to 30x for larger telescopes. This yields a pleasing image while avoiding the effects of irradiation, a contrast phenomenon that originates in the eye and causes brighter areas to encroach on dark adjacent areas. In the case of Mars, irradiation produces the apparent enlargement of the polar caps and the apparent loss of fine, darker details next to the desert areas. The effect is most troublesome at magnifications below 25x per inch of aperture.

Regardless of the instrumentation, experience is the key to detecting the wealth of detail that Mars can present to backyard observers. At first glance, the planet appears so small that you may wonder how anyone sees anything on it. The trick is to start observing Mars at least two months before opposition to train your eye to detect the ever-so-subtle features that abound on our neighbor world. Then, around opposition, when the best views are available, you will be ready to squeeze the most out of eye and telescope, rather than discovering at the time of optimum conditions how challenging it is to observe the red planet.

As displayed in the illustration at right, there are cycles embedded in Mars oppositions in addition to the "once every 26 months or so" rhythm. Seven or eight oppositions occur over a span of 15 to 17 years, ranging from favorable to unfavorable. The apparent diameter of Mars can be as great as 25 arc seconds or as little as 14. On top of that cycle, another one (not shown in the illustration) places Mars high in the sky for northern-latitude observers during unfavorable oppositions and low in the sky during favorable ones. (Lucky observers south of the equator enjoy the reverse of this arrangement.)

PLANETARY FILTERS

Inexpensive color filters (about \$20 each) that screw into the bottom of 1.25-inch eyepieces often improve the visibility of Martian surface features by reducing the effects of chromatic aberration in refractors and increasing contrast in all types of telescopes. A blue filter (Wratten No. 80A) reveals the few nondust clouds that float in the atmosphere of Mars. Other filters are orange (No. 21) and red (No. 23A), which

enhance the contrast of the dark areas. The red filter may be a bit dark for instruments with apertures smaller than 8 inches, but try both to get the most out of observing Mars.

Larger telescopes benefit from the filter's reduction of the brilliance of the Martian disk as well. In addition, a red filter improves seeing by eliminating the shorter wavelengths that are most affected by atmospheric turbulence. For telescopes greater than 8 inches in aperture, also try the deep red No. 25 filter. Generally, telescopes with more than 5 inches of aperture respond better to color filters than do smaller instruments. For aesthetic appeal, however, nothing matches an unfiltered view of the coral deserts, pure white poles and gray-green dark regions.

A minus-violet filter (\$40 to \$100) is useful for a specific type of telescope often favored for planetary viewing—achromatic refractors. The filter suppresses the effects of chromatic aberration (false color) in such telescopes. Chromatic aberration is apparent as a bluish purple halo around planets—Mars, Jupiter and Venus, in particular. The halo is just the obvious part of a wash of unfocused light that is actually smeared

Mars Oppositions

Every 26 months, on average, Mars and Earth are nearest each other, an event known as Mars opposition. Favorable oppositions (from an Earth observer's point of view) occur around Martian perihelion. The 2003 perihelion opposition is the closest Mars has come to Earth since biblical times, appearing 25 arc seconds in diameter. Compare that with the 14-arc-second diameter at aphelion oppositions, such as the one in 1980.

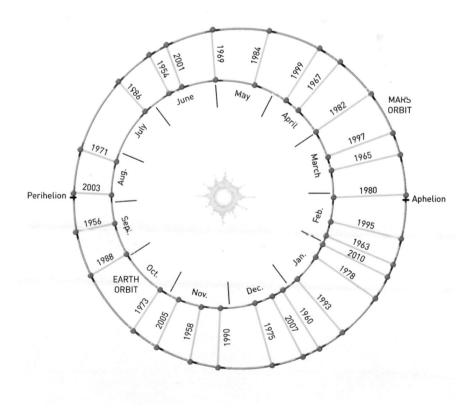

across the whole planet, reducing contrast and detail. We tested several minus-violet filters on achromatic refractors and found that they all suppress the bluish purple halo to varying degrees, but in doing so, they introduce a yellowish hue—a natural consequence of filtering out much of the blue part of the spectrum. Overall, though, contrast is improved. The best performer among the minus-violet filters we tested was the one offered by Lumicon.

But even the best minus-violet filter will not make an achromatic refractor perform like an apo refractor. Moreover, unlike the dramatic advantage that nebula filters bring to deep-sky observing, the various planetary filters mentioned above offer subtle rather than emphatic improvements. Experience at the eyepiece is the best way to enhance planetary detail visible in your telescope.

And here's a final thought regarding planetary filters: We feel there is an important aesthetic issue here. As longtime planet observers, we enjoy the beauty of natural planetary hues. For us, this is one of the strong attractions of planetary observing with apo refractors.

Jupiter

Unlike Mars, which requires superb optics and relatively high magnifications before much detail is seen, Jupiter has several features that are easily revealed by an 80mm refractor at about 100x: its main belts, the Red Spot (unless it is particularly faded) and the shadows of the four Galilean satellites. Through a telescope, Jupiter's disk can range from 4 to 100 times larger than the face of Mars, depending on Mars' distance from Earth. Major disturbances on Jupiter's equatorial belts and the dark "barges" in the tropical and temperate belts are also detectable in an 80mm refractor at 100x to 130x.

Every increase in telescope size reveals more, but as with all planetary observing, aperture is definitely secondary to optical quality. Jupiter is a bright object; there is plenty of light. Focusing that light into a sharp, high-resolution image is the key. In fairly good seeing, 25x to 35x per inch of aperture should be adequate for observing Jupiter. The image should remain sharpedged and well defined and snap into focus.

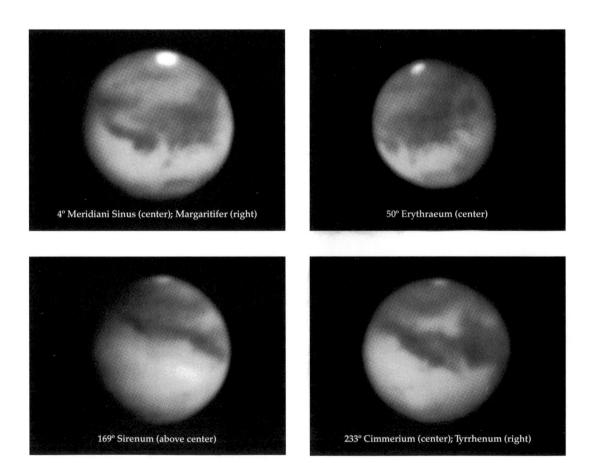

In autumn 1988, Mars was closer to Earth than it had been in a generation (a perihelion opposition). This sequence of eight images by Don Parker, taken through a 16-inch telescope, shows the same level of detail that a backyard observer can see under the best seeing conditions with an 8-inch or larger telescope. The degrees indicate the longitude on Mars at the central meridian. The major dark feature near the central meridian is named. Following long-standing tradition, south is up in these Mars pictures, as would be seen in a Newtonian reflector.

Mars: Full Rotation

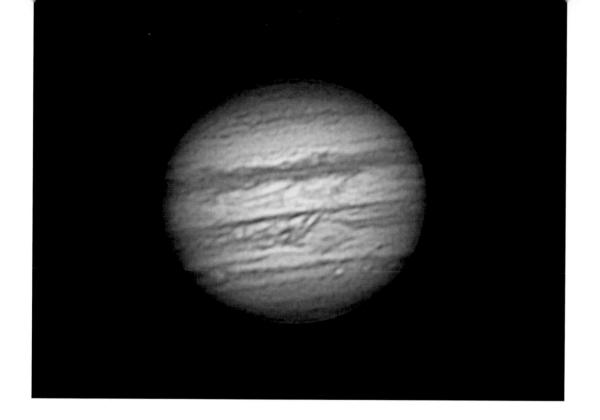

▲ Jupiter Belts This impressive image of Jupiter's cloud-belted face shows the maximum amount of detail that anyone can expect to see through a large telescope under the most favorable conditions. It is a webcam composite of hundreds of images taken in rapid succession through an 18-inch Starmaster Newtonian telescope on a night of perfect seeing. Photo by

Mike Wirths.

Selecting something typical—for example, a 4-inch refractor or an 8-inch Schmidt-Cassegrain—what can an observer expect to see? Because of Jupiter's constantly changing cloud-covered surface, the amount of detail varies from one observing season to the next. However, three or four dark belts are always visible and sometimes as many as 10, depending on how the wind circulation is divvying up the clouds. Bumps,

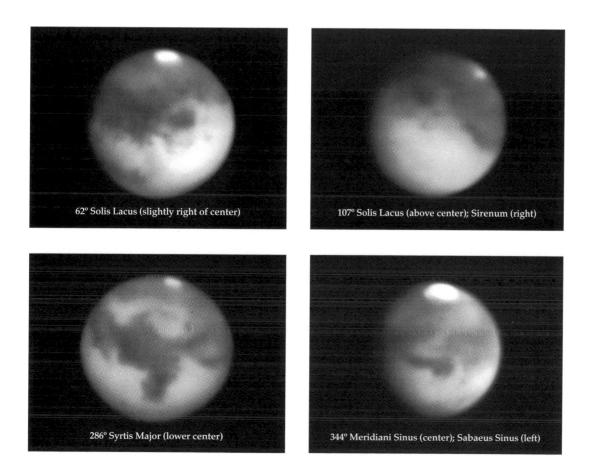

projections, loops and general turbulence would be evident along the edges of the equatorial dark belts. Even if the Great Red Spot has faded, its home—the Red Spot Hollow—should be visible as an indentation in the south equatorial belt. But there are few absolute rules when it comes to Jovian atmospheric circulation. In late 1989, for instance, the south equatorial belt disappeared in just a few weeks and the Red Spot, after years of near invisibility, regained some prominence. In 1990, the Red Spot faded again as the belt returned.

For many decades, several large, white ovals, one-quarter to one-third the size of the Great Red Spot, roamed in the next belt south from the one occupied by the Red

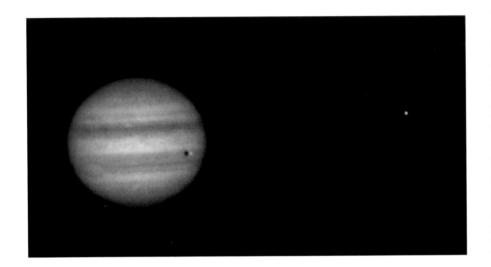

A Moon and Its Shadow When Jupiter is near opposition, its moons can appear next to the shadows they cast. Io is seen just to the right of its own shadow in this 10-inch Newtonian image by Luis Eguren, taken in November 2001. Europa is at far right. Two dozen images gathered by an inexpensive webcam were digitally stacked to produce the final image. Spot. During the 1990s, the white ovals began merging, and by 2002, only one, about one-third the size of the Red Spot, remained. Then, in 2006, this white oval turned reddish, similar in hue to the Great Red Spot. It has been dubbed the Little Red Spot. What happens next is anyone's guess.

The Red Spot is a swirling maelstrom of clouds pumped up from a vortex that penetrates to a lower level in the planet. Its coral or pinkish color (it rarely appears red) is usually quite distinct from the hue of any other feature on the planet, indicating that its source material is probably deeper than that of other features. The Red Spot completes a counterclockwise rotation once every six days, but the anticyclonic motion is generally below the detection threshold with amateur equipment. What can be seen is vague texture within the Red Spot and variations in the color over time. As the south equatorial belt moves past the Red Spot and is disturbed by it, a churning swath of clouds is heaved into the wake (the region behind it, in terms of the planet's rotation). This wake feature is usually more obvious than details within the spot.

In the early 1960s, the two equatorial belts almost merged, and the activity between them was extraordinary, with thick, twisting bridges of dark material crossing the lighter equatorial zone. Such activity is simply cloud and circulation phenomena. The light zones are at a higher altitude than the dark belts and consist mostly of ammonia haze; the dark belts are chiefly ammonium hydrosulfide. Incursions of one belt into another are constantly appearing and disappearing as the belts and zones slip by one another. The equatorial zone and the adjoining parts of the equatorial belts are known as System I, while the rest of the planet (except the polar regions) is System II. The polar regions are referred to as System III, but for amateur-observation purposes, only Systems I and II are of interest.

System I rotates in approximately 9 hours 50 minutes; System II has a general rotation speed about five minutes longer. The two systems continually slide by each other inside the equatorial belts, making them the most active areas of the visible surface of Jupiter. System II contains the Great Red Spot. Using tables and a calculation method outlined in the Observer's Handbook, you can determine the System II longitude. Sky & Telescope usually lists the Red Spot's longitude when Jupiter is well placed for viewing. If the System II longitude is within 50 degrees of the Red Spot, the spot should be visible. During the 1980s, the Red Spot stayed fairly constant with respect to System II, not straying too far from 10 to 20 degrees longitude. During the 1990s, it moved several degrees a year, and by 2008, it was near 120 degrees. In times past, the Red Spot has been known to shift by up to 30 degrees in a single year, so it is impossible to predict where it will be. Once seen, though, it will be visible in the same spot two days and one hour later (five Jupiter rotations).

Overall, Jupiter's disk is creamy white, bright and distinct, yet there is an aspect to it called limb darkening—the edge of Jupiter's disk is about one-tenth as bright

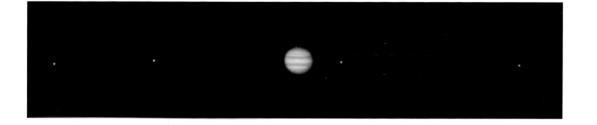

as its center—that becomes apparent only when sought out. It is not obvious to the eye, because the disk edge abuts the blackness of the sky. Limb darkening is caused by solar illumination that is absorbed by a thin haze in Jupiter's upper atmosphere, above the highly reflective clouds. The limbdarkening phenomenon subdues the visibility of the cloud features near the disk's edge. The Great Red Spot, for example, is not visible at the edge of the disk. Rather, it is seen clearly only when it has rotated onequarter of the way around. The same is true of all the Jovian features, which are seldom visible for more than 2¹/₂ hours before they rotate out of view.

If you have any inclination to draw what you see, Jupiter is probably the best planet on which to try it. Beautiful strip charts of Jupiter, sketched over a few hours as the planet rotates, have been made by absolute beginners with only a few nights' training at the telescope. "The more you look, the more you'll see" is an axiom that is never more apt than in the case of Jupiter.

TRACKING THE FOUR MOONS

Among the most dramatic sights in astronomy is the transit of one of Jupiter's moons across the planet's cloudy face. As one of the four large satellites appears to touch the Jovian disk, it is transformed from a dazzling spot against the dark sky to a tiny, fragile disk etched in the limb. Each moon has its own characteristic appearance as it crosses the planet.

Io, the innermost of the four big moons, has a light pinkish hue and high surface brightness. When it enters the disk, it is always a brilliant dot on the darker limb. As it begins its transit, Io can become lost in the white zones, which have similar reflectivity. When in front of the darker belts, the moon is usually a minute but distinct bright spot. Europa is the smallest of Jupiter's four major moons but has the most reflective surface. It is intensely white, especially as it enters the limb—a tiny, white dot against the edge of the cloud-strewn giant. As Europa marches in front of the big globe, it usually encounters the white clouds of the zones and disappears from view. It is probably the most difficult moon to see throughout a complete transit. On the rare occasion when it tracks across a dark belt, Europa can be observed for its entire journey.

Ganymede, the largest satellite, is easier to follow across Jupiter's face because of its size and because its color is duller than the white clouds and brighter than the dark ones. When transiting a white zone, Ganymede is light brown in color and resembles a washed-out satellite shadow. Superimposed on the limb, the reverse is the case: The limb is darker than Ganymede, so the moon appears as a bright dot on the darker background. As with Io, there is a transition zone in which Ganymede almost always disappears as its intensity matches the background between the limb and the brighter central part of the disk.

Galilean Moons

Jupiter and its four largest moons are seen in this digital-camera image just as they appear at about 100x in a small backyard telescope. Jupiter and the moons are bright enough to overwhelm any light pollution and will look like this even from a balcony "observatory" in the middle of a major metropolis. Photo by Jean Guimond.

▼ Jupiter Strip Map In the mid-1980s, five members of the Hamilton Centre of The Royal Astronomical Society of Canada used the club's 5-inch refractor to systematically chart Jupiter's appearance through a complete rotation by combining their sketches into a Mercator-like map of the planet (south is up).

Io3,6305.01.771381.21.0Europa3,1405.33.552201.00.6Ganymede5,2604.67.163511.71.1	Avg. MaximumEffectiveOrbitalDistance FromApparentShadowPeriodPlanet CenterDiameterDiameter(days)(arc seconds)(arc sec.)(arc sec.)	Period	Visual Magnitude	Diameter (km)	Satellite
Ganymede 5,260 4.6 7.16 351 1.7 1.1	1.77 138 1.2 1.0 1.1	1.77	5.0	3,630	Io
	3.55 220 1.0 0.6 0.8	3.55	5.3	3,140	Europa
	7.16 351 1.7 1.1 1.4	7.16	4.6	5,260	Ganymede
Callisto 4,800 5.6 16.69 618 1.6 0.5	16.69 618 1.6 0.5 0.9	16.69	5.6	4,800	Callisto

Jupiter's Four Major Satellites

Callisto is probably the easiest moon to follow, because its dull surface material makes it darker than almost anything it encounters, except at the very edge of the disk, when it enters or exits its transit. Callisto's crossings are by far the rarest of the four Galilean moons: It orbits Jupiter only once in 17 days, compared with 7 days for Ganymede, 3½ days for Europa and just 42 hours for Io. Also, for more than half of Jupiter's 12-year solar orbit, the planet's satellite system is angled so that Callisto passes above or below Jupiter as seen from Earth and misses transiting the disk altogether.

Shadow Trek 🕨

In this Hubble Space Telescope image, Jupiter's moon lo casts its shadow on the giant planet's clouds. Note the shadow's penumbral ring, referred to in the table above. The shadows of Jupiter's moons are much easier to observe than a transit, because they are black dots, far darker than any of the planet's surface features. However, the shadows vary in size, with Ganymede's the largest, Io's the second largest and Europa's and Callisto's the smallest. Ganymede's shadow is visible in a 60mm refractor; the others usually require a 70mm refractor for a definite sighting.

Saturn

No photograph or description can adequately portray the astonishing beauty of the ringed planet floating against the blackvelvet backdrop of the sky. Of all the celestial sights available through a backyard telescope, only Saturn and the Moon are sure to elicit exclamations of delight from first-time observers.

Saturn's rings were most likely created when a comet smashed into one of Saturn's moons and some of the debris remained in orbit around the planet, eventually forming the ring structure. Another possibility is that the rings are debris from a collision of two of Saturn's moons. In either case, repeated collisions among the myriad pieces would have ground them down, and today, the ring moonlets range in size from tiny crystals like those in an ice fog to flying icebergs the size of small mountains. Each particle in the rings has its own individual orbit about Saturn, although a gentle jostling occurs as the particles are affected by the gravitational pull of Saturn's major moons and of one another.

Saturn's ring system is truly enormous in extent. From one edge to the other, the rings span a distance equivalent to twothirds of the gulf between Earth and the Moon. Yet the particles that make up the rings seldom stray more than a few hundred meters from a perfectly flat disk, making the structure about as thick as the height of a 50-story building.

Almost any telescope will reveal Saturn's ring structure. A 60mm refractor at 30x to 60x clearly shows it. The view is outstanding in 4-inch or bigger telescopes. Such instruments also reveal several of Saturn's large family of satellites, which appear as tiny

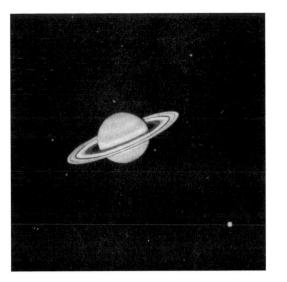

Magnificent Planet

This illustration of the ringed planet appeared in Richard Proctor's Saturn and Its System, published in 1865.

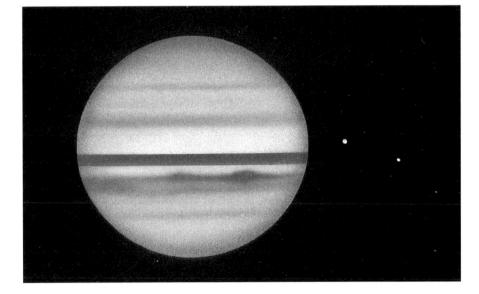

"stars" beside, above and below the planet.

Spacecraft have discovered hundreds of identifiable rings, but only three components can be readily distinguished through Earth-based telescopes. They are known simply as rings A, B and C. Rings A and B are bright and easily visible in any telescope. They are separated by Cassini's division, a gap about as wide as the United States. Cassini's division looks as black as the sky around Saturn but is actually a region of less densely packed particles rather than a true blank space. The division is largely the result of the gravitational perturbations of Saturn's moon Mimas. Ring particles orbiting in the gap are in resonance with Mimas and, over time, are gravitationally nudged into different orbits, thus largely clearing out the section. The other gaps that produce the many ▲ Saturn Without Rings As Saturn orbits the Sun, its rings are tilted by varying amounts to our point of view here on Earth (although, like the Earth's rotation axis, they are fixed in space). In 1966, Saturn's rings were edge-on to Earth and invisible for months. Only the ring shadow (darkest "belt") remained. Two of Saturn's moons are at right. Illustration by Terence Dickinson using a 7-inch achromatic refractor.

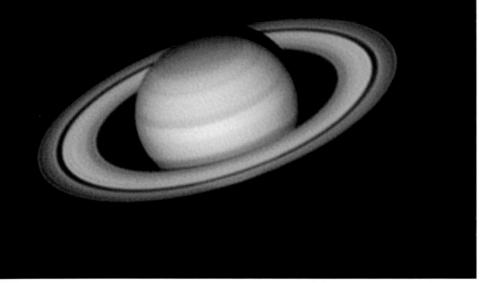

Lord of the Rings 🔺

One of the finest portraits of Saturn ever obtained with backyard equipment, this webcam composite image by Darryl Archer was captured using a Celestron 14-inch Schmidt-Cassegrain telescope. The main gap in the rings is Cassini's division. The Encke gap is the dark line close to the outer edge of the rings. Although Johann Encke never saw this gap, it was eventually named after him.

Glorious Saturn 🕨

This superb illustration of Saturn by English amateur astronomer and artist Paul Doherty is based on his observations with a 16-inch Newtonian reflector during the 1980s. The dusky zone in the middle of the outer ring was first noted by Johann Encke in 1837. rings seen by the Voyager and Cassini spacecraft are probably generated in much the same manner but involve far more complex interactions with other moons and large ring particles.

Ring A, the outermost ring, is less than half the width of ring B and is not as bright, although the difference between the two is subtle. The innermost ring, C, is so dim that an experienced eye and at least a 6-inch telescope are usually needed to distinguish it. Ring C, also known as the crepe ring, is a phantomlike structure extending about halfway toward the planet from the inner edge of ring B.

One other division besides Cassini's is

visible in large Earth-based telescopes: the Encke gap, located near the outer edge of ring A (seen in photo at left). The Encke gap is extremely difficult to detect with a backvard telescope. The first astronomer credited with seeing a gap in that position was James Edward Keeler, in 1888, when he was studying the planet visually using the Lick Observatory's 36-inch refractor at 1500x. Confusingly, this gap has come to be named after German astronomer Johann Encke, who, 60 years earlier, had noted a dusky region, not a gap, in the middle of ring A while using a much smaller telescope. He never saw what we now call the Encke gap. Encke's dusky zone is there (see illustration below), but it varies in intensity over time and has remained inconspicuous for the past quarter century. Astronomers have decided that it is too late to correct this misnomer by renaming the feature, so another gap in ring A, a much narrower one discovered by spacecraft, now honors Keeler.

OBSERVING SATURN

When observing conditions permit, you can spend hours at the eyepiece looking at Saturn, and the planet certainly deserves attention on nights of good seeing when it is well placed. Here are some features to look for, in order of increasing difficulty:

• The rings themselves. It usually takes

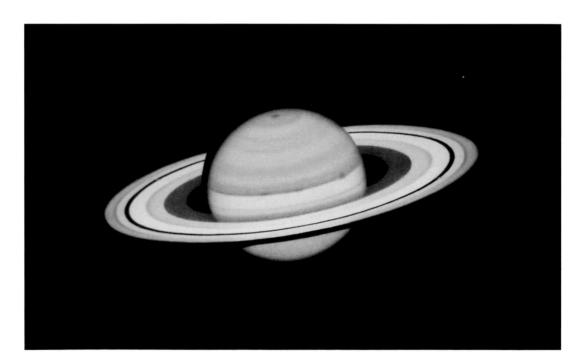

only 30x to see them clearly and 60x to show that they really do resemble a washer surrounding a marble.

• The shadow cast by the planet on the rings. It can be quite small around opposition but rapidly increases when the planet moves away from opposition.

• Cassini's division. An 80mm refractor will reveal it, but a good 5-inch instrument is generally required to detect it clearly all the way around.

• The dusky belt(s) of Saturn separating the creamy yellow equatorial region from the beige temperate zone.

• The shadow of the rings on the planet. This is usually narrow but is not that difficult to see if you specifically look for it. Depending on the geometry between Earth, the Sun and Saturn, the shadow can appear on the disk either above or below the rings as they pass in front of the planet.

• At a much higher level of difficulty are the gentle cloud features in the planet's atmosphere. Saturn seems to have a highlevel haze of ammonia ice crystals that is largely absent on Jupiter, and this tends to subdue the contrast of surface features. Very rarely, a white spot will erupt to disturb the scene for a few weeks. It happened in 1933, 1960 and 1990. At maximum intensity, the white spots were visible in 4-inch telescopes.

• Finally, there's the Encke gap, which is the most difficult Saturnian feature to discern. The gap is so thin—a meager 320 kilometers across—that it is detectable only by experienced observers using excellent scopes with serious aperture.

SATURN'S SATELLITE FAMILY

Seven of Saturn's moons are visible in an 8-inch scope. While their number surpasses the four big moons of Jupiter, the Saturn family is much more difficult to observe.

Titan, an eighth-magnitude object orbiting Saturn in approximately 16 days, is by far the largest of Saturn's moons and is easily seen in any telescope. When at its maximum distance from the planet, it appears to be five ring diameters from Saturn's center. Titan is the only satellite in the solar system known to have a substantial atmosphere.

A 70mm refractor should reveal Saturn's 10th-magnitude moon Rhea less than two ring diameters from the planet. Iapetus is next on the list of visibility, but only when it is in one part of its orbit. It has the peculiar property of being five times brighter when it is to the west of Saturn than when it is to the east. Iapetus ranges in brightness from 10th to 12th magnitude. One side of the moon has the reflectivity of snow, while the other resembles dark rock. When at its brightest, Iapetus is located about 12 ring diameters west of its parent planet. Because stars may appear at a similar distance from Saturn, several observations may be necessary for a confirmed sighting.

The next two moons inward from Rhea are Dione and Tethys, each of which is magnitude 10.4 and readily seen in a 6-inch or larger telescope. Inward from Dione and speeding around the edge of the rings are Enceladus and Mimas, both more than a magnitude dimmer and significantly more difficult to detect.

Uranus

Uranus was discovered in 1781 by English astronomer William Herschel, who is probably the greatest observational astronomer of all time. In the course of a systematic program to examine every object visible in his 6.2-inch Newtonian, Herschel observed a sixth-magnitude "star" that did not look like a point of light. Herschel was in the habit of using high magnification to study celestial objects, and when he came across Uranus, he was using 227x.

In his report of the discovery, published in *Philosophical Transactions* in 1781, Herschel stated: "From experience, I knew that the diameters of the fixed stars are not proportionally magnified with higher powers, as the planets are. Therefore, I now put on powers of 460 and 932 and found the diameter of the comet increased in proportion to the power, while the diameters of the stars to which I compared it were not increased in the same ratio."

Herschel thought he had discovered a comet, but it soon became clear that his find was a planet orbiting the Sun beyond Saturn. It had been seen before and had even been plotted in a star atlas. At magnitude 5.7, Uranus is barely visible to the unaided eye and is an easy target for binoculars.

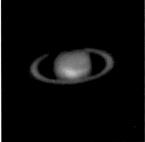

▲ Rare Saturn Events Top: An extremely rare passage of Saturn in front of a bright star was captured on film on July 3, 1988. Above: The ringed planet's seldom-seen white spot was observed in 1990. Both photos by Don Parker.

Saturn's Most-Observed Satellites

Satellite	Diameter (km)	Visual Magnitude	Orbital Period (days)	Avg. Maximum Distance From Planet Center (arc seconds)	Apparent Diameter (arc sec.)	Shadow Diameter* (arc sec.)
Titan	5,150	8.4	15.95	197	0.85	0.7
Rhea	1,530	9.7	4.52	85	0.25	0.2
Dione	1,120	10.4	2.74	61	0.17	0.15
Tethys	1,060	10.3	1.89	48	0.16	0.15

*Titan's shadow is seen only when the rings are nearly edge-on. Other satellite shadows are exceedingly difficult to see.

However, it takes about 100x before its 3.9arc-second disk ceases to resemble a star. Apparently, prior to Herschel, nobody had used enough magnification.

A modern telescope similar in size to Herschel's will easily reveal Uranus's pale, aquamarine disk—the top layer of the planet's thick atmosphere. Over the past two centuries, observers have reported bright and dark markings in the otherwise uniform haze of Uranus. Although these observations were often dismissed, the Hubble Space Telescope has shown that light and dark clouds do come and go on the seventh planet. They are exceedingly difficult to detect in backyard scopes.

In 1980, before the rotation period of Uranus had been determined, amateur astronomer and renowned visual observer Stephen O'Meara began a three-year Uranus observing program using Harvard Observatory's 9-inch refractor. Tracking vague markings in the planet's atmosphere, he was able to measure the rotation of Uranus at 16.4 hours. When the Voyager spacecraft reached Uranus in 1986, it confirmed that the rotation period at the latitude of the clouds O'Meara had observed was within a tenth of an hour of his result.

Five of Uranus's moons were known before the Voyager flyby, and 10 more were uncovered by the spacecraft's cameras, but the brightest are only 14th magnitude. Uranus is simply too distant to be a compelling target for most backyard astronomers.

Neptune

In some ways, Neptune is more interesting than Uranus for the backyard astronomer; it is certainly more challenging. For the binocular observer, Neptune appears starlike, at magnitude 7.7, in eastern Capricornus until 2010 and in western Aquarius for many years after that. In references such as the *Observer's Handbook* or in astronomy magazines, charts of Neptune's position for each year provide a guide for binocular or smalltelescope identification.

Although 100x will show Neptune as a disk, only powers close to 200 unmistakably reveal it as one. Its 2.5-arc-second disk is definitely blue in 6-inch or larger telescopes. In smaller instruments, the planet generally looks pale gray.

Neptune has one large and more than a dozen small satellites. Voyager 2 discovered six of the small ones when it encountered the planet in August 1989. Triton, the biggest moon, is 13th magnitude, making it visible in moderately large scopes.

On the night of May 28/29, 2009, Jupiter will be less than one-half degree from Neptune, offering an interesting pairing in a medium-power telescope field. A similar event happened during Galileo's lifetime. Neptune, then unknown, looked like a star near Jupiter in the great astronomer's crude telescope, and he duly marked it as such in his observing notes.

Follow Those Moons Using corkscrew diagrams like these for the current month, you can identify the four brightest satellites of Jupiter and Saturn. The horizontal lines represent 0 hours Universal time (UT) on the date indicated (0 hours UT = 7 p.m., EST,the previous day). The two straight vertical lines in the Jupiter diagram represent the disk of the planet. The wavy lines are the orbiting moons' positions at any time. The four vertical straight lines in the Saturn diagram are Saturn's disk (inner two) and its rings (outer two). The four satellites shown for Saturn are, in order outward, Tethys, Dione, Rhea and Titan. Saturn satellite charts for the current year are published in the Observer's Handbook. Jupiter charts are published in the Observer's Handbook and in all the major astronomy magazines. Courtesy U.S. Naval Observatory (Jupiter) and Larry Bogan (Saturn).

C H A P T E R E L E V E N

Finding Your Way Around the Sky

Familiarity with the night sky's geography and motions is what being an amateur astronomer is all about. While books like ours can serve as a guide, such knowledge can be gained only through the practical experience of observing the sky and understanding what you see. Without this knowledge, the most expensive telescope will add little to the hobby.

We have seen this advice ignored many times. People buy telescopes with fancy-looking mounts and setting circles (numbered dials on the mount) or computerized motors that can point automatically to thousands of objects, yet they do not know a single constellation. Or they know Orion and Andromeda but not the best season of the year to see them. Without a proper understanding of what the sky has to show or how it works, the observer will probably spend a few frustrating nights with the new telescope, then neglect it.

experienced amateur astronomers, Ron Ravneberg usually relies on no more than star charts, a finderscope and a laser pointer to locate deep-sky objects. His telescope is a restored 4.5-inch Fecker refractor from the 1930s on a modern homebuilt altazimuth mount. Photo by Terence Dickinson.

Like many other

Celestial Sphere 🕨

Imagining the sky to be a great dome rotating above our heads is a convenient way to picture how the sky works. From northernlatitude sites on Earth, that dome appears tilted, with the north pole of the dome halfway up the northern sky.

Chart adapted from Starry Night Pro™/Imaginova.

Spinning Sky 🕨

In this ultra-wide-angle 4-hour exposure looking northeast, the circumpolar stars spin at left around Polaris, while the seasonal stars rise out of the east at right.

How the Sky Works

Before we dive into the tools and techniques for finding your way around the sky, we'll explore the mechanics of the sky: how it moves and why stars and planets appear where they do. This emphasis stems from our observing philosophy.

We feel that the point of backyard astronomy is not just to peek into a telescope evepiece; rather, it is the total experience of a personal exploration of the cosmos, a process that begins with the first identification of the Big Dipper, Orion and the bright planets. Recognition of the less obvious constellations follows, as well as a growing appreciation of the sky's motion due to the Earth's rotation and its revolution around the Sun. The quest can then extend thousands or millions of light-years via binocular sightings of the brighter star clusters, nebulas and a galaxy or two. As the months pass, the seasonal shift of the celestial panorama overhead elicits a sense of cyclical change within a chamber of immense proportions. You see and understand the celestial sphere that turns above us each night.

Before this stage, a telescope of any description tends to be a distraction rather than an aid, diverting attention from the big picture. Until a novice stargazer understands the basics of how the sky is arranged and how it moves over time, attempting to navigate a telescope around the sky will only invite confusion. After you learn the basics, the next step is to learn to use star charts to find specific objects.

NIGHT MOVES

Feeling at home under the sky won't happen until a mental picture clicks in: You are standing under a large dome that appears to be perpetually spinning around an axis. The sky dome is tilted at an angle that depends on where you live on Earth. The sky's rotation axis lies not overhead but to the north if you live in the northern hemisphere or to the south if you live Down Under. Think of the stars and constellations as being fixed to that spinning dome, as ancient astronomers did. Riding on that dome, however, are several moving targets—the Sun, Moon and planets—that travel among the stars along set and predictable paths.

AS THE WORLD TURNS

The daily motion of the sky from east to west is an obvious fact of life—at least during the day. Everyone sees the Sun rise in the east and set in the west and knows that this motion comes not from the Sun but from Earth spinning on its axis. Although not so apparent, the same motion occurs at night, causing the starry dome to rotate above our heads. Stars, too, move from east to west, something that often surprises people unfamiliar with the sky. (We get UFO reports of objects hovering near the horizon that are no longer there an hour later!)

UNDER THE CELESTIAL SPHERE

To understand this motion, imagine Earth surrounded by a large dome studded with stars. The Earth's North and South Poles point to the poles of the celestial sphere. The sphere is divided into northern and southern halves by the celestial equator, a projection of the Earth's equator into space. Earth spins on its axis within that sphere, from west to east. Living on the surface, we don't sense the Earth's movement. Instead, we see the sky turn above us in the opposite direction, from east to west. The entire sky appears to rotate around its two poles.

Now here's where it takes a little mental gymnastics. If we lived at the North Pole, the pole of the sky would lie directly overhead. The sky would turn parallel to the horizon. But most readers live at the midlatitudes of the northern hemisphere (we picked 40 degrees north for the illustration at top right). Our local horizon, a line tangent to the Earth's surface at that latitude, cuts through the celestial sphere as indicated. Anything in the sky below that horizon line is out of our sight.

From our northern midlatitude viewpoint, the celestial sphere seems to be tipped over, with the north celestial pole and the North Star due north, 40 degrees above the northern horizon. The celestial equator arcs across the southern part of

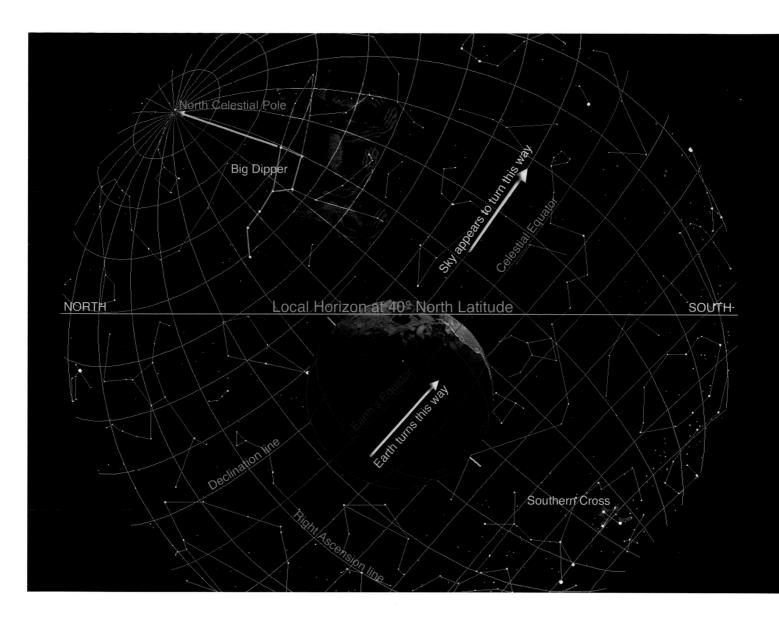

our local sky. It is here that we see the Sun, Moon and planets—in the south. The location of the poles and equator in your local sky does not change through the year unless you move north or south on Earth. But the whole sky does turn through the night.

WHERE'S THE NORTH STAR?

Most stargazers know the trick: The two stars in the pouring edge of the Big Dipper's bowl point to Polaris, the North Star. Locate that star, and you have found true north— Polaris never moves off its position in the sky as the night hours go by. But *where* you find Polaris depends on how far north or south you are on Earth. The altitude of Polaris above your northern horizon equals your latitude.

Looking North

When we look north at night, we see the sky rotating about the celestial pole, marked in the northern sky by Polaris, the North Star. This star barely moves through the night, and the celestial sphere appears to spin counterclockwise around it. Like the Big Dipper, stars and constellations near the North Star are circumpolar—they never set below the horizon but travel in endless circles - about the pole.

Circumpolar Trails 🔺

A 6-hour time exposure looking due north turns the stars into streaks as they spin around Polaris (the shortest bright streak near the rotation point), the north celestial pole.

Looking East 🕨

From northern latitudes, stars in the east appear to rise at an angle to the horizon, moving to the right as they climb higher.

All charts adapted from Starry Night Pro™/Imaginova.

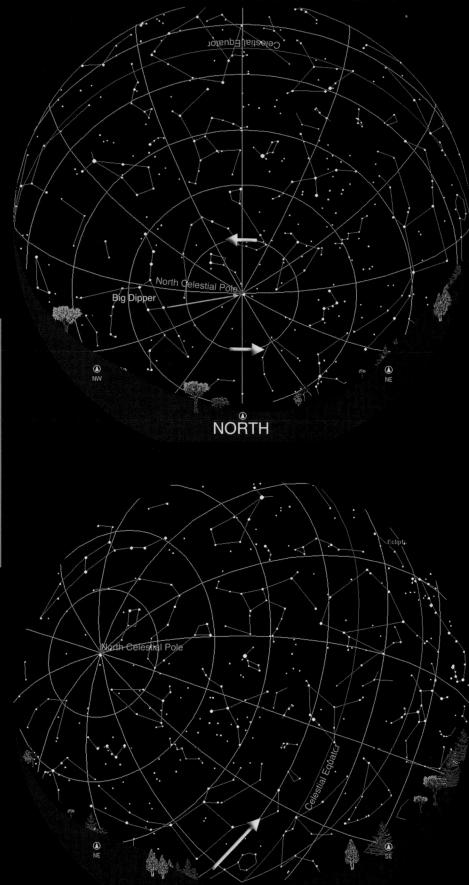

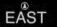

210

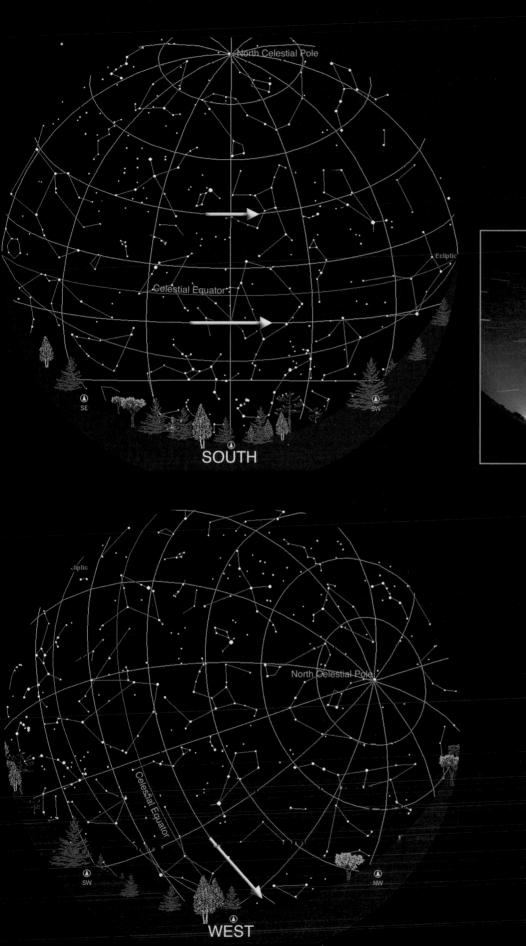

Looking South

As we gaze due south, stars drift from left to right (east to west) across the sky. This region of sky contains the so-called seasonal constellations—those which change through the year, unlike the circumpolar patterns that can be seen all year long.

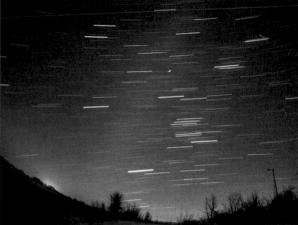

▲ South-Sky Trails This 1-hour time exposure looking due south shows how those stars appear to move in horizontal paths parallel to the horizon.

NOTE: In the southern hemisphere, the sky spins clockwise around a pole that lies to the south. Stars still rise in the east and set in the west, but as you look opposite the pole, to the north, east lies to your right and west is to your left. So as the hours pass, seasonal stars and the Sun and Moon move across the sky from right to left.

Looking West

Celestial objects set in the west. Stars appear to move to the right as they sink toward the western horizon. From 50 Degrees North From western Canada, for example, at a latitude of 50 degrees north, Polaris shines high in the north, 50 degrees above the northern horizon. The Big Dipper remains visible all night and all year, even as it swings under the pole.

From the Equator **>** For anyone used to northern skies, the view from the equator (perhaps from a game park in Kenya) is strange indeed. Stars rise straight up, perpendicular to the eastern horizon, and set straight down into the west. This makes for rapid sunrises and short-lived sunsets—the Sun drops below the horizon quickly, creating the fast onset of darkness typical of the tropics. From this location on Earth, the celestial equator passes directly overhead. The two celestial poles lie on the horizon, opposite each other, due north and south.

All charts adapted from Starry Night Pro™/Imaginova.

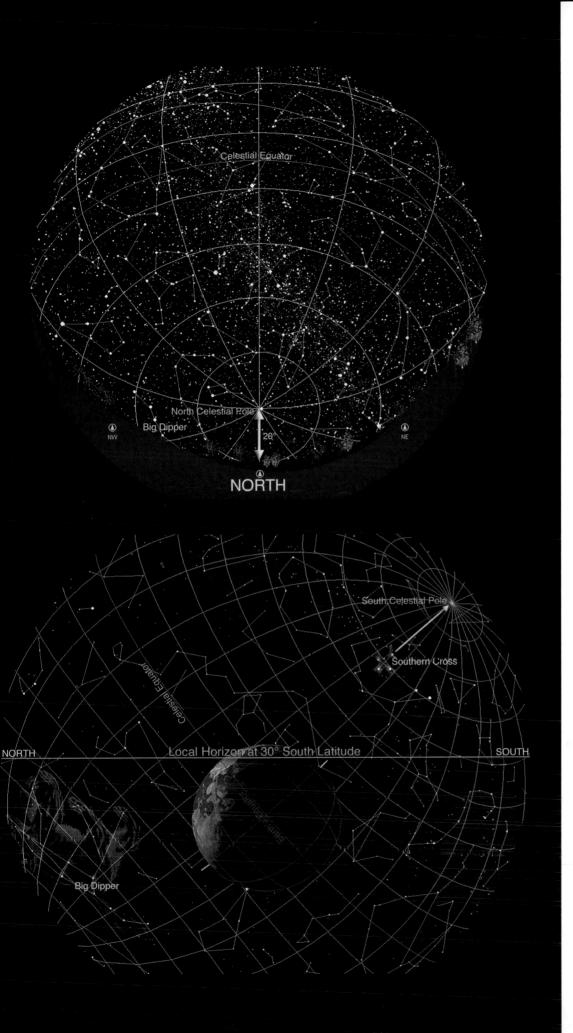

◀ From 20 Degrees North From the latitudes of Hawaii and Mexico, at 20 degrees north, Polaris shines low in the sky, just 20 degrees above the horizon. At certain times of the year, the Big Dipper slips below the horizon, as it is doing here.

From 30 Degrees South From the latitude of Australia, southern Africa or South America, the sky seems turned upside down compared with a northern viewpoint. Of course, to southerners visiting the north, the North American or European sky is upside down. From 30 degrees south, the north celestial pole is forever below the horizon. The sky turns clockwise around the south celestial pole, which lies due south (the Southern Cross points to it), at an angle above the horizon equal to the site's latitude below the equator. The celestial equator now arcs across the northern sky. Southerners look north to see the Sun, Moon and planets.

THE EARTH'S ORBITAL TREK

Earth is said to *rotate* around its axis, taking 24 hours to complete one rotation with respect to the Sun. Earth also *revolves* around the Sun, taking a year to complete

one orbit. The Earth's orbital period defines our 365-day year (more or less). The Earth's motion around the Sun gives rise to the sky's other great annual motion: the seasonal parade of constellations. We can't see Orion in June or Sagittarius in December.

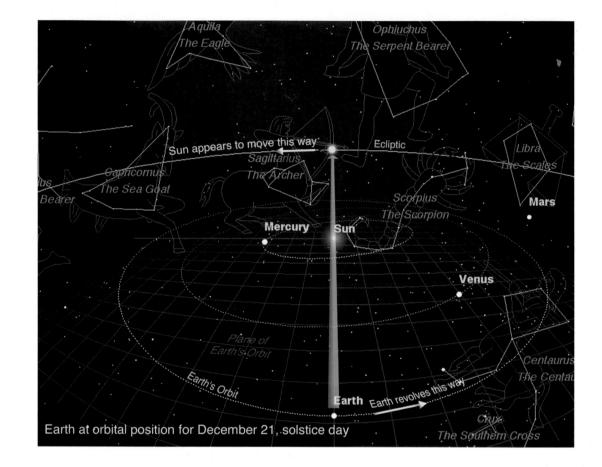

Path of the Sun 🕨

As Earth revolves around it, the Sun appears to move from west to east against the background stars. The imaginary line the Sun follows is called the ecliptic. This is the view we would see from space on December 21.

The Sun and Stars ► Taken by the orbiting SOHO satellite, this image of the Sun captures a view we can never see from the Earth's surface: the Sun (represented by the yellow disk) surrounded by stars (in this case, the star clouds of Sagittarius). Courtesy NASA/ESA.

Every constellation has its season, and here's why.

THE VIEW FROM SPACE

From an omniscient viewpoint, we gaze down on Earth at its place in its orbit on December 21, winter solstice for the northern hemisphere. Looking from Earth toward the Sun, we see the Sun apparently sitting in the constellation Sagittarius. As Earth revolves around the Sun, the Sun appears to shift eastward against the background stars. From Sagittarius, the Sun moves into Capricornus. The Sun's path in the sky is the ecliptic line. Over the course of a year, the Sun travels along the ecliptic, moving through 12 constellations, the familiar signs of the zodiac. The Sun spends approximately one month in each constellation of the zodiac. However, as you can see below, the Sun also spends some time in a thirteenth constellation, Ophiuchus, whose foot (historically speaking) was placed between the scorpion and the archer long ago.

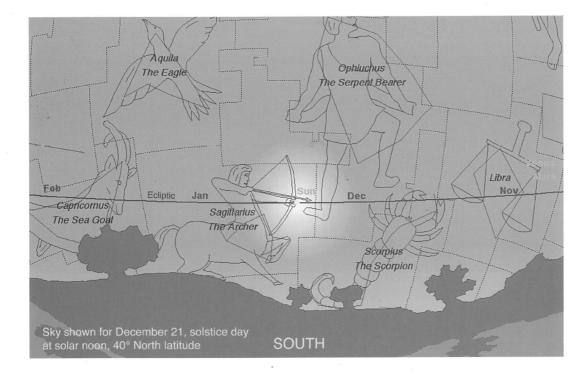

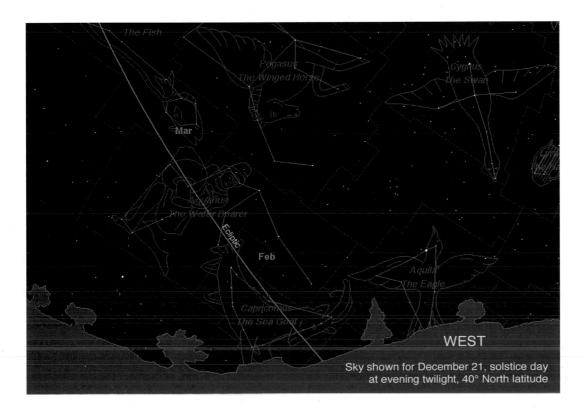

View From Earth by Day Shift your viewpoint from high in space to the Earth's surface at a midnorthern latitude. The date remains the same, December 21. At high noon, the Sun lies due south in the constellation Sagittarius. It and the surrounding constellations are, of course, invisible in the day sky. We'll see these constellations due south on summer nights six months later, when the Sun has moved 180 degrees along the ecliptic and lies in Gemini. In June, Gemini, Orion and the winter constellations will occupy the daytime sky.

View at Nightfall Wait until dark on December 21, then look west. Sagittarius has set with the Sun, and the stars of Capricornus and Aquarius shine low in the evening twilight sky—but not for long. As the Sun continues its trek along the ecliptic in the days to come (of course, Earth is actually doing the moving), these constellations disappear behind the Sun. By January, they are gone from the evening sky and the zodiac constellations of Pisces and Aries are low in the west. So it goes through the seasons—a parade of changing constellations that repeats like clockwork every year.

All charts adapted from Voyager III™/Carina Software.

MARCH OF THE CONSTELLATIONS

The annual motion of Earth around the Sun creates the shifting array of constellations we see each year. Like the birds of spring and the leaves of autumn, constellations are familiar signs of the seasons. People are always amazed that backyard astronomers can simply look up and name a star. But the stars and constellations return to the same place in the sky each year. Learn them one year, and you'll know their habits for every year to come. If it is February, for example, that bright star twinkling in the south must be Sirius. But two months later, Sirius is low in the southwest. To the south, new stars have taken its place.

The progression of Earth around the Sun makes stars rise and set about four minutes earlier each night. (To be precise, the difference is 3 minutes 56 seconds.) This adds up to two hours per month. For example, Orion sets two hours earlier in March than it does in February. After 12 months, this advance of the constellations adds up to 24 hours, and we have gone full cycle—the same constellations that were due south in February this year will be there again next February.

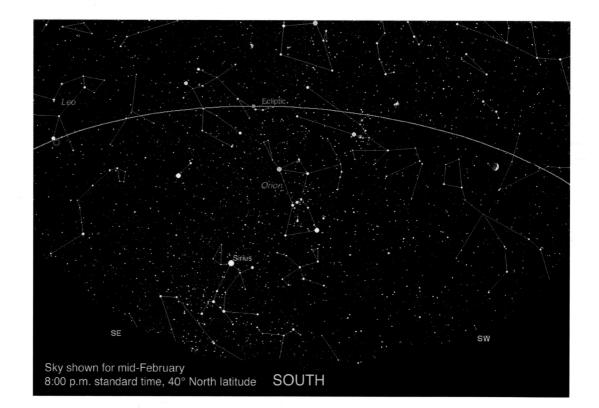

February: Orion 🕨 **Shines Due South** In this series of three diagrams (right and facing page), the sky is shown at the same time each night (8 p.m., standard time), looking south from a latitude of 40 degrees north. Each successive view is one month later. In mid-February, the stars of Orion shine due south at 8 p.m., as high as they get for the night. Sirius sparkles in the south-southeast. The stars of Leo the lion are just rising in the east.

Winter Sky Setting Looking west in April, we see the stars of Orion and the winter sky sinking into the combined glow of twilight and light pollution from a nearby city. From 40 degrees north, April nights are the last chance to see Orion until it emerges from behind the Sun in the dawn hours of August.

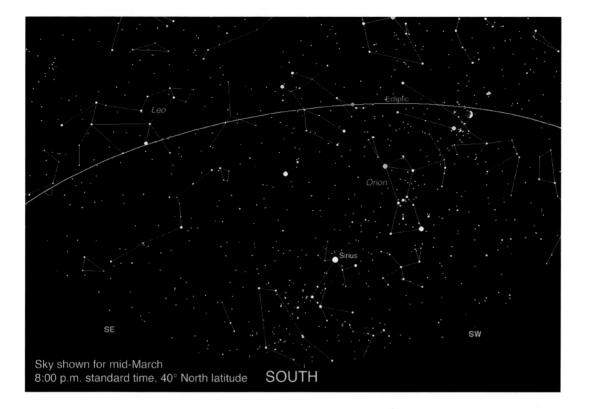

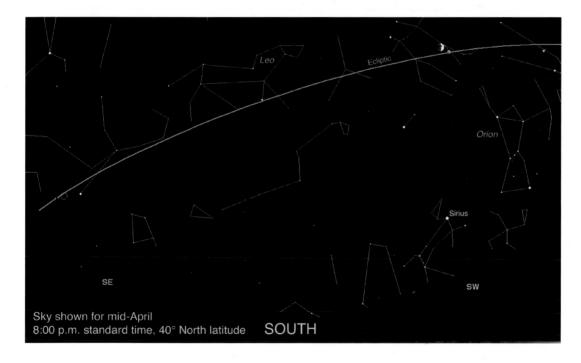

WANDERING PLANETS

While the stars and constellations return to the same place in the sky each year, the planets do not. Just as Earth revolves around the Sun, so do the other planets—each at its own rate. Of the bright naked-eye planets, Mercury travels the fastest around the Sun and Saturn travels the slowest. The orbital motion of the planets carries them against the background stars, a motion that can become obvious even after a few days or weeks. Jupiter, for example, moves eastward from one zodiac constellation to the next over the course of a year, taking 12 years to make one cycle around the sky.

• March: Orion in the Southwest

Thirty days later, at the same time of night, Orion is sauntering over to the southwest, two hours of sky rotation past the point where the celestial hunter stood a month earlier. Sirius is just past the meridian, the line that runs due south to north and bisects the sky. Leo is now well up in the east.

• April: Orion Sinking into the West

By mid-April at 8 p.m. (9 p.m., daylight time), Orion is sinking into the western sky and Sirius is shining low in the southwest. The spring stars of Leo are due south now, and the winter stars surrounding Orion give way to the spring constellations. By April, the Sun sets later and darkness doesn't come as early as it did in February. By the time the night is fully dark, Orion is gone.

All charts courtesy TheSky™/Software Bisque

PATH OF THE PLANETS

The celestial sphere contains several fundamental lines and points, the celestial poles and equator among them. But another key line is the ecliptic—the path the Sun apparently describes as it travels around the sky. It can also be pictured as the plane of the Earth's orbit around the Sun.

It is in this same plane, give or take a few degrees, that the planets orbit. The solar system is like a flattened disk, an artifact of its formation billions of years ago from a spinning disk of gas and dust. It is along the planets are tipped over on their rotation axes. Earth is one of them. Our planet is tilted 23.5 degrees off the vertical. For this reason, the ecliptic does not coincide with the celestial equator.

WOBBLING EARTH

Earth moves through another long-term motion whose effect is much more subtle than its daily rotation and annual revolution. Over 26,000 years, the Earth's spin axis, which is defined by the red arrows below, wobbles like a top around a radius of

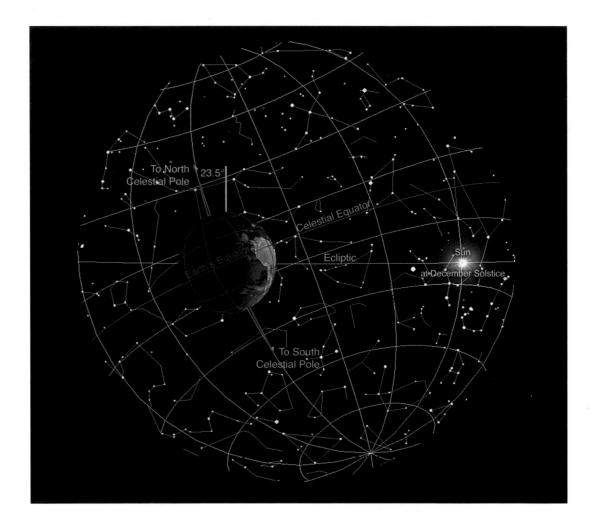

ecliptic line in our sky that we find the Moon and planets. Oddball dwarf-planet Pluto, some asteroids and many comets appear far off the ecliptic.

Their common origin explains why all the planets revolve around the Sun in the same direction, counterclockwise as seen looking down from the north. But some 23.5 degrees. The center of that wobbling motion is the ecliptic pole, the vertical green line protruding from Earth in the diagram above. This slow precession motion will gradually cause the north pole of the sky (the north celestial pole) to shift away from Polaris. In 12,000 years, Vega will be the pole star.

Ecliptic Plane 🕨

When viewing the solar system from space, we tend to depict it with the ecliptic as the standard horizontal plane. In this view, Earth is then tipped 23.5 degrees from a line perpendicular to the ecliptic. This tilt of the Earth's axis gives rise to the seasons. When the northern hemisphere is tipped away from the Sun, as it is here, people experience winter in the north, while the southern hemisphere, tipped toward the Sun, enjoys hot summer days. Six months later, with Earth on the opposite side of the Sun, the northern hemisphere is tipped toward the Sun, bringing summer to the north and winter to the southern hemisphere.

> Chart adapted from Starry Night Pro™/Imaginova.

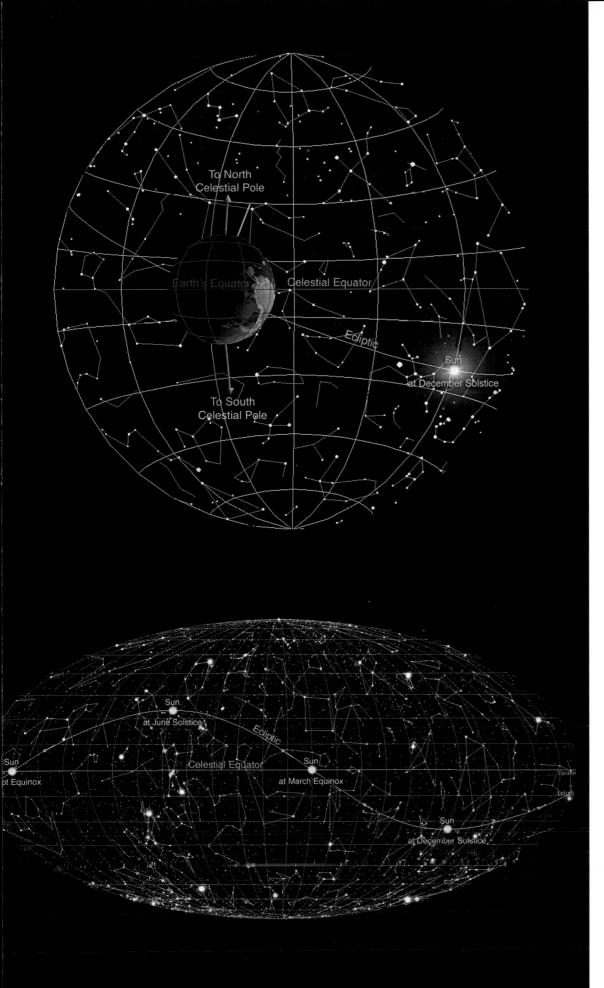

Tilting Earth Upright To understand why we see the ecliptic where we do in our sky, rotate the previous scene so that the Earth's rotation axis stands upright. The celestial equator becomes the horizontal plane, and the ecliptic swings above and below the equator at a 23.5-degree angle. The Sun lies south of the equator from September to March and north of it from March to September. Where the ecliptic crosses the equator are the two equinoxes.

Chart adapted from Starry Night Pro™/Imaginova.

The Sky Unwrapped

Now let's unwrap the entire heavens we see from Earth into one all-sky chart. The yellow lines are the grid work of the celestial coordinate system of right ascension and declination that maps the sky. The ecliptic swings above and below the equator. As the Sun moves along the ecliptic, it reaches four key points each year. Two are the solstices, when the Sun is at its maximum distance (23.5 degrees) above and below the celestial equator. The other two points are the equinoxes, when the Sun crosses the equator, heading north or south.

Chart adapted from SkyChart III™/ Southern Stars Systems.

ECLIPTIC HIGHS AND LOWS

It's a common misconception that the seasons are caused by the Earth's changing distance from the Sun. Although the Earth's orbit is slightly elliptical, the change in distance through the year has little effect on climate. It's the change in the Sun's altitude (due to the Earth's tilt), from high in summer to low in winter, that produces seasons. To know where to look for the Moon and planets, it's important to understand the wobbling ecliptic and to develop a mental picture of where the ecliptic sits each season. The following illustrations depict the sky from a latitude of 40 degrees north.

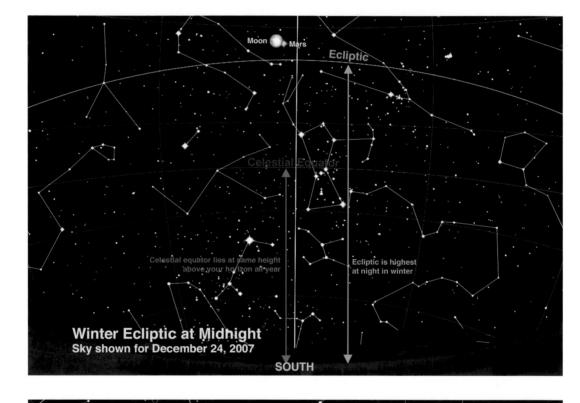

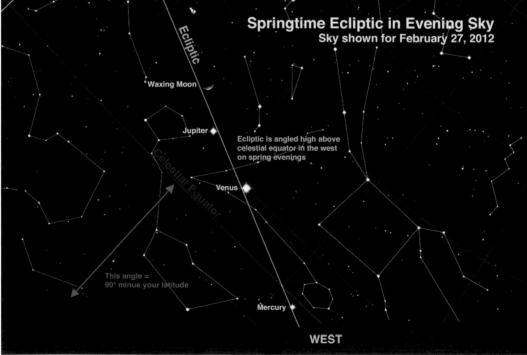

Wintertime Highs

In winter, the ecliptic swings low across the daytime sky (see "View From Earth by Day" on page 215). But at night, the opposite occurs. The ecliptic we see on a frigid winter evening is where the Sun sits on a summer day. As depicted in this scene from December 2007, wintertime planets always ride high in the sky (as Mars did that year). And winter full Moons shine down from the highest altitude of any of the year's full Moons.

All charts adapted from Starry Night Pro™/Imaginova.

Springtime Swing

As we look west on a latewinter or spring evening, the section of the ecliptic that rises above the celestial equator is now in the west. This swings the evening ecliptic to its highest angle above the horizon for the year, placing twilight planets, such as Mercury and Venus, at their highest altitude. The crescent Moon also rides high, making it easier to sight thin young Moons. Because planets lie along the ecliptic, they can create, as here, a line of worlds across the sky.

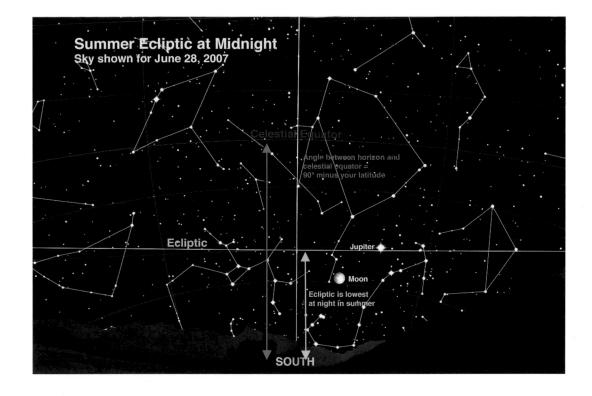

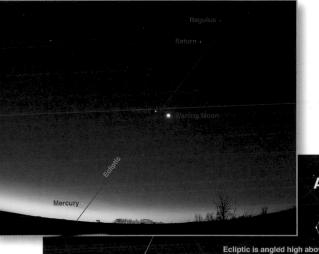

A REAL SCENE

The predawn image at left, taken on an early-November morning in 2007, shows how the planets and Moon lie along a line, the ecliptic, that on autumn mornings is angled steeply with respect to the horizon.

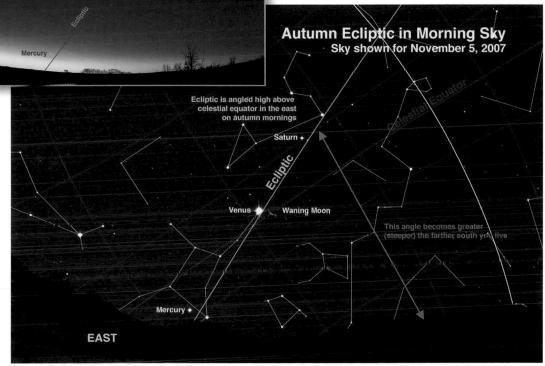

Summertime Lows The evenings may be warm and pleasant, but summer is not a good season for planet watching from the northern hemisphere. At night, the ecliptic swings low across the southern sky, as do the summer planets. When Jupiter was near Scorpius in June 2007, as depicted here, it sat low in the sky, putting it amid the murk and turbulence of our atmosphere and producing blurry telescopic views. Summer full Moons also appear low in the sky. In 2007, the Moon was especially low as it swung near its maximum of five degrees below the ecliptic.

NOTE: In the southern hemisphere, the same rules apply. At night, the ecliptic, which lies to the north not south, is high in winter and low in summer.

Autumn Angles

In autumn, the ecliptic arcs low across the evening sky, but just the opposite occurs at dawn. Late summer and autumn are the best times for seeing twilight planets and thin waning Moons in the morning sky. The ecliptic is then angled at its highest for the year in the eastern sky, making autumn best for sighting elusive Mercury in the morning. Autumn is also the best season for morning sightings of the faint glow of zodiacal light (which follows the ecliptic), while spring is the best season for evening sightings of zodiacal light.

GOING THROUGH A PHASE

Moon phases remain the most misunderstood natural phenomena. They are not caused by the Earth's shadow moving across the disk of the Moon, as is commonly believed. That's a lunar eclipse. The real explanation becomes obvious once you form a mental picture of Earth sitting in space, with the Moon revolving about us once a month in its own orbit.

Both Earth and the Moon bask in sunlight. The sides of our two worlds that face the Sun are in daylight, while the sides facing away from the Sun are in darkness. Now let's place ourselves away from Earth, facing the Sun and looking down on the nightside of our planet. As the Moon revolves around Earth, what do we see?

VIEW FROM SPACE

When the Moon comes between us and the Sun, the nightside of the Moon faces us.

This is new Moon, a phase that is invisible to us except when the Moon happens to cross directly in front of the Sun in a solar eclipse. As the Moon continues to revolve around Earth (from right to left in the illustration below), we see more and more of the lit dayside of the Moon. First, we see a thin crescent followed by first-quarter phase, about seven days after new. The Moon is then 90 degrees away from the Sun. After another week of so-called gibbous phases, the Moon reaches the point in its orbit opposite the Sun. The side of the Moon facing us is now entirely lit by the Sun, creating a full Moon 14.5 days after new.

VIEW FROM EARTH: EVENING

Dropping back to Earth, here is what we see through that same cycle. The scene at top right depicts the evening sky at the same time each night for a two-week period. We chose a scene early in 2002, but a similar

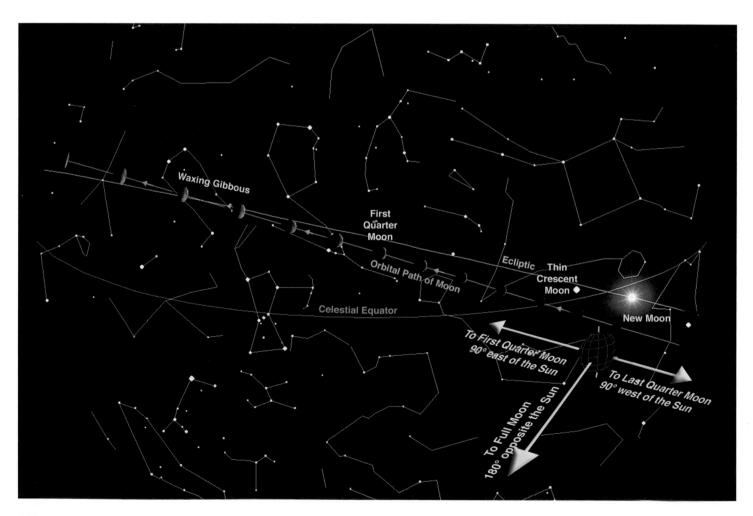

Synodic and Sidereal ▼ The Moon revolves around Earth once every 27.3 days, its sidereal period. However, because Earth has revolved partway along its orbit around the Sun in that time, it takes the Moon two more days to return to the same phase. The interval between new Moons is 29.5 days, the so-called synodic period that forms the basis of the calendar month.

Adapted from Starry Night Pro™/Imaginova. scene applies to any month in any year, with only the angle of the Moon's path shifting with the seasonal change in the angle of the ecliptic.

During the waxing (growing) cycle, we first sight the Moon as a thin crescent low in the evening twilight. This is possible about two days after new (anything less is tough to see). The Moon's motion around us carries it farther to the east each night—we see it higher and higher in the evening sky as the week progresses. By seven days after new (the number on each little moon indicates its age in days), the Moon lies due south at sunset. This is first-quarter Moon, so called because the Moon has traveled one-quarter of the way around its orbit. Half the disk of the Moon we see is now sunlit.

The Moon continues to wax through gibbous phases until it reaches full. Being opposite the Sun, any full Moon rises in the east as the Sun sets in the west. A full Moon sits due south at midnight and shines in the sky all night.

VIEW FROM EARTH: MORNING

Now let's switch to a morning-sky view. We are still looking south, but the Sun is just about to rise in the east. This places the full Moon over in the west, ready to set. With each passing night, the Moon wanes in phase as it moves back toward the Sun. Each night, the Moon is roughly 12 degrees farther to the east than it was the previous night. The Moon therefore moves its own diameter (0.5 degree) in about an hour. This motion is due to the Moon's revolution around us.

On clear mornings after sunrise, as the waning cycle proceeds, we see a gibbous Moon in the western sky. About 21 days after new, the Moon once again lies 90 degrees away from the Sun, creating a lastquarter Moon shining due south at sunrise. This wanes to an old, thin crescent Moon rising Just before the 3un, low in the dawn sky. The cycle completes itself 29.5 days after the previous new Moon, when the Moon comes between Earth and the Sun. The week or so around new Moon, a period called dark-of-the-Moon, is cherished by deep-sky observers, who must have dark moonless skies.

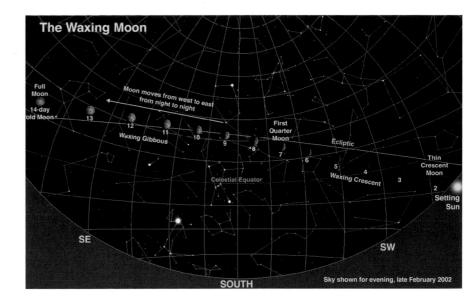

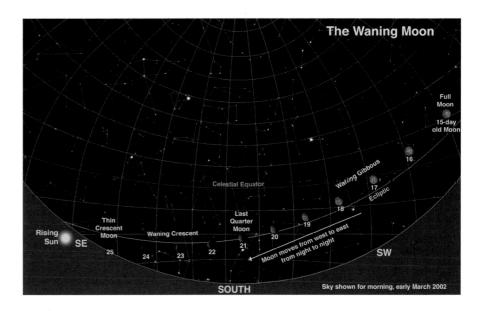

WHY NO MONTHLY ECLIPSES?

In the illustrations above, notice how the Moon follows the ecliptic, but not quite. Its orbit is tilted five degrees off the ecliptic, which is why we don't get an eclipse each month—because the Moon passes above or below the Sun's disk or the Earth's shadow. But when the Moon crosses the ecliptic at its new or full phase, we experience some type of eclipse. Such an alignment occurs from four to seven times each calendar year. Eclipses also come in pairs. Two weeks before or after every solar eclipse, when the Moon passes in front of the Sun, we usually have a lunar eclipse as the Moon moves through the Earth's shadow. ▲ Wax On, Wane Off When the Moon is increasing in phase each night, from new to full, the cycle is called a waxing Moon. After full phase, the Moon wanes, or decreases in illumination, each night.

Charts adapted from SkyChart III™/Southern Stars Systems.

Star-Hopping

Best Binocular Guide To help you explore the sky with binoculars, we recommend Binocular Highlights by Gary Seronik (Sky Publishing, 2007). Wide-angle and close-up charts of bino targets are presented in a compact format that is easy to use outside. With this guide, you can become a star-hopping master.

Star-Hopping Scope ► Gary Seronik, author of the binocular guide mentioned above, is a lifelong starhopper. His ultraportable homebuilt Newtonian was designed for travel to remote observing sites, where he uses the finderscope and visual cues from constellations to navigate the night sky. A prime question that every new telescope owner asks is, How do I find things? The quick answer is star-hopping. This technique, one every amateur astronomer masters, requires learning to read star charts, which are the maps of the night sky.

To become comfortable reading star charts, we recommend you spend a few months stargazing with binoculars first. Besides acquainting you with the capabilities of simple optics, binoculars will help you learn to use star charts to hop to bright binocular targets. After this, interpreting charts at the telescope (with its narrow field and inverted view) becomes a small step instead of the giant leap many newcomers find it to be.

LEARNING TO STAR-HOP

The key to successful star-hopping is pattern recognition. First locate your target on a suitable star chart, one deep enough to show enough stars to act as steppingstones across the sky. One of the sixth-magnitude atlases described in the next section is a minimum. Pick a bright star near your target, and identify a pathway of stars leading

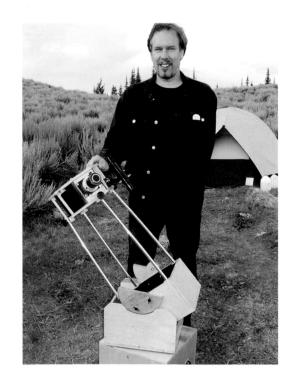

from that guide star to your destination. Look for identifiable chains or triangles of stars that can serve as signposts.

The next trick is to transfer that mental picture of your route to the sky. This is where familiarity with the sky, the size of the constellations and angular distances is important, as is the basic skill of knowing which way to turn the chart so that its orientation matches the sky. This comes with an understanding of how the dome of the sky is oriented above your head-knowing that when you look east, for example, the north celestial pole is to the left; therefore, star charts with north up must be twisted counterclockwise to match the naked-eye sky. A further trick is the simple act of turning the star chart upside down to match the view in an inverting finderscope.

A polar-aligned equatorially mounted telescope (as opposed to a Dobsonian telescope) can simplify star-hopping. No matter where it is pointed, the telescope moves only parallel to the lines of right ascension and declination, making it easier to track along east-west or north-south routes that match gridded star charts.

Star-hopping may sound like work, but star-hop routes will soon become as familiar as the backstreets of your hometown. With practice, you will soon be centering the telescope on any number of objects with no more than a couple of quick glances through the finderscope.

FINDER AIDS

A good finderscope (at least 6x30, but preferably 7x50) is essential for star-hopping. As a supplement or an alternative, we also recommend one of the reflex-style finders, such as the Telrad or the Rigel QuikFinder (see Chapter 5 for details). These are generally superior to the red-dot style of sighting aids, which are fine for homing in on bright stars but are not up to more rigorous star-hops to fainter targets (it is hard to see faint stars through the small sighting windows). In a dark sky, a Telrad or Quik-Finder is all you need to locate most targets. Many computer software programs allow you to overlay Telrad or QuikFinder reticle patterns onto the star field, a great feature for printing out your own custom star-hop charts at home.

For a convenient method of estimating angular distances in the sky, extend your hand to arm's length. The various configurations shown at left mark off standard units of distance that are typical of the leaps you'll be making in most star-hops. The Big Dipper also provides a constant gauge to angular distances in the sky.

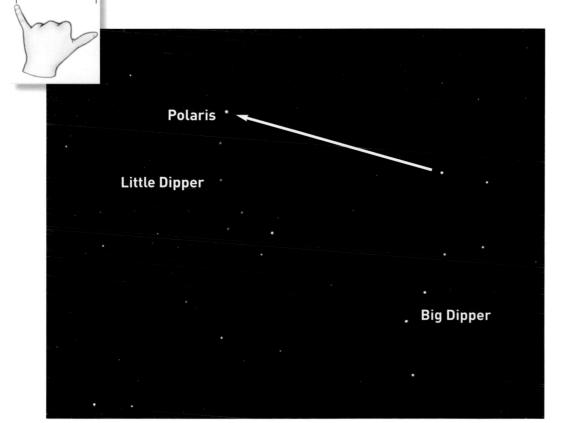

Star-Hopping Guides Specialized books offer a great selection of packaged star tours for telescopes. including maps with starhop routes marked. In their respective books, both titled Star-Hopping, Alan MacRobert (Sky Publishing) and Robert Garfinkle (Cambridge) conduct informative tours of selected regions of the sky. Advanced Skywatching (Time-Life; also sold in softcover under the title Backyard Astronomy), with contributions by Alan Dyer, contains standard background material complemented by monthly star charts and detailed starhopping maps. Turn Left at Orion (Cambridge), a fine beginner-oriented guidebook by Guy Consolmagno, provides maps for hunting down a hundred or so of the best deep-sky objects. A more advanced work is Erich Karkoschka's The Observer's Star Atlas (Springer), a small book of 50 charts, each with wide-angle constellation views as well as close-up charts that depict the view through a finderscope.

▲ Big Dipper and Polaris Compare the Big Dipper diagram at the center of this page with the real thing in the photo at left. The pointers from the bowl direct you to Polaris, the North Star, which is one dipper length away.

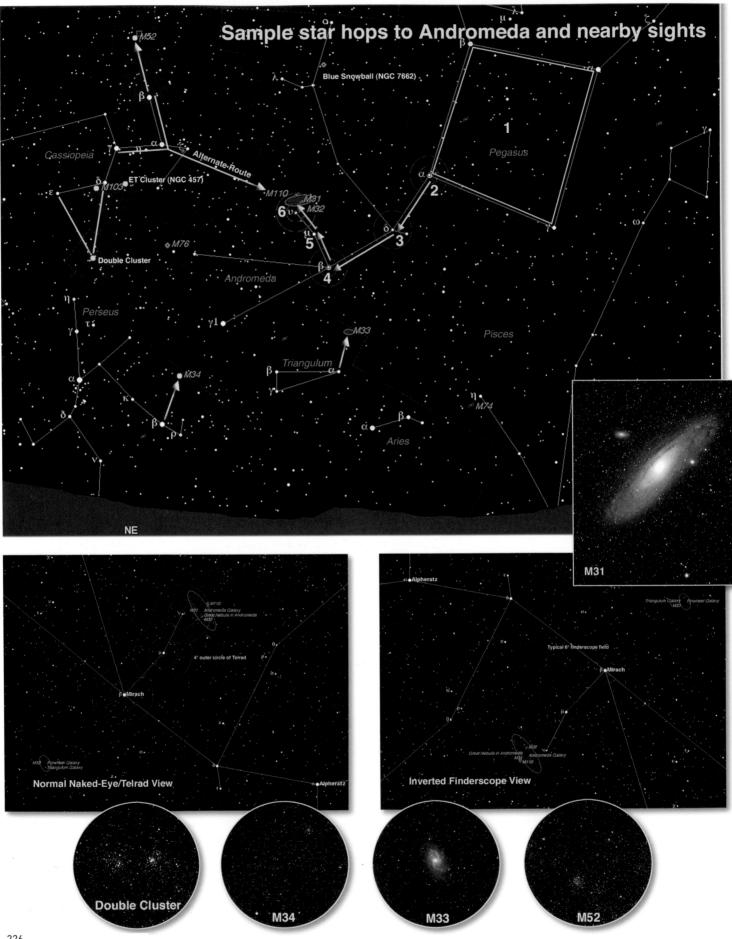

A SAMPLE STAR-HOP

It is a warm August evening on a dark-ofthe-Moon weekend. The Milky Way shines overhead, and the stars of autumn are rising in the east. Among them is one of the most popular destinations for stargazers: the Andromeda Galaxy. Located some 2.5 million light-years away, Messier 31 (M31), as it is also known, is the most distant object you can see easily with the unaided eye. It is the largest and brightest galaxy in the northern sky, providing a thought-provoking target for binoculars or any telescope. But how do you get there?

1. First locate the nearest distinctive constellation or star pattern (in this case, the well-known Square of Pegasus). In our August evening view, the Square is turned on its side, rising in the east. Once you have identified the Square, turn your star chart so that its orientation matches the sky.

2. Find a bright star to serve as a jumpingoff point (in this case, α Andromedae, or Alpheratz). The red circles indicate what a Telrad finder would show.

3. Get hopping! Swing away from the Square to the next brightest star, δ Andromedae, a couple of Telrad circles, or finder fields, to the east.

4. Keep going. Travel an equal distance again to β Andromedae, also called Mirach. Here's where you turn a corner.

5. Swing north about one Telrad circle, or finder field, until you come to a slightly dimmer star, μ Andromedae.

6. Keep going north for the last leg until you reach the next bright star, the slightly fainter υ Andromedac. M31 lics within a low-power eyepiece field of that star. You've arrived!

For an alternate route to Andromeda, imagine the three westernmost stars of Cassiopeia's W-shape forming an arrowhead pointing down to M31. Though it is a big leap for a telescopic star-hop, you can use this imaginary pointer line to confirm that you are in the right region. While you are in the area and primed for star-hopping, try to track down these fine sights:

• The Double Cluster sits off the first side of Cassiopeia's W, just far enough away to be a challenge to find in light-polluted skies. But the view of hundreds of stars sprinkling the field in two bright clusters is worth the hunt. Though it carries no Messier number, the Double Cluster exceeds most Messierobject clusters for spectacle.

• M34, a bright, loose open cluster listed in the Messier catalog (see Chapter 12), sparkles within a finder field of β Persei, also known as Algol, the Demon Star.

• Similarly, the spiral galaxy M33, located in Triangulum, is within a finder field of α Trianguli. It lies about the same distance below β Andromedae as M31 lies above it. Like M31, M33 is a member of the Local Group of neighboring galaxies. Note: M33 is a diffuse object that is hard to pick out in bright skies or with a small-aperture telescope in any sky.

• The line that joins α and β Cassiopeiae points to M52, another rich open cluster of hundreds of stars. With M52 just beyond the finder field (with β in the field) and no bright chain of stars to guide you, it is easy to get lost on this star-hop.

 Facing page, lower left: Mirach (β Andromedae)
 is a naked-eye star that serves as a starting point for a Telrad hop to M31.

Facing page, lower right: To start a hop with an inverting finderscope, place β Andromedae (Mirach) at the top of the finderscope's six-degree field.

 Determine Field of View It is useful to know the field of view of your lowpower eyepieces. Aim your telescope at a star on or near the celestial equator. Turn off the drive motor, and let the star drift across the field. An equatorial star takes four minutes to drift one angular degree. Divide the time it takes the star to cross the diameter of the field by four to get the eyepiece's actual field of view in degrees.

Charts adapted from TheSky™/Software Bisque.

Star Atlases

Stars and Planets

GUIDE

Even if you plan to use a computerized telescope or setting circles, you still need a star atlas. It is as essential to the backyard astronomer as a road atlas is to a highway traveler. And like the traveler, the

astronomer can become lost by not selecting the right atlas for the journey.

Planning for a cross-country trip requires, first, a national map for an overview, then state or provincial maps for more detail and, finally, regional or city maps for information about congested areas

or sites of special interest. Astronomers use the same procedure when exploring the night sky with binoculars or a telescope.

For the initial overview, the entire sky must be on one map. One such reference is the monthly circular charts in each issue of astronomy magazines. Also popular are rotating sky charts that can be dialed to show what is above the horizon for any time and night of the year. Of these planispheres, or star wheels as they have become known, our favorite is "The Night Sky," designed by David Chandler and available for about \$12 in durable plastic versions. Star wheels are configured for various latitude ranges. Buy the one suitable for your latitude or for the region where you might be traveling-planispheres are great aids to learning an unfamiliar tropical or southernhemisphere sky.

Despite the proliferation of laptop and handheld computers, don't plan to use computer software in the field. A \$1,000 computer isn't as convenient to use outside at night as a \$12 planisphere. However, software and on-line websites can be used to generate customized star-dome maps that can be printed out at home.

Unless you are doing solely unaidedeye viewing, you need more than a single all-sky chart. Star atlases divide the sky into smaller areas that plot the sky's contents in greater detail. Star charts are categorized by their limiting magnitudes. Each increase of one magnitude more than doubles the number of stars and other celestial objects shown but produces a substantially bulkier atlas. More detail also demands a higher level of experience to use the atlas.

FIFTH-MAGNITUDE STAR ATLASES

For those just beginning their tour of the night sky, several introductory books provide excellent fifth-magnitude star atlases along with plenty of support material. These include *NightWatch* by Terence Dickinson (Firefly Books), *The Edmund Sky Guide* by Terence Dickinson and Sam Brown (Edmund Scientific), *The Monthly Sky Guide* by Ian Ridpath and star-chart master cartographer Wil Tirion (Cambridge) and the *Universe Guide to Stars and Planets* by Ian Ridpath and Wil Tirion (Universe Books). A particularly attractive volume is *Skywatching* by David H. Levy (Nature Company).

Two of our favorite compact guidebooks are both named *Stars and Planets*, one in the Barron's Nature Guide series and one by publisher Dorling-Kindersley, the latter authored by Ian Ridpath. Both have excellent hemispherical monthly charts for learning the sky. A novel and truly shirt-pocketsized guide is *Stars* in the Collins Gem series, a tiny but surprisingly complete constellation guide that can slip into any telescope or binocular case.

SIXTH-MAGNITUDE STAR ATLASES

Every backyard astronomer needs a sixthmagnitude star atlas as a basic stargazing tool. In this category, there is none better than Wil Tirion's *Bright Stur Atlus* (Willmann-Bell), a superbly practical sixth-magnitude star atlas with 10 large, full-page charts covering the entire sky to magnitude 6.5. Facing each chart are tables of nebulas, clusters, galaxies and double and variable stars found on that chart. All open and globular clusters to magnitude 7 and all galaxies to 10 are shown. Double stars and nebulas are limited to those visible in small telescopes. In softcover, it's a bargain at \$10.

STARS

SKYWATCHING

A step up in attractiveness is the hardcover, full-color *Cambridge Star Atlas* (Cambridge; \$30), with 20 charts to magnitude 6.5 and 900 deep-sky objects plotted. This atlas contains modestly more information than the slimmer *Bright Star Atlas*. Both are highly recommended.

The world's best-known sixth-magnitude star atlas is *Norton's Star Atlas*, first published in 1910. The 20th edition, rewritten under the supervision of English astronomy writer and editor Ian Ridpath, is heavily revised with new atlas charts. There are 15 main maps to magnitude 6.5, each on a two-page, 11-by-17-inch spread, with reference tables on the preceding two pages. Unfortunately, the tables still emulate the style that was established by the original

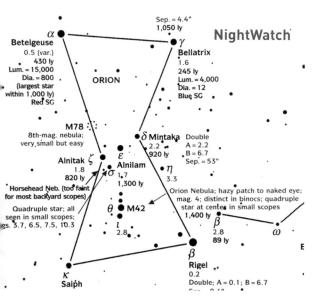

author, Arthur P. Norton, which reflects the observing tastes in vogue early in the 20th century.Variable stars and double stars constitute 70 percent of the objects listed, making this a good reference for fans of these objects. Clusters, nebulas and galaxies are relegated to the remaining 30 percent. The chart section is followed by 150 pages of tables and reference material.

SEVENTH-MAGNITUDE STAR ATLASES

Two volumes fall into the seventh-magnitude category. One is *A Field Guide to the Stars and Planets* by Jay M. Pasachoff, with

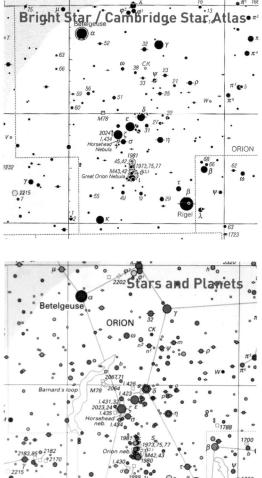

monthly sky maps and atlas charts by Wil Tirion (Houghton Mifflin). It is in the Peterson Field Guide series, the venerable and highly successful pocket-sized volumes for use by naturalists. Although the format may work for bird watchers, it fails in this instance. Tirion's beautiful seventh-magnitude star atlas is divided into 52 charts, but each is only four by five inches-too small for the detail they contain. The small-page format is unfortunate for a book this comprehensive, which is regrettable, because there is a lot of useful information here, packed into 575 pages of small type. Priced at less than \$25, though, it is an excellent value as a reference work, if not as a practical star atlas.

The other atlas in this category is a musthave in our opinion. Published in 2007 by Sky Publishing, the *Pocket Sky Atlas* is surprisingly detailed, plotting 1,500 deep-sky targets, including dark nebulas, on pairs of 80 charts formatted in a spiral-bound compact atlas that's convenient to handle at the

Comparing Charts

Star atlases are rated by their magnitude limit. Each increase in the limit corresponds to a significant boost in the amount of detail shown. The chart comparisons at left and on the following two pages show a section of the constellation Orion from each of seven atlases, revealing the sky lo progressively fainter limiting magnitudes.

▲ Two Books In One A unique and highly regarded reference, Men, Monsters and the Modern Universe, by George Lovi and Wil Tirion (Willmann-Bell), contains both the Bright Star Atlas and one of the best skymythology texts in print. scope and easy to pack into any kit bag. Stars are plotted to magnitude 7.6 and deep-sky objects to magnitude 11 or 12, including all 400 Herschel objects and 55 red carbon stars. It's all the atlas the majority of telescope owners are likely to need and, at \$20, one that everyone should own.

EIGHTH-MAGNITUDE STAR ATLAS

Astrocartographic genius Wil Tirion produced the definitive eighth-magnitude star atlas with his *Sky Atlas 2000.0* (Sky Publishing and Cambridge). This is a big atlas —the 26 charts are each 12 by 18 inches. Swatches of the sky, roughly 40 by 60 degrees, are presented. If they were smaller, they would not include enough of any individual constellation to provide a feel for the portion of the sky being examined.

The atlas is available in three formats:

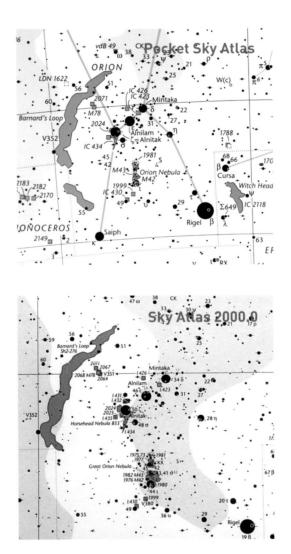

a deluxe spiral-bound edition with colorcoded charts; smaller individual charts in a desk edition, with black stars on a white background; and the so-called field edition, with white stars on a black background to help preserve night vision at the telescope. At approximately \$35, either the desk or the field edition is ideal for owners of 8-inch or larger telescopes. The deluxe edition costs about \$60. Plastic-laminated versions are available for just over double the price and are great for withstanding dew and abuse in the field—we recommend them. Sky Atlas 2000.0 is a step up from a sixth-magnitude atlas and is great for desk use, but the Pocket *Sky Atlas* is more convenient at the scope.

NINTH-MAGNITUDE STAR ATLAS

Compiling an atlas of stars down to magnitude 9.75 was a monumental undertaking. To accommodate the observing agenda of serious amateur astronomers, more than 300,000 stars had to be plotted, along with tens of thousands of deep-sky objects, to 14th magnitude. The task was first completed in the late 1980s with the publication of Uranometria 2000.0 by Wil Tirion, Barry Rappaport and George Lovi (Willmann-Bell). The scale of detail necessary meant that to show entire constellations on one chart would require a chart the size of a tablecloth. Obviously, that was impractical. Instead, the sky was divided into 220 double-page charts, printed in two bound volumes on 9-by-12-inch pages.

The package, greatly revised in 2001 for increased accuracy and ease of use, is a tour de force. The new edition adds improved wide-angle key charts plus 26 charts plotting crowded sky regions in close-up detail. Priced at \$160 for the two-volume set and the complementary one-volume *Field Guide* catalog, *Uranometria 2000.0* is probably the most advanced printed star atlas that backyard astronomers are likely to require.

ELEVENTH-MAGNITUDE STAR ATLAS

It is hard to imagine a star atlas more advanced than *Uranometria*, but the *Millennium Star Atlas* is it. Produced by Sky Publishing and the European Space Agency, this three volume set uses the Hipparcos satellite's superaccurate star-mapping data to plot more than one million stars down to magnitude 11. Depicting the whole sky requires 1,548 charts in three 9-by-13-inch volumes. The image scale is so large that each chart covers only 5.4 by 7.4 degrees, an area of the sky equivalent to the area of France on a map of the world. Deep-sky fanatics and lovers of star charts must have

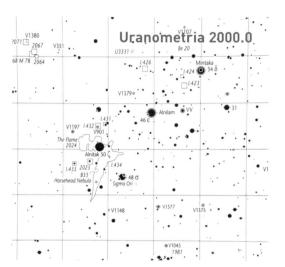

this set. But the softcover edition of the *Millennium Star Atlas* (\$250) is too massive to be used in the field and is likely to be bypassed by many observers in favor of custom printouts from advanced software such as Guide, MegaStar or TheSky.

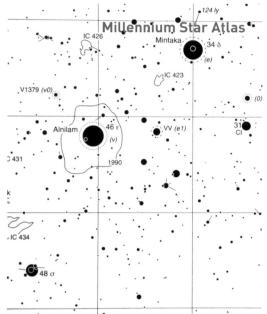

Helpful Finder Cards

Two great aids make hunting deep-sky objects a snap yet go largely unappreciated by most observers. Brent Watson's "Sky Spot" books of charts (top right) feature one object per chart, highlighted with a Telrad reticle. The charts are plastic-laminated and spiral-bound for durability in the field. They are available from Sky Spot Publishing, 1263 East Beverly Way, Bountiful, UT 84010, for \$25 to \$50 each.

Covering many more objects, George Kepple's wonderful Astro Cards (bottom right) feature one main deep-sky object and several nearby objects on each three-by-five-inch index card. Each card has a wide-angle chart indicating where to look in the constellation, plus an adjacent chart covering a finderscope field. The cards are easy to handle at the eyepiece and can be flipped over to match a right-angle finderscope (by shining a flashlight through them). There is a set of cards for the Messier objects and two sets for fainter deep-sky targets. At \$30 for all three sets of 70 cards each, they are a bargain. They can be ordered from Astro Cards, Box 35, Natrona Heights, PA 15065.

A recommended accessory for the Astro Cards is the backlit Cardlighter (\$40), which holds and illuminates one card at a time. The Astro Cards are also available as computer software (\$40) to allow users to print out their own custom charts. C H A P T E R T W E L V E

Exploring the Deep Sky

Professional astronomers at mountaintop observatories do not look through telescopes. The instruments they use are giant cameras recording starlight onto electronic detectors. Seeing the subtle light from distant galaxies and nebulas"live" through an evepiece is now the exclusive domain of amateur astronomers. As such, today's backyard stargazers share a common bond with the great visual observers of the 19th and early 20th centuries, who made their discoveries during all-night sessions at the eyepiece.

Through an amateur telescope, a cluster of galaxies might appear only as a field of faint fuzzies at the threshold of vision. Unimpressive at first glance, but not when you realize that each of those indistinct spots is another Milky Way, filled with stars, planets and, perhaps, curious minds like ours. Deep-sky observing is done as much with the mind as it is with the eye.

Deep-sky exploring for backyard astronomers means reaching out with binoculars and telescopes deep into our galaxy's spiral arms—and beyond, to other galaxies. It is the ultimate cerebral adventure to observe and contemplate the vastness of the universe. Photo by Alan Dyer.

Celestial Cloud The Trifid Nebula shines in both red and blue light. Photos on this page by Alan Dyer.

Globular Cluster ▲ Omega Centauri rates as the biggest and brightest globular by far. Such clusters of millions of stars are stunning sights in largeaperture telescopes

Geography of the Sky

The deep end of the sky officially starts at the edge of the solar system and extends out to clusters of galaxies and enigmatic quasars. Taken literally, it encompasses everything in the universe except our Sun and its family of attendant worlds. The deep sky includes the many types of stars that populate the night sky. And yet, when amateur astronomers speak of deep-sky objects, they are usually referring to extended objects: the star clusters and nebulas of our own Milky Way Galaxy and the many types of galaxies that lie beyond the Milky Way.

DEEP-SKY ZOO

Each of the thousands of objects within reach of backyard telescopes can be classified into one of half a dozen species in the deep-sky menagerie:

* Open Star Clusters Open star clusters are congregations of stars bound together by their mutual gravity. Individual stars in an open cluster were all born about the same time from a nebula similar

to the Orion or Trifid Nebula. Roughly 1,800 open star clusters have been cataloged in our galaxy; most are accessible to backyard telescopes. About 10 to 25 light-years across in the prime of their lives, open clusters eventually disperse, scattering their member stars along our galaxy's spiral arms.

* Globular Star Clusters

Like miniature spherical galaxies, globular star clusters contain hundreds of thousands of ancient suns packed into a space about 25 to 250 light-years wide. Approximately 150 have been found associated with the

Open Cluster 🕨

The Pleiades, the bestknown open star cluster, is easily visible to the naked eye and is a fine sight at low power in a small telescope. On a dark night, the brightest wisps of the enveloping nebulosity can be detected in the eyepiece. Milky Way Galaxy, the majority being suitable targets for amateur telescopes. Most are ancient, having formed 9 billion to 11 billion years ago as by-products of the creation of the galaxy itself. The nearest globulars lie several thousand light-years away, toward the core of our galaxy.

Star-Formation Nebulas Stars form from contracting clouds of interstellar dust and gas. These cold regions of hydrogen gas and complex molecules line the spiral arms of the Milky Way, where shock waves from nearby supernovas can trigger the initial collapse of the nebula. As stars begin to form in the densest regions of the nebulas, their ultraviolet starlight energizes the surrounding gas, creating the visible nebula. While most nebulas stretch a few dozen light-years across space, the Tarantula Nebula, the largest, spans a record 900 light-years.

Planetary Nebulas

At the end of their lives, stars with one to six times the Sun's mass lose weight by blowing as much as one-quarter of their mass into space through a continuous stellar wind. The process takes thousands of years and often involves several episodes of stellar belching, which creates complex nebula structures as fast-moving gas shells run into older, slower-moving shells. The aging star

then shrinks to a hot white dwarf the size of a small planet. About 1,500 planetary nebulas have been cataloged in our region of the galaxy.

Supernova Remnants

Very massive stars end their lives abruptly. In just minutes, 90 percent of a star's mass is blasted into space, while the remaining core collapses into a superdense neutron star or, perhaps, a black hole. In the process, the star gives off as much energy as an entire galaxy—a spectacular finale to a star's life, but a rare one. Only a few of the most

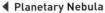

The Ring Nebula may well be the first deep-sky object many stargazers see through a telescope. It is easy to find in Lyra the harp and is bright enough to pick out even in light-polluted skies. Note the much more distant galaxy at upper right. Photo by Chris Schur.

◀ Supernova Remnant Off the east wing of Cygnus the swan lie these feathery arcs of light, the remains of a star that exploded thousands of years ago. A nebula filter makes the Veil Nebula components an easy sight, even in an 80mm telescope. Photo by Alan Dyer.

Our Milky Way 🕨

The biggest galaxy in the sky is our own, the Milky Way. On dark summer, fall and winter nights, its distant stars blend together to create a hazy band arching across the sky, bisected by dark lanes of interstellar dust. This view, taken from the southern hemisphere, shows the Milky Way from Alpha Centauri (bottom) to Altair (top), with the galactic core in the middle. Photo by Alan Dyer.

Distant Milky Way 🕨

Compare this view with the one above. They look similar because they are images of the same kind of object: a spiral galaxy seen edge-on. In the case of the Milky Way, we live in this galaxy, near its outer edge. In the case of NGC891, seen here, we are viewing it across intergalactic space, from a distance of nine million light-years. Photo by Robert Gendler.

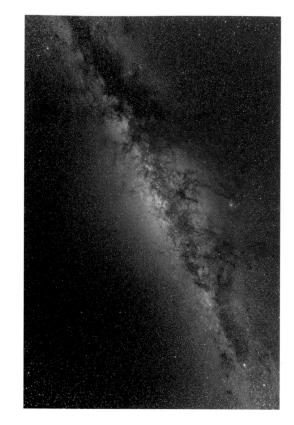

massive stars are supernova candidates. During historic times, just a handful of stars in our section of the galaxy have exploded as supernovas, and just a fraction of those have left visible nebulas.

* The Milky Way

The term Milky Way can be a little confusing. Everything we can see in the night sky with the unaided eyes (with the exception of the Andromeda Galaxy and the Magellanic Clouds) belongs to our spiral-shaped galaxy. We call the entire galaxy the Milky Way. But in its original sense, the term referred only to the gray band of light arching across the summer, fall and winter skies (*Via Lactea* in Latin). Greek mythology explains its origin in a tale of Hercules spilling milk over the sky. It took Galileo's telescope to discover that this milky band is actually made of stars. The stars we see with our unaided eyes all lie nearby, but the ones forming the Milky Way band are much more distant, their light blending together and glowing from thousands of light-years away in the spiral arms of the Milky Way.

Galaxies

Our Milky Way, with its stars, clusters and nebulas, is but one of tens of billions of galaxies—spirals, ellipticals, odd-shaped irregulars—that come in all sizes, from dwarfs to giants. In fact, the stars we think of as countless are really just a scant foreground clutter between us and the real universe—a space tangled with galaxies that clump together into clusters, the clusters forming strandlike superclusters. Galactic superclusters are the largest gravitationally bound structures in the universe.

MAKING SENSE OF THE SKY

Deep-sky objects aren't scattered at random about the heavens. Each species in the deep-sky zoo inhabits its own territory in the sky.

Nebulas line the spiral arms of our galaxy, so that's where we find them, almost exclusively along the Milky Way band. The vast majority of open star clusters, being the products of star-forming nebulas, also lie along the Milky Way.

Most globular clusters live in a halo thousands of light-years across that surrounds the distant core of the Milky Way. From our vantage point near the edge of the galaxy, we look toward the center and see a region of sky in Sagittarius and Scorpius populated with globulars, like bees buzzing around a distant hive.

Galaxies beyond our Milky Way inhabit the parts of the sky where the Milky Way isn't. We see few galaxies embedded along the Milky Way band, not because they aren't there but because they are either hidden or dimmed by the mass of star-stuff that makes up our galaxy.

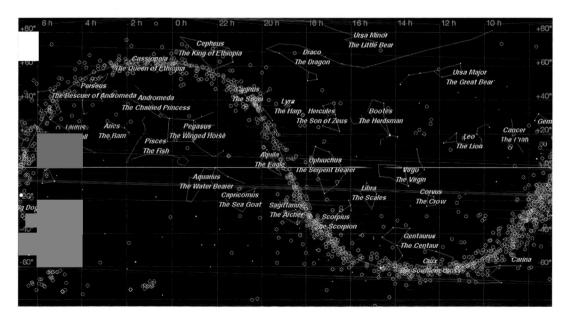

◀ Star-Forming Nebulas Glowing regions of star formation (in pink) line the spiral arms of the Milky Way, the S-shaped band on this map. Nebulas populate the Milky Way constellations of Cygnus, Cassiopeia, Cepheus, Auriga, Orion and Carina and also the dense regions surrounding the center of the Milky Way in Scorpius and Sagittarius. Few nebulas are found off the Milky Way.

◀ Planetary Nebulas
Also residents of our galaxy,
these stellar remnants
(in green) primarily dot the
Milky Way band, with a
heavy concentration toward
the center of the galaxy.
However, nearby planetaries, such as the Helix and
Owl Nebulas, can be found
far off the Milky Way, in our
local neighborhood of surrounding stars.

Diagrams on this page and on page 238 courtesy Voyager III®/ Carina Software

Open Clusters

Like planetaries, most open clusters (in yellow) are confined to the Milky Way. However, some open clusters lie close by and appear large enough to see with unaided eyes (for example, the Hyades, 150 light-years away; Coma Berenices, 260 light-years; the Pleiades, 440 light-years; and the Beehive, 525 light-years). These clusters sit well off the plane of the Milky Way.

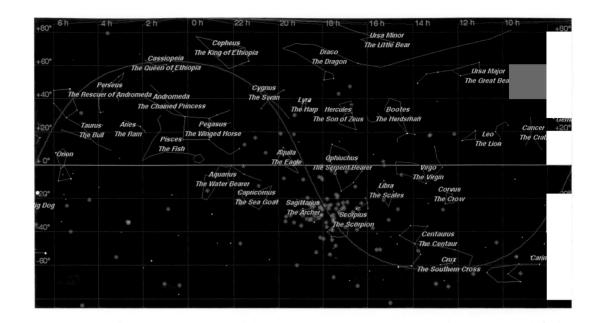

Globular Clusters Because the galactic center lies far away in Sagittarius, most globulars (the blue dots) inhabit a wide circle centered on the Sagittarius and Scorpius region of the northern summer sky. Some lie superimposed on the Milky Way, but most float above or below the plane of our galaxy. We see few globulars in the northern winter sky and just a handful in the northern spring and autumn skies.

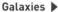

In spring and autumn, we look out the top or bottom of the thin disk of our galaxy, rather than deep into its arms as we do in winter and summer. We look through the thinnest amount of obscuring galactic dust and gas, which allows us to see other galaxies in the distance. The rich concentration of galaxies on the right side of this map is the nearby Coma-Virgo galaxy cluster that dominates the northern spring sky.

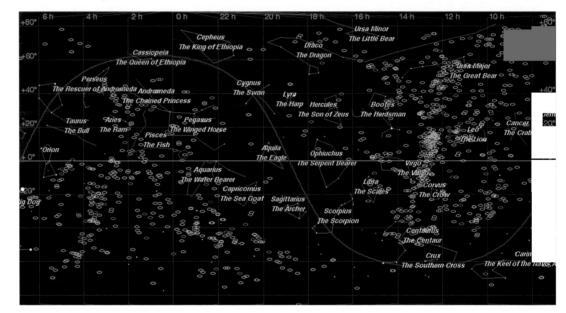

Running the Messier Marathon

Seeing all 110 objects in Charles Messier's catalog in one night seems an impossible feat. And yet that's just what some avid observers attempt to do.

The period between March 5 and April 12 is prime season, with the ideal nights being March 30 to April 3 if the Moon is new. On marathon night, the autumn Messiers provide the targets in the early evening, with participants hastily picking out of the evening twilight M74, M77, M33 and M31 plus its companions. The race then turns to easier winter targets. After a midnight breather, the marathoners move on to Heartbreak Hill: the multitude of spring-sky galaxies. From there, it's a downhill run to the dawn sky and the congestion of the final mile in Sagittarius. M30 in Capricornus is the elusive prize, rising before dawn.

To plan a Messier marathon, the best reference is the superb observing guidebook The Year-Round Messier Marathon Field Guide by Harvard C. Pennington (Willmann-Bell, 1997). Its finder charts are helpful for Messier hunting at any pace.

Diving Into the Deep Sky

You'll never run out of things to look at in the realm of the deep sky. From objects so large they can be seen with the naked eye to objects so small and faint they require a giant 24-inch telescope, the universe has much to offer. While deep-sky observing can be done with any instrument, it is hard to discount the need for sheer aperture.

Bigger telescopes resolve globular clusters into swarms of pinpoints. More aperture makes nebulas appear brighter and more like their photographs and turns galaxies from ill-defined spots into unmistakable spirals mottled with dust lanes. A field that barely shows one or two galaxies in a small telescope turns into a cluster of dozens of galaxies when viewed through a massive 24-inch reflector.

However, sheer brute-force aperture is not the sole requirement for deep-sky exploring. More important is the honing of some key observing skills.

LEARNING TO SEE

No matter what telescope you use for exploring the deep-sky realm, there are a few techniques that can help you see more than you might think possible.

 Cultivate Night Vision Becoming dark-adapted is essential for seeing the faint fuzzies that make up the deep sky. Don't expect to see much through the evepiece if you've just stepped outside from the bright indoors. Similarly, porch lights shining into your eyes will make it impossible to see faint objects. An initial dark adaptation, during which the pupil dilates to its maximum aperture, takes place in 10 to 15 minutes. But over another 15 to 20 minutes. a chemical reaction in the eye kicks in that further boosts its sensitivity While you can tolerate a brief exposure to white light, a prolonged blast can ruin your hard-won night vision. One trick is to fashion yourself a "monk's hood" to block out light.

See by Not Really Looking
 A faint object stands out better if you look
 just to one side of the object and not straight

at it. Such averted vision places the object on the more sensitive rod cells around the periphery of the retina. Seeing an object by not really looking at it sounds odd, but it really works.

Practice Jiggle Vision

Another trick is to jiggle the telescope. The slight motion in the field can reveal dim targets that might otherwise fade into the background. The trick works because our eyes and brain have been trained since the Pleistocene epoch to pick out nasty things moving in the night.

Apply Power as Needed For all the proscriptions against using high power on telescopes, sometimes power is just what you need. Boosting the magnification darkens the sky and enlarges the object enough to make it more obvious.

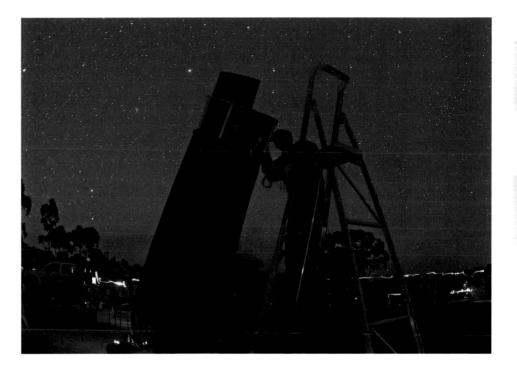

Small, faint galaxies invisible at 50x may pop into view at 150x. Magnifications of 100x to 150x are typical for most deep-sky viewing, with lower powers reserved for the biggest objects and for finding targets. On largeaperture scopes, even higher power is ideal for revealing faint planetary nebulas, dim open clusters and small globular clusters.

Head Out on the Highway The best accessory for any telescope is a dark sky. This is especially true of small telescopes. Well away from the interference

▲ Getting High on the Deep Sky

Big reflectors on Dobsonian mounts, with eyepieces accessible only by ladder, are favored by deep-sky observers, but telescopes of any size can be used to explore the realm of the deep sky. This scene was taken at Australia's South Pacific Star Party.

Panoramic Views Small reflectors and refractors, such as this Tele Vue NP101 4-inch refractor, complement the views through big-aperture Dobs. With a low-power, wide-angle eyepiece (the 31mm Nagler shown here is superb), small f/5 to f/6 telescopes can provide sweeping panoramic views of the Milky Way and large deep-sky objects that are impossible to see in any other telescope.

Big Object for Small Scopes ▼ A fine target for compact rich-field telescopes is the North America Nebula. Photo by Alan Dyer. of city lights, even an 80mm refractor can show all the brightest members of the Coma-Virgo galaxy cluster.

Don't Give Up on the City Confined to the city? The brighter Messier objects, especially star clusters, are visible even through the murk of urban sky glow. Double stars also make suitable targets for the urban stargazer. GoTo telescopes can locate the hard-to-find targets that are invisible in finderscopes and therefore difficult to find by star-hopping.

Drawing Upon Experience You may have already had this happen: At a star party, a veteran observer invites you, a novice, to look at this wonderful nebula. You look—and see nothing! The fault lies not in the stars or the equipment but in your inexperience. Seeing the faintest targets requires training the eye. As Gregg Thompson describes in his guest essay (page 265), the best way to learn to see is to draw what you see. Over time, you'll be amazed at the improvement in your visual acuity. Experience, often gained by sketching, and a dark sky are more important than aperture for seeing to the limits of the sky.

* Blog the Sky

Even if you choose not to cultivate your artistic talents, start a private or web deepsky journal. Check off the objects you find, and note the ones you didn't locate. Record your visual impressions and the sky conditions. The act of recording your observations in any form helps you learn the sky.

Low-Power Limit

Just as telescopes have a highpower limit, a boundary also exists at the low end of the power range. Use a reflecting telescope below its low-power limit, and you may see the dark shadow of the secondary mirror floating in the field. Use any telescope below its low-power limit, and you are effectively cutting down its aperture, as the cone of light leaving the eyepiece will be wider than the dark-adapted eye can accept. Not all the incoming light can make it into your eye.

To calculate the longest-focallength eyepiece (i.e., the lowest power) you can use at night, multiply the telescope's focal ratio by 7mm (the diameter of a dark-adapted pupil) or, if you are over 50, 6mm.

Telescope's focal	Longest eyepiece
ratio	usable
f/4	28mm
f/4.5	32mm
f/5	35mm
f/6	42mm
f/8	56mm

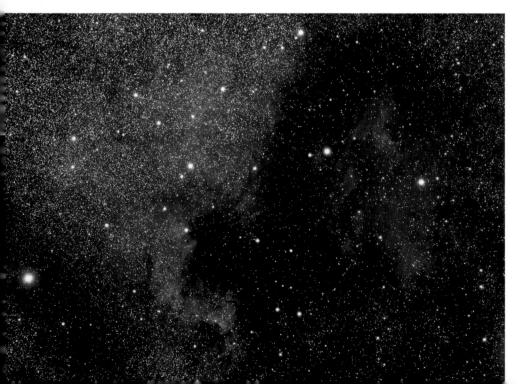

Inventories of the Sky

Using computerized telescopes, backyard stargazers can now call up the location and identity of thousands of deep-sky objects from a variety of digital catalogs. These inventories of the sky are the result of 200 years of meticulous observations. In the 18th and 19th centuries, explorers of the sky hunted down, charted and cataloged everything , thin reach of their often crude telescopes. The result was a series of celestial catalogs, complete with baffling nomenclature, that are still very much in use today.

MESSIER'S CATALOG

A6.

The most famous deep-sky catalog provides backyard astronomers with a ready list of the sky's best and brightest deep-sky targets. Ironically, it was compiled as a catalog of things *not* to look at.

In the late 1700s, Charles Messier did not set out to find deep-sky targets. To him, they were merely nuisance objects he kept bumping into during his searches for comets. He published lists of the fuzzy noncomets so that he and his comet-hunting colleagues would not be fooled by them. Today, Messier's comet discoveries are largely forgotten. It is his list of nuisance objects that is remembered.

Among the best-known Messier objects are M45, the Pleiades star cluster; M31, the Andromeda Galaxy; M13, a globular cluster in Hercules; and M42, the Orion Nebula. Modern versions of Messier's catalog contain 110 objects, providing a selection of the finest deep-sky targets for northern-hemisphere observers.

The identity of several Messier objects has often been questioned. Evidence exists that M91 and M102 are mistaken observations of M58 and M101, respectively. The objects M104 to M109 were discovered by an associate, Pierre Méchain, and reported to Messier but were never included in a published version of his catalog. These M objects are really "Méchain objects." NGC205, one of M31's companion galaxies, was apparently logged by Messier, although he never listed it in his catalog. Modern-day observers have dubbed this object M110.

Purists sometimes reduce the Messier list to 99 or 100 objects. A version compiled by author Dyer for The Royal Astronomical Society of Canada's *Observer's Handbook* lists a full 110 entries, including two faint galaxies that some astronomers propose as substitute candidates for M91 and M102.

▲ Binocular Cluster Many Messier objects can be seen in binoculars. Here, Messier 11 appears as it does in binoculars —a distinct stellar clump amid the rich star field of the constellation Scutum. Photo by Alan Dyer.

Charles Messier, 'Ferret of Comets'

On September 12, 1758, French astronomer Charles Messier was tracking a comet he had found when he came across something unexpected in the sky. He called it "a nebulosity above the southern horn of Taurus. It contains no stars; it is a whitish light, elongated like the flame of a taper." Messier wasn't the first to see the object; English astronomer John Bevis had logged it 27 years earlier. But Messier's rediscovery of what eventually became known as the Crab Nebula inspired him to inventory more "comet masqueraders," objects he and others might mistake for the real celestial prize of the day: comets.

From a rooftop observatory at the Hotel de Cluny in Paris, Messier discovered 13 comets from 1760 to 1798, winning him the title of "ferret of comets" from King Louis XV. Messier's first "Catalogue of Nebulae and Star Clusters," published in 1771, contained 41 objects that he and his colleagues had discovered. For good measure, Messier added four well-known

.....

objects, the Orion Nebula complex (M42 and M43), the Beehive cluster (M44) and the Pleiades (M45), bringing his first list to a tidy 45 objects. Messicr published revised versions of his catalog in 1783 and 1784, bringing the total inventory of published Messier objects to 103. Subsequent additions elevate the total to 109 or 110.

The Messier numbers follow a haphazard sequence across the sky, because the objects are numbered in the order Messler located them or learned of them. Although he intended to, he never did publish a list with entries renumbered in order of right ascension, west to east, across the sky. Illness, old age and the French Revolution intervened.

The largest telescopes used by Charles Messier were 190mm and 200mm reflectors. However, their mirrors of polished speculum metal would have had the light-gathering power of a modern 80mm-to-100mm reflector. Portrait courtesy Owen Gingerich.

Mr. NGC ▲ From 1874 to 1878, J.L.E. Dreyer used what was then the largest telescope in the world, the 72-inch Leviathan at Ireland's Birr Castle, to survey the sky. He then went on to compile the New General Catalogue, still in use today. Courtesy

Armagh Observatory.

From a rural site, all the Messier objects can be seen with an 80mm telescope and many with only 7x50 binoculars. The largest telescope Messier himself used was an 8-inch reflector. Tracking down the Messiers over the course of a year or two is a rewarding endeavor. In the process, you will become familiar with the sky, learn how to see faint objects through the telescope and gain enough credits to graduate to the level of an experienced observer.

THE NGC AND IC

Most deep-sky enthusiasts complete the Messier list. But then what? The next goal is collecting NGC objects.

NGC stands for New General Catalogue, now 120 years old. It was originally compiled by Danish-born astronomer John Louis Emil Dreyer under the aegis of the Royal Astronomical Society in England. Published in 1888, Dreyer's *New General Catalogue* of Nebulae and Clusters of Stars compiled observations of 7,840 objects from dozens of observers and replaced all previous lists and catalogs. Even the Messier objects were assigned NGC numbers. The NGC contained every nebula and cluster known in 1888. The fact that many of the "nebulas" were actually galaxies was unknown at the time; anything that could not be resolved into stars was called a nebula.

Unlike the random nature of the Messier catalog, NGC objects are all neatly ordered by right ascension. The numbering starts at 0 hours right ascension (or what was 0 hours right ascension in 1888) and increases from west to east across the sky. However, successively numbered NGC objects can be separated by many degrees north or south in declination.

Soon after the NGC was published, it required revision. Supplementary Index Catalogues were published in 1895 and 1908. Objects labeled IC (or simply "I") are from

The Herschel Dynasty

Few families have had an impact on science as significant as the Herschels' influence on astronomy. In the 1770s, William Herschel, a musician by profession, took up the craft of telescope making. His Newtonian reflectors, all with speculum metal mirrors, proved so superior to any of the day that Herschel became the equivalent of a millionaire just from telescope sales. On March 18, 1781, Herschel used his 6.3-inch reflector to sweep up what he at first thought was a comet. It proved to be Uranus, the first planet discovered in historic times. England's King George III appointed Herschel his private astronomer. Set for life, Herschel built ever larger reflectors, culminating in 1789 with a 48-inch telescope, which he used to survey the sky.

Herschel's principal assistant on his night shifts was his sister Caroline. In her own explorations of the sky, Caroline Herschel found eight comets and is credited with finding M110, one of the companions to the Andromeda Galaxy. Caroline was also instrumental in the publication of the catalogs of nebulas and clusters that the

brother-and-sister team had found and logged.

William's only son, John, continued the dynasty, discovering more than 2,000 new deep-sky objects, many during a stint in the southern hemisphere. In 1864, the younger Herschel published a compilation of the family's lifework, the General Catalogue, an exhaustive listing of 5,000 nebulas and clusters. The master of visual astronomy, John Herschel became one of the pioneers of photography. The first photo ever taken on a glass plate is John's 1839 image of his father's soon-to-be-dismantled 48-inch telescope on the grounds of their British country home.

William Herschel referred to it as his 40-foot reflector, in keeping with the old tradition of describing a telescope by its focal length, rather than aperture. From his backyard in Slough, England, Herschel found hundreds of deep-sky objects with the 40-footer.

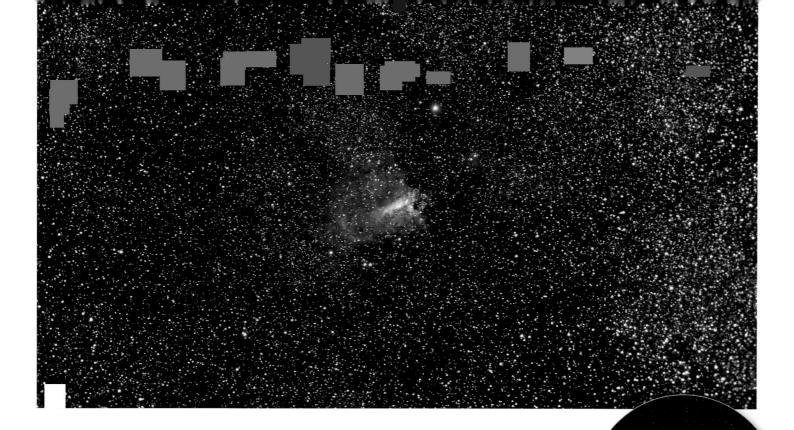

one of those listings. The first IC contains 1,529 objects discovered visually between 1888 and 1894.

The second IC offers another 3,856 entries, many found between 1895 and 1907 through the new technique of photography. Most of these later IC objects (with numbers higher than 1529) are too faint to detect visually. They are I-don't-see objects!

The brightest NGCs are easy targets for an 80mm telescope. But a 5-to-8-inch telescope is a minimum to dive deeply into the NGC list.

HERSCHEL'S CATALOG

Avid deep-sky observers wanting to venture beyond the Messier catalog can tackle hunting down 400 of the best Herschel objects. Prompted by a suggestion from observer and author James Mullaney in the 1970s, members of the Ancient City Astronomy Club in St. Augustine, Florida, embarked on a project to sort out the original core objects of the NGC, a total of 2,477 objects first observed by William Herschel in the late 1700s. From this, the club sifted out the 400 best, the so-called Herschel 400. All are known by NGC numbers but also carry Herschel numbers from his original catalogs, which predate the NGC by almost a century.

Herschel's catalog numbers and system for classifying deep-sky objects are largely obsolete and disused now, but a sampler of his original discoveries lives on for those who tackle the Herschel 400. Because William Herschel observed from England, this "best of" subset of the NGC contains only objects found in the northern hemisphere. For more details, check the Observing Clubs section of the Astronomical League's website at www.astroleague.org.

CALDWELL CATALOG

In 1995, a new deep-sky best-of list was introduced to the hobby, largely through the promotion of Sky & Telescope magazine. Patrick Moore, Britain's best-known astronomy author, presented his list of 109 of the best and most notable non-Messier objects, selected primarily from the NGC. Rather than have his list also contain M objects, he titled his list after his full last name, Caldwell-Moore. So we have Caldwell 1, or C1, better known as NGC188, a star cluster near the north celestial pole; Caldwell 2, NGC40, a planetary nebula in Cepheus; and so on. The objects are arranged from north to south in order of decreasing declination and include southern-sky targets.

The Caldwell catalog sounds like a helpful idea for venturing beyond the Messiers.

Celestial Swan

The Swan Nebula, also known as M17 or the Omega Nebula, is one of the brightest nebulas in the Messier catalog. The digital image by Alan Dyer (top) reveals its full extent as well as a mix of magenta and blue colors from glowing hydrogen gas. The simulated eyepiece view (above) shows what you will see visually through a modest-aperture telescope under dark skies with a nebula filter—a more delicate black and white view revealing only the brightest parts of the nebula.

Twin Clusters 🔺

One of the brightest and best-known deep-sky objects, the Double Cluster in Perseus, was missed or ignored by Charles Messier. Why this was so remains a mystery. Cataloged as NGC869 and NGC884, it is number 14 in Patrick Moore's Caldwell catalog. Photos on both pages by Alan Dyer. Many GoTo telescopes offer it as one of the menu choices for selecting targets. However, the list has rankled many deep-sky observers, who take exception to the relabeling of objects already well known by established catalog numbers. The other problem is that some of the Caldwell objects, though ostensibly the best in the sky, fall far short of that criterion. Caldwell 5 is IC342, a diffuse spiral galaxy that would challenge most small-scope observers. The same is true of Caldwell 17 (NGC147), a hard-tosee companion galaxy to M31; Caldwell 31 (IC405), a dim nebula in Auriga; and Caldwell 51 (IC1613), a faint Local Group galaxy in Cetus, to name a few. Data errors plague some editions of the catalog.

Both of us prefer not to use the Caldwell list. In the 1980s, author Dyer prepared a list of the "110 Finest NGC Objects," published each year in The Royal Astronomical Society of Canada's *Observer's Handbook*. Another good source is Orion Telescope's *Deep-Map 600*, which plots and lists all of the Messiers, plus 100 of the best variable, double and colored stars and about 400 superb non-Messier objects, as selected by Steve Gottlieb, one of the world's most experienced deep-sky observers.

Celestial Harvest: 300-Plus Showpieces of the Heavens by veteran skywatcher James Mullaney (Dover, 2002) is yet another fine source. Mullaney's choice of objects and the descriptions compiled from observers over the past century provide a wonder-filled introduction to the sky. Complement your computerized telescope with one of these recommended sky guides, and you'll have the information and tools to direct you to great deep-sky views.

BEYOND THE NGC

Even with its several thousand entries, the New General Catalogue ignores an entire class of object: dark nebulas. William Herschel commented on dark "starless spots" he encountered as he swept the skies in the late 1700s, but it was left to American astronomer Edward Barnard to compile the first catalog of these regions, or B objects, as they are called. Barnard's "Catalogue of 349 Dark Objects in the Sky" was included in his 1927 work *A Photographic Atlas of Selected Regions of the Milky Way*.

Within the class of emission nebulas, advanced amateur astronomers pursue elusive objects with prefixes such as Ced (S. Cederblad's 1946 list), Sh2 (Sharpless), Mi (Minkowski), vdB (van den Bergh) and Gum (Colin Gum's 1955 nebula survey). Most of the non-NGC nebulas are very small or very large. All are extremely faint.

With the advent of nebula filters, experienced amateur astronomers routinely pick off non-NGC planetary nebulas once thought to be invisible. Many come from Perek and Kohoutek's 1967 *Catalogue of Galactic Planetary Nebulae*, thus the PK designations. Most are 13th to 16th magnitude. A subset of this group is Abell planetaries, from George Abell's list of some 100 large, faint planetaries he discovered by examining photographs taken with the Palomar 48-inch Schmidt telescope in the 1950s.

Detailed star atlases plot open clusters with such prefixes as Be (Berkeley), Cr (Collinder), Do (Dolidze), H (Harvard), K (King), Mel (Melotte), Ru (Ruprecht), St (Stock) and Tr (Trumpler). Many of these non-NGC clusters were missed by earlier eyepiece surveys because they are either very large or so sparse they do not stand out from the background star field.

Over the past few decades, specialized surveys at research observatories have cata-

loged thousands of galaxies missed by the compilers of the NGC. Advanced star atlases and computer programs plot galaxies labeled UGC (1973 Uppsala General Catalogue of Galaxies), MCG (Morphological Catalogue of Galaxies compiled from 1962 to 1974) and ESO (European Southern Observatory's 1982 catalog of faint southernsky galaxies). Many star-atlas programs designed for home computers extract their galaxy data from the PGC (Principal Galaxies Catalogue), a 1989 reworking of earlier galaxy catalogs.

There is even a catalog of galaxies that are not included in any catalog: the MAC, or Mitchell's Anonymous Catalogue. This is amateur astronomer Larry Mitchell's compilation of 27,000 officially unnumbered galāxies lie has found on Palomar Observatory Sky Survey (POSS) images.

Large Dobsonian telescopes now allow amateur astronomers to sight entire clusters of galaxies whose existence was unknown until the advent of photographic surveys. The main catalog in this field was compiled by George Abell in the 1950s. The brighter Abell clusters (charted as A objects, but often with NGC or UGC galaxies as the brightest members) appear as fields of glowing spots through large reflectors.

Deep-Sky Tour One: The Stars

Not all deep-sky targets need superdark skies. From the confines of a city, some of the best sights are the many types of stars.

Southern Messier

Messier 7, first noted by Claudius Ptolemy in the second century A.D., is the southernmost Messier object and skims the horizon from northern latitudes. Yet from a southerly location, this open cluster is easily visible to the naked eye.

Can You See the Coathanger?

A large and unique star cluster missed by the Messier and NGC catalogs lies just south of the star Beta Cygni. Officially listed as Collinder 399, this binocular object is also known as Brocchi's Cluster, or the Coathanger. Can you see it hanging upside down amid the rich star field of the Milky Way?

Colorful Double Albireo, also known as Beta Cygni, is one of the sky's best double stars. Its gold and blue components are easy to split in any telescope, even at low power. Photo by Alan Dyer.

DOUBLE STARS: STELLAR JEWELS

The majority of stars (estimates suggest as much as 50 percent) aren't single but belong to systems of two or more stars orbiting each other, the result of a common origin in a spinning cloud of gas and dust.

Many double stars have measured orbital motions, though it may take centuries for the stellar partners to dance around each other. Some doubles are merely traveling together through space (dubbed CPM, or Common Proper Motion).

Some double stars don't belong together at all and are merely coincidental lineups in the sky. The best example of this type of optical double is Zeta (ζ) Ursae Majoris, better known as Mizar, the middle star in the handle of the Big Dipper. Its naked-eye companion, Alcor, lies three light-years farther away than Mizar, too far away to be in orbit. However, Mizar itself is a true physical double whose components, 14 arc seconds apart, are resolvable in any telescope.

In our opinion, the best double stars fall into two categories: strongly colored pairs (yellow and blue, for instance) and pairs with close but nearly equal-brightness stars (usually white or blue-white) that look like a pair of headlights in the eyepiece. Gamma (γ) Arietis and Gamma (γ) Virginis are classic "headlight" doubles. Doubles with too wide a range in magnitude or separation lose their attractive twin nature.

Double stars have also been compiled into catalogs. The master list is the Washington Double Star (WDS) catalog, which has a whopping 100,000 entries. A more practical list is the Aitken Double Star (ADS) catalog, published by Robert Aitken in 1932. It contains 17,180 entries. Famed double-star observers such as Wilhelm and Otto Struve and Sherburne Burnham compiled earlier lists in the 19th century. Some stars are still best known by their Struve (Σ or O Σ) or Burnham (β) numbers.

In historic guidebooks, the colors of

Eagle-Eyed Dawes

"Using a capital little refractor of only 1.6 inches aperture...I worked away almost every night, when uncertain health would permit, and found and distinctly made out...Castor, Rigel, ε^1 and ε^2 Lyrae, σ Orionis, ζ Aquarii and many others...The difficulty was often to get to bed in summer before the Sun extinguished the sight of the game."

Such dedication earned England's William Rutter Dawes the reputation of being one of the finest observers of the mid-1800s—that and his eagle eyes. Try splitting those double stars with a 1.6-inch refractor, and you'll appreciate Dawes' remarkable acuity. With a series of larger refractors, the Reverend Dawes (he was an ordained minister) performed measurements of double-star positions so accurate, they are still relied upon today. Seeking ever better telescopes, Dawes became the first important customer for refractors made in America by Alvan Clark. Dawes' endorsement established the Clark enterprise, which went on to create the largest refractors in the world.

In today's amateur circles, Dawes is best known for his rule on resolving power: "I thus determined...that a one-inch aperture would just separate a double star composed of two stars of the sixth magnitude, if their central distance was 4.56"...Hence, the separating power of any given aperture, a, will be expressed by the fraction 4.56"/a."

We still use this rule of thumb today for calculating the resolving power of a telescope. But keep in mind that this empirical rule was devised for stars of equal and moderate brightness. Double stars whose components exhibit a wide range in brightness may be harder to split.

For all his eagle-eyed ability at the telescope, William Dawes was so nearsighted that legend has it he could pass his wife on the street and not recognize her. Portrait courtesy Royal Astronomical Society.

double stars read like an artist's palette of pastel hues (azure, lilac, aquamarine, cerulean blue, rose) or a jeweler's tray of gems and minerals (golden, silvery, turquoise, emerald, topaz). Be warned, these tints are subtle and subjective. Only a few doubles, such as Albireo, or Beta (β) Cygni, Delta (δ) Cephei and Gamma (γ) Andromedae, show obvious and striking colors. Most exhibit pale tints at best.

In addition, the colors of fainter companion stars are often illusory, an effect of contrast with the brighter primary star. For example, the companion of Antares isn't really green; it just appears that way next to its bright yellow-orange primary.

The objective method of measuring a star's color subtracts a star's brightness in the visual yellow-green, or V, band of the spectrum from the star's brightness in the blue, or B, band. This B-V value, called the color index, has been set to 0 for blue-white stars such as Vega. Bluer stars have a slight negative color index. Moving the other way down the spectrum, our yellow Sun's color index is +0.65. Red giant stars have color indices around +1.5 to +2.0.

Double stars can put your telescope optics to the test. Stars with separations between one and two arc seconds will tax the resolving power of telescopes under 4 inches aperture, and stars less than one arc second apart will test 8-inch and larger telescopes. Because of pervasive atmospheric turbulence at most sites, telescopes of any size will seldom resolve stars closer than 0.5 arc second apart.

Very bright doubles with components two arc seconds apart, such as Castor and Alpha (α) Piscium, can be tough to split even in a large telescope, especially on nights of mediocre seeing. Doubles with faint companions orbiting brilliant primary stars (such as Antares, Rigel or the infamous whitedwarf star around Sirius) can be difficult to resolve in any backyard telescope.

Some stars show significant orbital motion over several years. Sirius is becoming easier to resolve after the 1993 minimum separation (2.5 arc seconds) between Sirius and Sirius B, its faint white-dwarf companion; the maximum separation of 11 arc seconds comes in 2022. Gamma (γ) Virginis (aka Porrima) reaches periastron in 2008, when the stars swing around each other only 0.4 arc second apart, then begin to move apart over a period of 169 years.

CARBON STARS: COSMIC COOL

Some stars pulsate in brightness over hours, days or weeks. Some, like Algol in Perseus, belong to pairs of stars that eclipse each other. Most variables are stars that actually physically pulsate in size and brightness.

Star Colors

The bluer the star, the hotter it is. Red stars are the coolest. This colorful field contains the nebula IC410, at left, and the Flaming Star Nebula, IC405, at right. Also visible is a chain of stars dubbed the Little Fish asterism, which includes cool red 16 Aurigae, hot blue 17 Aurigae and moderately warm and white 19 Aurigae.

Letters

Astronomers class stars by the arcane sequence of spectral letters, easily remembered from hot to cool by the mnemonic: Oh Be A Fine Guy/Girl Kiss Me. (All temperatures are in Kelvin, with 0K equal to absolute zero at -273°C.)

SPECTRAL CLASSES

O = blue Temp. = 25,000K and up B = bluc white Temp.=10,000K-25,000K A = white Temp. = 7,500K-10,000K F = yellow Temp. = 6,000K-7,500K G = yellow-orange Temp. = 5,000K-6,000K K = orange Temp. = 3,500K-5,000K M = red Temp. = 3,500K or less

Our Sun is an average G-type star with a surface temperature of 5,800K.

Stellar Garnet 🕨

On the north (top) edge of the large nebula IC1396 lies Herschel's Garnet Star, a bloated red giant and one of the brightest carbon stars in the sky. Photo by Alan Dyer.

A colorful subset is the long-period variables, which take months to cycle up and down in brightness. Many are also classed as carbon stars, among the coolest known, with surface temperatures of less than 3,000 degrees C. This alone makes them among the reddest stars in the galaxy.

Their atmospheres are cool enough to support sooty carbon compounds that absorb blue light. The filtering effect of their atmospheres contributes to the stars' distinctively deep red tints.

Carbon stars really do look red, like glowing coals, unlike red-giant stars, such as Betelgeuse and Aldebaran, which look more yellow-orange. One of the best known, Mu (μ) Cephei, was dubbed by John Herschel as the Garnet Star. Other fine examples are Hind's Crimson Star, or R Leporis, discovered in 1845 by John Hind, and Ruby Crucis, a red companion star to Beta (β) Crucis, in the Southern Cross. Its color index of 5.5 makes it one of the reddest stars known.

The intensity of the color varies with aperture; carbon stars sometimes look more intensely red in small telescopes than in large ones. Being variable, carbon stars can slowly pulse in a range of up to five magnitudes over many hundreds of days.

Not all observers see the stars as deep red, perhaps due to differences in individual color sensitivity. Try slightly defocusing the image to bring out the subtle color.

It's All Greek to Me

In 1603, Johannes Bayer published the *Uranometria*, a set of star charts in which he labeled stars with Greek letters. Usually, he called the brightest star in a constellation Alpha (α), the second brightest Beta (β), and so on, down the 24-letter Greek alphabet to Omega (ω). We still use these Bayer letter designations today. For example, Sirius is Alpha (α) Canis Majoris.

By tradition in such designations, the constellation name takes the Latin genitive, or possessive, case. Thus it is Gamma Arietis (not Gamma Aries), meaning Gamma of Aries. And it is Sigma Orionis, Delta Cephei and the awkward Alpha Canum Venaticorum.

A French edition of John Flamsteed's 1729 *Atlas Coelestis* introduced the system of numbering stars from west to east across a constellation, the so-called Flamsteed numbers. Most nakedeye stars carry Flamsteed numbers. Sirius is 9 Canis Majoris.

The first computer-generated star atlas, published by the Smithsonian Astrophysical Observatory in the 1960s, catalogs 260,000 stars down to ninth magnitude. Sirius, for instance, is designated SAO 151881. Most GoTo telescopes call up stars by their SAO numbers.

The most recent and complete star catalog, the Tycho, compiles data on one million stars observed by the European Hipparcos satellite in the 1990s. In this classification, Sirius is HIP32349.

Stars can have several names. Vega is Alpha Lyrae (Bayer), 3 Lyrae (Flamsteed) and SAO 67174 (Smithsonian). The Double-Double star is Epsilon¹ and Fpsilon² Lyrae, uka 4 and 5 Lyrae. Chart courtesy TheSky™/Software Bisque.

Deep-Sky Tour Two: Star Clusters

Astrophotographers can make a good case that the full glory of a nebula or a galaxy can be seen only on film or CCD chips, but when it comes to star clusters, they lose the argument. Few astrophotos capture a cluster's visual quality of glittering diamond dust.

OGLING OPEN CLUSTERS

The word open, which is used to describe these clusters, refers to their resolvability: All the stars in them can be seen individually, in contrast with the haze of globular clusters. Open clusters range from objects that fill the eyepiece with brilliant star fields to clusters that appear as smudges resolvable only with moderate power.

How well a cluster shows up in the eyepiece depends on several factors. One is size. Large clusters (more than 30 arc minutes in apparent diameter) require a wide field and low power. For example, the Pleiades and Beehive star clusters can look better in a finderscope than they do in a longfocal-length telescope. To appreciate a cluster fully, you need a field of view twice the size of the cluster so that the cluster appears distinct from its background. Conversely, small clusters (less than five arc minutes) require high power to resolve.

Magnitudes of open star clusters range from 1.5 for the Pleiades to fainter than 12 for the dimmest ones. You would think that the brighter the cluster, the better it would look. That is not necessarily the case. A cluster's magnitude is just a measure of the total brightness of all its member stars. If it contains merely a handful of bright stars, a cluster's appearance may be disappointing despite a high magnitude rating.

What makes a cluster interesting is its richness (the number of member stars) and the contrast between it and the surrounding star field. The best clusters usually contain 100 or more member stars, earning them the official designation of rich, as opposed to moderate (50 to 100 stars) or poor (fewer than 50 stars).

Gorgeous NGC7789 in Cassiopeia is one of the least known of the rich-cluster cream of the crop, while M11 in Scutum is one of the best known and also one of the finest star clusters in the sky. The stunning Jewel Box Cluster, NGC4755, contains a striking ruby-red star in a dazzling field of blue diamonds, as does the Gem Cluster, NGC3293. Several otherwise poor clusters are intriguing because of some unusual trait. Gaze at NGC457 in Cassiopeia, and you'll see the stellar outline of E.T. the Extra-Terrestrial. The pattern of stars in NGC2169 in Orion resembles the number 37 or an XY, depending on how your mind interprets this celestial Rorschach test.

▲ Wild Duck Cluster M11, seen here much as it appears in a small telescope, is one of the richest open clusters in the sky. Early observers likened it to a flight of wild ducks, thus its popular nickname.

◀ Contrast in Clusters Two Cassiopeia clusters display the range of cluster types. NGC7789 (far left) is a rich collection of faint stars. NGC457 (left) is a looser collection of brighter stars. Can you see the outline of E.T. the Extra-Terrestrial in this cluster? Photos on this page by Alan Dyer.

Rating Open Clusters

To categorize the appearance of open clusters, astronomers use the Trumpler system ratings (e.g., II3r), which are often listed in deep-sky catalogs:

Concentration of Stars

- I well separated, with a strong concentration to the center
- II well separated, with little concentration to the center
- III well separated, with no concentration to the center
- IV not well separated from the surrounding star field

Range in Brightness of Stars

- 1 small range in brightness
- 2 moderate range in brightness
- 3 large range in brightness

Richness of Cluster

- p poor, fewer than 50 stars m moderate, 50 to 100 stars
- r rich, more than 100 stars

The best open clusters have a concentration of I or II and lots of stars (r). The Pleiades cluster, above left, is a class I3r, while the larger Hyades, at bottom of frame (with Saturn nearby), is a looser, less rich class I13m. Photo by Alan Dyer.

GLORIOUS GLOBULARS

To see globulars in all their glory requires sharp, well-collimated optics as well as aperture. A good 4-inch telescope will begin to resolve the best northern globulars, such as M13 in Hercules, M3 in Canes Venatici and M5 in Serpens, and such southern-sky wonders as M22 in Sagittarius, NGC6397 in Ara and NGC6752 in Pavo. The legendary Omega Centauri and deep-southern globular 47 Tucanae both explode into stars with even smaller aperture. But apply a 10-to-12inch-aperture telescope to any of the sky's best globulars, and they turn into sugar bowls of stars.

Yet not all globulars are as dazzling as those showpiece objects. Globulars vary in appearance because of their apparent size and concentration.

Globular clusters range in size from 1 to 20 arc minutes. The best are the largest ones. Small globulars tend to be more difficult to resolve, appearing as fuzzy-edged spheres. How well even large globulars can be resolved depends on their concentration. Some are so highly compressed that they are impossible to resolve in even a largeaperture telescope.

At the other end of the scale, a few globular clusters are so loosely concentrated, they take on the appearance of very rich, finely resolved open star clusters. Good examples of this type are NGC288 in Sculptor, NGC5466 in Boötes and NGC5897 in Libra. All are best seen in large apertures; small telescopes at low power show them only as circular glows. One oddball globular in this class that is well worth a look is the bright M71 in Sagitta. For many years, it was considered to be an open star cluster. On the other hand, NGC2477 in Puppis is such a rich open star cluster, it borders on being a globular.

The most distant Milky Way globulars appear faint and small (one to two arc minutes across) and are difficult to resolve in all but the largest amateur telescopes. With intergalactic wanderers, such as NGC2419 in Lynx (300,000 light-years away) and NGC7006 in Delphinus (185,000 light-years away), the reward is simply seeing them.

250

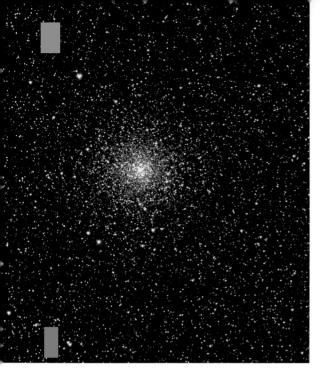

If reaching out to greater distances sounds appealing, try M55 in Sagittarius. This easily resolved globular belongs to another galaxy, the otherwise undetectable Sagittarius Dwarf, a recently discovered companion to the Milky Way.

If you live below 40 degrees north latitude, try NGC1049, an 11th-magnitude blur only 0.6 arc minute across that resides in a dwarf elliptical galaxy called the Fornax Dwarf. Although the galaxy is too faint to be seen in most amateur telescopes, this one globular stands out, shining from a distance of 400,000 light-years.

But NGC1049 is not the distance champ. Owners of big scopes can go after globular clusters 2.5 million light-years away, surrounding the Andromeda Galaxy. About 300 such globulars have been cataloged. The brightest can just be seen in a 12-inch or larger telescope. At about magnitude 15, these globulars are impossible to distinguish from faint foreground stars in our own galaxy. *The Night Sky Observer's Guide, Vol. 1* by Kepple and Sanner (Willmann-Bell, 1998) contains a good finder chart.

Another big-scope challenge is to hunt down the 15 Palomar globular clusters, most of which are buried in the Milky Way and heavily obscured by intervening dust. All of them were discovered on Palomar Observatory Sky Survey (POSS) photos and appear as no more than smudges in the eyepiece. When you finish those, you can then attempt the even more obscure (literally!) globulars (all 11 of them) in the Terzan catalog. It's the challenge of the hunt that is the attraction here.

▲ Distant Globular Dubbed the Intergalactic Wanderer, NGC2419 lies so far away that it appears as little more than a circular glow in most telescopes, impossible to resolve at the eyepiece. Photo by Chris Schur.

Rating Globular Clusters

As with open clusters, there is a classification system for rating the appearance of globular clusters. Devised by Harlow Shapley, the globular-cluster rating system goes from Roman numeral I through XII.

Ι	very highly concentrated; very difficult to resolve
II - XI	decreasing degree of concentration
XII	least concentrated; very loose globular; easily resolved but not as
	richly spectacular

The finest globulars fall in the middle of the range, about Class V to VII, which is the best compromise between richness and resolvability. Class I and II globulars seem star-poor, while Class XI and XII globulars are so loose, they resemble rich open clusters—pretty, but not the expected appearance.

One of the northern sky's finest sights, the great Hercules globular, M13, is rated as Class V for concentration. A 4-inch telescope begins to resolve it, but in a 10-inch or larger scope, it explodes into thousands of stars. Photo by Alan Dyer.

Deep-Sky Tour Three: Where Stars Are Born

Images of colorful nebulas are icons of astronomy, and the anticipation of seeing their technicolor forms swirling in the eyepiece entices many newcomers to a telescope. When that's the case, the views are bound to disappoint. The human eye is simply not sensitive enough to pick up the colors that film or CCD chips record in long exposures. The live views of these puffs of celestial smoke are in monochrome gray. Only a few (Orion, the core of Eta Carinae and some planetaries) are bright enough to excite the eye's color receptors.

Despite this, a 6-to-12-inch telescope can show a wealth of detail in the brightest nebulas, producing views that look almost photographic, albeit in black and white. Some nebulas, such as the Orion Nebula, look better in real life than they do in many astrophotos. The eye can capture the full range of detail, from bright to dim, along with stars embedded within the nebula that are often washed out in longexposure images.

Asterisms, the Un-Clusters

Everyone comes across these when scanning around the sky: interesting alignments of stars that *look* like something—and certainly not just random patterns. Yet that's exactly what they are—chance arrangements of stars which we perceive as familiar shapes. These are not star clusters but asterisms, which are unlabeled on many star charts.

The best-known example lies in dim Camelopardalis. Kemble's Cascade is a two-degree-long chain of fifth-to-eighth-magnitude stars that is obvious in binoculars. Look for it at R.A. 03h 57m and Dec. +63°, with the small open cluster NGC1502 at its southern end. Here's a sampler of other notable asterisms:

• Nearby in Cassiopeia, within a binocular field of M103, lies the Kite (at 1h 40m; +58° 30'), a three-degree-long gathering of fifth-to-seventh-magnitude stars forming a diamond with a tail.

• A binocular field southwest of M52 in Cassiopeia (at 23h 07m; +60°) is a three-degree-long chain of stars that looks like a number 7 on its side.

• Polaris forms the sparkling jewel of a 45-arc-minute-wide semicircle of faint stars dubbed the Engagement Ring by Robert Burnham Jr.

• The one-degree-long Little Fish cluster of a dozen stars lies in a rich field in Auriga (at 05h 18m; +33° 30').

• Three degrees southwest of the cluster M50, near the Monoceros-Canis Major border (at 06h 53m; –10° 12'), is the Number 3 cluster, a backwards "3" of stars half a degree across that was first noted by Canadian Randy Pakan.

• The "W" cluster in Draco (at 18h 35m; +72° 18') looks like a miniature Cassiopeia only half a degree across.

• Finally, the bright, sprawling gathering of stars that surrounds Alpha (α) Persei, or Mirfak, looks as if it should be an official cluster. Indeed, it carries the designation Melotte 20. But this group is classed as an OB Association, a collection of hot young stars that formed together 50 million years ago and are now only loosely bound in the nearby Perseus Arm of the Milky Way.

In the 1980s, Canadian observer Fr. Lucien Kemble first called attention to a twodegree-long chain of stars, shown above. Author Walter Scott Houston called it Kemble's Cascade. At left is the Perseus Association, a good target for binoculars.

GLOWING GAS CLOUDS

The Orion Nebula (M42) is one of the first deep-sky objects amateur astronomers observe, and it is the object everyone returns to time after time. It is an example of an emission nebula—a nebula that glows with its own unique light.

Embedded within every emission nebula is a very hot blue star (more often, a group of them, such as the four Trapezium stars at the heart of M42), newly formed out of the surrounding cloud. The star emits prodigious amounts of ultraviolet light into the heart of the nebula. The neutral hydrogen atoms in the nebula absorb the ultraviolet radiation and are pumped up by this shot of energy. As a result, the atoms are torn apart into a sea of free electrons and protons, a process called ionization, which turns the neutral hydrogen into singly ionized hydrogen atoms called H-II. Emission nebulas are often dubbed H-II regions.

The electrons and protons eventually recombine to form neutral hydrogen, but as the wayward electrons are recaptured, they give up their excess energy as visible light in a series of narrow wavelengths.

In photographs, emission nebulas look red, the result of light emitted at a wavelength of 656.3 nanometers, the hydrogen-alpha spectral line deep in the red end of the spectrum. In the eyepiece, however, emission nebulas, if they show any color at all, appear greenish. M42 is a case in point. Its green color is produced in part from the hydrogenbeta line at 486.1 nanometers, but it arises primarily from a pair of emission lines at 500.7 and 495.9 nanometers. These two lines come from oxygen that has lost two of its eight electrons. Doubly ionized oxygen is called O-III. The fact that nebulas emit light at these discrete wavelengths makes nebula filters possible-they allow the select wavelengths to pass through while rejecting all others, improving the contrast between object and sky.

The Eagle Nebula (M16) in southern Serpens is a good example. Spotting this nebula without a filter can be difficult even in a dark sky. A filter reveals it clearly as a field of grayish haze surrounding a cluster of stars. Other fainter nebulas that are normally barely visible in a dark sky stand out dramatically when seen through a filter.

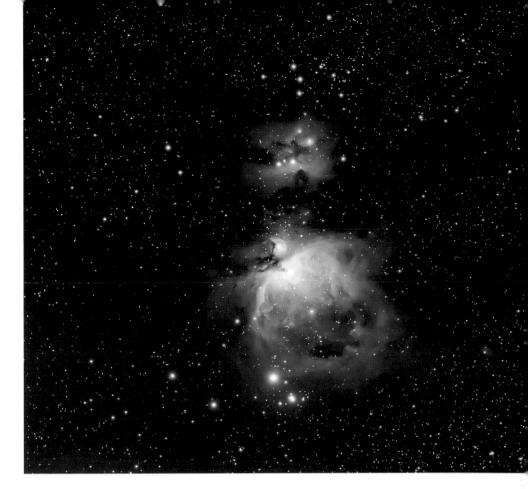

MISTY REFLECTION NEBULAS

Most nebula filters do little to enhance the view of reflection nebulas. These objects do not emit their own light but shine because the light of nearby stars scatters off the nebulas' clouds of dust particles. "Dust" is a catchall term for any interstellar matter larger than molecules. The dust inside nebulas is thought to be graphite coated with ice. The spectrum of a reflection nebula is the same as the continuous spectrum of a star. Since newly formed stars are usually bluish, reflection nebulas are blue as well.

Reflection nebulas are less common than emission types. Most are also fainter and more difficult to see, since they are often washed out by the glare of the nearby source star.

One hazard in seeking reflection nebulas is that dew or a film of dirt on the eyepiece or the main optics can produce a pale glow around a bright star. Seeing the nebulosity surrounding the Pleiades, for instance, requires clean optics. A humid atmosphere also creates hazy star images. Hunting reflection nebulas is best left for dry, transparent nights. Best Northern Nebula

The Orion Nebula, consisting of M42 and M43, is the brightest nebula visible to northern-hemisphere observers. Its hydrogen atoms glow reddish pink. Above it is the cyan-blue glow of the reflection nebula NCC1973-5-7, also known as the Running Man Nebula. See him?

▼ Best Reflection Nebula Not far from M42 lies M78, one of the sky's brightest reflection nebulas, paired with NGC2071 above it. Both photos by Alan Dyer.

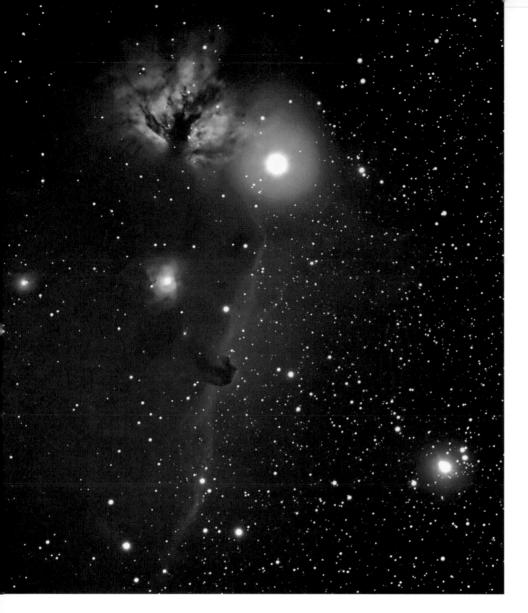

Infamous Horsehead 🔺

This dark nebula has the reputation of being well known but seldom seen. Visually, the horse's head barely shows as a dark bay in the dim band of IC434. Above the Horsehead is the blue reflection nebula NGC2023 and the rosy pink emission nebula NGC2024, also known as the Flame or Tank Tracks Nebula.

Snake Nebula 🕨

This sinuous cloud of obscuring dust cataloged as B72 lies in Ophiuchus. All photos by Alan Dyer.

DARK NEBULAS: SILHOUETTES ON THE SKY

Although composed of the same mixture of gas and dust as bright emission and reflection nebulas, dark nebulas lack any embedded or nearby stars to illuminate or warm them. They appear as nearly starless voids cold, black patches obscuring whatever lies behind them.

Some dark nebulas can be spotted with the unaided eye. The dark rifts and lanes that split the Milky Way in Cygnus are dust clouds lining the arms of our galaxy about 4,000 to 5,000 light-years away. The fivedegree-wide Coal Sack near the Southern Cross is a mass of obscuring dust roughly 500 light-years away.

Not all dark nebulas are so large. Many fit nicely into a telescope's low-power field. But how do you observe an object that gives off no light? The trick is to use a wide field (one degree or more) to see the dark area framed by the surrounding bright star field. A large scope is not needed—a short-focus 3.5-inch (90mm) refractor will do nicely, as will giant 10x70 or 11x80 binoculars.

Once you find dark nebulas, how do you identify them? Most GoTo telescopes don't include dark nebulas in their databases. To track them down, start with our Milky Way atlas (see page 338) or turn to printed star atlases such as the Pocket Sky Atlas, SkyAtlas 2000.0 or Uranometria 2000.0. In computer programs, try Guide 8.0, MegaStar or Starry Night Pro Plus. With these, you can locate dark nebulas such as B86 and B92 in Sagittarius, both small, opaque patches nestled in rich Milky Way star fields. A good binocular object is Barnard's E, a three-pronged nebula formed by B142 and B143 within a binocular field of Altair, the brightest star in Aquila.

The most famous dark nebula, but perhaps the most elusive, is B33, a protrusion of dusty material that forms the Horsehead Nebula, south of Orion's belt. Transparent skies, a telescope larger than 8 inches and a nebula filter or Hydrogen-beta filter help bring out the faint emission nebula IC434, which forms the glowing background to the Horsehead's surprisingly tiny silhouette.

A dark sky is imperative for observing any dark nebula. Unless the Milky Way is a shining river of light, forget about hunting for this elusive class of objects.

◀ What Do You See?

Nebulas often carry fanciful names inspired by their appearance. Perhaps the Dumbbell (M27) looks like a barbell, but a better name for this planetary nebula might be the "Apple Core Nebula." The photo at left reveals cyan and magenta colors, but to our less sensitive eyes, this object looks more like the simulated eyepiece view above.

Deep-Sky Tour Four: Where Stars Die

Not all nebulous regions are areas of star formation. Just the opposite. Some are sites of stellar death. Around the sky, we can see shells and arcs of gas cast off by dying stars at the end of their lives. Much of this material pollutes the Milky Way but is eventually swept up by star-forming nebulas, where it goes on to enrich a new generation of stars as part of a galactic recycling program. For example, our Sun is thought to be at least a third-generation star, made of atoms that have been processed by earlier generations of stars.

Indeed, all the elements heavier than helium, including carbon, oxygen, iron and every element critical for life, were forged inside stars. Look at planetary nebulas or supernova remnants, and you are seeing where the stuff that makes you came from.

SMOKE-PUFF PLANETARIES

Despite their name, planetary nebulas have nothing to do with planet formation. They are shells of gas expelled by aging stars during an unstable phase near the end of their lives. Uranus's discoverer, William Herschel, was the nomenclature culprit Ignorant of the role they play in the life cycle of stars, he called them planetary nebulas because they reminded him of the appearance of Uranus. The name stuck.

Since planetary nebulas are thought to last for little more than 100,000 years, they must be constantly forming. Indeed, a number of strange, compact objects apparent only through giant observatory telescopes are now classified as protoplanetaries, stars in the early stages of casting off a nebulous shroud. The older, well-formed planetary nebulas visible through amateur telescopes typically range from about one-quarter of a light-year to one light-year across, and the ones we can see all lie in our sector of the galaxy, no more than a few thousand lightyears away. A Plethora of Planetaries ▼ While usually spherical, planetaries do exhibit a variety of structures. Clockwise from upper left:

NGC40, an unusual red planetary in Cepheus;

NGC1514, in Taurus, has a bright central star;

> NGC2392, the Eskimo Nebula in Gemini;

NGC7008, an odd-shaped planetary in Cygnus;

NGC7662, the Blue Snowball in Andromeda;

IC289, a faint but distinct planetary in Cepheus.

All images by Chris Schur (ST-7 CCD camera) reproduced to the same scale. For the deep-sky observer, planetary nebulas fall into one of three broad categories: large and bright; bright but starlike; and large and faint. The differences are partly intrinsic and partly due to distance.

Large and Bright

As an example of a large, bright planetary, the Ring Nebula (M57) is the classic choice. At ninth magnitude and 70 arc seconds across, it has a high surface brightness for a planetary nebula. Its smoke-ring form is easy to see even in a 60mm telescope in a dark sky. However, one feature of the Ring Nebula is far from easy: its 15th-magnitude central star. We have seen it with a 14-inch Schmidt-Cassegrain under superb desert skies, but it is usually rendered invisible by the surrounding nebula.

Another showpiece glows nearby: the Dumbbell Nebula (M27) in Vulpecula, a planetary large and bright enough to be seen in binoculars. A filter-equipped large telescope reveals far more outlying detail than shown in many photos of the Dumbbell. M27 exhibits a classic double-lobed structure shared by many small planetaries, such as NGC5189, the Spiral Planetary in Musca, the southern sky's best planetary.

Small Planetaries

Large, bright planetaries like the Ring and Dumbbell Nebulas are the exception. The majority fall into the category of "bright but starlike," often difficult to distinguish from stars, especially at low power. Most have diameters of well under 20 arc seconds, making them smaller than the disk of Saturn. Few have annular smoke-ring structures like the Ring. Nevertheless, many of these tiny planetaries are worth the search.

A couple of our favorites are the Blue Snowball (NGC7662) in northern Andromeda and the Eskimo Nebula (NGC2392) in Gemini. They are bright enough—magnitudes 9 and 8, respectively—to take high magnification. With a diameter of 30 arc seconds, the Blinking Planetary (NGC6826) in Cygnus is large by planetary-nebula standards. It features a 10th-magnitude central star. Stare directly at the star, and the nebula seems to disappear; look to one side with averted vision, and the nebula pops back into view.

Planetaries with diameters of less than 10 arc seconds are tough to find no matter how bright they are. Even at high power, they can look like blue-green stars. One

technique that helps is to hold a nebula filter between your eye and the eyepiece and move it in and out of the light path. While the stars and background sky will dim with the filter in place, the planetary will remain at the same brightness, making it pop out. Try this on two tiny but bright (ninth-magnitude) blue planetaries: NGC6210 in Hercules and NGC6572 in Ophiuchus.

* Large and Faint

At the opposite end of the planetary-nebula scale are large (more than 60 arc seconds), dim objects. The Helix Nebula (NGC7293) is a classic example. It spans half the diameter of the Moon, but its faintness makes it elusive under average sky conditions. Two others in this class are NGC6781 in Aquila and NGC246 in Cetus. Such faint, diffuse planetaries can be difficult to see without a nebula filter. Yet when viewed with a filter under dark skies, they become showpiece objects in telescopes larger than 10 inches in aperture.

At the extreme end of visibility are plan etarico that, as recently as the late 1970s, were assumed to be strictly photographic objects. These large but faint planetaries from George Abell's list or from Perek and Kohoutek's catalog now fall prey to deepsky hunters armed with light-bucket telescopes. One of the best is Abell 21, also known as PK205 +14.1 or the Medusa Nebula, in Gemini. Its disk is more than 11 arc minutes across, huge for a planetary. When tracking down planetary nebulas, keep in mind that the official magnitude figures may not be reliable indicators of the actual brightness. Large, diffuse planetaries often carry ratings of eighth or ninth magnitude, making them seem like easy targets. But these magnitudes are measures of the total integrated light output of the object; a large, faint planetary could have the same magnitude rating as a compact, bright one.

Also, most magnitudes are measured using a standard set of photometric filters whose passbands do not coincide with the green part of the spectrum where planetaries emit the majority of their light. Small planetaries officially listed as 12th to 14th magnitude can appear brighter than, say, a galaxy of the same magnitude. This is especially true if you are using a nebula filter, an essential accessory for planetary-nebula hunting. This is one area of observing where it is best to ignore all presuppositions of what should and should not be visible through your telescope.

EXPLODING SUPERNOVA REMNANTS

We are long overdue for a bright naked-eye supernova in our section of the Milky Way. But until one occurs, we must be content to observe the remains of a handful of ancient supernovas that litter the sky. The best example is the Veil Nebula in Cygnus. Viewed with a nebula filter through a large telescope, the Veil's two main arcs appear as intricate, twisted lacework. Without a filter, the Veil is easy to miss, even in a dark sky.

IC443, a similar supernova remnant, appears as a crescent-shaped arc near the star Eta (η) Geminorum. Extremely faint, it is a challenge even for an experienced observer using a filter-equipped 12-inch telescope. In the southern sky, wispy fragments of the Vela supernova remnant can be sighted with large apertures.

An object sometimes wrongly labeled as a supernova remnant is the Crescent Nebula (NGC6888) in central Cygnus. While it resembles the debris of a violent explosion, this nebula is actually a shell of material blown away from a rare type of superhot star, called a Wolf-Rayet star, through intense stellar winds rather than from a single catastrophic explosion. The large arc of neb-

Elusive Medusa

In a modest-sized telescope, the Medusa Nebula, one of the faint Abell planctaries, is surprisingly easy to see, provided a nebula filter is used in the eyepiece. Without it, most faint planetaries are invisible. Photo by Chris Schur.

▼ Famous Crab Nebula M1's expanding red tendrils are obvious in photos such as this fine CCD image by Rob Gendler, but in the eyepiece, just the amorphous central glow is visible.

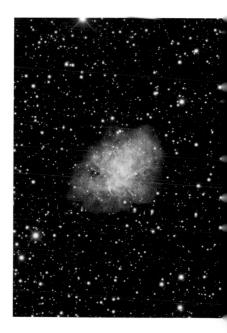

Impostor Supernova The Crescent Nebula (NGC6888) in Cygnus has the appearance of an exploded supernova remnant but is actually a windblown shell of gas puffed off by an active superhot star. Photo by Alan Dyer. ulosity on the east side of Orion, Barnard's Loop (Sh2-276), is another form of windblown bubble, not a supernova remnant.

The best-known supernova remnant is the bright Crab Nebula (M1), the remains of a supernova that was seen to explode nearly 10 centuries ago, in 1054 A.D. We say "seen to explode" because the Crab is 4,000 lightyears away, so the actual explosion took place 4,000 years before the light of the explosion reached us in 1054.

Because of its youth, M1 has not yet expanded into an open shell or arcs of material, like the much older Veil Nebula. Visually, the Crab is a disappointment to many observers. In small-to-moderate apertures, it resembles an amorphous blur. The wispy filaments that gave it its name can be seen only in large apertures. William Parsons (Lord Rosse) first observed the filaments in 1844 with his 36-inch reflector. Nebula filters make little difference with this object, since the brightest part of the nebula shines with a continuous spectrum generated by the 16th-magnitude pulsar at its center.

Deep-Sky Tour Five: Beyond the Milky Way

Everything described so far on our deep-sky tours—stars, clusters and nebulas—resides within our Milky Way Galaxy. Now we leave the Milky Way behind.

Galaxies are by far the most numerous class of deep-sky objects. Several thousand shine brighter than 13th magnitude, the effective dividing line between moderately bright galaxies and those which are just barely perceptible blurs.

However, as with other deep-sky objects, do not put too much stock in any published magnitude figures. Most galaxy magnitudes are photographic, which means they were measured in the blue part of the spectrum. These values are generally at least half a magnitude fainter than yellow-green visual magnitudes. Where only a photographic magnitude is given, the galaxy usually appears brighter than that value.

The best recipe for galaxy hunting is to combine a dark sky with a large-aperture telescope. To see galaxies as more than fuzzy blobs, use at least a 6-inch instrument. Galaxy aficionados will want a 12-inch or larger telescope.

But galaxies are not just for the big-telescope user. Binoculars will show a handful of the brightest galaxies, while many more can be seen in a small telescope, even a 3.5inch scope, which is quite remarkable when you consider that the closest major galaxy, the Andromeda, is so far away, its light takes 2.5 million years to reach us.

ANDROMEDA GALAXY

The first galaxy anyone observes is usually Andromeda (M31). But beginners are often disappointed with that initial glimpse. Expecting an eyepiece image that looks like a long-time-exposure photograph, they see, instead, a featureless smear. The best way to be introduced to Andromeda is with binoculars under dark skies. More than four degrees wide, Andromeda stretches across most of the field of even 7x35s. To see the Andromeda Galaxy as more than a diffuse patch, use a 6-inch or larger telescope and look for two dark bands crossing the glow of the central core. These dust lanes separate Andromeda's spiral arms. Farther out along the arms is a bright patch known as NGC206. Now switch to high power, and zoom in on the central core. Look for an intense starlike point of light coming from masses of stars circling what is thought to be a giant black hole.

As viewing the Andromeda Galaxy demonstrates, small telescopes may not reveal much detail in a galaxy, but they do show its overall shape, a characteristic that depends on the galaxy's morphological type and its orientation to our line of sight.

THE GALAXY ZOO

Galaxies come in a variety of forms, probably as a result of the initial conditions under which they formed billions of years ago. Older theories that had elliptical galaxies naturally evolving into flattened spiral galaxies have long fallen into disfavor. However, the classification scheme first devised by Edwin Hubble still remains in use.

Elliptical Galaxies

Andromeda's two close companion galaxies, M32 and M110, are good examples of elliptical galaxies, the most common type in the universe. Ellipticals are also the least interesting to observe. Most elliptical galaxies have no visible internal structure—no dust lanes, mottling or arm structure. They are just amorphous glows that fade from bright cores into the darkness of space.

Depending on the degree of ellipticity, such galaxies can vary from circular cometlike objects to elongated patches. Ellipticals are rated from type E0 to E7: E0 and E1 galaxies are circular; E4s are football-shaped; and E6s and E7s are very flattened. In the Messier catalog, many of the brightest members of the Virgo swarm of galaxies (namely, M59, M60, M84, M85, M86 and the giant M87) are ellipticals.

Spiral Galaxies

The type of object people think of when they hear the word galaxy is the spiral, its graceful curving arms the epitome of deepsky grandeur. While the majority of bright nearby galaxies are spirals, not all reveal their classic pinwheel structure. It depends

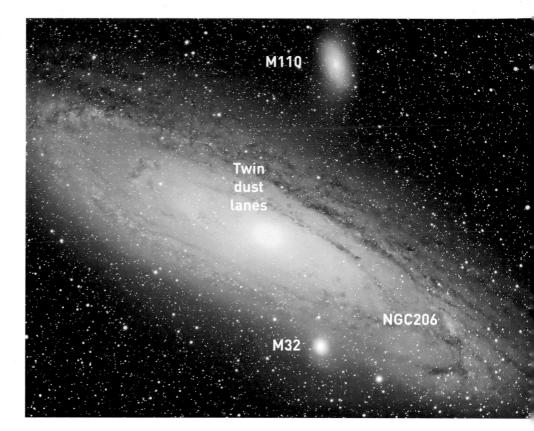

in part on whether the galaxy is tilted edgeon to us, face-on (the best orientation for seeing spiral arms) or somewhere in between (as is usually the case).

The finest spiral galaxy is M51, the Whirlpool Galaxy. How small a telescope will reveal its face-on spiral arms is debatable. Most people are so familiar with what this object is supposed to look like, they imagine blatant spiral structure where there is only

Milky Way Twin

Through binoculars from a dark site, the elliptical glow of M31 spans three to four degrees, half the field of most binoculars. The elliptical companion galaxies M32 and M110 appear as adjacent glows. Through a telescope, the most obvious features are the twin dark lanes separating the spiral arms. North is up in this image. Photos by Alan Dyer.

Classic Spiral

Not far from M31 and also a member of our Local Group is the Triangulum, or Pinwheel, Galaxy, M33. Note the pinkish nebula NGC604 in one of the spiral arms. Although M33 can be easily seen in binoculars, an 8-to-10-inch telescope is needed to see the spiral arms. Whirlpool Galaxy The classic spiral is M51, which is accompanied by the small galaxy NGC5195. Because of M51's face-on orientation, the spiral arms are beautifully defined, though it takes at least an 8-inch telescope to pick out the spiral structure. Photo by Robert Gendler.

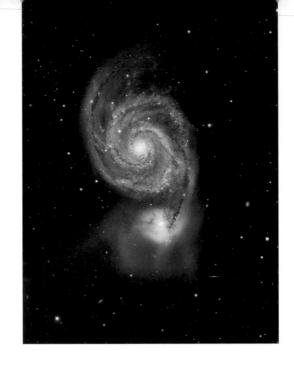

a hint of a circular glow. But it is safe to say that even novices perceive the suggestion of spiral arms through an 8-inch telescope.

A variation of the spiral is the barred spiral, where the arms start not from a central core but from a long stellar bar protruding from the core. The effect is obvious in photographs but often subtle at the eyepiece. M95 in Leo is a barred spiral, but it looks more like an elliptical in most telescopes. Even one of the best barred spirals, NGC1365 in Fornax, requires at least a 12-inch telescope to reveal its barred structure.

In contrast, edge-on galaxies are more obvious sights. With their disks tilted at an extreme angle, edge-ons appear as thin streaks. Because their light is concentrated

The Leviathan of Parsonstown

There was a time when the largest telescope in the world sat in misty Ireland, owned not by a government or university but by a wealthy individual. William Parsons, the third Earl of Rosse, constructed the Leviathan, a 72-inch reflector slung on cables between two brickwork walls at his family estate, Birr Castle, in Parsonstown.

The big telescope resolved many nebulous objects into stars. The Leviathan's select users boldly asserted that all nebulas were simply collections of stars. One observer, J.P. Nichol, exclaimed, "The great mirror itself continues baffled and hopeless in the presence of those unfathomed nebulosities, which doubtless also are streams and masses of correlated stars!" The Parsonstown astronomers were partly right. Some of the "nebulas" they found—the galaxies—are made

of stars. But it would take spectroscopy and photography, new techniques that made the Leviathan and the art of eyepiece sketching obsolete, to prove it.

Shown in this rare photo from the late 1800s, above, the unwieldy arrangement of the Leviathan allowed an observer perched on a side ladder only one hour of viewing an object as it paraded past the meridian due south. Despite the limitation, observers recorded numerous deep-sky objects with the only method of the time: making sketches at the eyepiece, as at center.

into a compact form, edge-on galaxies are good, distinct targets for owners of small telescopes. Most are spirals, but some are elongated ellipticals. Members of a transition type called S0 spirals, such as the Spindle Galaxy (NGC3115) in Sextans, also produce fine edge-ons.

For the best edge-on galaxy, search out the 10th-magnitude NGC4565 in Coma Berenices. Even a 3.5-inch refractor clearly reveals a remarkable sliver of light. A larger telescope shows that it is bisected by a galaxy-wide dust lane. This galaxy is 16 arc minutes long, large by galactic standards.

A great hunting ground for edge-ons is Canes Venatici. NGC4111, NGC4244 and the neat pair of NGC4631 and NGC4656, the Hockey Stick Galaxy, are all rewarding targets. To the south, NGC4762, on the outer limits of the Virgo galaxy cluster, has the distinction of being the flattest galaxy known.

When selecting candidates for observing, look for galaxies whose cataloged dimensions are asymmetrical—for example, 10 arc minutes long by 1 arc minute wide. This is an indication of an edge-on galaxy that is sure to be an interesting sight.

* Oddball Galaxies

A few galaxies—irregulars—do not fall into any neat category. This class of galaxies is a minority group whose members are oddly shaped or contain chaotic details, such as patches of nebulosity, mottled dark lanes or straggling appendages. The best example is M82 in Ursa Major, erupting with fountains of material ejected by a chain-reaction burst of star formation. NGC4449 in CanesVenatici looks oddly rectangular.

Another irregular object that doubles as a radio source is the southern-sky galaxy NGC5128, or Centaurus A. It looks like a bright elliptical with a dark band crossing its disk and is probably the product of two galaxies colliding.

The Antennae (NGC4038 and 4039) in Corvus and The Mice (NGC4676) in Coma Berenices are both colliding galaxies whose two participants have yet to merge.

Observers looking for twisted galaxies in abundance can turn to Halton Arp's 1963 listing of 338 of the sky's oddest galactic denizens. A superb modern reference is *The Arp Atlas of Peculiar Galaxies* by Jeff Kanipe and Dennis Webb (Willmann-Bell, 2007).

Other less deviant galaxies have distin-

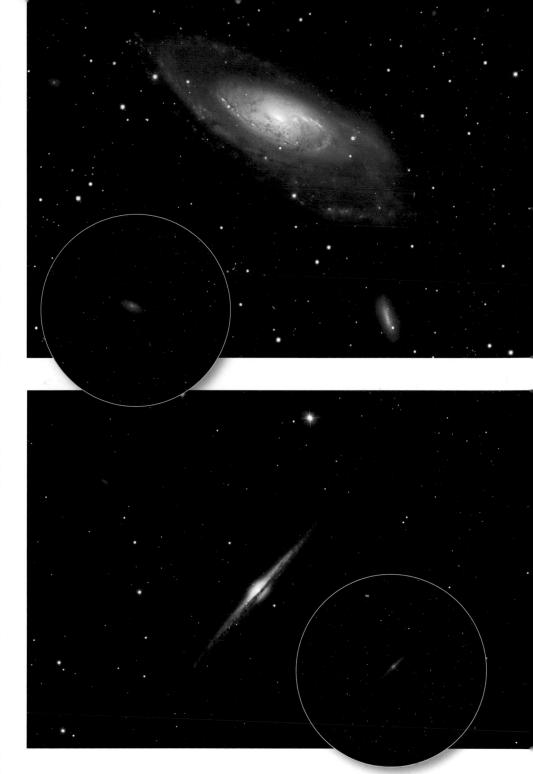

guishing characteristics. M77 in Cetus, for example, is a spiral with a starlike nucleus. It is the brightest example of a Seyfert galaxy, a class with energetic nuclei one step away from being quasars.

* Quasars

Most people have heard of quasars, but not all amateur astronomers realize they can see a quasar. At about 13th magnitude (the brightness varies), quasar 3C 273 in Virgo is the brightest member of this unusual class of objects. (The next brightest quasars are ▲ Spiral Perspectives Two of the finest galaxies are the dusty, tilted spiral M106 in Canes Venatici (top) and NGC4565 (above), the classic edge-on spiral in Coma Berenices. The inset images simulate the view through an 8-to-12-inch telescope under dark skies. Both color images by Robert Gendler.

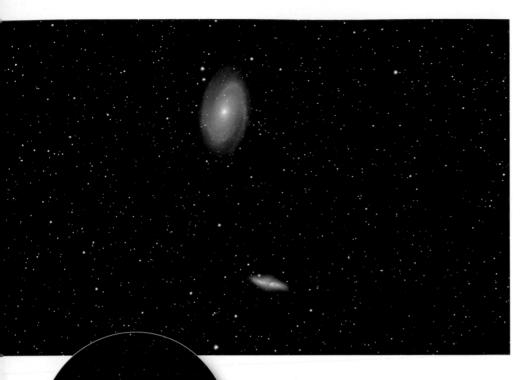

roughly 14th to 16th magnitude.) All that can be seen, however, is a faint "star." But at an estimated two to three billion lightyears away, 3C 273 is one of the most distant objects visible in an amateur telescope. Find it, and you are gazing at the ultraluminous core of a distant galaxy energized by matter pouring into a massive black hole.

Ursa Major Galaxy Pair M81, a classic spiral, and M82, the cigar-shaped irregular (remember, M82 is an even number but an odd galaxy!), are large and bright enough to be seen in binoculars. A small scope at low power will frame both in one field, as the eyepiece view shows. Photo by Alan Dyer.

Local Group Smudge ► Most Local Group galaxies, like IC10, are irregulars or dwarf ellipticals with low surface brightness. Just detecting their ghostly presence in the eyepiece is an accomplishment. Photo by Chris Schur.

THE LOCAL GROUP

Galaxies are gregarious creatures, living their cosmic lives in groups. The Milky Way is no exception. It belongs to a small gathering called the Local Group, whose two largest members are the Milky Way and M31, the Andromeda Galaxy. The only other prominent member in the northern sky is M33, the large spiral galaxy in Triangulum, just south of M31. In the southern hemisphere, the two Magellanic Clouds are naked-eye companion galaxies to the Milky Way.

Collecting views of Local Group members is a challenging observing project. Beyond the galaxies mentioned so far, the targets become faint and hard to see. About 40 galaxies make up the Local Group (new members are discovered almost yearly). A few are irregular galaxies, but most are dwarf ellipticals—galaxies that contain few stars and shine with a dim light.

The irregular galaxies NGC6822 (Barnard's Galaxy in Sagittarius), IC1613 in Cetus and IC10 in Cassiopeia carry relatively high magnitudes (about 10th) but are so diffuse, they are notoriously difficult to see even in the darkest skies.

The dwarf ellipticals are just plain faint. Using large-aperture scopes, amateurs have tracked down Andromeda II, Leo I, the Draco Dwarf and the Sculptor Dwarf, but none appear as more than barely perceptible glows, more imagined than seen.

GALAXY GROUPS

The sky contains other similar families of related, sometimes interacting, galaxies that are not populous enough to be called clusters but provide interesting fields containing three or more members.

One of the best is the Leo trio. M65 and M66 in Leo are two bright spirals that form a triangle with a large edge-on galaxy called NGC3628. A much fainter target, located seven degrees southeast of the Whirlpool Galaxy, is the NGC5353 group. Owners of 10-to-12-inch telescopes will find a highpower field containing five 12th-to-14thmagnitude galaxies. Perhaps the most famous galaxy group is Stephan's Quintet, a gathering of faint 13th-to-15th-magnitude galaxies in Pegasus, just an eyepiece field

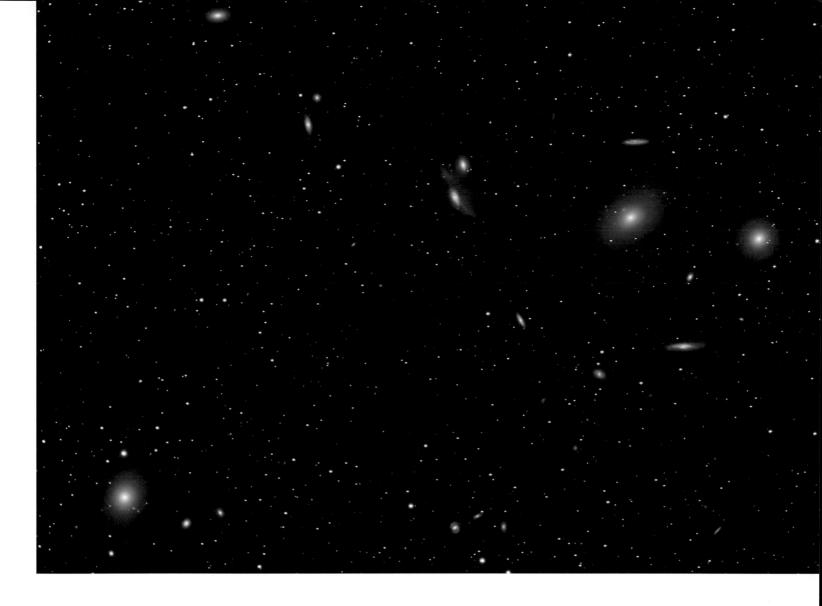

southwest of the spiral galaxy NGC7331.

For southern observers, the field surrounding NGC1399 in Fornax contains nine galaxies within a one-degree circle.

The primary listing of galaxy groups is Paul Hickson's 1994 *Atlas of Compact Groups of Galaxies,* a catalog of 100 tightly knit families of four or more galaxies. Most groups consist of faint 13th-to-16th-magnitude members, making hunting for "Hicksons" big-aperture work. Alvin Huey has published excellent observing guides available through www.faintfuzzies.com.

VIRGO GALAXY CLUSTER

When we face the northern spring constellations of Ursa Major, Canes Venatici, Coma Berenices, Leo and Virgo, we are looking straight up out of the disk of our galaxy toward its north galactic pole, which lies near the Coma Berenices-Virgo border. That sight line passes through the least amount of galactic dust, allowing us to see into the throngs of distant galaxies.

The crowd of galaxies in the Coma-Virgo area is a galaxy cluster, the nearest such grand-scale gathering. The center of the cluster lies about 70 million light-years distant, only a stone's throw away on the galactic scale. In fact, because of this cluster's proximity, member galaxies are scattered over a huge swath of sky, from Ursa Major south to Virgo. Our Local Group lies on the outskirts of this cluster.

The problem with exploring Coma-Virgo galaxies is that there are so many galaxies and so few bright guide stars, it is easy to become lost in a field of anonymous fuzzy spots. A good star chart is essential.

The heart of the "realm of the galaxies" lies around M84 and M86. These twin ellipticals are the brightest members of a string of galaxies called Markarian's Chain.

🔺 Galaxies Galore

Markarian's Chain, the string of galaxies across the top of this image, is one of the sky's greatest wonders. One night, we examined it with a 4-inch f/6.5 refractor using a 16mm Nagler eyepiece that gave 41x and a two-degree field. Ten galaxies floated like tiny, pale snowflakes in the star field. The view included the entire chain and the giant elliptical galaxy M87 to the southeast lbottom left in this image), the true gravitational center of the Virgo galaxy cluster. Photo by Alan Dyer.

Leo Trio ▶ M65, lower right, M66, lower left, and NGC3628, top, can all be framed within a one-degree field of view. Photo by Alan Dyer.

Nothing but Galaxies 🔻

At its heart, Abell 1656 contains two bright NGC galaxies, 4874 and 4889, surrounded by dozens of faint galaxies that form the rich Coma Cluster. This map was produced with Guide 8.0 software and includes images from Palomar Observatory Sky Survey (POSS) plates.

DISTANT CLUSTERS

If you enjoy observing the Coma-Virgo galaxy cluster, you may wish to attempt other rich but much fainter galaxy clusters. These objects are at the top of the cosmic hierarchy but are among the most challenging of deep-sky targets. Because of their great distance, each is contained within an area only one to two degrees wide at most. Often, the entire cluster can be seen in one field as a collection of faint, ill-defined smudges.

Galaxy clusters usually require a lot of aperture, preferably 14 to 20 inches. Printed finder charts generated by computer programs such as Guide, MegaStar or TheSky are great aids for pinpointing and identifying each member, as even the massive *Millennium Star Atlas* (MSA) charts are barely large enough to identify individual members of the biggest clusters.

A starter cluster is Abell 1656, the Coma Berenices galaxy cluster (MSA chart #653). The brightest members of this cluster are a pair of 12th-magnitude galaxies, NGC4874 and NGC4889, 350 million light-years away. We have seen these galaxies in a 5-inch telescope. Surrounding the two giant ellipticals are about 50 very faint 13th-to-16thmagnitude galaxies that require at least a 12-inch instrument.

Nearby is Abell 1367 in the constellation Leo, centered around the 13th-magnitude elliptical NGC3842 (MSA chart #703). Five dozen galaxies brighter than 16th magnitude make up this cluster. An autumn-sky favorite is Abell 246, just two degrees east of Algol, the eclipsing binary star in Perseus (MSA chart #98). This cluster is composed of a chain of 14th-to-15th-magnitude galaxies, with the exploding galaxy NGC1275 at its heart.

The distance recordholder for accessible galaxy clusters is Abell 2065, the Corona Borealis cluster (MSA chart #646). With a 14-inch scope under pristine skies, amateur astronomers have observed this cluster as a grayish mottling of the sky. Abell 2065 is at least one billion light-years away, nearly 400 times more distant than the Andromeda Galaxy. Except for a few of the brightest quasars, Abell 2065 marks the edge of the backyard astronomer's universe. So for a new frontier, try heading south!

Sketching at the Eyepiece

By Gregg Thompson, an expert deep-sky observer who lives in Brisbane, Australia, and coauthor of The Supernova Search Charts and Handbook (Cambridge; 1989).

A drawing of a celestial object records far more detail and subtlety than can be expressed in words. "But I can't draw," some people exclaim. Drawing astronomical objects does not require the talents of a Michelangelo. Typical drawings are records of simple shapes, with various degrees of shading.

The equipment is ordinary untextured white bond paper and a soft 2B or 4B lead pencil. Use the tip of the pencil for stars and other well-defined objects and the side of the pencil for nebulous objects. Lead pencil on paper provides the easiest medium for the soft smudging needed to give a natural look to deep-sky objects. Smudging is best done with an inexpensive artist's blending stump.

Of course, using pencil on paper means that you are making a drawing with black stars on a white background, much like a photographic negative, but this is of little consequence. It is far more practical than trying to use pieces of chalk or white crayon on black paper.

After more than 30 years of experimenting with astronomical drawings, I strongly recommend two things:

1. Make the circle representing the eyepiece's field of view six to eight inches across. Most observers draw a circle half this size, and it is too small.

2. Apply the highest magnification that permits you to see the object at its best. Contrary to advice in older books, most deep-sky objects reveal much more at high power than at low power, because of their increased size and enhanced contrast against a darker background.

Use most of the area of a page, keeping the bottom for notes about the factors that affect your drawing. Such notes become a valuable reference and encourage consistency. Record the name of the object, the image orientation (mark north and east by watching the drift of the image across the undriven field), the telescope's aperture and magnification, the type of eyepiece, the type of filter (if one was used), the object's elevation in degrees above the horizon, the steadiness of the air (seeing), the darkness of the sky (transparency), the observing site and whether you have made a detailed drawing or merely a rough sketch.

Start by drawing simple telescope objects such as the Ring Nebula (M57). Other good beginning subjects are naked-eye or binocular views of star clusters such as Coma Berenices, the Beehive, the Pleiades or the Hyades. Gradually progress to fainter and more detailed objects.

Always begin by positioning the main features relative to one another—some bright stars or the general shape of a galaxy, for instance. Once you are happy with the overall proportions, fill in the details. Don't be reluctant to draw brighter stars larger or to give them spikes or diffraction rings to indicate the relative brightness.

A proficient observer must learn how to see. Give your eyes time to adapt to the dark field. Novice observers simply glance at an object in the eyepiece for a few seconds and believe that they have seen it. Always inspect the object carefully.

When you make the effort to draw what you see, a wonderful thing happens: You will see far more than you ever imagined you could. Drawing the view in the eyeplece forces you to look for subtle structure. Scrutinizing a celestial object for 10 to 20 minutes often rewards observers with inspiring detail that is invisible to those who merely take a cursory glance.

An eyepiece sketch of the globular cluster M30 shows the detail seen by experienced observer Gregg Thompson, using a 12.5-inch Newtonian. Notice the standard observing form Thompson has developed for ease of consistent use at the telescope. Those who have tried sketching deep-sky objects say that it soon trains the eye to detect more detail.

Changing Attitudes ▲ From southern latitudes, many constellations familiar to northerners appear upside down. Here, Orion stands on his head as he dives into the west in April. His belt points up to Sirius, while Canopus and the Large Magellanic Cloud lie at upper left.

Southern Symbol 🕨

The stars of Crux, the Southern Cross, can be found on the flags of half a dozen nations in the southern hemisphere. Its bright, compact form sits next to the Coal Sack, arguably the best and most obvious dark nebula in the sky. Both photos by Alan Dyer.

The Other Side of the Sky

There's a saying in astronomy that God put all the astronomers in the north but put all the best celestial targets in the south. Until you have been below the equator, you don't appreciate how true that adage is. From 40 degrees north latitude (say, Europe and the central United States), any object south of -50 degrees declination is out of sight, below the horizon. The finest objects the sky has to offer lie beneath that horizon: the best nebulas, clusters and galaxies—they're all there, in the great southern sky.

THE 'BACKWARDS' SKY

From the midnorthern home latitudes of most readers, the sky appears to turn around a point halfway up the northern sky, the north celestial pole, conveniently marked by the North Star. Look north, and you see the sky turn counterclockwise through the night: Stars to the left set in the west, while stars to the right rise out of the east. Turn around and face south, and you see the Sun by day and the stars by night moving from left to right (east to west) across the heavens as the world turns. Now take a trek south, to a location 30 degrees below the equator (Sydney, Australia; Santiago, Chile; or Johannesburg, South Africa), and look up—you are sure to become quickly disoriented. By day, the Sun still moves from east to west, but to see it, you now look north, where it moves from right to left during the day, backward from what northerners are used to. Look north at night, and the stars also move "backwards." Now turn around, and look south. There, the stars are circling the south celestial pole, but clockwise, spinning around a blank area of sky that contains no bright "South Star."

WHERE TO GO

We've both been south of the equator several times and try to make the pilgrimage at every opportunity. The prime destinations lie in a latitude band about 30 degrees south, where ocean currents and trade winds create desert climates around the globe. Choice areas include Australia, Chile and southern Africa, all locations with astronomical meccas, such as major observatories and star parties.

The Atacama Desert and Andean foothills in central and northern Chile take the prize for the best skies, which is why more and more of the world's major observatories

are being located there. We've had the privilege of observing at the Las Campanas Observatory north of La Serena, and it was heaven on Earth. The skies are stunningly dark, and the seeing is so steady that stars and planets appear without a shimmer. It is like being beyond the atmosphere.

Chilean bound astronomers often make for the ElquiValley area north of La Serena, two hours by air north of Santiago and the nearest town to a cluster of American and European observatories. Another increasingly popular spot is the more remote San Pedro de Atacama, a high-altitude town in northern Chile where astronomer Alain Maury has set up a public observatory and lodge (www.spaceobs.com). Friends who have stayed there rave about it. In southern Africa, several rural retreats in South Africa and Namibia cater to amateur astronomers and have become popular with stargazers from Europe. For one accommodation that comes highly recommended, check out www.sossusvlei-namibia.com.

But for many North Americans, and for us in recent years, the destination of choice has been Australia—Oz. You can speak the language (sort of!), drive a rental car (sort of! —driving is on the left) and find ample places to stay and set up, often in the company of friendly local amateurs.

Australia, as with all southern-sky countries, has a sparse population, clean air and little light pollution. We've found it unnecessary to"go bush" (travel deep into the outback) for dark skies. Superb skies can be found just two or three hours from Sydney, Brisbane or Melbourne. From our experience, the skies at such sites are just as dark and the chances for clear nights just as good as those at outback locations such as Uluru, the site of Ayers Rock. For climate statistics,

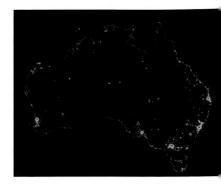

▲ The Dark Continent Australia is what the United States was like in the 1950s, with most of the country free of light pollution. Compare this with the map of North America in Chapter 8, and you can see why dark skies are easy to find in Oz.

Herschel at the Cape

Imagine being the first person in the world to explore an entire sky with an 18-inch telescope. Imagine having that sky, among the darkest in the world, at your disposal every night from the backyard of your idyllic country estate, located in a warm subtropical climate. A dream for observers today, but from 1834 to 1838, it was how John Herschel spent his time, scanning the southern skies from South Africa. "Whatever the future may be," wrote Herschel, "the days of our sojourn in that sunny land will stand...as the happy part of my earthly pilgrimage."

To extend his father William's catalog of the sky, John, his wife Margaret and their three children packed their belongings and an 18.25-inch reflector telescope and sailed off to the Cape of Good Hope. The Herschels quickly became celebrated citizens of Cape Town's European colony, making the social rounds by day and exploring the sky by night. During this time, John Herschel discovered 2,100 double stars and more than 1,300 nebulas and clusters. In 1837, he recorded the rare explosive flaring of the star Eta Carinae as it briefly shone as one of the brightest stars in the sky.

The years at the Cape marked the height of Herschel's astronomical career. Back in England, he rose to such positions as Master of the Mint, but he rarely looked through a telescope again, and the 18-inch mirror sat tarnished in a cellar. "With the publication of my South African observations," concluded Herschol, "I have made up my mind to consider my astronomical career as terminated."

John Herschel's main instrument at his site near Cape Town, South Africa, was a "20-foot" telescope of 18.25-inch aperture slung in a crude altazimuth mount in open air. An equatorially mounted 7-inch refractor was housed in a small hut.

🔺 Carina Nebula

It's bigger than the Orion Nebula and more complex in its structure, making this the best emission nebula in the sky. At its heart lies the erratic star Eta Carinae.

▲ Gem Cluster

Jewel Box

The open cluster NGC3293 sits above the Carina Nebula in a field of nebulosity.

This collection of stellar gems, named by John Herschel, can be found next to the Southern Cross.

Lambda Centauri Area Here's another stunning field, containing the open cluster NGC3766, at top, and the IC2944 nebula complex.

◀ Football Cluster John Herschel called the open cluster NGC3532 "the most brilliant of its kind" he had ever seen.

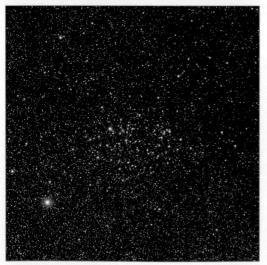

The Great Southern Sky

Below a declination of -50 degrees, the far southern sky contains showpiece objects that are the best in their class: the finest nebulas, open clusters and globular clusters. Add the wonderful Magellanic Clouds and the full sweep of the Milky Way, and you have a sky that beats the north for spectacle. All northern astronomers should make a southern pilgrimage.

47 Tucanae 🔻

Not as large as Omega Centauri, this magnificent globular cluster is still considered by many to be the finest in the sky. It is like looking into a tunnel of stars. A must-see!

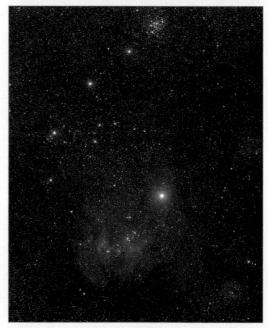

All the objects on this page and many other superb southern-sky sights are ideal targets for binoculars or a small 66mm-to-90mm telescope.

check the Australian Bureau of Meteorology website (www.bom.gov.au).

For the driest, clearest skies within easy driving distance of Sydney or Brisbane, head over the Great Dividing Range, which runs along the eastern coast, to sites away from coastal humidity and in the Central West or New England districts of New South Wales or in southern Queensland. Sites north of Melbourne, toward the Riverina-Murray River country, and north of Adelaide, in the Flinders Ranges, are also superb.

In these areas, you'll find annual star parties, such as the Arkaroola Star Party (Jan./South Australia), South Pacific Star Party (Apr./near Mudgee, NSW), Border Stargaze (Aug./near Albury, NSW), Queensland Astrofest (Aug./Linville), IceInSpace Astrocamp (Oct./Hunter Valley, NSW) and the Vic-South Star Party (Nov./near Nhill, Victoria). Just Google the star-party name to find a link.

A favorite destination in Oz is Coonabarabran (www.coonabarabran.com), the small town on the Newell and Oxley highways that bills itself as the "astronomy capital of Australia," and for good reason. Australia's major optical-telescope complex, the Siding Spring Observatory, is just down the Timor Road, and the skies can be spectacular. "Coona" is where we usually spend most of our Oz observing time.

WHEN TO GO

Try to arrange any business trip or personal vacation so that you can be away from city lights at new Moon. If you have a choice, by far the best time to travel Down Under is February to April, late summer and early autumn in the southern hemisphere. The Magellanic Clouds are up in the early evening, the Milky Way through Vela to Centaurus peaks in late evening, as the spectacular center of the galaxy rises, shining directly overhead by dawn. You see the full sweep of the southern Milky Way and the best of what the Austral sky has to offer. Go in October to December, and you see the Magellanic Clouds and Carina-Crux well but not the central Milky Way in Sagittarius and Scorpius. Go in June to August, and you see the center of the galaxy on cold winter nights, but the Magellanic Clouds swing low along the horizon.

While you might think of Australia as the sunburned land wracked by drought (it is), it can still be cloudy at night. We've been clouded out, even rained out, for a full week on some trips. Rain not seen in months starts the day astronomers arrive! On most trips to Oz, we've averaged about 50 percent clear nights. To maximize your chances for a serious observing trip, our advice is to allow two full weeks at a dark site if you can and

▲ Big Dob Down Under Attend a star party Down Under, and you'll be treated to some jaw-dropping sights. Be sure to ask someone to show you the Homunculus Nebula!

Magnificent Milky Way Taken in April, this wideangle panorama records the full sweep of the southern Milky Way, from Puppis and Vela in the west, at right, through Carina and Crux, high in the south above the south celestial pole, to the rich star fields of Norma. Ara, Scorpius and Sagittarius rising in the east, at left. In the Austral autumn, the Magellanic Clouds swing below the pole, above the treetops. Both photos by Alan Dyer.

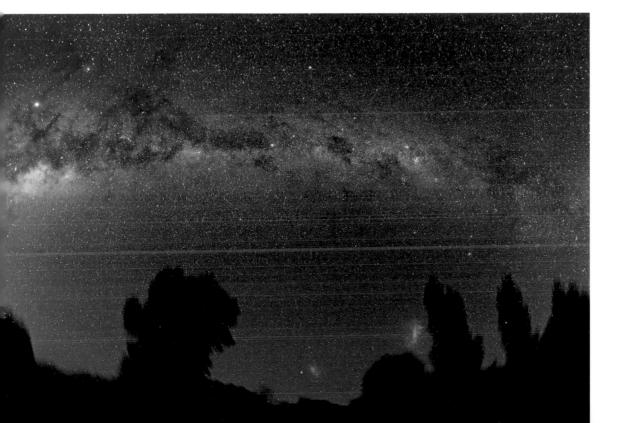

Large Magellanic Cloud 🕨 If the southern sky contained no new object other than the Large Magellanic Cloud, it would still be worth the trip south. Within a field just a few degrees wide, dozens of nebulas and clusters pepper this companion galaxy to the Milky Way. Among them, the massive Tarantula Nebula (NGC2070), at left, is visible to the unaided eye despite the fact that it's in another galaxy 160,000 light-years away. All photos on these pages taken from Australia by Alan Dyer.

Look Up, Way Up! 🔻

From 30 degrees south, the center of our galaxy passes overhead, its symmetrical spiral arms spanning the sky. You see it as the grand edge-on galaxy it really is, one of the finest sights the sky has to offer. arrive before the Moon gets out of the way. This will give you starter "shoulder nights" to check out your gear and get familiar with the sky. Remember, it's like starting over!

WHAT TO TAKE

You'll want a good book of simple seasonal star maps. Just identifying stars and con-

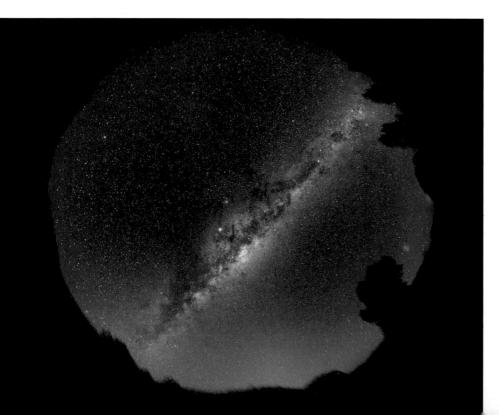

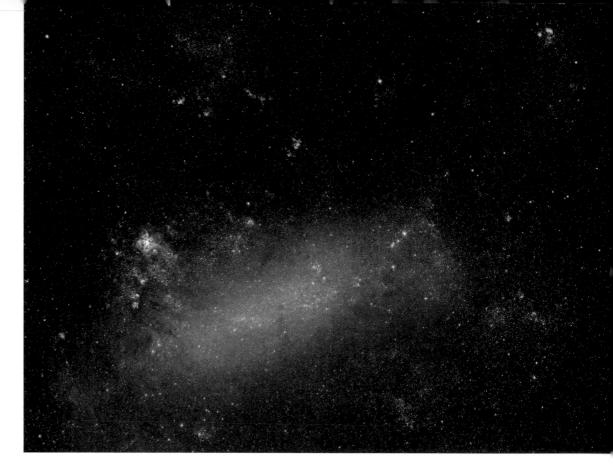

stellations requires going back to basics, with "star dome" charts, such as those in magazines or introductory guidebooks, or a planisphere for the southern hemisphere.

If you want to search out binocular and telescope targets, your favorite star atlas will cover the entire sky but may not list selected targets for those few nights you'll have under foreign skies. For that, the best guidebook specifically for the southern sky is *The Atlas of the Southern Night Sky* by Steve Massey and Steve Quirk (New Holland Publishers, 2007). The Royal Astronomical Society of Canada's *Observer's Handbook* also contains an excellent list of southern-sky "greatest hits." Using these references, you can arrive with an organized list of targets.

Take at least binoculars. Many southern splendors are large and bright enough to show up well in binoculars. The next step up would be a 66mm-to-80mm refractor on a light but solid tripod with a smooth pan head or a small altazimuth mount. All you need are two eyepieces: a low-power 20mm to 26mm and a higher-power 6mm to 10mm. But don't forget the star diagonal! While an equatorial mount and drive are not essential, a small GoTo mount is wonderful to have if you want to be really productive and see lots in a short time. (Even post-9/11, we have had no problem taking telescope gear through airport security.)

Now consider how much you can take. The weight limit for economy air travel is tight: typically, 50 pounds per bag for checked luggage and often as little as 15 pounds for carry-on. Telescopes advertised as "airline portable" may not be so under current regulations. Tripods tend to be the heaviest and most awkward items to pack. Cameras and lenses can add up fast, so rethink how much gear you really need.

TRAVELING THE OTHER WAY?

Of course, if you are a resident of the southern hemisphere, you already know about the wonders of the Austral sky. What you want to see are the mythical sights of the northern sky you read about in every astronomy book, the objects that are low or below your northern horizon. The Andromeda and Whirlpool Galaxies are your exotic targets. If you plan to head north, the best locations in North America are Arizona, New Mexico and Texas, where major observatories, astronomy resorts and star parties give you access to big scopes. The best time is either March to May, if you are seeking northern galaxies, or September to November, if you want the clusters and nebulas of the northern Milky Way from Cygnus to Auriga. June to August tends to be the rainy period in the American Southwest.

No matter where you live, if you think you have seen it all from your hemisphere and are considering spending \$3,000 or more on a new telescope, think, instead, about spending the money on a trip to the other side of the world. Step out under alien night skies, and when you look up and realize you don't recognize a thing, you'll break out in a big smile!

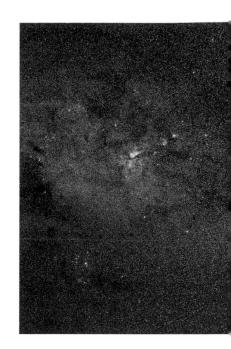

▲ Carina and Clusters The deep southern Milky Way contains one of the most remarkable fields for binoculars, with the huge Carina Nebula flanked by a diverse array of bright star clusters. While this area can be sighted from Hawaii and the Florida Keys, only from south of the equator does it rise high into the south for the best view.

◀ To the Galactic Core With this area high overhead, the dark lanes around the core of our galaxy in Scorpius and Sagittarius stand out so well, they lend a three-dimensional appearance to the Milky Way. Several nights of scanning the depths of the galactic center will reward you with vistas guaranteed to leave you wanting to travel Down Under again and again.

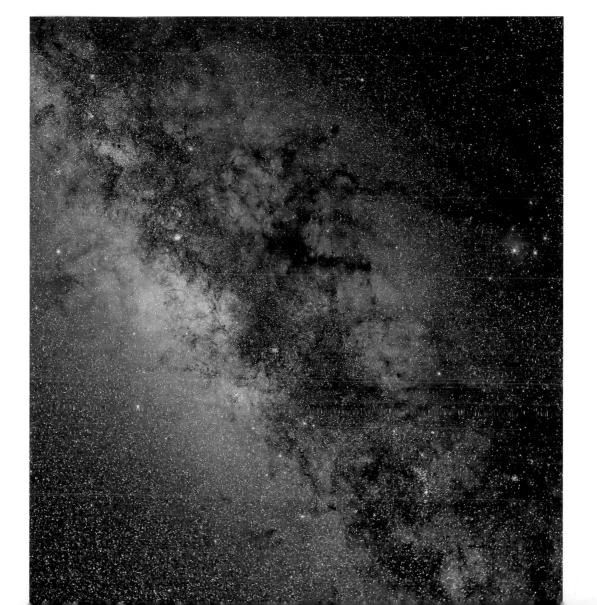

PART 3: ADVANCED TIPS AND TECHNIQUES

C H A P T E R T H I R T E E N

Digital Astrophotography

Film is dead. OK, we said it. If you are one of the few diehards still shooting film, congratulations on upholding a tradition. Unfortunately, keeping tradition alive is the only reason to still shoot film. Digital is better in almost every way, certainly when shooting the night sky, the hobby within a hobby called astrophotography.

We all saw the revolution coming. Back in the early 1990s, the laughably crude CCD astrocameras of the day produced equally crude results. But those 0.1-megapixel cameras were like the tiny mammals scurrying under the feet of the long-lived dinosaurs. One day, their descendants would take over the world.

> That day has come. So this chapter is all about how to use digital cameras to shoot the night sky. There are many types, but we focus on one style of camera that has completely changed the way we take images of the sky: the digital SLR camera.

Everything we see in the sky can be captured. The lure of astrophotography (we'll call it that even when done digitally) is its ability to pick up rich colors in objects that look black and white to the eye, as in this 8-minute exposure of the Lagoon and Trifid Nebulas. Photo by Alan Dyer using 77mm f/4 Borg apo refractor and modified Canon 5D

DSLR camera.

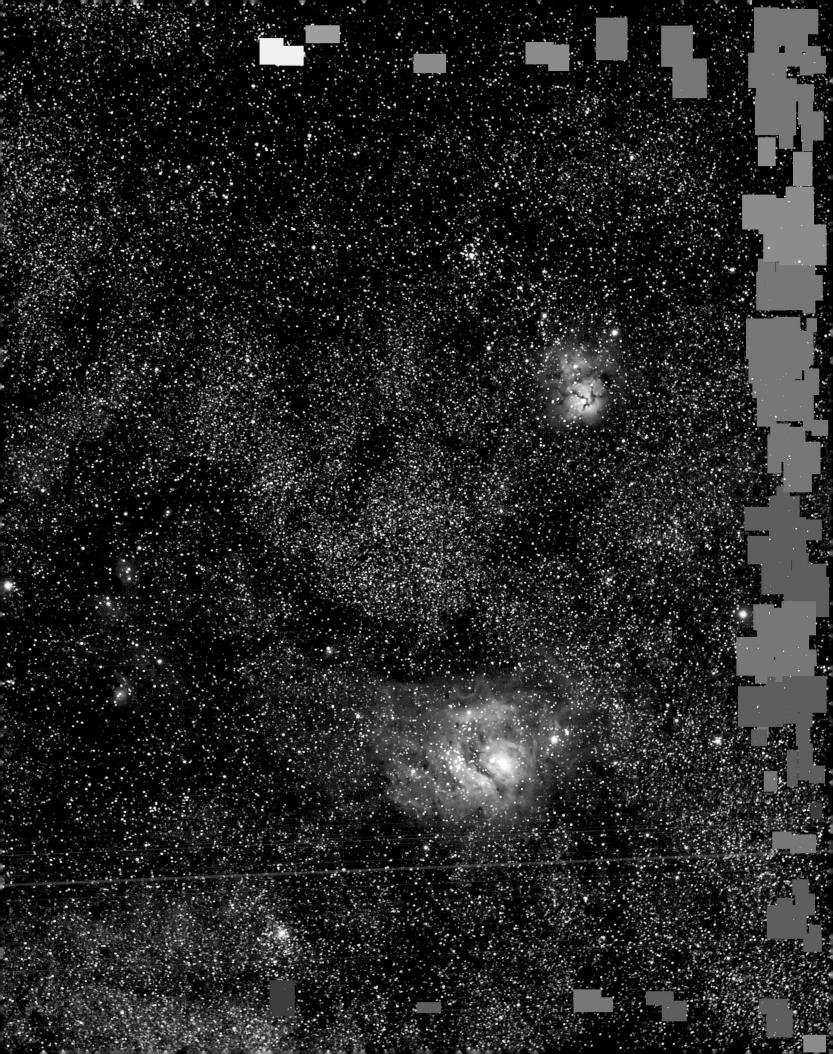

Film vs. Digital, Part 1 Both moonlit night shots of Lake Louise, in Alberta, were taken at ISO 100 for equivalent exposure times. Yet the digital image reveals far more in the

.m Digital

shadows, dim details film just isn't picking up. Digital cameras aren't faster than film (the bright areas here look similar); they simply do a better job converting photons into images.

Film's Last Stand 🔺

Long single exposures of star trails are the one area where film still works well, as revealed in this 6.5-hour shot on ISO 100 slide film. Ultralong exposures push, if not exceed, the noise limits of DSLR cameras.

The DSLR Revolution

In the previous edition of this book, we dismissed digital single-lens-reflex (DSLR) cameras as overpriced and offering no performance advantage for astronomy. How rapidly things changed! Within a year of the book's printing in 2002, Canon had introduced cameras that really worked, like its breakthrough 10D. Long exposures looked great. Faint nebulas that used to take an hour to pick up with film were recorded in just five minutes. Wow!

Users of specialized digital cameras made for astronomy (called CCD cameras, for the light-sensitive charge-coupled device chips they use) were long familiar with the ability of electronic sensors to record faint subjects far faster and better than film. But the learning curve for those cameras remains a steep one. By contrast, a DSLR works like a camera should—coming from decades of shooting film, we already knew how to use one.

Here was a camera you could buy in the local camera store that would shoot vacation snaps by day yet capture the colors of the Orion Nebula by night. Digital SLR cameras have democratized astrophotography, making it possible for anyone with determination to take publication-quality images of the sky.

Sure, there are other low-cost digital cameras out there specifically for shooting nebulas and galaxies. The beauty of DSLRs, however, is that they can be used to photograph any astronomical subject, from fisheye shots of sky-spanning auroras to telescopic close-ups of deep-sky objects. They can do this without computers, tangled cables and outboard power supplies, without having to learn to use complex control software and without the bewildering overhead of dark frames and flat-field exposures required by specialized CCD cameras.

We're both sold on DSLR cameras, each having now owned a few generations of models. Because of their versatility, ease of use and image quality, we're concentrating on DSLRs as the best of many available technologies for backyard astronomers who would like to capture images of the night sky. Even so, we recognize that other types of cameras stand out for specialized applications-webcams for shooting the planets, for example. But it is the DSLR camera that now dominates the field. For anyone wanting to shoot all that the sky has to offer, a DSLR is by far the best choice. In fact, you may already own one. If so, a few simple accessories and helpful tips are all you need to start a lifetime of astronomical photography.

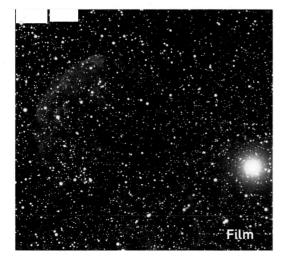

Buying a DSLR Camera

We'll be blunt. If you are thinking about purchasing a DSLR camera for astrophotography, buy Canon. Yes, we know you've collected a suite of Nikon or Pentax lenses. No matter. Buy Canon. Quite simply, no other camera manufacturer has matched Canon for image quality during long time exposures. Canon cameras consistently offer lower noise and freedom from image artifacts (oddly colored stars, stars blurred by overly aggressive noise reduction, random dark pixels, edge-of-frame glows from warm electronics) that plague other brands. Long-exposure images from Canon DSLRs are cleaner and smoother; the company simply pays greater attention to reducing noise and other problems that appear when exposures go over a minute or so in duration. For this reason, published camera tests often fail to pick up the differences in brand performance that become obvious only in long-exposure images of the night sky.

Recommending one brand over all others in a volatile market may be risky. It's possible that Canon could take a turn for the worse while some other brand shoots ahead and becomes the camera of choice. However, nothing we've seen in several years of DSLR evolution, and certainly nothing we've experienced in our own side-by-side testing, has suggested Canon might forfeit its edge. But Nikon is catching up, with 2007

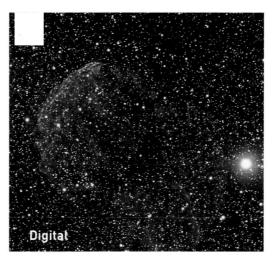

models such as the D300 beginning to match Canon for noise performance.

So what to do with all those non-Canon lenses? In many cases, adapter rings are available to allow Nikon, Pentax, Olympus and other brands of lenses to fit onto Canon EOS camera bodies. Non-Canon lenses must be used in purely manual mode, but for astrophotography, that's how we use lenses anyway. Or you'll do what author Dyer did the day after he took his first night-sky shots with a Canon DSLR: pack up 30 years of accumulated Nikon film cameras and lenses and get what you can for them at the local used-camera store. As of that day, film was well and truly dead.

WHAT'S INSIDE

Having touted Canon, we should be quick to point out that any brand of DSLR will work very well for short-exposure astrophotography. Many subjects—twilight scenes of conjunctions, moonlit nightscapes, displays of auroras and telescopic views of the Moon and planets—can be captured in exposures well under a minute, if not in quick snapshots. All brands work well for these short subjects. And there's enough of those subjects to occupy an astrophotographer for many years, if not a lifetime. But it's long exposures of colorful nebulas and star fields that tempt many into the hobby, and that's where Canon takes the lead.

At this point, many aspiring astrophotographers may wonder whether their compact point-and-shoot cameras would work as well. After all, it might be an ◀ Film vs. Digital, Part 2 On the left is a shot of the nebula IC443 taken on Kodak Supra 400 film. On the right is the same object captured with a Canon 20Da DSLR at ISO 400. The digital shot picks up more detail, with tighter stars and less "grain." But the big difference? The film shot is an 80-minute exposure; the DSLR took just 15 minutes.

▼ Comparing Cameras In side-by-side tests we've conducted over the years (such as this shoot-out among the Canon 400D, Nikon D80 and Pentax K10D), Canon has always come out the winner for low noise and artifact-free images in long exposures.

Sensor Sizes ► As of 2008, Canon and Nikon both offered DSLRs with full-frame chips the size of 35mm film frames (24mm x 36mm). However, most DSLRs feature smaller APS-sized chips (15mm x 22mm), which are more affordable and demand less of lens and telescope optics.

Point-and-Shoot vs. DSLR V It's noise city in this 30-second exposure (left) at ISO 400 taken with a goodquality point-and-shoot camera. There's no detail in the shadows, and few stars recorded. In the same exposure taken with a DSLR camera (right), we see stars, clouds and lots of detail in the shadows.

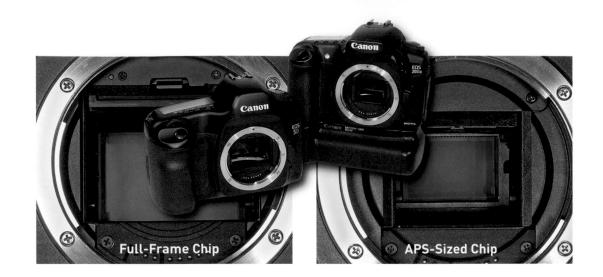

8- or a 10-megapixel camera, the same as a costly DSLR. The quick answer is no.

Understanding why requires knowing what's inside your camera. What we call point-and-shoot cameras all have fixed lenses—they may zoom, but they do not detach. The camera is a sealed unit. Light from the lens is directed straight onto the sensor chip, which feeds the display at the back of the camera, giving a constant electronic live view of what the camera is seeing.

By comparison, digital SLRs have lenses that can be changed, providing the option for using ultrawide or supertelephoto lenses or high-grade fixed-focal-length (i.e., nonzoom) lenses. Light from the single lens is directed not to the sensor but to a reflex mirror that reflects the light to a focusing screen, thus the term "single lens reflex." It is the image on this screen that you see when you look through the optical viewfinder. The sensor is covered by the mirror and shutter, protecting it from dust and damage when you remove the lens. In normal use, the sensor receives light only when you take the shot—fire the shutter, and the mirror flips up while a shutter in front of the sensor opens, allowing light to hit the sensor.

POINT-AND-SHOOT VS. DSLR

OK, that's how a point-and-shoot differs mechanically from a DSLR. But there's also a big difference in the sensor chips used. To keep the point-and-shoot compact, its chips are tiny, typically just 4 by 5 millimeters across. By contrast, the chips in many DSLRs are 15 by 22 millimeters. And yet a point-and-shoot camera still packs 8 to 10 million pixels onto its diminutive chip, the same number as in a DSLR. What gives?

What gives is the size of the individual pixels. In a DSLR, the pixels are typically 5 to 8 microns across (1 micron = 1/1,000 millimeter). That's small, but to cram 8 to 10 million pixels onto its tiny chip, a typical point-and-shoot camera has pixels a mere 2 to 3 microns across, not much bigger than light waves. Pixels that small are bad news for astrophotography. Like a small-aperture telescope, a small pixel can't gather as much light—accept as many photons—as can a big pixel. What photons are recorded and turned into a signal of electrons tend to be swamped by noise created by the unwanted random electrons milling about in any digital sensor. In a DSLR, the bad noise elec-

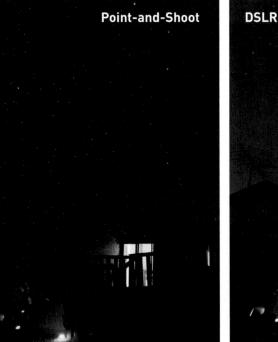

trons are there but are outnumbered by the good electrons generated by the light. We say that the images in a DSLR have a higher signal-to-noise ratio.

During the day, when there's lots of light to go around, a point-and-shoot camera works great. But at night, when photons are scarce, the differences become painfully obvious. Long-exposure images from a pointand-shoot are peppered with a blizzard of colored noise specks. Images from a DSLR look smooth and clean, all because the DSLR has larger pixels, each gathering more light during the exposure. The upshot is that despite an apparent similarity in megapixel counts, the point-and-shoot camera simply does not work as well as a DSLR for long-exposure astrophotography. In fact, it doesn't work at all.

DSLR CAMERA CHOICES

Camera models change rapidly, each typically having a market lifetime of only 12 to 18 months. So it is impossible for us to recommend specific models here. Should you opt for a used DSLR, consider nothing less than the Canon 20D or Rebel 350XT. Introduced in 2004 and 2005, both are 8-megapixel cameras that perform superbly for astrophotography. Since their introduction, no camera has offered significantly lower noise levels despite advances in features and increasing megapixel counts.

The Canon model that offered something better, though at a much higher price, was the 5D, providing 13 megapixels in a chip the size of a 35mm film frame, 24mm by 36mm. Other lower-cost Canons have what are called APS-sized sensors, chips 15mm by 22mm, the size of a frame in a now defunct film format called Advanced Photo System that was promoted just before digital took off. Most Nikon, Pentax and Sony DSLRs use similar-sized APS chips.

A full-frame camera, like the Canon 5D and 1Ds models and Nikon's D3, provides a wider field of view with any lens or when attached to a telescope. The bigger chip records more sky. But it also ruthlessly records every aberration a lens or telescope optic might have, flaws that often show up only at the corners of the frame, distorting stars into flared or colorful seagulls. A fullframe chip camera must be mated to superb

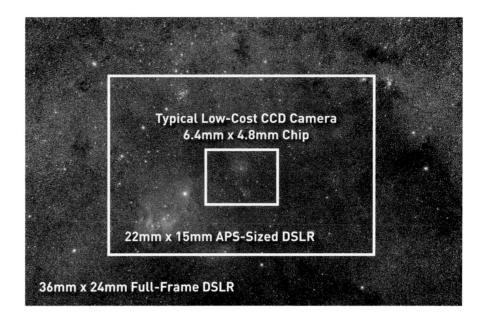

optics with flat fields, requiring telescopes designed for deep-sky imaging or capable of being fitted with field-flattener lenses. For most people, an APS-sized camera will be the most practical and affordable.

As of early 2008, by far the best buy for features versus price was the midrange Canon 40D, a 10-megapixel camera. However, the lower-cost Canon Rebel Series (as it is called in North America) offers excellent cameras at an entry-level price. In the Nikon line, the 12-megapixel D300 performs much better than all earlier models. Stepping above the midrange price takes you to a full-frame chip camera. This step should be taken only if you have the quality optics to feed it and the budget to pay for it. Otherwise, \$700 to \$1,800 will get you an entry-level to midrange DSLR capable of taking publication-quality images.

▲ Fields of View

The benefit of a bigger chip is a wider field with any given lens or telescope. Entry-level CCD cameras have tiny fields compared with even APS-sized DSLRs.

CCD vs. DSLR

In same-night tests, a DSLR (a Canon 20Da) picked up a nearly identical level of detail, faint stars and galaxies as did a cooled CCD camera (an ST-402). Both are 8-minute exposures, although the CCD needed three, through its red, green and blue filters.

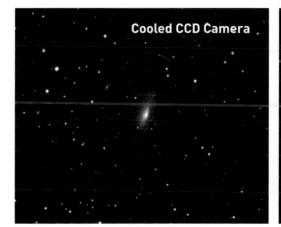

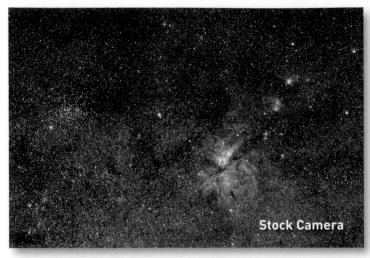

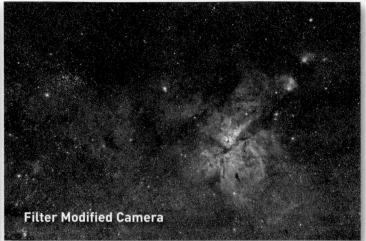

Stock vs. Modified A As these comparison shots of the Eta Carinae Nebula show, a stock DSLR does a fine job recording deep-sky objects. But the deepest images come from cameras that have been filtermodified to boost their sensitivity to the red hydrogen-alpha wavelength. A modified camera picks up faint nebulosity to which a stock camera is blind.

Low-Cost Imagers Cameras like Meade's DSI or Orion's StarShoot provide a good introduction to the techniques of advanced CCD imaging, but for image quality, chip size and megapixels for the dollar, a DSLR is hard to beat for value.

STOCK VS. MODIFIED

No matter what price level you choose, another option presents itself: Do you get a stock camera you can buy at your local camera shop or a modified camera? In a modified, or spectrum-enhanced, DSLR, a third-party company (for example, Hutech Scientific in the United States or KWTelescope in Canada) has improved the camera for astrophotography by extending its sensitivity to deep red, where hydrogen gas emits much of its light. This allows the camera to record faint nebulosity, which is mostly hydrogen, far better than can a stock camera, regardless of the exposure time.

To modify a DSLR, the dealer replaces the standard infrared cutoff filter in front of the sensor with a filter that passes more light deeper into the visible red end of the spectrum while still blocking infrared light that does not focus properly. (In 2005, Canon offered briefly the 20Da, a specialized camera equipped with such an Halpha-pass filter as a factory feature out of the box. Sometimes available on the used market, a Canon 20Da is a superb camera for any astrophotography without compromising daytime shots.)

Third-party modified cameras provide images that are tinted pinky red. While this can be corrected after the fact, a modified camera is not a good choice if you intend to use it mainly for normal daytime shooting. But if you want a camera first and foremost for deep-sky imaging, we highly recommend a modified Canon. We both use one and would not shoot deep-sky targets without it. It makes all the difference between a decent shot and a fabulous one.

Buying Lenses and Accessories

The standard DSLR kit lens works well for many camera-on-tripod subjects, such as twilight scenes, eclipses and auroras. But you'll soon find yourself wanting a wider range of focal lengths, from extreme wideangle lenses to longer telephotos. Another limitation of kit zooms is the focal ratiomany are slow f4 to f5.6 lenses, fine for bright scenes but a tad slow for nightscapes, constellation portraits and tracked piggyback shots, where a faster f2 or f2.8 lens is ideal. We prefer fixed-focal-length lenses, as star fields represent the severest test of any lens. While we tend to stick with Canon lenses, we've found favorites in the Sigma line, such as its 8mm and 15mm fish-eyes.

A must-have is a remote shutter release. A simple switch unit (about \$35) will suffice. But note that the lower-priced cameras in the Canon and Nikon lines use a different style of connector than the main line of DSLRs. We recommend an interval timer, like Canon's TC-80N3 or Nikon's MC-36 (\$200). These units fire a series of exposures of any length and interval you set. They are excellent for unattended deep-sky shots and time-lapse shooting. Unfortunately, they are not available in versions that fit the lowest-priced Canon and Nikon cameras.

Another essential need is power. Get extra batteries or an AC power supply that replaces the battery. Hutech offers an adapter that will run a Canon DSLR from 12-volt DC power; 12-volt adapters for other cameras must be homemade.

Accessory Kit

We recommend a remote shutter release with a simple switch (front right) or a programmable interval timer (front left), a rightangle magnifier focuser (back right) and a dualbattery pack (back left) for extended life in the field. An AC power supply is the better choice for shooting all night at sites with power. Don't forget the memory card! Its cost keeps coming down even as storage capacity goes up.

Zoom vs. Fixed Lens Note the comatic star images (top) in the corner of a frame taken with a highquality 16mm to 35mm Canon L-Series zoom lens shot wide open at f2.8. The same field shot with a fixed 35mm L-Series f1.4 lens stopped down to f2.8 (bottom) shows near pinpoint stars to the corners. The fast f1.4 and f2 apertures grab lots of detail in short exposures, such as untracked tripod shots of the Milky Way. Other favorite lenses are Canon's 135mm f2 and 15mm f2.8.

 00
 ■
 ■
 ■
 ■
 ■
 ■
 ■
 ■
 ■
 ■
 ■
 ■
 ■
 ■
 ■
 ■
 ■
 ■
 ■
 ■
 ■
 ■
 ■
 ■
 ■
 ■
 ■
 ■
 ■
 ■
 ■
 ■
 ■
 ■
 ■
 ■
 ■
 ■
 ■
 ■
 ■
 ■
 ■
 ■
 ■
 ■
 ■
 ■
 ■
 ■
 ■
 ■
 ■
 ■
 ■
 ■
 ■
 ■
 ■
 ■
 ■
 ■
 ■
 ■
 ■
 ■
 ■
 ■
 ■
 ■
 ■
 ■
 ■
 ■
 ■
 ■
 ■
 ■
 ■
 ■
 ■
 ■
 ■
 ■
 ■
 ■
 ■
 ■
 ■
 ■
 ■
 ■
 ■
 ■
 ■
 ■
 ■
 ■
 ■
 ■
 ■
 ■
 ■
 ■
 ■
 ■

35mm Fixed-Focal-Length Lens

Jargon Guide: DSLR Camera Specs

Bayer Array

The pixels in a DSLR are each covered by a tiny red, green or blue filter arranged in a Bayer array (right), named for Kodak's Bryce Bayer, who invented the system. Each pixel records a monochrome but filtered image. To create a color image, the camera determines what color each pixel should be by taking its data and blending it with the data from the surrounding pixels. This decoding is called de-Bayering.

Dark Frame

Most DSLRs have a Long Exposure Noise Reduction option. When it is turned on, the camera takes a second exposure with the shutter closed that is equal in length to the actual exposure. This dark frame records nothing but noise, which is then subtracted from the main exposure, thereby eliminating much of the speckly noise in long exposures.

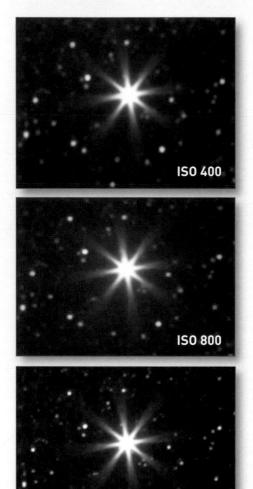

ISO Speed

Films are rated by their International Standards Organization (ISO) speed: an ISO 400 film is four times as fast as (i.e., required one-quarter the exposure time of) an ISO 100 film. DSLR cameras can be set to boost their sensitivity using similar ISO settings. Higher ISO settings record objects in shorter exposure times but at the expense of increased noise, as the series of images at left demonstrates. Each is a blowup of a section of a frame taken at a different ISO setting. The ISO 1600 image shows much more noise.

JPEG or JPG Images

A file format set by the Joint Photographic Experts Group compresses image data to reduce file sizes. It inevitably throws away some data.

Low-Pass Filter

DSLR sensors are covered by a filter that blocks infrared light. Another filter performs an "anti-alias, low-pass" smoothing of image detail to eliminate the jagged edges of the square pixels.

Megapixels

A chip with an array of 3,500 by 2,300 pixels has just over eight million pixels, or 8 megapixels. In theory, the more pixels, the greater the detail.

Micron

Pixel size, or pixel pitch, is given in microns (1 micron = 1/1,000 millimeter). The pixels in a typical DSLR range from 5 to 8 microns across. While small pixels provide sharper detail, large pixels provide lower noise, because they can collect more light photons.

Pixel

ISO 1600

Each photosensitive element in a digital sensor is more correctly called a photosite but tends to be referred to as a pixel.

RAW Images

DSLRs can also be set to record images in RAW format, retaining the pure full range of monochrome data untouched by compression, de-Bayering or any color correction. The RAW file is then de-Bayered in later processing with software such as Adobe Camera Raw or specialized programs for astronomical image processing.

Focusing a DSLR

Focusing during the day is easy: Just switch on the auto-focus, and press the shutter button down. The camera takes care of the rest. At night on the sky, the task is not so simple. Except for twilight scenes, a camera rarely finds enough to focus on. Without proper focus, the camera may not even allow a photo to be taken. The only solution is to switch the lens to manual focus. In the old days, before auto-focus lenses, you simply rotated the lens all the way over to infinity and you could be sure the lens would be in focus for the sky. But today's autofocus lenses focus past infinity, and the infinity mark itself may not be the point of best focus for the sky.

Not only do lenses need to be focused manually, but focusing must be done *very* precisely. If focus is off by even a hair's breadth, stars can look soft and bloated or surrounded by cyan or magenta halos caused by chromatic aberration inherent in all lenses. Good lenses will deliver colorfree star images, but only in precise focus.

With the camera fitted to a telescope's focuser, perhaps for Moon shots, the image can look dim and coarse, making it hard to judge where the point of best focus is. What's the solution?

Right-angle magnifiers from Canon, Nikon and third-party suppliers like Hoodman and Seagull help a lot. Their 2x power makes it easier to judge focus, and the rightangle viewing allows more comfortable sighting through a camera on a telescope. The best technique is to focus on a bright star first, rather than on the Moon or a planet. Rocking the focus back and forth blows the star up in size on either side of focus, allowing you to home in on the midpoint of best focus. Take several trial-anderror shots, then zoom in on playback to judge whether the focus improves or worsens at different focus settings.

The market offers some alternatives for shooting through a telescope. Stellar Technologies sells the Stiletto, a form of knifeedge focuser that you put in place of the camera, focus, then replace the camera on

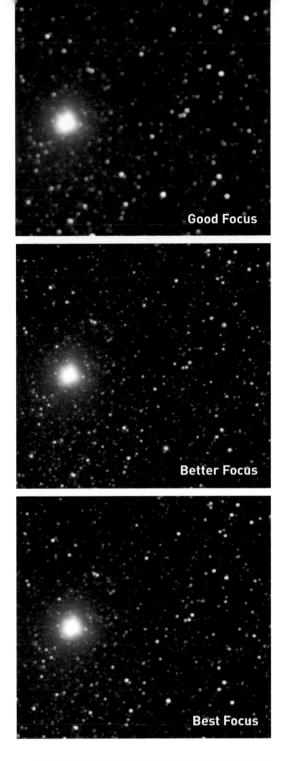

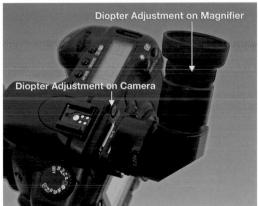

Good, Better, Best

The difference in focus between each of these telephoto-lens shots is about the smallest amount you can turn the lens, yet look at the results. The image at top is definitely soft. The middle one is sharp, but the stars are surrounded by a chromatic-aberration halo. The bottom image nails focus, with stars pinpoint and neutral in color.

Focus Point

While all auto-focus lenses have an infinity setting, it is rarely the point of sharpest focus on distant targets. With this lens, the point of best focus is just InsIde infinity.

Looking Sharp

A magnifier finder can help precise optical focusing through the viewfinder. But first, tweak the diopter adjustment on the camera for your eye, then turn the diopter adjustment on the magnifier for the sharpest image. Only then should you focus the lens or the telescope.

Setting a DSLR Camera for Astrophotography

In addition to setting exposure time, shutter speed and ISO speed, DSLRs offer a number of other settings never seen in film cameras.

File Format

All DSLRs offer a choice of saving images in either the compressed JPG file format or the RAW format (spelled in uppercase, although it doesn't stand for anything) or both at once. The JPGs can be saved in a choice of image sizes (L, M and S here) and amount of compression (indicated by the jaggedness of the stair-step icon). Unless you are shooting time-lapse movies that you know will be reduced in size anyway, always shoot maximum size and minimum compression JPGs, if not RAW as well.

Long Exposure Noise Reduction

Turning on this option, usually found under Custom Function, forces the camera to take a dark frame after any exposure longer than 1 second. This doubles the time before you see the image displayed on-screen and are able to take another shot. Some cameras also have a High ISO Noise Reduction option, which introduces a smoothing filter to shots taken at ISO 400 or higher. On some cameras, this blurs stars, but on the Canon 40D, it reduces color noise (on JPGs only, not RAWs) without eliminating stars.

Image Parameters or Picture Styles

All DSLRs allow you to change the contrast, sharpness and saturation of any images recorded via a number of presets (Picture Styles, as Canon calls them) or by adjusting the parameters yourself. These do not affect RAW images, only JPGs. For astrophotos, we've found that contrary to what you might think, turning down the contrast and sharpness improves the image quality and ability to pick up faint detail in nightscapes. Try different settings before settling on a custom set.

Color Temperature

As a general rule, leaving the camera on Auto White Balance (AWB) works well. But to ensure consistency from frame to frame in a time-lapse series, for example, try setting the color balance to a fixed value for daylight illumination—typically, 5,200 Kelvins. While this setting is preserved in a RAW file, the color temperature and white balance can be easily altered when converting the RAW image, say, in Adobe Camera Raw. So if you get it wrong and have shot RAW, it's easy to fix.

Color Balance

Similarly, the color balance is normally left at a neutral value. But for shooting typical daytime shots with a filter-modified camera, where you must compensate for the abnormal red tint, try shifting the color balance to the blue end (the setting here worked for a modified Canon 5D) and the color temperature to a lower value, perhaps 3,000 Kelvins. Another option is to create a Custom White Balance by shooting a white card, as per the camera's instruction manual. Experiment to see what works for your camera. the telescope. It does work, but nailing focus is still a fuzzy judgment. Another option for Canon owners is the FotoSharp from KWTelescope in Canada. This attachment goes between the camera and the telescope and connects to the camera's autofocus circuitry. When the telescope is aimed at a bright star, the camera beeps when the star is in focus, just as it does when autofocusing. Users are happy with both accessories, but they work only on telescopes and are not practical for focusing lenses, say, in piggyback shots, where focus can be hardest to judge by eve.

To ensure precise focus in all situations, many turn to outboard computers and specialized focusing software, such as DSLR-Focus, ImagesPlus, MaxDSLR and Nebulosity (www.stark-labs.com). The computer repeatedly fires the shutter; images then download to the computer and display on the screen, along with numeric or graphical displays of the intensity of the star image. While this sounds like the most precise method, variations in atmospheric seeing cause the readout numbers to jump up and down. That, and the several-second delay from one image to the next, makes it hard to judge when the focus has truly peaked. Patience is required.

By far the best solution for all instances and subjects is a feature now becoming common on many DSLRs: live view. In this mode, the camera's LCD screen presents a live view of what the camera is seeing. You can zoom in on one small area, such as a bright star, and focus as you would if you were looking through a telescope eyepiece —just adjust focus until the star is as small and colorless as possible. Boosting the camera to a higher ISO and turning the lens aperture to wide open can help reveal the point of best focus. With many cameras, a video output allows this live-view signal to be sent to an outboard TV monitor for easier viewing on a large screen. Live view is fast and real-time-no waiting for images to download, no tedious iterations.

One final tip is to refocus throughout the night —falling temperatures cause optics to shift focus. You can nail focus yet still see soft stars in images taken later at night. This applies to telescopes and lenses. Wait for the gear to cool off before final focusing, then refocus every hour or two.

◀ Fine Focus

No matter how you get sharp images, a focuser with a fine 10:1 dual-focus speed, like this Feathertouch Starlight focuser, makes fine adjustments very easy. Every telescope designed for astrophotography should have a good focuser like this.

Stiletto Focuser

For cameras without live focus, this knife-edge-style Stiletto focuser from Stellar Technologies works well for telescopes. It replaces the camera body. Aim at a bright star, and you see a bright disk of light crossed by dark bands. When the bands disappear, the scope is focused.

◀ Focus by Computer Another method requires downloading images to a computer where a program, such as Cercis DslrLite, analyzes the image and plots numerical and graphic readouts of the star size. Focusing requires a slow, iterative process: Take a picture, examine, adjust, snap, examine, adjust.

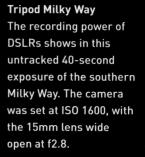

Techniques I: Tripod Subjects

If you can see it, you can shoot it. Even if you can't see it, you can shoot it! DSLRs are sensitive enough to record stars fainter than you can see with the unaided eye and to pick up the hazy band of the Milky Way. You can start your own atlas of the constellations with no more than a camera fixed to a tripod. Using equipment you may already own, you can capture awardwinning nightscapes. This is cameraon-tripod photography. Many beginners bypass this, convinced that telescopes and computerized tracking gear are essential for great astrophotos, but not so. What's needed is some creativity and basic photo skills.

РНОТО 101

Because most night-sky subjects are too dim to register on a camera's auto-circuits, think-and-shoot replaces point-and-shoot. To select the best combination of manual settings, you must understand a few basics.

The camera's shutter controls how long the light hits the digital chip. Double the exposure time (from 1/2 to 1 second, for instance), and you double the amount of light recorded. That much seems obvious, but there's another way to control light.

Like your own eye, a camera lens contains an iris that opens and closes to let in more or less light. Aperture is usually stated as a focal ratio, or f-ratio, a number that represents the focal length of the lens divided by the physical diameter of the iris opening. Focal ratios run in a standard series of numbers: f1, f1.4, f2, f2.8, f4, f5.6, f8, f11, and so on. The smaller the number, the wider the lens aperture, allowing more light to enter in a given exposure time. Each increment to a smaller number in the series (from f2.8 to f2, for example) doubles the amount of light allowed in, equivalent to doubling the shutter-speed duration. A combination of 1 second at f2 produces the same exposure as a shot taken for 2 seconds at f2.8, 4 seconds at f4 or 8 seconds at f5.6.

Another way to control light is by changing the sensitivity of the thing doing the recording. In the film era, that meant physically switching to another type of film. With DSLRs, you just change ISO settings. Doubling the ISO electronically boosts the signal coming from the chip by a factor of two, so a 1-second exposure at ISO 200 records the same image intensity as a 2-second exposure at ISO 100.

Now here's where your better judgment

comes in. Faster ISOs require shorter shutter speeds (usually a good thing) but result in a noisier picture, because amplifying the signal also turns up the noise.

SHORT SHOTS

When taking simple camera-on-tripod shots, a good time to start is in the morning or evening, when bright planets group together or line up in the twilight, sometimes joined by the crescent Moon. The kit zoom lens that came with your camera should work fine. Zoom the lens to frame the scene, and set its aperture to wide open (f2.8 to f5) and the camera to ISO 100 to 200. Try exposures of about 1 to 8 seconds.

▲ Going Manual

When shooting the night sky, all the multipoint autofocus and auto-exposure features are next to useless. Instead, we set cameras on manual and often the shutter on Bulb for shutter speeds that you, not the camera, determine.

Lens at f2

Aberrant Behavior

Opening up a lens to a wide aperture reduces exposure time and minimizes star trailing. But it often introduces distorted and blobby stars at the corners of the frame. Here, by stopping it down one stop to f2.8, this lens cleans up nicely. Doing so, however, meant doubling the exposure time from 15 seconds at f2 to 30 seconds at f2.8, allowing the trailing of stars from the sky's motion to begin to show up. Everything's a trade-off!

Long, Longer, Longest Wide apertures and fast ISO speeds are the combo for shooting constellations with a fixed camera (top). To record star trails, reduce the ISO to 100 (middle). To get really long star trails without washing out the frame from light pollution (bottom), stop the lens way down as well. This 80-minute shot pushes the limit for a single exposure with a DSLR.

80 minutes at ISO 100, f9

If a bright aurora materializes, grab your camera! Try a faster ISO 400 or 800 setting and exposures of about 5 to 30 seconds at f2 to f4. Short exposures will freeze the motion of the auroral curtains, while long exposures should pick up more of the subtle colors your eye might miss.

Exposures of 30 to 40 seconds will record constellation portraits or the passage of a bright satellite, like the International Space Station. At ISO 400, most DSLR cameras will pick up stars as faint as you can see with the unaided eye. Faster ISO 800 to 1600 settings will pick up even more stars, but with the inevitable increase in noise.

For a truly unique shot, pick a clear full Moon night and find a scenic spot well lit by moonlight (aim away from the Moon itself). Expose for about 30 seconds at ISO 400 and f2.8 to capture a scene that looks like daylight, but the blue moonlit sky will be filled with stars (see the shot of Lake Louise on page 274).

To shoot an unusual nightscape, try adding your own light. Use a flashlight or an electronic flash to paint the foreground or to backlight objects or artfully posed people. The instant feedback of DSLRs makes it easy to hone your light-painting artistry.

CAPTURING STAR TRAILS

You can put the Earth's rotation to work for you with long exposures, creating otherworldly scenes filled with colored streaks as stars trail across the sky. Star-trail photos were once the sole domain of film cameras, but on cool nights, many of today's digital SLR cameras can easily go for up to 60 minutes without the image degrading too much from noise. Set your lens to f4 to f8, use an ISO 100 setting, and open the shutter for anywhere from 5 minutes to ...? How long you can go depends on how dark your sky is, how cold the night (noise eases off with the cold) and how good the camera. Be sure to turn on the camera's Long Exposure Noise Reduction mode.

Another option is to use an interval timer. Take lots of 30-to-60-second shots in quick succession (no more than 1 second apart), then stack them in Photoshop using the Lighten blend mode to create a single long star trail. Startrails, a Windows program (www.startrails.de), automates the process.

Techniques II: Time-Lapse Shooting

DSLRs have made possible an entirely new area of astrophotography: time-lapse movies of the motion of the sky. These movies capture the rotation of the sky and the march of the constellations across the celestial sphere as they rise in the east and set in the west or turn in circles around the celestial pole. Movies bring waving curtains of auroras to life and reveal the slow rippling of noctilucent clouds.

The tool that makes this possible is an interval timer such as Canon's TC-80N3 (below). It can be set to take hundreds of exposures automatically, if need be, for as long as the memory card has room and the batteries have power!

To capture a movie of the night sky turning, a typical sequence would be 30-to-40second exposures at f2.8 and ISO 1600 (tor maximum stars), taken at intervals of one second—as soon as one exposure ends, another begins. Keeping the interval to a minimum produces the smoothest motion; longer intervals make the stars jump between frames. Basically, you use the same exposures that work for still shots. You're just taking a lot of them!

For shooting images you know will be turned into a movie, it's best to shoot JPG format images not RAW, to store as many frames as possible on one card.

GuickTime Player File Edit View Window Help	Animation Apple Intermediate Codec	HOUMES	P 40 1-1 € 0400 Wed 4267M Q
Consequent line as San Ar. Unified row Conservers	Apple Huler Video Apple VC H.263 BMP Cimppak Composer Video OV – PAL OVCHOLSO – NTSC OVCHOLSO – AL OVCHOLSO – AL Craphics H.261	Marie Eatrings	Nar I
Binne Bi	IPEC 2000 Motion IPEC A Motion IPEC B MPEC-4 Video None	B Automatic Generation Matabase	
ten ten seten op Shaa seten seten S		Canal De	

While the camera can be set to take images at a reduced size with fewer pixels, what often happens is that one frame is a keeper (perhaps because it contains a meteor). In that case, it's nice to have a high-quality full-sized original.

Once you have a folder of movie frames, all numbered in sequential order by the camera, the next step is to use software to link them together into a movie (we use Apple QuickTime Pro).

Making Movies

Apple QuickTime Pro can assemble a folder of images into a movie. Use Open Image Sequence (Step 1) to point to the first image in the folder. QuickTime asks (Step 2) for a frame rate (2 to 12 frames per second works well). It then makes a movie that you may need to export to play, to resize it smaller and compress it. Use Export and QuickTime Options to choose a frame size (Step 3; 1080 x 720 here) and a compression "codec" (Step 4; H264 here). The resulting movie should play back smoothly on any moderately fast computer.

Tripod Subject Exposures

Twilight Scenes 1 to 8 seconds, f2.8 to f5.6, ISO 100

.....

Auroras 5 to 30 seconds, f2 to f2.8, ISO 400

Constellations and Nightscapes 15 to 40 seconds, f2 to f2.8, ISO 800 to 1600

Star Trails layers of short constellation shots or single 5-to-60minute shots, f4 to f11, ISO 100

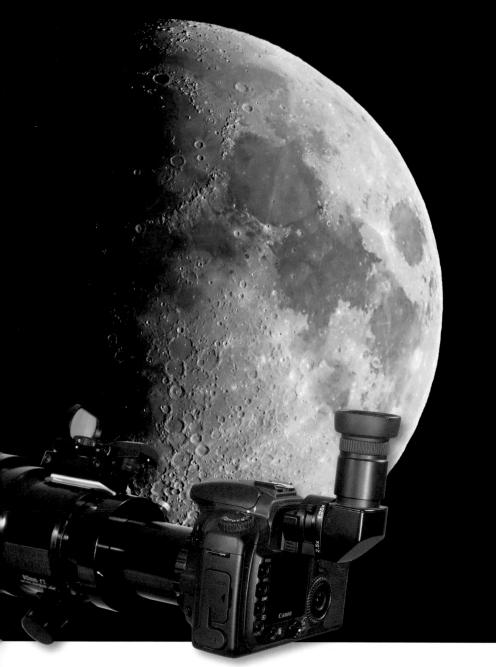

Prime-Focus Moon Removing the camera lens (possible only with a DSLR)

and coupling the camera body directly to the telescope is known as primefocus photography. With it, the telescope acts as a supertelephoto, ideal for close-ups of the Moon. This is a 1/50-second exposure at ISO 100 through a 5-inch apo refractor and 2x Barlow lens for an effective focal length of 1600mm and a focal ratio of f12.

Techniques III: Through the Telescope

If you want to fill your DSLR frame with the Moon, a telescope with a focal length of 800mm to 1200mm will do nicely. The key is a camera adapter, available from any telescope dealer. While there are adapters for afocal imaging with a DSLR with its lens in place, this is pointless. For the best image quality, remove the lens and attach the camera body to the scope via the basic adapter. Don't use any added extension tubes.

SHOOT THE MOON (AND SUN)

The same rig also works for the Sun, but you *must* have a safe solar filter fitted securely over the telescope's front opening.

When you try to focus, you may be in for a surprise—some Newtonian reflectors won't rack in far enough to allow the camera to reach focus. The usual solution is to move the primary mirror up the tube an inch or so or to replace the focuser with a low-profile unit, both significant modifications that may not be practical. The best advice when buying a telescope with photography in mind is to check with the dealer that it will, indeed, focus with a camera.

The Moon is bright, so ISO 100 works fine. Even then, exposures are not seconds or minutes but fractions of a second. After all, the Moon is a sunlit rock, one that just happens to be hanging in our nighttime sky. Exposures are so short, in fact, that you can shoot the Moon with any telescope which will accept a camera, even one without a motorized tracking system.

In the film days, we'd present a detailed table of suggested exposures here. But with a digital camera, just fire away and see what works. The right exposure will depend on the focal ratio of your telescope, the clarity of the sky and the phase of the Moon. Try 1/4 second for a thin crescent, 1/30 second for a quarter Moon and 1/250 second for a full Moon.

PLANET PORTRAITS

For shooting the planets or for close-ups of the Moon, we need more power! We get that power through an arrangement called eyepiece projection. That extra extension tube which came with the camera adapter is designed to hold an eyepiece that projects a magnified image onto the camera sensor. Using a typical 10mm to 20mm Plössl eyepiece, this type of projection setup can fur ther boost magnifications by four to eight times over what prime focus provides. With these levels of extreme magnification, you need a telescope with a drive that will track the sky and keep the object centered. Exposures for the Moon and planets are typically 1/4 to 2 seconds at ISO 200 to 800, long enough that the image will trail and blur without a tracking motor.

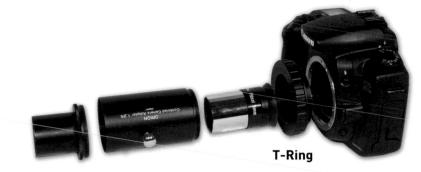

1.25-inch Prime-Focus Adapter

Eyepiece Projection Adapter

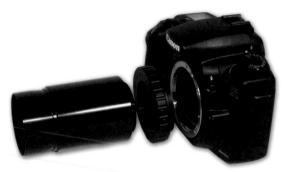

2-inch Prime-Focus Adapter

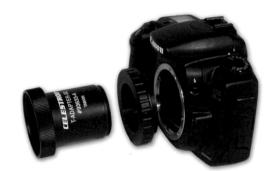

Schmidt-Cassegrain Adapter

Coupling Cameras Coupling a DSLR to a scope takes either a 1.25- or 2inch prime-focus adapter, depending on the focuser size. Many come with a projection adapter that allows an eyepiece to be placed in the path for high magnification. Schmidt-Cassegrains and Meade ETX scopes need a special adapter tube. All units require a cameraspecific T-ring to attach the threaded adapter to the camera lens mount.

Afocal Imaging with a **Point-and-Shoot**

While we are concentrating on DSLR cameras, owners of point-and-shoots aren't totally without astrophoto options. By aiming a pointand-shoot into the eyepiece of a telescope, it is possible to capture excellent portraits of the Moon. Called afocal photography, it can be done as simply as holding a camera up to the

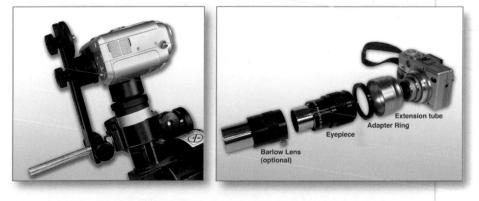

eyepiece, setting the camera on automatic and hoping for the best. But that's a little crude. A better method is to mount the camera securely to the eyepiece with either a clamp or a set of adapter rings that allows the camera to screw onto the eyepiece to form one solid unit. Scopetronix has traditionally been a good supplier of these rings.

Use a low-power eyepiece, then experiment with the camera's zoom settings to fill the frame and avoid dark corners or a vignetted tunnel effect. Focus the eyepiece by eye first, then attach the camera. Try auto-focus on the camera, or perhaps switch to macro mode. You may need to refocus the eyepiece, but the point-and-shoot's LCD screen live view makes focusing easy. Auto-exposure might work. If not, switch to manual settings—keep the aperture wide, and vary the shutter speeds. For the Moon, use an ISO 100 setting for the least noise.

Shooting through a telescope with a nonremovable-lens point-and-shoot camera can be done in two ways: A bracket clamps around the eyepiece (left) to position the camera looking into the eyepiece, or special adapters screw into threads around the camera lens (right) and onto the top of an eyepiece for a solid light-tight eyepiece-to-camera connection.

Working with Webcams

The main challenge when shooting the Moon and planets is the blurring effect of turbulence in our atmosphere. Astronomers refer to this atmospheric turmoil as bad seeing. To combat it, planetary photographers shoot movies, capturing hundreds of frames in the hope that some will be sharper than others. DSLRs can't do this. Instead, the tool of choice is the webcam.

State of the Art

Shooting Equipment

Webcams feed a video stream of 10 to 30 frames per second through a USB connection directly onto a computer's hard drive for recording. Yes, their 640-by-480-pixel chips are small, but they are ample to record the small disks of planets at high resolution. A popular webcam in the past has been the Philips ToUcam, but Celestron, Meade and Orion, whose Solar System Imager is shown above, offer planetary imagers (\$100 to \$200) fitted with the right nosepiece adapters. Higher-end cameras, from The Imaging Source and Lumenera (\$350 and up), for example, offer lower noise and faster frame rates. For the necessary magnification, a 2x to 5x Barlow is best.

Processing Planets

The real power of webcams comes from the postprocessing. The leading program is RegiStax by Cor Berrevoets (registax.astronomy.net). It's free! It can automatically analyze a movie, sort and select the sharpest of hundreds of frames, align and stack the frames to reduce noise, then sharpen the result for stunning images that are far superior to what any other technique can provide. It can also stitch a mosaic of smaller frames to create lunar panoramas. Learning to tune the program takes some time, but the results can rival Hubble Space Telescope views.

The secret to great webcam planets is to start with excellent seeing. Some of the best amateur planet images are taken at sea level, from sites with little to disturb the air as it flows over the land. The other key is sharp optics and enough aperture to ensure bright images, to keep exposure times down and noise levels low. The images below represent the best of what amateurs can achieve.

Webcam Images

Webcam images of Jupiter (left) and detail in the 95-kilometer-wide lunar crater Posidonius (middle) were obtained by Mike Wirths using an 18-inch Starmaster Newtonian. Mars webcam image (right) by Rolf Meier using a Celestron 14-inch Schmidt-Cassegrain. This level of detail far exceeds that of previous planetary and lunar imaging methods.

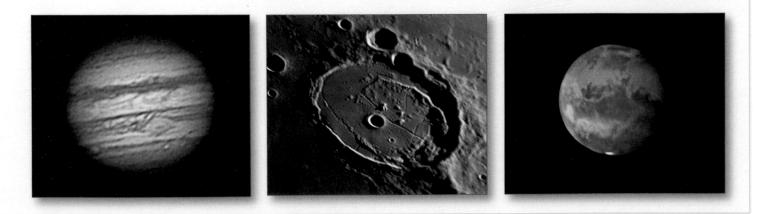

Selecting a Telescope and Mount

We're going to buck the marketing hype and suggest that if you want to get close-up images of colorful deep-sky objects, don't leap into big-aperture beasts like the 10-to-14inch Newtonians, Schmidt-Cassegrains and Ritchey-Chrétiens.Yes, people do use them to take marvelous images, but often only after years of dedication and self-denial.

Big scopes have long focal lengths, making precise polar alignment and tracking absolutely essential. Fork mounts can be hard to polar-align accurately in the field and tend to be bouncy when tilted over on an equatorial wedge (as they must be for long-exposure imaging). Photographers who use large reflectors often place them on costly heavy German equatorial mounts. Most people also need to travel to dark-sky sites. With that in mind, what we recommend for affordable deep-sky shooting is a short-focus 80mm to 100mm apo refractor on a high-quality but portable German equatorial mount. This system, which can be put together for about \$3,500, complete with guidescope and low-cost auto-guiding system, has many advantages:

• The fast optics (typically f4 to f6) require much shorter exposure times than the f8 to f11 focal ratios of many big scopes.

• Its short focal length (400mm-600mm) is far more forgiving of polar-alignment and tracking errors than the 2000mm-3000mm focal lengths of big optics.

• When combined with a DSLR, the two-to-three-degree-wide field is ideal for shooting big photogenic nebulas and rich Milky Way star fields.

• The mount and scope combo is portable, making it easy to transport to darksky sites and quick to set up.

• The German-style equatorial mount is easy to polar-align. The built-in polar scope allows accurate polar alignment in a minute or so—no tedious drift alignment.

• The mount is versatile and can handle other optical tubes, while the little apo refractor is great for all kinds of visual observ-

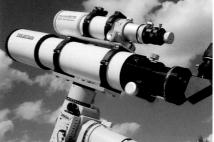

▲ Optical Choices Excellent apo refractors for deep-sky imaging are offered by (clockwise from top left) Borg; Stellarvue; TMB and Takahashi; and William Optics; not to mention A&M, Pentax, Tele Vue and Vixen.

What such a small-apo system cannot do well is shoot close-ups of small deep-sky objects, such as galaxies and planetary nebulas. Those targets need focal length, which means bigger scopes, bigger mounts *and* bigger budgets. Try deep-sky shooting with a portable system first, one with a wide field ideal for nebulas and star fields. Then, if you become addicted, go for the monster dream system for grabbing galaxies.

need lots of aperture? No. In photography,

what counts is focal ratio not aperture. A fast

f5 system will record objects in one-quar-

ter the exposure time of an f10 system.

WHAT ABOUT ...?

OK, we know—the ads show all kinds of amazing photos taken with big off-the-shelf

▼ Field Flattener Most apos need a fieldflattener lens. Without one, the outer portion of the field looks distorted (inner rectangle marks the field of an APS-sized camera).

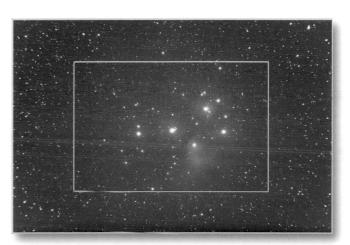

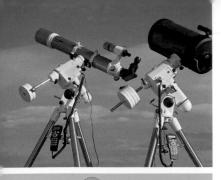

Mounting Decisions ▲ Popular and reasonably affordable mounts suitable for astrophotography that we can recommend include, from top to bottom, the Sky-Watcher HEQ5 and EQ-6 Pro (similar to the Orion Sirius and Atlas models), the Vixen Sphinx, Celestron's CGE and the Losmandy G-11 (also its smaller GM-8). Astro-Physics and Takahashi are other top-quality names.

Schmidt-Cassegrains the "first night out." The technique is to use a low-cost CCD camera, perhaps even on an altazimuth telescope, to take lots of underexposed 30-second exposures and additive-stack them to create the equivalent of a single long exposure (see page 296). This method does produce results. You get shots good enough to post on personal websites and to e-mail to friends. And perhaps that's all you need. But it isn't how the astrophotos are taken that you see in books and magazines and on the websites of the best astrophotographers. Virtually all are the result of long guided exposures, ensuring images with the lowest noise, the smoothest range of colors and the faintest detail.

We're suggesting a system that's reasonably easy to use, doesn't cost half as much as a new car and can yield results good enough for publication. Most of our deepsky images in this book were taken with such a system: a fast apo refractor and modest German equatorial mount. We prefer the compact tubes of apo refractors and the fact that the optics stay in collimation.

The other "what about?" question we are often asked is whether a Dobsonian can be adapted for deep-sky imaging. The short answer is no. A Dob can be used to take snapshots of the Moon but lacks the ability to track the stars. While tracking can be added (through Poncet platforms or computerized drive systems), such souped-up Dobs are suitable only for webcam planetary imaging, not for long guided exposures.

OPTICAL OPTIONS

To avoid blue halos around bright stars, we suggest going for at least a doublet-lens apo, rather than a short-tube achromat. An apo with an f6 to f7 focal ratio is ideal. Adding an 0.8x focal reducer/field flattener (essential) yields a focal ratio of f4.8 to f5.6, fast enough to keep exposure times short yet reach as faint as the sky will allow.

Typically, an 80mm to 90mm apo with a 0.8x reducer/flattener provides a three-bytwo-degree field with an APS-sized DSLR chip, ideal for many nebulas and star clusters. Excellent scopes in this class (\$600 to \$2,000) come from A&M, Astro-Tech, Borg, Celestron, Meade, Orion, Pentax, Stellarvue, Synta/Sky-Watcher, Takahashi, Tele Vue, TMB, Vixen and William Optics. Whew! We own or have used models from A&M (80mm triplet), Borg (77mm ED astrograph), Takahashi (Sky90), Sky-Watcher (Equinox 80ED) and William Optics (Megrez 90mm doublet) and highly recommend them. Key features to look for in this class are a 10:1 dual-speed focuser that rotates for framing and locks down to prevent it from slipping out of focus and an obstruction-free tube that can be placed into tube rings.

A larger 100mm f6 to f7 apo, with its longer focal length, provides a smaller field of view for tightly framing more compact objects. But it can be quite a bit heavier and require a larger mount. Excellent brands we can personally recommend include A&M (TMB-designed f6 triplet), Borg (101mm ED astrograph) and William Optics (110mm f6 ED doublet and FLT f7 triplet).

Of special note are three 100mm-class models designed specifically for deep-sky imaging with large-chip cameras: the Pentax 100 SDUF, Takahashi's FSQ106 and Tele Vue's NP101is. All feature built-in field-flattener/reducer lenses for tack-sharp images across a full-frame camera at fast f4 to f5 focal ratios. But all start at \$3,000 to \$4,000 just for the tube assembly. Bigger apos represent even more commitment, because their heavier tubes demand larger mounts.

MOUNTING CHOICES

By staying with an 80mm to 100mm apo, the mount can be kept small, portable and affordable. For this class of scope, we recommend the Synta/Sky-Watcher HEQ5 Pro Series mount (\$1,200), sold in the United States as the Orion Sirius. Tracking error is low, it works well with an auto-guider, and the GoTo system is excellent.

For a larger mount capable of handling a heavier telescope, move up to the Vixen Sphinx with the color Starbook GoTo system, Losmandy's GM-8 or G-11 with Gemini GoTo system or Takahashi's EM-11. (Vixen's smaller Great Polaris D2 is a fine mount but is handicapped by the mini Starbook-S controller—it relies on four AA batteries that die in cold weather, rendering the mount useless.) The Sky-Watcher EQ-6 Pro (aka the Orion Atlas mount) and Celestron CGE are heavier still but capable of handling a large refractor or Schmidt Cassegrain.

Recommended Astrophoto Outfit

Here's a sample setup based around proven equipment we've used and can recommend. The core is a short-focus 80mm to 100mm apo refractor on a solid but portable German equatorial mount. For guided deep-sky photography, you must add essential accessories, often from a variety of suppliers.

> Mounting Rings Vixen-standard dovetail plate and 80mm rings (William Optics, ADM or Losmandy). Approx. \$150.

Main Scope

A Sky-Watcher Equinox 80ED, but there are many choices, most f6 to f7. \$600 to \$2,000.

Guidescope

A 66mm William Optics model; similar models are available in other brands. A solid focuser is essential. Approx. \$300.

Guidescope Rings

To bolt securely onto the 80mm tube rings, with adjustable centering bolts (William Optics, Losmandy or ADM). Approx. \$100.

Guiding Camera Low-cost CCD camera, like Meade DSI or Orion Guider, is best for picking up faint guide stars. \$200 to \$400.

DSLR

As of early 2008, the Canon 40D (ideally, filter-modified) is the best choice (older Canon 20Da with optional right-angle finder shown here). \$1,200 to \$1,800.

Astrophoto-Capable German Equatorial Mount We like the Sky-Watcher HEQ5 for low-cost yet good tracking, GoTo and auto-guiding capability (aka Orion Sirius). Add heavy or extra counterweight for balance. Approx. \$1,200. Focuser Extension Tube Allows guide camera to reach focus straight through (Lumicon). Approx. \$30.

Field-Flattener/Adapter Includes camera-adapter ring. This is a Borg #7887; similar units are available from Tele Vue and William Optics. \$150 to \$300.

USB-to-Guider-Port Adapter For guider cameras with no autoguider port; translates guide pulses from laptop's USB to mount's guider jack (Shoestringastronomy.com). Approx. \$80 with cables.

Laptop (Mac or PC) For running auto-guiding software such as PHD Guider (can be older, slower machine). No cost if you already have one.

Camera Remote Fires shutter through

programmed exposure sequences. Very nice to have. Approx. \$200.

Not Shown:

- High-capacity battery(s) for powering mount and laptop in the field.
- Extra batteries or external power supply for DSLR.
- Field table and chair.
- Image-processing software.
- Spousal approval!

Beneath the Southern Cross

A Canon 5D camera, with a 35mm lens, frames this classic field for piggyback shooting. Exposure time 5 minutes at f4, ISO 400.

Riding Piggyback

Many tube rings have 1/4-20 stud bolts for attaching a ball-and-socket tripod head and piggyback camera. Just be sure the tripod head is very solid and accepts the 1/4-20 bolt. No Scope Needed For piggyback portraits with wide-angle lenses, no guiding, and therefore no telescope, is necessary, just a mount capable of being polar-aligned and of tracking the sky accurately.

Techniques IV: Piggyback Shooting

Now we advance to long, tracked exposures, where the telescope acts as a platform for a DSLR and its lens. This style of piggyback photography is simple to do, yet it can yield spectacular results. Because the camera is following the sky, light can build up on the sensor, allowing the camera to record stars and nebulas far fainter than your eye can see—and in vivid color.

The finest piggyback portraits of the Milky Way demand dark, moonless skies. The best exposure is usually the longest one you can take before sky glow starts to wash out the sky. Exposures of about 2 to 3 minutes at f2.8 and ISO 800 are typical.

For this class of images, a traditional equatorial mount that is polar-aligned is essential. While altazimuth-mounted GoTo scopes can track the sky, they are not suitThe mount need not be fancy. Indeed, piggyback shooting can be done with clever accessories like the Kendrick AstroTrac, a motorized platform (shown at right) that can be placed on any solid tripod. However, most people opt to use the mount they already have. If the lens focal length is kept short (below 85mm), the mount can probably be left to run on its own. As the focal length increases, though, you may begin to see trailing in star images. The mount might need more accurate polar alignment, or it might not be tracking well enough to allow unattended operation.

One solution is to use the telescope as a guidescope, as shown opposite, equipped with an eyepiece with an illuminated reticle. During the exposure, watch a bright star and use the push-button slow-motion controls to keep the star on the crosshairs. This is called guiding, and doing it manually like this is doing it the hard way. But it's a lowcost alternative.

Besides mistracking, other gremlins can plague the piggybacker. At left, we show a ball-and-socket head used to attach a camera to a mount. For lightweight lenses, this ▼ Innovative Tracker A tracking mount that duplicates the precision of a small equatorial mount yet weighs only three pounds? That's the Astro-Trac, introduced in 2007. It's a platform for guided sky shooting. Just add a slurdy camera tripod.

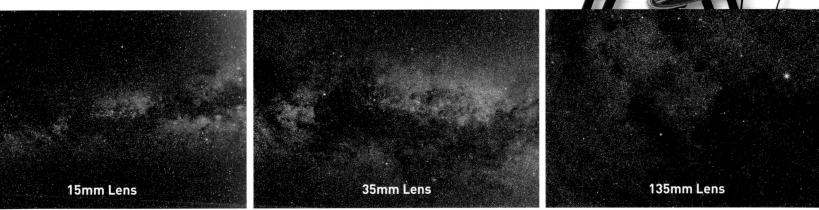

able—the sky will rotate with respect to the camera frame, creating circular star trails. Scopes like Meade's ETX models and Celestron's NexStars must be placed on a wedge and tilted up so that the polar axis aims at the pole (see Chapter 15 for details).

Another necessity is a motor on the right ascension axis, preferably with a speed control. A mount with a polar-alignment scope in the R.A. axis also makes it easier to polaralign, which should be done to within several arc minutes of the pole when shooting with a telephoto lens. is fine. But a heavy lens or camera can cause the ball heads to slowly shift position, trailing images, as one of us learned the hard way, losing half of the film shots from an Australia trip. The answer was a heavy-duty geared tripod head, a Bogen/Manfrotto #410. The problem has never happened again!

Dew, aircraft and fireflies also love to ruin photos. And you'll need battery power to spare. In cold weather, DSLR noise goes way down (which is good), but so does battery life (which is not good). Batteries can die after just a handful of long exposures.

Choose Your Lens

An ultrawide lens, such as a 15mm fish-eye, is ideal for panoramic sweeps along the Milky Way. A 35mm (a "normal" lens on an APSchip camera) is perfect for framing constellations. A moderate telephoto, like a 135mm, is great for portraits of star fields and nebulous regions of the Milky Way.

Deep-Sky Wonders

This setup (a Borg 77mm f/4 apo telescope, a Canon 20Da camera and an SBIG ST-402 auto-guider CCD camera) was used to fake this image of the North America and Pelican Nebulas in Cygnus. The Image is a stack of four 8-minute exposures at ISO 400.

Techniques V: Prime-Focus Deep Sky

This is the astrophotography many aspire to right from the start—close-ups of colorful nebulas and galaxies. It should be easy, right? After all, if you can shoot the Moon through your telescope, why can't you shoot the Orion Nebula or the Andromeda Galaxy? Isn't it just a matter of exposing longer? Yes, the recording power of digital cameras does allow prime-focus portraits of deepsky objects in just 5 to 15 minutes.

But when you open the shutter for a few minutes, even with the essential motorized equatorial mount aligned and tracking the sky, you'll likely get a sad-looking field of wiggly stars, hopelessly trailed. Shooting long exposures through a telescope reveals all the mechanical errors in the drive gears and misalignments of the mount.

To get around this, some photographers employ the track-and-stack method. They take lots of 30-to-60-second unguided exposures, short enough to avoid any significant effects of mistracking. But exposures that brief are severely underexposed. So they use software to register and stack the images, using an additive stacking command. In Photoshop CS3 and Elements 6, it's the Linear Dodge (Add) blend mode. This adds the signal together to create the equivalent image density of a single long exposure.

It does work, but we don't subscribe to that school. As CCD-imaging experts learned long ago, the best results come from shooting 5-to-20-minute exposures, then average-stacking them to smooth noise (see pages 300 to 301 for details). When shoot-

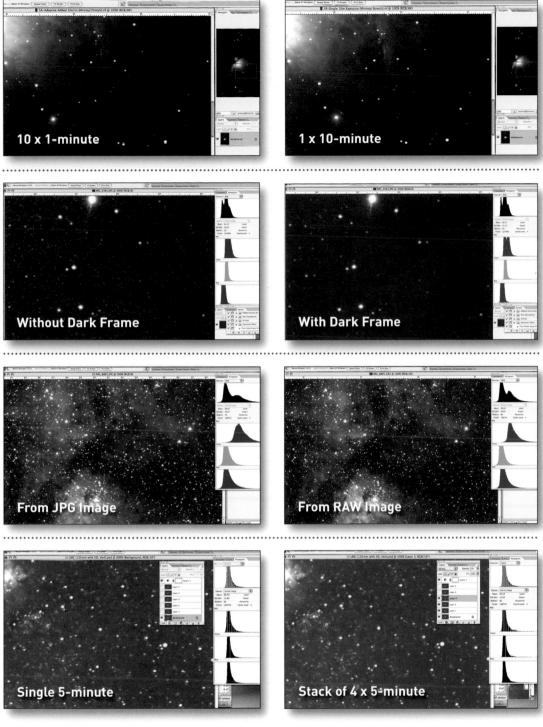

ing with DSLRs, the best results come from going longer (up to 20 minutes) at ISO 400 rather than trying to keep exposures short by shooting at ISO 800 or 1600 thinking that will keep noise down. It won't. Increasing the ISO speed adds far more noise than increasing the exposure time, at least on cool nights. But if time is tight, ISO 800 works fine, as it is almost as clean as ISO 400, certainly with the Canon cameras we've used.

Minutes-long exposures through a tele-

scope require an excellent mount (we've already recommended a few), aided by additional guiding gear to keep the mount tracking more precisely than it could on its own. We deal with this in the next section. Budget \$500 to \$1,500 for the guiding hardware, assuming you have a mount that accepts an auto-guider—and trust us, you will want an auto-guider. Imaging deep-sky objects through a telescope is a venture not to be undertaken lightly. ◀ Short Stacks or Long? Additive stacks of short unguided exposures (far left) can work but inevitably look noisier and have less faint detail than a single long exposure of the same total duration (left). Long exposures have better signal-to-noise ratios.

Dark Frame or Not?

On very cold nights, a DSLR can produce clean images without any dark frame. But here (far left), we see what happens on a warm night: pictures with pox! An internal dark frame taken by the camera cleaned this up (left).

◀ JPG or RAW?

Some wonder whether shooting and processing RAW frames is worth the hassle. It is. RAW frames capture more dynamic detail than compressed JPG frames can. This is especially noticeable on deepsky targets such as nebulas.

Single Shots or Stacks? For the cleanest final image with the lowest noise, the best practice is to shoot several exposures, each as long as the sky will allow, then stack them so that the images are averaged, not added together (see page 301 for details). This smooths out random noise. Stacking four images reduces background noise by a factor of two, making a visible difference to image quality. Beyond four, you get into diminishing returns -it takes nine images to reduce noise by a factor of 3, 16 images to reduce noise by a factor of 4.

Manual Guiding ▼ An illuminated reticle in the guiding eyepiece (below) aids in centering a guide star. A guiding eyepiece can go into a guidescope or an off-axis guider (bottom), often used with Schmidt-Cassegrains. Here, a small prism picks off a guide star from the edge of the field.

Auto-guiding Options ► A Meade DSI camera coupled with a Shoestring Astronomy GPUSB connector box (far right) and free software like PHD Guider (inset) are a low-cost auto-guider system. More costly CCD cameras, like SBIG's ST-402 and eFinder (right), also work great, with the bonus of serving as fine standalone imaging cameras.

Guiding Tips and Techniques

Motorized telescopes can track the sky, but they still need help to ensure stars don't wander around the frame during long time exposures. To prevent noticeable star trailing, stars shouldn't move more than two or three arc seconds, a tall demand. To achieve this precision, we guide the mount.

This can be done manually, using an illuminated-reticle eyepiece (left). In this case, since the main telescope is occupied with a camera, photographers use either a separate guidescope or an off-axis guider. We have long preferred a guidescope, since it provides greater freedom to select a bright guide star. We've also both paid our dues staring into a guiding eyepicce for hours and don't wish to go there again.

The alternative is to let a computer do the guiding. That entails a guidescope, a small digital guide camera and a laptop running auto-guiding software. The guide camera looks at a star near your target and detects any deviant motion of that guide star. When the guide star wanders off, the software reacts by sending a trigger pulse to the mount. This nudges the mount just enough to keep the star locked on target. By applying corrective nudges like this every few seconds, the auto-guiding system keeps stars looking like pinpoints, not worms.

The original auto-guider was the ST-4 from Santa Barbara Instruments, a tidy stand-alone box still available on the used market. Its successor, the now discontinued

STV, added a more sensitive camera, a screen to see the guide-camera image and onebutton setup routines. We each still use an STV and love it. But it sold for \$2,000 in its day. Today, there are much cheaper options.

Most involve having a laptop at the scope for running auto-guiding software. The camera can be a webcam (it works only on bright stars) or, far better, a low-cost CCD camera that can take exposures several seconds long to reveal fainter guidestar candidates. Some cameras, like Orion's StarShoot AutoGuider, have an output to connect directly to the auto-guider port of the mount (the mount needs one of these). This is a phone-style jack made standard by the old ST-4. For cameras lacking such an ST-4 jack, like the Meade DSI, Shoestring Astronomy offers its GPUSB box that translates guiding pulses from the laptop's USB port to the mount's auto-guider jack. The combination works very well.

For control software, we use Craig Stark's free PHD Guider program (for Windows or Mac OS X). The name stands for Push Here Dummy, in honor of its simple operation. It works great. Other free or low-cost guider programs include GuideDog, Guidemaster, K3CCD Tools and MetaGuide (Google them!), while advanced control and image-processing programs, such as AstroArt, CCDSoft, Equinox Image and MaxDSLR, all offer auto-guiding routines.

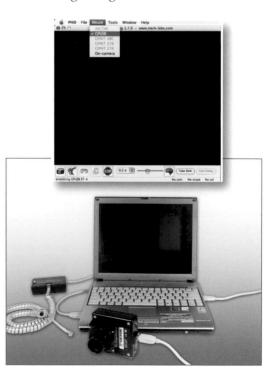

Beating the Guiding Gremlins

Despite the wonders of auto-guiders, stars can sometimes appear misshapen because of trailing in one or both directions. Here are some common causes.

Every Star Looks Double

Commonly called "nose and foot binaries," such images are created by bumping the tripod with your foot or, in manual guiding, nudging the guiding eyepiece with your nose sometime during the exposure, usually as you nod off to sleep.

Trailing in Right Ascension

If the guide star takes off suddenly at regular intervals, the motor drive has mechanical periodic errors. If the error is too extreme to compensate for by guiding, the only solution is to replace the entire motor-and-gear-drive mechanism or to buy a new mount. If the star keeps drifting out slowly in the same direction, make sure the drive is set to the sidereal rate. Try running the unit from a different power source.

Trailing in Declination

Some mounts can oscillate north and south under the constant commands of autoguiders. Back off the aggressiveness of the auto-guider, reduce the mount's backlash compensation or reduce the guide speed to half the value with which you calibrated the guider. These can prevent the mount from playing ping-pong with stars in response to every fluctuation in seeing.

Rotation Around the Guide Star

Do stars in your guided photographs appear to be trailed in arcs? If so, the telescope has not been accurately polar-aligned, and stars are drifting out in declination during the exposure. Correcting in the usual way for such drift ensures that the guide star is untrailed, while the rest of the frame gradually turns about the guide star.

Poor Polar Alignment for No Apparent Reason

If you polar-align accurately yet still get trailed stars, you are probably aligning with a polar bore-sight scope whose reticle is off-center and not pointing straight up the polar axis. The adjustment to fix this is shown in the photo below.

Trailing for No Apparent Reason

If you are using a separate guidescope, it could be shifting with respect to the main scope. Use more solid fittings. In piggyback photography, the camera can slip on its mooring as it changes orientation during the exposure. Use rings or clamps to hold long telephoto lenses both front and back. With Schmidt-Cassegrains, the primary mirror itself can shift as the telescope moves from one side of the sky to the other. Avoid exposures that will cross the meridian.

Success in deep-sky photography comes by learning from your mistakes: (1) Don't hit the tripod, or you'll get double stars galore. (2) Some forms of trailing can be reduced by purposely throwing the telescope slightly out of balance so that as it turns to the west, the mount has to work to pull the scope up. This ensures the right ascension drive gears remain meshed. (3) Poor polar alignment manifests itself as rotation around the guide star. The problem shows up more when you are shooting near the celestial poles. (4) If you or your auto-guider (as shown here in the top graph of an auto-guider readout) continually have to make declination corrections in one direction, it is a sign that you are not polar-aligned. Use the little setscrews on any polar scope (right) to move its reticle so that anything placed at the center of the reticle crosshairs stays dead center as the scope turns around its right ascension axis.

Power of Processing Good image processing can extract stunning detail from bland, discolored original images. This is an extreme-makeover case!

Photoshop Elements For a fraction of the cost, Photoshop Elements (v.6 shown) offers many of the features of the full Photoshop, including a "lite" version of Adobe Camera Raw (top). Its main drawbacks are limited Adjustment Layers and few functions for 16-bit images. A free third-party plug-in called SmartCurves adds the important Curves command. The Correct Camera **Distortion function (bot**tom) nicely compensates for lens vignetting.

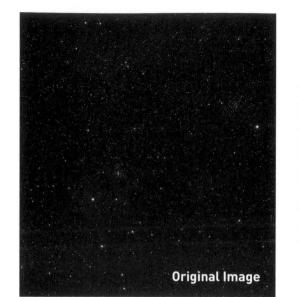

Image Processing I: Preparation

At the telescope, the task is to get sharply focused, well-guided images, ideally with exposure times as long as the sky will allow for maximum signal-to-noise ratio. To smooth out noise further, the best practice is to shoot not just one frame of an object but two or more frames of the object. To automate this process, we use the Canon interval timer (see page 287), avoiding the complexity and cables of computer control.

We've found that having the camera subtract a dark frame from each image does a better job than taking dark frames manually for subtraction later (see page 305). Yes, this might reduce the number of shots per night, but the results are better, in part, because the temperature and noise level of each dark frame exactly matches each image. (Unlike cooled CCD cameras, DSLRs are not temperature-regulated, so their noise levels change during the night as air and camera temperatures change.)

At the end of the night, we're left with a series of RAW files—typically four to six per deep-sky object. These must be converted (de-Bayered) into a format that an imageprocessing program can handle. There are many ways to do this. Every DSLR comes

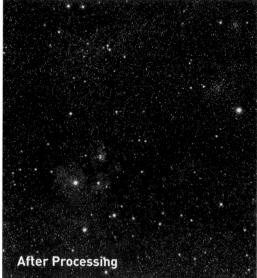

with software for RAW conversion, and astronomy programs such as ImagesPlus and MaxDSLR also do RAW conversion. Our choice is the industry-standard Adobe Camera Raw (ACR), a plug-in for Photoshop and Elements. If you have a new model DSLR, you need the current version of ACR (older versions can't read RAW files from new cameras). While ACR is free, the latest versions work only with the latest versions of Photoshop or Elements. So upgrading ACR may require upgrading those programs.

The advantage of ACR over other plain converters is that it contains a powerful set of routines for sharpening, noise reduction, exposure compensation, highlight recovery, color correction, lens-aberration correction and compensation for dark corners from vignetting by the optics. These all operate on the original raw data for minimal loss of information. (The version of ACR that works with Elements offers a more limited set of functions.)

What settings to use depends on your equipment and images. But we've found that backing off ACR's default sharpening (to 15 or 20) avoids ugly dark halos around stars, while upping the default value for Luminance noise reduction (to 40 or higher) smooths out the sky without wiping out detail. Keep Color noise reduction low (20 to 30), or star colors disappear. When converting images, set the Workflow options to 16-bit, 300dpi, while using the ProPhoto RGB color space option to preserve a wider range of colors.

Now that you have a set of converted images, the task is to stack and register them. Specialized image-processing programs for astronomy (such as AIP4Win, AstroArt, Christian Buil's Iris, ImagesPlus and MaxIm DL) can do a marvelous job aligning and stacking even wildly out-ofregister images, like those from an altazimuth mounted telescope. Registar can even precisely register images taken with vastly different focal lengths. However, we've found that when taking a series of nicely auto-guided images through a telescope on a well-aligned equatorial mount, very little needs to be done to register them so that they align precisely. Just a nudge of one or two pixels left-right or up-down is generally all that's needed. That's easy to do in Photoshop. Version CS3 has even automated the process with a superb Auto-Align Layers command. Elements 6 has a Photomerge: Panorama command that works for stacking and aligning identically framed images as well as stitching panoramas.

Stacking is done to average out the noise. When stacking in Photoshop or Elements, the procedure for maximum effect is to set the base background layer at 100% opacity. The second layer up (called Layer 1) is set to 50% opacity, the third layer to 33%, the fourth layer to 25%, the fifth to 20%, and so on, all in Normal blend mode.

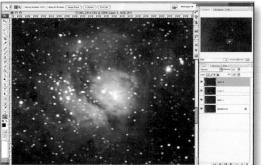

◀ Adobe Camera Raw: Basic and Tone Curve Clicking on a set of RAW images opens up ACR, one of the best RAW conversion programs available. Here, you can make basic corrections to exposure, highlight recovery, contrast and color

balance and saturation.

◀ Adobe Camera Raw: Detail and Lens Correction Also at this stage, ACR allows noise reduction, sharpening (apply just a little!) and correction of chromatic aberration and darkening of corners from lens vignetting. Very nice!

◆ Photoshop: Stacking Pick the best frame as the Background base layer. Select All and Copy each image, then Paste it into the base image to create a single image with multiple layers. Blend them: Layer 1 at 50%, Layer 2 at 33%, Layer 3 at 25%.

◀ Photoshop: Alignment Method #1 (Automatic) In Photoshop CS3, select all the layers and hit Auto Align Layers. In seconds, all are registered. In Elements, use the New: Photomerge Panorama command to select a set to align on top of one another.

Photoshop: Alignment Method #2 (Manual)

On earlier versions, turn on just two layers; switch the top one to Difference, 100% Opacity. Use the Move tool and arrow keys to nudge the top image so that the images cancel. Repeat as needed for all layers.

Advanced Imaging (or How to Spend Lots of Money!)

To improve upon Canon DSLRs to a significant degree requires a big switch to a different technology at considerable expense. The high end of astrophotography employs CCD cameras made specifically for astronomy and requiring a computer to operate and store images. To eliminate noise, the CCD chips are cooled to subfreezing temperatures, usually with thermoelectric coolers, although some cameras use water cooling.

Cooled single-shot color cameras are available and work well, but for the greatest flexibility and sensitivity, the avid astro-imager usually opts for a monochrome CCD equipped with a filter wheel. To create a color image, exposures are taken through each of the red, green and blue filters, and an unfiltered shot is taken for a high-resolution "luminance" channel. Together, these produce a four-color "LRGB" image. It is not unusual for photographers seeking the deepest, richest images to spend all night—even several nights—acquiring the frames needed to assemble a final image of just one object. Accumulated exposure times in the hours are the norm.

Although good cooled CCD cameras are available for under \$1,500, their chips are small and the field of view is limited. Even so, they can serve as an introduction to quad-color CCD imaging and work well as auto-guiders.

The high-end cameras incorporate Kodak's big chips—35mm to 40mm across. These cameras (from companies such as Apogee Instruments, Finger Lakes Instruments, Santa Barbara Instruments and Yankee Robotics) come with price tags of upwards of \$10,000, so they are only for the most dedicated astro-imagers. But in the hands of experienced users, the high-end cameras produce the finest astronomical images ever taken from the Earth's surface.

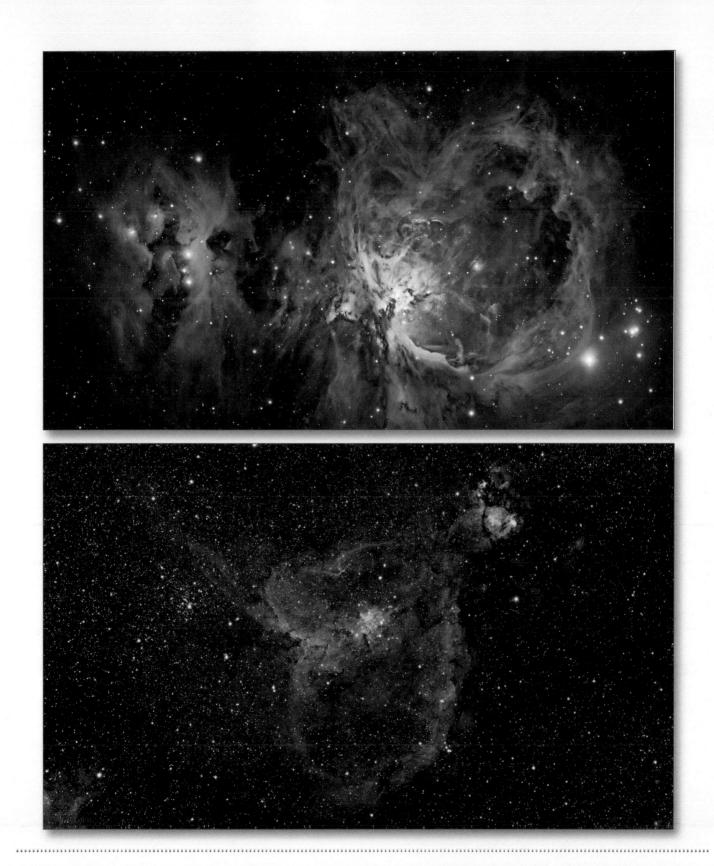

At dark-sky gatherings such as the Texas Star Party, advanced astrophotographers can be seen hunched over laptops, watching over high-end systems (left), featuring large Ritchey-Chrétien telescopes on massive mounts, like Software Bisque's Paramount, and large-chip CCD cameras, such as Santa Barbara Instruments' STL11000. The full extent of nebulosity around M42, the Orion Nebula (top), is evident in this deep-sky image by Tony and Daphne Hallas. The Heart Nebula, IC1805 (above), was imaged by Jay Ballauer.

The Digital Darkroom We've processed thousands of DSLR images with nothing more than Photoshop and its powerful array of tools. Despite its power, we find Photoshop much easier to use than most astronomical imageprocessing programs, because of its nondestructive Adjustment Layers, many levels of Undo, full-frame previews, fast filtering and recordable actions. This screen shot labels some of the key areas discussed in the tutorials here and on pages 300-301.

Sensor Cleaning 🔻

Too often, we get to this stage only to find ugly dust blotches on the image that can sometimes be tough to retouch out. The best solution is a clean camera sensor at the outset. Some cameras have self-cleaning sensors. For those that don't, there are (from left to right) compressed air guns, the Arctic Fly antistatic brush and Sensor Swab liquid and applicators.

Image Processing II: Enhancement

This is where the magic happens. To perform the tricks of image processing, many turn to astronomy programs—ImagesPlus and MaxDSLR being two of the most popular among DSLR users. However, our own workflow keeps us within Adobe Photoshop. Here's a suggested process.

Once you have a set of stacked images, as per the previous tutorial, the next step is further noise reduction. While Photoshop and Elements both have a Reduce Noise filter, we've long made use of an excellent third-party plug-in called Noise Ninja (www.picturecode.com). It can decrease noise by the equivalent of dropping ISO speed by a factor of two to four. The trick with Noise Ninja is to back off the default settings so as to avoid oversmoothing and creating a plastic-looking effect. The obsession with reducing noise, and doing so early in the workflow, is because everything we do after this will increase the visibility of noise.

From here on, employ Adjustment Layers. These sit on top of the stack and, by default, affect all the layers below. And this is where Photoshop Elements' limitations start to show, as some of the filters and functions ideal for astrophotographs aren't available as Adjustment Layers. In Elements version 6, Curves is still missing, but a crude version is available under Adjust Color: Color Curves. SmartCurves, a free thirdparty filter plug-in, is far better. Many of Elements' functions do not work on 16-bit images. You may have to convert the file to 8-bit, with some loss of data. (Keeping images in 16-bit mode retains more tonal values, for avoiding posterization effects when stretching contrast.)

The beauty of Adjustment Layers is that they are nondestructive. You can tweak away at any time. Start with an Adjustment Layer for Levels. Here, you can make major color corrections to adjust for off-color skies or pink tones from modified cameras. The next step is to apply Curves. Bringing down the low end and bumping up the midtones, while holding the highlights, brings out faint nebulosity without burning out bright bits. Watch the Histogram—don't let it slam against the left; that throws away data.

After you apply color and contrast en-

hancements, flatten the image to a single layer (save the layered master!). Now sharpen the image. Duplicate the image layer, and apply a High-Pass filter (found under Filters: Other) a few pixels in radius to the duplicate. Then blend that odd-looking layer with a Soft Light mode. Vary the opacity to vary the strength, a nice way to apply nondestructive sharpening. Use Actions to record the steps for future photos.

Breigh Srideboeu Gawad USW arture

+

In-Camera vs. Postprocessing Dark Frame At far left, an average of eight dark frames were subtracted later in processing. At left, one dark frame was subtracted by the camera. Our tests prove "in-camera darks" yield cleaner images, so we let the camera subtract the dark frame.

Noise Ninja

Before further processing, we pass each layer through noise reduction with the excellent Noise Ninja plugin to smooth out residual noise. Apply it sparingly by backing off the defaults.

1. Levels

A Levels Adjustment Layer corrects color cast from a modified camera or from sky glow. Use the Histogram to judge color balance as you adjust the RGB channels. The three peaks should overlap. But don't clip the low end!

2. Curves

Curves brings out faint nebulosity and darkens the sky. Several Curves layers are often required.

3. Selective Color This adjustment is good for making final tweaks to color balance.

4. Brightness and Contrast Used sparingly, this function helps snap up the image. Save the layered master, then flatten the image.

5. High-Pass Sharpening Sharpening with a High-Pass filter on a duplicate layer is the final step.

C H A P T E R F O U R T E E N

High-Tech Astronomy

Traditionally, the high-tech areas of the hobby were reserved for astrophotography. Today, though you might have no wish to touch a camera or a CCD, it can be tough to avoid computers. They can help us learn the sky, plan our observing sessions and aim our telescopes for us. They allow us to connect to a world of resources and fellow stargazers through the Internet. While they promise to make the hobby more enticing and accessible for newcomers, we find that computerized telescopes and related gadgets can do more to confuse than enthuse.

Beginners are often entranced by the high-tech gadgets—aren't we all!—only to be greeted by endless "error" and "alignment failed" messages or by telescopes that behave badly as batteries die. GoTo scopes collect dust not starlight. Here's our survival guide for living in the increasingly high-tech world of backyard astronomy.

Even a visual telescope can be fitted out with computers, as seen here on this GoTo Celestron connected to and controlled by a PC via a wireless Bluetooth receiver.

...................................

Aim and Identify

Skynscout

When aimed at the night sky, the Celestron SkyScout (top) and the Meade MySky (right) can identify objects. Manufacturers see these devices as one way to engage the video-game generation in exploring the sky.

Digital Setting Circles

Popular for Dobsonians, digital setting circle kits, like this Argo Navis, allow the user to find targets by watching position readouts count down to zero as the telescope is pushed around the sky.

High-Tech Finder Aids

We live in amazing times. A device you simply aim at the sky that can tell you what star you are viewing seems magical. Yet that is exactly what the Celestron SkyScout and Meade MySky can do. Both are handheld devices that can identify bright planets, stars, constellations and deep-sky objects.

These are not telescopes. Although you look through or along them, all you see is a naked-eye view of the sky. Both devices can be used to identify unknown objects, or you can call up an object from the database and have the device lead you across the sky till it is aimed at the selected target. The magic is provided by a built-in GPS receiver, which can determine your location and the local time from orbiting satellites, a compass that detects the left-right direction and level sensors that record the updown angle, telling the device where it is aimed in the sky. Very clever.

Hand one of these devices to someone learning the sky and he or she is amazed! Kids love them. Parents, used to buying video games, often don't balk at the \$400 price tag. True, a center-page map in an \$8 magazine can perform much the same purpose, but there is no denying the gadget appeal of the SkyScout and MySky. They do work, though nearby metal can throw off their accuracy. Compass errors in an early MySky unit we tested meant it failed to correctly identify objects about 40 percent of the time. A beginner wouldn't know the difference and would be happily ignorant of the fact that the bright cluster of stars identified as"Aries" was in fact the Pleiades.

Bugs aside, these devices can be fun for a few nights, but a backyard astronomer soon outgrows them. Frankly, the money would be better spent on introductory star charts and binoculars that have lasting value.

Repeating our advice from Chapter 3, we strongly recommend a no-frills Dobsonian as a high-value first telescope. Many Dobs can be fitted with a basic level of computerization through the addition of digital setting circles (DSCs) and the necessary axis encoders. Jim's Mobile, Inc. (JMI) makes kits for a wide range of models. But to be clear, these do not add tracking or motorized GoTo capability—you push the scope around the sky until the DSC indicates you are on target.

GoTo Tips and Techniques

The next step up in technology is the GoTo telescope with slewing motors that can point to any of thousands of objects. To do this, the GoTo scope contains a virtual map of the sky in a computer chip. For the telescope to match its virtual sky with the real sky, it must know where it is, what time it is and where it is pointed. With most GoTo scopes, the location needs to be input only once—the computer remembers that site and defaults to it upon start-up. Some models keep track of time (or get the time from a built-in GPS receiver); others require the user to input the time each night.

All GoTo scopes then require an initial alignment on two stars. The procedure is simple. For most models, the telescope is placed in a standard starting position. From there, the scope slews to the first alignment star. You can select that star yourself from the computer's list or let the "auto" mode (included on most units) select it for you. Inevitably, the telescope points only close to the star. That's normal. We've seen people struggle for hours with precise leveling, latitude, longitude and true north in a wasted effort to get the telescope to aim exactly at that first star. Forget it—it will always be off. Now, using only the push-button controls, center that star in the eyepiece, then hit the Enter or Align button. This tells the computer how far off the star is. (Celestron SkyAlign models have no starting position; you slew the scope to the first star.)

A precise alignment requires sighting a

second star. It will be off too. Center it, hit the Enter or Align button, and the alignment is done. (Some models need a third star.) The telescope now knows how the real sky deviates from its virtual map and how to point to other objects in the sky.

TIPS FOR ANY TELESCOPE

• If your home city is not on the telescope's list, enter your latitude and longitude, available from atlas maps or through Google Earth. Entering to the nearest half degree is fine, but watch the sign or direction: A minus latitude is in the southern hemisphere; a minus longitude is west of England's Greenwich meridian, which covers all of North and South America. Locations in Europe and Australia have a positive longitude east of Greenwich.

• Enter time zones correctly. In North America, eastern time is Greenwich time minus five hours. Don't correct for daylight time at this point; there is a separate choice for this.

• AnswerYes to the daylight-time question if it is currently in effect (mid-March to early November in North America).

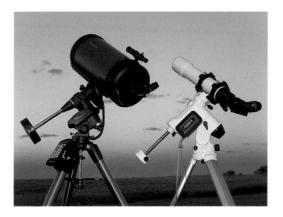

▲ When All Else Fails ... read the manual! Often buried in the dense instructions is a crucial bit of information that will explain why your scope is not behaving as it should. User groups on the web are another source of help. Check Yahoo groups or websites like Mike Swanson's NextStar Resource Site. Mike Weasner's Mighty ETX or the Meade Advanced **Products User Group** (Google them).

◀ Polar-Alignment Priority Most German equatorial mounts equipped with GoTo computers, like Celestron's CG-5 mount (far left) and the Vixen Sphinx (left), require traditional and fairly accurate polar alignment before you can conduct a two- or three-star GoTo alignment. See Chapter 15 for details.

▲ Alt-Az vs. Polar-Aligned Fork-mounted GoTo telescopes, like Meade's ETX Series, can bo operated in altazimuth mode (far left) or tipped over in equatorial, or "polar," mode (left). The latter requires polar alignment. For visual use, there is no need to set up in equatorial mode.

Picking a Star 🔺

If you cannot see the alignment star the scope is requesting, skip to the next star on the list. On a Meade (top), hit any direction button or the Down scroll key. On a Celestron (bottom), hit any direction button to stop a slew, then Undo. On Sky-Watcher mounts, hit ESC, then Exit Alignment?: No, and scroll to a new star.

Meade Starting Points

On ETX-90 and 125 models with mechanical stops, position the scope with the control panel aimed west. Unlock the azimuth axis, and turn the scope counterclockwise until it hits the hard stop. For LNT-equipped scopes, that's it. But older models must then be turned clockwise about one-third of a turn, until the fork arm with the numbered dial is over the control panel.

Polar Home Position 🕨

If you set up an ETX telescope as a polar-aligned equatorial, start with the scope in the home position: set to 90 degrees declination, with the base turned so that the control panel faces west. • The tripod should be fairly level, but there's no need to be overly fussy.

• Some telescopes require a starting position aimed as close to true north (Polaris) as possible. Don't aim at magnetic north (the direction a compass points).

• Aligning on the wrong star (Castor, for example, when the scope is asking for Pollux, just 4.5 degrees away) will cause the telescope to miss targets by a wide margin.

• Try to choose alignment stars that are widely separated in the sky. Stars that lie due north and south of each other can throw off some systems. The scope may accept the alignment, then fail to find things well. If so, try aligning on a different set of stars.

• Ensure that any add-on finderscope or red-dot device used to sight stars is aligned with the main optics.

• When aligning, move the scope only with the electric motions; do not unlock the scope or turn it by hand or shift the tripod.

• Always wait for the beep before hitting any motion button to center the star.

• Always check that internal batteries have not corroded after weeks of neglect.

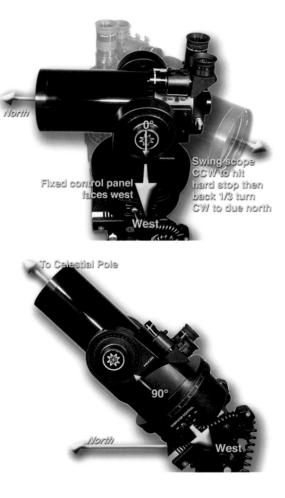

• If pointing at the Moon is consistently off, check whether you have entered the daylight-time correction.

• Don't worry about training periodic error correction—it is only for photography and has no effect on pointing accuracy.

• Don't worry about updating handcontroller firmware. Any problems are likely not because of old firmware.

• If the scope behaves oddly (running wild or failing to stop), check the batteries. Many scopes drain batteries so quickly, an external power source is a must, requiring the manufacturer's optional power cords or AC adapter. Get them!

• Always use cables and power supplies from the manufacturer; using others risks frying components (trust us, we know!).

• Altazimuth scopes will track stars only after completing a successful alignment.

FOR MEADE AUTOSTAR

• To activate the tracking motors, be sure your telescope is set for Targets: Astronomical (found in the Setup menu).

• An observing location may have been entered into your telescope already at the store. To see what location the scope is programmed for, go under Setup: Site, then hit Select. If you want to choose a new location, hit Add.

• Meade recommends not aligning on stars directly overhead or near the celestial pole (Polaris, in the northern hemisphere).

• Be sure the axes are snugly locked down. A loose axis will slip and lose alignment under motor control.

• When selecting a new target, always hit Enter (to put the object name in the top line of the display) before hitting GoTo.

• After problems caused by low batteries, it may be necessary to Calibrate Motors (found under Setup: Telescope). If problems persist, follow the instructions to Train the drive. Always train the drives with the scope set to the mode in which it will be used, either Polar or Altazimuth.

• For LNT scopes, the leveling/findingnorth dance takes awhile. This is normal.

FOR CELESTRON NEXSTAR

• Under the Menu button, set the Tracking to Altazimuth, then under Model Select, choose your telescope (scroll to it, and hit Enter).

• For 1-2-3 SkyAlign models, the scope must be carefully leveled if it is to correctly identify alignment targets in the SkyAlign mode. Other alignment modes, like Auto 2-Star Align, are not so fussy.

• If your telescope seems to run on or jerk backward after you hit a motion button, go into the Anti-Backlash settings (under Menu: Scope Setup) and set the values for each axis to between 010 and 050 to provide just enough backlash correction.

• When pressing one direction button, hold the opposite button down to momentarily accelerate the slew speed to Rate 9 this is handy when aligning.

FOR SKY-WATCHER SYNSCAN

• Like Celestron CG mounts, Sky-Watcher German equatorial mounts require a threestar alignment, with the controller picking two stars in the west, then one in the east. This is normal. Avoid stars that lie along a north-south line.

• The time must be entered in the 24-hour clock (e.g., 8 p.m. = 20:00).

• When doing the initial alignment, increase the slew rate from the default to a higher speed to slew the telescope over to the first alignment star.

• Like Celestrons, if the telescope seems to run on after you jog a motion button, go into the Alt Backlash and Az Backlash settings (under Setup), and set the values to 00 or some low value.

• Upgrading to version 3 or higher of the SynScan software (this requires a new hand controller) provides valuable new features and is worth the price.

FOR VIXEN STARBOOK

• When using the Starbook-S, turn on power to the motors first, then turn on the Starbook-S. Be sure the Starbook has fresh batteries.

• The Starbook does not pick alignment stars for you, and selecting them manually by scrolling around the star chart is tedious. Instead, go to Chart mode, and select them from the list under Objects: Star.

• Pick at least two stars in the west and two in the east.

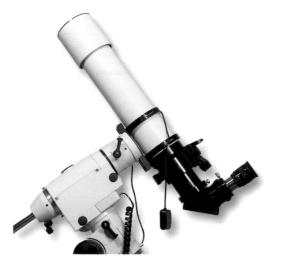

Resyncing on the Sky To improve pointing accuracy in one region of the sky, realign on a bright star in that area. On the Meade Autostar (top), slew to the new star. then center. Hold the Enter button for two seconds, then hit Enter again. On the Sky-Watcher with SynScan v.3 and higher (middle), do the same, but hit ESC for two seconds to get the recentering screen. On the Celestron NexStar (bottom), center the star in the eyepiece, then select that star under List: Named Stars, and press Align. When the display asks which of the two previous alignment stars you want to replace, choose the one closest to the new star, and hit Enter.

Sky-Watcher/Orion Starting Point

The HEQ5 and EQ-6 mounts and similar Orion Sirius and Atlas mounts require an initial starting position with the mount upright and closely polar-aligned and the scope aimed due north. The scope then slews to a spot close to the first alignment star. An optional GPS unit (shown) automatically inputs location and time.

◀ Vixen Starting Point Vixen mounts, like the Sphinx and GP-D2 shown here, require polar allgnment. The scope must then be aimed to the horizon due west as the initial starting position from which to slew to the first alignment star, which you select from the star map or a list of bright stars. Vixen Starbook ▼ Vixen mounts offer a GoTo controller, the Starbook, that includes a star map. (A smaller monochrome Starbook-S is available, but its display falls short of what even a PDA or smartphone running astronomy software can show.)

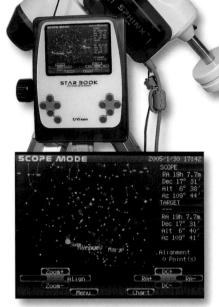

Planetarium Programs ► The two most powerful and popular realistic planetarium programs are Starry Night (top) and TheSky (bottom). Both are available in several editions, from basic to pro, for Windows and MacOS. The top-end versions have extensive deep-sky databases and can serve as detailed starcharting programs and scope-control software.

A Brief Guide to Software

While we never mentioned software in Chapters 4 and 5 when we dealt with recommended eyepieces and accessories, it is hard to imagine life now without a good astronomy-software package. It has become an essential accessory when planning observing sessions and photo shoots. By simulating the sky as it will appear on a future date, with planet positions, conjunctions and eclipses, software can help you determine how best to frame a scene with a camera and lens. You can also print out customized star charts and lists of targets for the night's viewing.

Here, we divide software into two main categories: sky simulation and star-atlas programs. Sky simulators will suit most observers' needs, while star-atlas programs are for hardcore deep-sky observers. Few of these programs will be available at your local computer store. To find them, visit on-line astronomy retailers and telescope shops. After purchasing a software package, visit the support website regularly

SKY-SIMULATION PROGRAMS

for updates and supplementary plug-ins.

The common feature of this class of software, often called a planetarium program, is the realistic depiction of the night sky, complete with landscape, twilight glow, lunar-disk details, even night sounds. Two programs that have taken sky simulation to extraordinary lengths are Starry Night (www.starrynightstore.com) and TheSky (www.bisque.com). Each is offered in three levels for both Windows and MacOS. The top-end programs can control a telescope and have a host of advanced star-charting features. The low-end or middle-level versions, however, have more than enough features to keep most observers happy for a long time. We use these programs extensively; indeed, many of the sky diagrams in Chapter 11 were created with these and other software packages.

Also in this league are programs such as

Voyager (www.carinasoft.com), available for both MacOS and Windows; the low-cost Equinox (www.microprojects.ca), for MacOS only; and Redshift (www.redshift.de), for Windows only.

STAR-CHARTING PROGRAMS

These programs make little effort to simulate the actual appearance of the night sky. The horizon might be drawn simply as a line, and the Moon and planets may appear as featureless dots or disks. Designed to be electronic star atlases, they plot every conceivable object and draw eyepiece and CCD-camera fields so that you are able to frame exactly what you will observe or image at the telescope.

The best programs in this class are certainly Guide (www.projectpluto.com) and MegaStar (www.willbell.com). Many deepsky observers have one of these programs running on a red-filtered laptop in the field beside a big Dob to identify every faint fuzzy in the eyepiece. However, we've also been

impressed with Earth Centered Universe (www.nova-astro.com). Loaded with deepsky databases, this is a great low-cost program to use to control a scope. Other programs that have a following are Cartes du Ciel (free at www.stargazing.net/astropc) and SkyMap Pro (www.skymap.com).

SPECIALTY PROGRAMS

NGC3 NGC4 NGC5 NGC5 NGC3 NGC1 NGC13 NGC12 NGC13 NGC14 NGC15 NGC15

Although all these programs have limited star-charting abilities, their forte is in being able to create lists of deep-sky objects that can be sorted and filtered to allow you to plan a deep-sky observing session. Included among the popular programs are Deep-Sky Planner (knightware.bix/dsp), Deepsky As-

User Obs. #2

tronomy Software (www.deepsky2000.com), both for Windows only, and AstroPlanner (www.ilangainc.com/astroplanner), for Mac and Windows.

Deep-Sky Charting MegaStar (top), from Willmann-Bell, offers a vast array of databases. Earth Centered Universe (far left), from Nova Astronomics, is also superb and low-cost, while Cartes du Ciel (left) is surprisingly powerful and free. All are for Windows only.

Deep-Sky Databases Many observers find a deepsky database program, such as AstroPlanner (far left) for Mac and Windows and Deepsky Astronomy Software (left) for PCs, helpful when planning observing sessions. Neither of us is in the habit of using one.

Lunar Atlases

Even lunar atlases have gone digital, with programs such as Lunar Phase Pro (far left) and the free Virtual Moon Atlas (left), both for Windows only. A digital atlas can show libration angles and the position of the terminator for accurately matching the eyepiece view.

PDA Software 🔺

Although handheld Personal Digital Assistants like this Palm Pilot are fast being replaced by all-purpose smartphones, they can both run astronomy software. One of the best programs is Astromist, available for Palm OS and Windows Mobile OS. Its features and displays rival laptop software.

Wired Connections

Connecting a recent-model laptop to a telescope requires a USB-to-serial adapter and the RS232 serial cable from the telescope manufacturer. The adapter creates a virtual serial port that appears as a COM port in Windows (check under Device Manager for COM number).

Wireless Connections ► To be able to talk wirelessly to a telescope's Bluetooth receiver, like Orion's Bluestar, might require adding a Bluetooth dongle to the laptop. Once connected to the scope's receiver, the Bluetooth device appears as either a new COM port or a device in the drop-down menu, as here on a Mac. The rise in popularity of Moon observing has inspired several lunar-atlas programs that simulate eyepiece views to help the user identify lunar features. Check out Alister Ling's Lunar Calculator, Lunar Phase Pro (lunarphasepro.nightskyobserver.com) and the excellent free Virtual Moon Atlas (www.astrosurf.com/avl). All these programs run only on Windows.

Getting Connected

OK, you've got a GoTo scope, and you've got software on a computer. It is a natural leap to connect the two so that the outboard computer can display the scope's position on an electronic star map and send the scope to targets at the click of a mouse. The first hurdle to overcome when making this connection is that all computers now use the USB (Universal Serial Bus) standard to connect to peripherals, while most telescopes require an old-style RS232 serial connection, often using a telephone-style RJ11 jack or a D-shaped DB9 connector. The solution is a USB-to-serial adapter (from Keyspan for Macs; Belkin and others for PCs). These are commonly found at computer and office-supply stores and usually come with driver software to install.

Once installed and connected, the computer then recognizes the adapter as a new serial port and offers it as a connect option under the Telescope Setup section of your astronomy software. Selecting the correct serial port is essential if the computer is to talk to the telescope.

You must select not only the right port but the right model of telescope, as even similar models within a brand can differ in their protocols for external control. If you have a new telescope but are using old astronomy software, your telescope may not be listed. If you get a "communication error" message, select another model of telescope or try another COM port—you may have to update your software. Many Windows programs use drivers from the ASCOM standard (ascom-standards.org).

The other key point is to have the right cable to go from your scope to the USB-toserial adapter (always use the one offered by the manufacturer of your telescope—cables that look alike might differ in the wiring).

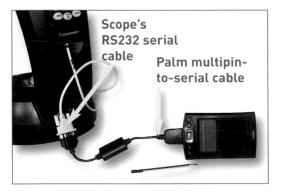

Then be sure you connect it to the right spot on the telescope (check the manual). For Meade #497 Autostars, for example, the serial cable connects to the hand controller, not the telescope. Most telescopes must be aligned and tracking before they can be connected to an external computer.

The other option is a wireless connection. For this, the computer must have Bluetooth wireless capability (built into most Macs, but many PCs require the addition of a plug-in dongle). At the telescope side, you will need a Bluetooth transmitter/receiver —Orion/Starry Night's Bluestar is one option, but we've also had success with the

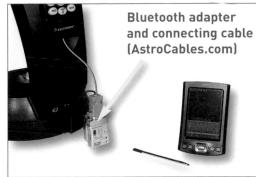

AirCable unit offered by AstroCables.com.

In testing the Bluestar, we had no problem connecting via a Mac once the driver software was installed as per instructions and the Bluestar was paired with the laptop, as it must be to enable the two to talk to each other in secure privacy. But making the connection with Windows was fraught with issues: A D-Link DBT120 dongle worked, but a DBT122 did not. For PCs, Orion suggests not installing the driver software that comes with the Bluetooth dongle but letting Windows install its own drivers. We had enough issues with Windows XP and have had no desire to testVista!

PDA Connections

You can connect PDAs and smartphones to a scope (far left) through a wired cable (Serialio.com is a good source) or, if the scope has Bluetooth (left) and a receiver, such as the AirCable unit here, wirelessly via software such as Astromist or TheSky Pocket Edition.

Going Remote

If you can control a telescope with a computer at the scope, why not control it with a computer in your warm house? Or why not have the telescope far away where skies are clear and it can slog through the night under robotic control while you sleep? All this is now doable. A setup at home might mean simply running some long USB cables out to your scope. A more sophisticated setup for a backyard observatory places a remote computer at the scope controlled by a host computer in the house via a WiFi connection. Of course, this assumes that you are happy capturing images through a telescope with a CCD or low-light video camera and have no desire to actually look through the scope.

The next step in complexity is controlling a distant telescope (and the dome that houses it) via an Internet connection. Some advanced amateurs have set up dream observatories at superdark host sites like New Mexico Skies and take stunning images while they live and work in light-polluted eastern North America. Companies such as Software Bisque have specialized in providing the hardware and software to make this possible. Of course, this scenario comes at a high price. By the time most of us might be able to afford such a remote robotic telescope, we'll be ready to retire and move to that site! Arizona Sky Village, in southeastern Arizona, is just such an astronomy retirement community; others are sure to follow as wealthy baby boomers retire.

A more affordable alternative to your own remote dream scope is to rent time on someone else's. Commercial operations like the novice-oriented Slooh.com (above right) sell imaging time on telescopes placed at world-class observatory sites. Rates range from Slooh's \$100 a year to upwards of \$50 to \$100 an hour charged by such specialized, high-end remote operations as Global Rent-a-Scope.

C H A P T E R F I F T E E N

Polar Alignment, Collimation and Cleaning

If German equatorial mounts (like the one depicted at right) and forkmounted telescopes with a wedge for angling them into equatorial mode are to track celestial objects, they must be polar-aligned. For the vast majority of backyard-stargazing situations, polar alignment requires little more than plunking the mount down with its polar axis aimed in the right direction. The time-exposure photo at right shows how, in the northern hemisphere, the mount's fixed polar axis points north to very near Polaris, the North Star. To polaralign a telescope, you don't need compasses, GPS receivers or calculations of magnetic deviation or sidereal time—just aim the polar axis at Polaris. Observers in the northern hemisphere have it easy—they have a bright North Star to aim at. But in the southern hemisphere, there is no convenient "South Star." This chapter provides polar-aligning details.

Later in the chapter, we focus on a chore reflector owners must perform now and then: collimation. This process involves adjusting the tilt of the mirrors so that light rays hitting the main mirror on-axis form an image in the exact center of the eyepiece. If the optics are out of collimation, stars in the center of the field will look like comets flared to one side. In severe cases, nothing reaches sharp focus.

Inevitably, after a cold night of observing, frost will form on equipment that is brought into a warm home. To avoid frost on the optics —always a good idea—cap the main optics and pack the telescope and eyepieces in their cases first. Then carry the protected optics inside to allow them to warm up gradually. This will prevent condensation from forming on the optics and leaving a filmy residue.

Sooner or later, though, dust and grime get on optics and a cleaning is required. But the rule is, clean optics only when absolutely necessary. Vigorous cleaning can scratch optics and coatings, inflicting more harm than some dust and dew spots.

As the sky turns through the night, it revolves around Polaris, the North Star, which barely moves. Polar-aligning is a simple matter of aiming the mount's polar axis at this star.

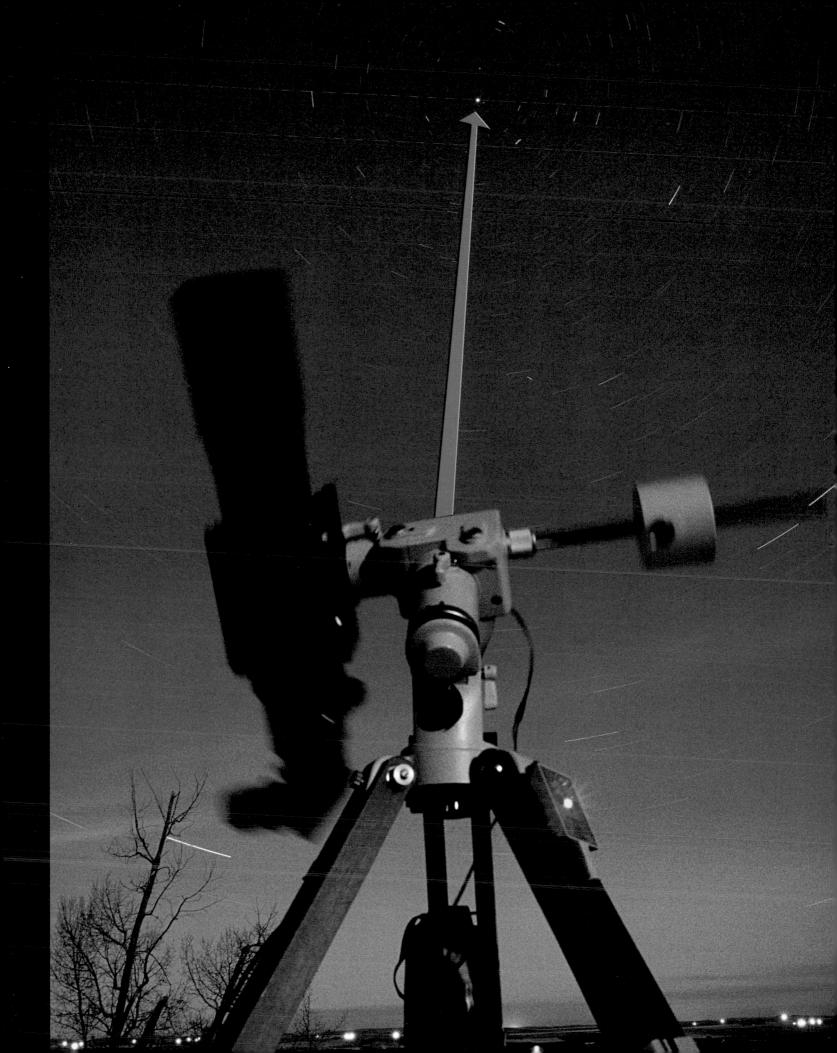

Up the Axis 🔺

The yellow arrow shoots through the polar axis of this German equatorial mount. The axis needs to be set at an angle equal to your latitude on Earth, then aimed due north at night to Polaris (or due south, if you live in the southern hemisphere).

Aligning a Fork

This Schmidt-Cassegrain telescope is set to 90 degrees declination, so the fork arms and main tube both aim toward the celestial pole. With the scope set like this, use the wedge's altitude and azimuth adjustments (or shift the tripod legs) to aim the finderscope, and therefore the main telescope, at the pole. It is important to adjust the finderscope first so that it does, indeed, point to exactly the same place in the sky as do the main optics. Note that aligning a GoTo fork-mounted scope in this manner is necessary only if you wish to take longexposure astrophotos.

The Quick Way to Align

Rigorous, time-consuming methods of precise polar alignment are necessary only for advanced astrophotography. For general observing, snapshots of the Moon or wideangle piggyback exposures, an alignment within one or two degrees of the celestial pole will be adequate. This is accomplished in a few seconds by adjusting the tripod to aim the polar axis toward Polaris, the North Star, as closely as possible.

Schmidt-Cassegrains can be aimed by peering up one of the fork tines and raising or lowering adjustable tripod legs to achieve approximate alignment. Precise leveling is a waste of time for casual viewing. The polar axis of German equatorial mounts can be eyeballed toward Polaris, as shown at left and on the previous page.

More Accurate Methods

For more demanding applications, particularly astrophotography, the telescope's polar axis should be within five arc minutes of the true celestial pole. The north celestial pole is conveniently near Polaris. To be exact, the true pole lies 0.9 degree from Polaris in the direction of Alkaid, the end star in the handle of the Big Dipper.

If you are observing from the southern hemisphere, locating the south celestial pole is a little more difficult. It lies one degree from a 5.4-magnitude star in Octans known as Sigma Octantis, a dim naked-eye star.

The finder charts included in this chapter will help you zero in on the celestial pole, north or south. With charts in hand, the first step is to aim the telescope's polar axis at the pole.

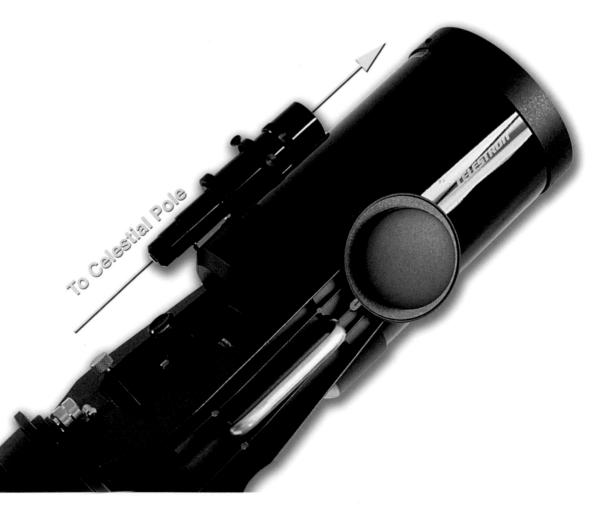

Finder Chart: North Celestial Pole

The Big Dipper's pointer stars aim at Polaris. This finder chart will help you aim your telescope's polar axis toward the precise location of the north celestial pole. Keep in mind that simply centering Polaris will provide sufficient accuracy for most visual observing.

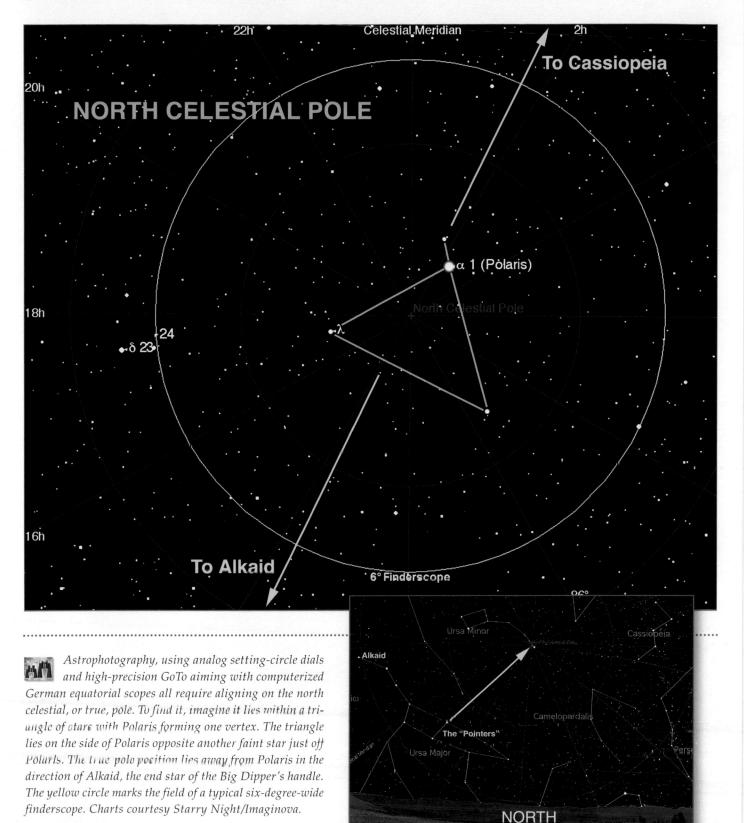

POLAR-ALIGNING A FORK-MOUNTED TELESCOPE

Which one is the polar axis? In fork-mounted telescopes such as Schmidt-Cassegrains, the polar axis is the one the forks revolve around. The other motion, which swings the tube up and down through the fork arms, is the declination axis. To be polar-aligned, the polar axis, and therefore the fork tines, must be aimed at the celestial pole. This requires a wedge, usually optional on GoTo models.

1. First, adjust the altitude setting on the wedge to an angle equal to your latitude. From a latitude of 40 degrees north, set the angle on the latitude scale to 40 degrees. This can be done at any time, even indoors.

2. At the observing site, place the telescope so that its forks are aimed northward. You can roughly level the telescope tripod if you wish, but precise leveling is not necessary.

3. Swing the tube so that it reads 90 degrees declination on the circles on the side of the tube, and lock it there. This should put the tube parallel to the forks. For GoTo scopes lacking circles, use the controller to point the telescope to a declination of 90 degrees.

4. Move the telescope left to right to center the pole in the finderscope (for a rough alignment, centering Polaris will suffice). Do this by moving the whole tripod or by using the fine azimuth adjustments on the wedge. Do not alter the telescope tube's declination or right ascension.

5. Move the telescope up and down to center the pole in the finderscope. (For this to work, the finder must be aligned so that it points precisely where the main optics are pointed.) This may mean raising or lowering a tripod leg (it is usually best to have a tripod leg pointing south for this) or using fine altitude adjustments on the wedge. Again, do not move the declination axis.

6. You may find it necessary to adjust the azimuth and altitude a few times to refine the aim point. With practice, this takes only 5 to 10 minutes. To aim at the north celestial pole, move the entire telescope so that the finderscope crosshairs are 0.9 degree from Polaris along a line toward the end star in the Big Dipper's handle. If that star is not visible, use a line joining Polaris and Epsilon (ϵ) Cassiopeia—the first star in the distinctive W shape—but still offset toward the Big Dipper's handle.

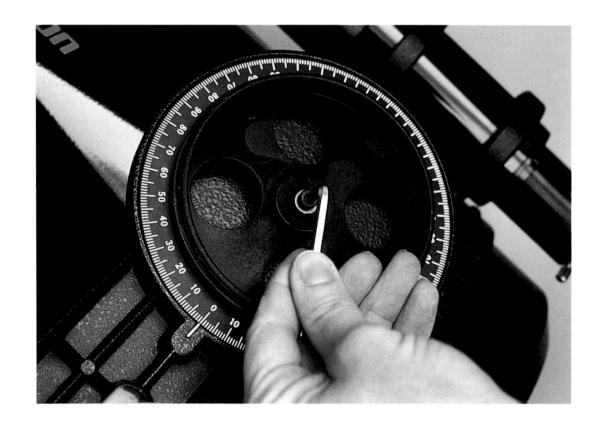

Calibrating the Declination Circle

To locate the pole with the finderscope, the declination setting-circle reading must be accurate. In other words, when the telescope is set at 90 degrees declination, the tube must be aimed at the same spot the polar axis is pointed. Declination circles can slip, so a setting of 90 degrees may not, in fact, be 90 degrees. Swing a fork-mounted telescope in declination so that it parallels the forks as closely as the eye can judge. For German mounts, move the instrument to bring its tube parallel to the polar axis. Look into the eyepiece of the main telescope at low power, and watch the stars (any stars) as you rotate the telescope around the polar axis. Do the stars circle the center of the field? If the telescope is truly set to 90 degrees declination, they will. If not, move the telescope slightly in declination to see whether the situation improves. Keep adjusting the declination until the stars move in concentric circles when the instrument is rotated in right ascension. Now, loosen the declination circle (it is designed to move), and set it to show 90 degrees. Once tightened, the declination circle should not need calibrating like this again.

Finder Chart: South Celestial Pole

Locating the south celestial pole is a challenge. It lies in one of the blankest regions of sky, with no bright "South Star" nearby. Alpha (α) and Beta (β) Centauri (called the pointers) aim at the Southern Cross, while the upright of the Cross points across the sky to the pole.

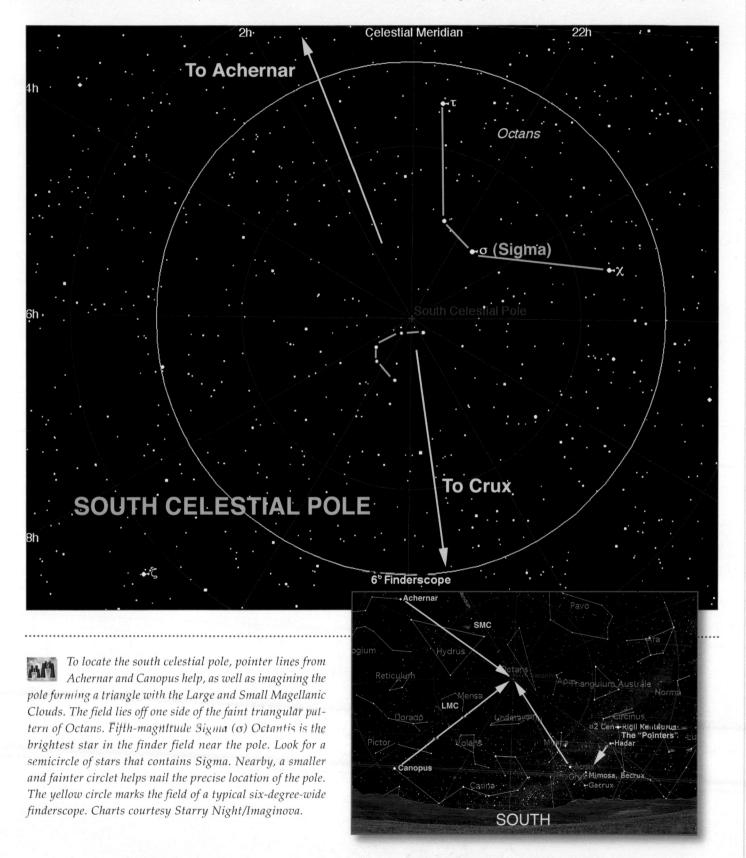

Polar-Scope Option 🔻 Many modest and premium German equatorial mounts, such as this Chinese-made EQ-3 model, offer polaraxis sighting scopes as a worthwhile option. (The lowest-cost entry-level mounts lack hollow polar axes.) While it is possible to roughly polar-align by sighting through the empty polar axis, a sighting scope like this makes it easier to zero in on the true pole. The large bolt seen here moves the mount up and down in altitude (needed when changing latitude). The main problem with this method is that it can be difficult to find the correct pole location, since it lies in a blank area of sky. Moreover, it is easy to move off the pole star by the required amount but in the wrong direction. In a straight-through finderscope, the sky appears upside down; in a rightangle finderscope, the sky is right side up but flipped left to right. Most finderscopes have a field of view about six degrees wide, which means that when the true celestial pole is in the center, the pole star (Polaris or Sigma Octantis) is about one-third of the way from the center to the edge of the field.

POLAR-ALIGNING GERMAN EQUATORIAL MOUNTS

The finderscope method described above can be applied to all telescopes on German equatorial mounts. The declination axis on such mounts has the telescope on one end and the counterweight on the other. The polar axis—the one the clock drive turns has the declination axis attached to it and is the part of the mount that must be aimed at the pole.

First, set the angle of the polar axis to your present latitude using the adjustment

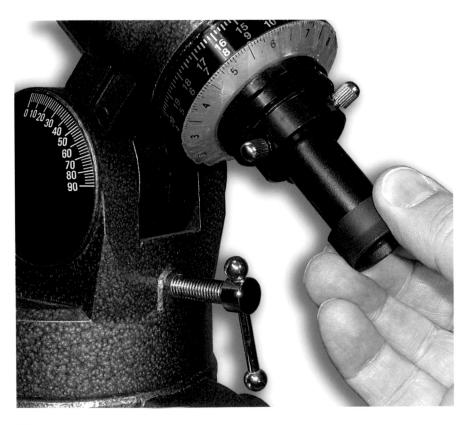

at the base of the mount—usually a large bolt with a graduated dial showing 0 to 90 degrees. Take extra care, though, because the whole mount can flop down when this bolt is loosened. If the telescope has a graduated dial, set the latitude and tighten the bolt. This adjustment should be made only once, when the instrument is purchased, unless the telescope is transported north or south to a new latitude (traveling east or west makes no difference). If the equatorial mount does not have a graduated circle for a local latitude setting, follow the steps in the next paragraph; otherwise, skip ahead.

Latitude adjustment: At the observing site, place the telescope so that the polar axis aims as close to Polaris as possible using the eyeball method. Adjust the tripod legs to level the base of the mount. (This is one case when you do have to level the mount. Some mounts have bubble levels for this purpose.) Swing the tube in declination so that it is at 90 degrees as read on the declination circle—the circle nearest the tube or the counterweight. The tube is then parallel to the polar axis and is pointed in the same direction. Lock both axes. Carefully loosen the bolt that clamps the tilt of the polar axis, and adjust it until Polaris is seen in the finderscope midway between the top and bottom of the field (not necessarily centered, just midway). Now tighten the bolt, and that should set the latitude angle. This procedure is necessary only once.

After the latitude adjustment is made and the telescope is leveled, the polar axis will be at the correct angle if it is aimed toward Polaris. On subsequent setups, with the tube at 90 degrees declination, use the fine altitude and azimuth adjustments on the mount to move the telescope left and right and up and down to center the pole area in the finderscope. If your telescope has no fine adjustments, alter the height of the south-pointing tripod leg and nudge the tripod left or right.

Most German equatorial mounts with GoTo computers must also be polar-aligned in order to find objects well. This can be done with the old-fashioned method (sighting up the polar axis). However, software routines can automatically swing the scope to where Polaris should be. You then use the mount's altitude and azimuth adjustments to center Polaris.

Polar-Alignment Sighting Scopes

Polar-alignment telescopes have reticles that show how far to offset from Polaris to center on the true celestial pole. (Other marks help in lining up the south celestial pole.) This is the pattern in one type of polar scope, but others are similar, with spots for key "guide stars" or a crosshair to show you the line from the Big Dipper through Polaris, to the true pole, then on to Cassiopeia. Don't fuss with dialing in sidereal time. Just rotate the polar scope or the entire polar axis so that the Dipper-to-pole line or the guide-star slots coincide with the real sky. Note that the image in the polar scope appears inverted, while the reticle pattern coincides with the naked-eye view. That is normal.

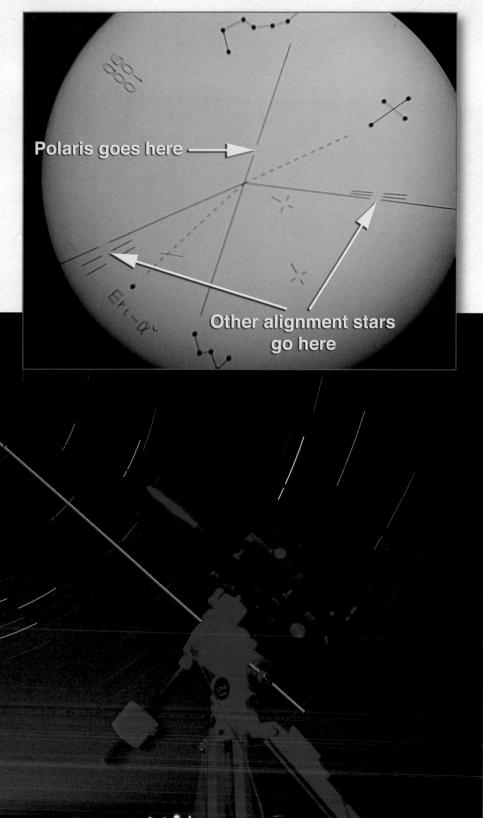

Changing Latitudes 🔺 The adjustments at the base of this and most equatorial mounts are suitable for the fine positioning needed to polar-align. After a major move north or south in latitude, you may need to loosen the main bolt(s) on the altitude axis to raise or lower the mount to set it for your new latitude. Traveling east or west but staying at the same latitude makes no difference to your mount's adjustments. For more information on basic setup and operation of a beginner's telescope, see Chapter 6.

Highly Precise Methods

Serious astrophotographers require stars to stay within a few arc seconds of their intended spot for an hour or more. This requires high-precision alignment.

THE SINGLE-STAR METHOD

With practice, this technique—described by Dennis di Cicco in the December 1986 *Sky* & *Telescope*—takes only 10 minutes. First, follow the steps in the previous section to align the mount with the celestial pole. Then aim the telescope at a bright star near the celestial equator whose right ascension is known, preferably in coordinates for the current year or so (see table opposite).

With the star centered in the eyepiece, rotate the right ascension setting circle so that it displays the star's right ascension. Now swing the telescope back until the circles show the coordinates of Polaris (2008: R.A. 2h 40.6m Dec. +89° 18'). Move right ascension first, then declination. When you swing the mount in declination, be sure you stop at the first 89-degree setting. Do not go past the 90-degree mark to the 89degree mark on the other side. Lock the mount in right ascension and declination. Don't worry if Polaris is not in the field.

Using the mount's fine altitude and azimuth adjustments, move it until Polaris is in the center of the field of a medium-power eyepiece. Do not move the declination or right ascension motions. Once Polaris is in the center, unlock the telescope and swing it back to the calibration star. Adjust the right ascension circle again, if necessary. Repeat the procedure. Each repetition should require fewer adjustments. If the starting position was fairly close, only a couple of iterations should be needed to zero in on the pole. As di Cicco points out, this method also works in the southern hemisphere with Sigma Octantis and its coordinates (2008: R.A. 21h 16.3m Dec. -88° 55').

If this technique is used often, keep the pertinent coordinates handy in a logbook. Or if the telescope is set up in the same spot every night, mark the ground so that the tripod returns to the same orientation.

THE TWO-STAR METHOD

Although more time-consuming, this is the method of choice for perfectionists. It is also the best way to achieve the final alignment of the mount when setting up a permanent site or a backyard observatory.

Again, use a simpler method to polaralign, then aim the telescope at a star on the celestial equator due south. If possible, put an illuminated-reticle eyepiece in the telescope, and align the crosshairs so that they run parallel to the lines of right ascension and declination motion. Ensure that the drive is running. Now watch the star carefully. Ignore any drift it makes east or west in right ascension, but watch for a drift in declination, that is, north or south. It may take a few minutes to show up.

• If the star drifts *north*, the polar axis is aimed too far *west* (it is to the left of the actual pole in the northern hemisphere).

• If the star drifts *south*, the polar axis is aimed too far *east* (to the right of the pole).

Be careful. Make sure you know which way north is in the eyepiece. Move the mount in azimuth in the appropriate direction, then go back to the star, and watch again. Has the drift improved? No drift should appear even after 20 minutes.

Once this stage is satisfactory, point the telescope at another star on the celestial equator, but one that is rising in the east. Observe it for a while, again ignoring any drift in right ascension.

• If the star drifts *north*, the polar axis is aimed too *high* (it is above the pole).

• If the star drifts *south*, the polar axis is aimed too *low* (it is below the pole).

Adjust the altitude of the polar axis accordingly. If the initial setup was good, only a small adjustment should be required. Now go back to the east star, and watch again. The drift should improve. Repeat all the steps. In the southern hemisphere, substitute south everywhere we have said north, and vice versa. Such a tedious procedure is best reserved for permanent setups or for times when only perfection will do.

Star	Name	R.A.	(2008)	Dec.	Sky
α Andromedae	Alpheratz	00h 08.8m		+29° 08′	northern autumn
α Arietis	Hamal	02h 07.6m		+23° 30′	northern autumn
lpha Tauri	Aldebaran	04h 36.4m		+16° 31′	northern winter
α Canis Minoris	Procyon	07h 39.7m		+05° 12′	northern winter
α Leonis	Regulus	10h 08.8m		+11° 56′	northern spring
a Boötis	Arcturus	14h 16.0m		+19° 09′	northern spring
a Scorpii	Antares	16h 29.9m		-26° 27′	northern summer
α Aquilae	Altair	19h 51.1m		+08° 53′	northern summer
α Eridani	Achernar	01h 38.0m		–57° 12′	southern hemisphere
α Carinae	Canopus	06h 24.1m		-52° 42'	southern hemisphere
α Cruxis	Acrux	12h 27.0m		-63° 08′	southern hemisphere
α Centauri A	Rigel Kentaurus	14h 40.1m		-60° 52′	southern hemisphere
α Piscis Austrini	Fomalhaut	22h 58.1m		-29° 35'	southern hemisphere

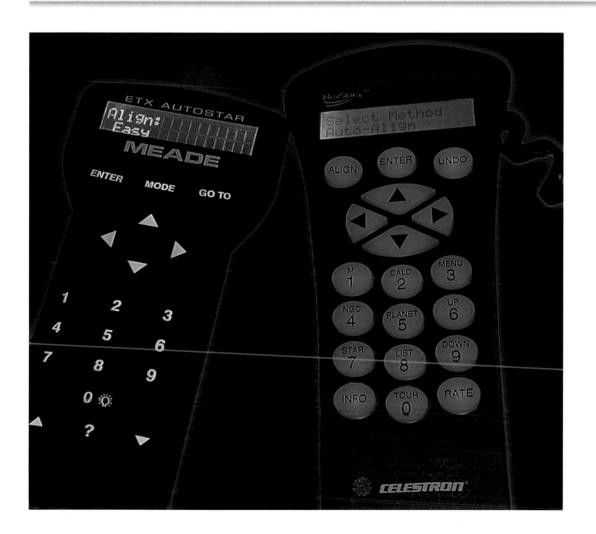

◀ Alignment, GoTo-Style Some computerized GoTo telescopes, such as the fork-mounted models, do not require polar alignment to find and track objects. Initially, however, they must be aimed at two stars, a process called "alignment." But GoTo scopes on German equatorial mounts, such as Meade's LXD-75 and Celestron's CGE and Advanced Series, do require at least rough alignment of the polar axis to the celestial pole to find and track objects accurately. Meade's Autostar, Celestron's NexStar and GoTo systems from other manufacturers contain software to aid polar alignment Computerized versions of the "single-star" method described opposite, they automatically aim at where Polaris should be.

Lens Cleaning Tips 🔻 • Do not use cleaning solutions or cloths sold for eyeglasses. These can leave filmy chemical smears. • Camera lens cleaners work fine for the small surface area of an evepiece but can smear larger areas of telescope optics. Instead, use our homebrew formula (see text). • Do not apply fluid directly onto a lens, as it can seep into lens cells and into the interior of eyepiece barrels. Clean eyepieces using a moistened cotton swab (below left). • Never take an eyepiece apart to remove eyepiece lenses from their mountings. You may never get them back correctly. In some refractors, it is possible to remove the front lens assembly (below right). This may be necessary to get at the rear lens surface, where stains can appear. But never take doublet or triplet refractor lenses apart or remove the lenses from their cell. Replace the cell in the same orientation on the tube that you found it.

Cleaning Optics

The number-one rule of optics care is preventing the intrusion of dust and fingerprints in the first place. Keep the optics covered when not in use! When dust does accumulate on the optical surfaces, remove it promptly while it is still dust, before a night of heavy dew transforms it into mud.

The best plan is to mix your own cleaning fluid: Use a 50-50 ratio of distilled water and isopropyl (rubbing) alcohol (the cheapest and least aromatic variety). Then add a few drops of dishwashing (*not* dishwasher) liquid, just enough to undo the surface tension that causes beading of the wateralcohol mixture on polished glass. This brew is a potent cleaning agent that is safe to use on any antireflection coating, and it dries clean with a minimum of polishing.

CLEANING EYEPIECES AND LENSES

Of all optical components, eyepieces require the most cleaning. The eye lenses pick up grease and oil from eyelashes and from misplaced fingers fumbling in the dark. In refractors and catadioptrics, the front lens or corrector plate can gather dust. If dew is allowed to form on these surfaces often, a filmy residue can accumulate.

1. First, blow loose dust and dirt off the exterior lens surfaces with a bulb-blower brush or a can of compressed air. (Be care-

ful with the canned air: If you tilt the can, some of the propellant may sputter out, spotting the optics with chemical gunk.)

2. Next, use a soft camel-hair brush and very light strokes to remove loose specks. Any that remain could scratch the surface when you perform the following step.

3. For eyepieces, moisten a cotton swab (a Q-tip) with a few drops of the cleaning fluid mentioned earlier. For a larger lens, moisten a cotton ball.

4. Gently wipe the lens. Do not press hard. If the stain is stubborn, use new swabs or cotton balls. Sometimes, gently breathing on the lens can help remove stains.

5. Use a dry swab or cotton ball for a final cleaning of moist areas, plus some more air puffs to blow off the bits of tissue that inevitably remain. There may still be a few smears, but a final polish with a light condensation from your own breath will restore the pristine appearance.

With Schmidt-Cassegrains, the front corrector plate, complete with the secondary mirror attached, can be removed from the front of the tube. But use extreme care; the corrector plates are very thin. Getting at the inside surface of the corrector may be required if the interior of the telescope has become contaminated with dust or moisture. *Important:* The corrector plate/secondary mirror assembly must be returned in exactly the same orientation you found it.

Remove mirror carefully

CLEANING MIRRORS

For most of the lifetime of a Newtonian, the primary and secondary mirrors should require only the occasional blast of canned air and a few strokes of a camel-hair brush. Aluminized surfaces can scratch easily, and a mirror full of microscopic scratches is far worse than a mirror with a few isolated specks of dust. Wash a mirror only if it develops a thick film of dust or grime. Follow these steps:

1. Remove the cell from the end of the tube, a task that might require some prying. Then loosen the three clips to remove the mirror from its cell.

2. Once the mirror is free from the cell and safely on a table, use a blower and brush to remove as much dust as possible.

3. Place the mirror on edge in a sink on a folded towel to prevent it from slipping.

4. Run cold water over the front of the mirror to wash off more dirt. Don't worry; this will not remove the aluminum coating.

5. Then fill the sink with warm water and add a few drops of a gentle liquid soap.

6. Lay the mirror flat on the towel in the sink, submerged under about half an inch of water. Use sterile cotton balls to swab the mirror gently. Always brush in straight lines across the surface. Never rub or use circular motions. Repeat with fresh cotton balls, moving perpendicular to the first swipes.

7. Drain the sink, then rinse the mirror with cool water.

8. Perform a final fluse with bottled dirtilled water (tap water can leave stains).

9. Let the mirror dry by standing it on edge. The mirror should not have to be subjected to this treatment again for many years.

▲ Washing a Mirror

Removing this mirror from its cell (top left) required pulling it free from dabs of silicone glue. Place the mirror on a towel in a sink. Remove any rings from your fingers to avoid scratching the mirror. Clean the mirror using the weight of the wet cotton ball as the sole source of pressure (top right). Rinse the mirror with distilled water, and stand it on edge so that the water runs off without staining (bottom left). When replacing the mirror in the cell (bottom right), tighten the clips until they just touch the mirror. Overtightening will pinch the mirror, introducing astigmatism. It is now necessary to recollimate.

OK, Bad and Awful ▲
 A star at high power as

 seen in a Schmidt-Casse grain is depicted here

 with, from top to bottom:

 1/4-wave of coma from
 slight miscollimation;
 1/2-wave of coma from
 poor collimation;
 1-wave of coma from
 severe miscollimation.

 Bottom two scopes would

 produce blurry images.

Collimating Cassegrains 🕨

Take two precautions when collimating a Schmidt-Cassegrain telescope:
Do not overtighten the three screws. If they warp the secondary, you'll see astigmatic star images.
Some cells (not this one) have a central screw. Do not loosen this; it holds the secondary mirror in place.

Collimating the Optics

To test for poor collimation, slowly rack a bright star out of focus. If the resulting expanding round disk is not symmetrical, there is a problem. On reflectors, the test is especially easy, because the central dark shadow that is cast by the secondary mirror should be dead center in the out-of-focus blur circle.

Commercially made refractors or Maksutovs are collimated at the factory and generally offer no user-adjustable settings. In the event that their optics do require collimation, it usually means a trip back to the manufacturer.

However, if you have a Newtonian or a Schmidt-Cassegrain, collimation is something you should be aware of. Telescopes can arrive out of collimation from the factory. And the accumulation of small shocks from road trips and nightly temperature changes over time can eventually degrade the alignment of mirrors.

COLLIMATING SCHMIDT-CASSEGRAINS

These are the simplest telescopes to collimate. The adjustments are done strictly using the three small screws on the secondary mirror cell. (The screws on some models are hidden behind a protective plastic cover that must be pried off or turned to reveal the collimation screws.) The idea is to use these screws to adjust the tilt of the secondary mirror so that it projects the light beam straight down the center of the telescope. On most Schmidt-Cassegrains, the secondary mirror magnifies the focal length by a factor of five; its collimation is therefore extremely critical. Even a slight maladjustment can degrade performance. Always approach collimation with a light handa mere fraction of a turn might be all that is required.

COLLIMATION PROCEDURE

1. On a night with steady star images, set up the telescope, and let it cool to outside air temperature. This may take up to an hour

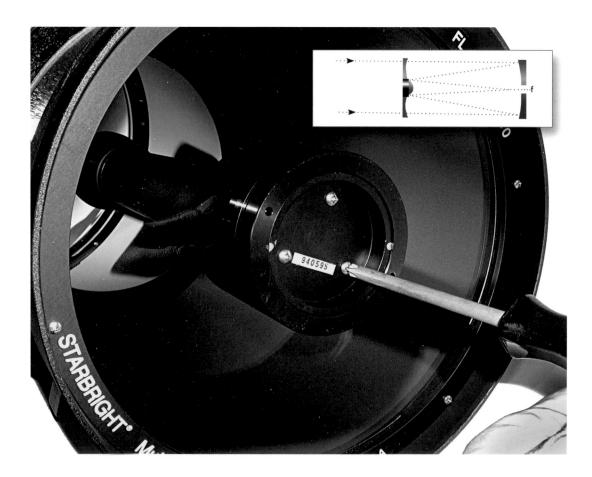

but is important, as the effects of thermal plumes can mimic poor collimation.

2. Aim the telescope at a second-magnitude star high above the horizon. Polaris is a good choice, as it won't move much during the process. Use a medium-power eyepiece, but if possible, do not use a star diagonal, because it can introduce collimation problems of its own.

3. Place the star dead center, then rack it out of focus until it is a sizable blob. If the telescope is out of collimation, the secondary mirror shadow will appear off-center.

4. Using the slow motions, move the telescope so that the star image is displaced from the center of the field. Move the telescope in the direction that makes the central shadow appear better centered.

5. Now turn the collimation screw that moves the out-of-focus star image back toward the center of the field. This takes trial and error. Remember to make very small adjustments.

6. If the image is still asymmetrical, repeat Steps 4 and 5. Turning one screw may not be sufficient. A combination of two may be required. If one screw gets too tight, loosen the other two to perform the same move. At the end of the whole procedure, all three screws should be finger-tight.

7. Once you have completed this at medium power, switch to high power (200x to 300x). Any residual collimation error that remains after Step 6 will show up now, especially if you rack the star just slightly out of focus. Perform Steps 4 and 5 again, making even finer adjustments.

You can do this procedure to a fair degree of accuracy during the day. Sight a distant power-pole insulator or a piece of polished chrome trim. Look for a specular glint of sunlight—it can serve as an artificial star. For the final adjustment, use a star at night.

COLLIMATING NEWTONIANS

Both mirrors in a Newtonian are subject to adjustment, which complicates the process. But you can bring Newtonian mirrors

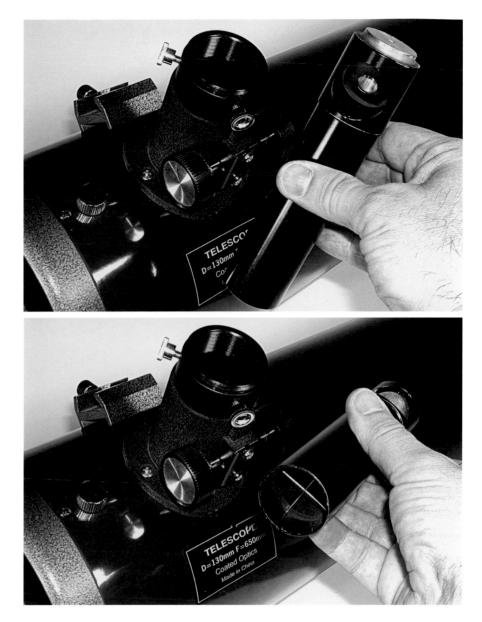

into close collimation in the comfort of your home simply by examining the appearance of the various reflections while looking down the focuser. To do this, you'll need to make a "collimating eyepiece."Drill or punch a pinhole in the exact center of a plastic eyepiece drawtube dustcap (one supplied with your scope or one from a telescope dealer). This makeshift device keeps your eye in the center of the focuser tube.

An alternative is a collimation tool such as a Cheshire eyepiece (shown above). A laser collimator, although more costly, also works well and is a worthwhile aid for keeping fast focal-ratio Dobs in line. You adjust the mirrors so that the laser's dot falls in the center of the mirrors, then reflects back on itself, hitting the bottom of the collimator. Collimation Eyepiece

A Cheshlre eyepiece con tains a small peephole (top) and an angled reflector for lighting up the secondary mirror. This model also has crosshairs (above) to aid in centering the optics. Suppliers such as Orion coll these tools. For more information on collimating Newtonians, see the June 2002 issue of Sky & Telescope or go to S&T's website: www.skyandtelescope.com/ howto/diy

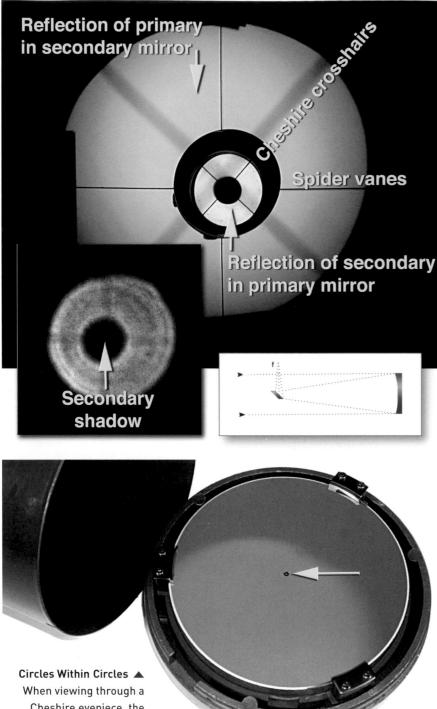

Circles Within Circles A When viewing through a Cheshire eyepiece, the crosshairs and the secondary's spider vanes should intersect at the center of the various reflections (top). This scope needs work, as revealed on a defocused star (inset) showing an offcenter secondary shadow. A black ink dot at the precise center of the primary mirror (above) is a great aid for centering optics.

COLLIMATION PROCEDURE

1. The first step is to center the secondary or diagonal mirror. It should be in the center of the tube and directly underneath the focuser. To get it in the center of the tube, adjust the spider vanes so that they are of equal length—simple! This should rarely be necessary with new commercial scopes.

2a. To get the mirror directly under the focuser, turn the threaded rod on which the secondary-mirror holder sits. This moves the secondary up and down the length of the tube. Look into the focuser through your collimation eyepiece to see whether the secondary mirror is centered on the focuser hole. Do not worry about any off-center reflections in the diagonal mirror; just get the mirror itself positioned.

2b. Rotate the diagonal holder until the top of the holder is directly under the focuser (so that the diagonal is not turned away from the focuser tube). It is fairly easy to eyeball this. (On most new commercial telescopes, Steps 1 and 2 should rarely be necessary. Homemade or used telescopes, however, can have many collimation ills.)

3. Adjust the tilt of the secondary mirror. This is where most Newtonian owners will need to start. To do this, adjust the three collimation screws on the diagonal holder so that the reflection of the main mirror. Ignore the reflection of the spider and secondary mirrors for now; just concentrate on getting the perimeter of the main mirror nicely lined up with the outline of the secondary mirror. So far, you have not touched the main mirror at all. That is next.

4. At this point, the main mirror's reflection of the spider and diagonal holder probably looks off-center. To bring them in line, you'll need to adjust the three collimation screws on the main (primary) mirror cell. The dark diagonal-mirror silhouette should end up in the center of the reflection of the primary mirror, which itself is centered in the secondary mirror.

5. Once the coarse mechanical adjustments are made, take the telescope out at night and check the out-of-focus star images to see whether they are symmetrical. Wait for the telescope to cool down, then follow the procedure outlined under Schmidt-Cassegrains (see page 328), but with a difference: Use the three collimation screws on the primary mirror cell to do the final fine-tuning with a magnified star image. Do not adjust the secondary mirror. In future, it is the primary that you'll usually need to adjust.

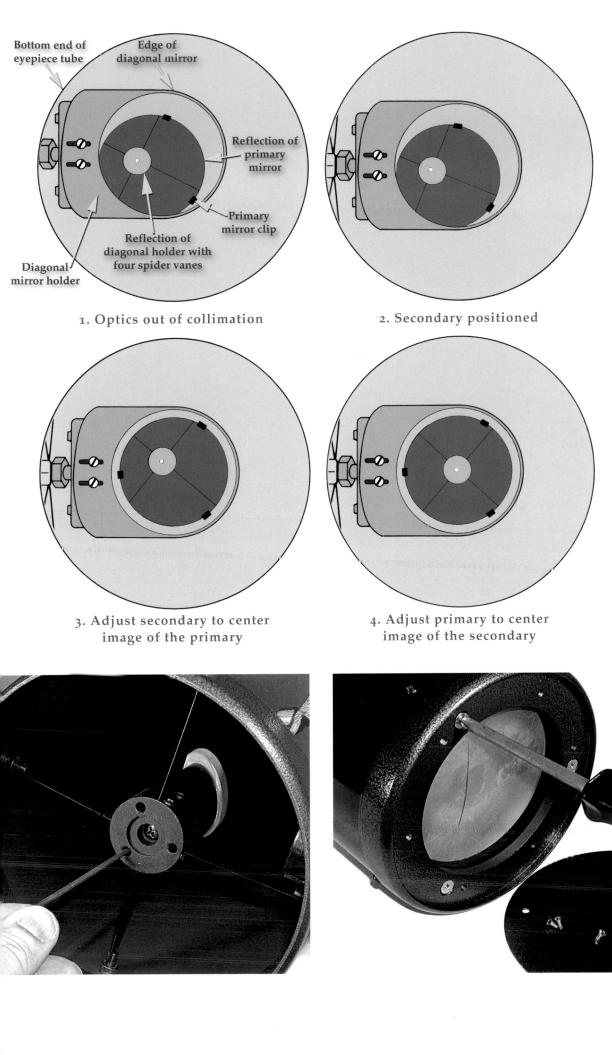

◀ Collimating a Newtonian The diagrams depict the view down the open focuser of a typical Newtonian.

1. Assess the situation. In this extreme case, the mirrors are out of collimation and the secondary mirror is not even centered in the focuser.

2. Physically position the secondary. Adjust the length of the spider vanes, and turn the diagonal mirror so that it is centered in the focuser's aperture.

3. Adjust the secondary mirror's three tilt screws (see photo bottom left). This may take a small Allen or hex wrench in a metric size. The goal is to center the reflection of the main primary mirror so that the final view looks like diagram 3.

4. Adjust the primary mirror's three tilt screws. Loosening two may be needed in order to tighten the third to provide sufficient tilt. The goal is to center the reflection of the secondary in the primary's reflection so that the final view looks like diagram 4. In the telescope at bottom right, the collimation screws are behind a plate that must be removed first. The Perfect Image ▼ Here, we compare two popular classes of telescopes:

4-inch Refractor

When in focus on a bright star, an unobstructed telescope produces a bright Airy disk surrounded by a faint inner diffraction ring (assuming textbook-perfect optics). Out of focus, the image expands to filled-in diffraction disks that look identical both inside and outside of focus.

8-inch Schmidt-Cassegrain

With its larger aperture, a Schmidt-Cassegrain telescope produces a smaller Airy disk in focus, but with a brighter first diffraction ring—an effect of the obstructed aperture. Although still identical, the two extra-focal images look more like donuts.

Star-Testing Optics

Final collimation often requires examining a star at high power, both in focus and out of focus. This is a sensitive test that can also reveal flaws and defects in the optics. It is a powerful way to check optics for quality.

THE IN-FOCUS DIFFRACTION PATTERN

At high power, a star looks like a distinct spot surrounded by a series of concentric rings, with the innermost ring being the brightest and most obvious. This is called the diffraction pattern. The spot in the middle is known as the Airy disk. Any telescope that claims to be "diffraction limited" must create a good likeness of that pattern. Your telescope may not produce as perfect a bull's-eye as we've depicted. Few scopes do. To see a perfect diffraction pattern, mask your telescope down to a one-to-two-inch aperture. Then focus the telescope on a bright star well above the horizon, using a magnification of 100x to 150x. You should then see a classic diffraction pattern that can serve as a standard of comparison when testing telescopes.

THE OUT-OF-FOCUS DIFFRACTION PATTERN

With the telescope stopped down, slowly rack the star out of focus. You'll see an expanding pattern of rings emerge. Defocus the instrument to the point where four to six rings show. Except for a fat outer ring, the light should be spread more or less uniformly among the rings. Now rack through focus to the same place on the other side of focus. The pattern should look identical, with a uniform distribution of light within the rings.

In an unobstructed telescope, such as a refractor, the out-of-focus pattern will be filled in. In an obstructed telescope (a reflector with a secondary mirror) the out-offocus pattern will look more like a donut. Examining the appearance of an out-offocus star image (called the extra-focal image no matter which way it is defocused) is the essence of the star test.

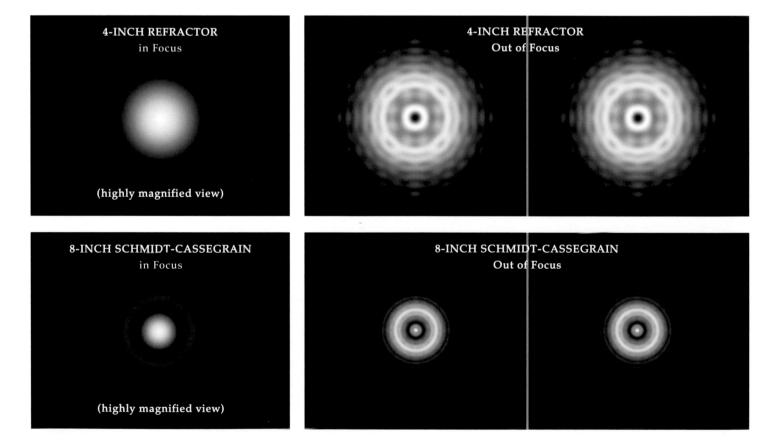

Atlas of Aberrations

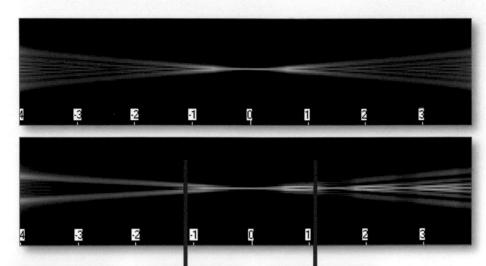

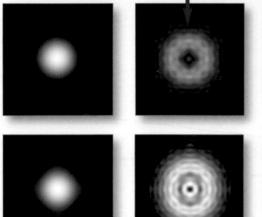

3. Chromatic Aberration (Longitudinal)

This aberration, found only in refractors, arises when all colors are not brought to the same focal point. The illustrations depict a focused star as seen through a 4-inch f/8 refractor with 0.6-wave (near right) and 1-wave (far right) of chromatic aberration. The latter is typical of standard f/6 to f/8 achromatic refractors. While the blue halos are distracting, this aberration does not degrade the image as badly as do other flaws.

Perfect Focus

In perfect optics, the converging and diverging light cones (seen here in profile) contain identical bundles of light rays. Light comes to a sharp focus.

▲ Imperfect Focus

In spherical aberration, light from the perimeter of a lens or mirror does not focus at the same point as the light from the optics' center. The result is unsymmetrical light cones and a smeared focal point.

1. Spherical Aberration

The basis of the star test is to look at the pattern of a defocused star, effectively slicing through the light cones on either side of focus. In the case of spherical aberration, this pattern can look fuzzy on one side of focus yet tightly defined on the other. In focus (far left), the first diffraction ring looks brighter.

2. On-Axis Astigmatism

If the lens or mirror is ground so that it is not rotationally symmetrical, the extra-focal diffraction disk might appear elliptical. Its axis flips 90 degrees from one side of focus to the other. In focus, stars always appear vaguely crosslike. Optics that are physically pinched can produce a similar effect.

4. Off-Axis Coma

Coma, an inherent aberration of many reflectors, makes stars that are off-center in the field look flared to one side. The farther the image is from the center of the field of view, the worse the aberration. Coma also becomes more severe In faster optics, with fast f/4 or f/5 Newtonians having a much smaller coma-free field than does an f/8 instrument. For this reason, collimation of fast Newtonians is critical, or else all images will look fuzzy.

The "big four" of aberrations represent the main optical flaws backyard astronomers are likely to encounter in some combination. All star-test simulations shown in this chapter were produced using a free astronomy software program called Aberrator, produced by Cor Berrevoets and available for Windows computers at http://aberrator.astronomy.net

Settling Down 🔺

A valid star test requires a night of good seeing. If the air is turbulent, the out-offocus diffraction disk will distort and blur (top). If warm air remains in the telescope tube, rising currents can produce plumes that can also distort star images (middle). But once the telescope has settled down, you'll see a smooth and uniform diffraction disk when a star is thrown out of focus (bottom). These images are actual photos of defocused stars.

Needing Collimation 🕨

A telescope that is out of collimation (in this case, a Newtonian reflector) produces a skewed diffraction disk when a star is defocused for testing.

What You Might See

It is important to keep in mind that star images can be ruined by factors other than the quality of the optics, or you may be blaming your telescope for a defect it does not have. To conduct a star test, use the full aperture of the telescope and a good-quality eyepiece, such as a Plössl or an Orthoscopic. Be sure to do the star test with the image centered in the field of view. If you can, remove any star diagonal so that you are looking straight through the optics (cheap diagonals can mimic the effects of poor collimation).

NOTE: In the diagrams at right and on the previous and following pages, the in-focus Airy disk pattern is shown at much higher magnification than the out-of-focus diffraction disks. The two types of images are not drawn to the same scale.

TELESCOPE COLLIMATION

A telescope that is out of collimation will likely fail the star test. The out-of-focus diffraction pattern will look like a striped, tilted cone as viewed from the pointy end. If your telescope offers up poor images, it is probably because of poor collimation. Follow the directions in the previous section before conducting a star test. The optics may be fine, just poorly collimated.

ATMOSPHERIC TURBULENCE

On nights of poor seeing, turbulent air churning above the telescope (sometimes many miles above) can turn the view into a boiling confusion. When this happens, don't bother testing or collimating. A large telescope, because it looks through a greater volume of air, is affected by this problem much more than a small one, making it difficult to find a good night to test a big instrument. Even so, on nights of bad seeing, a small scope may look sharper, but given good optics in both, a big scope will always show as much, if not more, detail.

.....

TUBE CURRENTS

Slow-moving currents of warm air inside a telescope can introduce defects that mimic permanent errors on the glass. Diffraction patterns look flattened or flared. Such image-distorting currents occur when a scope is taken from a warm house into the night air or when outside air is rapidly cooling after sunset. When star-testing, always allow the telescope, eyepiece and even the star diagonal to cool down. A warm eyepiece inserted into a cold scope can also introduce heat plumes. Expect to wait an hour or more, especially on cold nights.

.....

PINCHED OPTICS

Badly mounted optics create very unusual diffraction patterns that can be baffling at first. Most common for Newtonian telescopes is a triangular six-sided spiking or flattening (depending on which side of focus you are on). This occurs if the clips holding a mirror in its cell are too tight. The solution is to loosen them, although doing so requires removing the mirror and cell from the tube. Secondary mirrors and star diagonals glued onto holders can also suffer from pinching. Back off the bolts that hold the secondary mirror.

Nonoptical Problems

This series of simulations demonstrates the effect of various problems that can blur images but are not the fault of the optics. On the left is the magnified view of a star in focus. At right is the simulated appearance of the "extra-focal" disks seen on either side of focus.

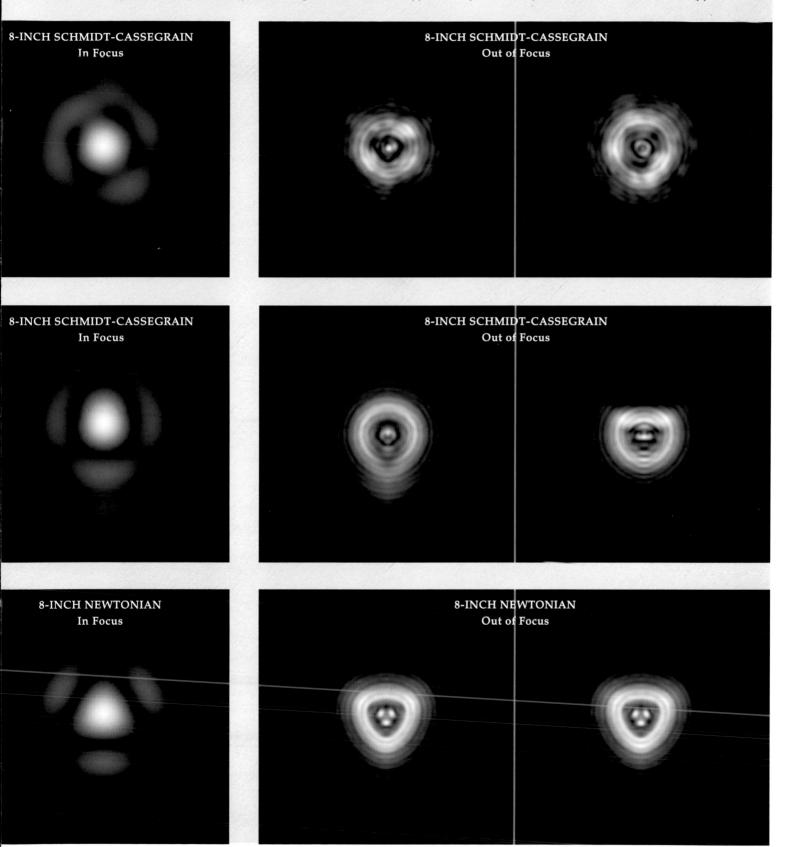

4-INCH REFRACTOR

The Double-Star Myth A persistent myth is that splitting close double stars is a good test of optics. Above is a 4-inch refractor; below, an 8-inch Schmidt-Cassegrain. In each pair, the top image depicts perfect optics, while the bottom image is the same scope with bad spherical aberration. Notice that the double star is still well resolved, but the poor optics surround the stars with a glow and haze from overly bright diffraction rings. The Airy disk pattern is not clean.

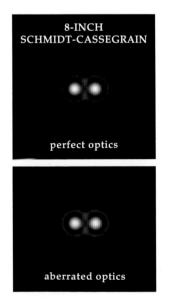

What You Don't Want to See

Now, on to determining whether there is a defect in the optics themselves. Errors on the optical surface are divided into categories. What you see is likely a combination of two or more defects. However, the most common flaw, present to some degree in all but the finest optics, is spherical aberration. Purchasing a slower f/8 Newtonian or an f/11 to f/15 refractor is one way to avoid this aberration, as fast lenses and mirrors are notoriously difficult to make well. This is a prime source of the adage, even myth, that slow focal-ratio telescopes are best for the planets. This was once a good rule of thumb, but today, superb optics can be found at all focal ratios, though at a price. It is optical quality, not focal ratio per se, that determines a telescope's suitability for its most demanding task: revealing subtle planetary detail.

ZONES

Zones are small figuring errors that often result from harsh machine polishing. Most commercial optics suffer to some extent from zones. Severe cases degrade image quality noticeably. To check for zones, defocus the image more than is usual in the star test. On one side of focus or the other, you may notice that one or more of the rings look weak.

.....

With reflectors, be careful in any star testing not to be confused by the secondary mirror's central shadow. The important point is that the pattern should be the same on both sides of focus.

ROUGH SURFACES

This defect, often present in mass-produced optics, appears as a lessening of contrast between the rings plus the appearance of spiky appendages to the rings. Do not confuse diffraction from spider vanes with these spikes—spider diffraction is spaced regularly. A velvety smooth ring system indicates that you do not have trouble with surface roughness.

SPHERICAL ABERRATION -

The most common of all optical flaws, spherical aberration can happen when a mirror or lens is undercorrected, resulting in light rays from the perimeter focus being closer in than rays from the center. Inside of focus, the diffraction pattern has an overly bright outer ring; outside of focus, the outer rings are faint and ill-defined. The opposite pattern, with a fuzzball inside of focus and a donut outside of focus, results from overcorrection. Either error leads to fuzzy images; stars and planets never snap into focus, and planetary disks look gauzy.

.....

ASTIGMATISM

A lens or mirror ground asymmetrically makes a star image look like a stubby line or an ellipse that flips over at right angles as you rack from one side of focus to the other. The best focus looks vaguely crosslike. The easiest way to detect astigmatism is to rock the focuser back and forth quickly. Mild astigmatism may show up with only three rings visible, when the star is just out of focus. Mild astigmatism will soften planetary images and blur the Airy disk of stars. Again, there is no crisp, snappy focus point. This is a flaw sometimes seen in refractors.

MIXED ABERRATIONS

A more common situation is a telescope suffering from a blend of maladies. These views simulate a mix of tube currents, coma, spherical aberration and astigmatism. If, after careful testing and a second opinion, you feel your optics are truly defective, contact the dealer or manufacturer.

.....

Adapted with permission from"Test Drive Your Telescope" in the May 1990 issue of *Astronomy* magazine. For more details, the star-testing bible is *Star Testing Astronomical Telescopes* by Harold Richard Suiter (Willmann-Bell, 1994).

Flaws in the Optics

This series of simulations demonstrates the effect of various aberrations that originate in the optics themselves. On the left is the magnified view of a star in focus. At right is the simulated appearance of the "extra-focal" disks seen on either side of focus.

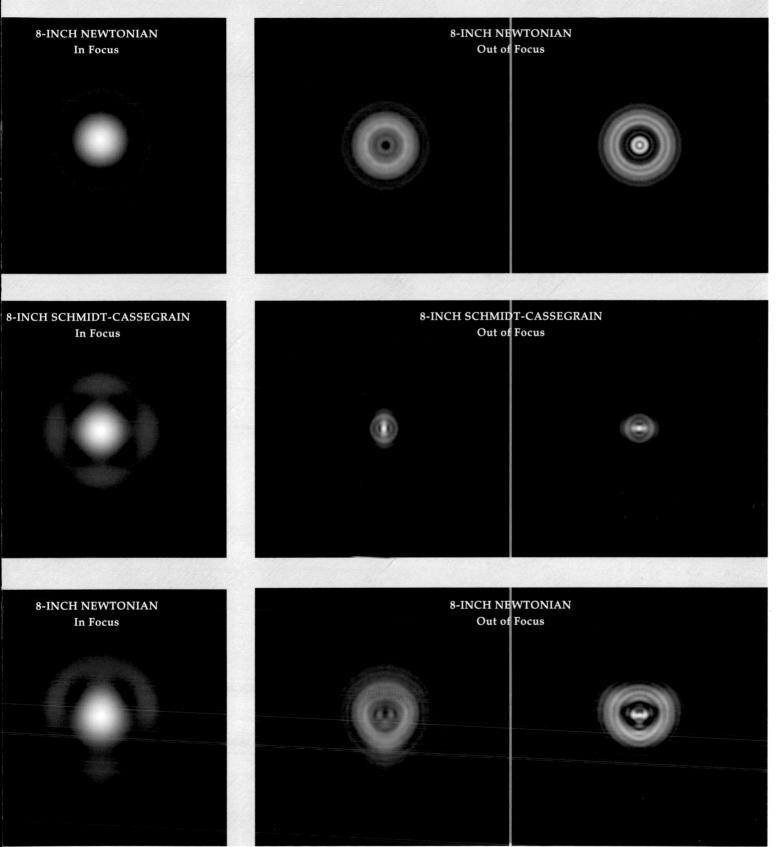

The Milky Way Atlas

The richest part of the Milky Way is revealed in this fish-eye-lens image taken from Australia. The atlas begins at the galaxy's core (overhead in this view) and works progressively to the left. Photo by Alan Dyer.

By Glenn LeDrew

Specially created for this edition of The Backyard Astronomer's Guide, this ninth-magnitude Milky Way atlas depicts the portion of the night sky that contains the majority of the mostobserved deep-sky objects

Under perfect conditions in a moonless sky, the unaided eye is able to detect at least as much detail in our home galaxy as the largest telescopes reveal in any of the external galaxies, with the possible exception of the nearby Large and Small Magellanic Clouds. Humble binoculars make obvious what the eve alone hints at: The band of the Milky Way is a rich tapestry of brilliant star clouds, intricate dust lanes, gauzy nebulas and splashy star clusters. In fact, the great majority of interesting deep-sky objects are found in or near the Milky Way Galaxy.

The illustrations featured in this atlas are intended to serve as an approximate representation of what an experienced observer might see from a dark site using binoculars or a small telescope. Star colors have been only slightly exaggerated in hue to reveal their inherently subtle differences. The magnitude limit of nine includes stars visible in 50mm binoculars from most suburbs or in 35mm binoculars from a rural site.

NEBULA TYPES

The faintest deep-sky objects shown are eighth to ninth magnitude, depending somewhat on type and size. Open clusters have been given the same bluish hue as the Milky Way, while the ancient, highly evolved globular clusters have been colored yellow. Most of the identified nebulas can be seen with a small telescope, although some require a narrowband nebula filter to be seen with certainty. For nebulas larger than, say, 30 arc minutes, total brightness is an almost meaningless guide to visibility; rather, the surface brightness and sky quality are the critical determinants. Some very large and dim emission nebulas, such as the cloud at Orion's head and the gigantic Gum Nebula, will probably be impossible to see but are included here due to their relative prominence in wide-angle photos-and because they are interesting in their own right. The charts present a great number of dark nebulas; however, only some of the more readily observed or well-known examples are labeled. The labels are positioned directly over the center of the object.

NEBULA COLORS

The main departure from realism in the following illustrations is apparent in the color of nebulas. Only a small percentage of the so-called bright nebulas (to differentiate them from the dark nebulas) are sufficiently luminous to exhibit perceptible color in the eyepiece, and then only the emission types, which usually appear green or greenish gray; reflection nebulas all appear as a colorless gray. In a concession to their familiar appearance in astro-images, however, emission nebulas (including supernova remnants) are rendered here as red or pinkish red, while reflection nebulas are colored blue. As a guide to the visibility of emission nebulas, the more pinkish ones are generally of higher surface brightness visually, because they are less reddened by intervening dust clouds. The brighter examples of planetary nebulas are a prominent bluish green and are presented that way in these charts to stand out among the similar-sized star symbols.

OB ASSOCIATIONS

One of the unique features of this atlas is the inclusion of most of the known OB Associations—loose groups of relatively young blue stars born in the Milky Way's spiral arms within the past few million years. Historically, their absence in observing guides and atlases is probably due to their large size and scattered nature in the sky, but the nearer ones are eminently observable with binoculars and even the unaided eye. Not gravitationally bound, these young stellar groupings will disperse into the general stellar field within a few tens of millions of years.

GOULD'S BELT

Also identified here is the plane of the 30-to-60-million-year-old Gould's belt, the remarkably flat stratum of interrelated stars and gas tilted to the galactic equator by nearly 20 degrees. Most OB Associations within about 2,000 light-years of us belong to Gould's belt, and most of these mark its expanding periphery, where new stars are still being minted.

GALACTIC LONGITUDE

Because we reside near the midplane of the Milky Way Galaxy's flattened disk, it forms a great circle that naturally defines the galactic equator. The zero point of longitude is in the direction of the center of the galaxy, itself hidden behind dust clouds—the Great Rift in Sagittarius. Longitude 90 degrees, near the star Deneb, in Cygnus, corresponds to the direction of galactic rotation. The galactic anticenter is in the direction of Taurus-Auriga, and the Milky Way is dimmest in this region mainly because of the smaller number of stars in the outer galaxy.

The charts are 45 degrees wide at the galactic equator and 56 degrees high. The central longitudes start at zero and are spaced 36 degrees apart, a scheme chosen, in part, because each chart includes interrelated constellations and/or Milky Way features. The rather generous overlap of nine degrees will ease the task of locating objects plotted near the edge of a chart. Taken together, these atlas charts cover nearly half of the entire sky.

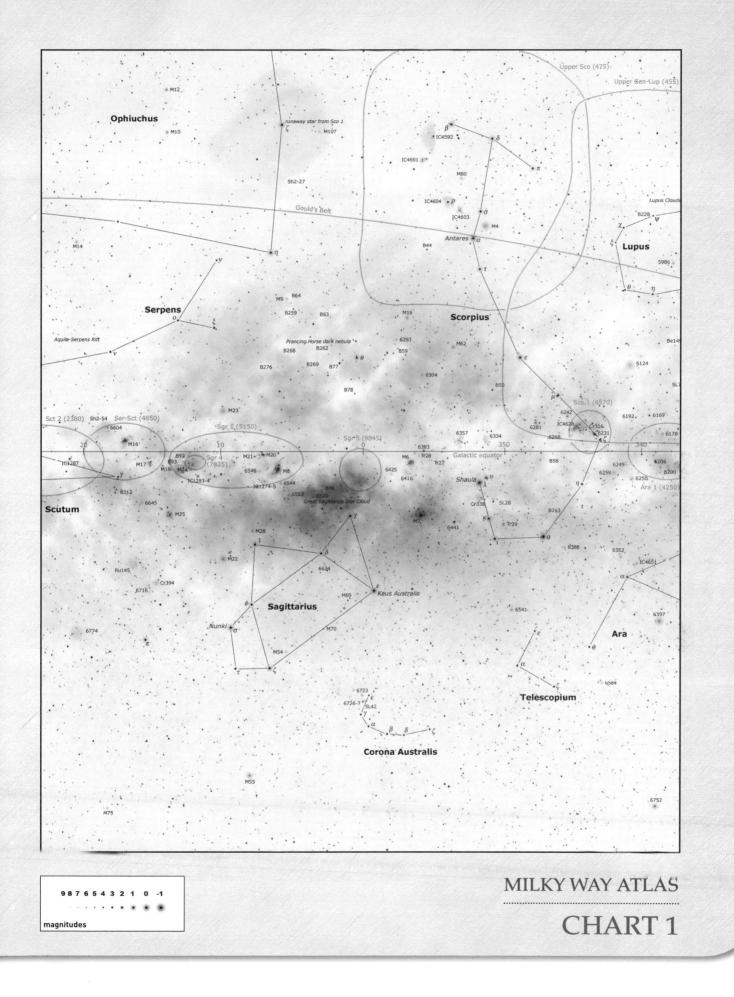

And the Art of the second s

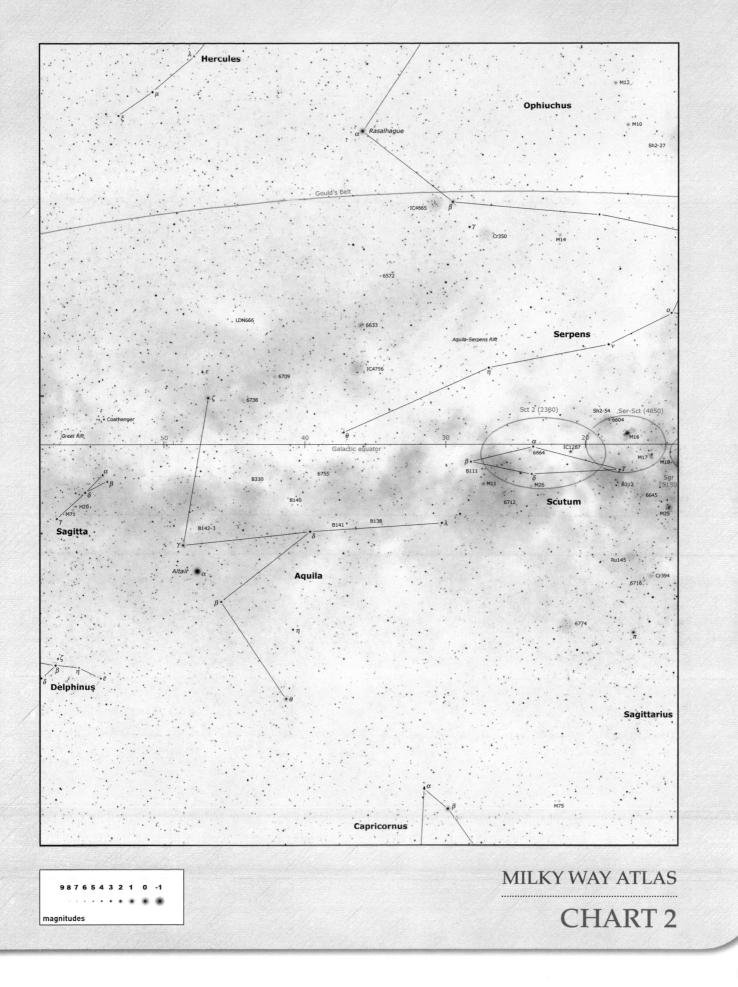

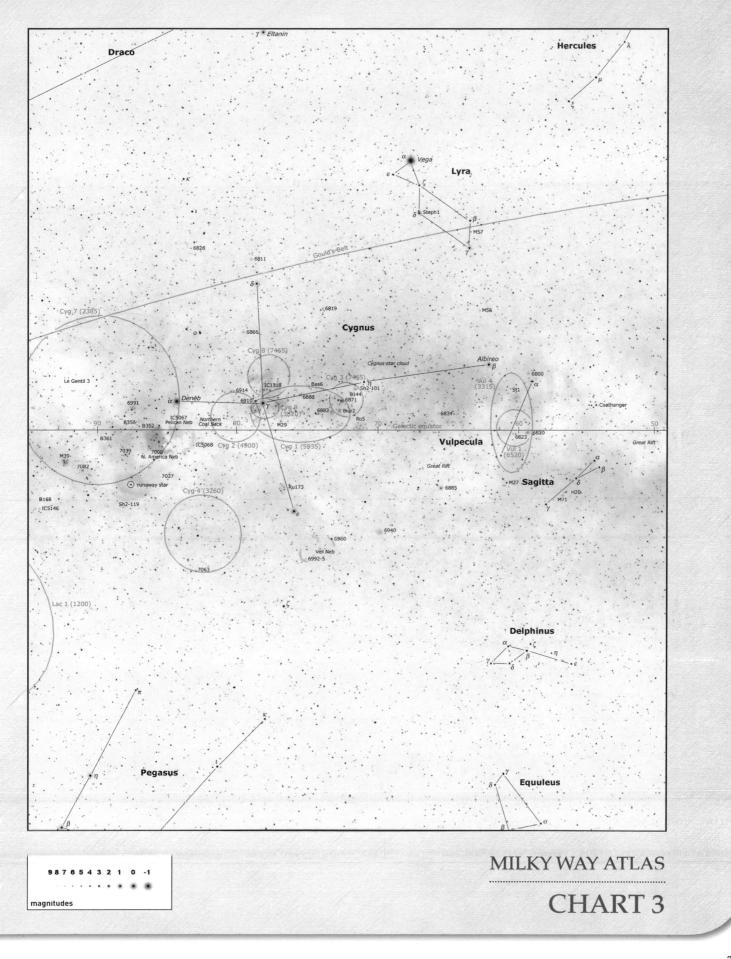

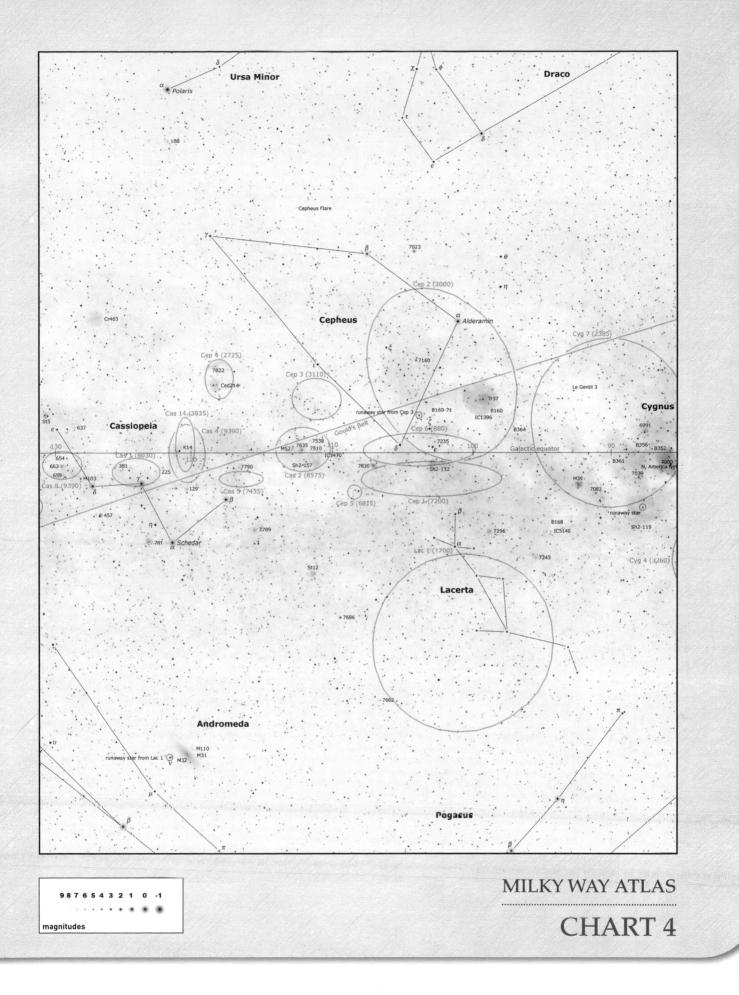

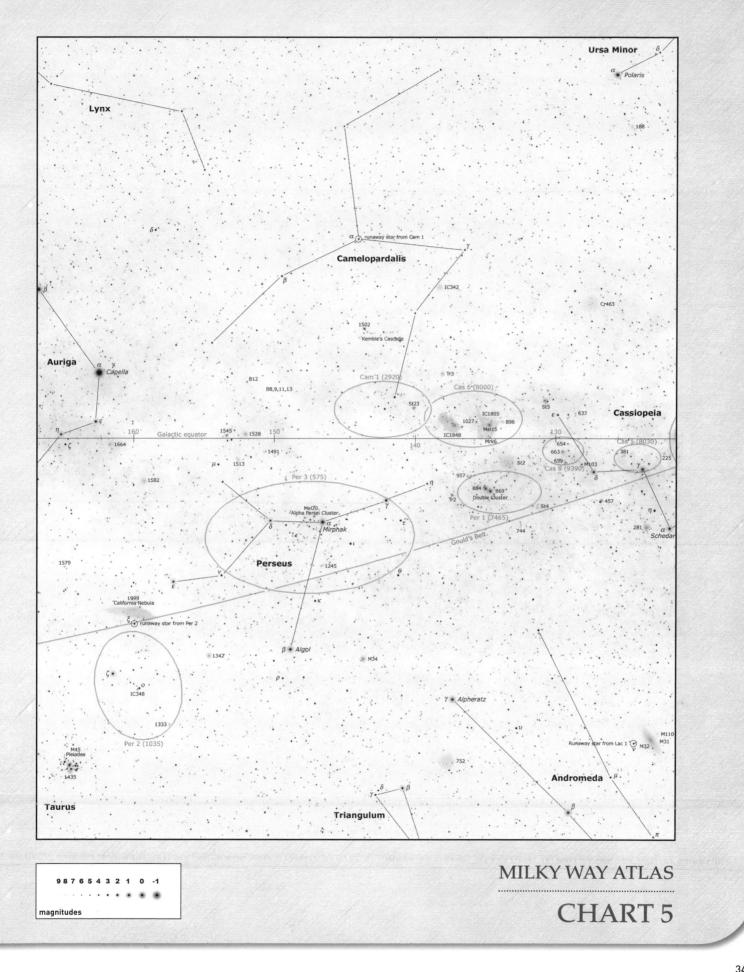

Auriga, Gemini, Taurus

gnitude

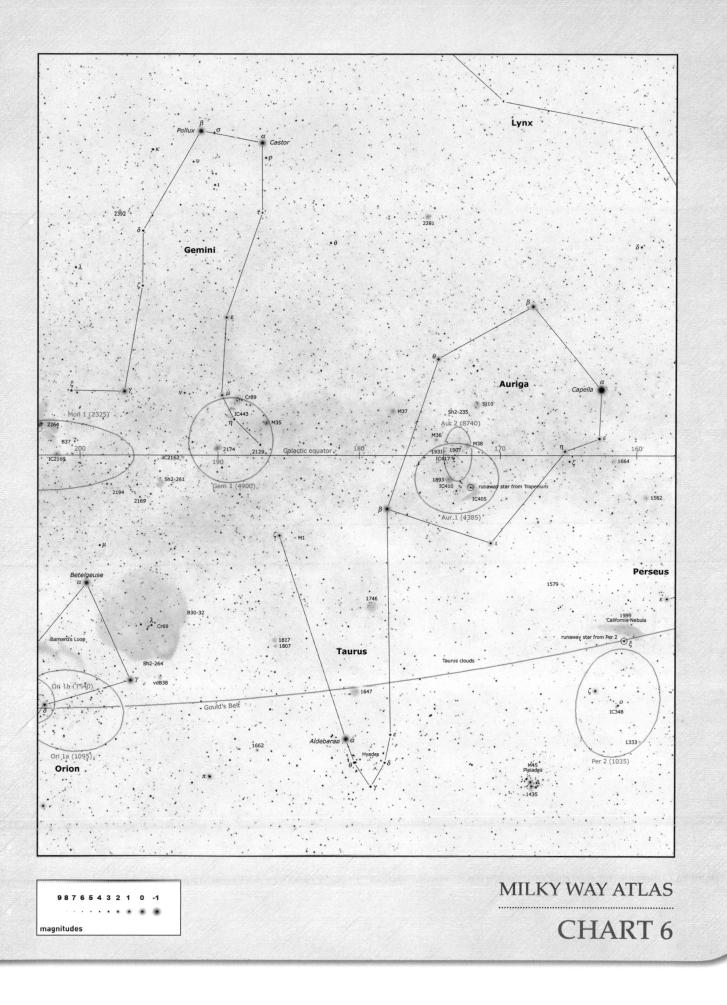

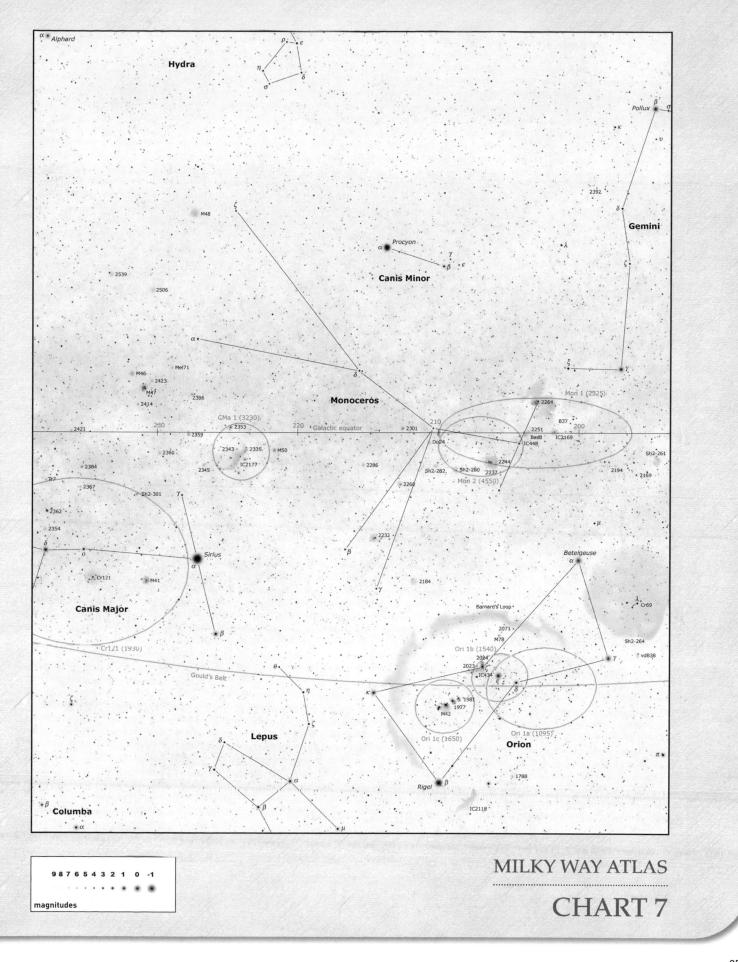

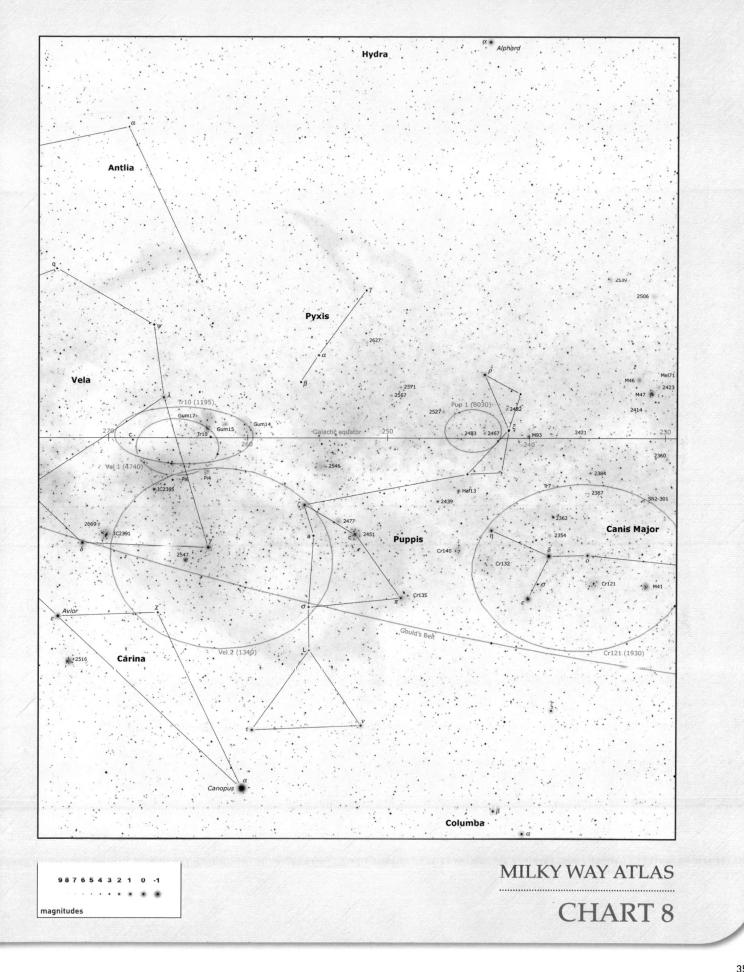

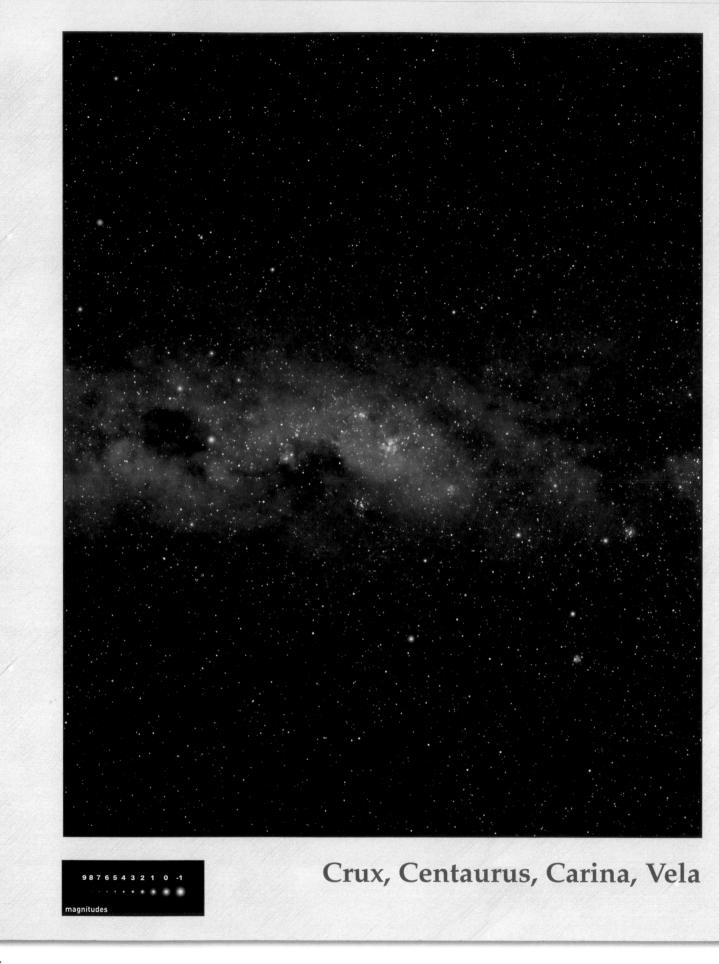

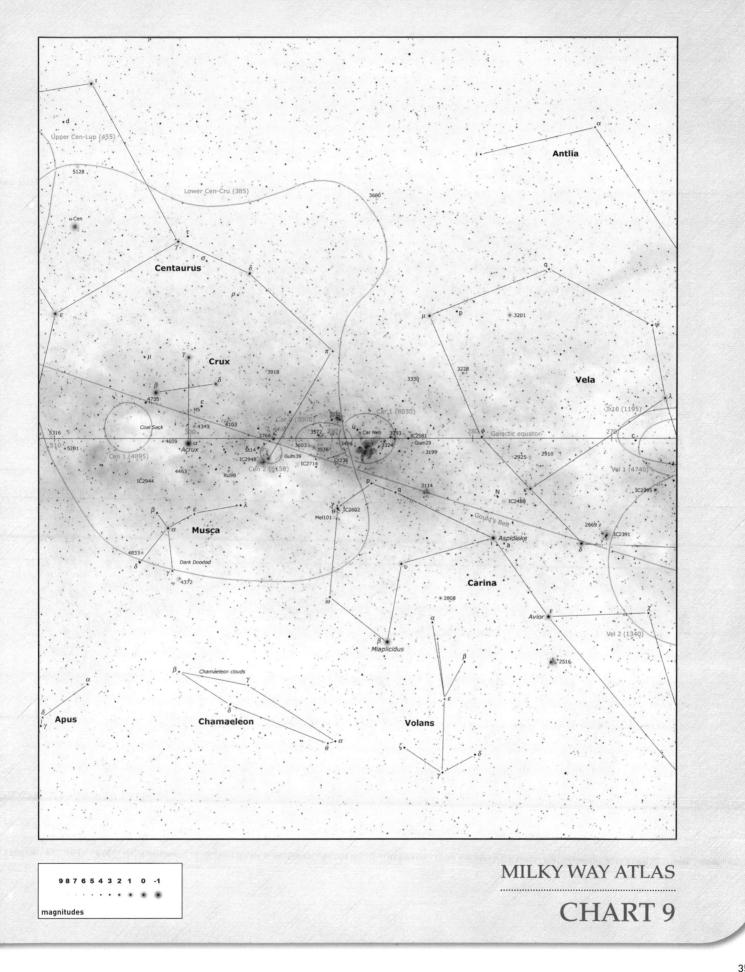

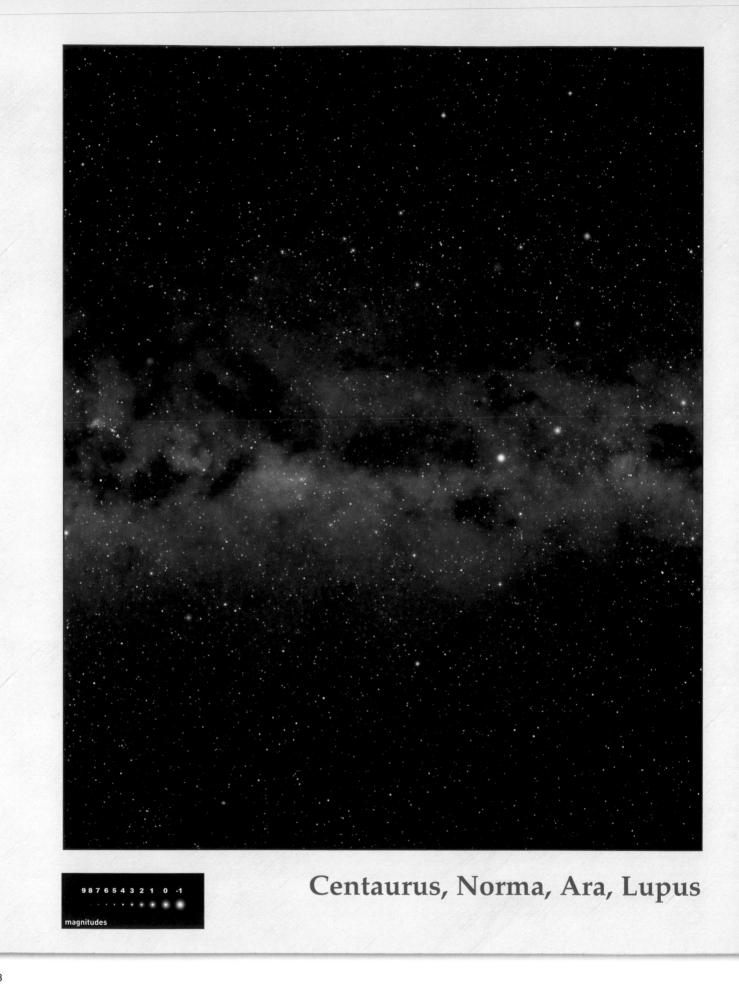

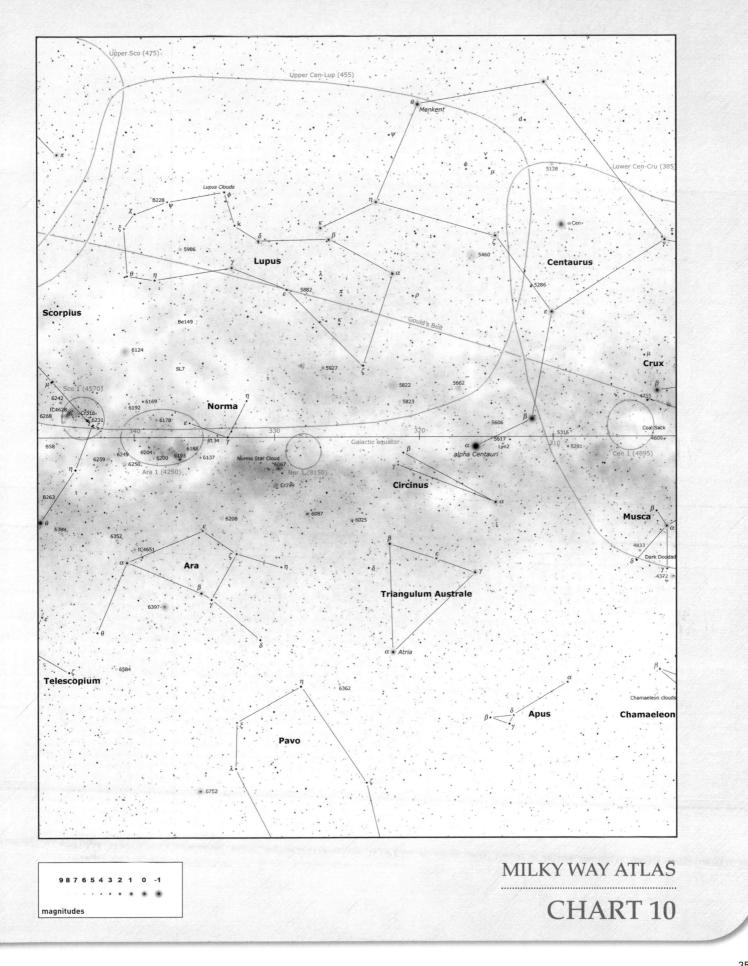

Epilogue

Every August, a small band of dedicated skywatchers navigates the tortuous 12½mile road up Mount Kobau, in southern British Columbia, in search of perfect skies. Sometimes, they are rewarded: The weather cooperates, and the black canvas of the sky is painted with the delicate brush strokes of the Milky Way. But other years, the normally dry summer weather turns foul. Isolated at the top of a 5,000-foot mountain, the troop of observers is forced to wait out a thunderstorm's torrential rains, hoping that the next night, or perhaps the next hour, will reveal the stars.

And yet even when the weather turns cold and wet, everyone leaves the Mount Kobau Star Party saying, "See you next year." They know they will be back. And so it goes at virtually every star party and amateur-astronomer gathering. The great thing about backyard astronomy is that it can extend much further than your backyard. There is a vast community of thousands of like-minded lovers of the sky. Perhaps as you pursue your interest in the stars, you will find yourself becoming a part of that community. You, too, may discover a place such as Kobau or Stellafane or one of the many other dark-sky observing meccas that have emerged across the continent.

On the other hand, your personal nirvana may always be as close as your backyard, and your community of fellow skywatchers no larger than your family and friends. But no matter: Wherever you observe, it's the same limitless sky overhead, a sky we hope this book helps you to explore.

THE UNIVERSE AWAITS

Throughout The Backyard Astronomer's Guide, we have tried to emphasize certain aspects of recreational astronomy that are often glossed over by other guidebooks. For example, we have talked in specific detail about equipment and brand names. We have done this because most of the inquiries we receive from beginners are variations on a single question: What should I buy? Our emphasis on hardware may lead to the impression that amateur astronomy is nothing more than collecting equipment. For some, this is, indeed, the case. But those collectors rarely sustain their enthusiasm for the hobby. Which brings us to the concluding topic-one that is seldom discussed in amateur-astronomy literature-why people lose interest in astronomy.

In Chapter 1, we said you cannot buy your way into astronomy. But some newcomers try. They purchase the best and most prestigious equipment on the market but never get around to investing the time to learn how to use it properly. Are they backyard astronomers? Not in our view. Even in the era of computerized telescopes, a full appreciation of the universe cannot come without developing the skills to find things in the sky and understanding how the sky works. This knowledge comes only by spending time under the stars with star maps in hand and a curious mind.

Since the first edition of this book appeared in 1991, equipment for backyard astronomy has evolved at an incredible rate. The high-tech gear is enticing. Yet our advice remains the same: The primary reason people lose interest in astronomy is that equipment absorbs their attention, and they neglect the stars. The sky never becomes a friendly place. The star patterns remain anonymous, and the locations of the sky's attractions remain hidden. Instruments that are too complex make setting up the gear an onerous chore. What could have been a lifelong interest becomes a passing phase. We have seen this happen many times, which is why we recommend using binoculars on the stars first, rather than a telescope, for most first-time buyers.

There are other reasons people lose interest in astronomy. Some leap into the deep end of the pool without learning how to swim first-perhaps by loading up on high-end astro-imaging equipment before trying anything more than a few shots of the Moon. But the reality is, many beginning backyard astronomers express an interest in taking astrophotos. That's why significant chunks of this book deal with imaging techniques. Although both of us began our astronomical careers as avid astrophotographers, we both gave it up. We found ourselves expending too much effort and too many dollars for the results we were getting. So we returned to visual astronomy for a decade until the equipment and films improved during the late 1980s, when we both cautiously inched back into astrophotography (and, more recently, into digital camera imaging). From experience, we advise others to start simply and go slowly.

SETTING YOUR PACE

Developing stargazing skills takes time, more time than many people can find. It seems the more leisure hours people have, the more they are filled with demanding activities that are far from leisurely. Finding time to be under the stars is, in our opinion, more a matter of attitude than scheduling. For us, the time spent pursuing this hobby is a quiet respite from life in the fast lane. And backyard astronomy does not have to be a solitary pursuit. Involving the family will make your moments under the stars all the more meaningful.

After the initial novelty wears off, some amateurs drift away from the hobby for lack of a purpose. To rekindle the interest, take on a project and work toward a goal, such as observing all the Messier objects, sketching the planets or photographing the constellations. Or schedule your next trip to include a few nights at a dark-sky location.

Every now and then, we all need a shot of inspiration to recharge our batteries. Sometimes, a casual observation of a planetary conjunction or an exceptionally clear night is enough to remind us of how inspiring the sky is. We have both been in the hobby for more than four decades yet never cease to be amazed at what new sights and wonders the sky presents us each year, if not each night. Keeping abreast of celestial happenings is essential to maintaining your interest and sustaining the feeling that you are a true naturalist of the night.

Other times, inspiration comes from a group therapy session, such as a star party, a motivating lecture at a club meeting or just touching bases with skywatching friends. A mild word of caution, though, about the Internet. The virtual clubs created by special-interest news groups and chat rooms can, indeed, be a source of helpful answers to specific questions. But the ratio of useful signal to annoying noise is often extremely low. We've found many astronomy e-groups rife with so much misinformation and immaturity that we avoid most of them. They are not a true reflection of the great people who populate the community of backyard astronomers.

Like every other leisure pursuit, astronomy can be taken seriously or casually. It is entirely up to you. Our task has been to provide advice on the tools and an introduction to the techniques of sky observing. Armed with that advice, you are ready to explore a hobby—and a universe—that can provide a lifetime of amazement and fun. Welcome to backyard astronomy.

Further Reading

• Star atlases are described in more detail in Chapter 11.

• Our website (www.backyardastronomy.com) contains additional information of interest to amateur astronomers.

Chapter One General Observer's Astronomy Guidebooks

NightWatch by Terence Dickinson (Firefly Books; Richmond Hill, Ontario; 4th Ed.; 2006). One of the world's best-selling guides to the hobby for beginners. *The Backyard Astronomer's Guide* is an advanced sequel to *NightWatch*.

Summer Stargazing by Terence Dickinson (Firefly Books; Richmond Hill, Ontario; 1996). A guide to the constellations and deep-sky objects of the summer sky, with plenty of charts.

Patterns in the Sky by Ken Hewitt-White (Sky Publishing; Cambridge MA; 2006). Excellent guide to the constellations and their mythology. Highly recommended for beginners.

The Backyard Stargazer by Pat Price (Quarry Books; Beverly, MA; 2005). This is a book you can recommend to anyone just starting out in astronomy and stargazing.

Secrets of Stargazing by Becky Ramotowski (Sky Publishing; Cambridge, MA; 2007). A small but surprisingly comprehensive guide to backyard observing; tips and techniques.

Starlight Nights: The Adventures of a Star-Gazer by Leslie C. Peltier (Sky Publishing; Cambridge, MA; 1999). Written by one of the 20th century's most gifted amateur astronomers, this wonderful book chronicles one man's odyssey in backyard astronomy. To show a skeptic why astronomy is so compelling, give him or her this charming book.

Skywatching by David Levy (Nature Company/ Time-Life; San Francisco; 1994). A lavishly illustrated introduction to astronomy as a science and a hobby. Good monthly star charts and individual constellation maps.

Advanced Skywatching (aka Backyard Astronomy in softcover) by Robert Burnham, Alan Dyer, Robert Garfinkle, Martin George and Jeff Kanipe (Nature Company/Time-Life; San Francisco; 1997). A sequel to Skywatching, with more detailed hobby information and excellent star-hopping charts.

Astronomy: The Definitive Guide by Robert Burnham, Alan Dyer and Jeff Kanipe (Weldon-Owen;

Sydney; 2002). A beautifully illustrated introduction to astronomy, with good seasonal star maps and star-hopping charts.

Seeing in the Dark by Timothy Ferris (Simon and Schuster; New York; 2002). A first-rate science writer examines the realm of the scientific amateur astronomer.

The Universe and Beyond by Terence Dickinson (Firefly Books; Richmond Hill, Ontario; 4th Ed.; 2004). Lavishly illustrated summary of current astronomical knowledge and "armchair" topics such as black holes and cosmology.

A Year in the Life of the Universe by Robert Gendler (Sky Publishing; Cambridge, MA; 2007). Lavish pictorial of deep-sky wonders featuring images taken by one of the world's finest astrophotographers. Informative and inspiring.

Chapter Two Binocular Guidebooks

Binocular Highlights: 99 Celestial Sights for Binocular Users by Gary Seronik (Sky Publishing; Cambridge, MA; 2006). Well-designed practical observing guide to all the top binocular sights.

Binocular Astronomy by Craig Crossen and Wil Tirion (Willmann-Bell; Richmond, VA; 1992). A comprehensive guide to deep-sky objects for binoculars (includes charts).

Touring the Universe Through Binoculars by Philip Harrington (John Wiley and Sons; New York; 1990). No charts, but lots of information on suitable targets.

Chapters Three, Four and Five Telescopes and Hobby Hardware

Star Ware by Philip Harrington (John Wiley and Sons; New York; 4th Ed.; 2007). Tons of brandand model-specific information with recommendations on telescopes and accessories by an experienced telescope user.

Choosing and Using a Schmidt-Cassegrain Telescope by Rod Mollise (Springer-Verlag; London; 2001). A user's guide to Schmidt-Cassegrain and Maksutov telescopes, with many model-specific tips.

Telescope Making

Build Your Own Telescope by Richard Berry (Willmann-Bell; Richmond, VA; 2001). Plans for five simple scopes of various sizes and styles, both Dobsonian and equatorial. *The Dobsonian Telescope* by Richard Berry and David Kriege (Willmann-Bell; Richmond, VA; 1997). Detailed construction plans for advanced builders from two telescope-making experts.

Chapter Seven Naked-Eye Astronomy Guides

Seeing the Sky by Fred Schaaf (John Wiley and Sons; New York; 1990). A fine compilation of neat things to look for in the sky.

Kaleidoscope Sky by Tim Herd (Abrams Books; NewYork; 2007). A beautiful collection of amazing and well-annotated images of atmospheric daytime and nighttime phenomena.

The 50 Best Sights in Astronomy and How to See Them by Fred Schaaf (Wiley; New York; 2007). Nice review of the best sights the sky has to offer, from the well known to sights even veterans might miss.

Atmospheric Phenomena

Color and Light in Nature by David K. Lynch and William Livingstone (Cambridge University Press; Cambridge; 1995). Beautifully illustrated guide to sky phenomena.

Exploring the Sky by Day by Terence Dickinson (Firefly Books; Richmond Hill, Ontario; 1988). An introduction to day-sky phenomena; aimed at all ages.

Light and Color in the Outdoors by Marcel Minnaert (Springer-Verlag; London; 1993). Revision of the classic comprehensive work that covers *all* optical sky phenomena.

Peterson's Field Guide to the Atmosphere by Vincent J. Schaefer and John A. Day (Houghton Mifflin; New York; 1981). A pocket reference to weather and clouds.

Rainbows, Haloes, and Glories by Robert Greenler (Cambridge University Press; Cambridge; 1980). Still the definitive work on these phenomena.

Sunsets, Twilights, and Evening Skies by Aden and Marjorie Meinel (Cambridge University Press; Cambridge; 1983). A fine companion volume to Rainbows, Haloes, and Glories.

Aurora

Aurora: The Mysterious Northern Lights by Candace Savage (Greystone Books; Vancouver; 1994). A fine popular-level work on the aurora.

Meteors and Meteorites

Cambridge Encyclopedia of Meteorites by O. Richard Norton (Cambridge University Press; Cam-

bridge; 2002). A comprehensive volume detailing types of meteorites and many falls and finds.

Meteors by Neil Bone (Sky Publishing; Cambridge, MA; 1992). A guide to making scientific observations of meteors.

Chapter Nine Guides to the Sun, Moon and Comets

Atlas of the Moon by Antonín Rükl (Sky Publishing; Cambridge, Mass.; 2004). The definitive lunar observer's atlas, with beautiful charts and concise descriptions. Superb.

New Atlas of the Moon by Thierry Legault and Serge Brunier (Firefly Books; Richmond Hill, Ontario; 2006). Large-format photographic atlas, well designed for observers. Nicely translated from French.

Epic Moon by William P. Sheehan and Thomas A. Dobbins (Willmann-Bell; Richmond, VA; 2001). A history of telescopic exploration of our Moon.

Comet of the Century by Fred Schaaff (Copernicus; New York; 1997). One of the best comet books; could have been titled "All About Comets."

Comets: A Chronological History of Observation, Science, Myth, and Folklore by Donald K. Yeomans (Wiley; New York; 1991). The title says it all. Outstanding 485-page reference packed with information.

Eclipses

Eclipses 2005-2017 by Wolfgang Held (Floris Books; Edinburgh; 2005). Recommended guide to coming lunar and solar eclipses, with color path maps and shadow diagrams for total and annular solar eclipses and total lunar eclipses until 2017.

Eclipse! by Philip Harrington (John Wiley and Sons; New York; 1997). A thorough guide to all upcoming eclipses, with paths, times and weather prospects.

Fifty Year Canon of Solar Eclipses (NASA RP 1178) and *Fifty Year Canon of Lunar Eclipses* (NASA RP 1216), both by Fred Espenak (NASA Reference Publications/Sky Publishing; Cambridge). Definitive technical information on upcoming eclipses.

Glorious Eclipses by Serge Brunier and Jean-Pierre Luminet (Cambridge University Press; Cambridge; 2000). A coffee table book filled with magnificent eclipse images.

Totality: Eclipses of the Sun by Mark Littmann, Ken WillCox and Fied Espenak (Onford University Press: New York; 1999). All about eclipses and why people travel the world to see them.

Transits

June 8, 2004: Venus in Transit by Eli Maor (Princeton University Press; Princeton; 2000). Good summary of the history of transit observations.

Transit: When Planets Cross the Sun by Michael Maunder and Patrick Moore (Springer-Verlag; London; 2000). A guide to the history and mechanics of transits.

Chapter Ten Planet Observing

The New Solar System, Beatty, Peterson and Chaikin, eds. (Sky Publishing/Cambridge University Press; Cambridge; 1999). A fact-filled summary of what we know about the solar system's worlds.

Mars: The Lure of the Red Planet by William Sheehan and Stephen James O'Meara (Prometheus Books; New York; 2001). An engaging history of what we thought we knew about Mars.

Chapter Eleven Astronomy Guidebooks

Annual Reference Works

Observer's Handbook, (The Royal Astronomical Society of Canada; Toronto). This indispensable annual guide to the year's celestial events is always within reach on the desks of both authors. Used worldwide.

Astronomical Calendar by Guy Ottewell (Universal Workshop; Middleburg, VA). Superbly illustrated annual guide to sky events; in large format. Highly recommended; available from Sky Publishing.

Star-Hopping Guidebooks

Star Hopping for Backyard Astronomers by Alan M. MacRobert (Sky Publishing; Cambridge, MA; 1993). Good charts and illustrations take you on 14 star-hopping tours of selected regions of the sky. Lots of practical tips.

Turn Left at Orion by Guy Consolmagno and Dan M. Davis (Cambridge University Press; Cambridge; 2000). A great star-hopping guide to the sky's best 100 objects, with finder charts and eyepiece sketches of object appearances.

The Observer's Sky Atlas by Erich Karkoschka (Springer-Verlag; New York; 1998). An overlooked but excellent guide to finding a choice selection of celestial targets.

Stars and Planets: A Viewer's Guide by Gunter Kötti (Sterling Publishing; New York; 1998). A fine guide to selected deep-sky objects, with charts.

Star Hopping: Your Visa to Viewing the Universe by Robert Garfinkle (Cambridge University Press;

Cambridge; 1994). The author provides 14 starhopping tours for the telescope owner.

Chapter Twelve Deep-Sky References

Introductory Works

Collins Gem: Stars by Ian Ridpath and Wil Tirion (HarperCollins; London; 2005). A constellation guide for a shirt pocket; a gem of a little book.

Eyewitness Handbooks: Stars and Planets by Ian Ridpath (Dorling Kindersley; London; 1998). One of the best of many constellation guidebooks titled *Stars and Planets*.

Peterson Field Guide to the Stars and Planets by Jay M. Pasachoff (Houghton Mifflin; New York; 2000). A comprehensive pocket field guide to the stars and constellations.

Atlas of the Night Sky by Storm Dunlop (Harper-Collins; London; 2005). Constellation-by-constellation survey with nice seventh-magnitude charts, plus Moon atlas and planet guide.

More Advanced Works

The Night Sky Observer's Guide (two volumes) by George Robert Kepple and Glen W. Sanner (Willmann-Bell; Richmond, VA; 1998). Guides to thousands of objects, with charts, descriptions, photos and sketches. A monumental and essential work.

Burnham's Celestial Handbook (three volumes) by Robert Burnham Jr. (Dover Publications; New York; 1978). A lifetime's compilation of lore, mythology, poetry and hard science information on all the finest deep-sky objects. A remarkable work; a must for any observing library.

Deep-Sky Wonders by Walter Scott Houston (Sky Publishing; Cambridge, MA; 2001). A wonderful collection of writings by the dean of deep-sky observers.

Celestial Sampler by Sue French (Sky Publishing; Cambridge, MA; 2006). Well-illustrated tours of deep-sky favorites through the seasons, reprinted from the author's excellent columns in *Sky & Telescope* magazine.

The Messier Objects by Stephen James O'Meara (Cambridge University Press; Cambridge; 1998). Finder charts and detailed information for all the Messiers as seen through a small telescope. Also by the same author and publisher are these excellent companion books. *Horochel* 400 Observing Guide, The Caldwell Objects and Hidden Treasures, the latter being O'Meara's personal selection of 109 deep-sky objects not in the Messier or the Caldwell catalogs but observable in a 4-inch telescope.

Deep Sky Objects by David H. Levy (Prometheus Books; Amherst, N.Y.; 2005). A personal list of the best 378 deep-sky objects, with descriptions, compiled by a renowned comet hunter.

The Year-Round Messier Marathon by Harvard C. Pennington (Willmann-Bell; Richmond, VA; 1997). A great guide with charts to all the Messiers; useful whether or not you are planning a one-night Messier marathon.

Star Names: Their Lore and Meaning by Richard Hinckley Allen (Dover Publications; New York; 1963). The authoritative guide to the origin of star names.

Southern Sky References

The Southern Sky Guide by David Ellyard and Wil Tirion (Cambridge University Press; Cambridge; 2001). Entry-level atlas with clear, well-designed charts for naked-eye and small-scope use.

A Walk Through the Southern Sky by Milton D. Heifetz and WilTirion (Cambridge University Press; Cambridge; 2007). A good introduction to the southern stars and constellations geared to naked-eye observing.

Atlas of the Southern Night Sky by Steve Massey and Steve Quirk (New Holland Press; Chatswood, MSW, Australia; 2007). Very nice southern-centric constellation-by-constellation guide to the best of the southern-hemisphere sky.

Chapter Thirteen Astrophotography Guidebooks

Digital Astrophotography: A Guide to Capturing the Cosmos by Stefan Seip (Rocky Nook Publishing; 2008). A well-illustrated and concise summary of essential techniques for point-and-shoot, webcam, DSLRs and advanced CCD cameras, including image processing. Perhaps the single best astrophoto guide on the market, though flawed by odd translation quirks.

A Guide to Astrophotography with Digital SLR Cameras by Jerry Lodriguss (Astropix LLC; 2006). A CDbased "book" using HTML pages to guide you through methods of shooting then processing DSLR images with Photoshop (a companion to the author's earlier and excellent CD, Photoshop for Astrophotographers.)

Photoshop Astronomy by R. Scott Ireland (Willmann-Bell; Richmond, VA; 1997). A thorough tutorialbased guide to advanced image-processing methods using Photoshop. Comes with DVD of samples.

Making Every Pixel Count by Adam Block (Caelum Observatory). A series of DVDs with detailed tutorials for image processing, primarily aimed at advanced tricolor CCD imaging.

Digital SLR Astrophotography by Michael A. Covington (Cambridge University Press; 2007).Guide to DSLR methods, though with only monochrome illustrations. Contains a section on using MaxDSLR software to process images.

CCD Imaging

The New CCD Astronomy by Ron Wodaski (New Astronomy Press; Duvall, WA; 2002). Published by the author, this is the most thorough guide to CCD imaging available. Visit the book's website at www.wodaski.com, where you can download a sample chapter.

The Handbook of Astronomical Image Processing by Richard Berry (Willmann-Bell; Richmond, VA; 2005). Teaches image-processing techniques and technicalities. Comes with a CD of images and the very capable AIP4Win software program (for Windows) to run the book's tutorials.

Chapter Fifteen Optics Testing

Star Testing Astronomical Telescopes by Harold Richard Suiter (Willmann-Bell; Richmond, VA; 1994). Technical but authoritative guide to star-testing telescope optics.

Top Ten Websites

Of the thousands of websites devoted to space and astronomy, these are the ones we frequent the most:

Astronomy Picture of the Day antwrp.gsfc.nasa.gov/apod/astropix.html Superb in every respect; a great homepage

Heavens-Above.com Predictions of satellite passes and Iridium flares

The World at Night: *www.twanight.org* A collection of fabulous nightscape images from around the world

SpaceRef.com; SpaceDaily.com; and Spaceflight.com Daily news from space exploration and astronomy

HubbleSite.org and *spacetelescope.org* Websites of the U.S. and European centers for Hubble; loaded with images, animations, etc.

Jet Propulsion Laboratory (*www.jpl.nasa.gov*) and Planetary Photojournal (*photojournal.jpl.nasa.gov*) Loads of images and vodcasts related to planetary exploration and space telescopes

Spaceweather.com Predictions of solar and auroral activity, plus galleries of reader images of sky phenomena Clear Sky Clocks: *www.cleardarksky.com/csk* Custom predictions of cloud cover, humidity, seeing and clarity for hundreds of sites in North America

CloudyNights.com

Peer reviews of telescopes and accessories with hundreds of reviews archived

dpreview.com

Not an astronomy site, but the best place for the latest reviews of digital cameras

Favorite Periodicals

Here are the major English-language magazines we can recommend:

Sky & Telescope: www.skyandtelescope.com The essential monthly magazine of the hobby

Astronomy: www.astronomy.com Cosmology and other research features, plus hobby features aimed at beginners

SkyNews: www.skynewsmagzine.com Canadian bimonthly. We write it! So we can recommend it.

The Sky at Night: www.skyatnightmagazine.com A print spin-off from Patrick Moore's long-running BBC show; nicely produced monthly

Astronomy Now: www.astronomynow.com The U.K.'s other long-running monthly with a mix of features for all interests

Australian Sky & Telescope: austskyandtel.com.au Good southern-hemisphere content; bimonthly

Home-Published Periodicals

Some of these are printed, some are published as downloadable PDFs; all require a subscription.

Amateur Astronomy: *www.amateurastronomy.com* A print quarterly with a nice mix of hobby features, interviews and star-party tales

Astrophoto Insight: *www.astrophotoinsight.com* A PDF-only periodical devoted to all areas of astrophotography

Astronomy Technology Today www.astronomytechnologytoday.com A print and PDF periodical on astro-hardware, software and noteworthy individuals in the industry

INDEX

aberrations in camera lenses, 297 aberrations in telescopes, 333, 336-337 achromatic refractor. See Telescope types afocal astrophotography, 289 Alcock, George, 161 amateur astronomers, 12-17 amateur astronomers' conventions. See Conventions for amateur astronomers amateur astronomy, definition of, 13-15, 320-321 Amici prism, 98 Andromeda (constellation), 226 Andromeda Galaxy. See M31 aperture fever, 36 apochromatic refractor. See Telescope types apparent motion of celestial objects, 208-223 Arizona Sky Village, 99, 315 asterisms, 252 astigmatism, 79, 336 Astro Cards, 231 astrophotographic telescopes, 291-293 astrophotography afocal, 289 cameras for, 274-293 guiding, 291-299 image processing, 300-305 of constellations, 284-286 of Moon and planets, 288-290, recommended telescopes for, 291-293 of star trails, 274, 286 techniques, 272-304 Astro-Physics mounts, 58 telescopes, 33, 41, 58-59 atlases and star charts, 225-231 atmospheric dispersion, 189, 191 atmospheric phenomena, 126-149 auroras, 144-150 auto-guiders, 302-304, 305 averted vision, 170, 239 Barlow lens, 76-79, 108 Barnard 168, 254 Barnard's Loop, 258, 299 Big Dipper, 8 binocular viewers for telescopes, 96, 98 binoculars for astronomy, 20-27 Canon image-stabilized, 24 coatings, 26 collimation, 26 evit pupil ??-?3 field of view, 24-25 giant, 27 high-eyepoint, 25 tripod adapter, 21 types of, 22 bolide, 143

books for backyard astronomers, 362-364 Borg telescopes, 42, 56 Brandon eyepieces, 71, 82 Bright Star Atlas, 229 Caldwell catalog, 243-244 cameras for astrophotography, 272-290 Carina Nebula, 268, 271 Cassini's division (in Saturn's rings), 201-202 CCD cameras, 277 compared with DSLR, 277 field-of-view comparison, 277 celestial sphere, 208-222 Celestron telescopes, 48-51, 53, 54, 55 central obstruction, 38 charge-coupled device (CCD). See CCD cameras and CCD imaging charts and star atlases, 225-231 Cheshire eyepiece, 94, 329 Clavius (lunar crater), 176 cleaning telescope optics, 326-327 Coal Sack (nebula), 254, 268 Coathanger cluster, 245 coatings, 26, 68 Cocoon Nebula, 254 collimation of telescope optics, 94, 328-331 coma correctors, 81 Comet Hale-Bopp, 13, 180, 183-184 Comet Hyakutake, 17, 182 Comet Ikeya-Seki, 180-181 Comet Ikeya-Zhang, 183, 184 Comet Kohoutek, 181-182 Comet McNaught (2007), 181, 183-184 Comet Shoemaker-Levy 9, 184 Comet West, 181, 182-183 comets, 180-185 computer software for amateur astronomy, 322-326 planetarium (sky simulation) programs, 322-325 conjunctions, 136-137, constellations apparent motion of, 214-217 conventions for amateur astronomers, 167-168 Cornado solar telescopes, 179 Coulter Dobsonian, 32 Crab Nebula. See M1 crepuscular rays, 132 Crescent Nebula (NGC6888), 258 Cygnus star cloud, 233 dark adaptation. See Vision sensitivity Dark Horse, 271 Dawes, William Rutter, 38, 246 Dawes limit, 38 day-sky phenomena, 126-134 deep-sky catalogs, 240-245 filters, 84-85 nomenclature, 232-264 objects, types, 232-270 observing, 232-270 southern-hemisphere objects, 266-

271

Deep-Sky Planner software, 313 dew and anti-dew devices, 90-92 diffraction-limited, 38 digital cameras, 274-278, 286-289, 292 Discovery telescopes, 43 Dobson, John, 32 Dobsonian. See Telescope types Double Cluster (in Perseus), 244 double stars, 246 drives and drive correctors, 92 DSLR cameras in astronomy, 274-290 Dumbbell Nebula. See M27 Dynascope RV-6, 30, 31 Earth Centered Universe software, 313 Earth's shadow, 133 Earthshine, 135 eclipses. See Lunar eclipses and Solar eclipses ecliptic plane, 214-223 ED (extra-low dispersion) glass, 41 Edmund RKE eyepieces, 70 elongation (diagram), 192 Encke gap, 201-202 equatorial mounts, polar-aligning. See website equatorial platforms. See Poncet platforms Eta Carinae Nebula, 266, 271 Evans, Robert, 14 exit pupil, 23 eve relief, 25, 73, 78 evepiece types Barlow. See Barlow lens comparison, 78 Erfle, 71 Huygenian, 71 Kellner, 70 Modified Achromat, 70 Nagler, 71, 74-76 Orthoscopic, 70 Plössl, 70-71 RKE, 70 Ramsden, 71 Wide-Field, 72-73, 75 zoom, 71 eyepieces, 64-81 actual field of view, 66-67 apparent field of view, 66-67 barrel diameters, 67-68, 69 coatings, 68 coma correctors, 81 eye relief, 68, 73-74 eyecups, 69-70 filter threads, 70 filters, 87-85 focal length, 66 magnification, 66 planetary, 80 star diagonal, 77 field of view, 24, 66, 67 orientation, 123 photographic, 297 filters. See also Solar filters lunar, 82-83

nebula, 84-85 planetary, 82-83, 195-196 for visual observing, 82-85 finderscopes, 88-89, 123 field orientation, 123 reflex sighting devices, 88-89 fireball meteors, 143-144 fluorite lens, 41 focal length, 38 focal ratio, 38 focusing a DSLR, 281, 283 focus motors, 97 galaxies, 236, 238, 258-264. See also specific names galaxy clusters, 263-264 Gamma Cygni Nebula, 310 Garnet Star, 248 globular clusters, 238, 250-251 glories, 131 Gould's Belt, 339 green flash, 132 Guide (Project Pluto) software, 324 guiding (for photography), 302-303 Halley's Comet, 180 halos, solar and lunar, 130 Harvest Moon, 133-134 Helix Nebula. See NGC7293 Herschel, Caroline, 242 Herschel, John, 242, 267 Herschel, William, 242, 243 Hewitt-White, Ken, 15-16 Horsehead Nebula, 254, 318 IC433, 315 inferior conjunction, 192 INTES telescopes, 54, 59 Iridium flares, 139 Jupiter, 196-201 moons of, 198, 199-201 Keeler, James Edward, 202 Kemble's Cascade, 252 Lagoon Nebula. See M8 LeDrew, Glenn, 338 Leonid meteors, 143 Levy, David, 262, 263 light-gathering power, 38 light pollution, 156-171 light-pollution filters. See Nebula filters limiting magnitude, 55, 168-171 atmospheric extinction, 171 averted vision, 170 charts, 169, 170 natural sky glow, 171 Local Group (of galaxies), 262 Losmandy mounts, 57-58 low-power limit, 240 Lowell, Percival, 193 lunar atlases, 313 lunar eclipses, 18-19, 140 lunar filters, 82-83 lunar halo, 130 lunar observing and photography. See Moon M1 (Crab Nebula), 257-258 M5, 251 M7, 245

M8 (Lagoon Nebula), 13, 270 M11 (Wild Duck Cluster), 249 M13 (Hercules cluster), 251 M16 (Eagle Nebula), 310 M20 (Trifid Nebula), 234, 270 M27 (Dumbbell Nebula), 255, 256, 266 M31 (Andromeda Galaxy), 226, 227, 241, 258-259, 262, 307 M33 (Triangulum Galaxy), 16, 226, 227, 308 M42 (Orion Nebula), 11, 253 M45 (Pleiades), 234 M51 (Whirlpool Galaxy), 259-260, 316 M57 (Ring Nebula), 235 M65, 264 M66, 264 M78, 253 M81, 262 M82, 262 M88, 310 M101 (Pinwheel Galaxy), 315 M103, 245 M106, 261 M110, 259 MAG1 telescopes, 43, 56 Magellanic Clouds, 267, 270, 271, 285 magnification, 35-36 magnitude, 168-171 Maksutov-Cassegrain. See Telescope types Markarian's Chain (of galaxies), 263 Mars, 192-196 dust storms on, 194 observing, filters, 195-196 oppositions, 195 surface features, 194-197 Meade ETX, 327-329 telescopes, 46-47, 48-51, 54 Medusa Nebula, 257 MegaStar software, 312 Men, Monsters and the Modern Universe, 229 Mercury, 188-190 Messier, Charles, 241 Messier catalog, 241-242 Messier marathon, 238 meteor showers, 142-143 meteors, 141-144 Milky Way Atlas, 338-359 Milky Way Galaxy, 150-154 Sun's position in, 150 viewed from southern hemisphere, 151, 236, 269, 285, 319 Millennium Star Atlas, 230-231 Moon eclipse photography, 18-19, 291-292 illusion, 134 motion of, 220-223 observing, 174-176 photography, 288, 290-291 sketching, 174 moonbow, 129 Moore, Patrick, 13, 243 motions of celestial objects, 208-223

Mount Kobau Star Party, 360 mounts. See Telescope, mounts Mullanev, James, 244 MvSkv, 308 Nagler, Al, 33, 76 naked-eve observing, 126-155 nebula filters, 84-85 nebulas. See also specific names planetary, 235, 237, 255-257 star-forming, 235, 237 Neptune, 204 Newton, Jack, 99, 179 Newtonian. See Telescope types NGC457, 249 NGC891, 236 NGC2392 (Eskimo Nebula), 256 NGC2403, 244 NGC2419, 251 NGC4565, 236, 261 NGC6826 (Blinking Planetary), 256 NGC6888 (Crescent Nebula), 258 NGC6946, 315 NGC7000 (North America Nebula), 233, 240 NGC7293 (Helix Nebula), 256 NGC7662 (Blue Snowball), 256 NGC7789, 249 NGC catalog, 242 NightWatch, 9, 228 noctilucent clouds, 139, 141 Noise Ninja (software), 305 North America Nebula. See NGC7000 north celestial pole, 209-213, 319 North Star. See Polaris northern lights. See Auroras Norton's Star Atlas, 31 observatories for amateur telescopes, 95, 96-97 observing site, 36-37, 162, 163, 164-167 OB associations, 339 Obsession telescopes, 43 Omega Centauri, 234 open clusters, 249-250. See also specific names oppositions of Mars, 195 organizations for amateur astronomers. See website Orion Nebula (M42), 11, 253 Orion telescopes, 43, 59 outdoor-lighting design, 158-162 Parsons, William (Lord Rosse), 260 Petriew, Vance, 184 photography. See Astrophotography piggyback astrophotography, 294-295, 297-299 pixels, 310-314 planetary conjunction, 137 filters, 82-83 nebulas, 235, 237, 255-257. See also specific names planets. See also specific names motion of, 217-218 observing, 188-205 photography, 290

Plato (lunar crater), 175 Pleiades. See M45 polar-aligning, 318-325 polar-alignment scopes, 92, 322-325 Polaris (North Star), 209-210, 225, 319 Poncet platforms, 57, 94-95 Questar telescopes, 45, 46 rainbows, 129 recording observations, 154-155, 174, 265 refractor. See Telescope types resolution, 38 right ascension, 103 Ring Nebula. See M57 Riverside convention. See Star parties Rosette Nebula, 299 rotation of Earth, 208-216 Sampson, Russell, 154-155 satellites, 183-184, 185 Saturn, 201-203 moons of, 203, 204, 205 rings of, 201, 202 Schmidt-Cassegrain. See Telescope types Schmidt-Newtonian. See Telescope types seeing, 169, 193 setting circles, digital, 326 sketching celestial phenomena, 265 Sky Atlas 2000.0, 230 sky measure, 224-226 sky motions of celestial objects, 208-223 SkyWatcher telescopes, 43, 54 Snake Nebula, 254 software for astronomy, 322-326 SOHO (satellite), 178 solar eclipses, 140 filters, 177-179 halo, 130 observing, 176-179 pillar, 130 projection, 178 Southern Cross, 213, 266 southern-hemisphere observing, 266-271 space stations, 138-139 spherical aberration, 336 stacking images, 309, 317, 318 star atlases, 228-231 star clusters Coathanger cluster (Brocchi's Cluster), 245 globular, 234, 238 open, 234, 237 star-hopping, 224-227 star nomenclature, 248 star parties, 167-168 star-trail photography, 274, 286 Starmaster telescopes, 13, 55-56 Starry Night software, 312 Claraplitter telescopes, 43, 59 Stellafane (star party), 167 Stellarvue, 41 streetlights. See Light pollution sundogs, 127, 130 sunset phenomena, 130-133 sunspots, 177 superior conjunction, 192

Takahashi telescopes, 41, 58 Tele Vue, 41, 55, 59 evepieces, 71-81 telecompressors, 312 telescope accessories, 88-99 basics, 124-125 central obstruction, 38 collimation, 94, 328-331 comparison charts, 46 computerized, 34-35 evolution, 30-35 field-of-view orientation, 123 focal length, 38 focal ratio, 38 GoTo, 47, 49, 309-311 GPS, 50-51 jargon, 37, 38 magnification. See Magnification mounts, 39-58, 102-121 altazimuth, 42-43, 47-49 basics, 35-58, 102-122 German equatorial, 53, 104 GoTo, 47, 309-311 polar-aligning. See Polaraligning optics cleaning, 326-327 optics tests, 346-351 performance, 55 resolution, 55, 193 storage, 95 used, 60-61 telescope types, 37, 46 Dobsonian, 32-34, 42-43, 45, 52 Maksutov-Cassegrain, 37, 45-46 Maksutov-Newtonian, 37, 47-48 Newtonian, 30-32, 37, 44 refractor, achromatic, 30, 37, 39-40 refractor, apochromatic, 33, 41-42, 55-61 Schmidt-Cassegrain, 32, 37, 46, 48-51 Schmidt-Newtonian, 37, 44, 46 telescopes for astrophotography, 299-305 Teliad, 89 Texas Star Party. See Star parties TheSky software, 312 Thompson, Gregg, 265 Tirion, Wil, 228-231 TMB telescopes, 42, 59 transits, 140 transient lunar phenomena, 176 Triangulum Galaxy. See M33 Trifid Nebula. See M20 Unition refractore, 30 Uranometria 2000.0, 230 Uranus, 203-204 Veil Nebula, 15, 235, 257, 258, 315 Venus, 190-192 vibration dampeners, 97 Virgo galaxy cluster, 263 vision sensitivity, 14, 89-90, 239 Vixen telescopes, 41, 57 Voyager software, 312 webcam imaging, 290

website: www.backyardastronomy.com websites (recommended), 364 Whirlpool Galaxy (M51), 259-260, 316 Wild Duck Cluster (M11), 249 William Optics, 41, 59 zodiacal light, 144 zoom eyepieces, 71

The Authors

Terence Dickinson

Alan Dyer

Terence Dickinson

Terence Dickinson is editor of *SkyNews*, Canada's national astronomy magazine. In the 1960s and 1970s, he was a staff astronomer at two major planetariums and, since then, has written 14 astronomy books and more than one thousand articles on the subject. His lifelong fascination with astronomy began at age 5, when he saw a brilliant meteor from the sidewalk in front of his home. At age 15, he received his first telescope (a 60mm refractor) as a Christmas gift from his parents.

Dickinson has received numerous national and international awards, among them the New York Academy of Sciences book of the year award and the Astronomical Society of the Pacific's Klumpke-Roberts Award for communicating astronomy to the public. Asteroid 5272 Dickinson is named after him. In 1995, he was awarded the Order of Canada, the nation's highest civilian honor. He and his wife Susan, who has been production manager and copy editor for all his books, live under the dark rural skies of eastern Ontario.

Alan Dyer

Alan Dyer is a writer and producer of multimedia astronomy shows that have played in planetariums across Canada and throughout North America. A former associate editor with *Astronomy* magazine, he currently serves as associate editor of *SkyNews* magazine and is a contributing editor to *Sky & Telescope*.

Dyer is widely recognized as an authority on commercial telescopes, and his reviews of astronomical equipment appear regularly in those publications. He is the author or coauthor of several books, including *Advanced Skywatching; Astronomy: The Definitive Guide;* and *Pathfinders: Space,* a children's astronomy book. Asteroid 78434 is named for him.

Dyer recalls, as a child, asking his parents' permission to stay up late to watch the stars. At 14, using money he had earned from delivering newspapers, he purchased his first telescope—a 4.5-inch Newtonian reflector. His telescope collection has since grown to take over his house in the big-sky country of rural Alberta.

Acknowledgments

We want to thank the readers of the first two editions of The Backyard Astronomer's Guide, who, through their questions and comments, richly contributed to the development of this new edition. A work of this magnitude can be brought to fruition only by a team of skilled professionals. Our thanks go to graphic designers Robbie Cooke, who designed the previous edition, and Michael Webb, for this new enlarged version. Special thanks to our dedicated production manager, Susan Dickinson, whose attention to detail amazes all who know her, and to Bookmakers Press editor Tracy C. Read, who navigated the project through a few tight spots. Janice McLean stepped forward with help when we really

needed it, and Glenn LeDrew created a splendid set of Milky Way atlas charts. Alan Dyer appreciates the contributions by Dennis di Cicco of Sky & Telescope; Simon Hum of ScienceWorks in Calgary; Ken From of All-Star Telescope in Didsbury; Walter MacDonald of Winchester Electronics; Don Hladiuk and the Calgary Centre/RASC (for the great eclipse trips); Christine Pearce, for her southern-hemisphere hospitality; John Sarkissian, Steve Lee, Chris Ramage, Donna Burton and Fred Koch and the 3RF Foundation, for their valuable assistance Down Under; and Bill Peters, Brad Struble and the TELUS World of Science-Calgary, for their ongoing support.